# Women and Music

# Women and Music

*A Selective Annotated Bibliography on
Women and Gender Issues in Music,
1987–1992*

## MARGARET D. ERICSON

G.K. Hall & Co.
*An Imprint of Macmillan Publishing Company*
*New York*

*Prentice Hall International*
*London  Mexico City  New Delhi  Singapore  Sydney  Tokyo*

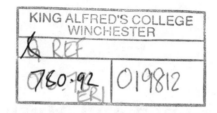
G.K. Hall & Co.
Simon & Schuster Macmillan
866 Third Avenue
New York, NY 10022

Library of Congress Catalog Card Number:

Printed in the United States of America

Printing Number
1 2 3 4 5 6 7 8 9 10

Library of Congress Cataloging-in-Publication Data

Ericson, Margaret.
    Women and music  :  a selective annotated bibliography on women and
  gender issues in music, 1987–1992 / Margaret Ericson.
      p.    cm.
    Includes index.
    ISBN 0–8161–0580–4 (alk. paper)
    1. Women musicians—Bibliography.    2. Feminism and music—
  Bibliography.    I. Title.
  ML128.W7E75    1995
  016.78'082—dc20
                                                              94–45222
                                                                 CIP
                                                                  MN

# Contents

Preface    ix

Acknowledgments    xv

Core Indexes, Catalogs, and Abstracting Sources Consulted    xvii

User's Guide    xix

**I.** Reference and Research Literature on Women,
Gender, and Music    1

   A. Access to Literature: Bibliographies, Discographies, and
       Catalogs    1
   B. Encyclopedias, Dictionaries, and Directories    11
   C. Statistical Data    15
   D. Online Information Sources    16

**II.** General Literature on Women, Gender, and Music    18

   A. Periodicals    18
   B. Collected Literature, Review Essays,
       and Other General Perspectives    23
   C. Festival, Concert, and Conference Review Literature    41
   D. Literature on the Production and Distribution of
       Women's Music: Publishers, Record Companies,
       Distributors, Libraries, and the Media    57

**III.** Recent Perspectives on Women in the Music Professions:
Professional Organizations and Issues of Professional Status    64

   A. General Perspectives    64
   B. Women Composers    73
   C. Women Performers and Conductors    79
   D. Women Music Educators and Musicologists    86
   E. Women in Arts Management, Technical Production, and Other
       Professional Roles    89

**IV.** Feminist Musical Aesthetics   93

**V.** Women and Gender Issues in Music Education   99

**VI.** Western Art Music, Secular and Sacred: Literature on Women Musicians and the Role of Women in European and American Musical Culture   113

    A. General Perspectives   113

    B. Historical Perspectives   133

       *1. To 500*   133

       *2. 500–1400*   135

       *3. 1400–1600*   139

       *4. 1600–1800*   145

       *5. 1800–1900*   153

       *6. 1900–present*   167

**VII.** Women in Jazz and Popular Music   187

    A. General Perspectives   187

    B. Popular Music and Musical Theatre   191

    C. Rock Music   195

    D. Jazz and Experimental Music   207

    E. Blues and Gospel Music   215

    F. Rap and Hip-Hop   219

    G. Folk and Country Music   222

    H. Woman–Identified Music   225

    I. Music of Labor and Political Protest   230

**VIII.** Women, Gender, and Music in Non-Western Cultural Contexts   232

    A. General and Cross-Cultural Perspectives   232

    B. Geo–Cultural Zones   241

       *1. Africa*   241

       *2. Asia, Australia, New Zealand, and Oceania*   246

       *3. Europe*   257

       *4. Middle East*   264

       *5. North America*   268

       *6. Central and South America*   271

# Contents

IX. Women, Gender, Music, and Forms of Representation   274
    A. General and Multidisciplinary Perspectives   274
    B. The Construction of Gender in Western Art Music   282
    C. The Construction of Gender in Popular Music Forms   295
    D. The Construction of Gender in Music Video
       and Cinematic Music   305
    E. Music Iconography and the Representation of Women   310

X. Gender and Audience Reception, Music Preference,
   and Women's Uses of Music   316

XI. Psychological and Physiological Studies on Women
   and Gender Issues in Music   323

XII. Score Anthologies in All Musical Genres   330

XIII. Sound Recording Anthologies   340
    A. Concert Music: Contemporary and "Classical"   340
    B. Recordings in Various Popular Genres   352

XIV. Audio/Visual Media   364

XV. Publishers, Record Labels, and Distributors Featuring
   Women in Music Materials   369

Name Index   373
Subject Index   387

# Preface

International in scope, and broad in its topical coverage, *Women and Music: A Selective Annotated Bibliography on Women and Gender Issues in Music, 1987–1992* is an annotated guide to publications issued during this period which investigate issues with regard to women, gender, and music, in a collective sense. Publications listed include books, essays, periodical articles, theses, conference papers, newspaper articles, score anthologies, sound recording anthologies, and media, as well as several online information sources. While this bibliography does not include biographical studies of individual women musicians, it does bring to light publications which consider not only the collective musical activities of women in historical and contemporary cultural contexts, but also the manner in which gender, as a sociocultural construct, has been an influential factor in the formation and production of musical culture, and thus also influences a woman's role in and relation to that culture. This latter perspective has particularly come to the fore since 1987, as music scholars utilize the windows of social, cultural, and psychological theory, and especially those theories informed by feminism and gender study, in order to open new vistas in the field of music criticism.[1]

The origins of this project can be traced back to 1986, when my professional activity within the Music Library Association involved moderating a plenary session at the Association's annual conference, which was held that year in Milwaukee, Wisconsin. The session was entitled "Making Changes: Women and Music 1970–1985." The variety of topics presented, the engaging and savvy manner in which the speakers[2] approached their subject, as well as the timely nature of this assemblage seemed to capture the minds and imaginations of those attending this forum, one of the very few (if not the first) devoted to women in music sponsored by the Music Library Association. Indeed, the enthusiasm with which these presentations were greeted was followed immediately by a series of actions leading to the formation, in 1986[3], of the Women and Music Roundtable of the Music Library Association, with the Juilliard School's Jane Gottlieb as Chair.

The Roundtable's first meeting at the 1987 MLA conference was one in which the participants took stock of their needs and interests, as both librarians charged with managing collections and information services, and as researchers preparing work for publication. While a handful of colleges and universities had

established programs in which women and gender issues in music were part of the course of study, others were just beginning. At that time, few libraries had strong collections on women in music; some were in the initial stages of building their library print and non-print collections to support new course offerings on women and music as well as faculty research; more were to begin this activity in the future. The Roundtable members noted that while a forum dedicated to general discussion as well as to the presentation of individual research was of major importance, something more immediate and tangible was needed—a bibliography (not surprisingly)—to enable music librarians to be apprised of the many new, but often elusive, publications on women in music issued in the form of books, journal articles, published research (e.g. dissertations, conference papers, etc.), musical scores, sound recordings, and other media.

As Information Coordinator of the Women and Music Roundtable, I was enlisted to produce an annual bibliography, so as to provide a modicum of access to the most current publications in the field of women and music. While a comprehensive list devoted to ALL material on women's individual and collective musical activities as well as feminist perspectives on women in music would be ideal, such an undertaking was beyond the scope of any individual effort at this early stage of the Roundtable's activity. Access to current material which examined the collective aspects of women's music-making, however, would provide a starting point from which further specialization on an individual woman musician could be pursued. In addition, it was very clear, even at this initial stage, that the field of "women and music" was not limited to a recovery of the history of individual women musicians throughout the musical past. The possibilities offered by feminist and gender theory as it could be applied to musicology, music theory, ethnomusicology, the sociology of music, and other realms of interdisciplinary music study were beginning to emerge, and this new phase of inquiry needed to be represented in any such bibliography.

From 1987 to 1990, I compiled a series of annual bibliographies for the Women and Music Roundtable under the title: *Women and Music: A Selective Bibliography on the Collective Subject of Women and Music.* The burgeoning amount of published information on women and music issued during this period, the continuation of this trend into the 1990s, and the sheer size of the database which I produced by creating these annual lists demonstrated the need for an indexed, annotated cumulation. It is from these roots that the volume before you has come forth.

This greatly expanded, book-length version contains citations to over 1800 sources on women, gender, and music issued between 1987 and 1992, as well as some important new publications issued in 1993. Reference materials from a variety of disciplines have been consulted. (See list of "Core Indexes, Catalogs, and Abstracting Sources Consulted," following the Acknowledgements.) Selected for inclusion are publications originating from the scholarly press, the alternative press, and the popular press. Both domestic and international publications are included. Literature on Western Art Music as well as numerous vernacular forms is included. It is the intention that through the presentation of a diverse range of topics, per-

spectives, and viewpoints, this bibliography may suggest avenues of possibility for future research.

As mentioned above, due to the general focus of the bibliography, biographies of individual women musicians have not been included. However, there is one case in which the author has taken exception to this parameter. Monograph-length essay collections devoted solely to women in music receive full analytic treatment, in order to provide access to the contents of a collected work. In doing so, a few essays focusing on individual women have been cited.

The literature enumerated in *Women and Music . . . 1987–1992* reflects both the new areas of inquiry and the more conventional methods of research and reportage in this subject area. This poses a challenge for the bibliographer when organizing a corpus of literature: does one simply continue to utilize the conventional methods of classifying information, or, does one begin anew? The author has chosen a path somewhere between, using conventional historical and geographic subdivisions for literature specific to a particular time or place, classifying some materials by format when appropriate (e.g. reference works, scores, sound recordings, media), and creating new classifications to accommodate the new forms of inquiry. In classifying the literature, and then by annotating and indexing the materials chosen for inclusion, the bibliography thus provides various means of subject access to information contained in such collective treatments.

Descriptive annotations have been written to accompany most of the citations, especially when the publication title does not adequately describe the intellectual content of the item for either reader purposes or indexing purposes. Occasional difficulties with access may have precluded the addition of an annotation to the citation.

Access also figures into the "Selective" designation in the title. While *Women and Music: A Selective Annotated Bibliography. . .* is reasonably comprehensive, there are conditions relating to the inaccessibility of materials that prevent the author from making any claims to comprehensivity.

Musicologist Marcia Citron recently recognized that there is "a serious problem in the distribution of [women in music] publications on the international level. Thus, countries on the Continent are not in the pipeline for English language materials, while the Anglo-American sector is hard-pressed to find out about materials in other languages."[4] By making this bibliography international in scope, this author seeks to redress some of these barriers. Some international literature, however, may have been inadvertently overlooked due to the boundaries of language and geographic distribution. Furthermore, the difficulties with the accessibility of newly published materials on women and gender issues in music go beyond those posed by geography and language.

A far more subtle question, and one which needs more research, is posed by the varietal nature of the practice of subject analysis as applied to materials in this field by those creating our indexes and library catalogs. Here, one often finds the inconsistent use of subject terms, various modes of specificity, and the inadequate application of existing standardized headings to publications on women musicians, their musical history as seen within a larger sociocultural context, and feminist and gender issues in music. The implications of this situation on information retrieval

have been recognized by Margaret N. Rogers[5], Joyce Duncan Falk[6], and Mary Wallace Davidson[7].

Another barrier to retrieving current material on this subject is the regrettable lack of timeliness in music's major indexing sources (e.g. *Music Index* and *RILM Abstracts*). In addition, the "small press" nature of many publications in this field, especially those offering feminist/lesbian perspectives, while not an insurmountable barrier, also makes expeditious access problematic.

Therefore, in addition to searching a selection of core indexes and catalogs, other methods of bibliographic sleuthing were utilized, and provided significant results. First, since current publications were of importance, music publisher and vendor catalogs were consistently perused. Second, lists of new publications and current bibliography columns in music journals such as such as *Notes, Ethnomusicology, Journal of the American Musicological Society, Sonneck Society Bulletin*, etc., were also consulted. The international, research-level collections of the Music Library and Olin Library at Cornell University provided much of the resource material needed. The third alternative used by this author was to regularly peruse the new acquisitions of the music libraries at Cornell University and Ithaca College. In this manner, I would serendipitously discover significant discussions on our topic which may not have been found through the traditional channels of bibliographic searching. Fourth, footnotes, lists of cited sources and bibliographies to relevant essays, articles, monographs, etc., also provided a means by which one might discover new sources. Fifth, reviews in current periodicals apprised the author of significant new publications. Ithaca College's Music Library served to be a fine resource for journal literature in music education and performance, and complemented Cornell's international collection of musicology and ethnomusicology periodicals.

With only a few exceptions, relevant materials not located at either Cornell University or Ithaca College were efficiently procured through the Interlibrary Loan Department of the Ithaca College Library. Most interlibrary loan requests were placed for materials published in Europe, as well as for "Other"[8] popular music literature, women's studies publications, and small press feminist/lesbian publications.

The above discussion only serves to emphasize that the comprehensive and accurate retrieval of timely information on this subject can be a challenging enterprise, and that one should approach research on women, gender issues, and music with both creativity and diligence.

## NOTES

1. For an eloquent introduction to the issues, concerns, and interdisciplinary nature of feminist musicology, see Jane Bowers, "Feminist Scholarship and the Field of Musicology: I," *College Music Symposium* 29 (1989): 81–92 and "Feminist Scholarship and the Field of Musicology: II," *College Music Symposium* 30, no. 1 (Spring 1990): 1–14.
2. The speakers at this session were Peggy Daub (Head, Special Collections and Arts Libraries, University of Michigan), Jane Bowers (Faculty, Department of Music,

University of Wisconsin-Milwaukee), Stephen Fry (Music Librarian, UCLA) and Bonnie Jo Dopp (then Reference Librarian, Music Division, District of Columbia Public Library)

3. Copy of a letter dated September 19, 1986, from Geraldine Ostrove, then the President of the Music Library Association, to Jane Gottlieb, Librarian of the Juilliard School, establishing the formation of the Music Library Association Women and Music Roundtable with Ms. Gottlieb as its first Chair.

4. Marcia J. Citron, "Conference Report: 'Beyond Biography: Seventh International Congress on Women in Music' and 'Music and Gender Conference'," *Journal of Musicology* 9, no. 4 (Fall 1991): 544.

5. Margaret N. Rogers, "Are We On Equal Terms Yet? Subject Headings Concerning Women in LCSH, 1975–1991," *Library Resources & Technical Services* 37, no. 2 (April 1993): 181–196.

6. Joyce Duncan Falk, "Humanities," in *Women Online: Research in Women's Studies Using Online Databases*, ed. Steven D. Atkinson and Judith Hudson. Haworth Series on Library and Information Science, no. 3. (New York: Haworth, 1990), pp. 7–72.

7. Mary Wallace Davidson, "American Music Libraries and Librarianship: Challenges for the Nineties," *Notes* 50, no. 1 (September 1993): 18–19.

8. For a definition of "Other," see Maggie Humm, *The Dictionary of Feminist Theory*. (Columbus, OH: Ohio State University Press, 1990), p. 156. The term is used in this case to describe publications often viewed as "outside the conceptual system" of mainstream musicology, and thus are sometimes considered to be marginal by those developing the collections of college and university libraries.

# Acknowledgements

The compilation of this volume would not have been possible without the helpful assistance and encouragement of the editorial staff of the G.K. Hall Library Reference Division, the library staff and administration of Ithaca College, my colleagues from the Music Library at Cornell University, and fellow members of the Music Library Association.

For her virtuous patience and belief in this project, I would like to thank, first and foremost, Donna Sanzone, Editor-in-Chief of G. K. Hall Library Reference. Hats off as well to G.K. Hall's Jennifer Karmonick, Andrew Ambraziejus, and Sabrina Bowers, for their prompt and always cordial editorial assistance.

For the ability to receive partially compensated leave time, I thank the Administration of Ithaca College and particularly W. Robert Woerner, the former Director of the Ithaca College Library, who firmly supported this endeavor from the project's beginnings in 1987 through its final phase in 1993. In addition, I would like to thank his successor, Margaret Johnson, whose flexibility enabled the author take some additional leave time from her position as Assistant Music/Audio Librarian, in order to finish the bibliography. The Ithaca College Library's Interlibrary Loan staff (Betty White, Natalie Sheridan, and Ben Hogben) did a first-rate job of expediting the steady stream of requests for hard-to-find materials which required my perusal. Reference Librarians John Henderson and Debra Lamb-Deans expertly performed the necessary online database searching (DIALOG) of certain indexes and abstracting sources. My colleagues in the Music/Audio Department of the Ithaca College Library, Betty Birdsey and Judith Andrew, were more than co-operative in accommodating for my leave of absence in 1993. Student library workers Mary Holzer, Eve Farr, and Jennifer Libby contributed to this effort as well, by performing a variety of clerical tasks during the bibliography's initial stages.

The librarians and staff of the Cornell University Music Library were most cooperative in allowing me to gain ready access to recently received materials on our topic. In particular, I would like to thank Lenore Coral, Music Librarian at Cornell University, for her efforts on my behalf. Lenore was, and continues to be, a valuable mentor and friend, always generous with her time, expertise, and support.

Colleagues in the Music Library Association, such as Jane Gottlieb, Cynthia Richardson, Stephen Fry, Bonnie Jo Dopp, Judy Tsou, Ralph Papakhian, Richard

Griscom, Jeannie Pool and others, offered encouraging words, advice, and informational assistance.

Authors, editors, and publishers of works supplied details concerning their publications and offered editorial advice): Marcia Citron, J. Michele Edwards, Judy Tsou, Antje Olivier, Barbara Garvey Jackson, Mary Louise Van Dyke, *Hot Wire* (Toni Armstrong, Jr.), Pauline Jones, Eva Rieger, Helen Weems, the Association of Canadian Women Composers, the International League of Women Composers (Elizabeth Hayden Pizer and Sally Reid), American Women Composers, *Women of Note Quarterly* (Jonathan Yordy), Johanna Johnson (Women's Philharmonic), Selma Epstein (Chromattica U.S.A.), Rosetta Reitz (Rosetta Records), John Gray, Joel Cowan, and others are to be thanked in this regard.

The author's desire to bring this project to fruition was most certainly bolstered by the kind and helpful encouragement of several individuals who have led the way in feminist musicology, including Nancy Reich, James Briscoe, Jane Bowers, and Eva Rieger.

For their assistance with translations of Swedish language publications, I thank Jenny Eklund and Birgitta Hansson.

Finally, for their advocacy of my professional pursuits while battling personal illness, perhaps too selfless a gesture given the circumstances, I would like to dedicate this volume to my late husband Jon Ericson and my late father Khatchik Donelian. The memory of their lives continues to affect me profoundly.

Margaret Donelian Ericson
Ithaca, New York
1994

# Core Indexes, Catalogs, and Abstracting Sources Consulted

*Academic Index*. Foster City, CA: Information Access.

*Alternative Press Index*. Baltimore, MD: Alternative Press Center.

*Arts and Humanities Citation Index*. Philadelphia, PA: Institute for Scientific Information.

*Bibliographic Guide to Music*. New York, NY: G.K. Hall.

*Book Review Index*. Detroit, MI: Gale Research.

*Books in Print,* also *Forthcoming Books*. New Providence, NJ: R.R. Bowker

*British Humanities Index*. London: Bowker-Saur.

*Canadian Periodical Index*. Toronto: Globe and Mail Publishing.

*The Classical Catalogue (Gramophone)*. Monthly Supplement. Harrow, Middlesex, England: General Gramophone Publications.

*Communications Abstracts*. Newbury Park, CA: Sage Publications.

*Deutsche Nationalbibliographie: Reihe M. Musikalien und Musikschriften.* Monatliches Verzeichnis. Frankfurt am Main: Buchhändler-Vereinigung Gbmh.

*Dissertation Abstracts*. Ann Arbor, MI: University Microfilms.

*ERIC*. Washington, DC and Bethesda, MD: Educational Resources Information Center, Office of Educational Research and Improvement, U.S. Department of Education.

*Essay and General Literature Index*. Bronx, NY: H.W. Wilson.

*Historical Abstracts*. Santa Barbara, CA: A B C-Clio.

*Humanities Index*. Bronx, NY: H.W. Wilson.

*Index to Black Periodicals*. New York, NY: G.K. Hall.

*Magazine Index*. Foster City, CA: Information Access.

*Modern Language Association International Bibliography of Books and Articles on the Modern Languages and Literatures*. New York, NY: Modern Language Association of America.

*Music Index*. Warren, MI: Harmonie Park Press.

*Music Article Guide*. Philadelphia, PA: Information Services.

*National Newspaper Index*. Foster City, CA: Information Access.

*Newsbank: Review of the Arts. Performing Arts*. New Canaan, CT: Newsbank, Inc.

*OCLC Database*. Dublin, OH: OCLC, Inc.

*PsychInfo*. New York, NY: American Psychological Association.

*RILM Abstracts of Music Literature*. New York, NY: International RILM Center, City University of New York.

*Schwann Catalogs: Opus and Spectrum*. New Listings Section. Santa Fe, NM: Stereofile, Inc.

*Sociological Abstracts*. San Diego, CA: Sociological Abstracts, Inc.

*Women's Studies Abstracts*. New Brunswick, NJ: Transaction Periodicals Consortium.

*Women's Studies Index*. New York, NY: G.K. Hall.

*Zeitschriftendienst Musik*. Berlin: Deutsches Bibliotheksinstitut.

# User's Guide

Since this bibliography is a compilation of sources on the collective treatment of topics relevant to women, gender, and music, access to the intellectual content of these sources is of utmost importance. The organization of this volume is such that the user will be able to utilize a variety of approaches to find literature of interest.

The basic organization of the bibliography is by subject. Below is a listing of the categories with a brief explanation as to the scope of each topic.

I. Reference and Research Literature: Cites bibliographies, discographies, catalogs; encyclopedias, dictionaries, directories; sources of statistical data; online information sources.

II. General Literature on Women, Gender, and Music: Lists periodicals focusing exclusively on women in music, as well as citations to special issues of other periodicals in the humanities devoted to feminist and gender issues in music; collected literature, review essays, and other general perspectives on the topic; reviews of festivals, concerts, and conferences; literature on the production and distribution of music by women, including sources on music publishers, record companies, libraries, media, and distributors of women's music.

III. Recent Perspectives on Women in the Music Professions: Enumerates literature on the activities of recently established professional associations representing the concerns of women in music, as well as literature focusing on the status of today's women employed in particular roles, i.e. as composers, performers, educators, musicologists, arts managers, etc.

IV. Feminist Musical Aesthetics: Cites material with a philosophical perspective on the creation of and appreciation for women's musical activities, as well as literature utilizing feminist theory to inform its consideration of music as an art form.

V. Women and Gender Issues in Music Education:
Includes research investigating gender differences in the education and practical training of music students, literature examining discriminatory attitudes against women as manifested in methods and materials music education, and literature which identifies strategies to reach the goal of gender equity in the music classroom.

VI. Western Art Music, Secular and Sacred: Includes general and historical perspectives on women's musical activities within the primarily European and American "concert" tradition, as well as the role of women in the cultivated musical milieu of the West.

VII. Jazz and Popular Musics: Identifies literature on women musicians in pop, musical theater, rock, jazz, experimental music, blues, gospel, rap, folk, country, as well as women musicians performing within the feminist and lesbian cultural network, and women's music associated with labor and political protest.

VIII. Women, Gender, and Music in Non-Western Cultural Contexts:
Identifies literature emanating primarily from publications within the fields of ethnomusicology, anthropology, and folklore, and/or literature examining women's musical activities either cross-culturally or within a particular geo-cultural area.

IX. Women, Gender, Music, and Forms of Representation: Includes literature which examines the manner in which gender manifests itself within writings about music, in musical works themselves, and in texts accompanying musical works, including the construction of gender in instrumental and vocal music, and the representation of women in particular in concert and vernacular musics; the construction of gender in music video and cinematic music, including again the representation of women in these forms; and the representation of women in music iconography and the insights we may gain from such analyses.

X. Gender and Audience Reception, Music Preference, and Women's Uses of Music: Primarily sociological perspectives on gender differences in the reception of music by listening audiences, studies investigating gender differences in preferences and uses of particular types of music, and the implications of such perceptions and preferences for cultural production.

XI. Psychological and Physiological Perspectives on Women and Gender Issues in Music: Literature emanating primarily from the fields of psychology (clinical, social, developmental, etc.), music therapy, and medicine; examines a variety of topics, such as the study of gender differences in creative ability as measured during the stages of human development, medical problems of female musicians, music therapy as used in a variety contexts, studies of female performers with disabilities, music and its effect on human behavior in social contexts, etc.

XII. Score Anthologies: Concert and popular musical works, published in musical score collections or series.

XIII. Sound Recording Anthologies: Recorded collections of musical works by women; includes concert music and vernacular music forms.

XIV. Audio/Visual Media: Videos, films, or other media on women musicians active in all genres.

XV. List of Women's Music Publishers, Record Companies, and Distributors; with addresses and phone numbers (whenever possible).

The Name Index provides access to all names in the body of a bibliographic entry: names of authors, compilers, and editors; names of persons about whom a particular source is written or produced; names of composers represented in anthologies; etc. Headings in the Name Index refer the reader to entry numbers in the bibliography (not page numbers). When the form of a woman musician's name varies from publication to publication (as it frequently does), I have chosen the most authoritative usage for the Name Index entry (e.g. Library of Congress, *New Grove Dictionary of Music and Musicians*, or, when usage varies even among standard reference works, the most common or current usage of a name as found in the publications cited). Cross-references have been made between the alternate forms of a name and the name chosen for the index entry.

The Subject Index provides more in-depth access to topics discussed in a given entry, and should be used to find additional sources on your topic than those already collocated through the general classifications used in the bibliography. Headings in the Subject Index refer one to entry numbers in the bibliography (not page numbers).

## SAMPLE ENTRIES

### An Essay in a Book:

[1]142. [2]Funayama, Nobuku. [3]"Frau und Musik in Japan." In [4]*Komponistinnen in Japan und Deutschland: eine Dokumentation*, [5]ed. Renate Matthei, [6]pp.9–17. [7]Furore Edition 853. [8]Kassel, Germany: [9]Furore-Verlag, [10]1991.
[11]ISBN 3927327093. In German. The author begins with a survey of the educational system in Japan and a discussion of the traditional and western-influenced musics of Japan. She then examines the roles and contributions of women to Japan's musical history.

1. Entry number.
2. Author of the essay.
3. Title of the essay.
4. Title of the book.
5. Editor.
6. Volume and/or page numbers.
7. Series.
8. Place of publication.

9. Publisher.
10. Date of publication.
11. Annotation, included when the entry does not provide enough description about the work. Includes, variously, ISBN (for non-U.S. publications; when available), language of publication, and a description of the contents. Annotations to full-length monographs often cite a reviewing source.

**Periodical article:**

[1]201. [2]Anderson, Jamie. [3]"Women's Music and Culture Festivals." [4]*Hot Wire* [5]8, no. 2 [6](May 1992): [7]32-34.
   [8]A listing of women's music festivals in the U.S. and Canada with basic descriptive information about each (e.g. date, ticket prices, audience, facilities, address, phone, etc.)

1. Entry number.
2. Author of the article.
3. Title of the article.
4. Title of the periodical.
5. Volume and issue number.
6. Date of issue.
7. Page numbers.
8. Annotation, when the title of the article does not fully describe the contents.

**Musical Score:**

[1]1625. [2]Harbach, Barbara, ed. [3]*Eighteenth Century Women Composers for the Harpsichord or Piano*. Volume 2. [4]Pullman, WA: [5]Vivace Press, [6]VIV 1802, [7]1992.
   [8]Reviewed in *Continuo* 16, no. 3 (June 1992): 30; *American Music Teacher* 42, no.3 (December/January 1992/1993): 71. Includes: *Sonata No. 3 in A Major* by Marianne Martinez; *Sonata in C Major, op. 7* by Maria Hester Park.

1. Entry number.
2. Editor or compiler.
3. Title of anthology.
4. Place of publication.
5. Publisher.
6. Music publisher number.
7. Date of publication.
8. Annotations, including (variously), a reviewing source, description of the edition and whenever possible, a listing of the contents.

# Reference and Research Literature on Women, Gender, and Music

## Part A. Access to Literature: Bibliographies, Discographies, and Catalogs

1. Allen, Sue Fay, and Kathleen Keenan-Takagi. "Sing the Songs of Women Composers." *Music Educators Journal* 78, no. 7 (March 1992): 48–51.

    Part of a special issue on women in music. An annotated list of choral repertoire by women composers for middle school, junior high, and high school voices.

2. Bickel, Jan E. *Contemporary Art Song: An Annotated Bibliography of Selected Song Literature Appropriate for the Undergraduate and Master's Level Mezzo-Soprano Voice*. Diss. D.M.A., American Conservatory of Music, 1992.

    Abstract in *Dissertation Abstracts International: A. Humanities and Social Sciences* 53, no. 4 (October 1992): 978. DA# 9223051.

3. Boenke, Heidi M. *Flute Music by Women Composers: An Annotated Catalog*. Music Reference Collection, no. 16. Westport, CT: Greenwood Press, 1988.

    Reviewed in *Choice* 26, no. 7 (March 1989): 1116; *Notes* 47, no. 2 (December 1990): 396–397. This guide to flute music by women composers is arranged alphabetically by composer name. Annotations include a brief biographical sketch (with the composer's dates, educational background, activities, awards, etc., according to availability of the information), followed by titles of works composed with the date of completion, instrumentation, publisher and date (if published), relevant commentary, and source of information. Instrumentation and title indexes are included, as are publisher and composer address listings and a bibliography.

4. Bowers, Jane M., and Urban Bareis. "Bibliography on Music and Gender—Women in Music." *World of Music* 33, no. 2 (1991): 65–103.

    Part of a special issue on "Women in Music and Music Research," this is an extensive bibliography of primarily ethnomusicological publications on women, music, and gender, dating from about 1960 to 1990.

5. Brady, Anna. *Women in Ireland: An Annotated Bibliography*. Westport, CT: Greenwood Press, 1988.

    See index: "Biography and Autobiography—Performing arts," #440–504; "Literature, folklore and mythology—Depiction of women," #824–981.

6. British Library. *The Catalogue of Printed Music in the British Library to 1980*. Ed. Laureen Baillie. London, England: K.G. Saur, 1981–1987.

    Entries in the catalog for titles of works are listed by the first word of "distinctive" titles. Therefore, a search under gender-specific terms such as "woman", "women", "women-folk", "female", "femme", "femmes", or "ladies" is particularly useful for identifying eighteenth and nineteenth-century songs, ballads, etc., on this particular theme.

7. Buzzarté, Monique. "Women's Contributions to the Brass Repertoire: A List of Works." In *The Musical Woman: An International Perspective. Volume 3, 1986–1990*, ed. Judith Lang Zaimont, Jane Gottlieb, Joanne Polk, and Michael J. Rogan, pp. 547–652. Westport, CT: Greenwood Press, 1991.

    This listing of 785 solo and ensemble brass compositions by 364 women from 33 countries is introduced by an explanation of the author's research methodology, as well as an analysis of the titles listed by instrumentation, composer nationality, availability through publication, etc. Appended is a discography, as well as composer/publisher/record company addresses.

8. Canadian Women's Indexing Group. *Canadian Feminist Periodicals Index, 1972–1985 / Index des périodiques féministes canadiens, 1972–1985*. Resource Series, no. 2. Toronto: Canadian Women's Indexing Group, 1991.

    ISBN 0774403470. Includes a separate thesaurus volume of descriptors used in the general subject index. Text in English and French. This comprehensive index to articles published from 1972 to 1985 in fifteen Canadian feminist periodicals provides collective access to information on the feminist music movement in this country, and particular access to music and festival reviews, and articles on women composers and musicians active in all genres published in these periodicals. There are indexes for authors, titles, and subjects (with English and French descriptors). The subject index is bilingual, with French language publications being indexed under corresponding French thesaurus terms, and English language publications being indexed under English thesaurus terms. Likewise, the specificity of indexing terms makes the separate thesaurus volume essential when consulting the

general subject index, so that one can ascertain the various permutations of music headings used if one is doing a general search on "musicians", for example. Otherwise, a monumental effort and one which provides access to information on feminist and lesbian perspectives on music.

9. Carr, Ian. "Diskographie." *du: Die Zeitschrift der Kultur*, no. 4 (April 1992): 92.
   A discography of female jazz vocalists.

10. Davis, Gwenn, and Beverly A. Joyce. *Personal Writings by Women to 1900: A Bibliography of American and British Writers*. London: Mansell Publishing Limited, 1989.
    See index: "Musicians" and "Festivals and Fairs."

11. DeVenney, David P. *Nineteenth-Century American Choral Music: An Annotated Guide*. Berkeley, CA: Fallen Leaf Press, 1987.
    See Index A4: Works for Women's Voices (pp. 131–133).

12. Dickstein, Ruth, Victoria A. Mills, and Ellen J. Waite. *Women in LC's terms: A Thesaurus of Library of Congress Subject Headings Relating to Women*. Phoenix, AZ: Oryx Press, 1988.
    See Chapter 12, "Visual and Performing Arts," pp. 130–135; also Appendix V, "Library of Congress Call Numbers Assigned to Women and Topics Relating To Women: M —Music," pp. 188-190.

13. Dopp, Bonnie Jo. "Building a Women's 'Message Music' Collection: A Bibliography for Librarians." *Cum Notis Variorum*, no. 112 (May 1987): 7–9.
    A core, annotated bibliography on feminist and women's music; includes periodicals, books, articles, printed music and record review sources.

14. Duckles, Vincent H., and Michael A. Keller. "Women and Music." In *Music Reference and Research Materials: An Annotated Bibliography*. 4th ed, pp. 528–530. New York: Schirmer, 1988.

15. Epstein, Selma. *A Guide For Researching Music by Women Composers*. Dickeyville, MD: Chromattica USA, 1990.
    The author provides a twofold approach to researching women composers and locating their repertoire, which fequently is either unpublished or accessible only through library collections or special research centers. The first three sections of the book identify the organizations supporting women composers and their activities: professional composer associations and national music centers; those institutions which collect, house and lend musical scores; and special research centers, particular those which specialize in the music of black composers. The remainder of the guide serves a bibliographical function, as it selectively lists bibliographies, collective and individual biographical works, journal articles and dissertations on women composers.

16. Gray, John. *African Music: A Bibliographical Guide to the Traditional, Popular, Art and Liturgical Musics of Sub-Saharan Africa*. Westport, CT: Greenwood Press, 1991.

    See references listed in the Subject Index (p. 449) under the headings "Women Musicians" and "Women's Music".

17. Gray, John. *Fire Music: A Bibliography of the New Jazz 1959–1990*. Westport, CT: Greenwood Press, 1991.

    The subject index, under the topic "Women Musicians" (p. 483) lists about 260 references to sources on various individual women jazz musicians.

18. Gray, Michael. "'Women composers' and 'Women musicians'." In *Classical Music Discographies: A Bibliography*, pp. 294–295. Westport, CT: Greenwood Press, 1989.

19. Green, Cynthia. "Published Oboe Works by Women Composers."*Double Reed* 10, no. 3 (Winter 1987): 33–34.

20. Guelker-Cone, Leslie. "Music for Women's Voices by Contemporary Women Composers of the United States and Canada." *Choral Journal* 32, no. 10 (May 1992): 31-40.

    This annotated bibliography of selected repertoire includes the following information: composer, title, voicing, instrumentation, length, difficulty level, publication information, and a brief description of each piece.

21. Harrison, Daphne Duval. "'Classic' Blues and Women Singers." In *The Blackwell Guide to Blues Records*, ed. Paul Oliver, pp. 83–111. Oxford: Blackwell, 1989.

22. Heinrich, Adel. *Organ and Harpsichord Music by Women Composers: An Annotated Catalog*. Music Reference Collection, no. 30. Westport, CT: Greenwood Press, 1991.

    This valuable addition to the bibliographic literature on the repertoire of women keyboard composers lists pieces for organ or harpsichord alone, and with instruments and/or voices. The main body of the book is comprised of an alphabetical composer listing, with annotations for each work composed. Information provided in each composer/title entry includes: composer name, country of origin, the title of the work, duration, difficulty level, commentary to aid in the identification and description of the piece (commissions, dedications, etc.), and availability of the score (either from a publisher, library collection or from the composer). Instrumentation and title indexes provide additional access. Particularly helpful for the performer and researcher is the "Composers' Biographies (with addresses)" section, providing paragraph length biographies of composers listed in the first section, with an indication as to the source(s) of the data. A "Chronological Listing of Composers by Country" adds another dimension of access for those interested in identifying women composers of a particular country.

23. Hessen, Ro van, and Helen Metzelaar. *Vrouw & Muziek: Informatiegids.* Swammerdamstraat 38, 1091 RV Amsterdam, The Netherlands: Stichting Vrouw en Muziek, 1989.

    In Dutch. Translated title: *Woman and Music: An Information Guide.* This bibliography on women in Western art and popular musics also features an extensive list of Dutch women composers and locations of their musical scores in public libraries in the Netherlands.

24. Horn, David, and Richard Jackson. "General Works: Women in Music." In *The Literature of American Music in Books and Folk Music Collections: A Fully Annotated Bibliography. Supplement I*, pp. 11–14. Metuchen, NJ: Scarecrow Press, 1988.

25. Horn, David, and Richard Jackson. "Rock and Roll, Rock, and Pop: Women Performers." In *The Literature of American Music in Books and Folk Music Collections: A Fully Annotated Bibliography.Supplement I*, pp. 374–376. Metuchen, NJ: Scarecrow Press, 1988.

26. Höft, Brigitte, Ulrike Greuelsberg, and Claudia Niebel. *Komponistinnen: Schriften, Noten, Tonträger. Ein Führer durch die Sonderssammlung der Stadtbücherei Mannheim*. Mannheim, Germany: Musikabteilung der Stadtbücherei Mannheim, 1989.

    In German. Translated title: *Women Composers: Books, Scores and Sound Recordings. A Guide to the Collection of the Mannheim City Library.* Introduction, including an essay entitled "Franziska Lebrun und Margarethe Danzi—zwei Komponistinnen der Mannheimer Frühklassik" (pp. 8–11), by Brigitte Höft. An attractively presented bibliography of this library's collection of materials by and about women composers. Includes a listing of general literature, biographies, scores, and sound recordings.

27. Jackson, Barbara Garvey. *Say Can You Deny Me: A Guide to Surviving Music By Women From the Sixteenth Through the Eighteenth Centuries.* Fayetteville, AR: University of Arkansas Press, 1994 (forthcoming).

    Compiled from information amassed by the author in her capacity as publisher of ClarNan Editions and as editor of numerous volumes of early music by women composers, this is a reference guide to locations of existing pre-1850 editions of works by women composers found in primarily European and American libraries. The arrangement of this bibliography/location guide is alphabetical by composer name. Each entry lists variations in spelling of composer name or form of name used, as well as the name of the composer's husband or husbands, as applicable. The date and place of the composer's birth and death is included when known. Titles of unpublished and published musical works (including various editions and arrangements published before 1850) are listed for each composer, with medium of performance included. The name of the holding library is then specified for each title; microfilm holdings are included as well. Each entry designates the reference source(s) from

which the information was obtained. Appended are the following listings: modern editions since 1850, women composers who have been misidentified as male (with source of documentation), and names of women composers whose works have yet to be located. The volume is indexed by medium of performance.

28. Jeffrey, Peter. "Liturgical Chant Bibliography." *Plainsong and Medieval Music* 1, no. 2 (October 1992): 175–196.

     Includes a section on sources relating to music of medieval women's religious communities (p. 190).

29. Johnson, Rose Marie. *Violin Music by Women Composers: A Bio-Bibliographical Guide*. Music Reference Collection, 22. Westport, CT: Greenwood Press, 1989.

     Reviewed in *Notes* 47, no. 2 (December 1990): 396–397; *Sonneck Society Bulletin* 16, no. 2 (Summer 1990): 86–87. This guide presents valuable information in a somewhat awkward arrangement. The master composer index appears first, referring the user to entries in the biographical and the music sections of the book. Biographies of women violin music composers are classified according to historical period or style (baroque, classical, romantic, 20th century American, 20th century international). The music listing arranges repertoire by instrumentation and/or genre (solo violin; violin/keyboard; sonatas, suites, and larger works with keyboard; piano trios; string trios; baroque trio sonatas; string quartets; piano quintets; other instrumental ensembles; violin and voice; violin and orchestra; educational music). A discography as well as publisher and record company addresses accompany the main text.

30. Karna, Duane. "Literature Forum: Second International Chamber Choir Competition—Women's Choirs." *Choral Journal* 33, no. 1 (August 1992): 47.

     A list of the repertoire performed at the this choral competition, held in Marktoberdorf, Germany, in May 1991.

31. Krummel, Donald William. "Women in American Music." In *Bibliographical Handbook of American Music*, pp. 80–81. Urbana, IL: University of Illinois Press, 1987.

32. Laster, James, and Nancy Menk. "Literature on the Women's Chorus, Part I." *American Choral Foundation. Research Memorandum Series*, no. 149 (July 1988): 1–7.

     Whole issue. An annotated bibliography of periodical and journal articles, research memoranda, theses and dissertations, and books relating to choral music for women's voices.

33. Laster, James, and Nancy Menk. "Literature on the Women's Chorus, Part II." *American Choral Foundation. Research Memorandum Series*, no. 150 (October 1988): 8–15.

Whole issue. An annotated bibliography of periodical articles, research memoranda, theses and dissertations, and books relating to choral music for women's voices.

34. Leder, Jan. *Women in Jazz: A Discography of Instrumentalists, 1913–1968.* Westport, CT: Greenwood Press, 1985.

    Reviewed in *Popular Music and Society* 11, no. 3 (1987): 110–111; *Coda* No. 217 (December/January 1987/1988): 6–7; *Black Perspective in Music* 16, no. 2 (Fall 1988): 250–252.

35. Lems-Dworkin, Carol. *African Music: A Pan-African Annotated Bibliography.* London: Hans Zell, 1991.

    ISBN 0905450914. The index lists 27 references under the subject headings "Women Composers" and "Women's Music" (p. 381).

36. Loeb, Catherine, Susan E. Searing, and Esther F. Stineman. "Art and Material Culture." In *Women's Studies: A Recommended Core Bibliography 1980–1985*, pp. 19–39. Englewood, CO: Libraries Unlimited, 1987.

    Musical references are included in this chapter.

37. Mabry, Sharon. "New Directions: Finding Music By Women Composers." *NATS Journal* 48, no. 3 (January/February 1992): 32.

    A basic list of in-print sources to locate music by women composers.

38. Maris, Barbara English. "A Preliminary Checklist of Selected Films and Videos Featuring Women in Music." In *Women's Studies, Women's Status*, pp. 159-205. College Music Society. Committee on the Status of Women in Music. CMS Report, no. 5. Boulder, CO: College Music Society, 1988.

    The needs of instructors seeking films on women in music for classroom use are addressed by this annotated checklist of films whose subjects focus primarily on women musicians working in various musical genres. Arranged alphabetically by film subject, each entry provides useful information such as film title, media format, duration, and distributorship, in addition to a brief annotation. Appended material includes listings of distributor names and addresses, university audiovisual services, and an index to the subjects and/or individuals featured in the films identified in the checklist.

39. McCray, James. "A Survey of Published Magnificats for Treble Voices." *Choral Journal* 28, no. 8 (March 1988): 5–11.

    This bibliography of published scores of early to modern Magnificats published for treble (e.g. women's) voices, includes several pages of commentary on selected works.

40. Musica Femina. "Black Women Composers: Resources." *Hot Wire* 6, no. 2 (May 1990): 13.

41. Olivier, Antje. *Komponistinnen: eine Bestandsaufnahme. Die Sammlung des Europäischen Frauenmusikarchivs.* Düsseldorf, Germany: Tokkata-Verlag für Frauenforschung, 1990.

     ISBN 3980160319. In German. Translated title: *Women Composers: A Catalog. The Collection of the European Women's Music Archives.* Reviewed in *Musik und Bildung* 24 (May/June 1992): 45; *Österreichische Musik Zeitschrift* 46, no. 7–8 (July/August 1991): 435. Focusing on European women composers (and women composers from other countries active in Europe), this catalog lists scores, musical literature, classical and non-classical sound recordings, as well as music publishers, organizations, and performing groups. The second revised and enlarged edition was published in 1994.

42. Olivier, Antje and Karin Weingartz-Perschel, ed. *Frauen als Komponistinnen: eine Bestandsaufnahme. Archiv des Internationalen Arbeitskreises 'Frau und Musik'.* 2nd rev. ed. Düsseldorf, Germany: Frauenmusik-Vertrieb, 1988.

     In German. Translated title: *Women As Composers: A Catalog of the Archive of the Internationaler Arbeitskreis "Frau and Musik".*

43. Ostleitner, Elena. "Bibliographie zum Thema 'Frau und Musik'." *Österreichische Musik Zeitschrift* 46, no. 7–8 (July/August 1991): 396–397.

     Part of a special issue devoted to women in music. A selective bibliography of sources, primarily in German, on women in music, this listing includes recent German–language monographs on individual women composers as well.

44. Petard, Gilles. *Black Female LPs Catalogue and Price Guide.* 8, Quai de Stalingrad, 92100 Boulogne, France: The Author, 1987.

     Reviewed in *Cadence* 13 (August 1987): 32.

45. Redpath, Lisa. "Women at the Podium: A Selected Bibliography." *Music Reference Services Quarterly* 1, no. 2 (1992): 59–76.

46. Reich, Nancy B., ed. "An Annotated Bibliography of Recent Writings on Women in Music." In *Women's Studies, Women's Status*, pp. 1–77. College Music Society. Committee on the Status of Women in Music. CMS Report, no. 5. Boulder, CO: College Music Society, 1988.

     This selected annotated bibliography covers a wide variety of publications dating mostly from 1980 to 1987, including general sources on women's studies and women in the arts, general reference sources for research on women in music, and books, scholarly articles, dissertations, biographies, and discographies on women in music. Other useful sections include a listing of special collections devoted to women in music, publishers of music by women composers, and record companies representing the work of women composers and musicans.

47. Rieger, Eva, Martina Oster, and Siegrun Schmidt, ed. *Sopran contra Bass: die Komponistin im Musikverlag; Nachschlagwerk aller lieferbaren Noten.* Furore-Edition, no. 850. Kassel, Germany: Furore-Verlag, 1989.

ISBN 3927327018. In German. Reviewed in *Musica (Germany)* 45, no. 2 (March/April 1991): 110; *Neue Musikzeitung* 40 (June/July 1991): 53; *Österreichische Musik Zeitschrift* 46, no.7–8 (July/August 1991): 433. This bibliography of published musical scores and educational materials written by women is arranged by instrumentation and/or genre. Works for solo instruments appear first, with subsequent sections listing repertoire for instrumental and mixed chamber ensembles, string orchestra, orchestra, concerto repertoire, etc. The vocal music section includes repertoire for solo voice, a capella chorus, chorus with instrumental accompaniment, and dramatic music (including cantatas, oratorios, operas, musical theater, ballet, film music, etc.) Educational literature, instrumental and vocal methods, and school music are then listed. Each entry lists the composer's name, dates (when available), title, publisher, date of publication, and publisher's number if applicable. Includes an alphabetical composer index.

48. Schlegel, Ellen Grolman. *Catalogue of Published Works for String Orchestra and Piano Trio by Twentieth-Century American Women Composers.* 1237 Stevens Rd. S.E., Bessemer, AL: Colonial Press, 1993.

String orchestra and piano trio works by eighty-three American women composers are identified, with entries featuring the following information: publisher, duration, level of difficulty, targeted performing group, available recordings, and in some cases, the composer's description of the work.

49. Vagts, Peggy. "Programming Flute Music by Women Composers." *Flutist Quarterly* 15, no. 2 (Spring 1990): 43–46.

Special issue on women and the flute. Includes a descriptive, graded repertoire list featuring works for flute and piano, works for unaccompanied flute, chamber works for with flute and strings, and works for woodwind chamber ensemeble.

50. Van Dyke, Mary Louise. *Bibliography of Women Whose Hymns Appear in American Hymnals.* Oberlin, OH: The Author, *Dictionary of American Hymnology* Coordinator, Oberlin College Library, Oberlin, OH 44074, 1992.

Phone inquiries: (216) 775–8622 or (216) 775–8285. Available on disc (3 discs) or in hard copy, at cost, from Mary Louise Van Dyke, *Dictionary of American Hymnology* Coordinator, Oberlin College Library, Oberlin, OH 44074. Funded by a grant from Mu Phi Epsilon, this index/bibliography identifies women hymnwriters found through the *Dictionary of American Hymnology* (DAH) project, based at the Oberlin College Library. Compiled as a database, the resulting bibliography is in two parts. Part one is arranged alphabetically by the name of hymnwriter with an entry for each which includes: biographical data (e.g. birth/death dates, denomination, publications, pseudonyms used, etc.), a listing of hymns written (first lines), and the

date a hymn first appeared in print. The second part of the bibliography is an index of first lines of hymns with references to the hymnwriter in part one (not the hymnal in which the hymn appears; this information must be obtained from the DAH). Also in process is a supplementary listing of names of women active in other aspects of American hymnody, culled from all publications of the Hymn Society from 1950 through 1993. This is being compiled by Margaret C. Miller.

51. Walker-Hill, Helen. *Piano Music by Black Women Composers: A Catalog of Solo and Ensemble Works*. Music Reference Collection, no 35. Westport, CT: Greenwood Press, 1992.

Reviewed in *International League of Women Composers (ILWC) Journal* (February 1993): 20. This valuable bibliography of instrumental solo and chamber piano repertoire by fifty-five black women composers is arranged alphabetically by composer name. Since much of the music is either out of print or unpublished, a useful feature of the bibliography is the inclusion of library locations and call numbers when a score is not available commercially. Appendices include listings by ensemble instrumentation and difficulty level, a chronology of surviving piano works before 1920, and a selected bibliography and discography. The women composers represented are: Amanda Ira Aldridge, Lettie Marie Beckon Alston, Mable Bailey, Regina A. Harris Baiocchi, Anne Gee Blackwell, Margaret Allison Bonds, Jean Butler, Valerie Gail Capers, Avril Gwendolyn Coleridge-Taylor, Alice McLeod Coltrane, Rosina Harvey Corrothers-Tucker, Dorothy Donegan, Mrs. J.E. Edwards, Rachel Amelia Eubanks, Estelle Ancrum Forster, Ruth Helen Gillum, Anna Gardner Goodwin, Frances Gotay (Sister Marie Seraphine), Diana R. Greene, Helen Eugenia Hagan, Jacqueline Butler Hairston, Mable E. Harding, Ethel Ramos Harris, Margaret R. Harris, Jeraldine Saunders Herbison, Nora Douglas Holt, Altona Trent Johns, Betty Jackson King, L. Viola Kinney, Ida Larkins, Tania Justina León, Lena Johnson McLin, Augusta Geraldine McSwain, Loretta Cessor Manggrum, Delores J. Edwards Martin, Dorothy Rudd Moore, Undine Smith Moore, Jeanette Latimer Norman, Ruth Norman, Julia Amanda Perry, Zenobia Powell Perry, Florence Beatrice Price, Victoria Richardson, Estelle D. Ricketts, Josie Wilhelmina Roberts, Gertrude Rivers Robinson, Philippa Duke Schuyler, Hazel Dorothy Scott, Margo Nelleen Simmons, Irene Britton Smith, Joyce Elaine Solomon, Jeanetta Taylor, Blanche Katurah Thomas, Amelia Tilghman, and Mary Lou Williams.

52. *Women's Studies Index*. New York, NY: G.K. Hall, 1989 (c. 1991)—. Annual.

This index to articles and reviews appearing in about eighty popular magazines, small press periodicals, and scholarly journals published primarily in the U.S. and Canada on women and feminism offers a generous sampling of topics and perspectives on women and gender issues in music, and provides some access to lesbian/feminist music material. *Hot Wire, Ms.*,

*Spare Rib*, *New Directions for Women,* and others receive comprehensive indexing coverage, for example. This is one of the few printed indexes which lists most of the music-related articles under the general subject heading of "music", with further subdivisions by genre (e.g. Music, Pop), topic (e.g. Music—Feminist Perspectives), and phrase headings for music (e.g. Music Festivals, Music Reviews, Musicians, etc.), thus obviating (for the most part) the need to follow up on voluminous specific cross-references dispersed throughout the alphabet.

# Part B. Encyclopedias, Dictionaries, and Directories

53. *Association of Canadian Women Composers. Directory.* 20 St. Joseph St., Toronto, Ontario, Canada, M4Y 1J9: The Association, 1987.
    The directory presents biographical entries on each composer, including date and place of birth, education and degrees received, works composed, commissions, publications, recordings, plus a brief professional profile. The last section of the directory includes a name/address/phone listing, organized by province.

54. Baroncelli, Nilcéia Cleide da Silva. *Mulheres compositoras: Elenco e repertório.* São Paulo, Brazil: Roswitha Kempf Editores, 1987.
    ISBN 8527000024. In Portuguese. This biographical dictionary of women composers contains approximately 1500 entries, each with a works list and, when available, locations of scores and recordings in Brazilian public libraries for the particular composer. A very select bibliography is included. There is an index of composers by country of origin.

55. Brennan, Shawn, ed. *Women's Information Directory: A Guide to Organizations, Agencies, Institutions, Publications, Services, and Other Resources Concerned With Women in the United States.* Detroit, MI: Gale Research Inc., 1993.
    See Master Name and Subject Index for references under "Music" and "Performing Arts". Includes names of U.S.-based professional organizations, performing ensembles, periodicals, scholarships, and music distributors specializing in the field of women and music.

56. Cohen, Aaron. *International Encyclopedia of Women Composers.* 2nd, rev. and enl. ed. New York: Books and Music, USA, 1987.
    Reviewed in *Cum Notis Variorum* 122, no. 1 (May 1988): 23; *Neue Zeitschrift für Musik* 151, no. 3 (March 1990): 43–45; *Notes* 46, no. 3 (March 1990): 633–635; *Music and Letters* 71, no. 1 (February 1990): 74–75. This is an impressive compendium of information about women composers and their lives and works. Introductory material is devoted to notable facts, quotations, and statistics relating to women composers. The

main body of the encyclopedia is devoted to biographical entries, each with a varying amount of information depending on the availability of facts and sources. Most entries include the dates of the composer, any pseudonyms used, educational background, biographical details, musical contributions, a list of compositions and other publications written by the composer, a bibliography, and a numeric bibliographic key referring to the source(s) used to compile the entry. Appendices include a comprehensive bibliography of sources cited, photos/portraits of women composers, a list of composers for which more information is needed, a composite list of pseudonyms used by women composers, operas and operettas by women composers, musical works by women based on Shakespearean texts, musical works listed by instrumentation or genre, lists of women's organizations and musical societies, and a discography.

57. Grattan, Virginia L. *American Women Songwriters: A Biographical Dictionary*. Westport, CT: Greenwood Press, 1993.
    Reviewed in *Feminist Collections* 14, no. 4 (Summer 1993): 25–26; *Choice* 31, no. 3 (November 1993): 432. Arranged by genre, and indexed by name, this volume presents biographies of nineteenth and twentieth-century popular women songwriters and lyricists from the U.S.

58. Hallgarth, Susan A., ed. "Music." In *DWM: A Directory of Women's Media*. 16th ed., pp. 123–128. New York: National Council for Research on Women, 1992.
    Formerly published by the Women's Institute for Freedom of the Press as *Index/Directory of Women's Media*. This annual publication lists women's music distributors, organizations, radio broadcasts, newsletters, record companies, producers, periodicals, music festivals, etc. The directory appears to be somewhat in-process, as one should consult the "Additional Resources" section (pp. 239–240) for items not incorporated into classified sections of the directory (e.g. *Hot Wire* is listed as an additional resource, not as a "Music" resource).

59. Hixon, Don L., and Don A. Hennessee. *Women in Music: An Encyclopedic Biobibliography*. 2nd ed. 2 vols. Metuchen, N.J.: Scarecrow Press, 1993.
    An index to biographies of women musicians appearing in approximately 160 music and general reference sources, *Women in Music* is one of the premier tools for research on women in music. Organized into two sections, section one is an alphabetical listing by musician name, with each name entry including date and place of birth and death, area of musical specialization, and a list of sources to which one may refer for biographical information. Section two is an alphabetical guide to musical specialization; thus, musicians included in section one are grouped into particular categories of musical activities, with reference to the corresponding entry in the name section.

60. International League of Women Composers. *ILWC Directory*. Comp.

Elizabeth Hayden Pizer. Three Mile Bay, NY: The International League of Women Composers, 1992—. Annual.

61. International Women's Brass Conference. *Directory of Women Brass Performer/Teachers*. St. Louis, MO: The Conference, 1991.

International Women's Brass Conference, 540 South Geyer Road, St. Louis, MO 63122.

62. LePage, Jane Weiner. *Women Composers, Conductors and Musicians of the Twentieth Century: Selected Biographies. Volume III*. Metuchen, NJ: Scarecrow Press, 1988.

Reviewed in *Notes* 47, no. 2 (December 1990): 380–381; *Fontes Artis Musicae* 37, no. 4 (October–December 1990): 310–311. This third volume of a proposed four-volume series presents biographical profiles of varying length (ten to twenty pages) on the following women musicians: Grazyna Bacewicz, Betty Beath, Anne Boyd, Sylvia Caduff, Ann Carr-Boyd, Gloria Coates, Selma Epstein, Nicola LeFanu, Priscilla McLean, Elizabeth Maconchy, Mary Mageau, Ursula Mamlok, Priaulx Rainier, Shulamit Ran, Ruth Schonthal, Margaret Sutherland, Joan Tower, Gillian Whitehead. Each biographical essay includes a portrait, an autobiographical statement, a works list, and discography. Publisher and record company addresses are included.

63. McLaren, Jay, and Hans Christophersen. *An Encyclopaedia of Gay and Lesbian Recordings*. Amsterdam, The Netherlands: The Author, Limited Edition, September 1992.

Available from Jay McLaren, P.O. Box 11950, 1001 GZ Amsterdam, The Netherlands. Copies of this manuscript have been distributed to major libraries in the U.S. and Europe. Recordings selected for inclusion in this annotated discography are those whose songs explicitly refer to male homosexuality or lesbianism in their titles or lyrics. A subject index provides access to the gay or lesbian thematic content existing in the songs listed in the main body of the encyclopedia. The main listing is arranged alphabetically by artist name, followed by the title of the individual song or record album (if multiple songs are relevant), format of recording (e.g. disc, cassette, LP), record label and number, country and year of release, language of text, a description of the content of the recording (which may include quotations from the song lyrics), and index codes reflecting the particular gay/lesbian theme or subject.

64. Olivier, Antje, and Karin Weingartz-Perschel. *Komponistinnen von A-Z*. Düsseldorf, Germany: Tokkata-Verlagf ür Frauenforschung, 1988.

ISBN 3980160300. In German. Translated title: *Women Composers from A to Z*. Reviewed in *Fontes Artis Musicae* 35, no. 3 (July–September 1988): 206; *Neve Zeitschrift für Musik* 151, no. 3 (March 1990): 43–45; *Musik und Bildung* 21, no. 4–5 (April/May 1989): 274. Each entry in this dictionary of

women composers includes of brief biography of the composer, a works list, and a portrait or other illustrative matter pertaining to the composer.

65. *Performing Woman; A National Directory of Professional Women Musicians.* 26910 Grand View Ave., Hayward, CA: J. D. Dinneen (editor and publisher). Annual.

66. Sadie, Julie Anne, and Rhian Samuel, eds. *Norton/Grove Dictionary of Women Composers.* New York: W. W. Norton, 1994 (forthcoming).

  For a preview of this new reference work see Rhian Samuel's article in the *ILWC Journal* (October 1993): 22–23.

67. Schlachter, Gail Ann. *Directory of Financial Aids for Women 1993–1995: A List of Scholarships, Fellowships, Loans, Grants, Awards and Internships Designed Primarily or Exclusively for Women; State Sources of Educational Benefits; and Reference Sources on Financial Aid.* 9th ed. San Carlos, CA: Reference Service Press, 1993.

  See Subject Index (p. 498), "Music". Lists approximately 40 sources of funding for women involved in musical activities. Each entry identifies the source of funding and includes the following information: the objective of the program, financial data, duration of funding offered, special features or limitations, number of awards issued per grant period, and application deadline.

68. Stafford, Beth, ed. *Directory of Women's Studies Programs and Library Resources.* Phoenix, AZ: Oryx Press, 1990.

  Arranged geographically by state, this volume lists colleges and universities offering women's studies programs and courses, with each entry including the name/address/phone number of the institution, the name of the program director or other contact person, names of the faculty teaching women's studies courses, titles of courses offered, degrees offered, library services and collection strengths, and other special resources. The volume includes indexes by institution, academic discipline, and library subject strength (i.e., by L.C. subject heading). In the "Discipline Orientation Index," twenty-one institutions offering courses in women in music are identified.

69 Tierney, Helen, ed. *Women's Studies Encyclopedia. Volume II: Literature, Arts and Learning.* Westport, CT: Greenwood Press, 1990.

  This is a valuable general reference tool, with articles by well-known authors on various topics regarding women in art, music, theatre, and literature. Articles on women in music include those on blues (pp. 40–42), twentieth-century composers (pp. 69–70), concert artists (pp. 70–72), conductors (pp. 72–74), jazz (pp. 185–190), economic status and opportunities for women in classical music (pp. 207–210), pre-twentieth century women musicians (emphasizing non-Western musics, pp. 210–214). Each article is accompanied by a short list of references for further study.

70. Women Band Directors National Association. *WBDNA Directory*. 344 Overlook Dr., West Lafayette, IN 47906: The Association, Annual.

71. *Women's Music Plus; Directory of Resources in Women's Music and Culture*. 5210 N. Wayne, Chicago, IL: Empty Closet Enterprises, Annual.
    Issued by the publishers of *Hot Wire*, this directory lists names, addresses, and phone numbers of women performers and composers, publishers and editors, photographers, producers, booking agents, stage managers, audio engineers, artists, cartoonists, etc. Also listed are feminist performance venues (e.g., coffeehouses, clubs, festivals, conferences, theater companies), feminist bookstores, periodicals, record companies and distributors, radio shows, and other media contacts.

# Part C.  Statistical Data

72. Cantor, Muriel G. *Employment Status of Performing Artists 1970–1980*. Washington, D.C.: National Endowment for the Arts, Research Division, 1987.
    Available from ERIC, ED# 298 024, in microfiche or paper copy. For an abstract see *Resources in Education* 24, no. 1 (January 1989): 150. This report compares U.S. census data from 1970 and 1980 with respect to the socioeconomic status of men and women employed as actors, dancers, or musicians.

73. Citro, Constance F., and Deidre A. Gaquin. *Women and Minorities in the Arts: A Portrait from the 1980 Census*. Washington, DC: National Endowment for the Arts, 1988.
    Available from ERIC, ED# 298 028, in microfiche or paper copy. For an abstract see *Resources in Education* 24, no. 1 (January 1989): 150.

74. Ellis, Diane C. *Earnings of Artists: 1980*. Washington, DC: National Endowment for the Arts, Research Division, 1987.
    Available from ERIC, ED# 289 761, in microfiche or paper copy. For an abstract see *Resources in Education* 23, no. 5 (May 1988): 129. Based on 1980 U.S. Census figures, this report presents data on the earnings of artists (including composers and musicians) related to factors such as age, sex, ethnic background, educational level, workplace, etc.

75. Ellis, Diane C. *Minorities and Women in the Arts: 1980*. Washington, DC: National Endowment for the Arts, Research Division, 1987.
    Available from ERIC, ED# 289 765, in microfiche or paper copy. For an abstract see *Resources in Education* 23, no.5 (May 1988): 129. Based on data from the 1980 U.S. Census, this report summarizes earnings figures for male and female artists and compares this data with that gathered from the 1970 census. The report finds that while more women made their living as

artists in 1980, their median income remained fairly static, being 59% of that earned by men in 1980.

76. Higher Education Arts Data Services. *Data Summary. Music.* Reston, VA: HEADS, Annual.

   Issued annually in 87/88, 88/89. With the 89/90 edition and subsequent editions, the volume is issued under the title *Data Summaries. Music.* Available from Higher Education Arts Data Services, 11250 Roger Bacon Dr., Suite 21, Reston, VA 22090. (703) 437–0700. The volume compiles data generated from the annual reports required of all member institutions of the National Association of Schools of Music. Relevant data summaries include: music faculty by rank, sex and highest degree earned; music faculty by sex and academic rank; music faculty by sex and highest degree earned; music faculty by sex and length of service; music faculty by sex and tenure status; full-time music faculty salaries, male/female ; part-time music instruction, male/female.

77. Robinson, Deanna Campbell, Elizabeth B. Buck, and Marlene Cuthbert. *Music at the Margins: Popular Music and Global Cultural Diversity*, pp. 212–213, 219–221, 223, 275. Newbury Park, CA: Sage Publications, 1991.

   This research study, based on interviews with 220 popular musicians from 8 countries, investigates economic, political, social and cultural factors affecting the daily lives of musicians from around the world. Statistics are presented which correlate gender, music preference, and country of the musician. Also presented are statistics correlating the role of a musician within a group, gender, and country of the musician. Equal opportunity for women and the role of the woman musician in popular music groups are discussed within a global context.

# Part D. Online Information Sources

78. *IAWM List.* ILWC@acuvax.acu.edu, 1993—.

   The online discussion list of the International Alliance for Women in Music (formerly the International League of Women Composers). Administered by Sally Reid, the IAWM List currently has the following objectives: 1) to expedite communications relating to in-house business matters, 2) to provide a mechanism by which timely information (e.g., opportunities listings) may be communicated to members during the interim between published journal issues, 3) to encourage communication and networking among members of the IAWM and on issues relating to women in music. In order to subscribe to the list send a message to: ILWC–request@acuvax.acu.edu. Send the message "subscribe."

79. *National Women Composers Resource Center. Database.*

    330 Townsend St., Suite 218, San Francisco, CA. 94107. Phone (415) 543–2297. FAX (415) 543–3244.

    Serving orchestras, composers and performers, the National Women Composers Resource Center was established by the Women's Philharmonic in order to disseminate information about, and thus promote the performance of, orchestral works by women composers. The Center's large database includes information on the availability of orchestral scores and parts, instrumentation, duration and other special performance requirements. Also included in the database is biographical and other information on women composers. Many of the scores collected by the center are those which have been performed by the Women's Philharmonic, or obtained by the Women's Philharmonic through their commissioning program or annual score reading sessions.

80. *New York Women Composers Inc. Catalog/Databank.* NYWC, 1990—.

    This databank of musical compositions by women composers from the greater New York area currently includes over 1500 works by NYWC members. Classified lists of compositions (e.g., by type of composition, instrumentation, composer) are available for a small fee. Also available is a composite catalog which is a printout of all entries in the database organized by performance medium. This catalog is reviewed in *Notes* 49, no. 3 (March 1993): 1092–1093. Contact New York Women Composers, Inc., 114 Kelburne Avenue, North Tarrytown, NY 10591. (914) 631–4361.

81. "Syllabi: Music and Women ; Music—Performance and Gender." *Women's Studies Database. University of Maryland at College Park Online Information System ("inforM").*

    Available via Internet, the "inforM" online information system at the University of Maryland at College Park includes the Women's Studies Database, one component of which is a listing of course syllabi contributed by faculty at colleges and universities throughout the country on topics relating to women's studies, including women in music. Course outlines, classroom strategies, reading lists, etc., are offered, as is the contributor's name and institutional affiliation. In order to access the database, use Internet and: 1) telnet to INFO.UMD.EDU; 2) enter your terminal type, or just press enter if your terminal type matches the default value (VT 100); 3) at the Gopher Information Client Menu, type the line number for Educational Resources; 4) at the Educational Resources menu, type the line number for Women's Studies; 5) type the line number for Syllabi; 6) page down (+), until "Music and Women" and "Music—Performance and Gender" are displayed; 7) choose the appropriate line. Online help will instruct you how to download information to your computer. For more information contact: Kathy Burdette, Information On-line, Women's Studies Database Coordinator, 4343 Computer Science Center, University of Maryland, College Park, MD 20742. Phone: (301) 405–2939. E-mail: burdette@info.umd.edu.

CHAPTER TWO

# General Literature on Women, Gender, and Music

## Part A. Periodicals

82. *ASCAP in Action*, Winter 1987.
Special issue devoted to women in ASCAP.

83. *Association of Canadian Women Composers (ACWC) Newsletter*.
20 St. Joseph St., Toronto, Ontario M4Y 1J9 Canada: the Association, 1982–1990.

84. *Association of Canadian Women Composers (ACWC) Bulletin*.
20 St. Joseph St., Toronto, Ontario M4Y 1J9 Canada: the Association, October 1990—. Quarterly. Available with a membership in the association.

85. *Association of Women's Music & Culture Newsletter*.
2124 Kittredge St. #104, Berkeley, CA 94704: the Association, 1988—. Available with membership in the association. Formed in 1987, the AWMAC's mission, as stated in the *Newsletter* is "to foster, encourage and empower women's music and culture through services, networking and the education and support of our members." An annual directory is also included with a membership.

86. *AWC News Forum*.
1690 36th St. NW, Suite 409, Washington, DC 20007: American Women Composers, Inc., 1977—. Semiannual. Published by this women composers organization whose mission it is to promote and disseminate music by American women composers, this periodical includes: feature arti-

18

cles on all aspects of women's contributions to musical life in America, with a focus on contemporary music by women composers; composer profiles; reviews of new publications; member news; opportunities for women composers; information on conferences, concerts, and music festivals; and information on new scores acquired for the AWC Library.

87. *Bitch: The Women's Rock Mag With Bite.*
    San Jose Face, Suite 164, 478 W. Hamilton Ave., Campbell, CA 95008: No. 1, August 1985—. Occasional. Reviewed in *Notes* 46, no.2 (December 1989): 411.

88. *du: Die Zeitschrift der Kultur*, no. 4 (April 1992).
    In German and English. This Swiss magazine of art and culture has produced a special issue devoted to women jazz singers, entitled "Body and Soul: Die grossen Sängerinnen des Jazz." Intelligent and beautifully produced (accompanying photographs are excellent), this issue includes feature articles on Billie Holiday, Ella Fitzgerald, Sarah Vaughan, and Laura Newton, as well as general essays focusing on jazz history and musical criticism by Dieter Bachmann, Sally Placksin, Peter Rüedi, Ian Carr, Jon Hendricks, Michael Naura, and Irène Schweizer, also cited individually in this bibliography.

89. *Feminist Collections: A Quarterly Journal of Women's Studies Resources.*
    430 Memorial Library, 728 State Street, Madison, WI 53706: Phyllis Holman Weisbard, Acting Women's Studies Librarian, University of Wisconsin System. Quarterly. This handy journal reviews topics relating to access to information in women's studies, and includes sections on special library collections and archives, new reference works and periodicals (including special issues of periodicals devoted to a particular women's studies topic), databases, electronic journals and discussion lists, new publications received, etc. It is most useful for its inclusion of publications available from small press publishers, broad subject coverage (i.e., music information sources are reviewed), and up-to-dateness.

90. *Flutist Quarterly* 15, no. 2 (Spring 1990).
    Special issue on women and the flute. Includes feature articles on flutists Marguerite de Forest-Anderson, Arma Pahlman, Elsie Wild, Lois Schaefer, Judith Mendenhall, flute maker Eva Kingma, Cécile Chaminade's *Concertino for Flute and Orchestra* (or Piano), Op. 107, as well as general articles cited elsewhere in this bibliography (by Glennis Stout, George Barrere, David Eagle, Linda Marianello, Ervin Monroe, and Peggy Vagts).

91. *Frauenmusik-Forum. Rundbrief.*
    Zurich, Switzerland: Frauenmusik-Forum. A quarterly newsletter issued by this Swiss women composers organization.

92. *Girl Groups Gazette.*
    Box 69A04, Dept. UL, W. Hollywood, CA: Fan Club Publishing, 1987- -. Quarterly. Fanzine of the Girl Groups Fan Club, which celebrates female rock groups of the 1960s.

93. *Helicon Nine: A Journal of Women's Arts and Letters.*
    Kansas City, MO: Helicon Nine, Inc. 1979–1989.

94. *Hot Wire: the Journal of Women's Music and Culture.*
    5210 N. Wayne, Chicago, IL 60640: Empty Closet Enterprises, 1984–. Three issues/year. Committed to "covering female artists and women's groups who prioritize lesbian and/or feminist content and ideals in their creative products and events," *Hot Wire* examines all types of women's issues in the performing arts, literature and film. Each issue includes a soundsheet featuring performances of woman-identified music.

95. *International Congress on Women in Music. Newsletter.*
    La Crescenta, CA: The Congress, 1983—1989. Quarterly. Ceased publication when the International Congress on Women in Music merged with the International League of Women Composers. The Congress also published several issues of a journal entitled, *Working Papers on Women in Music* (The first issue was No. 1, June 1985).

96. *International League of Women Composers (ILWC) Journal.*
    Abilene, TX: International League of Women Composers, c/o Sally Reid, Spring 1989—. Three issues/year. Previously *International League of Women Composers Newsletter*, 1981–1989. Includes feature articles on women and music; composer profiles; reviews of recordings, books, scores and musical performances; reports on ILWC activities (e.g., International Congress on Women in Music) and women composer organizations throughout the world; opportunities for composers (composer competitions, score readings, etc.); prizes awarded; announcements of conferences and festivals; announcements of works premiered; etc.

97. *Journal of American Folklore* 100 (October-December 1987).
    Special Centennial Issue entitled "Folklore and Feminism".

98. *Journal of Country Music* 15, no. 1 (1992).
    Special issue entitled "Women in Country".

99. *Key-Note.*
    R.F.D. 1, Box 142, East Calais, VT 05650: Harmony, Inc. A quarterly periodical issued to members of the International Organization of Women Barbershop Singers. Available by subscription to nonmembers. Includes news, information on conventions, articles on various aspects of women's barbershop singing, etc.

100. *Mixturen* no. 4 (1988)
    In Swedish. ISSN 0345–8105. Special issue on the theme "Kvinnor och musik" (women in music).

101. *Music Educators Journal* 78, no. 7 (March 1992).
    Special issue devoted to women in music. Articles examine the barriers encountered by women in their careers as music professionals. Stressed is the importance of presenting role models with whom young female students can identify. Strategies for increasing the visibility of women composers in the curriculum are offered.

102. *Music und Gesellschaft* 38, no. 3 (March 1988).
    In German. Special issue devoted to women and music. Includes articles on: the status of women in the musical life of the DDR; nineteenth-century composer Johanna Kinkel; the character of Kundry in Wagner's *Parsifal*; and the musical portrayal of women in Friedrich Schenker's *Bettina*.

103. *New Books on Women and Feminism.*
    430 Memorial Library, 728 State Street, Madison, WI 53706: Phyllis Holman Weisbard, Acting Women's Studies Librarian, University of Wisconsin System. Semiannual. Regular section entitled "Art/Architecture/Photography/Film Criticism/Music". See also subject index under "Music," "Singers," "Composers," etc.

104. *Opera News* 57 (July 1992).
    A special issue devoted to "Women in Opera".

105. *Out Loud.*
    P.O. Box 535 Eltham, Victoria 3095, Australia. (03) 439–7942. A quarterly magazine focusing on women's music and culture in Australia.

106. *Österreichische Music Zeitschrift* 46, no. 7–8 (July/August 1991).
    In German. Special issue devoted to women in music.

107. *The Pen Woman.*
    Pen Arts Building, 1300 17th St., NW, Washington, DC 20036: National League of American Pen Women, Inc. Nine issues/year. Magazine on women in the arts and letters (including music). Includes articles, works of poetry, music, and art; membership news.

108. *Rock Against Sexism.*
    Box 390643, Cambridge, MA 02139: Rock Against Sexism, 1988—1993. This recently-defunct publication promoted women's rock music and alternatives to sexism in mainstream rock.

109. *Siren*.
    P.O. Box 14874, Chicago, IL 60614: Girltime Productions, 1992—. This magazine promotes women's rock music (i.e., women's hard rock, punk, and other music forms which subvert and rebel against the norms of pop) and women's rock music groups not receiving coverage in the mainstream press.

110. *TENSO: Bulletin of the Société Guilhem IX* 7, no. 2 (Spring 1992).
    A special issue devoted to the trobairitz.

111. *The Woman Conductor*
    344 Overlook Dr., West Lafayette, IN 47906: Women Band Directors National Association. Quarterly. This journal reports on organizational news pertaining to the Women Band Directors National Association, and features articles on conducting, professional concerns, etc.

112. *Women: A Cultural Review* 3, no. 1 (Summer 1992).
    Special issue on women and music.

113. *Women and Performance: A Journal of Feminist Theory*
    721 Broadway, 6th Floor, New York, NY 10003: New York University. Issued twice yearly. Investigates feminist and gender issues in the study of the performing arts, including film, theatre, music, dance, and experimental forms of performance.

114. *Women in Music. Newsletter*.
    Battersea Arts Centre, Old Town Hall, Lavender Hill, London SW11 5TF, England: Women in Music, 1989?—. Quarterly. (Phone 071–978–4823). A publication offered to members of the organization 'Women in Music,' the *Newsletter* reports on all types of musical activities relating to women in rock, classical and jazz musics in Great Britian.

115. *Women of Note* 1, no. 1 (Spring 1992—).
    330 Townsend St., Suite 218, San Francisco, CA 94107: the Women's Philharmonic. (415) 543–2297. Published three times a year. This newsletter of the Women's Philharmonic is available to subscribers of the organization, and features articles on music performed by the Women's Philharmonic, as well as information on the activities of the Women's Philharmonic and its affiliated National Women Composers Resource Center.

116. *Women of Note Quarterly* 1, no. 1 (May 1993—)
    Emanating from the music publisher Vivace Press, and subtitled "the magazine of historical and contemporary women composers," this new periodical features scholarly articles, profiles of composers, a section on alternative musics, and reviews of books, music, and compact discs.

117. *Women's Jazz Archive. Newsletter.*
     Swansea, Wales: Women's Jazz Archive, 1992—. An occasional newsletter of the Women's Jazz Archive, University College of Swansea, Department of Adult Continuing Education, Hendrefoilan House, Sketty, Swansea SA2 7NB Wales. (Phone 0792–201231).

118. "A Womyn's Place." *Victory Review.*
     P.O. Box 7515, Bonney Lake, WA 98390: Victory Music, 1976—. Monthly. This review journal of acoustic music maintains this continuing column on women's music and women's issues in folk, traditional, and acoustic music, with a focus on West Coast music activities.

# Part B. Collected Literature, Review Essays, and Other General Perspectives

119. "Attack of the 'Isms'." *Keyboard* 16, no. 9 (September 1990): 8–9.
     Letters addressing the topics of women in the music business and women in rock music.

120. Barkin, Elaine. "'either/other'." *Perspectives of New Music* 30, no. 2 (Summer 1992): 206–233.
     This composer/author takes issue with the views expressed in Susan McClary's *Feminine Endings* and other writings by McClary. In particular, she criticizes McClary's assault on musical formalism and characterizes as polemical McClary's analyses revealing the construction of gender and sexuality in musical works. On the topic of musical elitism within the academy, Barkin defends university-based composer programs, maintaining that such programs have an important role in the preservation of artistic independence given our increasingly commercial musical culture.

121. Basart, Ann P. "Looking for Women." *Cum Notis Variorum*, no. 126 (October 1988): 11–12.
     On Aaron Cohen and the second edition of his *International Encyclopedia of Women Composers.*

122. Bohlman, Philip. "Viewpoint: On the Unremarkable in Music." *19th Century Music* 16, no. 2 (Fall 1992): 203-216.
     19th century musical historiography (e.g., the writings of Adolph Bernhard Marx) accepted a notion of music functioning within a social context. Until recently, twentieth-century music scholarship rejected this notion, viewing Art Music as autonomous, removed from "Other" musics and likewise removed from society. Surveying recent scholarship and summarizing the theories employed therein, the author explores the various ways in which

social contexts apply to music. Included is an examination of works by John Shepherd, Richard Leppert, and Susan McClary, whose writings reflect feminist perspectives in music.

123. Bowers, Jane M. "Feminist Scholarship and the Field of Musicology: I." *College Music Symposium* 29 (1989): 81–92.

Part one of a two-part series, this excellent introduction to the impact of feminist scholarship on the field of musicology identifies three general areas of inquiry to date and reviews the significant recent literature in each. Historical studies have investigated how socially constructed attitudes towards gender have influenced the degree to which women have created, performed and achieved in music. Likewise, historical approaches have examined the varieties of women's musical expression. Feminist criticism has analyzed the way gender is constructed in musical discourse; for example, how women or the feminine is represented in musical works.

124. Bowers, Jane M. "Feminist Scholarship and the Field of Musicology: II." *College Music Symposium* 30, no. 1 (Spring 1990): 1–13.

In part two of this two-part series, the author identifies topics needing additional investigation, so as to further inform our understanding of women's musical history and gender issues as they relate to music. The author notes that we should examine the way gender is constructed in dramatic musical works. Musical works by women should be critically examined and analyzed, with investigations into gender differences in compositional style and musical aesthetics. In particular, feminist music needs further attention. Recent feminist studies from other disciplines, such as sociology, history, psychology, anthropology, sociology, language study, etc., can offer new insights into aspects of music and music-making. Finally, Bowers stresses the importance of developing new methodologies or new approaches to organizing existing information, in order to challenge the principles and assumptions of the past which have led to exclusion of women and gender issues from serious musicological discourse.

125. Brett, Philip, Gary Thomas, and Elizabeth Wood, eds. *Queering the Pitch: The New Gay and Lesbian Musicology*. New York: Routledge, 1993 (forthcoming).

Contributors include Wayne Koestenbaum, Philip Brett, Lydia Hamessley, Susan McClary, Lawrence A. Mass, Elizabeth Wood, Joke Dame, Martha Mockus, Gary Thomas, Suzanne Cusick, Jennifer Rycegna, Karen Pegley and Virginia Caputo, and Paul Attinello.

126. Burstyn, Joan N., ed. *Past and Promise: Lives of New Jersey Women*. Ed. Joan N. Burstyn. Metuchen, NJ: Scarecrow Press, 1990.

An effort sponsored by the Women's Project of New Jersey, this collection of biographies of notable New Jersey women from 1600 to the present includes entries for a number of musical women (see Index,

p. 458), with each entry noting archival and published sources of information on the women discussed. Women profiled include: Adèle De Leeuw (author and music patron, pp. 266–267), Mary Ann Rowley Eager (popular songwriter, pp. 275–277), Lucy McKim Garrison (musicologist and author of *Slave Songs of the United States* (1867), pp. 143–144), Mary Belle Harris (organist/composer known primarily for her pioneering efforts in prison reform, pp. 311–213), Florence Lillian Haines (music teacher and suffragist, pp. 308–309), Carleen Maley Hutchins (violin maker and scientist, pp. 325–327), Maria Jeritza (operatic soprano, pp. 328–330), Dorothy Kirsten (operatic soprano, pp. 336–337), Lucille Manners (singer and radio star, pp. 349–350), Dorothea Miller Post (music patron and amateur violinist), Astrid Varnay (operatic soprano, pp. 411–412), Harriet Ware (composer and pianist, pp. 415–416), Viola Wells (blues/jazz singer, pp. 417–420).

127. Ch'maj, Betty E. M. "Reality Is On Our Side: Research on Gender in American Music." *Sonneck Society Bulletin* 16, no. 2 (Summer 1990): 53–58.

The first in a series of review essays on recent trends and theories in research on women and gender issues in American music, this article identifies five major stages of progression in the published literature over the past twenty-five years: literature on notable women and their contributions to the history of music; research which identifies women's roles in music-making; literature which critically examines the way patriarchal assumptions and values manifest themselves within a musical culture; reflecting the equality vs. difference debate, new writings which acknowledge the difference of a woman's experience and which argue for the existence of a feminine aesthetic in music; and most recently, literature which provides new insights into how gender is constructed in a piece of music, enabling one to listen to a musical work with a feminine aesthetic in mind.

128. Citron, Marcia J. "Feminist Approaches to Musicology." In *Cecilia Reclaimed: Feminist Perspectives on Gender and Music*, ed. Susan C. Cook and Judy S. Tsou, pp.15–34. Urbana, IL: University of Illinois Press, 1994 (forthcoming).

129. Citron, Marcia J. "Gender, Professionalism and the Musical Canon." *Journal of Musicology* 8, no. 1 (Winter 1990): 102–117.

130. Citron, Marcia J. *Gender and the Musical Canon*. Cambridge, England: Cambridge University Press, 1993.

The author utilizes feminist and interdisciplinary perspectives as she analyzes the processes which have excluded the music of women from the canon of Western art music. Beginning with an investigation of the properties of canons and the musical canon as a cultural paradigm, the book then examines theories of creativity as they relate to gender. Professionalism

becomes an important canon prerequisite, and the author notes that in the separation of the private/amateur vs. the public/professional musical worlds, women have traditionally been associated with the former and men with the latter. Music as a vehicle for the discourse of gender is examined through the author's discussion of the normative qualities of absolute music, her critique of the sonata form, and a consideration of theories relating to a feminine musical aesthetic. Gender as it pertains to critical reception and listener response to music is examined, with an important consideration of the performer as critic and listener, and an exploration of the notion of listening as a woman. The author closes with a look at how the musical canon functions in the present via its powerful presence in the academy, and offers suggestions for different models which would recognize the musical contributions of women as well as their historic roles and experiences.

131. Cohen, Aaron. "Looking for Women." *Pan Pipes* 80 (Winter 1988): 3–4.
    The author discusses his experiences compiling the second edition of the *International Encyclopedia of Women Composers*.

132. "Cohen Collection Arrives at CSUN." *International Congress on Women in Music Newsletter* 5, no.2 (June 1988): 1.
    This brief article announces that the Aaron Cohen collection of materials on women musicians has been received by the International Institute for the Study of Women in Music (California State University, Northridge).

133. College Music Society. Committee on the Status of Women in Music. *Women's Studies, Women's Status*. CMS Report, no. 5. Boulder, CO: College Music Society, 1988.
    Reviewed in *Cum Notis Variorum*, no. 34 (July/August 1989): 7; *Notes* 47, no. 3 (March 1991): 801–802. Includes: Reich, Nancy B. "An Annotated Bibliography of Recent Writings on Women in Music"; Block, Adrienne Fried. "The Status of Women in College Music, 1986–1987"; Maris, Barbara English. "A Preliminary Checklist of Selected Films and Videos Featuring Women in Music". Each essay is cited individually in this bibliography.

134. Cook, Susan C. and Judy S. Tsou, eds. *Cecilia Reclaimed: Feminist Perspectives on Gender and Music*. Urbana, IL: University of Illinois Press, 1994 (forthcoming).
    With foreword by Susan McClary. Ten essays explore a variety of topics relating to women and gender issues in western art music and some vernacular forms. Beginning with a general discussion of feminist musicology, this compilation also features essays discussing public/private musical performance, women in the music of the English Renaissance and seventeenth-century France, feminism and modernism in American music, music by women in American ladies' magazines, the image of women in rap music, gender and power in the narrative of American balladry, and individ-

ual studies of composer Amy Beach and Venetian musician Anna Maria della Pietà. Each essay is cited individually in this bibliography.

135. Cossé, Peter. "Schallplatten: Komponistinnen—Eine fragmentarische Bestandsaufnahme." *Österreichische Musik Zeitschrift* 46, no. 7–8 (July/August 1991): 442–445.

   In German. Translated title: "Recordings: Women Composers—A Selected Discography." Part of a special issue devoted to women in music. A review essay discussing recent recordings of works by women composers, followed by a selected discography arranged by composer.

136. Diederichs-Lafite, Marion. "Frau und Musik." *Österreichische Musik Zeitschrift* 46, no. 7–8 (July/August 1991): 361–362.

   In German. Translated title: "Women and Music". Part of a special issue on devoted to women in music. The author introduces the contributors and presents an overview of the articles featured in this special issue.

137. Durbin, Elizabeth. "Women and the Arts: A Survey of Recent Progress." In *'The Green Stubborn Bud': Women's Culture at the Century's Close*, ed. Kathryn F. Clarenbach and Edward L. Kamarck, pp. 199–351. Metuchen, NJ: Scarecrow Press, 1987.

   A working paper from the Second National Conference on Women and Arts held in Madison, Wisconsin, June 3–6 1985. In Part I, 'Enlarging and Enriching Our Views of Art', the author discusses the women's music movement and women musicians expressing themselves from a uniquely female and/or feminist perspective (pp. 215–221). In Part II (pp. 266–279), "Working Through Traditional Institutions," she describes the "muted progress" of women in the music profession (as composers, as faculty, as symphonic musicians and conductors, etc.) and notes the individuals and organizations working to improve the status of women in music. The essay includes several bibliographic components as well: 1) a review of recent significant contributions to the literature of women and music (pp. 309–314), and 2) an appended bibliography (pp. 331–351) entitled "Women and the Arts: A Survey of Recent Progress," a section of which is devoted to music publications issued between 1977 and 1986.

138. "Editorial: Is There Feminist Music Theory?" *In Theory Only* 9, no. 8 (May 1987): 3–4.

   The editors provide a brief definition of feminist music theory, drawing upon the framework provided by Jonathan Culler in his *On Deconstruction* (Ithaca, NY: Cornell University Press, 1982). Also noted is the formation of the Society for Music Theory's Committee on the Status of Women.

139. Edwards, J. Michele. "All-Women's Musical Communities—Fostering Creativity and Leadership." In *Bridges of Power: Women's Multicultural*

*Alliances*, ed. Lisa Albrecht and Rose M. Brewer, pp. 95–107. Philadelphia, PA: New Society Publishers, in cooperation with the National Women's Studies Association, 1990.

In her examination of women's music groups as agents of social change, the author focuses on two ensembles: the all-women's jazz band, the International Sweethearts of Rhythm; and the all-women's orchestra, the Bay Area Women's Philharmonic (now called the Women's Philharmonic) and its conductor JoAnn Falletta.

140. Edwards, J. Michele. "Women and Music." *NWSA Journal* 1, no. 3 (Spring 1989): 506–518.

Book review essay.

141. Epstein, Selma. "Researching Piano Music by Black Women Composers." *International League of Women Composers (ILWC) Journal* (October 1992): 24.

On the major published studies and research library collections focusing on black women composers.

142. Ferris, Lesley. "Absent Bodies, Dancing Bodies, Broken Dishes: Feminist Theory, Postmodernism, and the Performing Arts." *Signs* 18, no. 1 (Autumn 1992): 162–172.

A review essay discussing recent significant works (1989–1991) which utilize feminist theory to provide new insights to studies in cinema, theater, music, and literature, with particular reference to the relationship of the body to the consideration of these arts.

143. Fink, Monica, Rainer Gstrein, and Günter Mössmer, eds. *Musica Privata: Die Rolle der Musik im privaten Leben. Festschrift zum 65. Geburtstag von Walter Salmen*. Innsbruck, Austria: Edition Helbling, 1991.

ISBN 3900590206. In German. Reviewed in *Das Orchester* 40, no. 6 (1992): 789–790. Twenty-three essays explore various aspects of private music—domestic music, salon music, music in the ateliers, music in private settings as represented in works of art, chamber music as a private music making activity, private and autobiographical references in works by various composers, the oral transmission of folk music as a private activity, as well as general sociological and psychological considerations of music of the private sphere.

144. Forte, Jeanie Kay. *Women in Performance Art: Feminism and Postmodernism*. Diss. Ph.D., University of Washington, 1986.

Abstract in *Dissertation Abstracts International: A. Humanities and Social Sciences*. 47, no. 12 (June 1987): 4237. DA# 8706554.

145. Funayama, Nobuku. "Frau und Musik in Japan." In *Komponistinnen in Japan und Deutschland: eine Dokumentation*, ed. Renate Matthei, pp. 9–17. Furore Edition no. 853. Kassel, Germany: Furore-Verlag, 1991.

ISBN 3927327093. In German. The author begins with a survey of the educational system in Japan and a discussion of the traditional and western-influenced musics of Japan. She then examines the roles and contributions of women to Japan's musical history.

146. Gatens, William A., Ward A. Nelson, and K. Bryan Kirk. "Letters: Feminist Thought." *American Organist* 25, no. 12 (December 1991): 14–15.

     Three critical responses to: Milligan, Mary. "Professional Concerns Forum: An Introduction To Feminist Thought." *American Organist* 25, no. 9 (September 1991): 36–47.

147. Gillard, Cheryl. *Women in Music in Canada: An Introduction*. Thesis. M.A., Carleton University (Canada), 1987.

148. Godefroid, Philippe. *Divines and divas*. Paris: Editions Plume, 1989.

     ISBN 2908034050. In French. A pictorial volume on women singers.

149. Hickok, Gloria Vando, ed. *The Helicon Nine Reader: A Celebration of Women in the Arts. The Best Selections from 10 Years of* Helicon Nine, *the Journal of Women's Arts and Letters*. Kansas City, MO: Helicon Nine Editions, 1990.

     The portion devoted to women in music includes the articles: "Letter to the Editor" by Virgil Thomson (pp. 13–14); "Maria Theresia von Paradis" by Andrea Maxwell (pp. 96–99); "The Legendary Dame Ethel Smyth" by John Canarina (pp. 222–228); "The Murderous Marriage of Alma and Gustav Mahler" by Jack Diether (pp. 283–293); "Sweethearts on Parade" by Rosetta Reitz (on the all-women's jazz band, the International Sweethearts of Rhythm; pp. 325–334); "The Black Composer Speaks: An Interview with Undine Smith Moore" with Herman Hudson, David N. Baker, and Lida M. Belt (pp. 436–447).

150. Hubbs, Nadine Marie. *Musical Organicism and its Alternatives*. Diss. Ph.D., University of Michigan, 1990.

     Abstract in *Dissertation Abstracts International: A. Humanities and Social Sciences* 51, no. 7 (January 1991): 2192. DA# 9034443. The first half of this thesis takes a historical look at the organic principle in music, concentrating on its manifestation in musical compositions by Johannes Brahms and Arnold Schoenberg and in theoretical writings about music by Heinrich Schenker and Arnold Schoenberg. Part Two proceeds to investigate contemporary music's alternatives to this paradigmatic musical aesthetic. Included in this discussion is a feminist analysis of musical organicism (pp. 103–114), with a survey of recent work of feminist (and feminist-aligned) musicologists, such as Paula Higgins, Susan Cook, Catherine Parsons Smith, John Shepherd, and Susan McClary. The author uses the alternative perspectives identified in Part Two to inform her interpretation of Marilyn Shrude's *Solidarność:* (pp.115–124). A Meditation for Solo Piano.

151. Jennings, Lucile H. "Harp Music by Women Composers of the United States and Canada." In *The Musical Woman: An International Perspective. Volume 3, 1986–1990*, ed. Judith Lang Zaimont, Jane Gottlieb, Joanne Polk, and Michael J. Rogan, pp. 517–546. Westport, CT: Greenwood Press, 1991.

 The introduction features a discussion of the technical changes in the structure of the harp (single action versus double action), development of harp notation, the pioneering work of harpist/composer Henriette Renié, and the role of the harpist as composer. The main body of the essay consists of a list of harp music written by American and Canadian women composers, a selected discography, a bibliography of teaching materials by women harpist/composers, and an overview of women performing in the jazz, popular, and Celtic idioms.

152. Kassabian, Anahid. "The Sounds of Feminism." *Ms.* 3, no. 2 (September/October 1992): 64–66.

 An overview of recent developments in feminist music scholarship.

153. Kilmister, Sally. "Aesthetics and Music: The Appropriation of the Other." *Women: A Cultural Review* 3, no. 1 (Summer 1992): 30–39.

 Part of a special issue on women and music. The author examines the "notion of fetishism as a way of thinking about the music/language gap" in nineteenth-century instrumental music, and the ways in which gender surfaces as a consideration in this particular conceptualization of music. In doing so, she draws upon the theories of Theodor Adorno ("On the Fetish Character in Music and the Regression of Listening"), Sigmund Freud ("Fetishism"), Carl Dalhaus (his "topos of unsayability"), and the musical criticism of Virginia Woolf, to explain how music, once metaphorically symbolized as female prior to the nineteenth century, becomes privileged, enigmatic, exalted, (and masculinized) in its purely instrumental musical form, sublimating the forces of language which would give it referentiality.

154. Kivi, K. Linda. *Canadian Women Making Music*. Toronto: Green Dragon Press, 1992.

 ISBN 0969195583. In this interesting blend of contemporary and historical perspectives, accented with photographs of women musicians and women's ensembles, Kivi presents a survey of the contributions of women to Canadian musical culture. Giving equal recognition to the achievements of women in both vernacular and art musics, Part One is devoted to placing the musical contributions of women within the context of Canada's unique women's history during the nineteenth and the twentieth centuries. Twelve interviews with contemporary musicians comprise Part Two of the book, as women talk about their art and their identity as both women and Canadians. Included are autobiographical statements of: Salome Bey (blues and jazz singer, songwriter, and playwright from Toronto); Heather Bishop, Karen Howe, and Kris Purdy (three women singer/songwriters on the Canadian women's music scene); Pauline Julien (prominent Quebecois singer/song-

writer); Marie-Lynn Hammond (musician/ playwright); Lauri Conger, Julie Masi, and Lorraine Segato (rock musicians with Parachute Club and the Pillow Sisters); Connie Kadota and Eileen Kage (of the Vancouver-based ensemble Katari Taiko, a group fusing traditional Japanese and original musics); Margaret MacPhee (piano accompanist for Cape Breton traditional fiddling); Pamela Morgan (pianist, singer, and guitarist from Newfoundland, performing folk and traditional music); Alanis Obomsawin (Native Abenaki singer/songwriter/storyteller based in Montreal); Arlene Mantle (Toronto-based singer/songwriter of songs of social activism); Ann Southam (Toronto-based composer of electronic music); Marie-Claire Seguin (Quebecois songwriter and song stylist).

155. Latz, Inge. *Die Stille würde mich töten. Warum die Musik weiblich ist*. Bonn, Germany: Verlag Gisela Meussling, 1987.
    [author please add annotation, if necessary]

156. Lewis, Ruth A. "Letters: Feminist thought." *American Organist* 26, no. 4 (April 1992): 28–32.
    Letter supporting the article: Milligan, Mary. "Professional Concerns Forum: An Introduction to Feminist Thought." *American Organist* 25, no.9 (September 1991): 36–47.

157. MacAuslan, Janna, and Kristan Aspen. "Noteworthy Women: *Happy Birthday to You* and Other Well-Known Songs by Women." *Hot Wire* 5, no. 2 (May 1989): 12–13.
    The authors discuss the copyright suit initiated by the Hill Family over the unauthorized use of the song written by Mildred and Patti Smith Hill, *Happy Birthday to You*. They also note other circumstances where the contributions of women (e.g., as composers, lyricists, arrangers, etc.) are often overlooked.

158. Machover, Wilma. "Reviews: Videotapes." *American Music Teacher* 41, no. 6 (June/July 1992): 50–55.
    This helpful review article evaluates a number of video recordings of or about prominent women musicians. Reviewed are videotapes of women music educators: the Dorothy Taubman series (*The Choreography of the Hand* and *Master Classes*, total of six videocassettes; Amherst, MA: JTJ Films and the Taubman Institute, 1990–1991), *Nelita True at Eastman* (four videocassettes; Kansas City, MO: SH Productions, 1991); and *Conversations with Frances Clark* (two videocassettes; Kansas City: SH Productions, 1991). Also reviewed is *Jacqueline Du Pre and the Elgar Cello Concerto* (laserdisc and VHS; Hamburg, Germany: Teldec Video, 1990) and *Mademoiselle (Boulanger)*, a video profile of Nadia Boulanger (Bloomington, IN: Indiana University Center for Media Teaching Resources, 1987). Price, format, and complete publisher address information accompany each review.

159. McClary, Susan. *Feminine Endings: Music, Gender and Sexuality.* Minneapolis, MN: University of Minnesota Press, 1990.

> Reviewed in *Journal of Musicology* 9, no. 3 (Summer 1991): 397–398; *Notes* 48, no. 4 (June 1992): 1288–1291; *Journal of Aesthetics and Art Criticism* 50, no. 4 (Fall 1992): 338–340; *Signs* 18, no. 1 (Fall 1992): 162–172. This ground-breaking collection establishes a methodology for a feminist criticism of music and applies this methodology to a variety of musics and musical concerns. In her introduction, McClary delineates five major avenues of investigation which guide the six essays included in the book: 1) the semiotics of gender and sexuality as encoded in musical works, 2) the rhetoric of gender and sexuality in theoretical works on music, 3) how gender and sexuality is embedded and reproduced in the musical narrative of absolute music, with particular reference to the concept of tonality and the sonata-allegro form, 4) gendered associations (and anxieties) with relation to music as a cultural activity, and 5) alternative modes of musical discourse created by women composers and musicians. Her essays include "Constructions of Gender in Monteverdi's Dramatic Music," followed by "Sexual Politics in Classical Music," an exploration into sexual desire, gender relations, and patriarchal authority as constructed in the musical narrative of Bizet's *Carmen* and Tchaikovsky's *Symphony No. 4.* "Excess and Frame: The Musical Representation of Madwomen" is a socio-musicological look at women, madness, and their musical representations as illustrated through the works of Monteverdi ("Lamento della Ninfa," from his *Madrigals, Book Eight*), Donizetti (*Lucia di Lammermoor*), Strauss (*Salome*), and Schoenberg (in his music and theoretical writings). Female madness as a male construct in music is then contrasted with female rage as political protest, as created and enacted by performance artist Diamanda Galas; "Getting Down Off the Beanstalk: The Presence of a Woman's Voice in Janika Vandervelde's Genesis II," is an examination of one woman composer's musical response to the conventional phallicism of western music and culture. Final essays include "This is Not a Story My People Tell: Musical Time and Space According to Laurie Anderson," an analysis of the deconstruction of binary opposition in "O Superman" and the simulation of female pleasure in Anderson's "Langue d'amour," followed by "Living to Tell: Madonna's Resurrection of the Fleshly," a discussion of Madonna's challenge to male dominance and female annihilation via self-conscious constructions of female desire and pleasure in her music and videos.

160. McClary, Susan. "Foreword: Ode to Cecilia." In *Cecilia Reclaimed: Feminist Perspectives on Gender and Music*, ed. Susan C. Cook and Judy S. Tsou, pp. ix-xiii. Urbana, IL: University of Illinois Press, 1994 (forthcoming).

161. McClary, Susan. "Reshaping a Discipline: Musicology and Feminism in the 1990s." *Feminist Studies* 19, no. 2 (Summer 1993): 399–423.

> An essential resource, this review essay assesses the important literature in the field of feminist musicology. Lengthy bibliography included.

162. McClary, Susan. "A Response to Elaine Barkin." *Perspectives of New Music* 30, no. 2 (Summer 1992): 234–238.

    Responding to Elaine Barkin's critique of her writings in the same issue of this journal, McClary stresses the importance of the process of reception to the perpetuation of music within culture, and reiterates the need for an open musicological discourse accepting of alternative interpretations which expand upon those utilizing strict formalist techniques.

163. Mielitz, Christine. "Noch einmal: Frauen in der Musik." *Musik und Gesellschaft* 38 (June 1988): 316–318.

    In German. Translated title: "Once Again, Women in Music."

164. Milligan, Mary. "Professional Concerns Forum: An Introduction To Feminist Thought...What the Musician of the 1990s Should Know." *American Organist* 25, no. 9 (September 1991): 36–47.

    The author argues that an understanding of feminism is important for the musician in today's world. She provides an overview of feminist theology and the issue of inclusive language for the sacred musician. Includes an excellent bibliography, with a list of inclusive language sources for worship.

165. Moreno, Salvador. "A propósito de *La Mujer Mexicana en la Música*." *Heterofonia*, no. 104–105 (1991): 76–77.

    In Spanish. Translated title: "A proposal with regard to *The Mexican Woman in Music*." The knowledge gained since the initial publication in 1958 of Esperanza Pulido's book warrants a new edition.

166. Morris, Mitchell. "Reading as an Opera Queen." In *Musicology and Difference: Gender and Sexuality in Music Scholarship*, ed. Ruth Solie, pp. 184–200. Berkeley, CA: University of California Press, 1993.

    The culture of the opera queen—comprised of members of the gay community of who are devotees of opera, the female singer as diva, her musical and dramatic performance, and interpretation—is profiled here. As Morris reveals the various aesthetic concerns of the opera queen, an important aspect of which is feminine sexual identification, he maintains there should be a place within the discourse of musicology for these alternative readings. Richard Wagner's *Parsifal* is then interpreted from an opera queen's perspective.

167. Myers, Margaret. "Kvinnor och musik: nagra livstecken." *Musikrevy* 44, no. 1 (1989): 17–18.

    In Swedish. Translated title: "Women and Music: Some Lifesigns."

168. Öhrström, Eva. "Primadonnan: hora eller ängel?" In *Kvinnors Musik*, ed. Eva Öhrströhm and Märta Ramsten, pp. 89–100. Stockholm, Sweden: Sveriges Utbildningsradio AB and Svenska Rikskonserter, 1989.

ISBN 9126898101. In Swedish. Translated title: "Primadonna— Whore or Angel." In her discussion of the role of the female solo singer who performs with an accompanying ensemble, and the various female images which these singers project, the author discusses the lives, careers, and the reception of "primadonnas" from various musical genres and eras: Jenny Lind, Christina Nilsson, Bessie Smith, Edith Piaf, Billie Holiday, Janis Joplin, Nina Hagen, Madonna, and others.

169. Öhrström, Eva, and Märta Ramsten, eds. *Kvinnors Musik*. Stockholm, Sweden: Sveriges Utbildningsradio AB and Svenska Rikskonserter, 1989.
ISBN 9126898101. In Swedish. Translated title: *Women's Music*. Reviewed in *Tonfallet* no. 2 (1990): 14. This is the first monographic collection of essays in Swedish on women and their various roles and contributions to the music that country. The twenty-three essays included in this book correspond to the "Kvinnors Musik" series of 20 radio programs produced by Sveriges Utbildningsradio which, according to the endpage, are available at most schools and libraries (and are also distributed by the Brevskolan publishing firm, along with a study guide). Photographs and a variety of illustrative material on Swedish women musicians and composers make this an attractive and informative book, and one that both school and undergraduate collections in that country might find appropriate. The bibliography is useful for its inclusion of sources in the Scandinavian languages, not easily found elsewhere. Each essay is cited individually in this bibliography.

170. Pasler, Jane. "Some Thoughts on Susan McClary's *Feminine Endings*." *Perspectives of New Music* 30, no. 2 (Summer 1992): 202–205.

171. Pendle, Karin, ed. *Women and Music: A History*. Bloomington, IN: Indiana University Press, 1991.
Reviewed in *Sonneck Society Bulletin* 18, no. 3 (Fall 1992): 136; *Musical Times* 133 (November 1992): 574; *Notes* 49, no. 3 (March 1993): 1058–1059; *Music Educators Journal* 78, no. 7 (March 1992): 60–61; *Times Literary Supplement*, no. 4676 (13 November 1992): 12. Presented are fifteen essays by as many authors discussing the musical activities of women from antiquity to the present. The essays examine various topics such as patronage, female musical aesthetics, women in non-Western music, women in American popular genres (including blues and jazz), in addition to women in the history of western classical music, which is the focus of the book. Designed to function as a text, the book is meant to be used with tapes accompanying the *Historical Anthology of Music by Women* (1987), edited by James Briscoe. Includes bibliographical references and a discography. Each essay is cited individually in this bibliography.

172. Pieiller, Evelyne. *Musique maestra: le surprenant mais néanmoins véridique récit de l'histoire des femmes dans la musique du XVIIe au XIXe siècle.* Paris, France: Éditions Plume, 1992.

    In French. Translated title: *Music Maestra: The Surprising But Nonetheless True Account of the History of Women in Music from the 17th through the 19th Centuries.* Reviewed in *La Quinzaine Littéraire* No. 603 (16 June 1992): 27. This is a historical survey of role of women in French music, theatre, and culture from 1600–1900. Includes reproductions of period illustrations, as well as a selective bibliography and an index.

173. Ramsten, Märta, Lotta Höjer, and Hillevi Ganetz. "Skapande kvinnor." In *Kvinnors Musik*, ed. Eva Öhrström and Märta Ramsten, pp. 139–157. Stockholm, Sweden: Sveriges Utbildningsradio AB and Svenska Rikskonserter, 1989.

    ISBN 9126898101. In Swedish. Translated title: "Creative Women". Includes profiles of Swedish women musicians: Oltorgs Kajsa, folk fiddler and dance tune composer; Elise Einarsdotter, jazz pianist; Karin Rehnqvist, composer; and the group Tugga Terrier, "nasty princesses" of rock music.

174. Randel, Don Michael. "The Canons in the Musicological Toolbox." In *Disciplining Music: Musicology and its Canons*, ed. Katherine Bergeron and Philip V. Bohlman, pp. 10–22. Chicago: University of Chicago Press, 1992.

    An excellent introduction to the issues regarding recent challenges to the traditional musicological canon, including those areas of study regarding women's contributions to music and feminist theory as applied to music criticism.

175. Rieger, Eva. *Frau, Musik und Männerherrschaft: zum Ausschluss der Frau aus der deutschen Musikpädagogik, Musikwissenschaft und Musikausübung.* 2nd ed. Furore Edition, no. 828. Kassel, Germany: Furore-Verlag, 1988.

    ISBN 3980132684. In German. Translated title: *Women, Music and Male Domination: On the Exclusion of Women from German Music Pedagogy, Scholarship and Practice.* Reviewed in *Das Orchester* 37, no. 11 (November 1989): 1117. The four chapters presented discuss the educational system and its treatment of women; music as a bearer of a gender-specific ideology; creative women (e.g., Clara Schumann, Cosima Wagner, Fanny Mendelssohn Hensel, Alma Mahler, Eta Harich-Schneider) in conflict with men and their music; and the author's assessment of the current situation for women musicians, composers, scholars, and critics as compared with that of the past.

176. Rieger, Eva. "Zur Situation der Komponistin im Deutschsprachigen Kulturraum." In *Komponistinnen in Japan und Deutschland: eine Dokumentation*, ed. Renate Matthei, pp. 18–24. Furore Edition, no. 853. Kassel, Germany: Furore-Verlag, 1991.

ISBN 3927327093. In German. Translated title: "On the Situation of the Woman Composer in the Realm of German-Speaking Culture." Rieger outlines the various difficulties facing the professional woman composer today, such as prejudicial attitudes which prevent women composers from being recognized through commissions, performances, recordings, etc. She links these present attitudes to older societal norms which restricted women to the domestic sphere and prescribed only certain types of musical activities within that sphere. She then surveys the women who have been successful during the twentieth century as composers of experimental music and music for the concert hall, as well as the role of women in music pedagogy and in church music. She examines the question of the existence of a female musical aesthetic which can be identified in compositions by women.

177. Roma, Catherine, Debbie Fier, and Allen Family. "Mothers and Daughters." *Hot Wire* 4, no.2 (March 1988): 34–39.
    This exploration into the relationships between feminist artist/musician mothers and daughters profiles the following: Henia Goodman, a classical pianist and holocaust survivor, and her daughter Dovida Ishatova, also a pianist as well as a writer; Margaret Sloan-Hunter, songwriter and a co-founder of *Ms.*, and her daughter Kathleen; and the women of the Allen family (Donna, Martha, Dana and Indra), all of whom are active in the women's music and media scene through either publishing, performing, recording, or producing (e.g., Women's Institute for Freedom of the Press, Historic Originals Program, *Media Report to Women*, etc.) A bibliography of recordings and books on the mother/daughter theme is included.

178. Rorem, Ned. "Ladies' Music." In *Settling the Score: Essays on Music*, pp. 330–338. San Diego, CA: Harcourt, Brace, Jovanovich, 1989.
    This composer addresses the "why are there no great women composers" question.

179. Samuel, Rhian. "Feminist Musicology: Endings or Beginnings?" *Women: A Cultural Review* 3, no. 1 (Summer 1992): 65–69.
    The author assesses the status of feminist musicology, evaluating the major publications in the field which have emerged during the past decade. She particularly criticizes, however, Susan McClary's *Feminine Endings*, stressing the need for an apolitical approach to the criticism of music by women composers.

180. Samuel, Rhian. "Women Composers Today: A Personal View." *Contact*, no. 32 (Spring 1988): 53–54.
    Response to Nicola LeFanu's "Master Musician: An Impregnable Taboo?" *Contact*, no. 31 (Autumn 1987): 4–8. This composer responds to Lefanu's article, which documents discrimination against women composers, by offering some suggestions. Needed is more awareness amongst men and women as to when and how discriminatory attitudes are manifest-

ed, since much of this behavior is subtle and behind the scenes. She describes how women often defeat themselves in their efforts to achieve, with feelings of inadequacy which prevent them from assuming dominant or creative roles. Here, Samuel feels that educational institutions need to take the lead on several fronts. Colleges and conservatories should require all students, male and female, to take courses in composition and conducting as part of their musical training. Women students need to have more female role models in their educational experience. And finally, there must be more opportunities and recognition for women of ability and talent.

181. Schramm, Carola, et al. "Diskussion." *Musik und Gesellschaft* 38 (October 1988): 549–550.
     In German. Letters in response to the March 1988 issue of *Musik und Gesellschaft* entitled "Frauen in der Musik."

182. Senelick, Laurence, ed. *Gender in Performance: The Presentation of Difference in the Performing Arts*. Hanover, NH: University Press of New England, 1992.
     Nineteen essays concentrating on issues relating to gender presentation in the theater arts and dance from various cultures and periods of history are presented.

183. Shapiro, Anne Dhu. "A Critique of Current Research on Music and Gender." *The World of Music* 33, no. 2 (1991): 5–13.
     Part of a special issue entitled "Women in Music and Music Research." Over the past ten years research on music and gender has focused on historical study, genre research, and cultural anthropology. The author questions the polemical orientation of recent writings, and cautions against biased interpretations (reflecting sexual politics, ethnocentrism, or musicocentrism) which may limit the usefulness of research on music and gender.

184. Shapiro, Anne Dhu. "Music and Gender: Another Look." *Sonneck Society Bulletin* 17, no. 2 (Summer 1991): 58–60.
     An abridged version of the author's article, "A Critique of Current Research on Music and Gender" appearing in *The World of Music* 33, no. 2 (1991): 5–13.

185. Shepherd, John. "Difference and Power in Music." In *Musicology and Difference: Gender and Sexuality in Music Scholarship*, ed. Ruth Solie, pp. 46–65. Berkeley, CA: University of California Press, 1993.
     The hegemony of Western culture's "discursively constituted [and] preferred notions" (p. 60) of language, music and genre, which serve to control the affective power of music, a "socially grounded" (p. 65) sound medium which resonates within the body, is considered here. This "difference" of music and the control of its cultural reproduction is discussed here in gendered terms which render the former as feminine and the latter as masculine.

186. Shteir, Rachel B. "Critic! Good Old Boys and the A-Word." *Village Voice* 36 (9 July 1991): 84.

    This theatre critic examines male resistance to feminist criticism in the arts, and particularly the manner in which feminist criticism seeks to challenge the imposition of cultural authority upon the interpretation and assessment of a work.

187. Solie, Ruth,ed. *Musicology and Difference: Gender and Sexuality in Music Scholarship*. Berkeley, CA: University of California Press, 1993.

    This important volume of essays focuses collectively on notions of universality and difference in the discourse of musicology, with particular reference to issues regarding gender and sexuality. The book is divided into four main sections: "Systems of Difference" (essays by Leo Treitler, John Shepherd and Barbara Engh); "Cultural Contexts of Difference" (essays by Judith Tick, Carol E. Robertson, and Nancy B. Reich); "Interpretive Strategies" (essays by Ellen Koskoff, Elizabeth Wood, Mitchell Morris, and Gretchen A. Wheelock); "Critical Readings" (essays by Carolyn Abbate, Philip Brett, Suzanne G. Cusick, Lawrence Kramer, and Susan McClary). Each essay is cited individually in this bibliography.

188. Solie, Ruth. "What Do Feminists Want? A Reply to Pieter van den Toorn."*Journal of Musicology* 9, no. 4 (Fall 1991): 399–410.

    Replying to van den Toorn's "immoderate and global attack" on feminism, Solie critiques his dual view of music as both personal and universal. His case for musical formalism based on a personalized (male) response to a piece of music rejects other responses, such as Susan McClary's, as inappropriate. On the other side of the coin, she notes that his argument for the universal and shared qualities of music further necessitates conforming to a "tyranny that hears no dissenting voices." In the section of the essay entitled "Who Are These 'Feminists'," Solie contests van den Toorn's caricaturization of feminists and his monolithic view of feminist theory, and then proceeds to present the possibilities available within the field of musicology for the investigation of a vast array issues relating to sexuality, gender differences (and commonalities), and representation. In "What Women Do Not Want," Solie criticizes van den Toorn's overtly male sexual politics unsubtly cloaked in the rhetoric of academic discourse.

189. Stewart, Dave. "Inside the Music: Hormonal Home Truths." *Keyboard* 17, no. 8 (August 1991): 121, 123.

    Males are more innately capable of creating challenging, intellectual music. Letters supporting this contention are found in *Keyboard* 17, no. 8 (October 1991): 8. Letters criticizing this contention are found in *Keyboard* 17, no. 12 (December 1991): 180–181, 188.

190. Thomson, Margie. "A New Song: Women's Music in Aotearoa." *Music in New Zealand* 13 (Winter 1991): 22–29.

This article profiles a number of women songwriters, instrumentalists, and record producers from New Zealand, with a particular focus on contemporary Maori women singers and songwriters. The candid commentary by a number of these women is at times critical of the more ideologically feminist and lesbian-identified women's music scene found in the United States, and U.S.'s mainstream scene is criticized for being overly concerned with female sexual image instead of music. The author discusses how New Zealand's mainstream music scene, which is more localized and thus more independent than that in the U.S., offers women musicians more alternatives for performance, writing, recording, etc., and thus more opportunities to promote songs addressing feminist issues, racial equality, and social diversity to both male and female audiences. Musicians mentioned include the Maori group Moana and the Moa Hunters, guitarist Jan Hellriegel, Women in Blues, trumpeter and record producer Edwina Thorne, and songwriter Mahinarangi Tocker.

191. Toorn, Pieter C. van den. "Politics, Feminism and Contemporary Music Theory." *Journal of Musicology* 9, no. 3 (Summer 1991): 275–299.

Introduced by a general discussion of theoretical approaches to music, particularly as it is construed today by those in the mainstream, the author then attacks new Marxist and feminist approaches. The writings of Susan McClary, and in particular her feminist-influenced analyses of works belonging to the canon of Western music (e.g., Beethoven's Symphony No. 9), are heavily scrutinized.

192. Tremblay-Matte, Cécile. *Histoire des femmes auteures-compositeurs dans la chanson canadienne-française, 1730–1985*. Diss. Ph.D., Faculté de Musique, Université de Montréal, 1989.

In French. Translated title: *History of Women Author/Composers of French-Canadian Song, 1730–1985.*

193. Tremblay-Matte, Cécile. *La chanson écrite au féminin: de Madeleine de Verchères à Mitsou, 1730–1990*. Laval, Quebec: Éditions Trois, 1990.

ISBN 2920887165. In French. Reviewed in *Canadian University Music Review* 11, no. 1 (1991): 138–139. This 390-page book surveys the contributions of women composers and lyricists to the song repertoire of Quebec from a historical perspective, examining social, familial, economic and/or political themes expressed in songs composed by women and the changing musical language used as songs evolved over two centuries. The book contains an appendix listing over 6000 songs by over 400 composers and/or lyricists, with information such as the year of publication and edition available (printed and/or recorded).

194. Walker-Hill, Helen. "Discovering the Music of Black Women Composers." *American Music Teacher* 40, no. 1 (August/September 1990): 20–23, 63.

195. Wenzel, Lynn. "Yes, Mendelssohn was a Woman." *New Directions for Women* 19, no. 1 (January/February 1990): 9.

Bay Area Women's Philharmonic is dedicated to the discovery and promotion of women composers, conductors and performers.

196. Zaimont, Judith Lang, Jane Gottlieb, Joanne Polk, and Michael J. Rogan, eds.*The Musical Woman: An International Perspective. Volume 3, 1986–1990*. Westport, CT: Greenwood Press, 1991.

Reviewed in *American Music Teacher* 42, no.3 (December/January 1992/ 1993): 66; *Music Educators Journal* 78, no.7 (March 1992): 61. The same format as volume two in this series, (see entry #198) this volume features an expanded "Gazette" section, and includes nineteen new essays assessing the musical contributions of women and the status of women in various music professions, examined in historical and contemporary contexts. All essays are individually cited in this bibliography.

197. Zaimont, Judith Lang, and Mary Brown Hinely. "The Awakening: Creative Contributions to American Music by Southern Women, 1860-1960." In *A New Perspective: Southern Women's Cultural History from the Civil War to Civil Rights*, ed. Priscilla Cortelyou Little and Robert C. Vaughan, pp. 65–76. Charlottesville, VA: Virginia Foundation for the Humanities, 1989.

This essay first addresses the contributions of Southern women to concert music, noting women's professional activity as music educators in colleges and conservatories (e.g., Weenonah Poindexter), as pianists and prominent piano instructors (e.g., Amy Fay and Olga Samaroff), as musicians and music patrons (e.g., Bertha Roth Walburn Clark, founder of the Knoxville Symphony Orchestra), as concert managers and music critics, as composers (e.g., Mary Carr Moore, Mary Howe, etc.), and also as volunteer advocates and organizers of community music. The article recognizes the contributions of black women virtuoso singers from the post-Civil war period through the 1960s, as well as achievements of black women composers such as Florence Price and Undine Smith Moore. Part two of the essay surveys Southern black and white women's contributions to the vernacular repertoire, as both creators and performers of music as well as collectors/preservers of musical traditions. Women as consumers and (often anonymous) composers of parlor music is discussed, in addition to a very general overview of the role of women in more indigenous musical forms such as spiritual, gospel, traditional folk, country, blues, and jazz.

198. Zaimont, Judith Lang, Catherine Overhauser, and Jane Gottlieb, eds. *The Musical Woman: An International Perspective. Volume 2, 1984–1985*. Westport, CT: Greenwood Press, 1987.

Reviewed in *Frontiers: A Journal of Women Studies* 10, no. 1 (1988): 90-91; *Canadian Woman Studies* 9, no. 3–4 (Fall/Winter 1988): 149–150; *Notes* 47, no. 2 (December 1990): 380–381; *American Music* 8, no. 2 (Summer 1990): 236–238; *Fontes Artis Musicae* 37, no. 4 (October–December 1990): 309–310.

The second volume of this significant series dedicated to documenting recent musical activity of women reports new published resources on women in music and introduces new research on women in all aspects of music. The "Gazette" section identifies performances of women's works, festivals and conferences, prizes, commissions, women conductors, and new publications, recordings and films. The remainder of the book is devoted to essays, interviews, research articles, and reviews of conferences and festivals. (Essays are individually cited in this bibliography).

# Part C.  Festival, Concert, and Conference Review Literature

199. Alexiou, Margaret, and Gail Holst-Warhaft. "Voices of Greek Women: Two Introductory Comments." *Journal of Modern Greek Studies* 9, no. 2 (October 1991): 141–143.

    The authors review the conference entitled, "Voices of Greek Women," held at Cornell University (March 1990). Through academic papers on various topics and live performances of poetry, prose, and song, the conference explored the feminine voice as represented in Greek literature and music. This journal issue publishes the papers delivered at the conference.

200. Anders, Johannes. "Woman Piano Meeting 90: spannende Solotrips, intuitives Interplay." *Jazz Podium* 39, no. 4 (April 1990): 34–35.

    Festival review.

201. Anderson, Jamie. "Women's Music and Culture Festivals." *Hot Wire* 8, no. 2 (May 1992): 32–34.

    A listing of women's music festivals in the U.S. and Canada with basic descriptive information about each (e.g., date, ticket prices, audience, facilities, address, phone, etc.)

202. Armstrong, Toni, Jr. "All Quiet on the Eastern Front: Third Annual East Coast Lesbians' Festival." *Hot Wire* 7, no. 3 (September 1991): 35–37.

203. Armstrong, Toni, Jr. "Michigan Womyn's Music Festival 1991: A World of Women at Wombstock." *Hot Wire* 8, no. 1 (January 1992): 34–35, 43.

204. Armstrong, Toni, Jr. "National Women's Music Festival [Bloomington, IN]: Showcase 1988." *Hot Wire* 5, no. 1 (January 1989): 26–27, 58.

205. Barthelmes, Barbara. "Forum der Frauen: sechs Komponistinnen-portraitiert." *Musica [Germany]* 45, no.6 (November/December 1991): 384, 386.

In German. Organized by Musikfrauen e.V. Berlin, the "Klang-portraits" concert series (March through June 1991) featured the works of six women composers. This concert review discusses the works by Adriana Hölszky (Romania), Jacqueline Fontyn (Belgium), Younghi Pagh-Paan (South Korea), Kaija Saariaho (Finland), Myriam Marbé (Romania), and Christina Kubisch (Germany).

206. Benda, Susanne. "Vor dem freien Fall ins Nichts?: Russische Kompon-istinnen beim Heidelberger Musikfestival." *Neue Zeitschrift für Musik* 153, no. 2 (February 1992): 37.

In German. Sofia Gubaidulina and other Russian women composers (Tamara Ibragimova, Anna Ikramova, Olga Korowina, Olga Magidenko, Jekaterina Tschemberdschi, and Jelena Iskowa) were highlighted at Heidelberg's Seventh International Women Composers Festival, sponsored by Kulturinstitut Komponistinnen Gestern-Heute.

207. Borroff, Edith. "Spreading the Good News: Conferences on Women in Music." In *The Musical Woman: An International Perspective. Volume 2, 1984-1985*, ed. Judith Lang Zaimont, Catherine Overhauser, and Jane Gottlieb, pp. 335–346. Westport, CT: Greenwood Press, 1987.

This author/composer/musicologist reviews and compares two women-in-music conferences, the first a series of meetings sponsored by the University of Michigan, Ann Arbor (Opus 1: Women in Music [1982] and Opus 2: Women in Music [1983]), and the second a series of meetings spon-sored by the International Congress on Women in Music (New York [1981] and California [1982]). She examines the divergent but complementary approaches of both organizations via her investigation into the different con-stituencies (i.e., those in academe/women's studies vs. composers/perform-ers), meeting formats (i.e., academic/multi-session and musical/single session or performance), and the overall goals of each.

208. Brandes, Edda. "1st International Conference of the ICTM's Study Group 'Music and Gender' in Heidelberg from 21st to 26th June, 1988." *The World of Music* 30, no. 2 (1988): 107–108.

Review of the first meeting of the International Council for Traditional Music's Study Group on Music and Gender.

209. Cash, Alice H. "Conference Report. Feminist Theory and Music: Toward a Common Language. School of Music, University of Minnesota, Minneapolis, 26–30 June 1991." *Journal of Musicology* 9, no. 4 (Fall 1991): 521–532.

The author surveys the diverse range of topics discussed in the papers presented, including feminist issues in performance; the image of women in opera ; gender signification in the compositional process; music as gen-dered discourse; issues in gender, sexuality and musical reception; gay and lesbian composers, and interpretations of their music; women's music gen-

res; gender and music pedagogy; power and gender relations expressed
through music; musical poetics; gender and its influence on canon formation;
analyses of works by women composers; women and their representation in
music; women's and men's musical communities; gender and musical sub-
cultures; the interrelations of music, dance and physicality; and more. The
author summarizes Susan McClary's keynote address assessing progress in
feminist music criticism.

210. Citron, Marcia J. "Conference Report. Beyond Biography: Seventh
International Congress on Women in Music, Utrecht, The Netherlands, 29
May–2 June 1991." *Journal of Musicology* 9, no. 4 (Fall 1991): 533–538.

In this journal issue, the author reviews two of the three major confer-
ences in feminist musicology taking place during the summer of 1991. Here,
her focus is on several of the presentations offered at the Seventh
International Congress on Women in Music. She offers evaluative sum-
maries of the following: Eva Rieger's address on a female musical aesthetic;
Elizabeth Wood's presentation "Lesbian Fugue: Ethel Smyth's Contrapuntal
Arts," this being a narrative on the life and music of Ethel Smyth in the form
of a fugue; Joke Dame's "Unveiled Voices: Sexual Difference and the
Castrato"; Helen Metzelaar's assessment of the current state of women's
musicology in the Netherlands; Regina Himmelbauer's paper on the
trobairitz, entitled "Without a Picture the Mirror Breaks: The Use of Her
Story"; and Elisabeth Bosland's "Gender In/And Musicology." Panel discus-
sions and short presentations are noted as well, as well as an acknowledge-
ment of the conference's emphasis on performance of works by women
composers.

211. Citron, Marcia J. "Conference Report: Music and Gender Conference,
King's College, London, 5–7 July 1991." *Journal of Musicology* 9, no. 4
(Fall 1991): 539–543.

The second conference review by this author in this journal issue
focuses on the Music and Gender Conference held in London (1991). Citron
notes how the conference, (organized by Sophie Fuller and Nicola Lefanu,
and the first of its kind to emanate from England), addressed an impressive
array of subjects on women and gender issues in music. In the opening ses-
sion, the theme of diversity was echoed by Nicola Lefanu and Susan
McClary, and Marcia Citron presented "Gender and the Sonata Aesthetic."
The author highlights other presentations on topics such as: music pedagogy,
women, and feminism in academe; the construction of gender in musical
compositions; women composer/musician/music culture surveys of particu-
lar countries such as England, Ireland, the Netherlands, New Zealand,
Turkey, and Afghanistan; lesbian and homosexual considerations in music;
composer studies; sexual politics and musical aesthetics; and women in the
orchestra; women in popular music genres. She concludes by saying that
while language and geographical barriers often prevent the free-flow of ideas
and information to those scholars working in the discipline, conferences such

as those in Utrecht, London, and Minneapolis have "forged a sense of an international community."

212. Cook, Susan C. "Women, Women's Studies, Music and Musicology: Issues in Pedagogy and Scholarship." *College Music Symposium* 29 (1989): 93–100.

The 1988 meeting of the American Musicological Society in Baltimore featured a number of presentations on women's issues in music, and particularly pedagogical issues in musicology. This essay summarizes the presentations given by panelists James R. Briscoe, Elizabeth Wood, Susan McClary, and Susan C. Cook, all of whom addressed the integration of feminist musical scholarship into the classroom. James Briscoe, in "Mainstreaming Women in Music History Teaching," discussed his efforts to incorporate music by women composers into his music history classes after he realized that he was perpetuating an essentially masculine musical canon to a student body comprised mainly of women. Elizabeth Wood's presentation on "Feminist Re-Thinking: Women, Music, and Women's Studies," examined how feminist theory can be used to restructure our ways of thinking about music, and explained how her courses on gender and music explore broader historical and societal issues, as well as issues relating to a female musical aesthetic. Susan McClary debunked musicology's adherence to notions of music as an autonomous, objective art form, and stressed the need for a feminist approach which imparts music with meaning, pleasure, and emotion. Susan Cook's presentation focused on pedagogical issues, stressing the awareness of gender differences in the learning process, and identifying classroom strategies which serve to either encourage or discourage equal participation and treatment female and male students. The article includes a bibliography of feminist sources from various disciplines which the panelists have used in their research.

213. Corbett, John. "Women of the New Jazz." *Down Beat* 58, no. 8 (August 1991): 55.

Review of the jazz festival at the Hot House in Chicago, featuring singer Rita Warford, pianist Jodie Christian, soprano sax player Jane Bunnett, singer Sheila Jordan, pianist Myra Melford, cellist Deidre Murray and pianist Geri Allen.

214. Dalton, Jody. "New Music News: Women Scholars and Composers Unite." *Ear* 15, no. 3 (May 1990): 11.

On Jeannie Pool and the Tenth International Congress on Women in Music held in New York in March 1990.

215. Davis, Erik. "What About Power?" *Village Voice* 35 (31 July 1990): 78.

New Music Seminar's panel on women and music retreats from controversial gender and racial issues with respect to the music industry.

216. Dell'Antonio, Andrew. "Peacocks, Feminism, and Meraviglia: the AMS and SMT in Baltimore." *Cum Notis Variorum* 129 (January/February 1989): 5–7.

A review of the 1988 joint meeting of the American Musicological Society and the Society for Music Theory.

217. Duffy, Thom. "'Women's Way' is Everyone's Business." *Billboard* 102 (3 November 1990): 46.

   Women musicians perform a benefit concert for Women's Way, a coalition of groups providing services to women and children in Delaware County, PA.

218. Einemann, Marita. "5th International Congress on Women in Music: vier Tage 'Musik total' in Bremen." *Neue Zeitschrift für Musik* 149, no. 9 (September 1988): 57–60.

219. Emery, Ron. "Women to Play Music by Women." *Times Union* [Albany, NY] 4 March 1988, in *Newsbank: Review of the Arts, Performing Arts* 15, Fiche 56 (April 1988): G6.

220. Epstein, Selma. "Women Composer's Orchestra: A Concert Report [and] Women's Philharmonic: East Coast Debut." *International League of Women Composers (ILWC) Journal* (March 1992): 28.

   Reviews of two performances: the first by the Women Composer's Orchestra (formerly the Maryland Women's Symphony), and the second by the Women's Philharmonic taking place at the twenty-fifth anniversary celebration of NOW at the Kennedy Center.

221. Fink, Sue. "Report from Israel: The First International Women's Music Festival, June 23–28, 1986." *Hot Wire* 3, no. 2 (March 1987): 24–26.

222. "First International Women's Brass Conference Takes Place." *Historic Brass Society Newsletter* 4 (Summer 1992): 43.

223. "Five Impact Grants Announced by SAI Philanthropies." *Pan Pipes* 80 (Fall 1987): 16.

   Mentions a grant to support a 4-day symposium on women in music at the University of Puget Sound.

224. Gojowy, Detlef. "Blauer Komponistinnenhimmel? Uraufführungen von Ruth Zechlin, Brunhilde Sonntag und Viera Jánarčeková in Nordrhein-Westfalen." *Neue Zeitschrift für Musik* 150, no. 3 (March 1989) 40.

   In German. Translated title: "Blue Women Composers Heaven? Premieres of Ruth Zechlin, Brunhilde Sonntag, and Viera Jánarčeková in North Rhine-Westphalia."

225. Gojowy, Detlef. "Heidelberger Komponistinnen-Festival." *Musica [Germany]* 42, no. 5 (September/October 1988): 478–479.

   In German. Translated title: "Heidelberg Women Composers Festival."

226. Gojowy, Detlef. "Monumentale Konstruktionen zum 5. Mal: Komponistinnen-Fest Heidelberg 1989." *Das Orchester* 37, No. 12 (December 1989): 1212–1213.

　　In German. Translated title: "Monumental Constructions for the Fifth Time: 1989 Women Composers Festival in Heidelberg."

227. Gojowy, Detlef. "Phantasie und Reglement: Internationales Komponistinnen-Festival Heidelberg." *Neue Zeitschrift für Musik* 148, no. 9 (September 1987): 54–55.

　　In German. Translated title: "Imagination and Regimen: Heidelberg International Women Composers Festival."

228. Gray, Sarah. "Women From 20 Nations Share Values at State Music Festival." *Ann Arbor News* 20 August 1990, in *Newsbank: Review of the Arts, Performing Arts* 17, Fiche 139 (September 1990): E1.

　　Review of the 1990 Michigan Womyn's Music Festival.

229. Gronemeyer, Gisela. "Vom Schweigen befreit? Überlegungen zu Komponistinnen-Festivals aus gegebenem Anlass." *Neue Zeitschrift für Musik* 152, no. 1 (January 1991): 47–48.

　　In German. Translated title: "Freed from Silence? Considerations on the Reason for Presenting Women Composer Festivals." The increasing number of women composer festivals in Germany causes the author to now consider the question of whether such festivals further marginalize the music of women.

230. Guse, Celia. "The Third Annual Women's Choral Festival." *Hot Wire* 3, no. 2 (March 1987): 28–29, 60.

　　A review of this national festival of women's choral groups, held in November 1986 in Chicago, Illinois.

231. Hall, Alan. "Songs of Womanhood." *Musical Times* 131 (November 1990): 609.

　　Reviews two concerts featuring works by women composers: *The Bet*, a puppet music-drama by Elaine Feinstein, and an evening of music by Errollyn Wallen.

232. Hall, Corey. "Jordan, Allen Top Bill at Chi Women's Improv Fest." *Down Beat* 58 (May 1991): 11.

　　The "Women of the New Jazz" festival, held in Chicago in May 1991, featured pianist Myra Melford, saxophonist Jane Bunnett, vocalist Sheila Jordan, pianist Geri Allen, and other women working in the improvisatory realm of jazz.

233. Harper, Jorjet. "15th Anniversary Bash: Olivia Records at Carnegie Hall." *Hot Wire* 5, no. 2 (May 1989): 32–33.

234. Harper, Jorjet. "The 1990 AWMAC Conference." *Hot Wire* 6, no. 2 (May 1990): 34–35, 48.

    This report on the 1990 conference of the Association of Women's Music and Culture summarizes the presentation of the keynote speaker Ronnie Gilbert.

235. Harper, Jorjet. "1991 Southern Women's Music and Comedy Festival: A Hoot and a Holler." *Hot Wire* 7, no. 3 (September 1991): 34–35.

236. Henry, Murphy. "Women in Bluegrass Music: A Seminar." *Bluegrass Unlimited* 24 (December 1989): 28–29.

    A summary of the first-time seminar/panel discussion on women in bluegrass at a meeting of the IBMA. Speakers included Lynn Morris, Alison Krauss, Laurie Lewis, Hazel Dickens and others.

237. Henson, Brenda. "Women's Music in the Deep South at the First Annual Gulf Coast Women's Festival." *Hot Wire* 6, no. 1 (January 1990): 38–39.

238. Hettergott, Alexandra. "Zwei Konzerte mit dem 1. Frauen-Kammerorchester." *Österreichische Musik Zeitschrift* 45, no. 9 (September 1990): 508–509.

    In German. Translated title: "Two Concerts with the First Women's Chamber Orchestra."

239. Hochberg, Marcy. "A New Attitude—A New Festival: Rhythm Fest 1990." *Hot Wire* 7, no. 1 (January 1991): 38–39, 59.

    A review this women's music festival held on Lookout Mountain in northern Georgia.

240. Hoover, Katherine. "Festivals of Women's Music, I-IV." In *The Musical Woman: An International Perspective. Volume 2, 1984–1985*, ed. Judith Lang Zaimont, Catherine Overhauser, and Jane Gottlieb, pp. 347–377. Westport, CT: Greenwood Press, 1987.

    This essay examines the history of the Festival of Women's Music project, organized by the author (also a composer and flutist) in conjunction with the Women's Interart Center of New York (four festivals, 1978–1981). A pioneering effort of the late 1970's, the project was designed to present top-ranked ensembles in high-quality performances of music by women composers. Initially successful, the author describes subsequent problems with funding, sponsorial arrangements, public relations, and reviewers, pointing to the obstacles women composers must overcome in the promotion and artistic reception of their work. Appendix I includes "Notes for Concert Producers"; Appendix II includes the eighteen concert programs comprising the four Festivals of Women's Music.

241. "Improvising Women." *New York Times* 7 October 1987: C28.

    A review of the Second Annual Festival of Women Improvisors.

242. Ingenhoff, A. "Kassel: Vom Schweigen befreit—Internationales Komponistinnenfestival." *Dissonanz/Dissonance* No. 12 (May 1987): 26–27.

    In German. Translated title: "Kassel: Freed from Silence—International Women Composers Festival."

243. Jeske, Lee. "Key Women." *New York Post* 3 February 1992, in *Newsbank: Review of the Arts, Performing Arts* 19, Fiche 23 (March 1992): E13.

    This article previews "Femme de Piano," a festival of women jazz pianists taking place at the Knitting Factory in New York.

244. Kager, Reinhard. "Salzburger 'Aspekte'-Festival aber zeitgenossische Komponistinnen." *Österreichische Musik Zeitschrift* 45, 7–8 (July/August 1990): 433–435.

    In German. Translated title: "The Salzburg (Austria) 'Aspekte' Festival Focuses on Contemporary Women Composers."

245. Kane, Karen. "The Michigan Acoustic Stage." *Hot Wire* 5, no. 1 (January 1989): 10–11.

    The author discusses her experiences as the sound engineer for the acoustic stage at the 13th Michigan Womyn's Music Festival.

246. Kielian-Gilbert, Marianne. "Feminist Theory and Music Conference, Minneapolis, June 1991: Questions on Ecstasy, Morality, Creativity." *Perspectives of New Music* 30, no. 2 (Summer 1992): 240–242.

247. Kobe, Reiner. "Aktuelle Szene New York: Taktlos 89." *Jazz Podium* 38, no. 6 (June 1989): 28–29.

248. Kuhns, Connie. "Live! From Canada: Canadian Women's Music Festivals." *Hot Wire* 5, no. 2 (May 1989): 48–51.

    This overview of the history of women's music festivals in Canada investigates not only the development of all-women's music festivals but the successful integration of women's music into mainstream folk festivals in Canada.

249. Llewellyn, Becky. "Down Under But Up Together: A Report on the Australian 'Composing Women Festival'." *International League of Women Composers (ILWC) Journal* (December 1991): 20.

250. Lowe, Jim. "Duo [Musica Femina] Examines Work of Women Composers."*Montpelier Times Argus* 24 April 1987, in *Newsbank: Review of the Arts, Performing Arts* 13, Fiche 162 (June 1987): A8.

251. Lumpe, Vera. "Frauenmusik—gestern und heute: ein Festival und ein Wettbewerb in Unna." *Musikhandel* 39, no. 1 (January 1988): 13.

In German. Translated title: "Women's Music—Yesterday and Today: A Festival and a Competition in Unna."

252. Lück, Harmut. "Heraus aus dem Getto? 5. Internationales Festival 'Women in Music'." *Musica [Germany]* 42, no. 5 (September/ October 1988): 477–478.
     In German. Translated title: "Out of the Ghetto? Fifth International 'Women in Music' Festival."

253. Marez Oyens, Tera de. "A Report." *International League of Women Composers (ILWC) Journal* (July 1991): 30.
     A report on women composer activities in the Netherlands, including the commissioning of two works by women (Hanna Kulenty and Julia Wolfe) by the Rotterdam Art Association and a concert of music by women composers (Rosy Wertheim, Emmy Frensel Wegener, Elsa Barraine) sponsored by the organization "Vrouw en Muziek."

254. McDonnell, Evelyn. "New Music Seminar Stirs Angry Audience Reaction: Attendees Criticize Panelists' Views on Sexism and Racism as Too Moderate." *Billboard* 101 (12 August 1989): 30.

255. McElfresh, Suzanne. "Eareviews: Festival of Women Improvisors (New York, March 8–11, 1990)." *Ear* 15, no. 3 (May 1990): 44–45.
     The festival featured two newly composed works by Cynthia Hilts and Akua Dixon.

256. McElfresh, Suzanne. "New York Improvisors: A Woman's Work is Never Done." *Ear* 15, no. 1 (March 1990): 18–22.
     Profiles of musicians Marion Brandis (flute), Marilyn Crispell (piano), Shelley Hirsch (vocalist), Terry Jenoure (violin), and Myra Melford (piano).

257. Moenninger, M. "Vom Schweigen befreit: ein Komponistinnenfestival in Kassel." *Musikhandel* 38, no. 3 (1987): 107.
     In German. Translated title: "Freed from Silence: A Women Composers Festival in Kassel."

258. Morris, Bonnie. "The Importance of Documenting Women's Music Festivals." *Hot Wire* 8, no. 1 (January 1992): 40–42.

259. Murray, Judi. "Women in Percussion—You Can Make It Happen [seminar]." *Percussive Notes* 25, no. 6 (September 1987): 54–57.

260. "Music and Gender Conference (London, 5–7, July 1991)." *Journal of the Royal Music Association* 117, no. 1 (1992): 169–171.
     A listing of all papers read at this conference, with the names of the presenters and the institutions they represented.

261. Müllman, Bernd. "Kassel: Sinfoniekonzert zum Komponistinnen-Festival; Musik aus dem Untergrund." *Das Orchester* 38, no. 11 (November 1990): 1178.

    In German. A review of a concert of orchestral music presented at 'Vom Schweigen befreit,' the International Women Composers Festival in Kassel. Works reviewed include: Sofia Gubaidulina's *Sieben Worte*, Elena Firsowa's *Chamber Concerto No. 2*, and Ilse Fromm-Michaels' *Symphony in C minor*, op. 19.

262. Müllman, Bernd. "'Vom Schweigen befreit': Internationales Komponistinnenfestival in Kassel." *Das Orchester* 35, no. 6 (June 1987): 364–365.

    In German.

263. Noble, David. "Women Composers Will Star in Concert." *Albuquerque Journal* 20 March 1987, in *Newsbank: Review of the Arts, Performing Arts* 13, Fiche 135 (April 1987): B10–B11.

264. Norden, Barbara. "The Sound of Women's Music." *Guardian* (London) 23 May 1990: 17.

    On the Chard Festival of Women Composers.

265. O'Leary, Jane. "5th International Congress Women in Music." *International League of Women Composers (ILWC) Newsletter* (Fall 1988): 10–11.

    The 5th ICWM was held in Bremen and Heidelberg in June 1988. This article reports on the events held in Heidelberg during the second week of the Congress.

266. O'Leary, Jane. "Beyond Biography: Utrecht. A Report." *International League of Women Composers (ILWC) Journal* (September 1991): 30.

    A report on the Seventh International Congress on Women in Music in Utrecht, the Netherlands.

267. Oppenheim, Jill R., and Sylvia Stallings. "NEWMR 1991: Music in the Key of She." *Hot Wire* 8, no. 1 (January 1992): 30–31, 57.

    A review of the North East Women's Musical Retreat, held in September 1991 in Massachusetts.

268. Pfaff, Timothy. "A Stellar Cellist Leads the Way: Stirring Concert by Bay Women's Philharmonic." *San Francisco Examiner* 13 February 1989, in *Newsbank: Review of the Arts, Performing Arts* 16, Fiche 47 (March 1989): B14.

269. Polin, Claire. "New York: Women in Music and Soviet Contemporaries." *Tempo* 174 (September 1990): 32, 34.

    Review of the opening concert of the Sixth International Congress on Women in Music.

270. Pool, Jeannie. "The Status of Women in Music: Report from Chicago." *International League of Women Composers (ILWC) Journal* (March 1992): 16–17.

   The author investigates the impact of feminist theory and the women in music movement on academe by attending the joint meetings of six major music societies in Chicago in October of 1991: the Center for Black Music Research, College Music Society, International Association for the Study of Popular Music, Society for Ethnomusicology, Association for Technology in Music Instruction, and the Chinese Music Society of North America. She finds the representation of women in music topics to be lacking and the depth and quality of the presentations to be uneven.

271. Post, Laura. "AWMAC 1991 Conference in Durham: Weaving Our Webb of Cultural Diversity." *Hot Wire* 7, no. 3 (September 1991): 50–51.

   A report on the 1991 Association of Women's Music and Culture Conference.

272. Prammer, H. "1. Frauen-Kammerorchester musizierte in Wien." *Österreichische Musikzeitschrift* 42 (May 1987): 253.

   In German. Translated title: "The First Women's Chamber Orchestra Performs in Vienna."

273. Pschera, Alexander. "Heidelberg: Neue Freiheit und alte Avantgarde; Das 7. Internationale Komponistinnen- Festival." *Das Orchester* 40, no. 3 (March 1992): 327.

   In German. A review of the Seventh International Women Composers Festival in Heidelberg organized by the Kulturinstitut Komponistinnen under the direction of Roswitha Sperber. The festival featured the contemporary women composers of the (former) Soviet Union: Sofia Gubaidulina, Elena Firsova, Jekaterina Tschemberdschi, Olga Magidenko, Anna Ikramova and Tamara Ibragimova.

274. Putnam, Thomas. "Woodwinds Dominate Slee Show; Review: Women in Music Symposium — Music by Women Composers." *Buffalo News* 21 October 1989, in *Newsbank: Review of the Arts, Performing Arts* 16, Fiche 169 (November 1989): D7.

275. Reisinger, Eva. "Ware weniger vielleicht mehr gewesen? Zum Thema 'Frau und Musik' in Heidelberg." *Neue Zeitschrift für Musik* 149, no. 9 (September 1988): 58–60.

   In German. A review of the 1988 International Women Composers Festival in Heidelberg.

276. Ribouillault, Danielle. "Le Festival de Fribourg [Switzerland]: 'La femme et la guitare' ." *Les Cahiers de la Guitare et de la Musique*, no. 41 (1992): 11–14.

The author presents a general overview of the role of women as 'classical' guitarists, and reviews concerts by three women guitarists recently performing at the guitar festival in Fribourg: Celia Linde (Sweden), Maria Isabel Siewers (Argentina), and Deborah Mariotti (Switzerland).

277. Rickert, Janice. "Folksinger Buffy Sainte-Marie To Top Women's Music Festival." *Herald Times* (Bloomington, IN) 27 May 1990, in *Newsbank: Review of the Arts, Performing Arts* 17, Fiche 104 (July 1990): C3–C4.
    Preview of the 1990 National Women's Music Festival at Indiana University.

278. Rieger, Eva. "Vom Schweigen befreit—Kassel: Internationales Komponistinnenfestival." *Neue Zeitschrift für Musik* 148, no. 4 (April 1987): 45–46.
    In German. Translated title: "Freed from Silence—Kassel: International Festival of Women Composers."

279. Riis, Thomas, and Fred Maus. "Conference Report: Feminist Theory and Music." *Sonneck Society Bulletin* 17, no. 3 (Fall 1991): 103–104.
    "Feminist Theory and Music: Toward a Common Language" was a conference held at the University of Minnesota, Minneapolis, June 27–30, 1991. The article characterizes the conference as invigorating and enlightening, with topics covered such as: gender, sexuality, and musicality; feminist music theory and masculine, feminine, and anti-feminine rhetoric in music; American women composers and their music; feminist theory and the academic canon, and more.

280. Roma, Catherine. "The Fifth National Women's Choral Festival." *Hot Wire* 6, no. 2 (May 1990): 44–45.
    A report on the 1989 National Women's Choral Festival and an update on the status and activities of the Sister Singers Network.

281. Rosenberg, Donald. "It's a Salute to Female Composers." *Pittsburgh Press* 21 March 1992, in *Newsbank: Review of the Arts, Performing Arts* 19, Fiche 37 (April 1992): D4.
    Performing on original instruments, the Pittsburgh Early Music Ensemble devotes a concert to baroque and classical works by women composers.

282. Sachs, Lloyd. "Women's Jazz Fest Convinces." *Chicago Sun Times* 20 May 1991, in *Newsbank: Review of the Arts, Performing Arts* 18, Fiche 70 (June 1991): A12.
    A review of the first "Women of the New Jazz" festival, held at the Hot House in Chicago.

283. Scauzillo, Retts. "Winter WomynMusic I." *Hot Wire* 3, no. 3 (July 1987): 29, 58.

Background and review of this women-identified music festival held in Charlotte, North Carolina, in February 1987.

284. Seeger, Nancy. "Sisterfire 1987." *Hot Wire* 4, no. 1 (November 1987): 38–40.

    A review of the 1987 Sisterfire festival of women-identified music, sponsored by Roadwork and held in Upper Marlboro, Maryland.

285. Seeger, Nancy. "Sisterfire '88." *Hot Wire* 5, no. 1 (January 1989): 30–31.

    A review of the 1988 Sisterfire festival of women-identified music, sponsored by Roadwork and held in Upper Marlboro, Maryland.

286. Shaffer, Jeanne E. "Frauenmusik Forum Schweiz, 'Spitze des Eisbergs'." *International League of Women Composers (ILWC) Journal* (February 1993): 18–19.

    In English. A report on the Frauenmusik Festival, held in Bern, Switzerland in October 1992. The theme of the conference was "Tip of the Iceberg," reflecting how much more we need to learn of the wealth of music created by women composers.

287. Shona. "'Many Womyn, Many Voices': Womonsong's Tenth Anniversary." *Hot Wire* 5, no. 3 (September 1989): 28–29.

    This review of the tenth anniversary concert by Womonsong (Madison, Wisconsin's feminist choir) is accompanied by a brief history of the organization.

288. Smith, Catherine Parsons. "Music and Gender in London." *International League of Women Composers (ILWC) Journal* (December 1991): 18–19.

    A report on the conference on music and gender held at King's College, and organized by Nicola LeFanu and Sophie Fuller.

289. Solie, Ruth, and Gary Tomlinson. "Women's Studies in a New Key." *NWSAction* 2, no. 1 (Spring 1989): 6.

    Summary of papers on feminist musical studies presented at the 1988 meeting of the American Musicological Society.

290. Springer, Christina. "The National Women's Music Festival [Bloomington, IN]: Bringing Non-Dominant Women to Full-Boil." *Off Our Backs* 20, no. 5 (May 1990): 9.

291. Stephens, Kevin. "Report: Newcastle." *Musical Times* 129 (October 1988): 548.

    A review of Newcastle's third Electric Music Festival, a day of which featured electronic, electro-acoustic, and computer music by women musicians.

292. Stewart-Green, Miriam. "Hear the Painting: See the Song." *International League of Women Composers (ILWC) Journal* (February 1993): 13.

The author, a musician and painter, describes her vocal recital which featured songs by women composers from 1620 to the present, and during which paintings which she created based on structures found within the music were displayed. The program listing is included in the article.

293. Sturman, Susan. "Women Centre Stage: Festival Internationale de Musiciennes Innovatrices." *Fuse Magazine* 11, no. 6 (July 1988): 38–41.

294. Summerville, Suzanne. "Beyond Biography: Utrecht. Seventh International Congress on Women in Music: A Review." *International League of Women Composers (ILWC) Journal* (September 1991): 27–29.

295. Summerville, Suzanne. "Update on musicALASKAwomen 1993." *International League of Women Composers (ILWC) Journal* (October 1992): 16.
    A survey of events to be featured at this women composers festival sponsored by the University of Alaska in Fairbanks.

296. Summerville, Suzanne, and Jane O'Leary. "8th International Congress of Women in Music: Bilbao, Spain, March 18–22, 1992. A Report." *International League of Women Composers (ILWC) Journal* (June 1992): 28–29.

297. Sutton, Catherine. "Redefining the Language of Music Criticism: A Review of the Music and Gender Conference." *Women: A Cultural Review* 3, no. 1 (Summer 1992): 60–64.
    Part of a special issue on women and music. The author surveys the themes explored during the Music and Gender Conference (London, 5–7 July 1991), organized by Nicola LeFanu and Sophie Fuller and the first conference in Britain devoted to music and gender. A lengthy summary of Marcia Citron's paper on "Gender and the Sonata Aesthetic" is provided.

298. Szántó, Annamaria. "Damenwahl in Salzburg: Komponistinnenfestival bei den Aspekten 1990." *Neue Zeitschrift für Musik* 151, no. 11 (November 1990): 38–39.
    In German. Translated title: "Ladies Choice in Salzburg: Women Composers Festival at Aspekten 1990."

299. Tann, Hilary. "Women in Music: Moving On." *International League of Women Composers (ILWC) Newsletter* (Spring 1988): 11–12.
    A review of the events and presentations offered at "Women in Music: Moving On," a one-day symposium cosponsored by the Eastern Division of the International Congress on Women in Music and Brooklyn College's Conservatory of Music.

300. Thaler, Lotte. "Keine angst vor Komponistinnen: Beobachtungen beim Internationalen Festival in Heidelberg." *Neue Zeitschrift für Musik* 151, no. 1 (January 1990): 40.

    In German. Translated title: "No Anxiety for Women Composers: Observations from the International [Women Composers] Festival in Heidelberg."

301. Tick, Judith. "Remarks on Gender Studies at National Meetings of AMS, SEM, and SMT, Oakland, November 7–11, 1990." *Sonneck Society Bulletin* 17, no. 1 (Spring 1991): 13–14.

302. Van de Vate, Nancy. "5th International Congress Women in Music—Bremen." *International League of Women Composers (ILWC) Newsletter* (Winter 1988/1989): 7–9.

    The 5th ICWM was held in Bremen and Heidelberg in June 1988. This article reports on the events held in Bremen during the first week of the Congress.

303. Van de Vate, Nancy. "'Vom Schweigen befreit' (Freed from Silence): International Festival of Women Composers, Kassel, West Germany, 20–22 February 1987." *International League of Women Composers (ILWC) Newsletter* (Fall 1987): 10–11.

304. Wachtel, Peggyann. "Goddess Festival: New York Open Center, March 10–12, 1989 A.D.A." *Ear* 14, no. 3 (May 1989): 48.

305. Walowitz, Paula. "Report from Albuquerque: Wiminfest '89." *Hot Wire* 6, no. 1 (January 1990): 36–37.

306. Weissweiler, Eva. "Musizierende Frauen, die zu wenig reden: Internationales Komponistinnen-Festival in Kassel—Plagiat mannlicher Vorbilder?" *Neue Musikzeitung 36* (April/May 1987): 50.

    In German. Translated title: "Women Who Make Music, Speak Little: The International Women Composers Festival in Kassel—Plagiarizing the Male Model?"

307. "Well-seasoned Lady Performers Lend Their Graces to N.Y. Clubs." *Variety* 331 (15 June 1988): 65.

308. West, Martha Ullman. "Women Artists Unite in Oregon." *Dance Magazine* 66, no. 4 (April 1992): 23–24.

    Eugene (Oregon) Ballet company presents a program entitled "Celebration of the Uncommon Woman" featuring works choreographed by women and set to music by women composers (Hildegard von Bingen, Ellen

Spokane, Cécile Chaminade, Patricia Van Ness and Carla Bley). Marian Alsop was selected to conduct the Eugene Symphony Orchestra.

309. White, Adam. "Amnesty Focuses on Women: '92 Benefit Concert Set for Spain." *Billboard* 103 (2 November 1991): 5, 97.

"Women on the Front Line" was the theme of the September 1992 benefit concert for Amnesty International, held in Madrid. The theme addresses human rights abuses of imprisoned women.

310. Wohlthat, Martina. "Internationales Komponistinnenfestival in Kassel." *Musica [Germany]* 41, no. 3 (May/June 1987): 260.

In German. Translated title: "International Women Composers Festival in Kassel."

311. "Women Composers." *Pan Pipes* 85, no. 1 (Fall 1992): 6.

Mentions two concerts that featured works of women composers: "Women Composers Baroque to 1992" held in October 1992 and sponsored by the Thursday Musical of Minneapolis-St. Paul; and the tenth anniversary concert of American Women Composers Midwest held in September 1992.

312. "Women's Music Festival a Stylistic Melange." *New York Times* 28 August 1987: C32.

A review of this three-day festival which embraced women's music from several continents and cultures.

313. Zaimont, Judith Lang. "String Quartets by Women: Report on Two Conferences." In *The Musical Woman: An International Perspective. Volume 2, 1984–1985*, ed. Judith Lang Zaimont, Catherine Overhauser, and Jane Gottlieb, pp. 378–387. Westport, CT: Greenwood Press, 1987.

The author first notes that the contributions of women composers to the string quartet repertoire have remained unexplored. In order to bring these works into the limelight, two conferences devoted to this repertoire were convened. The first was the Conference/Workshop on Twentieth Century String Quartets (New York: Trinity School, 8 March 1980) directed by Jeannie G. Pool and Doris Hays, and sponsored by the International League of Women Composers and the First National Congress on Women in Music. Subsequently, composer Deena Grossman organized the Conference on Contemporary String Quartets by Women Composers (San Francisco: San Francisco Conservatory of Music, 7–8 August 1981). The author describes the planning process which took place to bring each conference to fruition, and reviews the repertoire performed. Appended to the article is a list of string quartet repertoire by women composers, compiled from a variety of sources.

## Part D. Literature on the Production and Distribution of Women's Music: Publishers, Record Companies, Distributors, Libraries, and the Media

314. Andrews, Cathy. "Doing the Festivals, or, How I Spent My Summer." *Hot Wire* 6, no. 3 (September 1990): 43, 58–59.

    This representative of Goldenrod, a distributor of women-identified music, discusses the planning and preparation involved in attending various summer women's music festivals as a festival music vendor.

315. Arnold, Gina. "Olivia Records: Can a Feminist Company Survive in a Post-feminist Era?" *Musician* 23, no. 1 (January 1989): 23–24.

316. Dlugacz, Judy. "If It Weren't for the Music: 15 Years of Olivia Records." *Hot Wire* 4, no. 3 (July 1988): 28–35, 52–53, 57 .

    This is the first of a two-part article tracing the history of Olivia Records, written by the label's President and Co-founder. Focusing on the years prior to the company's move Oakland, California, this article also presents profiles of the label's major artists: Chris Williamson, Lucille Blue Tremblay, Tret Fure, Deidre McCalla, Dianne Davidson, and Nancy Vogl.

317. Dlugacz, Judy. "If It Weren't for the Music: 15 Years of Olivia Records [Part Two]." *Hot Wire* 5, no.1 (January 1989): 20–23.

    Part two of this article traces the history of Olivia Records, focusing on the years from 1978–1984.

318. Engeler, Margaret. "Die Frauenmusik." In *Das Zürcher Konzertleben: Meinungen, Moden, Medien. Volkskundliche Aspekte der städtisch-bürgerlichen Kultur,* pp. 101–106, 136–137 (notes). Stäfa, Switzerland: Rothenhäusler Verlag Stäfa, 1990.

    ISBN 3907960335. In German. The author studies the subcultural aspects of women's music in Switzerland, as she profiles the Frauenmusik-Forum, an organization devoted to promoting the works of women composers, documenting women's musical activities, and producing concerts featuring works by women.

319. Epstein, Selma. "Chromattica Editions: A Tenth Anniversary." *International League of Women Composers (ILWC) Journal* (March 1992): 31.

320. "A European Archive of Women Composers Has Been Set Up in Düsseldorf." *Musical Times* 131 (June 1990): 334.

Announcement of the establishment of the Europäisches Frauenmusik-archiv.

321. Franckling, Ken. "Rosetta Records: By Women Only." *Jazz Times* 21, no. 6 (1991): 9.
     An article on Rosetta Records, a record company devoted to promoting early jazz and blues by women.

322. Friou, Robert E. "The New York Women Composers Catalog/Databank." *International League of Women Composers (ILWC) Journal* (July 1991): 12.

323. Fry, Stephen M. "The 1993 Pauline Alderman Prize." *International League of Women Composers (ILWC) Journal* (October 1992): 20.
     Background on the prize and guidelines for authors submitting publications.

324. Gardner, Kay. "Freestyle: Women's Windows; Women's Radio on the Air in Maine." *Hot Wire* 5, no.3 (September 1989): 53–54.
     The author discusses her women's music show on WERU–FM in Maine.

325. Gardner, Kay. "How to Get Airplay on Non-Commercial Radio." *Hot Wire* 6, no. 3 (September 1990): 50–51.
     A tutor on promoting concerts and recordings of women's music through community radio.

326. Hall, Marnie. "A Recording Company and How it Grew ." *Pan Pipes* 81, no.2 (Winter 1989): 3–4.
     On Leonarda Records.

327. Hennings, Patricia. "News from the R[epertoire] & S[tandards] National Committee on Women's Choruses." *Choral Journal* 33, no.2 (September 1992): 39.
     News, plus information on the Women's Chorus Repertoire Exchange ("a bi-annual listing of currently performed scores for women's chorus").

328. Hennings, Patricia. "Repertoire and Standards Committee Reports: Women's Choruses." *Choral Journal* 32, no.4 (November 1991): 45.
     Description of the American Choral Director's Association Women's Chorus Repertoire Exchange to facilitate information sharing on repertoire for women's chorus.

329. Hester, Karen, and Toni Armstrong Jr. "Redwood Records; Update." *Hot Wire* 5, no.3 (September 1989): 27, 44.

330. Hildebrand, Lee. "Olivia Celebrates 15 Years of Making Women's Music." *San Francisco Examiner* 8 May 1988, in *Newsbank: Review of the Arts, Performing Arts* 15.Fiche 100 (June 1988): F14–G1.

331. Humphreys, Nancy. "Music Libraries and Resources in the San Francisco Bay Area, No. 28: Women's Resource Center Library, UCB [University of California, Berkeley]." *Cum Notis Variorum* No. 119 (January/February 1988): 10.

332. Jackson, Barbara Garvey. "Early Music by Women Composers: A Personal Involvement." *Early Music New Zealand* 3, no.2 (June 1987): 15–21.
    The founder of the publishing company ClarNan Editions discusses how her initial experiences with researching early music by women composers (e.g., Hildegard von Bingen and Isabella Leonarda) impressed upon her the need to make their music more accessible via published performing editions of their works.

333. Jackson, Barbara Garvey. "Early Music by Women Composers." *American Organist* 23, no.5 (May 1989): 62–63.
    The author, founder of ClarNan Editions and editor of modern performing editions of classical music by women composers, comments on locating music manuscripts of early women composers, and on the particular composers and compositions represented in ClarNan catalog.

334. Jackson, Barbara Garvey. "SAI Publishes Music by Unknown Women Composers." *Pan Pipes* 80 (Summer 1988): 7.

335. Kane, Karen, and Chris Newport. "The Audio Angle: Demo Tapes." *Hot Wire* 4, no.2 (March 1988): 10–11, 62.
    This article on the whys and hows of making a demo tape includes a section entitled, "What are the Policies of Women's Music Labels Regarding the Acceptance of Demo Tapes."

336. Keyes, Cheryl L. "Women's Heritage Series: Rosetta Records." *Journal of American Folklore* 105 (no. 415) (Winter 1992): 73–80.
    The author reviews this landmark recorded series produced by Rosetta Records. The Women's Heritage Series surveys the musical contributions of women to the blues and jazz idioms from the 1920s through the 1950s. All nineteen recordings in the series are reviewed, and the article itself emerges as a mini-history of women in blues and jazz.

337. Kuhns, Connie. "Live! From Canada: Ten Years of Rubymusic Radio." *Hot Wire* 7, no. 3 (September 1991): 20–21, 57.

The producer and host of Rubymusic Radio (on Vancouver Cooperative Radio, CFRO–FM), the "longest running women's music program in Canada," recounts the program's ten-year history.

338. Lont, Cynthia M. "Persistence of Subcultural Organizations: An Analysis Surrounding the Process of Subcultural Change." *Communication Quarterly* 38, no. 1 (Winter 1990): 1–12.

Discusses the survival of subcultural organizations in a climate of social and cultural change, with reference to women-identified music, and specifically Redwood Records.

339. Lont, Cynthia M. "Subcultural Persistence: The Case of Redwood Records." *Women's Studies in Communication* 11, no. 1 (Spring 1988): 50–60.

340. Marez Oyens, Tera de. "Library of Women Composers: Unna, Germany." *International League of Women Composers (ILWC) Journal* (October 1992): 15.

The article provides information on the new Internationale Komponistinnen Bibliothek in Unna, formed through a merger of the European Frauenmusikarchiv (Düsseldorf) and the score collection of Elke Mascha Blankenburg. The Director of this new library is Antje Olivier.

341. "Notes from North and South: The Women's Association Music Resource Center of Chicago." *Pan Pipes* 84, no. 3 (Spring 1992): 22.

Recently incorporated as part of the Chicago Symphony Orchestra Archives and Oral History Collection, the Women's Association Resource Center of Chicago is developing their facility and collection. Inquiries should be addressed to: 244 S. Michigan Ave., Suite 660, Chicago, IL 60604.

342. Peebles, Sarah. "Classical Women: An Overview (September 1984–January 1992)." *International League of Women Composers (ILWC) Journal* (June 1992): 30.

Currently broadcast on CIUT–FM in Toronto, "Classical Women" is a radio show devoted to programming art music by women composers. The author, who is also the radio program's producer and host, presents an overview of the repertoire presented, as well as directions to those wishing to submit recordings for broadcast.

343. "Record Makers: Antone's Records." *Stereo Review* 57, no. 5 (May 1992): 10.

Presenting mostly contemporary women blues artists, Antone's Records in Austin, Texas, is one of the few record companies managed by women.

344. Roma, Catherine. "What's Round on the Outside and Hi in the Middle? Women's Culture in Ohio." *Hot Wire* 5, no. 3 (September 1989): 20–22, 45.
Women-identified musical performers and organizations, theatre companies, radio shows, clubs, bookstores, etc., in various cities in Ohio are listed.

345. Seeger, Nancy. "'Sophie's Parlor': On the Air." *Hot Wire* 3, no. 3 (July 1987): 18–19, 58.
Background on the Sophie's Parlor Media Collective, the producer of a feminist radio show broadcast over WPFW in the greater Washington, D. C. area.

346. Seeger, Nancy, and Rena Yount. "A Trip Through the Women's Communities of Washington D.C.: Music, Media, Bookstores, Social Life and Support Groups, and More." *Hot Wire* 6, no. 1 (January 1990): 40–44, 62.

347. Smith, Pamela. "Amazon Radio." *Hot Wire* 8, no. 1 (January 1992): 44–45, 57.
This article focuses on "Amazon Radio" a feminist/lesbian music program broadcast on WPKN–FM in the New Haven area of Connecticut.

348. Stamps, Wickie. "Group Pushes Nonsexist Rock: Rock Against Sexism." *New Directions for Women* 19, no. 1 (January/February 1990): 7.

349. Stephen, Lynnéa Y. "ARS FEMINA Ensemble: A Musical Treasure Trove." *Ms.* 2, no. 5 (March/April 1992): 70.
Established in 1985 to research music of women composers prior to 1800, the ARS FEMINA project has expanded its activities to performance, recording and publication of musical scores of women composers.

350. Stephen, Lynnéa Y. "Resurrected Harmonies." *Ms.* 1, no. 6 (May/ June 1991): 77.
Hildegard Publishing Company (Bryn Mawr, Pennsylvania) specializes in producing contemporary editions of music by classical women composers.

351. Sutro, Dick. "Ladies Sing the Blues: Rosetta Reitz Single-Handedly Runs the Only Label Devoted To Keeping Alive Rare Jazz and Blues Recordings By Female Artists." *Los Angeles Times* 12 April 1992, in *Newsbank: Review of the Arts, Performing Arts* 19, Fiche 60 (May 1992): B3–B4.

352. "Talk of the Town: Hallelujah." *New Yorker* 68 (21 September 1992): 28–29.

Newly-formed Nannerl Recordings, founded by members of the performing group Ars Femina, specializes in works by women composers of the seventeenth and eighteenth centuries. Ars Femina members Susan Reigler (trumpet) and William Bauer (viola) discuss their discoveries of works by Elisabeth-Claude Jacquet de La Guerre and Maddalena Lombardini Sirmen, as well as their new production of Francesca Caccini's *The Liberation of Ruggiero*.

353. Van Dyke, Elizabeth Artemis. *A Woman's Place Is In History: Communicating and Preserving the Culture of Minority Groups of Women and Their Organizations in an Archival Format*. Diss. Ph.D., Union Institute, 1991.

Abstract in *Dissertation Abstracts International: A. Humanities and Social Sciences*. 52, no. 2 (August 1991): 709. DA# 9119947. The author documents the establishment of the Ohio Lesbian Archives in Cincinnati (OH), an institution devoted to preserving all types of material relating to lesbian culture and history (including music).

354. Vetterlein, Hans. "'Komponistinnen—gestern und heute': eine Musiksammlung in der Amerika-Gedenkbibliothek." *Buch und Bibliothek* 40, no. 3 (March 1988): 269–273.

In German. Title translated: "Female Composers—Past and Present: A Music Collection in the America Memorial Library."

355. Vinebohm, Lisa. "Dykes on Mykes, and Other Good Vibrations." *Ear* 15, no. 10 (March 1991): 14–15.

This survey of women's programming on community radio includes a list of radio stations in the U.S. and Canada which offer programming on political, social, and cultural issues of pertaining to women.

356. Walker-Hill, Helen. "Music by Black Women Composers at the American Music Research Center." *American Music Research Center Journal* 2 (1992): 23–52.

Research undertaken for her lecture/recitals on black women composers ultimately led to the publication of the author's *Piano Music By Black Women Composers: A Catalog* and *Black Women Composers: A Century of Piano Music*. In the process, the author amassed a large collection of printed and manuscript music, now housed at the American Music Research Center. Walker-Hill describes this large collection of music representing the works of eighty-four black women composers of the nineteenth and twentieth centuries. She proceeds to discuss selected composers and their music chronologically, so as to provide an overview of the history of black women composers. The composers discussed are: Ella Sheppard, Estelle Ricketts, Ida Larkins, Viola Kinney, Helen Eugenia Hagan, Nora Holt, Florence Price, Julia Perry, and Margaret Bonds.

357. Webb, Betty. "Musicians Track Women Composers." *Phoenix [Arizona]Tribune* 12 January 1992: E4.

   The Ars Femina Ensemble from Louisville, Kentucky, is a group devoted to researching, performing, publishing and recording works by women composers of the Baroque era.

358. Yanow, Scott. "Rosetta Records: Women in Jazz." *Coda* 212 (February/March 1987): 10–11.

## CHAPTER THREE

# Recent Perspectives on Women in the Music Professions: Professional Organizations and Issues of Professional Status

## Part A.  General Perspectives

359. "1990 Meeting of the ICTM [International Council for Traditional Music] Study Group on Music and Gender in Oakland." *The World of Music* 31, no. 3 (1989): 129.

360. Armstrong, Toni, Jr. "Making Our Dreams Our Jobs: Making Ends Meet Through Music." *Hot Wire* 3, no. 2 (March 1987): 34–39, 60–64, 67.
    The author surveys the various strategies used by today's women musicians to enable them to make a living through music. In addition to performing professionally, the author notes other income-generating musical activities such as recording, teaching, songwriting, producing, writing, arts management, music therapy, studio work, technical work for stage and studio productions, etc. Profiles of a number of women musicians (e.g., Teresa Trull, Debbie Fier, Ruth Pelham, Betty MacDonald, Musica Femina, Rhiannon, and Jean Fineberg) illustrate the ways in which these alternatives are utilized by particular individuals.

361. Armstrong, Toni, Jr., et. al. "Behind the Scenes: Vada Vernée, Karen Hester and Carrie Barton." *Hot Wire* 5, no. 1 (January 1989): 50–52.
    Profiles of professional women working "behind the scenes": Vada Vernée (photographer working within the women's music scene), Karen Hester (Olivia Records), and Carrie Barton (bass player).

362. Aspen, Kristan. "Noteworthy Women: The International Congress on Women in Music." *Hot Wire* 4, no.2 (March 1988): 12–13.

The author (part of the duo Musica Femina) elaborates on her experiences attending the Mexico City (1984) ICWM, at which she initiated the formation of its Lesbian Caucus; also presented is an overview upcoming regional and international events sponsored by the International Congress on Women in Music.

363. Beath, Betty. "The International League of Women Composers." *The International League of Women Composers (ILWC) Journal* (July 1991): 1–2.

  The author presents a brief history of the ILWC, describes its mission and recognizes the efforts of individuals who have made significant contributions to the ILWC.

364. Bessman, J. "Women in Music [Inc.] Seminar Seeks Changes." *Billboard* 99 (14 March 1987): 48.

365. Borroff, Edith. "On the Edge of the Future." *International League of Women Composers (ILWC) Journal* (September 1991): 1–5.

  As the keynote address of the Sixth International Congress on Women in Music held in New York in March 1990, this essay by musicologist and composer Edith Borroff offers a healthy dose of "realism in the service of idealism" (p. 1), taking a critical look at music education in academe. The author first acknowledges that the cause of women composers will substantially improve only when academe is convinced to value the worth of all musics beyond the European male canon, including works by composers who are contemporary, American, African-American or female. "We will not succeed, even when we perform wonders in the concert hall, if the party line is still the rule in the classroom," states Ms. Borroff (p. 4). She states emphatically that teachers of music need to assimilate these musics into the classroom and publishers need to make this music readily available for study and performance. Thus, both the political and musical engagement of individual musicians and educators is necessary in order to expand the focus of the music establishment.

366. Brümann, Bettina, and Edda Straakholder. "Frauen im Kirchenmusikerberuf. Vom grossen Kantor bis grossen Künstler—oder: Ist der Kirchenmusikerberuf ein Männerberuf." *Der Kirchenmusiker* 43, no. 2 (March/April 1992): 41–49.

  In German. Translated title: "Women as Professional Church Musicians. From the Great Kantor to the Great Artist, or, Is the Church Music Profession a Male Profession?"

367. Buchau, Stephanie von. "Room at the Top: Today More Than Ever, Women are Calling the Shots on the American Opera Scene." *Opera News* 57 (July 1992): 8–12, 44.

Part of a special issue on women in music. Focusing on the status of women in the opera world, the author interviews two dozen women holding positions as either opera artists, directors, managers, patrons, or critics. Treating topics such as recognition of women's contributions to opera, opportunities and discrimination in the administration of opera companies, sexual harassment of women artists and women in managerial positions, new interpretations of establishment operatic repertoire, and criticism of female artists on the basis of looks rather than artistic merit, the statements of these women give credence to the argument made by the author that women have gained much, but still have much to achieve within the professional opera world. Individuals quoted include Dolora Zajick, Francesca Zambello, Christine Bullin, Sarah Billinghurst, Patricia Mitchell, Mary Ellis Peltz, Ardis Krainik and Lesley Valdes.

368. Cole, Patrick. "The Women." *Jazziz* 8, no. 2 (February/March 1991): 42–44, 72, 82–84.

    Sexism and discrimination in today's jazz scene is discussed by musicians and record producers.

369. Cook, Susan C. "Report of the Committee on the Status of Women." *American Musicological Society. Newsletter* 20, no. 2 (August 1990): 6–7.

370. Cook, Susan C. "Report of the Committee on the Status of Women." *American Musicological Society. Newsletter* 22, no. 1 (February 1992): 6.

    Summary of the panel discussion, "Windows of Opportunity? Surviving and Thriving in Academe," sponsored by the Committee on the Status of Women at the 1991 meeting of the American Musicological Society in Chicago. Issues regarding compensation, academic status, mentoring, and career counseling of graduate students were discussed.

371. Cook, Susan C. "Report from the Committee On the Status of Women." *American Musicological Society. Newsletter* 23, no.1 (February 1993): 5.

    A summary of the presentations and discussions taking place at the sessions sponsored by the Committee at the 1992 meeting of the American Musicological Society in Pittsburgh.

372. Duckett, Linda B. "Women in Music Administration: A Look at Several Minnesota Organizational Models." In *National Association of Schools of Music. Proceedings. No. 78*, pp. 73-77. 65th Annual Meeting, June 1990. Reston, VA: National Association of Schools of Music, 1990.

    Hierarchical models of administration are limiting; women have much to offer in providing alternatives to existing administrative styles, such as encouraging networking, leadership by consensus, fostering a cooperational (as opposed to confrontational) climate, etc. The author mentions the activities of several organizations in Minnesota which promote the efforts of

women in higher education: the American Council of Education's National Identification Program and Minnesota Women in Higher Education.

373. Duffy, Thom. "NMS Panel Explores Work/Family Issue." *Billboard* 103 (3 August 1991): 26.
　　　　Discusses New Music Seminar panel entitled "Get With the Program: Women, Sex and the Music Industry."

374. "Erfahrungen: Möglichkeiten von Frauen im DDR–Musikleben." *Musik und Gesellschaft* 38, no. 3 (March 1988): 115–120.
　　　　In German. Translated title: "Experiences: Possibilities for Women in the Musical Life of East Germany." Part of a special issue devoted to women and music. Each of the following women offers their unique perspective on the status of women in music in East Germany: Traude Ebert-Obermeier (musicologist), Ruth Zechlin (composer and a professor of composition), Romely Pfundt (conductor), Sabine Reichel (composer and music educator), and Ellen Hünigen (student of composition).

375. Fishell, Janette. "Professional Concerns Forum: A Survey of Women's Issues." *American Organist* 25, no. 2 (February 1991): 20–23.

376. Frisbie, Charlotte J. "Women and the Society for Ethnomusicology: Roles and Contributions from Formation Through Incorporation (1952/53–1961)." In *Comparative Musicology and Anthropology of Music: Essays on the History of Ethnomusicology*, ed. Bruno Nettl and Philip V. Bohlman, pp. 244–265. Chicago: University of Chicago Press, 1991.
　　　　Ten women made significant contributions to the Society for Ethnomusicology during its early years, 1952–1961: Frances Densmore, Helen H. Roberts, Rose Brandel, Roxane McCollester (now Carlisle), Gertrude Kurath, Nadia Chilkovsky-Nahumck, Barbara Krader, Johanna Spector, Rae Korson, and Barbara Smith. This essay focuses on the first two women: Frances Densmore and Helen H. Roberts, and then summarizes the data collected on all ten women in order to determine what patterns emerge concerning the role of women in the Society for Ethnomusicology during its formative years. The author finds that the SEM was an encouraging and supportive organization, providing opportunities for networking, and venues for women to present scholarly work to their peers. Male colleagues served as both mentors to women and as recruitors of women into positions within the SEM. While these ten women were extremely varied in their personal and professional backgrounds, they were all accomplished, skilled, and well-connected if not prestigious. While the SEM provided a nurturing climate, these women did experience discrimination in their careers and personal lives outside of the SEM.

377. Fry, Stephen M. "A Brief Historical Survey of the ICWM." *International Congress on Women in Music Newsletter* 5, no. 2 (June 1988): 3–4.

378. "Gay and Lesbian Study Group." *American Musicological Society. Newsletter* 21, no. 2 (August 1991): 5.

    Brief paragraph announcing the formation of the Gay and Lesbian Study Group of the American Musicological Society at the 1990 annual meeting in Oakland, CA.

379. Glickman, Sylvia. "Women's Performance in Music Competitions, 1967–1988." In *The Musical Woman: An International Perspective. Volume 3, 1986–1990*, ed. Judith Lang Zaimont, Jane Gottlieb, Joanne Polk, and Michael J. Rogan, pp. 293–320. Westport, CT: Greenwood Press, 1991.

    This study examines how women have fared in music competitions held between 1967 and 1988, focusing on winners in categories of performance (piano, strings, winds, vocal, conducting) and composition. Data about each music competition was collected from questionnaires prepared by the author, or gathered from existing reports from the competitions (e.g., news releases). Results about the numbers of male and female winners are tabulated. Overall comparisons of winners are made by gender, by gender and competition locale (American vs. foreign), and by gender and category of competition (composition vs. performance). The author demonstrates that women have made only marginal advances in the competitive music world when one examines the net results from 1967 to 1988. This mirrors the general trend regarding public consciousness of the movement towards equality for women, where gains were evident up until the early 1980s, with a subsequent loss of momentum in public support for women's issues throughout the remainder of the 1980s.

380. Gottlieb, Jane. "Women in Music Organizations: A Preliminary Checklist." In *The Musical Woman: An International Perspective. Volume 3, 1986–1990*, ed. Judith Lang Zaimont, Jane Gottlieb, Joanne Polk, and Michael J. Rogan, pp. 652–662. Westport, CT: Greenwood Press, 1991.

    Since 1975, a good number of organizations have been established to "document, promote and support the activities of women in music" (p. 652). The author profiles thirteen of these organizations now active in various countries around the world. These include: The Association of Canadian Women Composers, Women in Music Association of Denmark, Women in Music (Great Britain), Mujeres en la Musica (Spain), Federation of Women Composers in Japan, Stichting Vrouw en Muziek (Netherlands), Frauenmusik-Forum (Switzerland), American Women Composers, Inc., International Congress on Women in Music (based in the U.S.), International League of Women Composers (based in the U.S.), New York Women Composers, Inc., Frau und Musik—Internationaler Arbeitskreis (Germany), and Musikfrauen e.V. Berlin. Special library collections resulting from these women's music festivals or activities of these associations are: the International Institute for the Study of Women in Music (California State University, Northridge), Musiksammlung in der Amerika-Gedenkbibliothek (Berlin Zentralbibliothek), and Panopticon (New York).

381. Greene, Michael. "Editorial: Sexism in the Music Industry Gives Women the View But Closes the Window." *Grammy Magazine* 7, no. 2 (August 1989): 2–3.

382. Harper, Lea. "Bursting the Champagne Bubble: Hollywood or Diapers? Women in Music Broaden the Options." *Music Scene*, no. 361 (May/June 1988): 16–17.

383. Horowitz, Is. "Classical: Keeping Score—Women in Music." *Billboard* 100 (5 November 1988): 100.

384. Jais-Mick, Maureen. "Professional Concerns Forum: Where are the Women Organists?" *American Organist* 25, no. 5 (May 1991): 32, 34, 36–37.
    The author explains how societal/external and psychological/internal factors work together to hinder women seeking a career as a professional organist. These societal/external factors include: expectations and assumptions that a woman will ultimately seek a domestic rather than professional role in her life, behavioral stereotypes, sex discrimination against women seeking of quality positions, salary inequities, inadequate encouragement or mentoring of women students by faculty in higher education, inadequate or nonexistent family care services from churches, etc. Psychological factors (i.e., those attitudes which women have internalized because of years of societal conditioning mentioned above) often cause women to undervalue their own work, and produce a fear of failure in women. Women often lack the self-esteem necessary to market and promote their work, and women often feel the weight of responsibility for the success of their domestic life while pursuing their careers. The author's simplistic solution rests on the shoulders of women: "work hard, be tough. . , take chances, fight back."

385. Kämpfer, Frank. "Sozialer Freiraum, Ästhetische Nische: Frauen und Musik in der ehemaligen DDR." *Neue Zeitschrift für Musik* 152, no. 10 (October 1991): 25–28.
    In German. Translated title: "Social Freedom, Aesthetic Niche: Women and Music in the Former East Germany." On the status of professional women musicians in the former East Germany.

386. Kimberlin, Cynthia Tse. "'And Are You Pretty?': Choice, Perception and Reality in Pursuit of Happiness." In *Music, Gender, and Culture*, ed. Marcia Herndon and Susanne Ziegler, pp. 221–239. International Council for Traditional Music. ICTM Study Group on Music and Gender. Intercultural Music Studies, no. 1. Wilhelmshaven, Germany: Florian Noetzel Verlag, 1990.
    ISBN 3795905931. The author's conversations with five professional women musicians, differing in age, family background, degrees of self-esteem, and working in different musical milieus, reveal the manner in which gender has influenced their professional musical and personal life choices as well as their attitudes with regard to art, money and power. Although gender

was evident as a "crucial determinant in decision making" (p. 236), the five women were reluctant to discuss the issue directly, or openly recognize the reality of how gender has operated in their lives.

387. Kozinn, Allan. "Women in Theater and in Music Pause to Assess Their Status: At Juilliard Gains are Recounted." *New York Times* 22 October 1988, I: 11.

388. Maurstad, Tom. "Torchsong: Deep Ellum and the Rest of Musical Dallas is a Man's World. . . Listen to Five Women [musicians] Who Know." *Dallas Morning News* 25 June 1989, in *Newsbank: Review of the Arts, Performing Arts* 16, Fiche 101 (July 1989): A3-A7.

389. Nelson, Florence. "AFM Women's Caucus is Formed." *International Musician* 90, no. 3 (September 1991): 25.

This article documents the founding of the Women's Caucus of the American Federation of Musicians, taking place during the AFM's convention in June 1991. Sexual discrimination, child care, parental leave, and the election of women into decision-making ranks of the AFM were identified as priority issues.

390. "New Music Seminar Panels: Women in Music." *Billboard* 102 (21 July 1990): N–22.

Lists panelists for session on women in music at the New Music Seminar in New York.

391. Olivier, Antje. "Frau und Music." In *Vom Schweigen befreit: Internationales Komponistinnen-Festival Kassel, 20. bis 22. Februar 1987*, pp. 69-70. Internationales Komponistinnen-Festival Kassel (1987), spons. and org. Hans Eichel, Kulturamt der Stadt Kassel, Internationalen Arbeitskreis "Frau und Musik", Roswitha Aulenkamp-Moeller, and Christel Nies. Gustav-Freytag-Strasse 1, 6200 Wiesbaden, Germany: Bevollmächtigten der Hessischen Landesregierung für Frauenange-legenheiten, 1987.

In German. Background on the formation of the Internationaler Arbeitskreis "Frau und Musik" and the establishment of its Archive.

392. Pool, Jeannie. "The Consolidation of the ILWC and the ICWM." *International League of Women Composers (ILWC) Journal* (September 1991): 10–11.

The President and Founder of the International Congress on Women in Music delineates a proposal which would make the Congress (as an event) a project of the International League of Women Composers, and merge memberships of the organizations.

393. Poole, Jane L. "Viewpoint." *Opera News* 57 (July 1992): 4.

An overview of the content of this special "Women in Opera" issue of *Opera News*, featuring articles on women as opera performers, composers, administrators and directors.

394. Reid, Sally, and Mary Chaves. "Electronic Networking: Two Case Studies." *International League of Women Composers (ILWC) Journal* (July 1991): 22–23.

On the authors' use of electronic communication to share and distribute information related to the activities of the ILWC, and a report on the American Music Center's networking activities.

395. Reid, Sarah Johnston. "Images of Leadership for Women Music Executives." *National Association of Schools of Music. Proceedings. No.78* pp. 83–84. 65th Annual Meeting, June 1990. Reston, VA: National Association of Schools of Music, 1990.

Suggestions are offered concerning the perils which may confront women in administrative positions. Topics covered include affronts to one's authority, communications, maintaining control of decision-making processes, objectivity vs. emotionalism, etc.

396. Rosenbluth, Jean. "Grass Route: NMS [New Music Seminar] Panels Cover All But Sexism." *Billboard* 100 (6 August 1988): 44.

397. Schmidt, Mia. "Sappho in Prozenten: Zur statistischen Repräsentanz der Frau in der neuen Musik." *Vom Schweigen befreit: Internationales Komponistinnen-Festival Kassel, 20. bis 22. Februar 1987*, pp. 67-68. Internationales Komponistinnen-Festival Kassel (1987), spons. and org. Hans Eichel, Kulturamt der Stadt Kassel, Internationalen Arbeitskreis "Frau und Musik", Roswitha Aulenkamp-Moeller, and Christel Nies. Gustav-Freytag-Strasse 1, 6200 Wiesbaden, Germany: Bevollmächtigten der Hessischen Landesregierung für Frauenangelegenheiten, 1987.

In German. On the statistical representation of women in new music programming in Germany.

398. "Sidelines." *Melody Maker* 63 (25 July 1987): 15.

An interview with E. Wallen about Women in Music, Inc.

399. Tick, Judith. "Report of the Committee on the Status of Women." *American Musicological Society. Newsletter* 18, no. 2 (August 1988): 6.

400. Tick, Judith. "Report of the Committee on the Status of Women." *American Musicological Society. Newsletter* 19, no. 2 (August 1989): 4.

401. Van de Vate, Nancy. "Opinion and Commentary:   Reflections." *International League of Women Composers (ILWC) Journal* (December 1991): 22–23.

Reflecting on the moderate gains achieved by women composers in recent months, the author cautions that subtle (and not so subtle) occurrences of backlash are evident in the music establishment, and specifically in the domain of music criticism. She urges individual women musicians to contribute to the music review media, and advocates that the ILWC engage in collective action, by bringing the issue of the recognition and assessment of music by women composers to the attention of the Music Critics' Association.

402. Van de Vate, Nancy. "Orchestra Symposia and the Woman Composer: Some Observations." *International League of Women Composers (ILWC) Newsletter* (Winter 1987): 6.

   The keynote address to the West Coast Women Conductor/Composer Symposium, February 23–25, 1985 at the University of Oregon.

403. Verdino-Sullwold, Carla Maria. "Generous With Our Uniqueness: Forging New Directions For African-American Women in the Arts." *Crisis* 99, no. 7 (October 1992): 29–30, 32–36.

   The author surveys the current status of African-American women in the arts (visual art, music, dance, acting, and arts education) from a historical perspective which recognizes the unique contributions of African-American women to the arts in light of both race and gender discrimination. Commentary on the current status of African-American women in the arts and on the prospect for change in the future is offered by prominent women such as dancer Judith Jamison, Harlem School of the Arts director Betty Allen, opera singers Leona Mitchell and Reri Grist, artists and professors Howardena Pindell and Adrian Piper, and others. Successful women need to take an active role in both the education of future generations of African-American artists and the education of today's arts managers.

404. Walker, Hazel, et. al. "Sister to Sister: Life on the Road for Women Musicians." *International Musician* 90, no. 10 (April 1992): 19–20.

   Four women musicians address various concerns regarding travel and touring: avoiding tour pitfalls, dealing with sexual harassment, discrimination, maintaining a professional attitude, being a female employer in a man's world, and acting as a role model to younger women.

405. Weissman, Dick. "Minorities in the Music Business: The Position of Women." In *The Music Business: Career Opportunities and Self Defense*, rev. ed., pp. 192–197. New York: Crown Publishers, 1990.

406. Zannino, Mimi. "Creating a Musical Career: Reality and Illusion." In *The Musical Woman: An International Perspective. Volume 3, 1986–1990*, ed. Judith Lang Zaimont, Jane Gottlieb, Joanne Polk, and Michael J. Rogan, pp. 321–336. Westport, CT: Greenwood Press, 1991.

According to the individual musicians interviewed in this article, technical excellence, commitment, individual energy, self-promotion, confidence, networking, and flexibility are important factors in building a successful career in music. Since most performers and composers combine their music-making with another career, such as teaching, a thorough academic background in music allows for additional flexibility in the job market. While there may be equal access to musical career paths, one must still overcome obstacles on the way to actually achieving an acceptable job offer. Though not as prevalent as in the past, discriminatory attitudes and pay inequities persist.

# Part B. Women Composers

407. Andersen, Leslie. "Women Film and Television Composers in the United States." In *The Musical Woman: An International Perspective. Volume 3, 1986–1990*, ed. Judith Lang Zaimont, Jane Gottlieb, Joanne Polk, and Michael J. Rogan, pp. 353–370. Westport, CT: Greenwood Press, 1991.

The author finds very few women actively scoring films and television programs today. The reasons for this are examined, and include resistance to women as creators in a male-dominated field, the money-making rather than artistic orientation of the film world, lack of formal educational programs for film composition, etc. Several women film and television composers are profiled, interviewed, and their credits enumerated, and they offer commentary on topics relating to training and education, career goals, being a woman in a male-dominated profession, the politics of the film industry, and dealing with discriminatory attitudes. The composers featured are: Ann Ronell, Nicky Holland, Nan Schwartz, Ann Dudley, Shirley Walker, Elizabeth Swados, and Suzanne Ciani.

408. Bialosky, Marshall. "Opinion and Commentary: SCI (Society of Composers, Inc.) Committee on Women and Minorities." *International League of Women Composers (ILWC) Journal* (July 1991): 20.

Letter announcing the establishment of the SCI Committee on Women and Minorities, an event taking place at the organization's National Meeting, April 5–8, 1990.

409. Block, Adrienne Fried. "The Role of New York Women Composers, Inc." *International League of Women Composers (ILWC) Journal* (July 1991): 11.

410. Burrell, Diana. "Accepting Androgyny." *Contact*, no. 32 (Spring 1988): 52–53.

Response to Nicola Lefanu's "Master Musician: an Impregnable Taboo?" in *Contact*, no. 31 (Autumn 1987): 4–8. While agreeing with many of the assertions made by Lefanu, the author (also a composer) believes that a balanced representation of women composers in the concert hall will be achieved when society becomes flexible enough to accept more equalized attitudes towards gender roles and sexuality. While concert promoters, festivals and ensembles need to be more aware of the work of women composers, she questions the trend of presenting women-only composer concerts, since this only further marginalizes women composers as a group. She stresses that works by women are diverse, and should stand on their own in the concert hall with those by male composers.

411. Coates, Gloria. "Letters From the Front Lines. The State of the Art for Women Composers: Germany." *Ear* 15, no. 10 (March 1991): 17–18.

This is a succinct assessment of the professional status of women composers in Germany, the growth of women composers' advocacy groups there, and the increased visibility of works by women composers in concert performance.

412. Davidson, Tina. "Another Decade of Low Funding to Women Composers: A Look at NEA Funding." *International League of Women Composers (ILWC) Newsletter* (Spring 1988): 1, 6–7, plus page insert.

Based on statistics gathered from annual reports and from direct requests for information from the National Endowment for the Arts (NEA), this article reveals gender discrimination in the NEA's decision-making process, as demonstrated by 1) the relatively high numbers of women applicants and the very low acceptance rate of grants submitted by women composers from 1977 to 1987, and 2) the lack of women appointed to peer review panels judging these applications. The author urges both collective and individual action on this matter.

413. "Female Composers Seeking Parity." *New York Times* 1 November 1987, XXII: 32–33.

On the New York Women Composers group.

414. French, Iris T. "The Association of Canadian Women Composers (L'Association des femmes compositeurs canadiennes): A Report." *International League of Women Composers (ILWC) Journal* (March 1992): 21.

415. Fromm, Paul. "Creative Women in Music: A Historical Perspective." In *A Life for New Music: Selected Papers of Paul Fromm*, ed. David Gable and Christoph Wolff, pp. 42–51. Cambridge, MA: Harvard University Press, 1988.

This essay reproduces the last public presentation delivered by its author, the well-known patron of contemporary music and Director of the

Fromm Foundation. Given on February 3, 1986 at Tulane University (New Orleans) in conjunction with "Vivace—A Contemporary Music Festival", this essay addresses a number of major issues regarding the status of the woman composer in today's music world. Citing the Fromm Foundation's support for women composers of new music, the author laments the lack of attention given to contemporary music in orchestral concert programming, and especially works by women composers in this regard. Fromm states, "I am embarrassed that—this late in the 20th century—a performance by an orchestra of a work by a female composer is still an uncommon event" (p. 43). Then speaking as a "male feminist...on behalf of the neglected women composers of the past, and the emerging women composers of the present" (p. 45), he examines the barriers women composers have faced in achiev-ing recognition for their creative work: lack of educational opportunity; the exclusion of women from public musical performance "in contexts that make a difference to budding composers" (p. 45); the restricted role for women in a society governed by patriarchal standards; the manner in which stereotypical notions of "masculine" and "feminine" infiltrate theoretical cultural discourse; and the psychological effect of all these social and cul-tural forces when they become internalized by the individual. While recog-nizing the need to research, publish, perform and study historical women's works so that they might be integrated into the standard repertoire, and the need for "present-day women composers. . .to be given a sense of their own tradition" (p. 50), he takes issue with separatism (e.g., in women com-poser concerts, festivals, etc.) as a means to further the cause of the woman composer. "We ought not to segregate the music of women into ghetto concerts, but to play it on regular programs...I don't think we do women composers of today a service by offering them a handicap as if they were golfers. . ." (p. 50). Instead, Fromm posits that music by women composers should be able to be appreciated and evaluated alongside works by their male counterparts.

416. Henahan, Donal J. "From EAR to Eternity: Let's Hear it for Composer Persons." *Ear* 14, no. 3 (May 1989): 66.
    Reprinted from the New York Times, c.1975.

417. Kinney, Michelle. "Letters From the Front Lines. The State of the Art for Women Composers: Minnesota." *Ear* 15, no. 10 (March 1991): 18–19.
    A brief overview of the positive environment which Minnesota offers to women composers and to the performance of contemporary music in general.

418. LeFanu, Nicola. "Master Musician: An Impregnable Taboo?" *Contact*, no. 31 (Autumn 1987): 4–8.
    This English composer, prompted by the then-current wave of conser-vatism in England which resulted in women composers losing many of the gains they had won in the 1970s, arms herself with a cadre of "shameful

statistics" (p. 5) documenting systematic discrimination against women composers in the classical music world in the 1980s. Arts agencies, festivals, music series, and ensembles are investigated for the frequency with which they have awarded women composers grants or commissions. The performance repertoire of music festivals, concert series and ensembles is surveyed to determine how many works by women composers are performed in concert. Music literature is criticized for lack of recognition of women's musical contributions in music history texts and twentieth century composer surveys. She questions the concept of importance that would overlook composers such as Hildegard von Bingen, Clara Schumann, Thea Musgrave, and Ethel Smyth in favor of music by more mediocre male composers. While there has been gradual acceptance of the notion of "men and women working together as equals" (p. 6), the author still finds male resistance to the possibility of a woman being a leader, director, and (if a composer) the final authority. She states that for a woman to succeed as a composer in today's world, she must be willing to follow a male model consisting of a university training with few female role models, sacrificing of family for career, and self-promotion. Lefanu states that both men and women musicians are hindered by stereotypes, since normative roles and attitudes are restrictive to all those working in a creative world.

419. Mageau, Mary. "The Australian Women Composers Network: A New Direction?" *International League of Women Composers (ILWC) Journal* (March 1992): 18–20.

    Part I of this article reproduces the author's address to the 1991 Composing Women Festival (Adelaide, Australia), which speaks to the issues of the status of women composers in Australia, their underrepresentation in newly published reference works, commissions, concert performances, and commercial recordings, and the subsequent formation in 1990 of the Australian Women Composers Network. Part II is a facsimile of a letter sent by the AWN to Australian senators concerning the discrimination against women composers in government-sponsored cultural programs.

420. Mertl, Monika. "Komponistinnen: unsichtbare Gegner." *Bühne*, no. 355 (April 1988): 32–34.

    In German. Translated title: "Women Composers: Invisible Adversary."

421. "New York Women Composers Organization Growing." *Pan Pipes* 82, no. 2 (Winter 1990): 15.

422. Ostleitner, Elena. "Anmerkungen zur situation der Frau als Komponistin in Österreich." *Österreichische Musik Zeitschrift* 46, no.7–8 (July/August 1991): 373–376.

    In German. Translated title: "Remarks on the Situation of Women as Composers in Austria." Part of a special issue devoted to women in music.

Beginning with a general overview regarding the professional status of women as musicians and teachers of music, the author then focuses on composers in particular, noting the lack of representation of women composers in Austrian music reference works. She then discusses the various ways in which gender discrimination manifests itself in the lives of women composers.

423. Ostrander, Linda. "Creative Nature and its Nurture." *International League of Women Composers (ILWC) Newsletter* (Winter 1988): 11–12.

    Sixty women composers from around the world participated in this author's study of motivation and productivity in the creative process of women composers. This first in a series of articles summarizing the findings of this study introduces the issues which inform the debate over the importance of innate genius versus that of social and cultural conditions which either nurture or hinder creativity. Specifically, the author has sought to determine the degree to which the composers' perceptions of cultural inequality, as well as their individual experiences with gender-based conflict, have affected their creativity as composers. The author briefly describes the methodology used in the study, delineates a list of motivators and conditions which the author seeks to verify as enhancing factors in creativity, and surveys the relevant literature on this topic.

424. Ostrander, Linda. "Speculations on the Creative Process." *International League of Women Composers (ILWC) Newsletter* (Spring 1988): 8–9.

    This is the second in a series of articles based on the author's study of motivation and productivity as factors in the creative process of women composers. (See also the Winter 1988 issue of this periodical). This article surveys various writings on the creative process, with discussion focusing on the manner in which an idea, insight, or inspiration evolves into musical form.

425. Ostrander, Linda. "Women Composers' Motivation and Productivity." *International League of Women Composers (ILWC) Newsletter* (Fall 1988): 7–9.

    This is the third in a series of articles on women composers' motivation and productivity. Here, the author summarizes the responses of women composers to specific questions regarding cultural inequity, negativity, and economic hardship as it affects creativity, interaction versus isolation as it affects personal development, dealing with resentment and anger at the lack of opportunity for composers, specific conditions which nurture the creative process, and the effects of race, class or gender on creative development.

426. Petersen, Barbara A. "Women Composers Yesterday, Today, and Tomorrow." *International League of Women Composers (ILWC) Journal* (July 1991): 8–9.

    On the occasion of BMI's fiftieth anniversary, the author assesses the status of women composers represented by BMI and evaluates BMI's support of young women composers through its Student Composer Awards program.

427. Strauss, Neil. "Letters From the Front Lines. The State of the Art for Women Composers: New York." *Ear* 15, no. 10 (March 1991): 19, 21.

    A brief survey of the activity and professional status of New York City area women composers.

428. Swados, Elizabeth. "Writing as a Woman." In *Listening Out Loud: Becoming a Composer*, pp. 179–185. New York: Harper and Row, 1988.

    The author reflects on the sexual politics of being a professional woman composer. Reviewed in *Kirkus Reviews* 56 (15 September 1988): 1393; *Choice* 26 (May 1989): 1529; *Women's Review of Books* 6, no. 6 (March 1989): 1, 3; *Ear* 14 (May 1989): 56.

429. Van de Vate, Nancy. "Freedom of Information  Correspondence." *International League of Women Composers (ILWC) Journal* (March 1992): 26–27.

    The article reproduces the author's letter to the National Endowment for the Arts, which suggests a process of blind judging for applicants requesting NEA Composer Fellowships; a copy of the NEA's response to her letter follows.

430. Van de Vate, Nancy. "Is There Life After Fifteen? Some Observations on the League." *International League of Women Composers (ILWC) Journal* (Fall 1989): 1, 10–12.

    The author (and composer) stresses that the ILWC and its members need to continue to act as advocates on behalf of all women composers, as discrimination in the musical establishment continues to be a problem for women composers seeking grants and commissions, full-time academic employment, quality performances of their works, objective assessment of their work in the review media, etc.

431. Waleson, Heidi. "Women Composers Find Things  Easier...Sort of: Despite Some Prizes and Commissions and Faculty Jobs, Discrimination Still Seems a Potent Factor in Hindering Careers." *New York Times* 28 January 1990, II: 27, 30.

    Libby Larsen, Joan Tower, Judith Shatin, Elinor Armer, Deborah Dratell, and others are interviewed.

432. "Women in Modern Music: Air Combat Would Be Easier." *The Economist* 324 (19 September 1992): 108–109.

    Few women composers are listed in standard reference works (5 to 6% of total), placing music composition in the same league as aerial warfare and coal mining in terms of the number of women represented. Despite discriminatory practices, Nancy Van de Vate has emerged as one of the top composers of this generation, with her *Concerto for Violin and Orchestra* being enthusiastically received at its premiere during the Vienna Summer Music Festival (1992).

433. "Women Seeking Status as Composers." *New York Times* 1 December 1987, XV: C19.

    On West Virginia University's workshop "Turning the Page: Women and Music."

434. Young, Gayle. "Gayle Young Writes. . .[on the status of women composers]." *International League of Women Composers (ILWC) Journal* (September 1991): 25.

    These comments first appeared in *Ear* 15, no. 10 (March 1991): 16–17.

435. Young, Gayle. "Letters From the Front Lines. The State of the Art for Women Composers: Canada." *Ear* 15, no. 10 (March 1991): 16–17.

    This assessment of the professional status of women composers in Canada notes the paucity of women in the grant applicant pool and delves into the reasons for this situation, such as the unfocused conditions under which women often compose, and the ambivalence with which women often approach competition and success.

# Part C. Women Performers and Conductors

436. Armstrong, Toni, Jr. "Red, White, and (Visa) Blues." *Hot Wire* 3, no. 2 (March 1987): 20–21.

    This article examines the recent changes in U.S. immigration laws which restrict the ability of non-mainstream performing artists to work in America; the author addresses the ramifications of the law on the women's music community.

437. Bayton, Mavis Mary. *How Women Become Rock Musicians*. Diss. Ph.D., University of Warwick (United Kingdom), 1989. Abstract in *Dissertation Abstracts International: A. Humanities and Social Sciences*. 51, no. 9 (March 1991): 3254. BRD# 91404.

    Based on interviews conducted in the 1980s with 36 women rock musicians, this thesis examines the reasons for the absence of women in rock, with particular reference to gender socialization, discrimination, and other social factors. The careers of the women interviewed provide models of how women overcome gender constraints and find viable careers within and outside the mainstream of popular music. All-women bands and feminist musicians are included in this study.

438. Bayton, Mavis Mary. "How Women Become Musicians." In *On Record: Rock, Pop, and the Written Word*, ed. Simon Frith and Andrew Goodwin, pp. 238–257. New York: Pantheon, 1990.

    Based on interviews with women rock musicians as well as the author's own experiences playing in a rock band, this essay concentrates on creative

processes and group dynamics within all-women's rock bands. Bayton examines how women choose and learn to play an instrument, and discusses the musical readjustments that classically trained women musicians make when they begin to perform rock music. She notes women's experiences with instrumental and vocal amplification. Group dynamics is explored in sections discussing playing as a group, rehearsal protocols, learning how to arrange, etc. The challenge of acquiring the technical knowledge needed to set up and repair equipment, as well as communicate with others in the recording and music business is discussed. For more experienced female band members, other concerns become important, such as developing an identity as a musician, and commitment to musicianship and the band vs. commitment to a partner and family.

439. Brandt, Kate. "Back to the Closet?" *Hot Wire* 3, no. 2 (March 1987): 22, 58.
    The author comments on the U.S. immigration law with regard to visas issued to musicians booked for performances in the U.S., and the impact of the law on lesbian musicians performing women-identified music.

440. Bruenger, David. "Women Trombonists in North American Orchestras and Universities." *International Trombone Association (ITA) Journal* 20, no. 2 (Spring 1992): 12–21.
    Interviews with eighteen women trombonists provide insights into attitudes about gender and performing ability, sexual stereotyping of musical instruments, early music training and mentoring, discriminatory practices towards women brass players in professional situations, and coping with discrimination and harassment. The women trombonists interviewed expressed both positive and negative opinions about all-women performing groups and the idea, proposed by Susan Slaughter (principal trumpet, St. Louis Symphony), of a Women's Brass Conference.

441. Buehlman, Barbara. "Should a Woman Become Band Director." In *Conductors Anthology, Volume 1: School Music Director Off the Podium. A Compendium of Articles from the Instrumentalist from 1946 to 1986 on the Administrative Side of Being a School Music Director*, pp. 312–313. Northfield, IL: The Instrumentalist, 1989.
    Reprinted from the February 1965 issue of *The Instrumentalist*.

442. "Chicago Club of Women Organists." *Diapason* 83, no. 12 (December 1992): 2.
    An announcement of the Club's forty-second annual Gruenstein Memorial Organ Competition for young women organists.

443. Cloutier, Lise. "Double vie des musiciennes d'orchestre." *Châtelaine (Francais)* 28, no. 7 (July 1987): 96–98, 100.
    In French. Translated title: "The Double Life of Female Orchestra Musicians."

444. Crouch, Mira, and Jenny Lovric. *Paths to Performance: Gender as a Theme in Professional Music Careers— A Pilot Study of Players in Two Orchestras. Report To Australia Council.* Melbourne, Australia: Australia Council, 1990.

ISBN 0646059114. Gender as a factor in the professional development and career success of women musicians employed by the Sydney Symphony Orchestra and the Australian Chamber Orchestra is investigated.

445. Dyer, Richard. "Of Gender, Bravado and Brass: A Trumpet Star's Blare at Female Students Stirs Debate Over Stereotyping." *Boston Globe* 21 April 1991, Arts and Film Section: B1, B5.

This report delves into student objections to Rolf Smedvig's gender-based criticisms of female brass players during an Empire Brass master class at Boston University. His remarks prompted the school to organize a forum on discriminatory attitudes towards women brass players, at which Rolf Smedvig reiterated his views. This report offers commentary on the situation from flutist Doriot Anthony Dwyer, trumpeter Susan Slaughter, and composer Marti Epstein.

446. Feather, Carol Ann. "Women Band Directors in American Higher Education." In *The Musical Woman: An International Perspective. Volume 2, 1984–1985*, ed. Judith Lang Zaimont, Catherine Overhauser, and Jane Gottlieb, pp. 388–410. Westport, CT: Greenwood Press, 1987.

The status of women in the band directing profession is the subject of this article. The author first examines the historical reasons for the lack of female representation in the ranks of college-level band directors and the discriminatory hiring practices of institutions of higher education. She notes that while women students are now plentiful as instrumentalists in bands and wind ensembles, and a large number go on to earn advanced degrees in music education, few are employed as band directors at the college level. The author conducted a study in 1979/80, in which she surveyed all 21 women college band directors from the ranks of the 1,679 existing positions. Questions focused on the respondent's educational preparation and professional background, conditions of employment (type of institution, job responsibilities, salary), personal characteristics, sexual politics and gender discrimination, and respondent suggestions for solving or overcoming problems with regard to gender and professional status. These women comment on the lack of female role models and the discouraging attitudes shown by their advisors while pursuing their education. Once employed these women had a variety of experiences with salary inequities, isolation, skepticism from male colleagues, sexual harassment, negative attitudes due to the conservative milieu surrounding the band in some communities, etc. Appended are the complete responses of the women band directors on the question of the problems which they have faced as women in a male dominated profession, and their recommended solutions.

447. Fordham, John. "The Struggle for Sax Equality." *The Listener* 119 (21 January 1988): 29–30.

    The author profiles women saxophone players Kathy Stobart, The Guest Stars, Annie Whitehead, and Lindsay Cooper.

448. Friend, Lisa. "Letter: Response to Linda Marianello's 'Struggling Women Musicians: Europe in the 1980's'." *Flutist Quarterly* 15, no. 3 (Summer 1990): 6–7.

    The author counters Ms. Marianello's article [*Flutist Quarterly* 15, no. 2 (Spring 1990): 41–42] by noting the musical opportunities for women in Italian orchestras and mentions the prominent professional women flutists currently active in Europe, particularly in Italy.

449. Gourse, Leslie. "Beating the Odds: Emerging Women Drummers." *JazzTimes* 21, no. 8 (November 1991): 33, 72.

    Women drummers performing within the contemporary jazz scene are profiled, and they comment on sexual politics in their profession. These drummers include Cindy Blackman, Bernice Brooks, Sylvia Cuenca, Sherri Maricle, and Barbara Merjan.

450. Handy, D. Antoinette. "Black Women and American Orchestras: An Update." In *New Perspectives On Music: Essays in Honor of Eileen Southern*, ed. Josephine Wright, and intro. Samuel Floyd Jr., pp. 451–461. Detroit Monographs in Musicology. Studies in Music, no. 11. Warren, MI: Harmonie Park Press, 1992.

    The author surveys the status of black women in symphony orchestras since 1975. There is a discussion of the career and plight of timpanist Elayne Jones, who was appointed and later dropped from the roster of the San Francisco Orchestra, precipitating an unsuccessful discrimination suit. Career advancements of violinist Sylvia Medford, bassist Lucille Dixon, keyboard player Patricia Prattis Jennings, and harpist Ann Hobson-Pilot are noted. Since her publication of *Black Women in American Bands and Orchestras* (Metuchen, NJ: Scarecrow Press, 1981), the author reports that statistical data on employment of orchestral musicians now incorporates race and gender information. In this essay, she identifies a number of new, young black women instrumentalists, conductors, and music administrators. Some of these women include: percussionist Lovie Smith, violinist Diane Monroe, bassoonist Gail Hightower, and conductors Kay Roberts, Tania León, Anne Lundy, and Marsha Mabrey.

451. Hoekstra, Dave. "Despite Earlier Gains, Women in Country Play Second Fiddle." *Chicago Sun Times* 13 October 1991, in *Newsbank: Review of the Arts, Performing Arts* 18, Fiche 131 (November 1991): D9–D10.

    Despite the gains made by women country music artists in the 1980s, male artists still dominate amongst country music award-winners and in record sales.

452. Jacobs, Tom. "The Best Conductor For The Job." *Los Angeles Daily News* 14 November 1991, in *Newsbank: Review of the Arts, Performing Arts* 18, Fiche 150 (December 1991): D13–D14.

Women conductors Marin Alsop (Los Angeles Philharmonic) and JoAnn Falletta (Women's Philharmonic, San Francisco) are interviewed, and comment on the status of women in the conducting profession.

453. Jepson, Barbara. "Women Seek New Visibility in the Pit—On the Podium." *New York Times* 8 August 1993, II: 27.

"A new crop of female conductors combat lingering prejudice in the opera house with talent and hard work." The article mentions conductors Karen Keltner, Sian Edwards, Simone Young, Carol Crawford, and others.

454. Johnsen, Gladys. "An Interview with Rebecca Bower." *Music Educators Journal* 78, no. 7 (March 1992): 39–41.

Part of a special issue on women in music. Rebecca Bower, coprincipal trombonist for the Pittsburgh Symphony, describes the obstacles she had to overcome as a female brass player (e.g., discriminatory practices, male/female instrument stereotypes). She offers advice to female brass students and suggests that all music educators further examine their own methods and attitudes so as to create a positive, encouraging, gender-free atmosphere for students.

455. Kosky, Christine, and Cathi White. "On Being a Female Bassist: An Interview Between Former ISB Manager Cathi White and Bassist Christine Kosky, 9/18/90." *International Society of Bassists* 18, no.1 (Fall/Winter 1991/1992): 26–27.

456. Lawson, Kay. "Women Conductors: Credibility in a Male-Dominated Profession." In *The Musical Woman: An International Perspective. Volume 3, 1986–1990*, ed. Judith Lang Zaimont, Jane Gottlieb, Joanne Polk, and Michael J. Rogan, pp. 197–219. Westport, CT: Greenwood Press, 1991.

The author begins by identifying the historical precedent for a woman in the conductor's role (e.g., musical performances by nuns in the convent of St. Vito during the sixteenth century). However the thrust of the article is on recent conditions which have afforded women the opportunity to pursue successful careers as conductors. Profiling the careers of Margaret Hillis (Chicago Symphony Chorus), JoAnn Falletta (Women's Philharmonic), and Catherine Comet (American Symphony Orchestra), with briefer coverage of Beatrice Brown, Judith Somogi, Victoria Bond, Eve Queler and Sarah Caldwell, she examines the commonalities of their experiences in order to identify the conditions which have both impeded and encouraged women in their efforts to achieve equal access to the podium. She concludes that equity must be predicated by equal access to education, mentoring, practical training, blind orchestral auditions, and a professional climate which recognizes the special career needs of women.

457. Lebrecht, Norman. "Left Outside: Gays, Women, Blacks." In *The Maestro Myth: Great Conductors in Pursuit of Power*, pp. 263–271. Secaucus, NJ: Birch Lane Press, 1991.

    Focusing on such topics such as conductor persona, body size, and sexual orientation, this is a cavalier discussion of discriminatory attitudes towards women as conductors and orchestral musicians, and the establishment of all-female ensembles due to these conditions. The author provides cursory views of the careers of such notables as Margaret Hillis, Ethel Leginska, Antonia Brico, Dame Ethel Smyth, Nadia Boulanger, Sarah Caldwell, Eve Queler, Iona Brown, Sian Edwards, and Catherine Comet.

458. "Letters: Women Violinists." *Musical America* 110, no. 4 (July 1990): 24–25.

459. Magliocco, Hugh. "A Special Endurance." *International Trombone Association (ITA) Journal* 20, no. 2 (Spring 1992): 22–28.

    This is a detailed summary of the sex discrimination case involving trombonist Abbie Conant and the Munich Philharmonic, and its musical director Sergiu Celibidache. The author places this particular case within a historical context, discussing the employment of women in major orchestras in the U.S. and Europe, and the difficulties faced by women auditioning for and working in European orchestras.

460. Maher, Beverly. "Where are the Women?" *Soundboard* 18, no. 2 (Summer 1991): 3–4.

    Letter addressing the lack of advertising and promotion of concerts by women guitarists.

461. Marianello, Linda. "Struggling Women Musicians: Europe in the 1980's." *Flutist Quarterly* 15, no. 2 (Spring 1990): 41–42.

    Special issue on women and the flute. The author relates her experiences with auditioning and playing for several German orchestras, noting the obstacles women face in the professional orchestral world, and the alternate career paths of solo work, chamber music performance, and teaching taken by women musicians in Europe.

462. McCarthy, Hazel. "Attitudes Will Have to Change." *Winds* 8, no. 2 (Summer 1993): 18.

    The author "outlines the problems facing the woman conductor and suggests a possible way forward."

463. Monroe, Ervin. "Women in the Orchestra." *Flutist Quarterly* 15, no. 2 (Spring 1990): 34–35.

    Special issue on women and the flute. The author, principal flutist of the Detroit Symphony, presents an anecdotal assessment of the status of women in American orchestras today.

464. O'Neil, Jean. "Trois virtuoses de la musique. Oui! Elles arrivent à faire car-rière au Québec." *Châtelaine (Francais)* 28, no. 7 (July 1987): 96–98, 100.
      In French. Canadians Denise Lupien, Francine Lavallée, and Lise Roy have built careers as concert musicians.

465. Phalen, Tom. "Women of Notes: More and More Are Rocking to the Fore as the Seattle Scene Gets Bigger and Noisier." *Seattle Times* 1 November 1992, in *Newsbank: Review of the Arts, Performing Arts* 19, Fiche 147 (December 1992): B13–B15, C1–C2.
      Women rock musicians and music industry representatives comment on the status of women in Seattle's rock music scene.

466. Post, Laura. "Two Roads to Solo Keyboard Work: Julie Homi and Adrienne Torf." *Hot Wire* 6, no. 2 (May 1990): 28–30, 57.

467. Riley, Richard. "Women in Orchestras: Early Days of Male Chauvinism Seem Far Behind." *Union-News (Springfield, MA)* 8 November 1987, in *Newsbank: Review of the Arts, Performing Arts* 14, Fiche 91 (December 1987): B11–B13.

468. Rosen, Jesse. "Equal Opportunity—Assessing Women's Presence in the Exxon/Arts Endowment Conductors Program: An Interview with Jesse Rosen." In *The Musical Woman: An International Perspective. Volume 2, 1984–1985*, ed. Judith Lang Zaimont, Catherine Overhauser, and Jane Gottlieb, pp. 91–119. Westport, CT: Greenwood Press, 1987.
      Judith Lang Zaimont interviews Mr. Jesse Rosen, Director of both the Exxon/Arts Endowment Conductors Program and the Affiliate Artists' Conducting Assistants Project, on the presence of women as applicants and appointees to the program. Tables illustrating percentages of women partici-pating in the program are included.

469. Rosenbaum, Joshua. "Breaking Barriers: The Uptown String Quartet." *Strings* 6, no. 5 (March/April 1992): 68–71.
      The four black women of the Uptown String Quartet (Maxine Roach, Eileen Folson, Diane Monroe, and Lesa Terry) discuss race and gender dis-crimination in their careers as string players. The quartet attempts to expand the string quartet repertoire by performing their own compositions, as well as those by other black composers, including those in idioms of jazz, ragtime and contemporary music.

470. Waleson, Heidi. "Female Quartets Not Just Sister Acts." *Wall Street Journal* 1 April 1987, 26: 1.

471. Waleson, Heidi. "Music, Maestra, Please: Though Barriers Still Remain, a Growing Number of Women are Embarked on Significant Careers in the Field of Orchestral Conducting." *New York Times* 16 April 1989, II: 1, 36.

472. Walsh, Michael. "Siren Songs at Center Stage: Women Violinists of Talent and Temperament Invade a Male Preserve." *Time* 131 (11 April 1988): 70–71.

    Viktoria Mullova and Anne-Sophie Mutter are prominently featured in this article on the new generation of violin virtuosas; also mentioned are Midori, Nadja Salerno-Sonnenberg, and Kyung-Wha Chung.

473. Wigler, Stephen. "Women Pianists and Grand Success: A Rarely Sounded Chord."*Baltimore Sun* 8 December 1991, in *Newsbank: Review of the Arts, Performing Arts* 18, Fiche 4 (January 1992): A11–A12.

474. Wohlthat, Martina. "Störfaktor im Männerclub? Wie Musikerinnen sich Orchester zurechtfinden—eine Basler Fallstudie." *Neue Zeitschrift für Musik* 153, no. 11 (November 1992): 4–6.

    In German. Translated title: "Intruders in the All-Male Club? The Experiences of Women Orchestra Musicians—A Case Study of Basel (Switzerland)." This article investigates the experiences of women in three symphony orchestras in Switzerland—the Basler Sinfonieorchester, the Radio-Sinfonieorchester Basel, and the alternative model of the basel sinfonietta—and compares their experiences with those of women in other large European orchestras. Problems with appointments, status, discrimination and general working conditions are discussed with particular reference to several instrumentalists working in European orchestras. A comparison with the progressive 'basel sinfonietta' demonstrates that this orchestra, which not only hires women instrumentalists but also supports the concept of family care, can serve as a role model for other orchestras which maintain discriminatory attitudes towards women.

475. "The Women's Issue: Personal Narratives of Four American Conductors." *Journal of the Conductors' Guild* 9, no. 2 (Spring 1988): 42–59.

    This transcript of a panel discussion at the 1988 National Conference for Conductors features the statements of conductors Victoria Bond, Beatrice Brown, Eve Queler, and Alice Parker; the moderator is Gloria Steinem.

# Part D.  Women Music Educators and Musicologists

476. Baker, Katherine Marie. *Significant Experiences, Influences and Relationships in the Educational and Professional Development of Three Music Educators: Gretchen Hieronymus Beall, Eunice Louise Boardman, and Mary Henderson Palmer*. Diss. Ed.D, University of Illinois at Urbana–Champaign, 1992.

    Abstract in *Dissertation Abstracts International: A. Humanities and Social Sciences* 53, no. 10 (April 1993): 3466. DA# 9305459.

477. Block, Adrienne Fried. "The Status of Women in College Music, 1986–1987: A Statistical Report." In *Women's Studies, Women's Status*, pp. 79–165. College Music Society. Committee on the Status of Women in Music. CMS Report, no. 5. Boulder, CO: College Music Society, 1988.

    The third report of this type issued by the College Music Society, this essay compares past statistics with those more recently collected, and the author's analysis provides a historical perspective on the changing status of women music faculty employed at the post-secondary level. Presented are statistics which compare data for both men and women in areas relating to degrees conferred, specialization, rank and tenure status, and salary.

478. Diemer, Emma Lou. "Women Composers as Professors of Composition." In *The Musical Woman: An International Perspective. Volume 3, 1986-1990*, ed. Judith Lang Zaimont, Jane Gottlieb, Joanne Polk, and Michael J. Rogan, pp. 714–738. Westport, CT: Greenwood Press, 1991.

    Introduced by a general discussion on the teaching of composition and women's participation in that profession, the author then examines the status of women as professors of composition in the United States, utilizing data published by the College Music Society, as well as data gathered from composers via the author's questionnaire. Figures on the numbers of men and women employed as teachers of composition, salary, rank, and numbers of women composition students are presented. Women composers comment on managing a dual career, mentoring, and discriminatory attitudes in academia. The author identifies Vivian Fine (U.S.), Jacqueline Fontyn (Belgium), Beverly Grigsby (U.S.), Jean Eichelberger Ivey (U.S.), Nicola Lefanu (U.K.), and herself as composers who have been successful in their careers as teachers and composers. Included are appendices listing women composers teaching composition at universities, colleges, and conservatories in the United States and abroad.

479. Hale, Mimi. "Women Composers Who Teach: A Profile of Women Composers Who Teach in Colleges and Universities in the United States." *International League of Women Composers (ILWC) Journal* (October 1992): 4–7.

    Based on a survey of about 60 women composers, the author uses the data gathered to provide a profile of the careers of these women, while also presenting their views regarding why they compose, the relationship between teaching and composing, and gender discrimination. Footnotes to the article appear in the February 1993 issue of the *ILWC Journal (p.2)*.

480. Jezer, Rhea. "Women in Music Academia: A Statistical and Humanistic Analysis." In *Gender, Culture and in the Arts: Women, the Arts, Society*, ed. Ronald Dotterer and Susan Bowers, pp. 152–167. Selinsgrove, PA: Susquehanna University Press, 1993.

    The author first introduces us to "Susan", whose story epitomizes the problematic experiences faced by women in higher education in music and in

their subsequent professional lives in music. The article then surveys the literature on the status of women in music academia and assesses the degree to which women's status has changed since 1970.

481. Killam, Rosemary N. "Women in Academic Music: How We Have Achieved Our Roles." Paper presented at the Third Annual Women in Music Symposium, Buffalo, NY, 1989.

Available from ERIC, ED 345979, in microfiche or paper copy. For an abstract see *Resources in Education* 27, no. 10 (October 1992): 169. The results of a survey of over 1000 women employed as full-time faculty at colleges and universities provide information on their early career development, educational experiences, obstacles encountered, the degree to which they identify themselves as feminists, and other details relating to the achievement of these women and their role and status as music faculty.

482. Rabson, Carolyn. "Women's Contributions to Music Scholarship." In *The Musical Woman: An International Perspective. Volume 3, 1986-1990*, ed. Judith Lang Zaimont, Jane Gottlieb, Joanne Polk, and Michael J. Rogan, pp. 238–292. Westport, CT: Greenwood Press, 1991.

Though not as visible as women performers, composers, conductors, or critics, the subtle but significant work of women musicologists, librarians, and independent scholars to research, bibliography, and scholarly publication in music is recognized in this essay. The author begins with a general discussion of the evolution of the professions of musicology and music librarianship, presenting data from a variety of bibliographical and statistical sources to provide an illuminating historical overview of the representation of women in these professions, and their relative status within these professions as compared to their male colleagues. Nine women who have made their mark as musicologists and/or music librarians are profiled: Louise Cuyler, Anna Harriet Heyer, Dena Epstein, Eileen Southern, Edith Borroff, Susan T. Sommer, Maria Calderisi (Bryce), Sue Carole DeVale, and Gillian Anderson.

483. Richardson, Carol P. "The Improvised Lives of Women in Music Education." *Music Educators Journal* 78, no. 7 (March 1992): 34–38.

Part of a special issue on women in music. Inspired by Mary Catherine Bateson's *Composing a Life* (New York: Atlantic Monthly Press, 1989), the author conducts a survey of 18 female music educators (9 public school, 9 university) with either a master's degree or doctorate in music education, to gather information about professional lives of women music educators. The respondents are queried about the decision the leave one's first teaching job, career detours and interruptions, the role of administrators and mentors, setting goals, job satisfaction, attitudes toward success, etc. The "artful improvisation" practiced by the women surveyed enables them to balance factors such as professional achievement, personal fulfillment, and change, in order to forge meaningful careers and lives.

484. Sheridan, Wilma. "Elements of Leadership for Women Executives." In *National Association of Schools of Music. Proceedings. No. 78*, pp. 78–82. 65th Annual Meeting, June 1990. Reston, VA: National Association of Schools of Music, 1990.

   The author discusses leadership strategies for women administrators in academe, ranging in subject matter from personal style (mentoring, encouragement of colleagues, etc.) to management issues (budgeting, problem solving, communication, faculty development, reward system, etc.); particular examples relating to music school administration are offered.

# Part E. Women in Arts Management, Technical Production, and Other Professional Roles

485. Armstrong, Toni, Jr. "Behind the Scenes. Women in Live Sound: Myrna Johnston and Shelley Jennings." *Hot Wire* 8, no. 1 (January 1992): 12–13, 57.

   A profile of these two women who operate Myrna Johnston Audio, a sound engineering company in Boston working within the women's music network.

486. Briccetti, Joan, Judith Lang Zaimont, and Catherine Overhauser. "Orchestra Manager on the Go: An Interview With Joan Briccetti." In *The Musical Woman: An International Perspective. Volume 2, 1984–1985*, ed. Judith Lang Zaimont, Catherine Overhauser, and Jane Gottlieb, pp. 71–90. Westport, CT: Greenwood Press, 1987.

   The editors of *Musical Woman* interview the general manager of the Saint Louis Symphony Orchestra. In the latter half of the interview, Briccetti expresses her views about women in the profession of orchestra management.

487. Davies, Cynthia. "Behind the Green Apron — A Woman's View." *The Strad* 101 (February 1990): 110–114.

   On recent female graduates of the Violin Making School of America (Salt Lake City, Utah).

488. Diamond, Lucy. "Behind the Scenes: Pokey Anderson, Merle Bicknell, and Tam Martin." *Hot Wire* 3, no. 3 (July 1987): 54–55, 60.

   Profiles of three women who work "behind the scenes" in the women's music network: Pokey Anderson, a producer with Hazelwitch Productions in Houston and a co-host of a women's music radio show there; Merle Bicknell, the force behind Women's Independent Label Distributors (WILD), located in Boston; and booking agent Tam Martin.

489. Diamond, Lucy. "Behind the Scenes: Brynna Fish and Leslie Ann Jones." *Hot Wire* 4, no. 1 (November 1987): 56–57.

Profiles of two women who work "behind the scenes" in the women's music network: Brynna Fish, a producer, artist promoter, and sound technician; and Leslie Ann Jones, a prominent recording engineer.

490. Driscoll, F. Paul. "Leading Ladies: Thea Dispeker and Nelly Walter, Grandes Dames of Arts Management, Have Guided the Careers of Countless Musicians." *Opera News* 57 (July 1992): 20–25, 33.
     Part of a special issue on women in opera.

491. France, Kim. "Women with Attitude: Rap Music's Female Executives are as Powerful as the Medium." *Working Woman* 17, no. 1 (January 1992): 61–64, 87.
     Despite the violence and sexism of the lyrics, rap and hip-hop record labels have afforded women more opportunities to advance, giving these executives the authority to hire additional women into the music industry, and most importantly to offer women artists contracts. The female recording executives interviewed view this as an affirmation of rap's message of rebuttal to and rebellion against the status quo.

492. Jepson, Barbara. "Women in the Classical Recording Industry." In *The Musical Woman: An International Perspective. Volume 3, 1986–1990*, ed. Judith Lang Zaimont, Jane Gottlieb, Joanne Polk, and Michael J. Rogan, pp. 337–352. Westport, CT: Greenwood Press, 1991.
     In identifying and profiling a number of women who are active now as successful managers and producers, the author addresses the issues of opportunities for and discrimination against women in the classical recording industry. Examined are the contributions of pioneering individuals, such as Wilma Cozart Fine (Mercury Records), Marni Hall (Leonarda Records), Amelia Haygood (Delos Records), and Teresa Sterne (Elektra/Nonesuch Records). Polygram Records is noted as an industry leader in the appointment of women into upper-level management positions; women mentioned include Nancy Zannini (Philips Classics), Lynne Hoffman-Engel (London), Allison Ames (Deutsche Grammophon), and others. Women record producers such as Judith Sherman, Patti Laursen, Elaine Martone, and Elizabeth Ostrow receive attention. Comments from all women advise potential newcomers to be adept at playing the corporate politics game, and to avoid projecting a defensive or confrontational stance when experiencing male intimidation. Of primary importance is self-confidence and professionalism which is based on competence and accomplishment.

493. Lazier, Kate. "Where Are the Women in the Pop Music Business? / La place de la femme dans les entreprises musicales." *Canadian Composer/ Compositeur Canadien* 244 (October 1989): 20–23.
     In French and English. A discussion on the status of women in the Canadian music business, highlighted by experiences of a few of the women holding top management positions.

494. Mayfield, Geoff. "Retail Track: Keeping Score...The Still Small Presence of Women and Blacks in the Sales and Distribution Networks of Major Music Companies." *Billboard* 102 (28 April 1990): 40–41.

495. McDonnell, Evelyn. "Feminine Critique: The Secret History of Women and Rock Journalism." *Village Voice. Rock and Roll Quarterly Section* 37 (20 October 1992): RR 6–9, 18–19.
    This in-depth article surveys the status of women rock music journalists within the music business and the degree to which opportunities have improved for women rock music critics over the past twenty-five years, while also examining gender as a factor differentiating the listening practices and writing styles of male and female rock critics. Examined are the individual perspectives of a number of present and former women rock music critics, such as Ellen Willis (*New Yorker*), Patti Smith (*Creem*), Lisa Robinson (*Creem* and *New York Post*), Karen Durbin (*Village Voice*), Deborah Frost (*Village Voice* and *Spin*), Sue Cummings (*L.A. Weekly*), and others.

496. McLane, Daisann. "The Girl in the Tweed Jacket." *Rolling Stone* No. 641 (15 October 1992): 95–97.
    The author reflects on her early career as a rock reporter for *Rolling Stone* during the 1970s, the tweed jacket symbolizing the sexless attire which was donned in order to gain access to the male-dominated rock music scene.

497. Monson, Karen. "Byline Monson: Music Critic." In *The Musical Woman: An International Perspective. Volume 2, 1984–1985*, ed. Judith Lang Zaimont, Catherine Overhauser, and Jane Gottlieb, pp. 59–70. Westport, CT: Greenwood Press, 1987.
    Karen Monson reflects upon on her career as a music critic.

498. Morris, Chris. "New Sex-Harassment Suit vs. Babineau, Geffen Execs."*Billboard* 104 (28 November 1992): 10, 100.
    This article examines the charges brought against male executives of Geffen Records by Christina Anthony, a former employee of the record company.

499. Morris, Chris, and Phyllis Stark. "Biz Faces Sexual Harassment Onus: *L. A. Times* Inquiry Turns Up Charges." *Billboard* 103 (16 November 1991): 6, 88.
    Elaborates on the front page article in the November 3, 1991 *Los Angeles Times* on sexual harassment allegations against four music industry figures.

500. Nathan, David. "Women Execs Form Crucial Quartet at Capitol." *Billboard* 102 (14 July 1990): 18.

501. Nathan, David. "Women in Publishing: A Profile." *Billboard* 102 (29 September 1990): 29, 32.

Profiles of female executives in contemporary black music publishing: Brenda Andrews, Rachelle Fields, and Carol Ware.

502. Paolucci, Bridget. "Joan Dornemann: Opera's Master Coach." In *The Musical Woman: An International Perspective. Volume 3, 1986–1990*, ed. Judith Lang Zaimont, Jane Gottlieb, Joanne Polk, and Michael J. Rogan, pp. 220–237. Westport, CT: Greenwood Press, 1991.
    The author examines the life and career of Joan Dornemann, who became the Metropolitan Opera's first woman prompter and assistant conductor in 1975.

503. Parsons, Patrick R. "The Changing Role of Women Executives in the Recording Industry." *Popular Music and Society* 12, no. 4 (1988): 31–42.

504. "Recording Women." *Home and Studio Recording* 4, no. 11 (August 1991): 10–16.
    Interviews with songwriter/producer Lauren Wood and the President of Gold Castle Records, Paula Jeffries.

505. Reynolds, Margaret. "Opera—An Unsuitable Job for a Woman." *Women: A Cultural Review* 3, no. 1 (Summer 1992): 47–50.
    Part of a special issue on women and music. The author examines the problems confronting women in management and production positions in opera companies, and focuses on the experiences of several women working on the British operatic scene: Christine Chibnall (planning director, Opera North), Clare Venables (producer, Monstrous Regiment), Clare West (assistant producer, English National Opera), Julia Hollander (producer, English National Opera), and Sian Edwards (musical director, English National Opera).

506. Spagnardi, R. "Editor's Overview: Here's to the Ladies [free-lance MD writers]." *Modern Drummer* 12 (April 1988): 2.
    On women writers for *Modern Drummer*.

507. Studdal, Ashley. "Delicate Touch: Ashley Studdal Visits the Exhibition of Women [Violin] Makers at Phelps in London." *Strad* 99 (September 1988): 704–705.

508. Wadsworth, Susan. "My Life and Career with Young Concert Artists." In *The Musical Woman: An International Perspective. Volume 2, 1984–1985*, ed. Judith Lang Zaimont, Catherine Overhauser, and Jane Gottlieb, pp. 120–135. Westport, CT: Greenwood Press, 1987.
    Susan Wadsworth, Director of Young Concert Artists, a non-profit organization devoted to assisting unknown young artists with establishing and building careers as concert performers, discusses the activities of YCA, her background, and her observations on the difficulties that young women face in their careers as performing artists.

CHAPTER FOUR

# Feminist Musical Aesthetics

509. Armstrong, Toni, Jr. "What is Women's Music? An Endangered Species: Women's Music By, For, and About Women." *Hot Wire* 5, no. 3 (September 1989): 17–19, 57.

Of concern to the author, the editor of *Hot Wire*, is the appropriation of the term "women's music" in the labeling of mainstream recordings by women performers which lack a feminist focus and which are not primarily under the artistic control of the woman artist, and its resultant effect of attracting the feminist/lesbian music audience to mainstream products. In this article she elaborates on the social, political, and artistic concerns which she feels differentiate "woman-identified" music from music performed by women but controlled by the "male-dominated mainstream industry." She does this by posing and answering a series of questions: "Does every project in women's music have to be women-only?"; "How can instrumental music, with no lyrics, ever be 'woman-identified'?"; "Does every act have to be explicitly lesbian-identified in order to be called 'women's music'?"; "What if the artist doesn't feel that being feminist-identified or lesbian-identified is part of her art?"; "What about women who are strong but who reject the terms 'feminist' and/or 'lesbian'?"; "How do you personally decide if something should be labeled 'women's music' or not?"

510. Berendt, Joachim Ernst. "Why Women Have Higher Voices." In *The Third Ear: On Listening to the World*, trans. Tim Nevill, pp. 129-151. Longmead, Shaftesbury, Dorset, England: Element Books, 1988.

ISBN 1852300493. The author's "reflections on woman's vocal dominance and linguistic superiority" (p. 151).

511. Cox, Renée. "A History of Music." *Journal of Aesthetics and Art Criticism* 48, no. 4 (Fall 1990): 281–291.

Part of a special issue entitled "Feminism and Traditional Aesthetics", this is a panoramic view of music history written with a feminist aesthetic in mind. In the ancient world the author focuses on music as interwoven into the daily lives of women, and on the interrelations of goddess worship, dance, music. Aspects of the masculine and feminine with regard to the musical aesthetics of the Greeks is discussed. Attitudes of the early Christian patriarchs towards women's involvement in the church and its music is examined. Mozart's *Die Zauberflöte*, Wagner's *Tannhäuser*, and the music of Mick Jagger and the Rolling Stones are all analyzed from a feminist perspective.

512. Cox, Renée. "Recovering Jouissance: An Introduction to Feminist Musical Aesthetics." In *Women and Music: A History*, ed. Karen Pendle, pp. 331–340. Bloomington, IN: Indiana University Press, 1991.

The author cites examples of works of feminist music criticism which analyze the construction of gender in works by male composers from the canon of Western music. The author hypothesizes whether a uniquely feminine musical aesthetic exists, and speculates as to what music expressing this aesthetic might sound like. Drawing first upon literature from the French feminist movement on the "nature of *l'écriture féminine*" (p. 333), so as to define what might be expressed in a uniquely feminine voice, Cox then considers the sparse literature available on musical works by women composers, such as Kay Gardner, Laurie Anderson, and Ellen Taaffe Zwilich, to further inform her discussion. Female pleasure, female sexuality, sensuality, and the uniquely female perspective on the life cycle processes are themes which emerge in artistic expressions of women, including music. However, Cox questions whether the music itself is distinguishable from that written by male composers constructing their own notions of the feminine, and whether emphasizing the body and sexuality in discussions relating to a feminist musical aesthetic will only reinforce patriarchal stereotypes and further ghettoize music by women composers. Cox stresses that scholars must be open to all interpretations, especially in this new and developing area of inquiry.

513. Davidson, Tina. "Cassandra Sings."*Ms.* 2, no. 4 (January/February 1992): 64–67.

The author argues for the existence of a feminine aesthetic expressed in music by contemporary women composers, and is critical of the emphasis in conservatories and universities on the performance and study of music from the classical Western European male canon. She likewise questions composer training which stresses process over aesthetics. Women who compose with a discernable female voice are identified (e.g., Linda Bouchard, Mary Ellen Childs, Gloria Coates, Tina Davidson, Eleanor Hovda, Mary Jane Leach, Annea Lockwood, Bunita Marcus, Pauline Oliveros, Janika Vandervelde, Lois Vierk, and Julia Wolfe); a listing of published scores and recordings by these women is included.

514. Detels, Claire. "Soft Boundaries and Relatedness: Paradigm for a Postmodern Feminist Musical Aesthetics." *Boundary 2* 19, no. 2 (Summer 1992): 184–204.

Part of a special issue devoted to feminism and postmodernism. The author draws upon feminist musical criticism, feminist aesthetic theory, and postmodern theory to devise a new aesthetic paradigm for music which may provide an alternative to "the positivistic mode of mainstream musicology and its overly reified conception of music, as especially seen in the theory, pedagogy, and production of Western art music" (p. 185). The author examines how this paradigm, which incorporates the concepts of "soft boundaries and relatedness (p. 185)," can inform three aspects of the musical experience which heretofore have received little attention: "(1) relatedness of musical experience to the body; (2) relatedness among the constituencies of musical experience, including the composer, performer, audience, critics, and community; and (3) relatedness of musical style to culture" (p. 191).

515. Fox, Mimi, Lynn Lavner, and Kristan Aspen. "Creativity." *Hot Wire* 7, no. 2 (May 1991): 34–35, 57, 59.

Mimi Fox (jazz guitarist and teacher), Lynn Lavner (lesbian cabaret performer and songwriter), and Kristan Aspen (currently flutist for the Music Femina duo) reflect on music and creativity.

516. Gardner, Kay. *Sounding the Inner Landscape: Music as Medicine.* Stonington, ME: Caduceus Publications, 1990.

A culmination of her philosophy on the "curative properties and healing effects of music," this composer states, "I have written this book as a feminist with a strong belief in Woman as healer, bringer of balance and wholeness" (p. 226). Drawing upon the "feminine" aspects of musics from ancient and non-Western cultures, she specifically addresses the concept of the existence of a female musical aesthetic with relation to musical form (circular, pp. 192–195) and melody (modes, pp. 131–136 and ragas, pp. 143-147).

517. Gardner, Kay. "Women's Music and the Divine Proportion." *Hot Wire* 6, no. 2 (May 1990): 50–52, 55.

Excerpted from the author's book, *Sounding the Inner Landscape: Music as Medicine.* The author examines composing with the divine proportion (e.g., golden section) as a means of creating a healing effect in music.

518. Gates, Eugene. "The Female Voice: Sexual Aesthetics Revisited." *Journal of Aesthetic Education* 22, no. 4 (Winter 1988): 59–68.

The author scrutinizes feminist arts and literary criticism and concentrates on assessing the validity of the theory which asserts that a discernable female voice exists in women's works of art. He finds dangers and flaws in present gender-based theories of musical aesthetics, drawing parallels to the musical aesthetics and criticism of the nineteenth century, in which music

was also imparted with gendered characteristics, but instead served the political ends of discriminating against the musical pursuits of women. In defining arts criticism as an activity which both interprets and evaluates an aesthetic object (in this case music), Gates finds feminist criticism to be "impoverished" (p. 61) as an adjudicatory endeavor, especially when the object of this criticism is a woman's creative work. He likewise dismisses the existence of a gendered voice in music, "the most abstract and autonomous of the arts" (p. 63). To illustrate his point he examines works by women composers of the nineteenth century which were mistakenly identified as being authored by male composers, and which were highly acclaimed as such. The examples used here are: 1) "Suleika und Hatem" and "Italien" two songs by Fanny Mendelssohn Hensel published as part of Felix Mendelssohn's Op. 8 songs, and 2) three songs by Clara Schumann included as part of Robert Schumann's Op. 37, *12 Gedichte aus 'Liebesfrühling'* (Rückert). Gates thus concludes that the voice theory has no merit "as a potential framework for a system of critical practice" and instead judges it to be "a political strategy designed to aid the assimilation of women's artistic productions into the canon" (p. 68).

519. Göttner-Abendroth, Heide. *The Dancing Goddess: Principles of a Matriarchal Aesthetic*. English trans. Maureen T. Krause. Boston, MA: Beacon Press, 1991.

    The arts aesthetic in matriarchal societies is explored, with a particular emphasis on the interrelations between the visual arts, music, poetry, drama, dance, myth, and ritual. The author examines how art in a patriarchal society is separated into disciplines, leading to the conception of art as object and to the perpetuation of the creator-critic-consumer system. Drawing on references to the Muses of Ancient Greece, the author theorizes as to how a matriarchal arts aesthetic would apply to the contemporary arts of women.

520. Gunden, Heidi Von. "The Music of Pauline Oliveros: A Model for Feminist Criticism." *International League of Women Composers (ILWC) Journal* (June 1992): 6–8.

    On the uniquely female aspects of the music of Pauline Oliveros, and those characteristics which are "at variance with our mainstream, masculine tradition" (p. 6).

521. Harper, Jorjet. "The Tenth Muse: Towards a Lesbian Aesthetic. Is There Such a Thing as True 'Women's Music'." *Hot Wire* 6, no. 1 (January 1990): 14–15, 59.

522. Hotaling, Ann Caroline. "Environmental Music and Women." *News of Music* 13 (Winter 1992): 33–46.

    In her search for a definition of environmental music, the author explores the various ways in which contemporary composers, a good number of whom are women (e.g., Priscilla McLean, Annea Lockwood,

Catherine Schieve), consciously utilize environmental and natural sounds in their compositions.

523. Öhrström, Eva. "Kvinnliga och manliga musikvärldar: en kultursociologisk Översikt." In *Kvinnors Musik*, ed. Eva Öhrström and Märta Ramsten. pp. 7–20. Stockholm, Sweden: Sveriges Utbildningsradio AB and Svenska Rikskonserter, 1989.
ISBN 9126898101. In Swedish. Translated title: "Female and Male Music Worlds: A Sociocultural Overview." Discusses issues relating to gender, musical aesthetics, and musical performance; sexual stereotypes creating boundaries for women as musicians; musical education for women; and Swedish women composers, conductors and orchestral musicians.

524. Rieger, Eva. "'I Recycle Sounds': Do Women Compose Differently." *International League of Women Composers (ILWC) Journal* (March 1992): 22–25.
In an effort to encourage further investigation and discussion on the topic of the connections between sexual identity, gender roles in society, cultural aesthetics and music composition, the author identifies a series of aesthetic commonalities in compositions by women which she has garnered through listening to numerous works and conducting historical research and analysis. Characteristics which are based on the female experience include: the size and intimacy of the work; functionality of the music; communicative/emotive qualities; making music based on sounds which are part of the "constituent substance" of one's world; emphasis on accord rather than opposition; "Ganzheitlichkeit" (a fusion of the performing arts with an awareness of humanity and nature); and the importance of the body and voice as musical conduits. While she does not seek to generalize or categorize all works by women, the author does reveal important "female" aspects in music by a variety women composers, even those who do not identify with feminism or the concept of a female aesthetic.

525. Rieger, Eva. "'Ich recycle Töne': Schreiben Frauen anders? Neue Gedanken zu einem alten Thema." *Neue Zeitschrift für Musik* 153, no. 2 (February 1992): 14–18.
In German. Translated title: "'I Recycle Sounds': Do Women Compose Differently? New Thoughts on an Old Theme." The author explores the existence of a female musical aesthetic, the encoding of gender in musical compositions, the music of women who compose without resorting to the dynamic of binary opposition, and the voice and the body as important considerations in compositions by women. The author's English translation of this article appears in the *International League of Women Composers (ILWC) Journal* (March 1992): 22–25.

526. Said, Edward W. "Music." *Nation* 244 (7 February 1987): 158–160.
Discussion of feminine musical style and gender expressed in music.

527. Van Dyke, Mary Louise. "Women Hymnwriters A to Z." *Triangle of Mu Phi Epsilon* 82, no.3 (1988): 7–10.

A grant from Mu Phi Epsilon has made way for an index/ bibliography to hymn texts written by women, culled from entries in the ongoing *Dictionary of American Hymnology* being sponsored by the Oberlin College Library. Van Dyke, the compiler of this bibliography, here analyzes the hymn texts as poetry, noting patterns of what she describes as "feminine" characteristics: delight in sound, sensory images, figurative language, etc. Interesting is her observation of the positivism found in women's hymns.

528. "Women Explore a Percussive Path of Expression."*New York Times* 2 January 1993: 27.

No author cited. Exploring the percussive traditions of various music cultures and pursuing the path of women's spirituality and personal growth, growing numbers of women are participating in women's drumming circles, led by instructors such as Penny Gnesin, Ubaka Hill and Layne Redmond.

529. Wood, Elizabeth. "Gender and Genre in Ethel Smyth's Operas." In *The Musical Woman: An International Perspective. Volume 2, 1984–1985*, ed. Judith Lang Zaimont, Catherine Overhauser, and Jane Gottlieb, pp. 493–507. Westport, CT: Greenwood Press, 1987.

A general examination of the musical discourse of Dame Ethel Smyth's operas reveals that she found opera to be an effective medium for communicating her feminist vision and the struggles which she fought to overcome in her lifetime.

530. Wood, Elizabeth. "Lesbian Fugue: Ethel Smyth's Contrapuntal Arts." In *Musicology and Difference: Gender and Sexuality in Music Scholarship*, ed. Ruth Solie, pp. 164–183. Berkeley, CA: University of California Press, 1993.

Wood seeks to decode certain aspects of Smyth's lesbianism with a contrapuntal explication of themes and events revealed in her letters and memoirs, considered together with an examination of themes revealed through her instrumental music compositions.

# Women and Gender Issues in Music Education

531. Atterbury, Betty W. "Old Prejudices, New Perceptions." *Music Educators Journal* 78, no. 7 (March 1992): 25–27.

Part of a special issue on women in music. The author discusses barriers to success for women musicians and challenges music educators to take a critical look at how gender bias and stereotypes influence teaching style, curriculum content, and opportunities for employment. Included is a brief annotated bibliography/discography of basic resources which can be used to mainstream music by women into the curriculum.

532. Barry, Nancy H. *The Effects of Practice Strategies, Individual Differences in Cognitive Styles, and Sex Upon Technical Accuracy and Musicality of Student Instrumental Performance.* Diss. Ph.D., Florida State University, 1990.

Abstract in *Dissertation Abstracts International: A. Humanities and Social Sciences* 51, no. 7 (January 1991): 2306. DA# 9100056.

533. Barry, Nancy H. "The Effects of Practice Strategies, Individual Differences in Cognitive Style, and Gender upon Technical Accuracy and Musicality of Student Instrumental Performance." *Psychology of Music* 20, no. 2 (1992): 112–123.

Fifty-five male and female brass and woodwind students, grades 7–10, participated in this study investigating the variables of practice procedures (structured vs. free practice), cognitive style (field-dependence/independence), and gender on melodic/rhythmic accuracy and musicality of performance.

534. Bobbett, Gordon C., et. al. "The Relationship Between Postsecondary Instrumental Student's Musical Independence and Grade-Level, Instrument Family, Gender, and Instrumental Ensemble." Paper presented at the

Annual Meeting of the National Band Association, Chicago, IL, 16 December 1992.

Available from ERIC, ED# 353891, in microfiche or paper copy. For an abstract see *Resources in Education* 28, no.6 (June 1993): 89.

535. Brandenberg, Neal A. "Sex Stereotyping and Student Preferences." *School Music News* 55, no. 1 (September 1991): 32–38.

This study examines the choices of musical instruments made by male and female students in grades 2–8, and how these choices were influenced by associations of musical instruments with stereotypical gender roles or characteristics.

536. Cant, Stephanie. "Women Composers and the Music Curriculum." *British Journal of Music Education* 7, no. 1 (March 1990): 5–13.

The author seeks to combat negative attitudes towards women's ability to compose at the source—in primary and secondary music education. The lack of attention given to historical and contemporary works by women composers in the education and training of music teachers reproduces a lack of confidence in women music teachers with regard to their own abilities to introduce compositional and improvisational activities to children. Programs of music pedagogy must impart new teachers with an awareness of the contributions of women throughout the history of music, as well as an awareness of social obstacles which have prevented more women from pursuing musical endeavors. Without this preparation new music teachers risk reproducing the perception that women are inferior in their compositional ability, through the continued exclusion of women composers' works in music education programs in primary and secondary schools. Case studies of Clara Schumann and Luise Adolpha Le Beau demonstrate the effect of restrictive sex roles on their professional careers as women composers. The author then offers some strategies to music teachers as to how they can introduce the compositions of women into the classroom.

537. Comber, Chris, David J. Hargreaves, and Ann Colley. "Girls, Boys and Technology in Music Education." *British Journal of Music Education* 10, no. 2 (July 1993): 123–134.

Presented are the preliminary findings of a study conducted by the University of Leister (England) concerning gender differences with regard to boys' and girls' familiarity with and use of music technology in British music education programs. Research in three relevant areas is summarized, these areas being: 1) "gender-related patterns of musical behavior" (p. 124) in students of twelve to eighteen years of age, 2) the use of technology in the music classroom, and 3) the use of information technology by girls and boys in this age group. "Although music has traditionally been an area in which girls predominate, technological developments (and their association with rock and pop music) have made it more attractive and accessible to many boys who would not have otherwise shown any musical interests" (p. 126).

The study's findings show that students (and some teachers) regard technology as being a male preserve, posing challenges for music educators in their efforts to provide a nonthreatening, gender-free learning environment. Therefore, the author concludes that, "Music education has the potential to play a major role in redressing the imbalance between the sexes, so that it is essential that teachers and researchers work collaboratively to identify those factors which contribute to current inequalities, and to devise teaching practices which best address them" (p. 133).

538. Corbin, Lynn A. "Response to 'Sex Equity and Policy in Music Education: A Change of Vision, a Change of Values'." In *Policy Issues in Music Education: A Report of the Proceedings of the Robert Petzold Symposium, University of Wisconsin–Madison, October 1990*, ed. Gerald Olson, Anthony Barresi, and David Nelson, pp. 146-148. Madison: University of Wisconsin-Madison. School of Music, [1991].

    This respondent to a conference paper by Julia Ekland Koza, published in the same volume, takes issue with Ms. Koza's criticism of textbook illustrations and the policies of textbook publishers. Referring to problems in the recruitment of boys into school music ensembles, Corbin suggests that the relative frequency and context of illustrations of male and female musicians may indicate that textbooks are trying to encourage younger males to participate in what they might perceive as a feminine activity. The respondent states that progress has been made regarding nonsexist language use in textbooks, and cautions that in order to further the cause of sex equity issues, music educators must have a lobby which can inform and convince state textbook adoption agencies, thus offering publishers economic reasons for altering status quo policies.

539. Cowden, Robert L., and Robert H. Klotman. "Special Topics: Sexual Harassment." *Administration and Supervision of Music.* 2nd ed., pp. 231-233. New York: Schirmer Books, 1991.

540. Delzell, Judith K. "Gender Association of Musical Instruments and Preference of Fourth Grade Students for Selected Instruments." *Journal of Research in Music Education* 40, no. 2 (Summer 1992): 93-103.

    The author first reviews previous research from the 1970s and 1980s on gender associations with musical instruments, and student preferences for instruments with gender as a factor in the study. This article investigates attitudinal changes which may have occurred since, estimating the current musical instrument preferences of fourth graders, and examining possible reasons for these gender associations and preferences.

541. Delzell, Judith K. "Response to 'Sex Equity and Policy in Music Education: A Change of Vision, a Change of Values'." In *Policy Issues in Music Education: A Report of the Proceedings of the Robert Petzold Symposium, University of Wisconsin–Madison, October 1990*, ed. Gerald Olson, Anthony

Barresi, and David Nelson, pp. 149–152. Madison, WI: University of Wisconsin–Madison. School of Music, [1991].

In response to a conference paper by Julia Ekland Koza in the same volume, Delzell comments that the predominance of boys versus adult males in music-related illustrations in textbooks seems to indicate that publishers are trying to encourage boys to partake in what society views as a "female" activity. However, textbooks also reflect the male dominance in the traditional musical canon. Teachers must make a difference by fostering performance of instruments in ensembles regardless of gender or race of the student. Most teachers are female and thus can have an influence on how to look at textbook materials if they are trained to be critical examiners of the values perpetrated by these materials.

542. DuPree, Mary. "Beyond Music in Western Civilization: Issues in Undergraduate Music History Literacy." *College Music Symposium* 30, no. 2 (Fall 1990): 100–105.

The eurocentric emphasis of college music study has come under scrutiny recently, and college music programs now face the challenge of how to effect a solid foundation in Western music literacy given the expanding canon of musical literature in the 1990s. A questionnaire sent to five hundred NASM-accredited colleges reveals the strategies used by these institutions to meet this challenge and assesses the degree to which undergraduate college music programs have incorporated often-overlooked musics—i.e., jazz, ethnic music, music by women composers, early music, and contemporary American music—into the core history survey courses taken by music majors and non-majors. In her report, the author stresses that in order to meet the mandate for a musical literacy which is broad-based, college music programs should undertake a more in-depth approach to fewer representative works and in turn concentrate on instilling their students with the capacity and desire for lifelong learning, through the development of solid listening and analytical skills, as well as training in library research. The statistical tables at the end of the article summarize the survey responses.

543. Gates, J. Terry. "A Historical Comparison of Public Singing by American Men and Women." *Journal of Research in Music Education* 37, no. 1 (Spring 1989): 32–47.

The author first documents the involvement of men and women in public choral singing in colonial Boston and in contemporary American music education programs, demonstrating that during the course of history there has been a shift in vocal predominance from males to females in the twentieth century, as the social and moral values associated with public singing have shifted. The forecast for the future indicates that interest among both men and women in public choral singing is on the wane; the author discusses the implications of this trend on music literacy and on general music education programs in the public schools.

544. Harley, Donald V. S. "'Singin' the Blues': Women in Song." *Social Education* 56, no. 1 (January 1992): 66.

    The author suggests an activity for use in middle school or high school classrooms which explores the stereotypical portrayal of women in popular music song texts.

545. Jezic, Diane Peacock, and Daniel Binder. "A Survey of College Music Textbooks: Benign Neglect of Women Composers." In *The Musical Woman: An International Perspective. Volume 2, 1984–1985*, ed. Judith Lang Zaimont, Catherine Overhauser, and Jane Gottlieb, pp. 445–469. Westport, CT: Greenwood Press, 1987.

    College music texts are scrutinized for inclusion of discussions about works by women composers. In order to determine the degree to which music textbooks cover material on women composers, Jezic surveys fourteen introductory music appreciation texts published between 1976 and 1985, and Binder examines forty-seven specialized and general music history texts published between 1940 and 1985. Results show poor representation, if any, even in the most recent texts. (In fact, music histories from the 1940s were more representative.) The authors point out that school music textbooks offer a more balanced representation, and criticize the obvious exclusion of women from college level materials. The resistance of upper level textbook authors and publishers to the mainstreaming of information about women composers into standard texts is challenged.

546. Jones, Jenna Jordan. *The Development and Evaluation of Materials for a Women Composers Course Designed for Secondary Level Students*. Diss. Ph.D., Kent State University, 1992.

    Abstract in *Dissertation Abstracts International: A. Humanities and Social Sciences* 54, no. 2 (August 1993): 454. DA# 9317547. The author investigates whether the incorporation of works by women composers into the high school music appreciation curriculum effects a change in student attitudes towards female creativity, student attitudes towards women in general, and the knowledge of students regarding music by women. Results of pretests and posttests of the experimental (i.e., including music by women in the curriculum) and control (i.e., using standard music curriculum) groups lead to author to conclude that while exposure to the music of women composers did expand the knowledge of students in the experimental group, student attitudes towards women and their creative abilities were not significantly altered.

547. Koza, Julia Eklund. "The 'Missing Males' and Other Gender-Related Issues in Music Education: A Critical Analysis of Evidence from the Music Supervisor's Journal, 1914–1924." Paper presented at the Annual Meeting of the American Educational Association, San Francisco, CA, 22 April 1992.

    Available from ERIC, ED# 352302, in microfiche or paper copy. For an abstract see *Resources in Education* 28, no. 4 (April 1993): 146. Here,

this author's continuing investigation into gender roles and sexual discrimination in music education publications explores the "missing male" problem in elementary/secondary education, i.e., the reluctance of boys to participate in school music programs. Her detailed study of the male-oriented content of *Music Supervisors' Journal*, an early journal in the field of music education, reveals that the music education profession, in its eagerness to attract young males to school music programs and careers in music, has overlooked educational issues relating to females and their musical interests.

548. Koza, Julia Eklund. "Music Instruction in the Nineteenth Century: Views from *Godey's Lady's Book*, 1830–77." *Journal of Research in Music Education* 38, no. 4 (Winter 1990): 245–257.

549. Koza, Julia Eklund. "Picture This: Sex Equity in Textbook Illustrations." *Music Educators Journal* 78, no. 7 (March 1992): 28–33.
 Part of a special issue on women in music. The author stresses that music education, through its classroom methods, materials, and practices, must realize its responsibility for the perpetuation of gender inequities and bias. Music textbooks are analyzed and criticized for their stereotypical portrayal of women as anonymous singers or pianists. The author offers teachers solutions to these problems.

550. Koza, Julia Eklund. "Sex Equity and Policy in Music Education: A Change of Vision, a Change of Values." In *Policy Issues in Music Education: A Report of the Proceedings of the Robert Petzold Symposium, University of Wisconsin–Madison, October 1990*, ed. Gerald Olson, Anthony Barresi, and David Nelson, pp. 135–145. Madison, WI: University of Wisconsin–Madison. School of Music, [1991].
 Includes bibliography. Results of the author's research are presented. A content analysis of nearly 3500 illustrations in middle school music textbooks reveals that the images representing women in music-related activities portray a pattern of exclusion, stereotyped roles for women, and anonymous representations of women. The author questions how these images persist when most textbook publishers have explicit equity policies. Textbook publishers, under pressure from powerful state textbook adoption committees, often make policy and editorial decisions which they consider to be the "least offensive," in order to sell their product. Music teachers, the majority of whom are women, must be responsible and look critically at material in their textbooks, introduce alternative material, and teach their students to look critically at material presented in the textbooks used in the classroom.

551. Kwami, Robert. "An Approach to the Use of West African Musics in the Classroom Based on Age and Gender Classifications." *British Journal of Music Education* 8, no. 2 (July 1991): 119–137.

The author proposes that the classification of West African musics by age, social function, and gender of the performer may provide a mechanism by which a teacher might choose a particular kind of musical activity for use in the classroom.

552. Lamb, Roberta K. "Are There Gender Issues in School Music." *Canadian Music Educator* 31, no. 6 (May 1990): 9–13.

553. Lamb, Roberta K. *Including Women Composers in Music Curricula: Development of Creative Strategies for the General Music Class, Grades 5–8.* Diss. Ed.D., Columbia University Teachers College, 1987.

    Abstract in *Dissertation Abstracts International: A. Humanities and Social Sciences* 48, no. 10 (April 1988): 2568–2569. DA# 8721136. The author presents a design for integrating music by women composers into the middle school curriculum. See also her article in the *Musical Woman. Volume 3.*

554. Lamb, Roberta K. "Women Composers in School Music Curricula, Grades 5–8: A Feminist Perspective." In *The Musical Woman: An International Perspective. Volume 3, 1986–1990,* ed. Judith Lang Zaimont, Jane Gottlieb, Joanne Polk, and Michael J. Rogan, pp. 682–713. Westport, CT: Greenwood Press, 1991.

    The author encourages music educators to employ nonsexist approaches to teaching music at various grade levels. Beginning with a clearly written introduction to the concepts of feminist theory, she offers strategies as to how teachers may apply feminist theory to the music classroom. She moves on to demonstrate how most of the current curriculum materials available to school music teachers are inadequate in their inclusion of women's musical contributions, or stereotypical in their illustrations of women and men in musical contexts, or even worse, exclusionary altogether. She then presents excerpts from her own women composers music curriculum project, designed for use in middle school classrooms. (See Lamb's *Including Women Composers in Music Curricula.* Ph.D. diss., Columbia University Teachers College, 1987.) Copious references, a comprehensive bibliography and an appendix listing all units contained in the author's model curriculum are included.

555. Lindeman, Carolynn A. "Teaching About Women Musicians: Elementary Classroom Strategies." *Music Educators Journal* 78, no. 7 (March 1992): 56–59.

    Part of a special issue on women in music. The author strongly voices the need for change in school music curricula, particularly at the elementary school level, so as to reflect the musical contributions of women throughout history. Her evaluation of elementary and middle school music textbooks finds them to be lacking in their representation of works by women, requiring teachers to rely on supplemental material in order to adequately

mainstream the works of women composers into the classroom. Lindeman offers strategies in the form of sample lessons, suggested resources, etc., to assist teachers in this endeavor.

556. Little, Lowell. "Should Girls Play Wind and Percussion Instruments." In *Conductors Anthology, Volume 1: School Music Director Off the Podium. A Compendium of Articles from "The Instrumentalist" from 1946 to 1986 on the Administrative Side of Being a School Music Director*, pp. 183–185. Northfield, IL: The Instrumentalist, 1989.

Reprinted from the September 1957 issue of *The Instrumentalist*.

557. Livingston, Carolyn. "Characteristics of American Women Composers: Implications for Music Education." *Update: Applications of Research in Music Education* 10, no. 1 (Fall/Winter 1991): 15–18.

The author examines the backgrounds and careers of twenty-six nineteenth and twentieth-century women composers to determine possible social, economic, and cultural patterns which may point to successful paths for young women of today who aspire to be composers. The existence of a female role model emerges as an important factor in the lives of the women studied, reinforcing the theory that teaching about creative women in the arts serves to both encourage young women seeking musical careers, while educating both sexes about individual talent and ability.

558. Marshall, Clifford T. "The Girl's Place in Instrumental Music." In *Conductors Anthology. Volume 1: School Music Director Off the Podium. A Compendium of Articles from "The Instrumentalist" from 1946 to 1986 on the Administrative Side of Being a School Music Director*, p. 191. Northfield, IL: The Instrumentalist, 1989.

Reprinted from the January 1966 issue of *The Instrumentalist*. Brief article by a music educator outlining his views of the potential and the limitations of young women in their ability to achieve as wind instrumentalists.

559. May, Wanda. "'Whose' Content, Context, and Culture in Elementary Art and Music Textbooks? Elementary Subjects Center Series No. 23." Paper presented at the Annual Meeting of the American Educational Research Association, Boston, MA, April 1990.

Available from ERIC, ED# 328511, in microfiche or paper copy. For an abstract see *Resources in Education* 26, no. 6 (June 1991): 140. This study examines the ideological question posed in the title of the paper as it relates to an analysis of two elementary arts textbook series: "Discover Art" (Davis Publications) and "World of Music" (Silver/Burdett & Ginn). These standard, authoritatively-viewed texts are critiqued from a sociological standpoint, revealing the manner in which they reflect dominant ideologies of class, gender, race, and culture. The role of mediation on the part of teachers and students then becomes an important one in order to present cultural possibilities other than those prescribed in standard music texts.

560. Moore, Randall S., and Anthony Kemp. "Effects of Nationality and Gender on Speaking Frequency, Singing Range and Preferred Tessitura of Children From Australia, England and the United States." *Canadian Music Educator/Musicien Educateur au Canada. Research Edition* 33 (December 1991): 149–156.

    Part of a Special ISME Research Edition publishing the proceedings of the Thirteenth ISME International Seminar in Music Education taking place in Stockholm in July 1990. The results of this study show that, for the most part, both male and female children will refrain from using the upper parts of their voice register unless they are encouraged and trained to do so by music educators. While the authors measure the slight cultural differences in speaking and singing practice within the English-speaking groups studied, they note a gap in the research literature on multi-cultural investigations of children's singing practice with gender as a consideration.

561. Moskovitz, Elisa M. *An Examination of Sex-Role Stereotypes in Relation to Current Trends of Repertoire Choice Among Undergraduate Pianists.* Diss. D.M.A., University of South Carolina, 1989.

    Abstract in *Dissertation Abstracts International: A. Humanities and Social Sciences* 50, no. 9 (March 1990): 2700. DA# 9005140.

562. Moskovitz, Elisa M. "Genre and Gender: A Look At How Stereotypes Affect Repertory Selection." *American Music Teacher* 40, no. 1 (August/September 1990): 16–19, 62.

563. Neuen, Donald. "Choral Conductors Forum: The Young Soprano Voice." *American Choral Review* 33, no. 1 (Winter/Spring 1991): 40–42.

    Instructional tips for the choral conductor on the training of the soprano voice.

564. Nichols, Elizabeth. "Music Workshops for Mothers and Babies: Accent on Music and Dance." *Orff Echo* 25, no. 1 (Fall 1992): 6–8.

    This article summarizes recent research on music in infant care and introduces a series of music and rhythm activities for parents and their babies.

565. Orsoni, Jerry. "Band Mothers—My First Encounter." In *Conductors Anthology, Volume 1: School Music Director Off the Podium. A Compendium of Articles from the Instrumentalist from 1946 to 1986 on the Administrative Side of Being a School Music Director*, pp. 377–378. Northfield, IL: The Instrumentalist, 1989.

    Reprinted from the June 1966 issue of *The Instrumentalist.*

566. Ostleitner, Elena, and Ursula Simek. *Ist 'die' Musik männlich? Die Darstellung der Frau in den österreichischen Lehrbüchern für Musikerziehung.* Vienna, Austria: WUV Universitätsverlag, 1991.

ISBN 3851140508. In German. Translated title: *Is Music [German feminine article accentuated] Masculine? The Representation of Women in Austrian Music Textbooks*. Reviewed in *Musik und Bildung* 24 (May/June 1992): 46; *Österreichische Musik Zeitschrift* 46, no. 7–8 (July/August 1991): 432–433. The author compares the manner in which men and women are represented in the illustrations and narrative contained in music textbooks so as to reveal the subtle, but pervasive, discriminatory attitudes in the music educational system.

567. Palmer, Robert V. "Not Playing Second Fiddle ." *Rochester Democrat and Chronicle* 12 November 1988, *Newsbank: Review of the Arts, Performing Arts* 16, Fiche 16 (January 1989): A12–A13.

Betty Friedan addresses students at the Eastman School of Music as part of a day long seminar, 'Second Stage: Changing Roles in Music'.

568. Palmquist, Jane E., and Barbara Payne. "The Inclusive Instrumental Library: Works by Women." *Music Educators Journal* 78, no. 7 (March 1992): 52–55.

Part of a special issue on women in music. This general discussion on women composers of instrumental music includes educational strategies for integrating the repertoire into the curriculum. The author presents a selective list of repertoire for school orchestras and bands.

569. Pemberton, Carol. "Sense and Nonsense: Exploring the Implications of Gender Roles as Reflected in the Work of Lowell Mason." *Quarterly Journal of Music Teaching and Learning* 3, no. 3 (Fall 1992): 5–12.

This article examines how nineteenth-century attitudes towards women are reflected in the letters, textbooks, and educational philosophy of Lowell Mason. Music education as socialization was intended to preserve the status quo, and education for girls and women was not so much meant to prepare them for a music profession, as to prepare them so that they might foster an atmosphere of culture and learning within the woman's sphere, the home and family. The author challenges the reader to contemplate the degree to which these attitudes persist, e.g., through the choice of teaching materials, even though there has been a degree of social change.

570. Phillips, Kenneth. "Breathing and its Relationship to Vocal Quality Among Adolescent Female Singers." *Journal of Research in Singing and Applied Vocal Pedagogy* 15, no. 2 (June 1992): 1–12.

Research addressing the adolescent female changing voice is minimal. This study focuses on 14 to 15 year-old adolescent females who sing in a high school freshman girls' chorus. The extent to which breathiness is a factor in their vocal quality is examined, as well as the modes of breathing used, and the impact of instruction in breath management on vocal quality.

571. Picard, Patricia. "Does Gender Matter? An Evaluation of the Arts Curriculum." In *The Claims of Feeling: Readings in Aesthetic Education,* pp. 200–279. London: Falmer Press, 1989.

Cultural traditions and normative assumptions about gender in arts education today tend to limit personal development. Four general criteria for a gender-aware arts education are offered as a guide to the reevaluation of the arts curriculum on the basis of gender equity.

572. Post, Laura. "The Institute for Musical Arts."*Hot Wire* 5, no. 3 (September 1989): 46–48.

This article provides information on the Institute for Musical Arts, and profiles its founder, June Millington, a guitarist and record producer. The Institute, located in Oakland, California, has as its mission the support and education of women (and particularly women of color) who wish to pursue careers in the music business.

573. Power, Kikuyo Matsumoto. *A Cross-Cultural Study of Mother's and Teacher's Attitudes Toward Music Education in the U.S.A. and Japan.* Diss. Ph.D., University of Hawaii, 1990.

Abstract in *Dissertation Abstracts International: A. Humanities and Social Sciences.* 52, no. 1 (July 1991): 107. DA# 9118050.

574. Rieger, Eva. "Die Geschlechterrollen in Mozarts *Figaro:* Möglichkeiten ihrer Aktualisierung im Unterricht." *Zeitschrift für Musikpädagogik* 12, no. 38 (1987): 48–53.

In German, with summary in English. Translated title: "Sex Roles in Mozart's *Figaro*: Possibilities for Introducing the Topic in Music Instruction."

575. Rieger, Eva. "Feministische Musikpädagogik: Sektiererischer Irweg oder Chance zu einer Neuorientierung." *Musikpädagogische Forschung* 8 (1987): 123–132.

In German. Translated title: "Feminist Music Education: Sectarian Error or a Chance for a New Orientation." A curriculum which recognizes feminist theory as an informing element in the discipline of music pedagogy is needed. The author identifies the various issues raised by feminist music pedagogy and encourages the mainstreaming of these issues into training for music educators (e.g., gender and musical instrument preferences, gender bias in music textbooks, recognition of the contributions of women musicans, etc.).

576. Scotto Di Carlo, Nicole, and A. Rutherford. "Effect of Pitch on the Perception of a Coloratura Soprano's Vocalic System." *Journal of Research and Applied Vocal Pedagogy* 13, No. 2 (June 1990): 11–24.

577. Shayne, Julie. "Women's Music and Social Consciousness: In School With Angela Davis." *Hot Wire* 7, no. 2 (May 1991): 45, 57.

    A student enrolled in Angela Davis' class on "Women's Music and Social Consciousness" (San Francisco State) presents an overview of the content of the course, describes her learning experiences, and profiles Ms. Davis.

578. Smetko, Paul David. *A Study of Social Support for Female Classical Musicians Studying for a Career in Musical Performance.* Diss. Ph.D., Northwestern University, 1990.

    Abstract in *Dissertation Abstracts International: B. The Sciences and Engineering* 51, no. 9 (March 1991): 4608. DA# 9031990. This study examines patterns in the support systems (i.e., family, peers, teachers, intimate relations) of young women between the ages of eighteen and twenty-seven enrolled in classical music training programs. Findings indicate that the psychosocial condition of support plays a significant role in identity development and commitment to the choice of a career in musical performance amongst college-age women.

579. Söderberg, Marianne. "Fâ kvinnor söker till linjerna för tonsättare och dirigenter."*Tonfallet*, no. 2 (1990): 17.

    In Swedish. Translated title: "Few Women Apply to Music Study Programs for Composers and Conductors." The article describes the "Kvinnor och Musik" [Women and Music] project of the Forum for Women in Working Life and Research at the University of Luleå in Sweden. The project was designed to encourage women to pursue challenging careers in music through seminars with women musicians and concerts featuring music composed and performed by women.

580. Tarnowski, Susan M. "Gender Bias and Musical Instrument Preference." *Update: Applications of Research in Music Education* 12, no. 1 (Fall/Winter 1993): 14–21.

    This investigation seeks to expand upon conclusions reached in previous studies indicating that a young student's selection of a musical instrument is influenced by student gender and on the gendered association of the musical instrument. Tarnowski seeks to pinpoint the source of this bias in young children. Her study: 1) assesses the current level of awareness of gendered associations with instruments amongst children in grades K–2; 2) assesses the extent to which preservice elementary teachers exhibit gender-based associations with musical instruments; 3) measures the influence of gender–neutral teaching methods on students and teachers with pre-existing biases. The author concludes that musical instrument preference amongst the young is still often based on the association of an instrument with a gendered characteristic, and that teachers about to enter the classroom are still reproducing these attitudes. The implications of this situation on the young and on music education programs is briefly discussed.

581. Taylor, Louise Ganter. "How Early is Early." *Orff Echo* 25, no. 1 (Fall 1992): 14–15.

    This article summarizes recent research and professional activity in prenatal and perinatal music education, with a particular focus on the writings of Dr. Michael Lazarev, a leading pediatrician at the Moscow Health Center and author of *Sonatal*, a book on prenatal music education. The article also mentions the founding of the International Music Society for Pre-Natal Development, and surveys the music educators from various countries who offer classes in infant and prenatal music education.

582. Thurman, Leon, Margaret Chase, and Anna Peter Langness. "Reaching the Young Child Through Music: Is Pre-Natal and Infant Music Education Possible." *International Society for Music Education (ISME). Yearbook* 14 (1987): 21–28.

    Study discussing the effect of music on the fetus in the various stages of a woman's pregnancy.

583. Vagts, Peggy. "Introducing Students to Music by Women Composers: A Philosophical and Practical Approach to the Neglected Literature." *American Music Teacher* 39, no. 1 (August/ September 1989): 10–13.

    The author suggests a number of strategies for mainstreaming music by women into the curriculum, including recital programming, classroom presentations and discussion topics, and student assignments. A list of "Resources for Locating Music By Women Composers" is included.

584. Winner, Joan K. *The Effects of Temperament-Based Teaching Strategies and Gender on Undergraduate Music Achievement in an Introductory Music Course.* Diss. Ph.D., University of North Carolina, Greensboro, 1991.

    Abstract in *Dissertation Abstracts International: A. Humanities and Social Sciences* 51, no. 12 (June 1991): 4056. DA# 9110080.

585. Wubbenhorst, Thomas Martin. *Personality Characteristics of Music Educators and Performers as Measured by the Myers–Briggs Type Indicator and the Bem Sex-Role Inventory.* Diss. Ph.D., University of Missouri–Columbia, 1992.

    Abstract in *Dissertation Abstracts International: A. Humanities and Social Sciences* 53, no. 11 (May 1993): 3838–3839. DA# 9307471. Personality types and the characteristics of psychological androgyny are measured and compared in a sample of male and female graduate students enrolled in university music education and music performance programs.

586. Zdzinski, Stephen F. "Relationships Among Parental Involvement, Music Aptitude and Musical Achievement of Instrumental Music Students." *Journal of Research in Music Education* 40, no. 2 (Summer 1992): 114–125.

    This investigation finds a significant interaction between parental involvement, musical aptitude, and gender of the student. Parental

involvement often produces inhibited musical performance in females, while enhancing the musical performance of males. The results are supported by the findings of previous studies which conclude that females perceive parental feedback as controlling, while males find it reinforcing.

CHAPTER 6

# Western Art Music, Secular and Sacred: Literature on Women Musicians and the Role of Women in European and American Musical Culture

## Part A. General Perspectives

587. Adkins Chiti, Patricia. *Almanacco delle virtuose, primedonne, compositrici e musiciste d'Italia dall'A.D. 177 ai giorni nostri*. Novara, Italy: Istituto Geografico De Agostini, 1991.

　　　ISBN 8840292322. In Italian. Translated title: *Almanac of Italian Women Virtuosos, Primedonne, Composers and Musicians from 177 A.D. to the Present*. Reviewed in *International League of Women Composers (ILWC) Journal* (February 1993): 10. Significant dates in the lives of women musicians are presented in a calender format; entries under each date include paragraph-length explanations, biographies, etc. for the particular woman musician referred to. Throughout the almanac, Chiti intersperses short articles in the form of original essays, quotations, excerpts of correspondences, etc. Numerous illustrations, portraits, musical examples, etc., add to the textual component of the book. Appendices include a listing of operas by Italian women composers, a name index to entries in the almanac, and a short discography. The book is accompanied by a compact disc of the same name, featuring historic recordings of these female opera singers: Adelina Patti, Luisa Tetrazzini, Lina Cavalieri, Amelita Galli-Curci, Claudia Muzio, Toti Dal Monte, Rosetta Pampanini, Iva Pacetti, Gina Cigna, Ebe Stignani, Maria Caniglia, Chloe Elmo, and Gina Cigna.

588. Battersby, Christine. *Gender and Genius: Towards a Feminist Aesthetics*. Bloomington, IN: Indiana University Press, 1989.

The author explores the history of gender bias in notions of creativity by focusing on Romanticism's masculine conception of artistic genius and then by examining "the older traditions of cultural misogyny that Romanticism assimilated and transmuted" (p. 23). For specific page references to music, see p. 188 of the index.

589. Berdes, Jane L. Baldauf. *Women Musicians of Venice: Musical Foundations, 1525–1855.* Oxford Monographs on Music. Oxford, England: Clarendon/ Oxford University Press, 1993.

590. Bowers, Jane and Judith Tick, eds. *Women Making Music: the Western Art Tradition, 1150–1950.* Urbana, IL: University of Illinois Press, 1987.

    Reviewed in *Ethnomusicology* 32, no. 3 (Fall 1988): 474–478; *Sonneck Society Bulletin for American Music* 13, no. 3 (Fall 1987): 120–121; *Signs* 13, no. 2 (Winter 1988): 354–357; *Music and Letters* 69, no. 1 (January 1988): 61–64; *Notes* 47, no. 1 (September 1990): 56–59. Fourteen well-researched essays exploring the contributions of women musicians as both composers and performers of Western art music from the Middle Ages through the early twentieth century are presented. Chapters focus on the musical contributions of Medieval nuns, the trobairitz, women composers and singers in Italy from the fifteenth through the eighteenth centuries, women musicians of the aristocracy and bourgeoisie in ancien régime France, women composers of the lied, British women composers, and musical life in America from 1870 through the 1940s. Several chapters focus on particular women composers, such as Barbara Strozzi, Clara Schumann, Luise Adolpha Le Beau, Ruth Crawford Seeger, and Ethyl Smyth. Each essay is also cited separately in this bibliography.

591. Brand, Bettina, Martina Helmig, Barbara Kaiser, Birgit Salomon, and Adje Westerkamp, eds. *Komponistinnen in Berlin.750 Jahre Berlin 1987.* Berlin, Germany: Musikfrauen e.V. Berlin, 1987.

    In German. Translated title: *Women Composers in Berlin. 750th Year of Berlin, 1987.* Reviewed in *Notes* 47, no. 2 (December 1990): 380–381. Published in conjunction with musical festivities and a symposium on women in music organized to honor the 750th anniversary of Berlin, this collection of biographical articles on forty women composers (contributed by almost twice that many individuals) offers a pastiche of information about each composer represented (e.g., biographical essays, works lists, correspondences, autobiographical statements, reproductions of archival materials, excerpts of musical scores, photographs, previously published musical criticism, etc.) The composers profiled include: Anna Amalia, Princess of Prussia (1723–1787), Luise Reichardt (1779–1826), Bettina von Arnim (1785–1858), Fanny Mendelssohn Hensel (1805–1847), Johanna Kinkel (1810–1858), Clara Schumann (1819–1896), Emilie Mayer (1821–1883), Luise Adolpha Le Beau (1850–1927), Ethel Smyth (1858–1944), Elisabeth Kuyper (1877–1953), Margarete von Mikusch (1881–1968), and Evelyn

Faltis (1890–1937). More contemporary composers include: Patricia Jünger, Christina Kubisch, Lotte Backes, Chris Baumgarten, Ka-Hyun Cho, Jenny Dieckmann, Leonore Feininger, Birgit Havenstein, Elizabeth Johnston, Jivka Klinkova, Taisook Koo, Mayako Kubo, Felicitas Kukuck, Ilse Fromm-Michaels, Aleida Montijn, Gabriela Moyseowicz, Graciela Paraskevaídis, Alice Samter, Tona Scherchen, Ruth Schonthal, Verdina Shlonsky, Laurie Schwartz, Chaya Zernovin-Shwartz, Minako Tanahashi, Sabine Wüsthoff-Oppelt, Toyoko Yamashita, Ruth Zechlin, and Grete von Zieritz.

592. Canning, Hugh. "Who's Right for Handel? Hugh Canning Argues for More Sexual Ambiguity in Performances of Handel's Italian operas." *Classic CD*, no. 32 (January 1993): 18.

   The author supports the utilization of mezzos and female altos in male roles (i.e "trouser" or "transvestite" roles), as opposed to recent use of countertenors in those roles. He argues that Handel, in the absence of a castrato singer, would often use a woman to sing the part of the heroic castrato.

593. Carpenter, Ellon D. "Women Music Scholars in the Soviet Union." In *The Musical Woman: An International Perspective. Volume 3, 1986–1990*, ed. Judith Lang Zaimont, Jane Gottlieb, Joanne Polk, and Michael J. Rogan, pp. 456–516. Westport, CT: Greenwood Press, 1991.

   This examination of the development of Russian musicology from the seventeeth through the twentieth centuries highlights the prominent role played by women throughout the history of the discipline in this country, and profiles a number of notable women in twentieth-century Soviet musicology. These women include: ethnomusicologist Yevgeniia Eduardovna Lineva, active at the turn of the century; Tamara Nikolaevna Livanova (1906–1986); Vera Andreevna Vasina-Grossman (b. 1908); Elena Mikhailovna Orlova (1908–1985); Valentina Dzhozefovna Konen (b. 1910); Ol'ga Yevgen'evna Levasheva (b. 1912); Varvara Pavlovna Dernova (1906–1989); Valentina Nikolaevna Kholopova (b. 1935).

594. Crutchfield, Will. "Crutchfield at Large: Rossini Mezzos, Divine and Mortal." *Opera News* 54 (3 March 1990): 36.

   The author presents a brief historical survey of famous mezzo-sopranos from the nineteenth century to the present associated with the performance of operatic works by Gioacchino Rossini.

595. Dunaway, Judy. "Femme Fretale." *Ear* 15, no. 2 (April 1990): 14–15.

   This brief history of women as guitarists in Europe and America notes the changing role of the woman guitarist from amateur to professional.

596. Ellison, Cori. "Breaking the Sound Barrier: How Women Finally Made Their Way to the Opera Stage." *Opera News* 57 (July 1992): 14, 16–17, 37.

   Part of a special issue on women in opera. This article takes a historical look at the various exclusionary practices which prevented women from

singing for public performance, and which allowed women access to the musical world only through the convent, aristocratic court, or by virtue of being a member of a professional musical family. One dramatic manifestation of this dedication to the exclusion of women was the cultivation of the castrati for treble singing in sacred and secular music, and especially in early opera. The article focuses on early women singers/composers who led the way for the female voice to be heard, legitimized, and cultivated for public performance.

597. Gläss, Susanne. "Als Frau Geige spielen: Heute eine Selbstverständlichkeit, vor 100 Jahren ein Zeichen emanzipierten, modernen Frauentums, vor 200 Jahren eine Rarität." *Das Orchester*, 41, no. 2 (1993): 130–133.

    In German. Translated title: "Women as String Players: Self-Evident Today, a Century Before a Sign of Women's Progress and Emancipation, Two Centuries Before a Rarity."

598. Gojowy, Detlef. "Komponistinnen in der Sowjetunion." In *Vom Schweigen befreit: Internationales Komponistinnen-Festival Kassel, 20. bis 22. Februar 1987*, Internationales Komponistinnen-Festival Kassel (1987). Spons. and org. Hans Eichel, Kulturamt der Stadt Kassel, Internationalen Arbeitskreis "Frau und Musik," Roswitha Aulenkamp-Moeller, and Christel Nies, pp. 56–59. Wiesbaden, Germany: Bevollmächtigten der Hessischen Landesregierung für Frauenangelegenheiten, 1987.

    In German. Translated title: "Women Composers of the Soviet Union."

599. Goldner, June Riess. *The Emergence of the Role of the Solo Vocalist and the Position of Women as Singers*. Diss. Ph.D., City University of New York, 1987.

    Abstract in *Dissertation Abstracts International: A. Humanities and Social Sciences* 48, no. 12 (June 1988): 3205–3206. DA# 8801714. The author examines the roles and status of women as solo singers in Western music, from the earliest documented occurrence through the seventeenth century. She thus places gender at the center of her investigation into the various ideologies-religious, social, political, economic, and cultural— which precipitated changes in musical style and performance practice, and likewise gave rise to the virtuosa singer.

600. Gradenwitz, Peter. *Literatur und Musik in geselligem Kreise: Geschmacksbildung, Gesprächsstoff und musikalische Unterhaltung in der bürgerlichen Salongesellschaft*. Stuttgart, Germany: Franz Steiner Verlag, 1991.

    ISBN 3515053360. Translated title: *Literature and Music in the Social Milieu: Artistic Taste, Conversation, and Musical Entertainment in Bourgeois Salon Society*. Reviewed in *Notes* 49, no. 3 (March 1993): 1022–1023. This examination of salon culture in Germany, Austria, and the

Netherlands recognizes not only the participation of women in European intellectual life, but addresses the role played by women as initiators, promoters, and hostesses of the cultural salon, and as such their importance as arbiters of musical and artistic taste.

601. Gross, Olga. "Gender and the Harp (Part 1)."*American Harp Journal* 13, no. 4 (Winter 1992): 30–33.

This article examines the harp as an instrument associated with the female gender, as well as its association with a woman's role in music-making amongst different social classes of the eighteenth and nineteenth centuries. Contrasted are the musical lives of women harpists of the aristocracy (Marie Antoinette, Mlle de Guines and Mme de Genlis) as compared with professional female harpists (Anne-Marie Steckler [later known as Mme Krumpholtz], Sophia Corri Dussek, and Dorette Scheidler Spohr). Changes in harp construction during the nineteenth century masculinized the instrument (stronger frame, more pedals, more powerful sound), accentuating differences between male and female venues for music making (e.g., public vs. private).

602. Gross, Olga. "Gender and the Harp (Part 2)." *American Harp Journal* 14, no. 1 (Summer 1993): 28–35.

Part two continues to examine the harp as an instrument associated with femininity, wealth, and gentility well into the twentieth century. The author establishes connections between female accomplishment on the harp and the social role of women in the nineteenth and twentieth centuries, and covers topics such as conservatory training for women harpists, the role of women as professional harpists in the orchestra beginning in the late nineteenth century, and the manner in which male harpists differentiated themselves from the stereotyped image of the female musician at the harp. The final section of the article focuses on visual images of women at the harp, as found in period illustrations and photographs.

603. Gruber, Clemens M. *Nicht nur Mozarts Rivalinnen: Leben und Schaffen der 22 Österreichischen Opern-Komponistinnen*. Vienna, Austria: Neff's Kleine Bibliothek der Schönen Künste, 1990.

ISBN 3701403023. In German. Translated title: *Not Only Mozart's Rivals....The Life and Works of 22 Austrian Women Composers of Opera*. Reviewed in *Österreichische Musik Zeitschrift* 46, no. 7–8 (July/August 1991): 433-434 ; *Opernwelt* 33, no. 4 (1992): 61. Presented are profiles of twenty-two Austrian women opera composers whose lives span the eighteenth, nineteenth and twentieth centuries: Luna Alcalay, Maria Bach, Leopoldine Blahetka, Mary Dickenson Auner, Alexandrine (Countess Esterházy- Rossi), Hilde Firtel, Emma von Fischer, Ida Fischer-Colbrie, Karoline (Countess Hadik), Irma von Halácsy, Margarete Jung, Michaela von Kodolitsch, Mathilde Kralik von Meyerswalden, Alma Mahler, Lise Maria Mayer, Josepha Müllner-Gollenhofer, Maria Theresia von Paradis,

Maria Anna von Raschenau, Lilly Scheidl-Hutterstrasser, Emilie Stöger, Hedda Wagner, and Vilma Weber von Webenau. Several introductory essays add to the biographical component of the book, including a general discussion on the contributions of women composers, an article on women as composers of opera, and an essay on Austrian women composers. The author reprints the well-known essay written by S. Jessel in 1898, "Warum gibt es so wenige Komponistinnen?" ["Why are there so few women composers?"].

604. Hoffmann, Freia. *Instrument und Körper: Die musizierende Frau in der bürgerlichen Kultur*. Insel Taschenbuch, no. 1274. Frankfurt am Main, Germany: Insel Verlag, 1991.

ISBN 3458329749. In German. Translated title: *Instrument and Body: The Woman Musician in Bourgeois Culture*. Reviewed in *Österreichische Musikzeitschrift* 47, no. 12 (December 1992): 771. This is a fascinating historical survey of the relationships between the human body, patriarchal norms of female social behavior, and gender considerations in instrumental musical performance during the eighteenth and nineteenth centuries. The book is impressively documented with references to theoretical works on music, music criticism, pedagogical publications, and other historical sources from the time period under consideration. In Part I the author demonstrates the incongruity between the communicative/sensual/expressive nature of musical performance and the patriarchal social mores of the eighteenth and nineteenth centuries which, in order to maintain idealized notions of female beauty, amusement, and repose, prescribed restrictive norms of physical deportment for women and deemed as improper the playing of many musical instruments, thus discouraging women from entering the sphere of public performance. The manner in which these conditions affected a woman's ability to achieve as a professional musician is thus examined. Part II studies women as instrumentalists in concert from 1750 to 1850, with chapters devoted to the piano, glass harmonica, harp, plucked instruments (guitar, lute, etc.), organ, violin (includes a discussion of an eighteenth-century Venetian women's orchestra), violoncello, flute and clarinet, french horn and trumpet, as well as percussion instruments. These chapters also discuss the corporeal nature of these musical instruments and their gendered associations. Part III examines the difficult road to professional achievement for women instrumentalists by profiling several women musicians: Dorette Scheidler Spohr (harpist and wife of Louis Spohr), Leopoldine Blahetka (pianist and composer), Caroline Schleicher-Krähmer (clarinetist, violinist and composer), and Eleonore Prochaska (a flutist who, who disguised as a man, joined the German military). The book includes a satisfactory sampling of artworks and illustrations, extensive bibliographical references, and personal name and subject/instrument indexes.

605. Hoffmann, Freia, and Eva Rieger, eds. *Von der Spielfrau zur Performance-Kunstlerin: auf der Suche nach einer Musikgeschichte der Frauen*. Kassel, Germany: Furore-Verlag, 1992.

ISBN 3927327115. In German. Translated title: *From Musician to Performance Artist: In Search of a Music History of Women.*

606. Innaurato, Albert. "Those Demonic Divas: Often Those of Us Sensitive to Women's Singing are Derided." *Opera News* 57 (October 1992): 20–26, 37.

This diva-worshipper's guide to the golden age of female operatic singing on compact disc is perhaps more visually and verbally sensational than "sensitive." The author's "siz[ing] up of golden-age sopranos" nostalgically looks at new CD reissues of early original recordings of "she-devils" Nellie Melba, Luisa Tetrazzini, Ninon Vallin, Lucrezia Bori, Meta Seinemeyer, Germaine Lubin, Félia Litvinne, and Eleanor Steber.

607. Internationales Komponistinnen-Festival Kassel (1987). *Vom Schweigen befreit: Internationales Komponistinnen-Festival Kassel, 20. bis 22.* Februar 1987. Spons. and org. Hans Eichel, Kulturamt der Stadt Kassel, Internationalen Arbeitskreis "Frau und Musik," Roswitha Aulenkamp-Moeller, and Christel Nies. Wiesbaden, Germany: Bevollmächtigten der Hessischen Landesregierung für Frauenangelegenheiten, 1987.

In German. Translated title: *Freed from Silence: Kassel International Festival of Women Composers.* The proceedings of this festival include not only concert programs, background on the pieces performed, and biographical information on the composers and performers represented, but a pastiche of introductory material focusing on particular women composers, the collective contributions of women composers to the musical life in various countries, and the musical role of women within culture and society. For example, Eva Weissweiler contributes essays on the recent history of the women composers' movement in Germany (pp. 14–16) and on the situation of avant-garde women composers in Germany (pp. 64–66). Also presented is Weissweiler's brief essay on Barbara Strozzi (pp. 16–19) and a transcript of her interview with composer Grete von Zieritz (pp. 38–40). Excerpts of composer correspondences and historical writings are reproduced here, including a facsimile of excerpts (pp. 33–37) from Adolf Alfred Michaelis' *Frauen als Schaffende Tonkünstler: ein biographisches Lexicon* (Leipzig: A. Michaelis, 1888), as well as letters of Fanny Hensel (pp. 20–23), and composer Johanna Kinkel's essay (1855) on Friedrich Chopin (pp. 25–32; ed. Weissweiler). Gisela Gronemeyer interviews Korean composer Younghi Pagh-Paan (pp. 41–43) and presents an essay on women in U.S. avant-garde music, emphasizing the importance of the voice and body as "original instruments" (pp. 60–64). Eva Rieger discusses the woman musician within a larger cultural and social context in her essay on the woman pianist of yesterday and today (pp. 44–46). Brunhilde Sonntag presents a short social history of women composers, addressing questions relating to the scarcity of women composers and the professional discrimination faced by women composers throughout history (pp. 47–55). Detlef Gojowy discusses women composers in the Soviet Union (pp. 56–59). Mia Schmidt takes a statistical look at the representation of women's works in contemporary music programming in

Germany. Antje Olivier discusses the formation of the Internationaler Arbeitskreis "Frau und Musik" and the establishment its Archive (pp. 69–70).

608. Jacobsson, Stig. "Det är kvinnan bakan allt." *Tonfallet*, no. 2 (1990): 27.
    In Swedish. Translated title: "Behind All There is a Woman." The woman as muse and musician is the subject of this article, as the author considers the contributions of women to the careers of successful European male composers.

609. Jezic, Diane Peacock. *Women Composers: The Lost Tradition Found*. New York: Feminist Press, 1989.
    Reviewed in *Library Journal* 114, no. 7 (April 15, 1989): 70; *Sonneck Society Bulletin* 15, no. 2 (Summer 1989): 89–90; *American Music Teacher* 39, no. 6 (June/July 1990): 54–55; *Notes* 47, no. 3 (March 1991): 801. Accompanied by two cassettes issued on Leonarda Records (LPI 3–4) under the same title. Intended for use in undergraduate music appreciation or women's studies courses, this book utilizes a biographical approach to the study of the history of women in Western art music. The introduction briefly considers the question of the representation of women in music history and the definition of a female musical aesthetic. Selecting twenty-five women composers from the eleventh through the twentieth centuries, and presenting them in chronological order, Jezic includes in each composer profile a biographical overview, a discussion of the signifcant factors (family background, socioeconomic conditions, access to education, influence of male composers, etc.) which shaped the composer's musical life, an analysis of one or more pieces of the composer's music, and a selected works list, bibliography, and discography. There are six appendices: "Music Appreciation Textbooks Ranked in Order of Number of Women Composers Mentioned"; "Record Companies Featuring Women Composers"; "An Outline of Western Music from 850 through the 1940s"; "A Selected List of Twentieth Century Composers Born After 1920"; "A Selected List of Twentieth Century Women Conductors"; "Recordings Available from Leonarda Records." The composers who are profiled include: Hildegard of Bingen ("Life in the Medieval Convents"), Francesca Caccini ("The Medici Court of Florence"), Barbara Strozzi ("The Venetian Musical Academies"), Isabella Leonarda ("The Convent in Novara"), Elisabeth-Claude Jacquet de La Guerre ("The Court of Louis XIV"), Anna Amalia, Princess of Prussia ("The Court of Frederick the Great"), Anna Amalia, Duchess of Saxe-Weimar ("The Court of Weimar"), Maria Theresia von Paradis ("Vienna and Beyond"), Luise Reichardt ("The Romantic Spirit"), Fanny Mendelssohn Hensel ("Domestic Music Making"), Josephine Lang ("The Public Sphere"), Clara Wieck Schumann ("Touring Artist and Composer"), Pauline Viardot-Garcia ("InternationalRecognition"), Jeanne-Louise Dumont Farrenc ("Pianist, Composer, Scholar"), Louise Pauline Marie Héritte-Viardot ("Musical Families"), Cécile Chaminade ("Chevalière de la Légion d'Honneure"), Lili Boulanger ("The Prix de Rome"), Amy Marcy

Cheney Beach ("U.S. Symphonist"), Rebecca Clarke ("English Performer and Composer"), Katherine Hoover ("Virtuoso Flutist and Composer"), Ellen Taaffe Zwilich ("The Pulitzer Prize"), Ruth Schonthal ("Emigré Composer and Teacher"), Barbara Kolb ("New Vistas"), Marga Richter ("Chamber Music and Orchestral Composer"), Judith Lang Zaimont ("Pianist, Author, Composer").

610. Kämpfer, Frank. "Unser Thema: Frauen in der Musik." *Musik und Gesellschaft* 38, no. 3 (March 1988): 113–114.
    In German. Part of a special issue devoted to women and music. The author presents a historical overview of the social status of women in relation to their involvement with music.

611. Kuwabara, Mari. "A Woman's Place." *Symphony Magazine* 39, no. 5–6 (October/November 1988): 14–18.
    The Bay Area Women's Philharmonic performs music by historical and contemporary women composers.

612. Kydd, Roseanne. "Les femmes compositeurs au Canada: données soci-ologiques et historiques." *Sonances; Revue Musicale Quebecoise* 6, no. 3 (1987): 16–22.
    In French. Translated title: "Women Composers in Canada: A Sociological and Historical Overview."

613. Laredo, Ruth. "Sex and the Single Pianist." *Keyboard Classics* 11, no. 5 (September/October 1991): 6–7.
    This pianist discusses the sexual stereotypes that women concert pianists have had to overcome throughout the ages. Reprinted in large-print for the visually impaired in *Musical Mainstream* 16, no. 1 (January/March 1992): 35–36.

614. Lefebvre, Marie Thérèse. *La création musicale des femmes au Quebec.* Montreal: Éditions du Remue-Ménage, 1991.
    ISBN 2890911020. Distributed by Diffusion Dimédia, 539 boul. Lebeau, Saint-Laurent, QC H4N 1S2 Canada. In French. Translated title: *Music Created by Women from Quebec.* Reviewed in *Revue d'histoire de l'Amerique Française* 45, no. 4 (Spring 1992): 609–611; *Journal of Musicological Research* 13, no. 1–2 (1993): 113–115. This monographic sur-vey of women's contributions to music in Quebec begins with a historical look at the period from 1534–1918, focusing on the important role played by women's religious communities in the provision of education, training, and support for female musical endeavors; women composers in those communi-ties are identified. Twentieth-century developments in both secular and sacred higher education expanded musical opportunities for women, and a chronolo-gy of the musical training programs for women instituted at colleges and con-servatories is presented. In the secular vein, the author turns to the role of

women musicians in the salon culture of the late nineteenth and early twenti-
eth centuries. In twentieth-century composition, five women composers are
singled out as making significant contributions: Micheline Coulombe Saint-
Marcoux, Marcelle Deschênes, Gisèle Ricard, Ann Lauber, and Ginette
Bellavance. The author discusses the work of several contemporary women
musician/composers: Caroline Dupré (film); Roxanne Turcotte (progressive
rock); Ginette Bertrand and Michelle Boudreau (mixed media); Nicole
Carignan, Isabelle Marcoux, Sylvanie Martin and Isabelle Panneton (art
music). Appended are works lists for Anne Lauber and Micheline Coulombe
Saint-Marcoux. Included also is an extensive bibliography.

615. Lindmayr, Andrea. "'Weibsbilder, junge oder alte, haben auf dem Domchor
    überhaupt nichts zu suchen!' Allgemeines und spezielles zum Thema 'Frau
    und Kirchenmusik'." *Kirchenmusikalisches Jahrbuch* 74 (1990): 67–86.
       In German. Translated title: "'Females Young or Old, Need Not Apply
    to the Cathedral Chorus!' Generalities and Specifics on the Theme of 'Women
    and Church Music'." This historical look at the role and status of women as
    church musicians in Europe investigates the particular restrictions on women
    as musicians in the Salzburg Cathedral at the turn of the twentieth century.

616. Lipman, Samuel. "The Pupils of Clara Schumann and the Uses of
    Tradition." In *Music and More: Essays, 1975–1991*, pp. 130–140. Evanston,
    IL: Northwestern University Press, 1992.
       In this essay the author refers to the nine-LP set of recordings entitled
    *The Pupils of Clara Schumann* issued by Pearl Records (CLA 1000), featur-
    ing historical performances by Fanny Davies, Ilona Eibenschütz, and
    Adelina de Lara. The performances are criticized on strictly pianistic
    grounds, leading the author to question the value of these recordings as his-
    toric documents which may further inform us about the intent of the com-
    posers who created the music, in this case Robert Schumann and Johannes
    Brahms. "The proper relation of a performer to a work of music is directly
    to that work, not to that work as it has been digested, domesticated, and mer-
    chandized by generations of other performers" (p. 140).

617. Loesser, Arthur. *Men, Women and Pianos: A Social History*, New fwd.
    Edward Rothstein. New York: Dover Publications, 1990.
       Unabridged republication of the original 1954 edition published by
    Simon and Schuster; preface by Jacques Barzun. This well-known survey of
    the piano as a symbol of western culture and society examines the associa-
    tion of the piano with feminine (pp. 64–67) and the predominance of the
    piano as a bourgeois domestic symbol signifying female accomplishment
    (pp. 195–203, 267–283). Consult index under "women, middle-class" and
    "female accomplishment" for additional page references.

618. MacAuslan, Janna. "Noteworthy Women: Our Musical Foremothers on
    Disc." *Hot Wire* 5, no. 1 (January 1989): 12–13.

The author, a member of the flute/guitar duo Musica Femina, provides information on the lives, music, and existing recordings of five classical women composers whose music is featured in the duo's performances: Jane Pickering, Francesca Caccini, Isabella Leonarda, Elisabeth-Claude Jacquet de La Guerre and Maria Theresia von Paradis.

619. McGovern, Dennis. "Ladies of Spain: Cheryl Studer, Patricia Schuman and Dawn Upshaw, Stars of this Season's Don Giovanni at the Met, Share Thoughts about the Opera." *Opera News* 55 (2 February 1991): 11–14.

620. Matthei, Renate, ed. *Komponistinnen in Japan und Deutschland: eine Dokumentation.* Furore-Edition, 853. Kassel, Germany: Furore-Verlag, 1991.

   ISBN 3927327093. In German. Translated title: *Women Composers in Japan and Germany: A Documentation.* Reviewed in *Das Orchester* 40, no. 9 (1992): 1084; *Musikerziehung* 45 (June 1992): 227; *MusikTexte* 44 (April 1992): 66. Here are the published proceedings of a special session devoted to women and music taking place at the "Die Frau in Kunst und Gesellschaft" conference, sponsored by the Goethe-Institut Tokyo. The Japanese composers Kikuko Massumoto (pp. 25–31) and Haruna Miyake (pp. 41–44) discuss their life and works, as does the Romanian-born composer Adriana Hölszky (pp. 32–40). Both Eva Rieger (Germany) and Noboku Funayama (Japan) present overviews of the contributions of women composers to the musical history of their respective countries (Rieger, pp. 18–24; Funayama, pp. 9–17), discussing the status of women composers and the difficulties they face as professionals. Also presented is a transcription of the panel discussion featuring all the above individuals, plus Furore publisher Renate Matthei (pp. 45–56). Biographical profiles of all six women are included.

621. Metzelaar, Helen, et al. *Zes vrouwelijke componisten.* Bibliotheek Nederlanse Muziek. Netherlands: Centrum Nederlandse Muziek and Walburg Pers, in conjunction with Stichting Vrouw & Muziek, 1991.

   ISBN 9060117336. In Dutch. Translated title: *Six Women Composers.* This is a significant addition to the literature on Dutch women composers. The introduction surveys contributions of Dutch women composers during the nineteenth and twentieth centuries, while the main body of the book is comprised of long biographical essays on Gertrude van den Bergh, Catharina van Rennes, Elisabeth Kuyper, Henriëtte Bosmans, Iet Stants, and Tera de Marez Oyens. Each essay is accompanied by a comprehensive works list. Notes and an index are appended.

622. Miller, Philip L. "Point of View: The Gender of Songs." *American Record Guide* 52, no. 5 (September/October 1989): 5–6.

   On women singing lieder written in the "male voice" and traditionally interpreted by male singers.

623. Moore, Julianna. *A Comprehensive Performance Project in Flute Literature with an Essay, A Study of Female Flutists Born Before 1900*. Diss. D.M.A., University of Iowa, 1990.

624. Motte, Diether de la. "Komponistin: Warum denn nicht?" *Österreichische Musik Zeitschrift* 46, no. 7–8 (July/August 1991): 363–367.

    In German. Translated title: "Woman Composer: Why Not?" Part of a special issue devoted to women in music. While the past twenty years have seen many gains for women in music, the author discusses the patriarchal attitudes and practices which have hindered women in the field of music composition, concentrating in particular on the life of Fanny Mendelssohn Hensel.

625. Myers, Margaret. "Kvinnan som skapande musiker: Tankar i tre kapital." *Musikrevy* 43, no. 1 (1988): 2–15.

    In Swedish. Translated title: "Women Who Create Music: Three Perspectives." This article-length survey discussing the role and history of women in music is presented in three parts. Through a series of composer profiles, part one ("Nine Centuries of Women's Music") summarizes the contributions of women to the musical life in Europe, Great Britain, and Scandinavia from the Middle Ages to modern times. European women composers profiled include: Hildegard von Bingen, Francesca Caccini, Elisabeth-Claude Jacquet de La Guerre, Faustina Borghi, Isabella Leonarda, Anna Amalia (Duchess of Saxe Weimar), Maria Antonia Walpurgis, Marianne Martinez, Lucile Grétry, Julie Candeille, Agathe Backer-Grøndahl, Luise Adolpha Le Beau, Elfrida Andrée, Helena Munktell, Ethel Smyth, Louise Farrenc, Cécile Chaminade, Marie Gabriel, Claude Arrieu, Lili Boulanger, Germaine Tailleferre. Twentieth-century women composers from Iceland (Karólína Eiríksdóttir and Mist Thorkelsdóttir), Denmark (Gudrun Lund and Birgitte Alsted), Norway (Pauline Halls, Anne-Marie Orbecks, Synne Skouens, Maj Sonstevold, and Ruth Bakke), Finland (Helvi Leiviskä and Kaija Saariaho, and Sweden (Dorkas Norre and Carin Malmlöf-Forssling) receive attention. Part two of the article examines the social and cultural barriers confronting the professional female composer of the nineteenth and twentieth centuries. Part three focuses on the life and works of the contemporary Dutch composer Tera de Marez Oyens.

626. Neuenschwander, Leni, André Sutter, and Brigitte Höft. "Die Rolle der Frau in der Musik." In *Humane Zukunft*, ed. Herbert Kessler, pp. 267–280. Abhandlung der Humboldt-Gesellschaft für Wissenschaft, Kunst und Bildung e.V., Band 10. Mannheim, Germany: Verlag Humboldt-Gesellschaft für Wissenschaft, Kunst und Bildung e.V., 1988.

    ISBN 3927030090. In German. This general survey of the role of women in European art music from antiquity through the twentieth century is presented in three parts. First, André Sutter considers the role of women in music from Antiquity through the Middle Ages. In Part II, Brigitte Höft



---

briefly surveys women's contributions to music from the Renaissance through the Romantic era. Part III, by Leni Neuenschwander, continues with a look at the situation of the woman composer in the twentieth century and focuses on the First International Women Composers Competition held in Basel in 1950.

627. Nevin-Schor, Amanda M. *Documentation of the One-Person Show of Designing Performance Attire for Female Classical Musicians Through the Examination of Traditional Attire, Kinesiology, Fabric Properties, and Performance Requirements*. Thesis. M.S., Northern Illinois University, 1991.
   Illustrated text, with accompanying slides.

628. Nichols, Janet. *Women Music Makers: An Introduction To Women Composers*. New York: Walker and Company, 1992.
   Reviewed in *Piano Guild Notes* 42, no. 2 (September/October 1992): 52. Written for elementary to junior high school readers, this book introduces children to the lives and accomplishments of ten women composers, focusing on the difficulties they faced in their musical pursuits. The composers include Barbara Strozzi, Fanny Mendelssohn Hensel, Clara Schumann, Ethel Smyth, Amy Beach, Florence Price, Vivian Fine, Joan Tower, Ellen Taaffe Zwilich, and Lauri Anderson. Brief biographies of twenty-four others are included, as are suggested listening and reading lists.

629. Öhrström, Eva. "Kvinnor i ensembler: en översikt." In *Kvinnors Musik*, ed. Eva Öhrström and Märta Ramsten, pp. 110–115. Stockholm, Sweden: Sveriges Utbildningsradio AB and Svenska Rikskonserter, 1988.
   ISBN 9126898101. In Swedish. Translated title: "Women in Ensembles: An Overview." The author presents an interesting pastiche of text, artwork, and photographs relating to the subject of all-women's concert ensembles from the middle ages to the present, with a special focus on groups and musicians in Sweden.

630. Öhrström, Eva. "Kvinnors musicerande." *Handbok i svensk kvinnohistoria*, ed. Gunhild Kyle, pp. 184–194. Stockholm, Sweden: Carlsson Bokförlag, 1987.
   ISBN 9177981391. In Swedish. Translated title: "Women Musicians." An overview of the history of women in music in Sweden from the seventeenth century to the present.

631. Pendle, Karin. "Lost Voices." *Opera News* 57 (July 1992): 18–19, 44.
   Part of a special issue on women in opera. This article surveys the operatic works of "unjustly neglected women composers" from the seventeenth through the twentieth centuries. Seventeenth and eighteenth-century composers mentioned are Francesca Caccini, Elisabeth-Claude Jacquet de La Guerre, Antonia Bembo, Maria Margherita Grimani, Maria Theresia von Paradis, Wilhelmine of Bayreuth, Maria Antonia Walpurgis, and Anna

Amalia, Duchess of Saxe-Weimar. Nineteenth-century composers mentioned are Louise Bertin, Loïsa Puget, Pauline Viardot-Garcia, Augusta Holmès and Cécile Chaminade. Early twentieth-century composers discussed are Ethel Smyth, Eleanor Everest Freer, Amy Beach, and Mary Carr Moore. More twentieth-century composers include Miriam Gideon, Louise Talma, Libby Larsen, Julia Perry, Evelyn Pittman, Peggy Glanville-Hicks, Thea Musgrave, Judith Weir, Vivian Fine, and Meredith Monk.

632. Polk, Joanne. *Distaff Dynasties*. Diss. D.M.A., Manhattan School of Music, 1990.

633. Polk, Joanne. "Distaff Dynasties." In *The Musical Woman: An International Perspective. Volume 3, 1986–1990*, ed. Judith Lang Zaimont, Jane Gottlieb, Joanne Polk, and Michael J. Rogan, pp. 739–768. Westport, CT: Greenwood Press, 1991.

   The author traces the lineages of numerous women musicians, and concludes that familial associations and heredity have played an extremely important role in the development of musical talent (affording access to training, role models, and support), especially in the period prior to the twentieth century. Consequently, these women musicians were able to forge professional careers. The author discusses female musicians from extended families of famous male musicians, mother-daughter relations, sister relations, etc. She also charts the lineages of the Couperin family, the Dussek-Corri family, and the Barthélemon-Young family.

634. Polk, Joanne. "Distaff Dynasties." *American Music Teacher* 41, no. 5 (April/May 1992): 34–43, 90, 92–93.

   Reprinted from the essay originally published in *The Musical Woman: An International Perspective. Volume 3, 1986–1990*.

635. Pugh, Aelwyn. *Women in Music*. Cambridge, England: Cambridge University Press, 1991.

   Accompanied by a companion cassette. Reviewed in *Winds* 7, no. 2 (Summer 1992): 40; *International Journal of Music Education* 20 (1992): 83. Written for the general reader, this slim book provides an overview of women's contributions as both performers and composers of classical and concert music. Section One focuses on women as performers throughout the history of music, mentioning domestic music-making by women, music in the convents, the 'concerto della donne', women's admittance to music schools and conservatories, women as conductors, women as orchestral musicians, women in brass and military bands, women as solo concert artists, as well as women in pop, rock, and jazz. Section Two offers profiles of women composers: Hildegard von Bingen, Raffaella Aleotti, Francesca Caccini, Barbara Strozzi, Fanny Mendelssohn Hensel, Clara Schumann, Ethel Smyth, Elizabeth Maconchy, Elisabeth Lutyens, Thea Musgrave, Nicola LeFanu, and Judith Weir. A listening list accompanies the text.

636. Pulido, Esperanza. "La Mujer Mexicana en la Música." *Heterofonia*, nos. 104–105 (1991): 5–51.

In Spanish. Part of a special issue dedicated to the memory of the Mexican musicologist Esperanza Pulido. This article contains revised excerpts from the author's history of women in Mexican music published under the same title (Mexico: Ediciones de la Revista Bellas Artes, 1958). Within the context of a history shaped by both foreign and male domination, the article surveys women's contributions to music in Mexico during the pre-hispanic period, the colonial era, and from the seventeenth through the early twentiethth centuries, highlighting the contributions of particular individuals and institutions. Noted are the contributions of composer/poet Sor Juana Inés de la Cruz; singer Angela Peralta ; pianist and musicologist Alba Herrera y Ogazón; singers Fanny Anitúa, María Luisa Escobar, María Romero, Elvira González Peña, Lupe Medina de Ortega, and María Bonilla; composer Julia Alonso ; pianists Ana María Charles and Angélica Morales; violinist Celia Treviño; contralto Josefina Aguilar; and others.

637. Pulido, Esperanza. "Mexico's Women Musicians." In *The Musical Woman: An International Perspective. Volume 2, 1984–1985*, ed. Judith Lang Zaimont, Catherine Overhauser, and Jane Gottlieb, pp. 313–334. Westport, CT: Greenwood Press, 1987.

Mexican women seeking to expand their knowledge of music in order to participate in cultural music-making have been impeded by *malinchismo* (individual feelings of inferiority reinforced and perpetuated by dominating foreign forces) and *machismo* (dominating male behavior). The author surveys Mexico's leading women musicans, from Colonial times to the 1980s, and discusses their contributions in light of Mexico's history of foreign and religious domination, in addition to the machismo present in society. Musicians mentioned include: Sor Juana Inés de la Cruz (1651–1695), a nun, composer, and "the greatest woman poet of the New World"; Angela Peralta (1845–1883), an accomplished singer of opera and a composer of period piano pieces; Alba Herrera Y Ogazón (1885–1931), a concert pianist, and later a music historian, critic, and author of several books on music. The author introduces a host of singers who have achievcd prominence since the turn of the century, such as contralto Fanny Anitúa (1887–1967); María Bonilla (b. 1903), a voice teacher known for her singing of lieder. Outstanding women pianists of the twentieth century receive attention as well: Angélica Morales, Esperanza Cruz, María Teresa Rodríguez, María Elena Barrientos, Guadalupe Parronda, etc. Modern and contemporary women composers covered include Emiliana de Zubeldia, Maria Teresa Prieto, Gloria Tapia, Rosa Guraieb, Alida Vásquez, Alicia Urreta, Maria Grever, and Consuelo Velazquez. With the exception of Alba Herrera Y Ogazón, there have been few prominent women music critics and scholars from Mexico, since musicology departments have only recently been established in Mexican universities. However, several notable women include ethnomusicologist Carmen Sordo Sodi, musicologist Clara Meierovich, pianist

and writer Elisa Osorio Bolio Saldívar, and journalist María Teresa Castrillón.

638. Rhéaume, Claire. *La création musicale ches les religieuses de trois commu-nautés montréalaises*. Thesis. M.A., University of Montreal, 1987.

    Translated title: *Music in Three Women's Religious Communities in Montreal*.

639. Rhéaume, Claire. "La création musicale chez les religieuses enseignantes de Montréal." *Les Cahiers de l'ARMuQ (l'Association pour l'Avancement de la Recherche en Musique du Québec),* no. 10 (June 1988): 34–40.

    In French. Translated title: "Music in Religious Education for Women in Montreal." This journal issue contains the published proceedings of Sixth Colloquium of this Association, held in May 1987. In this paper, the author explores the important educational role of women's religious communities in Montreal in that they provided women with musical training and the opportunity to compose and perform.

640. Richmond, Eero. "Finnish Women Composers." In *The Musical Woman: An International Perspective. Volume 3, 1986–1990,* ed. Judith Lang Zaimont, Jane Gottlieb, Joanne Polk, and Michael J. Rogan, pp. 439–455. Westport, CT: Greenwood Press, 1991.

    Noting the active role of women in Finnish history, society, and cul-ture, the author focuses on ten of this country's most prominent women composers. The women profiled include: composer and performer Kreeta von Haapasalo (1813–1893); composer Ida Georgina Moberg (1859–1947); Helvi Lemmiki Leiviskä (1902–1982), "Finland's most important woman composer"; composer, pianist, and teacher Heidi Gabriella Wilhelmina Sunblad-Halme (1903–1970); folk singer and songwriter Barbara Helsingius (194?–); pianist and composer Ann-Elise Hannikainen (1948–); composer, flutist, and teacher Anneli Arho (1951–); composer-pianist Carita Holmström (1954–); pianist, teacher, and composer Liisa Karhilo; and Kaija Saariaho (1952–), who is known internationally for compositions of electro-acoustic music.

641. Rieger, Eva, ed. *Frau und Musik: mit Texten von Nina D'Aubigny....* Furore-Edition, no. 844. Kassel, Germany: Furore Verlag, 1990.

    ISBN 392732700X. In German. Translated title: *Women and Music, with Texts by Nina D'Aubigny, et. al..* This is a compilation of writings on women in Western art music, penned by women musicians throughout the history of music; included also are other works of historic music criticism addressing the "woman question" in music. Included are excerpts of the writings of Nina D'Aubigny von Engelbrunner, Johanna Kinkel, Luise Adolpha Le Beau, Agnese Schebest, Claire Glümer, Fanny Mendelssohn Hensel, Clara Schumann, Cosima Wagner, Alma Mahler, Sabine Lepsius, Elisabeth Kuyper, S. Jessel, Adele Gerhard/Helene Simon, Anna Plehn,

Philippine Schick, Mathilde Ludendorff, Luise Büchner, and Fanny Schindelmeisser.

642. Rieger, Eva. "Zwischen Klimperei und Kunst: Die Pianistin gestern und heute." In *Vom Schweigen befreit: Internationales Komponistinnen-Festival Kassel, 20. bis 22. Februar 1987*, pp.44–46. Internationales Komponistinnen-Festival Kassel (1987). Spons. and org. Hans Eichel, Kulturamt der Stadt Kassel, Internationalen Arbeitskreis "Frau und Musik," Roswitha Aulenkamp-Moeller, and Christel Nies. Wiesbaden, Germany: Bevollmächtigten der Hessischen Landesregierung für Frauenangelegenheiten, 1987.

In German. Translated title: "Between Dabbling and Art: The Female Pianist of Yesterday and Today." The author examines the role of the woman musician within patriarchal culture with particular reference to the role and reception of the woman pianist throughout history.

643. Ripley, Colette S. *Concert Music for Organ by Women Composers*. Diss. D.M.A., University of Kansas, 1992.

644. Robertson, Ruth. "Women Winners of the Prix de Rome: a Chronological Analysis." *International League of Women Composers (ILWC) Journal* (February 1993): 4–7.

645. Roselli, John. *Singers of Italian Opera: The History of a Profession*. Cambridge: Cambridge University Press, 1992.

The author includes a lengthy discussion of the history of women as professional singers in Italy, tracing the transition of women as singers in semi-public Italian courtly entertainments to their public appearance on the operatic stage through the end of the nineteenth century. The professional lives of women opera singers, rather than their minibiographies, are investigated in this study in great detail: societal attitudes towards a woman in a professional vs. domestic role, male attitudes towards women as singers as compared to the castrati, transsexual casting (for castrati and women singers), vocal training, the activities and concerns of singers pursuing operatic careers (contracts, rehearsals, competition for roles, etc.), a documentary account of the amount of pay women received as professional singers, sexual conduct, etc.

646. Sandman, Susan G. "Early Music by Women Composers: Making a Recording." *Continuo* 14, no. 6 (December 1990): 7–10.

The author describes the process by which she came to record *Early Music by Women Composers*, and discusses her experiences with locating repertoire and resolving performing practice issues.

647. Schechter, John M. *The Indispensable Harp: Historical Development, Modern Roles, Configurations, and Performance Practices in Ecuador and Latin America*. Kent, OH: Kent State University Press, 1992.

This monograph includes references to virtuoso women harpists Isabel Coello and Inés de Mendoza (Spain, sixteenth century, p. 23), and nineteenth-century Ecuadoran harpists Mercedes Páliz and Pastora Chaves (pp. 62–63). There are other general references to women harpists in Chile (pp. 36–37, 44–45), and Colombia (p. 48).

648. Solie, Ruth A. "Sophie Drinker's History." In *Disciplining Music: Musicology and its Canons*, ed. Katherine Bergeron and Philip V. Bohlman, pp. 23–43. Chicago: University of Chicago Press, 1992.

   The author critically examines the musical canon with regard to the lack of female representation, and focuses on the writing and critical reception of Sophie Drinker's groundbreaking book *Music and Women: The Story of Women in Relation to Music* (New York: Coward-McCann, 1948).

649. Sonntag, Brunhilde. "Künstlerin und Gesellschaft. Hat die Gesellschaft eine Verpflichtung der Künstlerin gegenüber? Hat die Künstlerin eine Verpflichtung der Gesellschaft gegenüber?" In *Vom Schweigen befreit: Internationales Komponistinnen-Festival Kassel, 20. bis 22. Februar 1987*, pp. 47–55. Internationales Komponistinnen-Festival Kassel (1987). Spons. and org. Hans Eichel, Kulturamt der Stadt Kassel, Internationalen Arbeitskreis "Frau und Musik," Roswitha Aulenkamp-Moeller, and Christel Nies. Wiesbaden, Germany: Bevollmächtigten der Hessischen Landesregierung für Frauenangelegenheiten, 1987.

   In German. Translated title: "The Female Artist and Society. Does Society Oppose the Woman Artist? Does the Woman Artist Oppose Society?" The author presents a short social history of European women composers, addressing questions relating to the scarcity of women composers and the professional discrimination faced by women composers throughout history.

650. Sonntag, Brunhilde, and Renate Matthei, eds. *Annäherung—an sieben Komponistinnen 2: mit Berichten, Interviews und Selbstdarstellungen.* Furore Edition, no. 805. Kassel, Germany: Furore-Verlag, 1987.

   ISBN 3980132641. In German. Translated title: *Focus on Seven Women Composers, Volume 2: With Reports, Interviews, and Self-Portraits.* The series is reviewed in *Musikhandel* 40, no. 1 (1989): 78; *Kirchenmusiker* 39, no. 5 (1988): 199. This volume includes biographical profiles of women composers from various periods of music history: Alma Mahler, Adriana Hölszky, Ruth Schonthal, Felicitas Kukuck, Myriam Marbé, Violeta Dinescu, and Vivienne Olive. Also available is Volume 1, published in 1986 (Furore Edition 802, ISBN 3980132633).

651. Sonntag, Brunhilde, and Renate Matthei, eds. *Annäherung—an sieben Komponistinnen 3: mit Berichten, Interviews und Selbstdarstellungen.* Furore Edition, no. 821. Kassel, Germany: Furore-Verlag, 1987.

ISBN 398013265X. In German. Translated title: *Focus on Seven Women Composers, Volume 3: With Reports, Interviews, and Self-Portraits*. This volume features biographical profiles of Kerstin Thieme, Ethel Smyth, Mia Schmidt, Verdina Shlonsky, Elisabeth Kuyper, Tu Wen-hui, and Jacqueline Fontyn.

652. Sonntag, Brunhilde, and Renate Matthei, eds. *Annäherung—an sieben Komponistinnen 4: mit Berichten, Interviews und Selbstdarstellungen*. Furore Edition, no. 827. Kassel, Germany: Furore-Verlag, 1988.

ISBN 3980132668. In German. Translated title: *Focus on Seven Women Composers, Volume 4: With Reports, Interviews, and Self-Portraits*. This volume features biographical profiles of Barbara Strozzi, Marianne de Martinez, Fanny Mendelssohn Hensel, Elisabeth Lutyens, Sofia Gubaidulina, Barbara Kolb, and Viera Janárčeková.

653. Sonntag, Brunhilde, and Renate Matthei, eds. *Annäherung—an sieben Komponistinnen 5: mit Berichten, Interviews und Selbstdarstellungen*. Furore Edition, no. 843. Kassel, Germany: Furore-Verlag, 1988.

ISBN 3980132692. In German. Translated title: *Focus on Seven Women Composers, Volume 5: with Reports, Interviews, and Self-Portraits*. This volume includes biographical profiles of Grazyna Bacewicz, Lili Boulanger, Annette von Droste-Hülshoff, Lucija Garuta, Moya Henderson, Tera de Marez Oyens, and Clara Schumann.

654. Steane, J. B. *Voices: Singers and Critics*. London: Duckworth, 1992.

ISBN 0715623885. Reviewed in *Opera News* 57, no. 5 (November 1992): 69; *Musical Times* 133 (November 1992): 575. Part I of this book contains the author's previously published articles (in *Opera Now* magazine, 1989–1990) on the various voice types found in the operatic repertoire, how these voice types represent a particular stereotype or characterization, operatic roles associated with each voice type, and the singers who are representative of each category. There are five essays on the soprano voice (leggiero/soubrette, pp. 3–8; coloratura, pp. 8–16; lyric, pp. 16–22; lyric-dramatic, pp. 22–28; heroic, pp. 29–34), two on the mezzo-soprano (lyric, pp. 35–40; dramatic, pp. 40–46), and one on the contralto (pp. 47–55).

655. Story, Rosalyn M. *And So I Sing: African-American Divas of Opera and Concert*. New York: Warner Books, 1990.

Reviewed in *Opera News* 54 (17 March 1990): 46. This is a most welcome addition to the literature on black American women singers, as it relates the biographical details of these women's lives in discussions which recognize the broader issues of race, culture, and society. Individual singers profiled include: Sissieretta Jones, Elizabeth Taylor-Greenfield, Marie Selika, Marian Anderson, Dorothy Maynor, Leontyne Price, Martina Arroyo, Grace Bumbry, and Shirley Verrett. Other chapters in the biographical vein include: "Pioneers

and Pathfinders," on women concert singers of the nineteenth century (e.g., Anna Madah and Emma Louise Hyers, Flora Batson, Emma Azalia Hackley); "Dorothy Maynor and the Mid-Century Divas" (e.g., Dorothy Maynor, Carol Brice, Ellabelle Davis, Inez Matthews, Abbie Mitchell, Florence Cole Talbert, La Julia Rhea, Lillian Evanti, Caterina Jarboro, and Muriel Rahn); and "Voices of a New Generation," on African-American women opera singers of the 1980s (e.g., Kathleen Battle, Jessye Norman, Leona Mitchell, Barbara Hendricks, Florence Quivar, Cynthia Clarey, Wilheminia Fernandez, Gwendolyn Bradley, Hilda Harris, Roberta Alexander, and Mavis Martin). Essays exploring significant areas of African-American music history (the Harlem Renaissance, the black church as concert hall, the importance of the spiritual as a musical genre, and musical criticism regarding vocal and visual ethnicity) raise important racial issues with relation to the performance of vocal music, adding to the biographical component of the book.

656. Stout, Glennis. "Women and the Flute: A Symposium. Introduction." *Flutist Quarterly* 15, no. 2 (Spring 1990): 6–7.

Special issue on women and the flute. The *Flutist Quarterly* editor offers some general comments on gathering historical material on women flutists and on the focus of this special issue.

657. Tubeuf, André. "A deux voix." *L'Avant Scène Opéra*, nos. 119/120 (April/May 1989): 168.

A survey of the female operatic duet as performed by great singers of the past.

658. Whitesitt, Linda. "'The Most Potent Force' in American Music: The Role of Women's Music Clubs in American Concert Life." In *The Musical Woman: An International Perspective. Volume 3, 1986–1990*, ed. Judith Lang Zaimont, Jane Gottlieb, Joanne Polk, and Michael J. Rogan, pp. 663–681. Westport, CT: Greenwood Press, 1991.

Women's music clubs supported composers and performers, organized concerts and tours, and offered scholarships and other educational opportunities. Women musicians could publicly participate in the musical world through their involvment in music clubs at a time when most women's lives were restricted to the domain of the private. American music was championed by women's music clubs, and symphony orchestras were established through their patronage. The author thus documents the vital contributions of the women's music club movement to the creation of musical culture in communities throughout the United States in the nineteenth and twentieth centuries.

659. Whitesitt, Linda. "Women's Support and Encouragement of Music and Musicians." In *Women and Music: A History*, ed. Karin Pendle, pp. 301–313. Bloomington, IN: Indiana University Press, 1991.

This essay is a chronological investigation into the role of women in the "fashioning of nurturing environments for musical culture" (p. 302).

Beginning with the "private sphere of home, court and salon" (p. 301), the author examines the activities of women music patrons and supporters through the mid-nineteenth century, noting their responsibility for the musical education of their children, their employment of performers and composers, and denial of their own talents in order advance those of their husbands/partners. With the rise of public concerts for the middle classes and the decline of the aristocratic salon in the late nineteenth century, musical patronage by women was directed toward supporting the public institutions of music within their communities (e.g., orchestras, educational institutions, community ensembles, festivals, women's music clubs) and took on various forms of support including establishing ensembles, schools, or women's music clubs; direct financial support to existing institutions; grants and scholarships to individuals; and assistance at the community level with concert organization, publicity, etc.

660. Zschunke, Andrea. "Ein festgefügter Männerbund: Warum die Philharmoniker noch immer keine Frauen aufnehmen." *Die Bühne* (March 1992): 30–33.

   In German. Translated title: "A Steadfast Bonding of Men: Why the Philharmonic Still Will Not Accept Women." An exploration into the history behind the exclusion of women from the ranks of the Vienna Philharmonic.

# Part B.  Historical Perspectives

## B. 1  HISTORICAL PERSPECTIVES—TO 500 A.D.

661. Ferguson, Marijke. "Musica—muzenkunst? Een ontmoeting met de negen muzen." *Mens & Melodie* 47 (November/December 1992): 603–606.

   In Dutch. Translated title: "Music—Art of the Muses? An Introduction to the Nine Muses."

662. Haas, Gerlinde. "Musikarchäologie aus 'anderer' Sicht." *Studien zur Musikwissenschaft* 38 (1987): 7–21.

   In German. Translated title: "Music Archeology from the 'Other' Point of View." The author delves into the world of antiquity in her investigation of written and visual evidence relating to ancient women's musical cults, with a particular focus on the syrinx as an instrument associated with the Muses and nymphs.

663. Harper, Jorjet. "Sappho: A Woman's Place." *Hot Wire* 4, no. 3 (July 1988): 14–15, 56.

   This investigation into the wedding songs of Sappho attempts to reconcile her lesbianism with the social and cultural practices of Ancient Greece.

664. Harper, Jorjet. "Sappho's Musical Genius." *Hot Wire* 4, no. 1 (November 1987): 14–15, 53.

665. Maas, Martha, and Jane McIntosh Snyder. *Stringed Instruments of Ancient Greece*. New Haven, CT: Yale University Press, 1989.

   Artistic, archeological, and literary evidence form the basis of this study of stringed instruments of ancient Greece. See index ("Musicians," p. 259; "Women," p. 261) for all references to discussions about and illustrations of women in musical life. These include references to women playing the aulos, various types of lyre (such as the chelys-lyra, pp. 87–92; the phorminx, kithara, lyra, and barbitos, pp. 115–120), and the harp (pp. 147–154).

666. McKinnon, James, ed. *Music in Early Christian Literature*. Cambridge, England: Cambridge University Press, 1987.

   Early Christian attitudes towards pagan musical culture, as well as musical imagery used in Christian writing, are illustrated through excerpts from original texts from the New Testament to 450 A.D. Discussed are patristic views of women singing in the church (pp. 61, 75–76, 93–94, 126–127, 145) and of women employed as instrumental musicians (especially harpists) for banquets, festivities, etc. (pp. 1–3).

667. Meyers, Carol L. "Of Drums and Damsels: Women's Performance in Ancient Israel." *Biblical Archaeologist* 54, no. 1 (March 1991): 16–27.

   Iron Age terracotta figurines, other art objects from Ancient Israel, as well as ancient texts establish the existence of drum-dance song as a women's performance genre. The existence of women's performance groups leads the author to discuss women musicians as part of the public sphere in an ancient society.

668. Michelini, Ann N. "Women and Music in Greece and Rome." In *Women and Music: A History*, ed. Karin Pendle, pp. 3–7. Bloomington, IN: Indiana University Press, 1991.

   Based on archaeological and literary sources, the author pieces together a brief history of women's role in the music in Ancient Greece and Rome, noting the segregated nature of female music-making, the important links between poetry and music in Ancient Greece, and the significance of female poets, such as Sappho, to our knowledge of women in music in ancient times. The role of women in the *choros*, and in public entertainments (e.g., playing the aulos, dancing, and singing) is mentioned.

669. Neubecker, Annemarie Jeanette. "Frauen im altgriechischen Musikleben." In *Musik und Dichtung: Neue Forschungsbeträge; Viktor Pöschl zum 80. Geburtstag gewidmet*, ed. Michael von Albrecht and Werner Schubert, pp. 13–23. Quellen und Studien zur Musikgeschichte von der Antike bis in die Gegenwart, no. 23. Frankfurt am Main, Germany: Peter Lang, 1990.

ISBN 36314418582. In German. The author documents the role of women in the musical life and lore of ancient Greece, using specific references to its literary and artistic works.

670. West, M. L. (Martin Litchfield). *Ancient Greek Music*. Oxford, England: Clarendon Press, 1992.

Archeological evidence documenting the participation of women in the musical life of ancient Greece is presented, with particular reference to women as vocal performers (pp. 320–321, 378–379) and women as harpists (pp. 71–72, 379).

## B.2 HISTORICAL PERSPECTIVES—500 TO 1400

671. Borroff, Edith. "Women and Music in Medieval Europe." *Mediaevalia* 14 (1991 for 1988): 1–21.

In her overview of the history of women in medieval music, the author stresses that it is necessary to consider the relatedness of the arts within culture (i.e., the ties between music, dance, poetry, theater, and religion) when studying medieval music, particularly if we are to understand the participation of women in medieval music. The author uses the framework of the three types of music education in Gothic Europe (music as rhetoric, music as philosophy, and training in professional musicianship, or minstrelsy), by which to investigate the contributions of women to medieval music. Music as rhetoric was taught to novices in the nunneries, and singing is a well documented musical activity for women. While the philosophy of music was studied in universities, which were closed to women, notable women who wrote on the subject were Hildegard of Bingen and Herrad of Landsberg, Abbess of Hohenburg. Women were professional minstrels, playing instruments and singing. Women were troubadors, poet-composers known as the trobairitz. The life and musical contributions of Hroswitha, a Saxon poet/musician/playwright who chose to live a secular but celibate life within a cloistered women's community, is discussed in detail. The author contends that women flourished within medieval music up until the fourteenth century, when increased urbanization and the formation of musical guilds, which excluded women, led to the gradual disappearance of women as professsional musicians.

672. Callahan, Anne. "The Trobairitz (c. 1170- 1260)." In *French Women Writers: A Bio-Bibliographical Sourcebook*, ed. Eva Martin Sartori and Dorothy Wynne Zimmerman, pp. 495-502. Westport, CT: Greenwood Press, 1991.

A good starting point for research into the *trobairitz*, medieval Occitan women poet/composers, this essay provides historical background, surveys the literary forms used in trobairitz lyrics, identifies the topical themes expressed in these poems and songs, and considers the activities of

the trobairitz given the role of the medieval woman within culture and society. Though scant information is available on the individual trobairitz, Callahan presents a summary of what is available in individual capsule biographies. The bibliography identifies collections of trobairitz literature, works available in translation, and scholarly studies on the trobairitz.

673. Coldwell, Maria V. "'Jougleresses' and 'Trobairitz': Secular Musicians in Medieval France." In *Women Making Music: the Western Art Tradition, 1150–1950*, ed. Jane Bowers and Judith Tick, pp. 39–61. Pap. ed. Urbana, IL: University of Illinois Press, 1987.

   Considered within the larger context of the changing social and political status of women in medieval France, this essay first explores the musical activities of women of the aristocracy, with further discussion focusing on the musical activities of courtesans and itinerant jougleresses. The contributions of the women poet/composers known as the trobairitz are surveyed.

674. Edwards, J. Michele. "Women in Music to ca. 1450." In *Women and Music: A History*, ed. Karin Pendle, pp. 8–28. Bloomington, IN: Indiana University Press, 1991.

   The author adeptly uses a variety of sources (e.g., iconographic and literary references, wills, accounts, religious documents, guild records, music treatises, manuscripts, and song texts) to provide an overview of the nature of women's secular and religious music-making activities in Europe from the first through the fifteenth centuries. In the realm of the secular, she identifies various musical roles for women, and discusses women as composer-poets (e.g., trobairitz) and as well as performers. Though there is evidence of a musical role for women in the early stages of Judaism and Christianity, voices of women were soon to be silenced. Most religious music by women emanated from women's faith communities, particularly nunneries. The music of the twelfth-century theologian Hildegard von Bingen is examined. Evidence of polyphonic music manuscripts found in nunneries in Europe suggests that the musical repertoire of women's religious communities mirrored the religious musical forms by men composers. Edwards concludes that while musical cultivation for women was valued in both sacred and secular life, private performance was considered proper, and professional performance subjected women to both class and sexual bias.

675. Galles, Duane L. C. M. "Canonesses and Plainchant." *Sacred Music* 114, no. 1 (Spring 1987): 7–11.

   A survey of the contributions of early Christian canonesses to the cultivation of plainchant in Europe.

676. Macy, Laura W. "Women's History and Early Music." In *Companion to Medieval and Renaissance Music*, ed. Tess Knighton and David Fallows, pp. 93–98. New York: Schirmer Books, 1992.

677. Mölk, Ulrich. "'Frauenlieder' des Duecento im Gewande der Ballade." In *Gestaltung— Umgestaltung: Beiträge zur Geschichte der romanischen Literaturen. Festschrift zum sechzigsten Geburtstag von Margot Kruse*, ed. Bernhard König and Jutta Lietz, pp.245–254. Tübingen, Germany: Gunter Narr Verlag, 1990.

    ISBN 38233441022. In German. The author reveals how the woman's voice is reflected in the texts of Italian ballata of the 13th century.

678. Mölk, Ulrich, comp., trans. and ed. *Romanische Frauenlieder*. Klassische Texte des Romanischen Mittelalters in zweisprachigen Ausgaben, no. 28. München, Germany: Wilhelm Fink Verlag, 1989.

    ISBN 34770525701. In German. The woman's voice in medieval poetry and song is the subject of this study. The introduction discusses the manner in which the woman's voice is communicated through the texts: through a monolog from the point of view of a woman, daughter, mother, sister, etc.; through a dialog between a man and woman, mother and daughter, woman and her friend, etc.; or by a third party commenting on a monolog or dialog. The texts themselves are then presented in their original languages (Provençal, French, Italian, Catalan, and Portuguese) with German translations. Most helpful are the indices: 1) mode of presentation (monolog, dialog, etc.); 2) character types occurring in the texts; 3) motifs; 4) metrical/poetical forms; 5) and metrical/musical (text) forms.

679. Nilsson, Ann Marie. "'Adest dies leticie': Studies on Hymn Melodies in Medieval Sweden." In *Proceedings of the First British-Swedish Conference on Musicology: Medieval Studies, 11–15 May 1988*, ed. Ann Buckley, pp. 67–85. Royal Swedish Academy of Music, no. 71. Stockholm, Sweden: Royal Swedish Academy of Music, 1992.

    ISBN 918542871X. The author presents some preliminary findings from work in progress on the second volume of *Die liturgischen Hymnen in Schweden*. In comparing melodic structures of certain Swedish hymn tune endings, variations occur in two distinct patterns. An investigation into the texts of these hymn tunes shows these ending melodic differences to be related to the gender of the male or female saints for whom these hymns are composed. On a different subject, additional research reveals details concerning the hymns tunes used in the *Cantus Sororum*, the musical liturgy of the Brigittine order of nuns.

680. Paden, William D. "Some Recent Studies of Women in the Middle Ages, Especially in Southern France." *TENSO: Bulletin of the Société Guilhem IX* 7, no. 2 (Spring 1992): 94–124.

    Part of a special issue devoted to the trobairitz. This review essay provides extensive coverage to recent literature on the trobairitz, and mentions several studies which focus on women musicians (p. 108).

681. Paden, William, D., ed. *The Voice of the Trobairitz: Perspectives on the Women Troubadours*. Middle Ages Series. Philadelphia, PA: University of Pennsylvania Press, 1989.

This is a collection of eleven essays studying various aspects of the lives and compositions of the women troubadors. Articles concern the literary aspects of trobairitz songs (e.g., content, structure, motifs, imagery, etc.), as well as woman-woman relations and female rhetoric in trobairitz songs and poetry.

682. Page, Christopher. *The Owl and the Nightingale: Musical Life and Ideas in France 1100–1300*. London: J.M. Dent & Sons, 1989.

Republished in 1990 by the University of California Press. In his investigation into the relations between religious doctrine and secular cultural expression in early Renaissance France, Page considers in Chapter 4 "'Jeunesse' and the Courtly Song Repertory." Here, he discusses how, in keeping with the image of the ideal woman, young ladies (*puceles* and *damoiseles*) were expected to acquire a musical education to demonstrate accomplishment and most importantly to adorn courtly musical entertainments (pp. 102–109). Regarding this point he introduces evidence which demonstrates the role of domestic chaplains in the education of young ladies. Page also concentrates on the religious invective directed against women for their participation in the carole, a public, secular dance/music form enjoyed by men and women of all social classes during feast days and celebrations, and the efforts of schoolmen of the time (e.g., Albertus Magnus) to affect a more tolerant viewpoint on the matter (pp. 14–15, 110–133, 182–183, 189, 196–198).

683. Poe, Elizabeth Wilson. "A Dispassionate Look at the Trobairitz." *TENSO: Bulletin of the Société Guilhem IX* 7, no. 2 (Spring 1992): 142–164.

Part of a special issue devoted to the trobairitz. The author takes a detailed and critical look at scholarly literature on medieval women troubadors, and reveals problems in the attribution of specific *cansos*, or trobairitz song lyrics, to particular women.

684. Rieger, Angelica. "Beruf: 'Joglaressa'. Die Spielfrau im okzitanische Mittelalter." In *Feste und Feiern im Mittelalter. Paderborner Symposion des Mediävistenverbandes*, ed. Detlef Altenburg, Jörg Jarnut, and Hans Hugo Steinhoff, pp. 229–242. Sigmaringen, Germany: J. Thorbecke Verlag, 1991.

ISBN 3799554025. In German. Translated title: "Profession: 'Joglaresse'— The Female Minstrel in Occitania During the Middle Ages." This essay focuses on the professional female minstrel as well as on the more aristocratic trobairitz.

685. Seebass, Tilman. "Idee und Status der Harfe im europäischen Mittelalter: Die Frau als Harfenspielerin." *Basler Jahrbuch für historische Musikpraxis* 11 (1987): 149–150.

In German. Woman as harpists in medieval Europe.

686. Servatius, Viveca. *Cantus Sororum: Musik und liturgiegeschichtliche Studien zu den Antiphonen des birgittinischen Eigenrepertoires.* Studia Musicologica Upsaliensis. Nova Series, no. 12. Uppsala, Sweden: Acta Universitatus Upsaliensis ; Stockholm: Almqvist and Wiksell International (dist.), 1990.

    ISBN 9155426026. In German. The *Cantus Sororum*, a fourteenth-century compilation of antiphons from the liturgy of the sisters of the Brigittine order (Sweden), is the subject of this study. Thirteen manuscript sources and fragments of the *Cantus Sororum* were consulted as the basis for the ninety-one musical transcriptions presented in the monograph. The author discusses the uses of notation, modal patterns, and chant variation found within the sources studied. In tracing the provenance of these antiphons, the author discovers that more than one-half appear to be unique to the *Cantus Sororum*, adding to our knowledge of liturgical chant and the musical history of women in medieval religious communities.

687. Yardley, Anne Bagnall. "'Ful weel she soong the service dyvyne': The Cloistered Musician in the Middle Ages." In *Women Making Music: the Western Art Tradition, 1150–1950*, ed. Jane Bowers and Judith Tick. Pap. ed, pp. 15–38. Urbana, IL: University of Illinois Press, 1987.

    This article explores gender issues with regard to the practice of liturgical music during the Middle Ages. In particular, the author discusses the role of medieval nunneries in providing musical education for women, as well as musical composition and the performance of both plainchant and polyphony by women in medieval religious communities. Included is a table listing "Polyphony in Manuscripts from Medieval Nunneries."

688. Yardley, Anne Bagnall. "The Marriage of Heaven and Earth: A Late Medieval Source of the *Consecratio virginum*." *Current Musicology*, nos. 45–47 (1990): 305–324.

    The author examines the *Consecratio virginum*, the service for consecrating nuns into the service of God. A primary source dating from the late medieval period giving the details of this service is the *Ordo consecrationis sanctimonialium* from the Abbey of St. Mary's in Winchester (Cambridge, University Library, Mm 3.13). Comparisons between this and earlier versions of the service are made and provide insight into life in the nunneries in medieval England, and into this initiation ritual in particular. Included are eleven musical portions of the service, which the author has transcribed into modern notation.

### B.3 HISTORICAL PERSPECTIVES—1400 TO 1600

689. Austern, Linda Phyllis. "Music and the English Renaissance Controversy over Women." In *Cecilia Reclaimed: Feminist Perspectives on Gender and Music*, ed. Susan C. Cook and Judy S. Tsou, pp. 52–69. Urbana, IL: University of Illinois Press, 1994 (forthcoming).

690. Austern, Linda Phyllis. "'Sing Againe Syren': The Female Musician and Sexual Enchantment in Elizabethan Life and Literature." *Renaissance Quarterly* 42, no. 3 (Autumm 1989): 420–448.

   The author meticulously details music's associations with femininity in both the Platonic and Christian-influenced writings of the English Renaissance. An analysis of literary, educational, religious, and philosopical works, as well as musical treatises, etiquette manuals, ladies' diaries, and accounts of Elizabethan life reveals the dualism inherent in Renaissance thought with regard to both the sensual and the spiritual associations attached to music and to the female sex. While a gentlewoman's education included training in the musical arts, the alluring aural qualities of music and the alluring visual qualities of women dictated that women's musical activities (a powerful combination of aural and visual beauty potentially exciting to men's passions) should ideally be restricted to the private domain (so as to encourage spiritual meditation), and to the performance of only certain instruments. In poetry, prose, and drama of the late sixteenth and early seventeenth century, however, the emotions and actions of characters are often propelled via musical encounters in which women play a central role as performers, thus consummating this theme of men's desire being aroused by female musical performance.

691. Bosi, Kathryn. "The Ferrara Connection: Diminution in the Early Madrigals of Benedetto Pallavicino." In *Essays on Italian Music in the Cinquecento*, ed. Richard Charteris, pp. 131–158. Sydney, Australia: Frederick May Foundation for Italian Studies, University of Sydney, 1990.

   ISBN 0949269999. The author challenges previous claims that the madrigals of Pallavicino were written for the virtuoso female singers of Mantua. Instead she presents musical evidence, such as specific elaborate diminutions characteristic of the luxuriant madrigal style, which show the compositional influence of Luzzasco Luzzaschi, organist and composer to the Este court of Ferrara in the late sixteenth century. The author thus argues that Pallavicino's madrigals were likely to have been written for the *concerto delle donne*, the virtuoso female singers known as the Ladies of Ferrara.

692. Brown, Howard Mayer. "Chapter VIII. The Renaissance: Introduction." In *Performance Practice: Music Before 1600*, ed. Howard Mayer Brown and Stanley Sadie. Norton/Grove Handbooks in Music. New York: W.W. Norton, 1989.

   The performance of sacred and secular vocal polyphony is discussed with particular reference to the size of ensembles and the utilization of the the female voice (women, boys and the male falsetto) (pp. 150–151, 162–163).

693. Brown, Howard Mayer. "Women Singers and Women's Songs in Fifteenth-Century Italy." In *Women Making Music: the Western Art Tradition,*

*1150–1950*, ed. Jane Bowers and Judith Tick, pp. 62–89. Pap. ed. Urbana, IL: University of Illinois Press, 1987.

This essay first explores women's participation in music-making through an examination of the educational and cultural pursuits of women of the aristocracy and the bourgeoisie, as well as the musical activities of itinerant women musician/entertainers. Here, the author notes that while some women were highly educated and received private musical training as part of their overall preparation as noblewomen, institutionalized acceptance of women to the musical training grounds of the cathedral school and university was withheld, thus hindering the ability of women to fully realize their potential in the realm of composition. Regarding women's song repertoire, extant written evidence can only inform our knowledge of the songs which might have been performed by women of the upper classes. The author examines the repertoire in a Florentine chansonnier, analyzing the musical and poetical forms contained therein, and identifying songs which communicate through the voice of a woman. In this manner, the author contributes to our knowledge of the extent of female involvement in the performance of secular music, while also providing insight into the status of women in society through a study of the thematic content of the song texts.

694. Dobbins, Frank. *Music in Renaissance Lyons*. Oxford, England: Clarendon Press, 1992.

The cult of feminism in literature, poetry, and music of sixteenth-century Lyons is examined. In "Pernette du Guillet and the Ladies of Lyons" (pp. 79–85), the author discusses the poetry of Guillet and musical settings of her work by sixteenth-century composers, as well as her musical talents. The musical and literary achievements of Louise Clémence de Bourges receive attention as well. In "Feminism, Platonism and Lyricism in the Poetry of Lyons" (pp. 85–89), the author discusses the ideal, virtuous woman of the Renaissance as one who is represented as being musically accomplished.

695. Elias, Cathy Ann. "Musical Performance in 16th Century Italian Literature: Straparola's *Le piacevoli notti*." *Early Music* 18, no. 2 (1989): 161–173.

The depiction of musical subjects in sixteenth-century art, and references to musical events in historical accounts, treatises, instruction manuals, and "imaginative literature" (p. 161) provide insights into performance practice during this period, especially with regard to the use of instruments to accompany madrigal singing, and to vocal and instrumental performances by women. *Le piacevoli notti*, Giovan Francesco Straparola's imaginative impressions of the Venetian carnival, as well as other written accounts are examined in this regard. Excerpts from Straparola's work (in Italian, with English translations) are included, as are reproductions of five period artworks.

696. Fallows, David. "Chapter XI. Secular Polyphony in the 15th Century." In *Performance Practice: Music Before 1600*, ed. Howard Mayer Brown and

Stanley Sadie. Norton/Grove Handbooks in Music. New York: W.W. Norton, 1989.

Briefly discusses the utilization of women as singers of fifteenth-century vocal polyphony (pp. 210, 219).

697. Higgins, Paula. "Parisian Nobles, A Scottish Princess, and the Woman's Voice in Late Medieval Song." *Early Music History* 10 (1991): 145–200.

The author's exploration into the works of Antoine Busnoys and the connections between music and literature in late fifteenth-century France extends to an analysis of the texts of Busnoys' songs which refer, through acrostics and word puzzles, to a Jacqueline Hacqueville. In her research into Jacqueline Hacqueville (there were two women by that name in French aristocratic circles of the fifteenth century), Higgins reveals amongst manuscript sources a wealth of information about the creative activity of women, particularly as poets. The author asks, "How do we weigh the independent evidence of sworn depositions and contemporary documents attesting to the otherwise unknown literary creativity of a circle of medieval women against the powerful silence of contemporary authors and paucity of attributions that seem to deny their very existence?" (p. 168). Higgins examines the existence of the woman's voice in texts of French medieval song, discusses problems with identifying anonymously composed music and texts, notes the misattribution of poetical works to male authors when evidence points to the contrary, and finally explores the larger question of the role of women musicians and poets in medieval culture. Given the documentary evidence of women's literary activity in fifteenth-century France, as well as women's activity as composers before 1300 and after 1566, she states that we need to critically assesss standard accounts of music history which indicate a void in women's musical activity during the fifteenth century. Higgins concludes, "Perhaps it is now time to acknowledge that the historical variable of gender, once shifted to the centre of a critical discourse, cannot fail to have an unexpected and often powerfully transformative impact on our understanding of music" (p. 195).

698. Kelly-Gadol, Joan. "Did Women Have a Renaissance?" In *Becoming Visible: Women in European History*, ed. Renate Bridenthal, Claudia Koonz, and Susan Stuard, pp. 175–201. 2nd ed. Boston, MA: Houghton Mifflin Company, 1987.

The author explores the relation between politics, culture, class, and sex roles in Renaissance Italy. Noblewomen of the prominent ruling families (e.g., Este, Gonzaga, Sforza), while receiving a humanist education (including training in music), did so under a male cultural authority which prevented them from "shaping a culture responsive to their own interests" (p. 188). Their artistic achievements, which served to charm, entertain, and decorate in the courtly setting, advanced the patriarchal notion of woman as aesthetic object.

699. Macey, Patrick. "*Infiamma il mio cor*: Savonarolan Laude by and for Dominican Nuns in Tuscany." In *The Crannied Wall: Women, Religion,*

*and the Arts in Early Modern Europe*, ed. Craig A. Monson, pp. 161–189. Studies in Medieval and Early Modern Civilization. Ann Arbor, MI: University of Michigan Press, 1992.

Girolama Savonarola (1452–1498), a Dominican friar and martyr for the cause of religious and social reform, was a spiritual force in the community of Dominican nuns in Tuscany. He wrote texts for *laude*, a hymn form particularly associated with Dominican nuns and cultivated by them to honor him and carry on his message. This essay investigates the practice of laude singing and the texts of these hymns, with particular reference to the convents of Santa Lucia and Santa Caterina da Siena (Florence), and San Vincenzo (Prato).

700. Monson, Craig A. "Disembodied Voices: Music in the Nunneries of Bologna in the Midst of Counter-Reformation." In *The Crannied Wall: Women, Religion, and the Arts in Early Modern Europe*, ed. Craig A. Monson, pp. 191–209. Studies in Medieval and Early Modern Civilization. Ann Arbor, MI: University of Michigan Press, 1992.

The effects of the Counter-Reformation and the imposition of *clausura*, restrictive enclosure of nuns within the walls of the convents, is examined with relation to the Church's effort to both separate nuns and silence their musical activity. The musical means by which nuns in the late sixteenth and early seventeenth centuries subverted the forces which sought to silence them is examined. The singing of nuns could be heard outside their walled enclave, often interacting with music performed for public services held in convent churches. The author explains how the efforts of nuns to practice music within the confines of *clausura* was a most extreme realization of the Baroque musical conventions of monody, separated choirs, and concertato ensembles.

701. Newcomb, Anthony. "Chapter XII. The Renaissance: Secular Polyphony in the 16th Century." In *Performance Practice: Music Before 1600*, ed. Howard Mayer Brown and Stanley Sadie. Norton/ Grove Handbooks in Music. New York: W.W. Norton, 1989.

In a discussion of the voice types utilized in secular polyphony of the sixteenth century, the author notes an increased emphasis on the treble voices coinciding with the rise to prominence of the female madrigal singer in courtly life (pp. 233–234, 239).

702. Newcomb, Anthony. "Courtesans, Muses, or Musicians? Professional Women Musicians in Sixteenth-Century Italy." In *Women Making Music: the Western Art Tradition, 1150–1950*, ed. Jane Bowers and Judith Tick, pp. 90–115. Pap. ed. Urbana, IL: University of Illinois Press, 1987.

The author examines the changes in society and culture in mid-sixteenth-century Italy leading to the establishment in 1580 of the *concerto delle donne*, the professional women singers of the Este court at Ferrara. Historical details regarding the formation, personnel, and subsequent activities of the



*concerto delle donne* are presented. History is reexamined for immediate precursors to the *concerto della donne*, revealing sparse details regarding several women who were composing and performing professionally, such as the Venetian composer Maddalena Casulana, singer/instrumentalist Virginia Vagnoli, and Laura Ruggeri, a singer/instrumentalist employed as a member of the *musica secreta* of Pope Paul III. Upper class women also contributed to musical performance of the Venetian salon during the mid-sixteenth century. The author notes how the role of the woman musician changed from courtesan to music professional after the establishment of the *concerto della donne*; their esteemed status, professionalism, and musical virtuosity had important implications for a woman seeking a career as a professional musician or composer during the late sixteeth and early seventeenth centuries.

703. Pendle, Karin. "Women in Music, ca. 1450–1600." In *Women and Music: A History*, ed. Karin Pendle, pp. 31–53. Bloomington, IN: Indiana University Press, 1991.

The musical role of women during the Renaissance is examined, and particular attention is given to the influence of gender and class on the type of music making (e.g., private or professional) in which women participated. Women of nobility were instructed in music as a matter of course. However, their social rank dictated that they perform only in a domestic or court setting. Professional women musicians did exist amongst the famous courtesans, actresses from the commedia dell'arte, and hired musicians for the courts of the nobility. The *concerto delle donne* of the Este court of Duke Alfonso II of Ferrara is one of the outstanding examples of a virtuoso ensemble of women singers appointed as court musicians and ladies in waiting to Duchess Margherita. Prominent composers wrote polyphonic vocal works geared toward the virtuosic treble singing of the *concerto delle donne*, thus having an important impact on secular vocal composition in the sixteenth century. Liturgical and secular instrumental and vocal music was also performed by nuns from convents in cities throughout Italy; however this trend was curbed by seclusionary and musical restrictions of the Council of Trent. Women composers are discussed, and the work of Maddalena Casulana and Vittoria Aleotti (Sister Raffaella) is noted.

704. Prizer, William F. "Games of Venus: Secular Vocal Music in the Late Quattrocento and Early Cinquecento." *Journal of Musicology* 9, no. 1 (Winter 1991): 3–56.

Here, the subject is music-making amongst the Italian elite during the fifteenth and sixteenth centuries, with a focus on the types of love songs performed. Part One of the article discusses women as both patronesses of music and as amateur musicians, with documentary evidence demonstrating the importance of musical literacy for the gentlewomen of the Italian elite. The textual component of the secular love songs of this era dwelt on lofty courtly love, but more popular, rustic song texts offered more realistic views of male/female relationships with lyrics which were often sexually explicit.

Both the popular and courtly songs were performed and enjoyed with equal frequency, and served as a release from the strictures of upper class society.

705. Riley, Joanne. "Tarquinia Molza (1542–1617): A Case Study of Women, Music, and Society in the Renaissance." In *The Musical Woman: An International Perspective. Volume 2, 1984–1985*, ed. Judith Lang Zaimont, Catherine Overhauser, and Jane Gottlieb, pp. 470–492. Westport, CT: Greenwood Press, 1987.

Tarquinia Molza was a musician of the court of Duke Alfonso II d'Este of Ferrara, known for her virtuoso singing and association with the influential *concerto delle donne*, often referred to as the "Singing Ladies of Ferrara." The author looks critically at existing scholarship relating to Molza and musical life in sixteenth-century Italy, and introduces new documentary evidence which demonstrates that Molza's talent went beyond mere female solo vocal virtuosity. Her knowledge of linear (solo) and vertical (contrapuntal) improvisation, music theory, and instrumental accompaniment (viola da gamba, clavier, lute) demonstrates that she expanded the vistas for women performers of the Renaissance. While she was a member of the *concerto delle donne*, evidence leads the author to conclude that Molza was a teacher and mentor to the group, and in developing their virtuoso singing and improvisatory technique influenced the style and manner of Renaissance and early Baroque composition by male composers.

## B.4 HISTORICAL PERSPECTIVES—1600 TO 1800

706. Berdes, Jane L. Baldauf. "Anna Maria della Pietà: The Woman Musician of Venice Personified." In *Cecilia Reclaimed: Feminist Perspectives on Gender and Music*, ed. Susan C. Cook and Judy S. Tsou, pp. 134–155. Urbana, IL: University of Illinois Press, 1994 (forthcoming).

707. Berdes, Jane L. Baldauf. "The Women Musicians of Venice." In *Eighteenth-Century Women and the Arts*, ed. Frederick M. Keener and Susan E. Lorsch, pp. 153–162. Contributions in Women's Studies, no. 98. Westport, CT: Greenwood Press, 1988.

The author's research into the music of Maddalena Laura Lombardini-Sirmen leads to her discovery of the significant role played by the Venetian *ospedali* in women's music history. These Venetian charitable institutions which also functioned as conservatories of music for young women, provided rigorous musical training and professional opportunities for at least 650 female performers and composers from the sixteenth through the eighteenth centuries, two of whom were composer Lombardini-Sirmen and Anna Maria della Pietà, a virtuoso violinist and player of other stringed instruments.

708. Bowers, Jane M. "The Emergence of Women  Composers in Italy, 1566–1700." In *Women Making Music: the  Western Art Tradition,*

*1150–1950*, ed. Jane Bowers and Judith Tick, pp. 116–167. Pap. ed. Urbana, IL: University of Illinois Press, 1987.

The author's objective in this article is twofold: 1) to assess the activities of women composers in Italy from 1566 to 1700 and to consider their unprecedented musical achievements within a larger context of cultural and social change (e.g., increased distribution of music due to the growth of music printing, professionalization of singing as a career for women, the fostering of the performance and composition of polyphonic musical works in convents, desirability of private music instruction for children); 2) to explore the restrictive social and cultural realities for women during this time period and the limitations that patriarchy placed on their musical lives and their potential as composers (e.g., lack of professional musical opportunities, social boundaries restricting women to the domestic realm, male disdain regarding the creative capacity of women, increased regulation of women's musical activities within convents as a result of the enclosure of nuns as dictated by the church Fathers in the Council of Trent).

709. Citron, Marcia J. "Women and the Lied, 1775–1850." *Women Making Music: the Western Art Tradition, 1150–1950*, ed. Jane Bowers and Judith Tick, pp. 224–248. Pap. ed. Urbana, IL: University of Illinois Press, 1987.

The author examines the contributions of outstanding women composers to the German lied, noting the early exposure of these women to the flourishing music/literary salon culture of the late eighteenth century and the early nineteenth century. The women composers considered here are: Corona Schröter, Maria Theresia von Paradis, Luise Reichardt, Emilie Zumsteeg, Annette von Droste-Hülshoff, Fanny Mendelssohn Hensel, Josephine Lang, and Clara Wieck Schumann.

710. Cusick, Suzanne G. "Of Women, Music and Power: A Model from Seicento Florence." In *Musicology and Difference: Gender and Sexuality in Music Scholarship*, ed. Ruth Solie, pp. 281–304. Berkeley, CA: University of California Press, 1993.

Commissioned by the Archduchess Maddalena of Austria, Francesca Caccini's *La liberazione di Ruggiero dall'isola d'Alcina* (1625) is a uniquely female-conceived work in the court opera genre. As Cusick analyzes both music and plot, she demonstrates the manner in which gender issues intersect with those having to do with personal and political power. The author emphasizes Caccini's musical negotiation of the concomitant paradox in this political allegory on the appropriate and inappropriate uses of female power within a patriarchal world, given her patron's powerful position as a monarch.

711. Eagle, David. "Flautistes of the Georgian age." *Flutist Quarterly* 15, no. 2 (Spring 1990): 9–10.

Special issue on women and the flute. This brief survey of English women flutists from 1750–1850 discusses several who performed professionally (Marianne Davies, Sara Schofield, Miss Cann).

712. Gärtner, Heinz. *'Folget der Heissgeliebten': Frauen um Mozart.* München, Germany: Langen Müller, 1990.

ISBN 3784423027. In German. This book on the women friends, loves, pupils, singers, and patronesses in Mozart's life discusses: Marianne Thekla Mozart (known as "Bäsle"; Mozart's "little cousin"); primadonnas Aloysia Weber (later Lange), Caterina Cavalieri, Nancy Storace, and Josepha Duschek; pupils Frau Therese von Trattner and Magdalena Hofdemel; patron and Baroness Martha Elisabeth Waldstätten; and his wife Constanze (Weber) Mozart, the younger sister of Aloysia Weber. Includes illustrations, portraits, excerpts of letters, bibliography.

713. Gianturco, Carolyn. "Caterina Assandra, suora compositrice." In *La musica sacra in Lombardia nella prima metà del Seicento*, pp. 117–127. Como, Italy: A.M.I.S., 1988.

In Italian. While focusing on the seventeenth-century Italian nun and composer Caterina Assandra, this essay also notes other nun composers of the time, and includes a survey of musical life and musical training within the convents of that era.

714. Gidwitz, Patricia Lewy. "'Ich bin die erste Sängerin': Vocal Profiles of Two Mozart Sopranos." *Early Music* 19, no. 4 (November 1991): 565–579.

In English. The article concerns sopranos Caterina Cavalieri and Aloysia Weber Lange and how their style and technical ability influenced Mozart's composition.

715. Gidwitz, Patricia Lewy. *Vocal Profiles of Four Mozart Sopranos.* Diss. Ph.D., University of California at Berkeley, 1991.

In two volumes. Based on the premise that eighteenth century opera arias were composed for premier singers of the day as vehicles for their vocal display, the author constructs vocal portraits for four late eighteenth-century operatic virtuosas (Aloisia Weber Lange, Caterina Cavalieri, Anna Selina Storace, and Adriana Ferrarese del Bene) by: 1) examining the music written for these sopranos by Mozart and others, comparing original versions and revisions created for revival performances in order to demonstrate the reworking of arias for particular singing voices; 2) examining published reviews and other written accounts (e.g., composer and librettist correspondences on the composer/performer relationship), in order to substantiate the musical evidence. Supported by a separate volume of musical examples, the author also explores the ways in which the Mozart/Da Ponte operas were shaped by the abilities of these singers, with an examination of musical and

dramatic elements in each. The operas discussed include: *La Nozze di Figaro*, *Don Giovanni*, and *Cosi fan tutte*. With a vocal profile established, the author posits that we may be able to ascertain whether an aria which is unattributed could have been performed by the profiled singer.

716. Gordy, Laura Ann. *Women Creating Music, 1750–1850: Marianne Martinez, Maria Theresia von Paradis, Fanny Mendelssohn Hensel and Clara Wieck Schumann*. Diss. D.M.A., University of Alabama, 1987.

Abstract in *Dissertation Abstracts International: A. Humanities and Social Sciences* 48, no. 6 (December 1987): 1350. DA# 8720691.

717. Hay, Beverly. "Dorothea Bussani and the Miscasting of Despina." *NATS Journal* 47, no. 5 (May/June 1991): 14–15, 45–46.

By examining the tessituras of various female operatic roles sung by one of Mozart's singers, Dorothea Bussani, the author argues that it was Mozart's intention that the role of Despina in *Cosi fan tutte* be sung by a mezzo-soprano, which differs from the current practice of employing a light soprano voice for the role.

718. Hayes, Deborah. "Some Neglected Women Composers of the Eighteenth Century and Their Music." *Current Musicology*, no. 39 (1985 [c1987]): 42–65.

The author utilizes a geographical framework by which to examine the contributions of prominent European women composers to the music of the Classical era. In order to promote further interest in the works of these women composers, Hayes provides biographical information, enumerates significant works composed, and briefly assesses the composer's music. Italian women composers examined include Anna Bon, Maria Teresa Agnesi, and Maddalena Lombardini Sirmen. Women composers from Germany include Maria Antonia Walpurgis, Marie Charlotte Amalie (Duchess of Saxe-Goethe, Princess of Saxe-Meinungen), Margravine Wilhelmine of Bayreuth, Princess Anna Amalie of Prussia, and Duchess Anna Amalie of Saxe-Weimar. From Vienna came Marianne Martinez, Josepha Barbara von Auernhammer, and Maria Theresia von Paradis. French women composers of this era include Marie-Emmanuelle Bayon (later known as Mme Louis) and Amelie Julie Candeille. Elisabetta De Gambarini, Elisabeth Weichsell, Harriet Abrams, Maria Barthélemon and her daughter Cecilia Maria Barthélemon, Jane Mary Guest (later known as Mrs. Miles), and Maria Hester Parke are among the women composers mentioned who were based in England.

719. Hildebrand, David K. *Musical Life In and Around Annapolis, Maryland, 1649–1776*. Diss. Ph.D., Catholic University, 1992.

Abstract in *Dissertation Abstracts International: A. Humanities and Social Sciences*. 53, no. 3 (September 1992): 657. DA# 9221882. This examination of the place of music in the social and cultural lives of residents

of colonial-era Annapolis focuses on class and gender as major areas of study. Public records, newspapers and magazines, various descriptions of town, church, and home life, musical collections, tutors, and other materials are used in the author's research, and provide insight into the musical life of an early-American city in the south.

720. Jackson, Barbara Garvey. "Musical Women of the Seventeenth and Eighteenth Centuries." *Women and Music: A History*, ed. Karin Pendle. pp. 54–94. Bloomington, IN: Indiana University Press, 1991.

　　The author introduces her essay with a discussion of the involvement and status of women musicians in sacred and secular music, in public concerts and salons, and as composers, instrumentalists, and vocalists. She then focuses on certain Italian, French, German, and Austrian composers : Francesca and Settimia Caccini, Barbara Strozzi, Isabella Leonarda, Maddalena Lombardini Sirmen, Elisabeth-Claude Jacquet de La Guerre, Antonia Bembo, Anna Amalia (Duchess of Saxe-Weimar), Corona Schröter, Juliane Benda Reichardt, Marianne von Martinez, and Maria Theresia von Paradis. She likewise examines the roles of convents, conservatories, private music schools, and the salons of Europe in providing women with the opportunities for musicial training and venues for performance.

721. Jones, Edward Huws. "Women's Voices." In *The Performance of English Song: 1610–1670*, pp.26–33. Outstanding Dissertations in Music from British Universities. New York: Garland Publishing, 1989.
　　Diss., Ph.D., University of York, 1978.

722. Kendrick, Robert. "The Traditions of Milanese Convent Music and the Sacred Dialogues of Chiara Margarita Cozzolani." In *The Crannied Wall: Women, Religion, and the Arts in Early Modern Europe*, ed. Craig A. Monson, pp. 211–233. Ann Arbor, MI: University of Michigan Press, 1992.

　　This essay examines the musical activities of nuns in seventeenth-century Milanese convents in relation to the religious and social milieu of the time. The author discusses how music functioned in the lives of nuns living under the strictures of *clausura*, focusing on the compositions (motets in the form of the sacred diaglogue) of the Benedictine nun Chiara Margarita Cozzolani.

723. Keyser, Dorothy. "Cross-Sexual Casting in Baroque Opera: Musical and Theatrical Conventions." *Opera Quarterly* 5, no. 4 (Winter 1987/1988): 46–57.

　　With the utilization women, boys, and castrati as singers of treble vocal roles in Baroque opera, cross-sexual casting was accepted as a convention in seventeenth-century Italian opera. The author investigates the operatic and theatrical history of this performance practice, and offers suggestions to contemporary producers of Baroque-era operatic works.

724. Kroll, Renate. "La chanson des femmes poètes au XVIIe siècle: Mme de la Suze et Mme Deshoulières—Une contribution féminine à la poésie

chantée." In *La chanson française et son histoire*, ed. Dietmar Rieger, pp. 27–45. Études littéraires franççaises, no. 39. Tübingen, Germany: Gunter Narr Verlag, 1988.

ISBN 387808739X. In French. Translated title: "Songs by Women Poets of the 17th Century: Mme de La Suze et Mme Deshoulières—A Feminine Contribution to Sung Poetry." The author examines the contributions of these two French women poets to the seventeenth-century song repertoire, with a particular focus on the woman's voice articulated through the texts.

725. Lindmayr, Andrea. "Mozart und die Frauen—Die Frauen und Mozart." *Mozart-Jahrbuch* (1992): 139–146.

In German. This review essay evaluates six recent books of varying degrees of merit on women and their association with Mozart. These books are: Rieger, Eva. *Nannerl Mozart: Leben einer Künstlerin im 18. Jahrhundert*. (Frankfurt am Main: Insel Verlag, 1990); Valentin, Erich. *'Madame Mutter': Anna Maria Walburga Mozart (1720–1778)*, ed. Deutschen Mozart-Gesellschaft. (Augsburg: Eigenverlag, 1991); Wintersteiner, Marianne. *Anna Maria und Nannerl Mozart: Zwei Frauen um Wolfgang Amadeus. Biographischer Roman*. (Heilbronn: Eugen Salzer-Verlag, 1991); Welsh, Renate. *Constanze Mozart: Eine unbedeutende Frau*. (Wien: Jugend und Volk Verlag, 1990); Leonhart, Dorothea. *Mozart: Liebe und Geld. Ein Versuch zu seiner Person*. (München: Mathes & Seitz Verlag, 1991); Gärtner, Heinz. *'Folget der Heissgeliebten': Frauen um Mozart*. (München: Langen Müller, 1990.)

726. Mathiesen, Penelope. "Winds of Yore: What's New With Old Woodwinds? Women Woodwind Composers of the Eighteenth Century." *Continuo* 15, no. 2 (April 1991): 9–12.

Focus on Anna Bon di Venezia.

727. Metzelaar, Helen. "An Unknown 18th-Century Dutch Woman Composer: Josina Boetzelaer (1733–1797)." *Tijdschrift van de Vereniging voor nederlandse Muziekgeschiedenis* 40, no. 2 (1990): 3–56.

In English. Though the primary focus of this article is on Josina Boetzelaer, the "Overview of Early Dutch Women Composers" presented in the introduction (pp. 3–5) is drawn from information on Dutch women composers of the seventeeth and eighteenth century mentioned in Aaron Cohen's International Encyclopedia of Women Composers.

728. Mullally, Robert. "A Female Aeneas?" *Musical Times* 130 (February 1989): 80–82.

The first performance of Henry Purcell's *Dido and Aeneas* (1689) took place at Josias Priest's School for Young Ladies. While evidence indicates that the original production utilized female singers in male roles, little attention has been given to this fact in the literature. Absence of the original

manuscript impedes the determination of the exact musical details of this first performance. Yet, it has been assumed from the vocal designations in the earliest extant score (the Tenbury manuscript of 1775) that both male and female voices were utilized at the first performance.

729. Öhrström, Eva. "Salongen." In *Kvinnors Musik*, ed. Eva Öhrström and Mörta Rämsten, pp. 48–52. Stockholm, Sweden: Sveriges Utbildningsradio AB and Svenska Rikskonserter, 1989.
     ISBN 9126898101. In Swedish. Translated title: "The Salon." Examines the musical contributions of women to the Swedish aristocratic salons of the eighteenth and nineteenth centuries.

730. Quintana, J. Terrie. "Educating Women in the Arts: Mme. Campan's School." In *Eighteenth-Century Women and the Arts*, ed. Frederick M. Keener and Susan E. Lorsch, pp. 237–244. Contributions in Women's Studies, no. 98. Westport, CT: Greenwood Press, 1988.
     Beginning with a discussion on the state of arts education for women in eighteenth-century France, the author then concentrates on the opportunities for professional training in music, art, and dance provided by the Saint-German-en-Laye school for ladies, founded by Jeanne Genet Campan during the period after the French Revolution.

731. Rieger, Eva. *Nannerl Mozart: Leben einer Künstlerin im 18. Jahrhundert*. 2nd ed. Frankfurt am Main, Germany: Insel Verlag, 1991.
     ISBN 3458161139. In German. Reviewed in *Österreichische Musik Zeitschrift* 46, no. 7–8 (July/August 1991): 435–436; Notes 49, no. 3 (March 1993): 992–994; *Mozart-Jahrbuch* (1992): 140–142.
     While most of this book is devoted to the life of Nannerl Mozart, about one-third considers broader issues relating to the role of women in music during the eighteenth century. The introduction, entitled "Das Frauenbild in der Mozart-Biographik," discusses the treatment of women (e.g., Constanze Mozart and her mother Maria Caecilia Weber) in biographies of Mozart. The last section of the book, entitled "Nannerls Umwelt" (Nannerl's World), examines the portrayal of women in eighteenth-century literature and theatre, the opportunities and limitations for women artists in the eighteenth century, the beliefs of Leopold Mozart regarding a woman's role in society, and the influence of all these factors on Nannerl's short musical career. The author demonstrates that the eighteenth century model of a composer was a man working in a man's world. In this context, the author states that Nannerl's art was thwarted by the boundaries of the male model of a woman's destiny.

732. Rosand, Ellen. *Opera in Seventeenth Century Venice: The Creation of a Genre*. Berkeley, CA: University of California Press, 1991.
     In this scholarly study, the author focuses on several topics pertaining to women as singers, and the musical and dramatic conventions used in female roles in seventeenth-century Venetian opera. The rise of the prima

donna and her influence over the composer, librettist, and the conditions sur-
rounding an operatic performance is discussed, with specific references
made to Anna Renzi, Lucretia "Dolfin" and Vincenza Giulia Masotti (pp.
227–240). The love duet is discussed (pp. 335–338) as an expression of
amorous accord and/or united sentiment between male and female charac-
ters, opposite-sex protagonists cast as females, and same-sex protagonists.
The lullaby is discussed as a musical device (pp. 338–342) as is that of the
lament (pp. 361–386). The convention of madness in opera, often assigned
to female characters is examined (pp. 346–360). Woman as the dramatic
heroine of Venetian opera is briefly mentioned (p. 390).

733. Rosand, Ellen. "The Voice of Barbara Strozzi." *Women Making Music: the
Western Art Tradition, 1150–1950*, ed. Jane Bowers and Judith Tick, pp.
168–190. Pap. ed. Urbana, IL: University of Illinois Press, 1987.

This study of the life and works of the seventeeth-century Venetian
composer and singer Barbara Strozzi discusses her accomplishments in light
of the social and cultural milieu in which she worked, with particular refer-
ence to the status and role of women in seventeenth century Italian music.
Includes musical examples.

734. Ruggieri, Eve. *Mozart: L'Itinéraire sentimental.* France: Michel Lafon, 1991.
ISBN 2863914422. Somewhat simplisic and not as well documented
as the similar book by Heinz Gärtner, this book discusses the influential
women in Mozart's life, with some discussion of Mozart's personal relations
as they pertain to the composer's treatment of male/female relationships in
his operas. Chapters are devoted to the death of Mozart's mother and the
resulting control that his father Leopold exerted on Nannerl Mozart, the tal-
ented sister of Wolfgang. Relationships with young Anna Maria Thekla
Mozart (la Bäsle), Aloysia Weber (later Lange), and Constanze Weber
Mozart (Aloysia's younger sister and Mozart's wife) are discussed. Marital
infidelities are discussed in later chapters.

735. Sadie, Julie Anne. "Musiciennes of the Ancien Régime." *Women Making
Music: the Western Art Tradition, 1150–1950*, ed. Jane Bowers and Judith
Tick, pp. 191–223. Pap. ed. Urbana, IL: University of Illinois Press, 1987.

The author examines the lives and private accomplishments of musical
women of the French nobility and likewise women of the bourgeoisie who,
through apprenticeships or familial/hereditary musical ties, were able to
acquire the musical training to become accomplished singers, instrumentalists,
and composers. Their achievements are viewed within the context of the
increased acceptance of women as musicians in late-seventeeth and eigh-
teenth-century France, both in public and private milieus, which is also reflect-
ed in the artwork of the period, several examples of which are included.

736. Sadie, Julie Anne. "Score Review Essay: *Selected Compositions by
Isabella Leonarda; Arias from Oratorios by Women Composers of the*

*Eighteenth Century, Vol. 1*; *Zwölf Lieder auf ihrer Reise in Musik gesetzt (1784–1786)* by Maria Theresia von Paradis; *Three Violin Concertos* by Maddalena Laura Lombardini Sirmen." *Early Music* 20, no. 1 (February 1992): 163–164.

737. Sawkins, Lionel. "For and Against the Order of Nature: Who Sang Soprano." *Early Music* 15, no. 3 (August 1987): 315–324.

The *dessus* (soprano) part in the repertoire of the French Baroque era was sung by women, boys, falsetti, and castrati. This study of court and theatre documents, scores, and libretti presents a detailed picture of performance practice with regard to the utilization of these soprano singers in the Académie Royale de Musique (Paris Opéra), the royal chapel at Versailles, court stage presentations, and the Concert spirituel.

738. Shafer, Sharon Guertin. "A Survey of Eighteenth-Century Women Composers: Dilettantes or Professional Musicians." *International League of Women Composers (ILWC) Journal* (March 1992): 6–8.

This article examines the limitations on women's lives in the eighteenth century and identifies women who were able to overcome these obstacles to become professional composers: Elisabeth-Claude Jacquet de La Guerre, Camilla de Rossi, Marianne von Martinez, Corona Schröter, Maria Theresia von Paradis, Eleanore Sophia Maria Westenholz (born Fritscher), and Luise Reichardt.

739. Viano, Richard J. "By Invitation Only: Private Concerts in France During the Second Half of the Eighteenth Century." *Recherches sur la Musique française classique* 27 (1991/1992): 131–162.

Detailed accounts of three distinguished salon hostess/musicians of the French aristocracy (Madame de Genlis, Madame Vigée-Lebrun and the Duchess d'Abrantes) form the basis for this exposition of the private concert world of the French aristocracy from 1750 to 1789. "The private concert was the only acceptable arena for performances of the aristocracy. Accomplished musicians belonging to their ranks established musical reputations in the salon often equal to that of their professional counterparts" (p. 160). The author notes the importance of aristocratic women of the salon, who, as hostesses, patronesses, concert organizers and musicians, were influential in determining musical taste.

## B.5 HISTORICAL PERSPECTIVES—1800 TO 1900

740. Aldrich, Elizabeth. *From the Ballroom to Hell: Grace and Folly in Nineteenth-Century Dance*. Evanston, IL: Northwestern University Press, 1991.

This collection of over a hundred excerpts from nineteenth-century etiquette, dance, beauty, and fashion manuals describes the manners, morals

and protocols of American nineteenth-century ballroom dance, and the society of which it was a part. Quotes include those pertaining to the rules of deportment and etiquette for ladies and gentlemen playing an instrument or singing, and opinions of the day concerning the importance of musical education for women.

741.  Allison, Doreen R., and Hélène Pouffe. "Ladies' Colleges and Convent Schools." In *Encyclopedia of Music in Canada*, ed. Helmut Kallmann, Gilles Potvin, et al., 2nd ed., pp. 706–707. Toronto: University of Toronto Press, 1992.

A history of women's music education offered in the ladies' academies and women's religious communities in Canada in the nineteenth and early twentieth centuries.

742.  Ballstaedt, Andreas, and Andreas Widmaier. *Salonmusik: Zur Geschichte und Function einer bürgerlichen Musikpraxis*. Beihefte zum Archiv für Musikwissenschaft, no. 28. Stuttgart, Germany: Franz Steiner Verlag Wiesbaden, 1989.

ISBN 3515049363. In German. Reviewed in *Journal of Musicological Research* 12, Supplement (1992): 195–197. This detailed social and cultural history of bourgeois domestic music-making in nineteenth-century Germany examines the role of women in domestic musical performance, the significance of the piano in the lives of female family members, derisive attitudes towards salon music in the late nineteenth century, and the iconography of women, the piano, and domestic music as illustrated through music title pages, advertisements, paintings, etc.

743.  Bernstein, Jane A. "'Shout, Shout, Up With Your Song!': Dame Ethel Smyth and the Changing Role of the British Woman Composer." In *Women Making Music: the Western Art Tradition, 1150–1950*, ed. Jane Bowers and Judith Tick, pp. 304–324. Pap. ed. Urbana, IL: University of Illinois Press, 1987.

Advocating equal opportunity for women musicians and challenging stereotypical late nineteenth-century British conceptions of ladies' music, the life and musical art of pioneering composer Ethel Smyth is examined.

744.  Block, Adrienne Fried. "Arthur P. Schmidt, Music Publisher and Champion of American Women Composers." In *The Musical Woman: An International Perspective. Volume 2, 1984–1985*, ed. Judith Lang Zaimont, Catherine Overhauser, and Jane Gottlieb, pp. 145–176. Westport, CT: Greenwood Press, 1987.

A survey of the business records, catalogs, printed music, and correspondence in the Arthur P. Schmidt Collection at the Library of Congress reveals that this music publisher was a promoter of works by American women composers. The author identifies a number of women composers whose work Schmidt published during the late nineteenth and early twenti-

eth centuries, summarizes the musical accomplishments of the women, and focuses on the working relationship between Schmidt and these composers as surmised from documentary evidence. The composers discussed are: Clara Kathleen Rogers, Helen Hopekirk, Margaret Ruthven Lang, Amy Marcy Cheney Beach, Mary Turner Salter, Emilie Frances Bauer, Mabel Wheeler Daniels, Gena Branscombe, and Marion Bauer.

745. Block, Adrienne Fried. "The Child is Mother of the Woman: Amy Beach's New England Upbringing." In *Cecilia Reclaimed: Feminist Perspectives on Gender and Music*, ed. Susan C. Cook and Judy S. Tsou, pp. 107–133. Urbana, IL: University of Illinois Press, 1994 (forthcoming).

746. Block, Adrienne Fried. "Two Virtuoso Performers in Boston: Jenny Lind and Camilla Urso." In *New Perspectives on Music: Essays in Honor of Eileen Southern*, ed. Josephine Wright and intro. Samuel Floyd Jr., pp. 355–371. Detroit Monographs in Musicology. Studies in Music, no. 11. Warren, MI: Harmonie Park Press, 1992.

This essay documents the importance of the American tours of two European virtuosas—concert singer Jennie Lind and violinist Camilla Urso—to concert life in United States. Their appearances in Boston, in 1850 and 1852 respectively, stimulated the building of new concert halls for high caliber European artists coming to America. The author demonstrates how the talent and professionalism displayed by these two women musicians served as an impetus for change for women musicians in this country, as they served as role models for younger women seeking a musical education and also for those American women wishing to further their careers as solo and ensemble concert musicians.

747. Block, Adrienne Fried, and Nancy Stewart. "Women in American Music, 1800–1918." In *Women in Music: A History*, ed. Karin Pendle, pp. 142–172. Bloomington, IN: Indiana University Press, 1991.

The author explains how improved access to education for women, the emergence of women as professional musicians, and post-Civil War feminism factored into America's changing musical climate for women from the nineteenth to the twentieth centuries. Touring America during this period were European virtuosic female singers of the opera and concert. Their importance as role models to aspiring, young, black and white American women singers (e.g., Elizabeth Taylor Greenfield, Clara Louise Kellogg, Emma Abbott, Sissieretta Jones) is examined. Music education for women as well as the role of women in the development of American music schools (e.g., Julia Crane, Clara Baur, Jeannette Thurber) is discussed. The contributions of women (both black and white) as composers and performers of religious music is noted. While women achieved prominence as professional solo pianists (e.g., Sophia Hewitt, Teresa Carreño, Julie Rivé-King, Fannie Bloomfield Zeisler) and violinists (e.g., Camilla Urso, Maud Powell), all-women's orchestras were formed so that trained women musicians would

155

have the opportunity to perform ensemble music. As composers, women contributed to the genre of the parlor song (e.g., Jane Sloman, Mrs. E. A. (Susan) Parkhurst, Faustina Hodges, Marion Dix Sullivan, Carrie Jacobs-Bond, Augusta Brown, Mary Turner Salter), and, as members of Boston's Second New England School, contributed to concert music composed during this period (e.g., Clara Kathleen Rogers, Helen Hopekirk, Margaret Ruthven Lang, Amy Beach).

748. Broyles, Michael. *'Music of the Highest Class': Elitism and Populism in Antebellum Boston.* New Haven, CT: Yale University Press, 1992.

In a chapter entitled "Private Music Making and Amateur Organizations," the participation of women in the musical life of pre-Civil War Boston is discussed (pp. 147–151). The involvment and treatment of women in Boston's Handel and Haydn Society while under Lowell Mason's direction is examined. Although women's music-making took place primarily in the milieu of the domestic, with narrowly defined gender associations with musical instruments (pp. 19–20) and societal roles which limited their broad participation, the author documents the activity of women as amateur and professional singers, as keyboard players (piano, organ), and teachers of music.

749. Cai, Camilla. "Clara Schumann: 'A Woman Must Not Desire To Compose..'." *The Piano Quarterly* 37, no. 145 (Spring 1989): 55–63.

750. Campbell, Margaret. "Ladies on the Bass Line." In *The Great Cellists*, pp. 200–209. North Pomfret, VT: Trafalgar Square Publishing, 1988.

Also appears in *The Violexchange* 4, no. 2 (1989): 30–35. The author presents brief profiles of women cellists of the nineteenth and early twentieth centuries: Lisa Cristiani, Gabrielle Platteau, Beatrice Eveline, May Mukle, Guilhermina Suggia, and Beatrice Harrison.

751. Citron, Marcia J. "European Composers and Musicians, 1880–1918." In *Women and Music: A History*, ed. Karin Pendle, pp. 123–141. Bloomington, IN: Indiana University Press, 1991.

The author begins with a discussion of the impact of politics, social reform, and industrialization on the lives of women in the late nineteenth and early twentieth centuries. The author then concentrates of the lives and work of these women composers: Augusta Holmés, Cécile Chaminade, Agathe Backer-Grøndahl, Lili Boulanger, Alma Mahler, and Ethel Smyth.

752. Crutchfield, Will. "Producing Heroines on Demand: Mathilde Marchesi Developed Some of the Finest Soprano Voices of Her, or Any, Time." *New York Times* 29 August 1993, II: 24–25.

Early recordings of Emma Calvé, Nelli Melba and Emma Eames, now reissued on compact disc, give the author occasion to also examine the musi-

cal life and pedagogical methods of the teacher of these famous sopranos, Mathilde Marchesi (1821–1913).

753. Dahm, Cecilie. *Kvinner komponerer: ni portretter av norske kvinnelige komponister i tiden 1840–1930.* Oslo, Norway: Solum Forlag, A.S, 1987.
ISBN 8256004851. In Norwegian. Beginning with an introductory essay on the role of women in the music of Norway, the author then presents lengthy biographical articles on nine Norwegian women composers of the nineteenth and early twentieth centuries: Frederikke Egeberg, Emma Dahl, Sophie Dedekam, Agathe Backer-Grøndahl, Mathilde Berendsen Nathan, Hanna Marie Hansen, Borghild Holmsen, Mon Schjelderup, and Signe Lund. The last section includes shorter, paragraph length biographies of twelve additional women composers: Magda (Magdalena) Bugge, Theodora Nicoline Cormontan, Judith Heber, Sine (Hansine) Holck (b. Lützow), Caroline Schytte Jensen, Signe Augusta Lindeman, Inger Bang Lund, Inga Laerum-Liebich, Hannah Løvenskiold (b. Parr), Marie Mostue (b. Horn), Gudrun Nordraak-Feyling, Fredrikke Rynning Waaler.

754. "Early European Women Flutists as Reported in *Allgemeine Musikalische Zeitung.*" *Flutist Quarterly* 15, no. 2 (Spring 1990): 8.
Special issue on women and the flute. Translated from the German by John Ranck. Excerpts of concert notices, 1819–1838.

755. Edmonds, Edward. "Anglican Spirituality: The Contributions of Victorian Women Hymnodists." *Anglican Free Press* 7, no. 2 (15 June 1990): 12–13.

756. Feldman, Ann E. "Being Heard: Women Composers and Patrons at the 1893 World's Columbian Exposition." *Notes* 47, no. 1 (September 1990): 7–20.
During the Chicago World's Columbian Exposition of 1893, seven orchestral works by women composers were performed, three of which were featured at the opening ceremonies of the Exposition's Woman's Building (Ingeborg von Bronsart's *Grand March*, Frances Ellicott's *Dramatic Overture*, and Amy Beach's *Festival Jubilate*; the four other works were composed by Helen Hood, Margaret Ruthven Lang, Alexandra Josiphovna, and Augusta Holmès). Feldman provides the historical background to this landmark series of performances, detailing the importance of women's patronage to the staging of these orchestral works, and noting in particular the advocacy of Bertha Honoré Palmer, the President of the Board of Lady Managers of the Columbian Exposition. The author then focuses on the reception of these women's compositions, noting the degree to which gender bias is manifested in published musical criticism of the time. Corrections and additions to this article appear in *Notes* 47, no. 3 (March 1991): 985.

757. Fuller, Sophie. "Unearthing a World of Music: Victorian and Edwardian Women Composers." *Women: A Cultural Review* 3, no. 1 (Summer 1992): 16–22.

Part of a special issue on women and music. With their lives and musical accomplishments virtually forgotten or ignored, the author reemphasizes the contributions of late nineteenth-century and early twentieth-century women composers and the difficulties they faced in making the transition from student to professional. Fuller explains how women composers of note during this time period (e.g., Maude Valerie White, Amy Woodforde-Finden, Liza Lehman, Adela Maddison, and Ethel Smyth), though confronted with all-male musician networks and societal attitudes which frowned upon public careers and notoriety for women of the upper and middle classes, were able to publish and stage performances of their works through self-reliance and promotion and/or through networking with family, patrons, fellow musicians, and friends. These informal networks forged by pioneering women composers of this time period culminated with the formation of the Society of Women Musicians in 1911.

758. Haas, Gerlinde. "Ein Aspekt bürgerlicher Musikkultur—dargestellt anhand eines 'Musikeralbums'." In *"Das Weib existiert nicht für sich": Geschlecterbeziehungen in der bürgerlichen Gesellschaft*, ed. Heide Dienst and Edith Saurer, pp. 162–173. Österreichische Texte zur Gesellschaftskritik, no. 48. Vienna: Verlag für Gesellschaftskritik, 1990.

ISBN 3851151232. In German. Translated title: "An Aspect of Bourgeois Musical Culture as Exhibited in One Musician's Album." The author examines the significance of the music album as a document for historical research on women composers in nineteenth-century Europe, with particular reference to a music album presented as a wedding gift to the Empress Elisabeth Amalia Eugenie of Austria in 1854. The *Huldigung der Tonsetzer Wiens an Elisabeth Kaiserin von Österreich (Wien 1854)*, reproduced in facsimile in *Denkmäler der Tonkunst in Österreich* (Band 142–144), contains works by five women composers: Julie von Britto, Josepha Fröhlich, Constance Geiger, Nina Stollewerk, and Emma Freiin von Staudach. Their contributions are studied within the more general context of the history, status, and reception of women composers in Austria, and includes comparisons with the other (male) composers represented in this volume.

759. Haas, Gerlinde. "Ein Urteil lässt sich widerlegen aber niemals ein Vorurteil: Gedanken zur Konzeption eines Komponistinnenporträts." *Studien zur Musikwissenschaft* 39 (1988): 387–399.

In German. Translated title: "A Judgement Can Be Refuted, But Never a Prejudice: Thoughts Regarding the Portrayal of Women Composers." The author explores the subject of male bias with regard to the reception of works by women composers, with particular reference to the life and compositions of Mathilde Kralik von Meyrswalden (1857–1944).

760. Hazen, Margaret Hindle, and Robert M. Hazen. *The Music Men: An Illustrated History of Brass Bands in America, 1800–1920*. Washington, D.C.: Smithsonian Institution Press, 1987.

Although brass bands were primarily men's organizations, this book documents women as performers in both professional and amateur bands. Professional touring family bands (pp. 33–35) included girls, boys and adult musicians of both sexes. Helen May Butler (later Young) organized and conducted first the Talma Ladies Orchestra, and later the Helen May Butler's Ladies Military Band, which concertized and achieved artistic and financial success up until 1912 (pp. 186–189). In the latter part of the nineteenth century, all-women amateur town bands were organized and musical instrument companies began promoting sales of brass band instruments to women (pp. 55–57).

761. Hyde, Derek. *New-Found Voices: Women in Nineteenth-Century English Music.* New ed. Ash, Near Canterbury, Kent, England: Tritone Music Publications, 1991.

ISBN 095175470X. Originally published by Belvedere Press (1984). This monograph surveys the contributions of women, as both professional and amateur musicians, to the musical life of England during the nineteenth century. In doing so, Hyde not only identifies the significant musicians of this era, but examines their roles and contributions within the context of social history. Beginning with a discussion of women as professional concert musicians, Hyde then focuses on women as composers, noting the contributions of women to the Victorian ballad genre. In the field of music education, Hyde discusses the activities of women as both teachers and writers about music, devoting a substantial part of this discussion to the life and work of Sarah Glover, whose Tonic Sol-fa method of teaching psalm singing and music notation was further developed and promulgated by John Curwen. Hyde then profiles the work of musician and music educator Mary Wakefield, who introduced the idea of the amateur community choral festival competition to England. The author then discusses the life of composer Ethel Smyth, and follows with an analysis of several of her works.

762. Irving, Howard. "'Music as a Pursuit for Men': Accompanied Keyboard Music as Domestic Recreation in England." *College Music Symposium* 30, no. 2 (Fall 1990): 126–137.

Drawing upon early nineteenth-century musical literature (e.g., *Quarterly Musical Magazine and Review*), and books on conduct and education for ladies and gentlemen, the author examines how prevailing attitudes regarding gender associations with the performance of musical instruments dictated the role of the male and female amateur music-maker in the performance of accompanied keyboard music, i.e., "ensemble works, particularly sonatas, in which a piano or harpsichord is the dominant musical force and various accompanying parts for violin, flute, or cello, are of lesser importance" (p. 127). While he demonstrates that both men and women of the upper classes were limited by biases which discouraged certain types of musical performance, the author also explains that accompanied keyboard music achieved a popularity precisely because it enabled men and women to

perform music together "in a manner consistent with established roles of the sexes" (p. 137).

763. Jensen, Byron William. *College Music on the Konza Prairie: A History of Kansas State's Department of Music from 1863 to 1990*. Diss. Ph.D., Kansas State University, 1990.

    Abstract in *Dissertation Abstracts International: A. Humanities and Social Sciences* 51, no. 6 (December 1990): 1928. DA# 9029272. Discusses Kansas State's history of providing collegiate study for women musicians, beginning in 1874.

764. Jordan, Carolyne Lamar. "Black Female Concert Singers of the Nineteenth Century: Nellie Brown Mitchell and Marie Selika Williams." In *Feel the Spirit: Studies in Nineteenth-Century Afro-American Music*, ed. George R. Keck and Sherrill V. Martin, pp. 35–48. Contributions in Afro-American and African Studies, no. 119, Westport, CT: Greenwood Press, 1988.

765. Kreitner, Kenneth. *Discoursing Sweet Music: Town Bands and Community Life in Turn-of-the-Century Pennsylvania*. Urbana, IL: University of Illinois Press, 1990.

    This historical and sociological study of the town band in America during the Victorian age briefly mentions the activity of women as band musicians (pp. 131–132). Commonly, rigid gender roles of this era dictated that women act as supporters and patrons of the bands, rather than performers within the bands (pp. 188–190).

766. Ling, Jan. "Die weibliche Rezeption von Kunst- und Popularmusik im bürgerlich-landlichen Milieu Schwedens." In *Musica Privata: Die Rolle der Musik im privaten Leben. Festschrift zum 65. Geburtstag von Walter Salmen*, ed. Monika Fink, Rainer Gstrein, and Günter Mössmer, pp. 141–149. Innsbruck, Austria: Edition Helbling, 1991.

    In German. Translated title: "The Female Reception of Art and Popular Music in the Cultural Milieu of Sweden's Rural Middle Class." This essay examines the domestic musical accomplishments of Swedish middle-class women in the nineteenth century, focusing on women's private music-making and the music they performed, as reflected through the music albums found in the homes of amateur women musicians.

767. Mayhall, Walter, and Marcellene Hawk Mayhall. "The First Women Commentators on the Life and Work of Johann Sebastian Bach: Women in the Forefront of Music Education." In *Women in History, Literature and the Arts: A Festschrift for Hildegard Schnuttgen in Honor of her Thirty Years of Outstanding Service at Youngstown State University*, ed. Lorrayne Y. Baird-Lange and Thomas A. Copeland, pp. 317–325. [Youngstown, OH]: Youngstown State University, 1989.

Amongst the material in their extensive personal library of materials on J. S. Bach, the authors have located a number writings by nineteenth-century women musicologists, music educators, and writers, including those by: Lina Ramann (Germany), Elise Vogel Polko (Germany), Ida Marie Lipsius (a.k.a. La Mara; Germany), Henrietta Keddie (a.k.a. Sarah Tytler; England), Henriette Fuchs (France), and Alice Maude Bowers (America).

768. McCarthy, Margaret W. "Feminist Theory in Practice in the Life of Amy Fay." *International League of Women Composers (ILWC) Journal* (December 1991): 9–12.

Amy Fay's life and musical career is "accounted for in light of three present day theories articulated by feminist scholars: 1) the theory of affiliation, 2) the theory of women's illness in the nineteenth century, and 3) the theory of the clubwoman as feminist" (p. 9).

769. Miller, Bonny H. "Ladies' Companion, Ladies' Canon? Women Composers in American Magazines from Godey's to the Ladies' Home Journal." In *Cecilia Reclaimed: Feminist Perspectives on Gender and Music*, ed. Susan C. Cook and Judy S. Tsou, pp. 156–182. Urbana, IL: University of Illinois Press, 1994 (forthcoming).

770. Molinari, Guido. "Aspetti della vita e dell'arte di tre compositrice." *Rassegna Musicale Curci* 43, no. 3 (September 1990): 23–28.

In Italian. The lives and art of nineteenth-century women composers Fanny Mendelssohn Hensel, Clara Wieck Schumann, and Alma Schindler Mahler are examined.

771. Moore, Julianna. "Women and the Flute in the Nineteenth Century." In *Fluting and Dancing: Articles and Reminiscences for Betty Bang Mather on Her 65th Birthday*, ed. David Lasocki, pp. 51–60. New York: McGinnis and Marx, 1992.

Research utilizing nineteenth-century treatises on the flute, music tutors, music criticism, and articles in journals and ladies' magazines provides insights into gender associations with the flute, and male attitudes towards emerging women flutists of the nineteenth century. May Lyle Smith is noted for advancing the cause of women flute players, and an appendix containing "Preliminary Biographical Notes on Female Flutists of the 19th Century" provides information on these women: a Miss Cann, Cora Cardigan, Anita Paggi, the Hudson Sisters, Florence Mukle and Elsie Wild (all from England); Maria Bianchine (Italy); and Julie Peterson (Denmark).

772. Olson, Judith E. "Luise Adolpha Le Beau: Composer in Late Nineteenth-Century Germany." In *Women Making Music: the Western Art Tradition, 1150–1950*, ed. Jane Bowers and Judith Tick, pp. 282–303. Pap. ed. Urbana, IL: University of Illinois Press, 1987.

773. Öhrström, Eva. *Borgerliga kvinnors musicerande i 1800–talets Sverige.*
Diss. Ph.D., Musikvetenskapliga institutionen, Göteborgs Universitet,
1987. Skrifter från Musikvetenskaplica institutionen, Göteborg, 15.
ISBN 9185974064. Published doctoral dissertation available from the
Musikvetenskapliga institutionen, Viktor Rydbergsgatan 24, S–41256
Göteborg, Sweden. Translated title: *Bourgeois Women Musicians in 19th
Century Sweden.* In Swedish, with English summary (pp. 191–196) and
abstract. Reviewed in *Svensk Tidskrift for Musikforskning* 70 (1988):
122–125. The author examines the dynamics between the musical worlds of
the aristocratic salon and bourgeois public performance in nineteenth-century
Sweden, focusing on the changing roles and opportunities for women musi-
cians in each milieu and relating these changes to the concurrent political, eco-
nomic, and social history of Swedish women during this era. Elfrida Andrée,
an organist, composer, orchestral conductor and feminist, is identified as a pio-
neering woman musician of late nineteenth-century Sweden, and her musical
contributions receive attention (musical examples included.) An appendix
includes biographical sketches of other notable women musicians of this time:
Carolina and Charlotte Åhlström, Jeanna Elizabeth Åkerman, Nanny
Angerstein, Valborg Aulin, Lovisa Bennet, Ellen Bergman, Therese Bolin,
Constance Brandh, Ingeborg von Schellendorf Bronsart, Hanna Brooman,
Fredrika Böorjesson, Maria Cederborg, Charlotte Cederström, Calla Curman,
Lotten Edholm, Princess Eugenie (Charlotta Eugenia Augusta Amalia
Albertina), Jenny Fahlstedt, Ida Fleetwood, Gerda Fock, Maria Frykholm,
Henrietta Gyllenhaal, Matilda d'Orozco, Adéle Haasum, Maria Mathilda
Hagbom, Hilma Hagelbäck, Aurore von Haxthausen, Wendela Hebbe, Amalia
Hjelm, Thecla Hjorth, Emilie Holmberg, Clary Magnusson, Amanda Maier-
Röntgen, Agnes M-n, Anna Moberg, Hulda Molinder, Helena Munktell, Anne
Sophie Myrberg, Lotten Mörner, Laura Netzel, Kristina Nilsson de Casa
Miranda, Elisabeth Nyström, Sophie Öberg, Ada Oterdahl, Wilhelmina
Christina (Mina) Ouchterlony, Lina Palin, Frerika Peyron, Amalia Redec,
Caroline Ridderstolpe, Helene de Ron, Alma Sahlberg, Amanda Sandborg,
Amanda Schmidt, Eva Louise Stackelberg, Fredrika Stenhammar, Elisa
Strömbom, Bertha Tammelin, Hélène Gustava Tham, Hilda Thegerström,
Thérése (Duchess of Dalarna), Emma Trägardh, Isidora Uddén, Agnes
Unnerus, Nina Wahlström, Annette Walter, Hildegard Werner, Fredrika
Wickman, and Anna Hedvig Wrangel. Bibliographies included.

774. Öhrström, Eva. "Elfrida Andrée och 'det kvinnliga släktets höjande'." In
*Kvinnors Musik,* ed. Eva Öhrström and Märta Ramsten, pp. 78–82. Stockholm,
Sweden: Sveriges Utbildningsradio AB and Svenska Rikskonserter, 1989.
ISBN 9126898101. In Swedish. Translated title: "Elfrida Andrée and
the Enhanced Role of Women." Discusses the status of women in music in
the mid-to-late nineteenth century in relation to the multiple musical
achievements of Elfrida Andrée, a composer, conductor, harpist, and cathe-
dral organist; these achievements paved the way for other women to pursue
careers as professional musicians in Sweden.

775. Öhrström, Eva. "I barnkammaren: Alice Tegnér och barnvisorna." In
*Kvinnors Musik*, ed. Eva Öhrström and Märta Ramsten, pp. 57–60.
Stockholm, Sweden: Sveriges Utbildningsradio AB and Svenska
Rikskonserter, 1989.
ISBN 9126898101. In Swedish. Translated title: "In the Nursery: Alice
Tegnér and Her Songs for Children." A brief look at Alice Tegnér's contri-
butions as a Swedish music educator and composer of children's songs dur-
ing the late nineteenth and early twentieth centuries.

776. Öhrström, Eva. "Konsten att bli en god värdinna." In *Kvinnors Musik*, ed.
Eva Öhrström and Märta Ramsten, pp. 22–28. Stockholm, Sweden:
Sveriges Utbildningsradio AB and Svenska Rikskonserter, 1989.
ISBN 9126898101. In Swedish. Translated title: "The Art of Being a
Good Hostess." A woman's ability to perform on the piano in the domestic
sphere was necessary in order to provide the proper social entertainments;
the article also demonstrates how the piano was used as an icon of female
domesticity with its numerous illustrations.

777. Öhrström, Eva. "Mathilda d'Orozco: salongernas näktergal." In *Kvinnors
Music*, ed. Eva Öhrström and Märta Ramsten, pp. 62–70. Stockholm,
Sweden: Sveriges Utbildningsradio AB and Svenska Rikskonserter, 1989.
ISBN 9126898101. In Swedish. Translated title: "Mathilda d'Orozco:
Nightingale of the Salon." Examines the career and repertoire of this Italian
singer who captivated the audiences of the Swedish salons of the 1820s.

778. Peeples, Georgia. "Nineteenth-Century Strictures Against Female Wind
Players." *NACWPI [National Association of College Wind and Percussion
Instructors] Journal* 36, no. 1 (Fall 1987): 11–16.

779. Powell, Maud. "Women and the Violin." *Journal of the Violin Society of
America* 8, no. 2 (1987): 112–116.
Originally published in *Ladies Home Journal* (February 1896).

780. Reich, Nancy B. "Clara Schumann." In *Women Making Music: the Western
Art Tradition, 1150–1950*, ed. Jane Bowers and Judith Tick, pp. 249–281.
Pap. ed. Urbana, IL: University of Illinois Press, 1987.
This scholarly study details the various aspects of the life of Clara
Wieck Schumann: as composer, concert pianist, pupil/daughter of Friedrich
Wieck, wife of Robert Schumann, mother, and woman artist living in nine-
teenth-century society.

781. Reich, Nancy B. "European Composers and Musicians, ca. 1800–1890." In
*Women and Music: A History*, ed. Karin Pendle, pp. 97–122. Bloomington,
IN: Indiana University Press, 1991.
Concurrent to the rise of the middle class in the nineteenth century was
the growth of public concerts, the rise to prominence of the professional

performer, a more fully developed educational system for music, and an increase in amateur musical activities. Women not only had opportunities for musical training, but established and taught in music schools, composed, performed professionally, wrote about music. etc. Yet, as the author points out, women were often restricted to performing their music in segregated groups, or more commonly, in the domestic sphere. Reich, therefore, examines how women musicians overcame limitations so as to practice their art. Women composed in all genres including the art song (Luise Reichardt, Josephine Lang, Fanny Mendelssohn Hensel, Clara Schumann, Pauline Viardot-Garcia), opera and operetta (Louise Bertin, Marie de Grandval, Ingeborg von Bronsart), and choral music (Fanny Mendelssohn Hensel, Johanna Kinkel, Clara Schumann, Luise Adolpha Le Beau, etc.). Women both concertized on the piano and composed for the instrument, including Maria (Wolowska) Syzmanowska, Louise Farrenc, Léopoldine Blahetka, Fanny Mendelssohn Hensel, and Clara Schumann. Chamber music (e.g., by Louise Farrenc, Clara Schumann, Fanny Mendelssohn Hensel) and orchestral music (e.g., by Louise Farrenc, Clara Schumann, Luise Adolpha Le Beau) were also genres in which women composed. Women became prominent as singers, pianists, harpists, and violinists. Thus, the author demonstrates how women, though still limited by societal, cultural and masculine notions of ideal feminine behavior, participated in a wide array of professional and private musical activities in the nineteenth century.

782. Reich, Nancy B. "Women as Musicians: A Question of Class." In *Musicology and Difference: Gender and Sexuality in Music Scholarship*, ed. Ruth Solie, pp. 125–146. Berkeley, CA: University of California Press, 1993.

The author maintains that both class and gender must be taken into consideration in the history of women's participation in music in nineteenth-century Europe. Reich compares the status and musical experiences of both professional women musicians of the "artist-musician class" (p. 125) and the nonprofessional women musicians of the aristocracy and the bourgeoisie, noting how the former and latter groups were subjected to the limitations and prejudices characteristic of the "cult of domesticity." She presents an account of the life of the female music student enrolled in the conservatory, and explains how social status came to dictate the musical role of a woman upon completion of her education. She emphasizes that while the female professional musician of the artist-musician class had opportunities awaiting her which may not have been available to the woman musician of the aristocracy, the woman who decided to "go public" often underwent a personal scrutiny which focused on issues relating to her behavior and appearance rather than talent. In order to further reinforce one's understanding of the contrasting lives of nonprofessional and professional women musicians, she profiles the differing experiences of Fanny Mendelssohn Hensel and Clara Wieck Schumann.

783. Roell, Craig H. *The Piano in America, 1890–1940*. Chapel Hill, NC: University of North Carolina Press, 1989.

Introductory material (p. xi–xii, xiv) traces the piano's function as a cultural icon, including the piano's association with women, domesticity, and "feminine" traits. Chapter 1, "The Place of Music in the Victorian Frame of Mind," discusses the aesthetic which ascribed music with moral, spiritual, and restorative qualities. Furthermore, the piano symbolized social respectability, manners, domestic harmony, and female accomplishment. It was believed that women should be educated in music as a preparation for wifehood, insuring that their children would be properly instilled with these cultural and social values.

784. Roske, Michael. "The Professionalism of Private Music Teaching in the 19th Century: A Study with Social Statistics." *Bulletin of the Council for Research in Music Education* 91 (Spring 1987): 143–148.

Using documents such as directories and address books from Altona (now part of Hamburg) in northern Germany, the author compiles an occupational profile of private music teachers active from 1800 to 1850, delineating the gender makeup of this group. The author demonstrates that though fewer females than males were employed as music teachers, the percentage of females employed increased considerably during this time period. However, women's professional careers lasted for a shorter duration than their male counterparts. Often the records show an unsteady employment pattern for females, with inconsistent vocational descriptions and a general status that could be considered unstable and changing. The author points to problems with identifying the gender of an individual by their vocational title, as gender was not often indicated in the German language designation of a professional music teacher at that time.

785. Rothenbusch, Esther. "The Joyful Sound: Women in the Nineteenth-Century United States Hymnody Tradition." In *Women and Music in Cross-Cultural Perspective*, ed. Ellen Koskoff, pp. 177-194. Contributions in Women's Studies, no. 79. Westport, CT: Greenwood Press, 1987.

This article discusses the social, cultural, and religious underpinnings of the increased role for women as composers of gospel hymns, reflecting the increased role of women in nineteenth century American religious life as a whole, as evidenced by the change from "hard" to "soft" religious doctrine, and coinciding with the prevalence of the cult of female domesticity in the nineteenth century. Hymn writers profiled are Phoebe Knapp, Fanny Crosby, Eliza Edmunds Hewitt, May Whittle Moody, Clara H. Scott, Susan Parkhurst, as well as the temperance activist/hymn editor Anna Gordon.

786. Salsini, John Louis. *The Guitar and the Ideal of Femininity in Nineteenth Century America*. Thesis. M.A., University of Minnesota, 1990.

787. Smith, Elizabeth J. "On Singing Hymns by Women Writers: Reflections on Some Hymn Texts from The Australian Hymn Book." *The Hymn* 44, no. 2 (April 1993): 12–16.

Four hymns by women writers of the late nineteenth and early twenti-
eth centuries contained in the *The Australian Hymn Book* are analyzed from
a feminist perspective. These hymnwriters include: Sarah Betts Rhodes,
Dorothy Frances Gurney, Katie Barclay Wilkinson, and Bessie Porter Head.

788. Thomas, Jean Waters. *Music of the Great Sanitary Fairs: Culture and Charity
in the American Civil War*. Diss. Ph.D., University of Pittsburgh, 1989.
    Abstract in *Dissertation Abstracts International: A. Humanities and
Social Sciences* 50, no. 6 (December 1989): 1480. DA# 8921361. As musi-
cal events to raise funds for the relief effort to benefit Union soldiers during
the U.S. Civil War, Sanitary Fairs depended on the charity of women orga-
nizers and on the participation of women musicians. In her investigation, the
author provides a historical background to the relationship between charita-
ble efforts and music, and the significant role played by women in these
activities throughout history.

789. Tick, Judith. "Passed Away is the Piano Girl: Changes in American Musical
Life, 1870–1900." In *Women Making Music: the Western Art Tradition,
1150–1950*, ed. Jane Bowers and Judith Tick, pp. 325–348. Pap. ed. Urbana,
IL: University of Illinois Press, 1987.
    This essay discusses the changing role of women in music at the turn of
the twentieth century as being representative of this era's cultural feminism
and increasingly progressive attitudes towards women as professionals in
American society. The passé Victorian "piano girl" made way for the "New
Woman" at the beginning of the twentieth century, with advances in music
education for women, and an increase in the numbers of women as profes-
sional music teachers, instrumentalists, and composers. Women also repre-
sented an economic threat to the male-dominated music profession. The
author discusses the conservatism and discriminatory practices of the musical
establishment towards trained women musicians, giving rise to the formation
of all-women's musical ensembles. Amidst the polemical musical criticism
concerning the ability of women to compose and musical aesthetics based on
masculine/feminine polarities, the author notes that increasing numbers of
women composers (e.g., Amy Beach, Helen Hopekirk, Margaret Ruthven
Lang) were able to have their works performed and published.

790. Urso, Camilla. "Women and the Violin: Women as Performers in the
Orchestra." *Strad* 102 (February 1991): 154.
    A previously unpublished manuscript of a paper presented by this vio-
linist for the Woman's Musical Congress of the 1893 World's Columbian
Exposition. A brief history of women playing the violin is presented, and
Urso makes a case for equal professional and economic opportunity for
women as orchestra musicians.

791. Whitesitt, Linda. "The Role of Women Impresarios in American Concert
Life, 1871–1933." *American Music* 7, no. 2 (Summer 1989): 159–180.

792. Wright, David. "Cherchez la femme!" *Chamber Music* 10, no. 1 (Spring 1993): 9, 31.

   A discussion of three nineteenth-century chamber works by women composers: Clara Schumann's *Piano Trio in G minor* (op. 17), Fanny Mendelssohn Hensel's *Piano Trio in D minor* and Teresa Carreño's *String Quartet in B minor*.

793. Wright, Josephine. "Black Women in Classical Music in Boston During the Late Nineteenth Century: Profiles of Leadership." In *New Perspectives on Music: Essays in Honor of Eileen Southern*, ed. Josephine Wright and intro. Samuel Floyd Jr., pp. 373–407. Detroit Monographs in Musicology. Studies in Music, no. 11. Warren, MI: Harmonie Park Press, 1992.

   This valuable addition to the literature on black women in music documents the participation of black women in the concert life of Boston. Introductory material focuses on the sociocultural environment of nineteenth century Boston which, as one of America's oldest free-black communities, allowed black citizens to gain advancements in education and the arts. Specifically, some of Boston's well-known conservatories opened their doors to black students and women as early as the 1860s. Eighty-one black women with careers in music in Boston from 1870–1900 are identified, including not only singers, but pianists, organists, string players, composers, patronesses, impresarios, music teachers, and writers about music. The appendix lists these women, with a brief annotation and source(s) documenting the information included with each entry.

## B.6  HISTORICAL PERSPECTIVES—1900 TO THE PRESENT

794. "The 1992–93 Lili Boulanger Award." *International League of Women Composers (ILWC) Journal* (February 1993): 23.

   This article provides background information on the three women composers (Michelle Ekizian, Lori Dobbins, and Bun-Ching Lam) receiving the 1992/1993 Lili Boulanger Award granted by the National Women Composers Resource Center in San Francisco.

795. Adams, Daniel. "Women Composers and the Noble Snare." *International League of Women Composers (ILWC) Journal* (October 1992): 1–3.

   The author analyzes two works by twentieth-century women composers appearing in *The Noble Snare*, a four-volume collection of unaccompanied solos for snare drum (Baltimore, MD: Smith Publications, 1988–1990). The two works discussed here are "Amazonia Dreaming" by Annea Lockwood (in volume 3), and "The Single Stroke Roll Meditation" by Pauline Oliveros (in volume 4).

796. Allen, Doris. "Women's Contributions to Modern Piano Pedagogy." In *The Musical Woman: An International Perspective. Volume 2, 1984–1985*, ed.

Judith Lang Zaimont, Catherine Overhauser, and Jane Gottlieb, pp. 411–444. Westport, CT: Greenwood Press, 1987.

The author identifies women of the twentieth century who have contributed to the field of piano pedagogy. The essay is introduced by a general historical discussion of women in the music teaching profession through the turn of the century. Women not only taught, but they founded preparatory schools and conservatories, wrote pedagogical materials, concertized, composed, added to our knowledge of performance practice, offered new insights into keyboard music by specific composers, etc. Early pioneers were Harriette Brower, Amy Fay, Clara and Bertha Baur, Florence Sutro, Fanny Morris Smith, Janet Daniels Schenck, May Garrettson Evans, Angela Diller, Julia Etta Crane. Other innovative educators mentioned include Helen M. Hosmer, Kathryn Obenshain, Mary Lou Hunger, and Frances Clark. Those mentioned as women who concertized and taught include Teresa Carreño, Lucy Marie Olga Agnes Hickenlooper (better known as Olga Samaroff), Wanda Landowska, Rosalyn Tureck, Abby Whiteside, Rosina Lhevinne, and Adele Marcus. Composer/teachers discussed include Nadia Boulanger and Louise Talma. Authors of music teaching materials for children include Mrs. John Spencer Curwen, Ruth Crawford Seeger, Frances Aronoff, and Donna Wood. Composers of new teaching pieces which focus on the challenges of twentieth century music include Joan Last, Gertrude Firnkees, Betty Beath, Barbara Pentland, Mary Elizabeth Clark (also publishes twentieth century pedagogical material via her company, Myklas Press), Ruth Schonthal, and Judith Lang Zaimont. Authors of college-level pedagogy texts include Yvonne Enoch, Isabelle Byman, Ellen Thompson, and Joan Last.

797. *American Women Composers, Inc.: A Tenth Anniversary Celebration 1976–1986*. Washington, D.C.: American Women Composers, Inc., 1987.

This forty-page commemorative volume includes the program notes for the twelve concerts of women's music produced during AWC's anniversary season. Also presented are "Notes on the Tenth Anniversary" by AWC's Founder and President Tommie Ewert Carl (pp. 2–6), "The Lost Classicists: A Tribute to Black American Women Composers," by Betty Jackson King (pp. 30–31), and numerous photographs.

798. Andrews, Mildred Tanner. "Ladies' Musical Clubs." *Washington Women as Path Breakers*, pp. 114–118. Dubuque, IA: Kendall/Hunt, 1989. pp. 114–118.

The author chronicles the activities of white and black ladies' musical clubs in Washington State during the late nineteenth and early twentieth centuries, particularly those located in Takoma and Seattle. She notes the individual achievements of composer Mary Carr Moore and concert violinist/conductor Madame Mary Davenport Engberg, and concludes with a discussion of the contributions of Nellie Centennial Cornish, musician, instructor, and founder (in 1914) of Seattle's Cornish Institute, a private school for the visual and performing arts.

799. Ardoin, John. "A Pride of Prima Donnas." *Opera Quarterly* 5, no. 1 (Spring 1987): 58–70.

   The author profiles twentieth-century opera sopranos Mary McCormic, Maria Jeritza, and Bidú Sayão.

800. Baier, Christian, Ursula Simek, et al. "Österreichische Komponistinnen des 20. Jahrhunderts." *Österreichische Musik Zeitschrift* 46, no. 7–8 (July/August 1991): 377–391.

   Part of a special issue devoted to women in music. The following twentieth-century Austrian women composers are profiled: Luna Alcalay, Maria Bach, Sophie Carmen Eckhardt-Gramatté, Lio Hans (Lili Scheidl-Hutterstrasser), Maria Hofer, Frida Kern, Mathilde Kralik von Meyrswalden, Alma Mahler, Johanna Müller-Hermann, Olga Neuwirth, Helga Schiff-Reimann, Andrea Sodomka, Silvia Sommer, Flora St. Loup, Luise Walker, Mia Zabelka, and Grete von Zieritz.

801. Barrere, George. "Woodwind Instruments Attracting Women." *Flutist Quarterly* 15, no. 2 (Spring 1990): 11.

   Reprinted from *The Flutist*, December 1926. Special issue on women and the flute. The author comments on the increasing numbers of women studying the flute and other woodwind instruments.

802. Bindas, Kenneth J. *All of This Music Belongs to the Nation: The Federal Music Project of the WPA and American Cultural Nationalism 1935–1939.* Diss. Ph.D., University of Toledo, 1988.

   Abstract in *Dissertation Abstracts International. A. Humanities and Social Sciences* 50, no. 2 (August 1989): 528. DA# 8909905. Chapter 9, "Stepdaughters of Orpheus: Women Musicians in the FMP" (pp. 216–232), examines the status of women musicians before the Federal Music Project and the subsequent employment and promotion of women performers and composers by the Federal Music Project.

803. Brown, Dorothy M. "The Cultural Landscape." In *Setting a Course: American Women in the 1920's*, pp. 195–219. Boston, MA: Twayne Publishers, 1987.

   This exploration into the changing lives of American women in the 1920s addresses women's contributions to literature, dance, theatre, and music (both classical and popular forms).

804. Brown, Rae Linda. "The Woman's Symphony Orchestra of Chicago and Florence B. Price's *Piano Concerto in One Movement.*" *American Music* 11, no. 2 (Summer 1993): 185–205.

   This article is introduced by a history of the Woman's Symphony Orchestra of Chicago, which, under the directorship of Robert Czerwonky, Ebba Sundstrom, and Ethel Leginska, championed the music of American and women composers. The author then focuses on the ensemble's special

relationship with composer Florence Price, and examines the details surrounding the performance, by the Woman's Symphony Orchestra of Chicago, of her *Piano Concerto in One Movement*. A musical analysis of the concerto is then presented.

805. Chambers, R. *British Women Composers and Music Technology*. Unpublished Master's Thesis, University of Leicester, 1993.

A survey of the use of technology by contemporary women composers living in Britain and Ireland. Cited in Comber (1993; see #537).

806. Cohen, Paul. "Vintage Saxophones Revisited: Early Professional Women Saxophonists." *Saxophone Journal* 15, no. 1 (July/ August 1990): 8–13.

Before America's Great Depression, numerous women forged professional careers as saxophonists, either as soloists, members of chamber ensembles, or in the performance of vaudeville. Some of the more accomplished performers of the early twentieth century were Hilda Elhardt, Alta R. Wells, and Kathryne E. Thompson, who was also a music educator and composer. German-based Ingrid Larssen was one of the few women concert saxophonists performing during the 1930s and 1940s. In recent years, women have once again gained recognition as professional virtuosas; Carina Rascher and Linda Bangs (both members of the Rascher Saxophone Quartet), the Fairer Sax (an all-female saxophone quartet), and other soloists in the fields of classical music and jazz are mentioned in this regard.

807. Creech, Kay. "Michigan Festival Concert Band: Birth of a New Tradition." *Hot Wire* 6, no. 1 (January 1990): 32–33, 61.

This article describes the origins of the Michigan Women's Festival Concert Band and profiles its musical director, Sharon Still. For the 1989 Festival, the group commissioned and performed concert band works by composers Anne McGinty, Clair Johnson, and Gwyneth Walker.

808. Crews, Thomas L. *American Choral Music for Women's Chorus Since 1960*. Diss. D.M.A., University of Washington, 1987.

Abstract in *Dissertation Abstracts International: A. Humanities and Social Sciences* 48, no. 12 (June 1988): 3005. DA# 8802210.

809. "Critical Attitudes Towards Women Violinists." *Musical America* 112, no. 1 (January/February 1992): 64.

Reprint of article in *Musical Americana* (January/February 1912), paraphrasing Maud Powell's views on women violinists of her day.

810. Danner, Peter. "The Guitar in America as Mirrored in *Cadenza* (1894–1924)." *Soundboard* 18, no. 3 (Fall 1991): 10–19.

Includes information on four prominent women guitarists: Vahdah Olcott Bickford (also known as Ethel Lucretia Olcott), Jennie M. Durkee, Gertrude T. Miller, and Elsie Howard (née Tooker).

811. "Distinguished Musicians Made Honorary  Members." *Pan Pipes* 84, no. 2 (Winter 1992): 8–9.
    Paragraph length biographies of Roberta Rymer Balfe, Zoe Erisman, Elizabeth Powell, Sabine Meyer, and Patricia Prattis Jennings; portraits included.

812. Duncan, Scott. "Ellen Taaffe Zwilich: Emerging from the Mythos." In *The Musical Woman: An International Perspective. Volume 3, 1986–1990*, ed. Judith Lang Zaimont, Jane Gottlieb, Joanne Polk, and Michael J. Rogan, pp. 410–438. Westport, CT: Greenwood Press, 1991.
    This survey of the career and the music of Ellen Taaffe Zwilich includes a works list and a discography.

813. Edwards, J. Michele. "North America Since  1920." In *Women and Music: A History*, ed. Karin Pendle, pp. 211–257. Bloomington, IN: Indiana University Press, 1991.
    This discussion focuses first on women composers since 1920 and the various musical languages utilized, and then considers the role and status of women as orchestral performers and conductors since the early twentieth century. Edwards ends with a brief survey of women's contributions to the musics of Mexico, Latin America, and Canada. Composer profiles comprise the main body of this essay, including those discussing: Marion Bauer, Mary Howe, the African-American composer Undine Smith Moore, Ruth Crawford Seeger, Vivian Fine, Louise Talma, Barbara Kolb, Joan Tower, Nancy Van de Vate, Annea Lockwood, Pauline Oliveros, Laurie Anderson, Joan La Barbara, Meredith Monk, Jean Eichelberger Ivey, Ellen Taaffe Zwilich, Julia Perry, Beth Anderson, Joyce Mekeel, and others. An interesting discussion focuses on works written for religious worship and those reflecting a female spiritual aesthetic. General overviews of women composers in the mediums of electronic and computer music, as well as those synthesizing new and old musical styles, literature, drama and/or technology also reveals the breadth of the female voice in contemporary music.

814. Elkins-Marlow, Laurine. "'Music at Every  Meeting': Music in the National League of American Pen Women and the General Federation of Women's Clubs, 1920–1940." In *Politics, Gender and the Arts: Women, the Arts and Society*, ed. Ronald Dotterer and Susan R. Bowers, pp.  185–199. Susquehanna University Studies. Selinsgrove, PA: Susquehanna University Press, 1992.
    This essay examines the importance of women's clubs to the promotion of musical endeavors of women during the early twentieth century, examining in particular the support given to music and musicians by the National League of American Pen Women (NLAPW) and the General Federation of Women's Clubs (GFWC). Though each had a different focus (e.g., the NLAPW represented professional women authors, composers, etc., while the GFWC advocated cultural philanthropy and outreach at the local

level) both supported women's musical aspirations and activities in the United States.

815. Evans, Carmen Murphy. *Some Twentieth-Century American Women as Composers and Conductors of Orchestral Art Music.* Thesis. M.M.E., Virginia Commonwealth University, 1991.

816. Fainlight, Ruth. "An Operatic Collaboration." *Women: A Cultural Review* 3, no. 1 (Summer 1992): 44–46.

Part of a special issue on women and music. This poet/librettist describes her collaboration with composer Erika Fox on their opera *The Dancer Hotoke*, a story of two Japanese women.

817. Feng Jing. "Women Chamber Philharmonic Orchestra." *Beijing Review* 34 (22 April 1991): 53–54.

The Aiyuenu Chamber Philharmonic Orchestra, an all-women's ensemble in China, celebrates its first anniversary. The article describes how the orchestra was formed, focuses on the women musicians who perform in the group, describes their repertoire, and reviews their performances.

818. Finger, Susan Pearl. *The Los Angeles Heritage: Four Women Composers, 1918–1939.* Diss. Ph.D., University of California at Los Angeles, 1986.

Abstract in *Dissertation Abstracts International: A. Humanities and Social Sciences* 48, no. 6 (December 1987): 1349. DA# 8711686. Reviewed in *Inter-American Music Review* 9, no. 1 (Fall/Winter 1987): 117–119. The author profiles the lives and musical accomplishments of four women composers of early twentieth-century Los Angeles: Carrie Jacobs-Bond, Fannie Charles Dillon, Pauline Alderman, and Elinor Remick Warren. Included in each profile is an extensive biographical essay, a works list, bibliography, and an examination of works of musical criticism on each composer. The author also supplies information on a number of other women composers, including Carolyn Alchin, Kathleen Lockhart Manning, Mary Carr Moore, Frances Marion Ralston, and Gertrude Ross.

819. Firnkees, Gertrud. "Klaviermusik europäischer Komponistinnen des 20. Jahrhunderts." *Üben und Musizieren* 4, no. 3 (1987): 208–212.

In German. Translated title: "Piano Music by European Women Composers of the Twentieth Century." This survey of piano music by European women composers of the twentieth century discusses the works of the following: Natalie Pravossudovitch, Yvonne Desportes, Ruth Zechlin, Siegrid Ernst, Jacqueline Fontyn, Myriam Marbé, Biancamaria Furgeri, Brunnhilde Sonntag, and others.

820. Frauenmusik-Forum. *Schweizer Komponistinnen der Gegenwart: eine Dokumentation.* Ed. Sibylle Ehrismann and Thomas Meyer. Edition Hug, no. 11338. Zurich, Switzerland: Hug, 1985.

In German or French. Translated title: *Contemporary Swiss Women Composers: A Documentation.* Reviewed in *Neue Zeitschrift für Musik* 148 (March 1987): 72.

821. Gaume, Matilda. "Ruth Crawford Seeger." In *Women Making Music: the Western Art Tradition, 1150–1950*, ed. Jane Bowers and Judith Tick, pp. 370–388. Pap. ed. Urbana, IL: University of Illinois Press, 1987.

   This biographical profile of the early twentieth century American composer includes a list of her works and a discography.

822. Groh, Jan Bell. *Evening the Score: Women in Music and the Legacy of Frédérique Petrides.* Fayetteville, AR: University of Arkansas Press, 1991.

   Reviewed in *Library Journal* 116 (August 1991): 103; *Pan Pipes of Sigma Alpha Iota* 84, no. 3 (Spring 1992): 8, 22; *Music Educators Journal* 78, no. 8 (April 1992): 92. The focus of this important book is on Frédérique Petrides, orchestral conductor, founder (in 1933) of the all-women's Orchestrette Classique, and editor and publisher of *Women in Music*, a newsletter published from 1935 to 1940. The book reprints all issues of this newsletter, and includes a generous sampling of photographs of the women musicians, conductors, and orchestras of the day, thus documenting the women in music movement of this era.

823. Gronemeyer, Gisela. "Kommunikationskraft der Gefühle: Zu Meredith Monk und Laurie Anderson." *MusikTexte* 44 (April 1992): 5–16.

   In German. On the compositional and performance art of Meredith Monk and Laurie Anderson.

824. Gronemeyer, Gisela. "Voice is the Original Instrument: Die weibliche Avantgarde in den USA." In *Vom Schweigen befreit: Internationales Komponistinnen-Festival Kassel, 20. bis 22. Februar 1987*, pp. 60–64. Internationales Komponistinnen-Festival Kassel (1987). Spons. and org. Hans Eichel, Kulturamt der Stadt Kassel, Internationalen Arbeitskreis "Frau und Musik," Roswitha Aulenkamp-Moeller, and Christel Nies. Gustav-Freytag-Strasse 1, 6200 Wiesbaden, Germany: Bevollmächtigten der Hessischen Landesregierung für Frauenangelegenheiten, 1987.

   In German. Emphasizing the importance of the voice and body as "original instruments," this short essay discusses women in U.S. avant-garde music, with particular reference to the artists Pauline Oliveros, Meredith Monk, Laurie Anderson, Joan La Barbara, Jana Haimsohn, and Beth Anderson.

825. Hayes, Deborah. "Peggy Glanville-Hicks: A Voice From the Inner World." In *The Musical Woman: An International Perspective. Volume 3, 1986–1990*, ed. Judith Lang Zaimont, Jane Gottlieb, Joanne Polk, and Michael J. Rogan, pp. 371–409. Westport, CT: Greenwood Press, 1991.

This profile of twentieth-century Australian composer Peggy Glanville-Hicks includes a works list, discography, selected bibliography, and a list of primary resources held in archival collections.

826. Hill, Robert. "A Ruling Passion: Conservatory Regulations Were Aimed at Keeping Female Students Free from the Temptations and Dangers of School Life." *Ithaca College Quarterly* (Fall 1991): 18–21.

Examines campus life for female students of the Ithaca Conservatory of Music [later Ithaca College] in the early 1900s.

827. Hinkle-Turner, Elizabeth. "Recent Electro-Acoustic Music by Women." *International League of Women Composers (ILWC) Journal* (October 1992): 8–14.

Examines the contributions of Daria Semegen, Laurie Spiegel, Anna Rubin, Priscilla McLean, Carla Scaletti, Cindy McTee, Sally Reid, Sylvia Pengilly, Joanne Carey and Jean Eichelberger Ivey.

828. Jacobson, Marion S., et al. "Women on the Podium." *AWC [American Women Composers] News/Forum* 8, no. 1–2 (Spring/Summer 1988): 2–11.

Profiles of conductors JoAnn Falletta, Ann Kearns, Victoria Bond, Kate Tamarkin, and Catherine Comet.

829. Kakinuma, Toshie. "Letters From the Front Lines. The State of the Art for Women Composers: Japan." *Ear* 15, no. 10 (March 1991): 18.

This brief survey of the activity of contemporary women composers in Japan mentions the contributions of Kikuko Masumoto, Haruna Miyake, Mieko Shiomi, and Yuko Katsumata.

830. Kareda, Urjo. "Ladies of Spain." *Opera Canada* 33, no. 1 (Spring 1992): 24–28.

The author "salutes some of the legendary Spanish divas of our time" (p. 24): Teresa Berganza, Conchita Supervia, Pilar Lorengar, Montserrat Caballé, and Victoria de los Angeles.

831. Knight, Ellen. "The American String Quartette: Loeffler's 'Feminine Flonzaleys'." *Sonneck Society Bulletin* 18, no. 3 (Fall 1992): 98–101.

The author traces the career successes of women violinists who were students of Charles Martin Loeffler, a composer and a prominent teacher of the violin in New England during the early twentieth century. Knight examines how Loeffler's association with William Longy, musical director of a number of musical societies and ensembles in Boston, created opportunities for many women students of this renowned violin teacher, a number of whom led successful concert careers as both professional soloists and orchestral musicians (e.g., Nina Fletcher, Carmela Ippolito, Irma Seydel). When deciding to coach a string quartet, Loeffler formed the American String Quartette, an ensemble of women string players from the Boston area,

led by first violinist Gertrude Marshall. Considered to be the premier women's chamber ensemble of the time, the author discusses the personnel of the ensemble, their performance history, and their reputation for excellence as evidenced by their positive reception in the musical press.

832. Kohno, Toshiko, and Jan Gippo. "Retiring Flutists of the Boston Symphony Orchestra: A Portrait of Doriot Anthony Dwyer [and] a Personal Tribute to Lois Schaefer." *Flutist Quarterly* 15, no. 2 (Spring 1990): 25–30.

833. Krydl, Hans M. "Zeitgenössiche Komponistinnen in Ost und West." *Österreichische Musik Zeitschrift* 45, no. 5 (May 1990): 271–272.

In German. Translated title: "Contemporary Women Composers of the East and West." The author discusses composers Violeta Dinescu and Nancy Van de Vate, and pianist Rosario Marciano, with regard to their efforts to promote the music of women composers.

834. Kulturinstitut Komponistinnen Gestern-Heute. ed. *Komponistinnen gestern-heute: Festival International Heidelberg 85–89: Dokumentation.* Düsseldorf, Germany: Frauenmusik-Vertrieb, 1989.

In German. Translated title: "Women Composers, Yesterday and Today: A Documentation of the International Festival at Heidelberg, 1985-1989."

835. Lefanu, Nicola. "Blood Wedding: A New Opera." *Women: A Cultural Review* 3, no. 1 (Summer 1992): 40–43.

Part of a special issue on women and music. Commissioned by the Women's Playhouse Trust (England), the composer briefly describes her new opera, noting its exploration into male and female sexual relations.

836. Lievense, Willy. "Componerende vrouwen vragen meer aandacht." *Mens en Melodie* 42, no.3 (March 1987): 136–139.

In Dutch. This article briefly summarizes recent developments in the field of women in music in the Netherlands, including the release of an album entitled *Honneur aux Dames*, the activities of musicologist Helen Metzelaar and the women composers organization Vrouw en Muziek, and recognizes the contributions of several twentieth-century Dutch women composers (e.g., Tera de Marez Oyens, Jeanne Beyerman-Walraven, and Reine Colaco Osorio-Swaab).

837. Locke, Ralph P., and Cyrilla Barr, eds. *Cultivating Music in America: The Work of Women Patrons and Activists Since 1870.* Berkeley, CA: University of California Press, forthcoming.

838. Mabry, Sharon. "Music by Contemporary Women Composers for Soprano." *NATS Journal* 47, no. 1 (September/October 1990): 33.

Focuses on vocal works by Jacqueline Fontyn and Elizabeth Bell.

839. Mabry, Sharon. "Music by Contemporary Women Composers, Part 2." *NATS Journal* 47, no. 2 (November/December 1990): 28.

Focuses on vocal works by Victoria Bond and Jean Eichelberger Ivey.

840. Mabry, Sharon. "Music by Contemporary Women Composers, Part 3." *NATS Journal* 47, no. 3 (January/February 1991): 40.

Focus on the vocal music by Nancy Van de Vate and Mary Howe.

841. Mabry, Sharon. "Music by Contemporary Women Composers, Part 4." *NATS Journal* 47, no. 4 (March/April 1991): 32.

The art songs of Elizabeth Vercoe are featured.

842. MacAuslan, Janna. "Noteworthy Women: The Boulanger Sisters." *Hot Wire* 6, no. 1 (January 1990): 12–13, 62.

Brief article on Nadia and Lili Boulanger.

843. MacAuslan, Janna, and Kristan Aspen. "Noteworthy Women: Price, Bonds, and Perry: Three Black Women Composers." *Hot Wire* 5, no. 3 (September 1989): 12–13, 41.

On composers Florence Price, Margaret Bonds, and Julia Perry.

844. Matheopoulos, Helena. *Diva: Great Sopranos and Mezzos Discuss Their Art*. London, England: Victor Gollancz, 1991.

Republished in 1992 by Northeastern University Press, Boston. Reviewed in *Opera* 43, no. 1 (January 1992): 71; *Opera News* 57 (December 19, 1992): 50–51. In short chapters (about 10 pages each), the following singers discuss their life, work, and music. Sopranos include: June Anderson, Josephine Barstow, Hildegard Behrens, Montserrat Caballé, Ghena Dimitrova, Mirella Freni, Edita Gruberova, Dame Gwyneth Jones, Eva Marton, Rosalind Plowright, Lucia Popp, Leontyne Price, Katia Ricciarelli, Renata Scotto, Cheryl Studer, Dame Joan Sutherland, Dame Kiri Te Kanawa, Anna Tomowa Sintow. Mezzos include: Agnes Baltsa, Teresa Berganza, Grace Bumbry, Brigitte Fassbaender, Christa Ludwig, Tatiana Troyanos, Lucia Valentini Terrani, Frederica von Stade.

845. McGinty, Doris Evans. "Black Women in the Music of Washington, D.C., 1900–1920." *New Perspectives on Music: Essays in Honor of Eileen Southern*, ed. Josephine Wright and intro. Samuel Floyd Jr., pp. 409–449. Detroit Monographs in Musicology. Studies in Music, no. 11. Warren, MI: Harmonie Park Press, 1992.

The author examines the contributions of black women to Washington D.C.'s musical life, focusing on the church, public schools, the studio, and the concert hall. Noting that Washington was a free-black community in the early nineteenth century, the author stresses the accessibility to public school and higher education for blacks, which led to the city's recognition as an Afro-American cultural center. Concert music was cultivated enthusiastically, espe-

cially by women, in the large black churches (which also functioned as concert halls) and in the homes of prominent blacks. Black women made significant contributions as musicians, music teachers, or concert organizers for the various musical clubs, societies, and performing ensembles. The first black-owned and operated conservatory, the Washington Conservatory of Music and School of Expression, was founded in 1903 by Harriet Gibbs Marshall. This impressive documentation of black women's musical contributions to Washington, D.C. concludes with a bio-bibliography of 170 women singers, pianists, organists, string players, choral directors, school and studio music teachers, musical educators and directors, composers, writers about music, and concert managers.

846. Mendl-Schrama, Heleen. "Frauen am Dirigentenpult, ein Bericht aus englischen Konzertsälen und Opernhäusern." *Musikhandel* 41, no. 1 (January 1990): 1–3.

In German. Translated title: "Women at the Podium: A Report from the English Concert Halls and Opera Houses." The author profiles English women conductors Jane Glover, Odaline de la Martinez, and Sian Edwards.

847. Mitgang, Laura. "Germaine Tailleferre: Before, During, and After Les Six." In *The Musical Woman: An International Perspective. Volume 2, 1984–1985*, ed. Judith Lang Zaimont, Catherine Overhauser, and Jane Gottlieb, pp. 177–221. Westport, CT: Greenwood Press, 1987.

This in-depth study of French composer Germaine Tailleferre (1892–1983) also includes a list of her published works, a discography, and a selected bibliography.

848. Moor, Paul. "Bay Area Women's Philharmonic." *Musical America* 108 (November 1988): 48.

849. Neuenschwander, Leni. *Frau in der Musik: die internationalen Wettbewerbe für Komponistinnen 1950–1989—Eine Dokumentation.* Elisabethstrasse 5, D-6800, Mannheim 1, Germany: The author, 1989.

Reviewed in *Neue Zeitschrift für Musik* 151, no. 9 (September 1990): 53; *Das Orchester* 38, no. 9 (September 1990): 963. A documentary survey of this women composers' competition first held in Basel, and then in Mannheim, Germany. Documents include concert programs, as well as short essays on various topics concerning the history of women in music. Also included are biographies and photographs of the prizewinners, press reviews, and a composite composer/country index of all women who have participated in the competition. Introductory essays include "Cäcilie, Patronin der Musik," by Hans Vogt (pp. 25–29).

850. Neuls-Bates, Carol. "Elizabeth Sprague Coolidge, Twentieth Century Benefactress of Chamber Music." In *The Musical Woman: An International Perspective. Volume 2, 1984–1985*, ed. Judith Lang Zaimont, Catherine

Overhauser, and Jane Gottlieb, pp. 136–144. Westport, CT: Greenwood Press, 1987.

851. Neuls-Bates, Carol. "Women's Orchestras in the United States, 1925–1945." In *Women Making Music: the Western Art Tradition, 1150–1950*, ed. Jane Bowers and Judith Tick, pp. 349–369.Pap. ed. Urbana, IL: University of Illinois Press, 1987.

   Noting the lack of acceptance of female orchestral musicians by the male symphonic establishment of the early twentieth century, the author concentrates on the development of the unprecedented number of all-women's ensembles during the years following World War I, identifying the pioneering women and organizations active in this milieu.

852. Ostleitner, Elena, and Marion  Diederichs-Lafite. "Österreichische Interpretinnen des 20. Jahrhunderts." *Österreichische Musik Zeitschrift* 46, no. 7–8 (July/August 1991): 393–395.

   In German. Translated title: "Austrian Interpreters of the 20th Century." Part of a special issue devoted to women in music. The author profiles three Austrian women musicians: conductor Agnes Grossmann, pianist Rosario Marciano, and trumpet player Carole Dawn Reinhart.

853. Palacios, Diane. "Music, Three in Concert." *Ms.* 1, no. 1 (July/ August 1990): 72–73.

   The musical and personal lives of Ruth Laredo, Eugenia Zukerman, and Nadja Salerno-Sonnenberg are featured.

854. Palmer, Larry. *The Harpsichord in America: A Twentieth Century Revival.* Bloomington, IN: Indiana  University Press, 1989.

   This volume includes chapters devoted to Wanda Landowska as well as "Two 'First Ladies of Harpsichord,'" harpsichordists Yella Pessl and Sylvia Marlowe.

855. Parker, David. *Discipline, Perfection and  Beauty: A History of Choral Music at Furman University and  Greenville Woman's College.* Greenville, S.C.: A Press, 1988.

856. Parker, Linda F. "Women in Music Education in St. Paul, Minnesota from 1898–1957." *Bulletin of  Historical Research in Music Education* 8 (July 1987): 83–90.

857. Perry, Pamela J. "Women as Patrons of Music: The Example of Connecticut, 1890–1990." *International League of Women Composers (ILWC) Journal* (June 1992): 9–12.

   Based on the author's doctoral dissertation, this article first surveys the contributions of women patrons to musical life in Connecticut. The author notes the establishment of the Norfolk Music Festival achieved by the impe-

tus and substantial donations of Ellen Battell Stoeckel, the substantial endowments given by women patrons to the Yale University School of Music, women's support of the New Haven Symphony Orchestra, the "collective patronage" of musical activities at the local level through women's musical clubs, and the building of a music hall in Hartford with financial support from patroness Dotha Bushnell. In her summary, Perry reveals patterns in women's forms and styles of patronage. For example, about three-quarters of the most prominent women patrons had no children of their own; most women patrons chose to be anonymous donors; most subsidized institutions rather than individuals. These commonalities then further inform our knowledge of women's patronage in America during the late nineteenth and twentieth centuries.

858. Petersen, Barbara A. "The Vocal Chamber Music of Miriam Gideon." In *The Musical Woman: An International Perspective. Volume 2, 1984–1985*, ed. Judith Lang Zaimont, Catherine Overhauser, and Jane Gottlieb, pp. 222–255. Westport, CT: Greenwood Press, 1987.

   While concentrating primarily on Miriam Gideon's vocal chamber music, this article is introduced by a general discussion of the life and work of this American composer, followed by a presentation of Gideon's views about composing as a woman. A comprehensive works list, as well as a discography and selected bibliography is included.

859. Philipp, Beate, Susanne Elgeti, Martina Schläger, and Ulrike Schwandt, eds. *Komponistinnen der Neuen Musik: Alice Samter, Felicitas Kukuck, Erna Woll, Ruth Bodenstein-Hoyme, Ruth Zechlin, Eva Schorr und Siegrid Ernst. Eine Dokumentation*. Furore-Edition, no. 858. Kassel, Germany: Furore-Verlag Matthei, 1993.

   ISBN 3927327131. In German. Translated title: "Women Composers of New Music." The seven chapters in this book correspond to the seven contemporary European composers named in the book's title. Each chapter includes an interview with the composer, background information on her compositions, a comprehensive works list, a discography, and musical examples.

860. Pollack, Howard. "Four Women: Eugenia Frothingham, Victoria Glaser, Betsy Warren and Rosamond Brenner." In *Harvard Composers: Walter Piston and His Students, from Elliot Carter to Frederick Rzewski*, pp. 357–369. Metuchen, NJ: Scarecrow Press, 1992.

   The musical lives of these four women are profiled. Musical examples are included.

861. Pool, Jeannie. "Researching Women in Music in California." In *California's Musical Wealth: Sources for the Study of Music in California. Papers Presented at the Joint Conference of the Northern and Southern California Chapters of the Music Library Association, 17-18 May 1985*, ed. Stephen

M. Fry, pp. 123–130. S.l.: Music Library Association. Southern California Chapter, 1988.

The author reports on the research undertaken for completion of a project entitled, "The Story of All-Women's Orchestras in California, 1893–1955." The project entailed preparation of a bibliography and a pamphlet on the subject, as well as the compilation of a traveling exhibition which included photographs collected during the project, production of a public radio documentary and a videotaped television program, and the archiving of materials collected and used (which are now housed at the International Institute for the Study of Women and Music, Department of Music, California State University, Northridge, California.) The project documents how women musicians used creative solutions to circumvent discriminatory practices, thus enabling them to gain education, training, and opportunity to perform professionally.

862. Richter, Ottfried. "Zur Stellung der Frau im Laienchorwesen." *Lied und Chor* 79, no. 9 (1987): 205.

In German: Translated title: "The Position of Women in the Lay Chorus." The author surveys women choral singers in order to develop a profile of their educational, musical, and personal backgrounds.

863. Ripley, Colette S. "Organ Music by Women from Poland." *American Organist* 27, no. 3 (March 1993): 62–63.

The author discusses the following twentieth-century organ works: *Esquisse* by Grazyna Bacewicz; *Spotkania* by Maria Amelia Dziewulska; *Mater Polonica* by Joanna Bruzdowicz.

864. Robinson, Susan Louise Bailey. *Three Contemporary Orchestral Compositions by American Women: A Guide to Rehearsal and Performance for the University Orchestra Conductor.* Diss. Ph.D., Texas Tech University, 1991.

Abstract in *Dissertation Abstracts International: A. Humanities and Social Sciences* 52, no. 10 (April 1992): 3472. DA# 9204408. The author's intent in this dissertation is to encourage the performance of orchestral works by women composers by compiling a guide to these three compositions: *Celebration for Orchestra* by Ellen Taaffe Zwilich; *Sequoia* by Joan Tower, and *Symphony: Water Music* by Libby Larsen. Each guide includes an analysis of the work, biographical details about the composer, and additional sources for reference.

865. Roma, Catherine. *The Choral Music of Twentieth Century Composers Elisabeth Lutyens, Elizabeth Maconchy, and Thea Musgrave.* Diss. D.M.A., University of Cincinnati, 1989.

Abstract in *Dissertation Abstracts International: A. Humanities and Social Sciences* 50, no. 9 (March 1990): 2701. DA# 8917964.

866. Roma, Catherine. "Contemporary British Composers." In *Women and Music: A History*, ed. Karin Pendle, pp. 175–186. Bloomington, IN: Indiana University Press, 1991.

   The author concentrates on the musical careers of Elisabeth Lutyens, Elizabeth Maconchy, Grace Williams, Priaulx Rainier, Thea Musgrave, Nicola LeFanu, and Judith Weir. She also discusses the status of the woman composer in England during the twentieth century, and the existence of women composer organizations in England (such as the Society of Women Musicians (1911–ca.1970) and Women in Music (1987—).

867. Roma, Catherine. "The Sister Singers Network." *Hot Wire* 3, no. 2 (March 1987): 30–31.

   The author examines the history of the Sister Singers Network, an organization of over 30 women's choirs, and explores its role within the larger context of the women's music movement in the U.S.

868. Roma, Catherine. "Women's Choral Communities: Singing for our Lives." *Hot Wire* 8, no. 1 (January 1992): 36–39, 52.

   Adapted from a paper presented at the "Feminist Theory and Music I" conference at the University of Minnesota and at the "Music and Gender" conference at King's College in London. The author presents a history of women's choral groups from the formative years (1970) to the present, concentrating on the dedication of these groups to music, feminism, and community activism. The article identifies various organizations, examines their repertoire and programming concerns, and presents several of their mission statements.

869. Roos, James. "Modern Prima Donnas Sing Different Tune." *Miami Herald* 17 September 1989, in *Newsbank: Review of the Arts,* Performing Arts 16, Fiche 149 (October 1989): D3–D4.

870. Rosen, Judith. "Composers Speaking for Themselves: An Electronic Music Panel Discussion." In *The Musical Woman: An International Perspective. Volume 2, 1984–1985*, ed. Judith Lang Zaimont, Catherine Overhauser, and Jane Gottlieb, pp. 280–312. Westport, CT: Greenwood Press, 1987.

   Taking place at New York University on March 28, 1981, the First International Congress of Women in Music presented a panel discussion on electronic and computer music, moderated by Ruth Anderson and featuring composers Tera de Marez Oyens, Liz Phillips, Alice Shields, Daria Semegen, Maryanne Amacher, Beverly Grigsby, Laurie Spiegel, and special guest Otto Luening. Here, the author has transcribed and edited the presentations of each panelist, followed by subsesquent interviews with composers Annea Lockwood and Ruth Anderson.

871. Russell, Dave. "'What's Wrong with Brass Bands?' Cultural Change and the Band Movement, 1918–c.1964." In *Bands: The Brass Band Movement*

*in the 19th and 20th  Centuries*, ed. Trevor Herbert, pp. 57–101. Milton
Keynes;  Philadelphia: Open University Press, 1991.

Included is a brief discussion (pp. 65–66, 97) of the forces of change
during the 1930s which enabled women to expand their limited musical
association with brass band organizations from that of spectator/patron to
performing band musician. The availability of instrumental music training,
combined with the shift in the male population to wartime activities boosted
opportunities for women brass players.

872. Ryder, Georgia A. "Thea Musgrave and the  Production of Her Opera
*Harriet, the Woman Called Moses*: An  Interview With the Composer." In
*New Perspectives On  Music: Essays in Honor of Eileen Southern*, ed.
Josephine  Wright and intro. Samuel Floyd Jr, pp. 463–477. Detroit
Monographs in Musicology. Studies in Music, no. 11. Warren, MI:
Harmonie Park Press, 1992.

This interview with Thea Musgrave delves into the origin of this opera
and its subsequent production. The opera is based on the life of Harriet
Tubman, heroine of the Underground Railroad, who (in the composer's
words) represents "every woman who dared to defy injustice and tyranny."

873. Saba, Therese Wassily. "Women in Music."    *Classical Guitar* 10
(September 1991): 50.

This article profiles the classical guitarist and music publisher Rose
Andresier. As a performer, Ms. Andresier has promoted guitar music by
women composers from around the world. Guitar chamber and solo works
by about twenty contemporary women composers are identified.

874. Seltzer, George. "How Do Women and Older  Musicians Fare." In *Music
Matters: The Performer and the  American Federation of Musicians*, pp.
211–221. Metuchen:  Scarecrow Press, 1989.

The author examines the status of the female membership of the musi-
cian's trade union, the American Federation of Musicians. The author dis-
cusses the involvement and experiences of women in big bands and
symphony orchestras throughout the history of the AFM, women as orches-
tral conductors, as well as the formation of all-women's ensembles, such
women's symphonies and jazz bands. Discrimination against women
orchestral musicians is discussed.

875. Shatin, Judith. "Women in Computer Music: A  Sampling." *AWC
News/Forum* 9  (Spring/Summer 1991): 3–7.

The following women composers of electronic and computer music
are profiled: Joanne D. Carey, Emma Lou Diemer,  Janis Mattox, Linda
Seltzer, Judith Shatin, and Diane Thome. Includes a discography.

876. Shropshire, Liz. "Where are the Woman  Composers?" *Cue Sheet* 6, no. 2
(April 1989): 53–62.

In conducting research into the history of women film composers, this student composer finds a dearth of information in the literature. Through a series of interviews of older, established male film composers, women musicians and composers, and finally three women film composers currently active in Hollwood (and their agents), the author finds that patterns of past prejudice against women as composers linger on in the present. Interviews and detailed background information are presented for these contemporary female television and film composers: Angela Morley, Nan Schwartz, and Shirley Walke.

877. Smith, Catherine Parsons. "'A Distinguishing Virility': Feminism and Modernism in American Art Music." In *Cecilia Reclaimed: Feminist Perspectives on Gender and Music*, ed. Susan C. Cook and Judy S. Tsou, pp. 90–106. Urbana, IL: University of Illinois Press, 1994 (forthcoming).

878. Stephen, Lynnéa Y. "Music To Our Ears." *Ms.* 1, no. 6 (May/June 1991): 77. Bay Area Women's Philharmonic enters its second decade.

879. Stout, Glennis. "Women and the Flute: Three Early 20th Century Flutists." *Flutist Quarterly* 17, no. 2 (Spring 1992): 17–27.
Here the former *Flutist Quarterly* editor has compiled material, both biographical and autobiographical, profiling three women flutists of the early twentieth century. Included are: an autobiography of Ardelle Hookins (first female to graduate as a wind player from the Curtis Institute); a feature on Marion Jordan, "the child flute prodigy of Burlington," as related by her daughter Shirley Stolley; and a reprint of a short biographical piece by Robert Brown on Constance Pether, a virtuoso performer and flute teacher from Australia.

880. Tignac, Catherine Z. "Becoming 'One of the Boys'." *Journal of the International Double Reed Society* 19 (July 1991): 23–26.
A former woman bassoonist reflects on the obstacles faced by the woman orchestral musician during the 1930s and 1940s.

881. Timbrell, Charles. "Three Sisters." *The Strad* 102 (April 1991): 316–318.
The sisters Marguerite (cellist), Suzanne (violinist) and Thérèse (pianist) Chaigneau comprised the Chaigneau Trio, a well-known chamber ensemble performing in early twentieth-century France. In addition to discussing the accomplishments of the Chaigneau Trio as a chamber group, Timbrell profiles each sister, noting their individual contributions to music education and concert life in France during this time period.

882. Walker-Hill, Helen. "Black Women Composers in Chicago: Then and Now." *Black Music Research Journal* 12, no. 1 (Spring 1992): 1–23.
The author describes the conditions in Chicago which fostered the development of many black women composers, and examines the

contributions of Nora Holt, Florence Price, Margaret Bonds, Irene Britton Smith, Dorothy Donegan, Micki Grant, Margaret Harris, Betty Jackson King, Lena Johnson McLin, and Regina A. Harris Baiocchi.

883. Weber, J. F. "The First Woman Conductor (Practically)." *Fanfare* 12, no. 2 (November/December 1988): 182–184.

The compact disc reissue of a 1937 recording of Nadia Boulanger conducting Monteverdi madrigals inspires the author to discuss other women conductors and composers of the twentieth century; a list of women conductors on record is included.

884. Weems, Helen R. *The History of the Women's String Symphony Orchestra of Baltimore, Inc.* Thesis. M.M., Peabody Institute of the Johns Hopkins University, 1990.

The thesis presents a detailed history of the Women's String Symphony Orchestra of Baltimore, Inc., and explores the significance of the formation of women's symphonies in general during the 1930s with relation to the integration women musicians into the American symphony orchestra. Appendices include information about individual members of the Women's Symphony, results of a survey of eleven major U.S. orchestras in cities which had produced a women's symphony, and programs presented by the Women's String Symphony of Baltimore, Inc.

885. Weissweiler, Eva. "Einführung in das Thema." In *Vom Schweigen befreit: Internationales Komponistinnen-Festival Kassel,* 20. bis 22. Februar 1987, pp. 14–16. Internationales Komponistinnen-Festival Kassel (1987), Spons. and org. Hans Eichel, Kulturamt der Stadt Kassel, Internationalen Arbeitskreis "Frau und Musik," Roswitha Aulenkamp-Moeller, and Christel Nies. Wiesbaden, Germany: Bevollmächtigten der Hessischen Landesregierung für Frauenangelegenheiten, 1987.

In German. The author introduces the theme ("Freed from Silence") of the Kassel International Festival of Women Composers in this essay on the recent history of the women composers' movement in Germany (pp. 14–16).

886. Weissweiler, Eva. "Zur Situation der Avantgarde-Komponistinnen in der Bundesrepublik." In *Vom Schweigen befreit: Internationales Komponistinnen-Festival Kassel, 20. bis 22. Februar 1987*, pp. 64–67. Internationales Komponistinnen-Festival Kassel (1987). Spons. and org. Hans Eichel, Kulturamt der Stadt Kassel, Internationalen Arbeitskreis "Frau und Musik," Roswitha Aulenkamp-Moeller, and Christel Nies. Wiesbaden, Germany: Bevollmächtigten der Hessischen Landesregierung für Frauenangelegenheiten, 1987.

In German. Translated title: "On the Situation of Avant-Garde Women Composers in (the former) West Germany."

887. Weissweiler, Eva, and Roswitha Sperber, eds. *Die Frau in der Musikgeschichte. Komponistinnen gestern-heute e.V.: 3. Internationales Festival Heidelberg, 12.–14. Juni 1987. Programm Dokumentation* Heidelberg, Germany: Kulturinstitut Komponistinnen, gestern-heute e.V., 1987.

    ISBN 3920679016. Conference program for the third Internationales Festival Komponistinnen, gestern-heute e.V. Includes introductory statements (by Prof. Dr. Rita Süssmuth, Barbara Schäfer, Reinhold Zundel, Eva Rieger, and Roswitha Sperber), the schedule of concerts and lectures, bio-graphical information on women composers, etc.

888. Wenzel, Lynn. "Black Women Blaze Musical Trails." *New Directions for Women* 19, no. 1 (January/February 90): 9.

    Capsule biographies of black women composers Julia Amanda Perry and Florence Price.

889. "Women's Musical Clubs." In *Encyclopedia of Music in Canada*, 2nd ed. Helmut Kallmann, Gilles Potvin, et al., p. 1420. Toronto: University of Toronto, 1992.

    Identifies sixteen women's musical clubs in Canada, ten of which are still active. Each named club also has its own entry. These clubs include: Duet Club of Hamilton (p. 387); Club Musical de Québec (p. 278); Ladies' Morning Musical Club of Montreal (pp. 707–708); Concert Society of Ottawa (listed under Morning Music Club, p. 889); Women's Musical Club of Winnipeg (p. 1420); Women's Musical Club of Toronto (pp. 1419–1420); Calgary Women's Musical Club (p. 187); Halifax Ladies' Musical Club (pp. 569–570); Vancouver Women's Musical Club (p. 1362); Victoria Musical Art Society (p. 1370); Regina Musical Club (p. 1120); Edmonton Musical Club (p. 404); Women's Musical Club of Saskatoon (p. 1419); Orpheus Club, Regina (p. 1001); Lethbridge Music Club (p. 746); Wednesday Morning Musicale, Winnipeg (p. 1391).

890. Zierolf, Robert. "Composers of Modern Europe, Australia, and New Zealand." In *Women and Music: A History*, ed. Karin Pendle, pp. 187–207. Bloomington, IN: Indiana University Press, 1991.

    The introduction focuses on the effects of war, politics, and social and economic change on the experience of the artist in modern Europe. The author then surveys the musical activity of women in various countries or regions, concentrating on women who have achieved prominence as composers. He examines the lives and careers of the following French women composers: Nadia Boulanger, Germaine Tailleferre, Claude Arrieu, Betsy Jolas. He notes that while Germany has been a country in which women musicians have had difficulty in overcoming prejudicial attitudes, certain women composers such as Grete von Zieritz, Ilse Fromm-Michaels and Ruth Zecklin have achieved a modicum of success. He stresses the importance of

women's music advocates in Germany, who, by establishing international women composer organizations, have promoted (through festivals, concerts, publication activity, etc.) both new and older musical works by women composers. He considers Polish women composers (Wanda Landowska, Grazyna Bacewicz, Marta Ptaszynska) as well as those from Russia and Eastern Europe (Sofia Gubaidulina, Violeta Dinescu). Moving to another part of the world, the author briefly discusses the contributions of women composers from Australia and New Zealand (e.g., Peggy Glanville-Hicks, Margaret Sutherland, Jennifer Fowler, Alison Bauld, Gillian Whitehead, etc.)

CHAPTER 7

# Women in Jazz and Popular Music

## Part A.  General Perspectives

891.  Ainley, Rosa, and Sarah Cooper. "Who's Conning Who?" *Trouble and Strife: The Radical Feminist Magazine*, no. 23 (Spring 1992): 11–15.

The authors scrutinize the superficiality of mainstream popular music, focusing on two fronts. They question the appeal of women artists of the musical mainstream (e.g. Madonna, k.d. lang, etc.) to the lesbian audience, and reject the gloss and androgyny donned by such artists for commercial ends. They also criticize the politics of the music industry, and note the gratuitous appropriation of formerly "marginal" musics, including traditional and popular non-Western musics. The authors lament as "boring and unadventurous" (p. 15) the music choices made by the lesbian music audience, and offer the names of women musicians whose creative and challenging music is artist-controlled rather than industry-controlled.

892.  Archer, Robyn, and Diana Simmonds. *A Star is Torn*. New York: Dutton, 1987. Originally published by Virago Press (London) in 1986. Reviewed in *Popular Music* 6, no. 3 (1987): 355–357.

This book grew out of Robyn Archer's preparatory research for her role in a successful one-woman cabaret show staged in London, Sydney, and Melbourne entitled "A Star is Torn," in which she portrayed many of the song stylists mentioned in this book. Archer provides a feminist appreciation and assessment of the rise to stardom and demise of famous women singer/entertainers: Marie Lloyd, Bessie Smith, Helen Morgan, Jane Froman, Carmen Miranda, Billie Holiday, Edith Piaf, Judy Holliday, Judy Garland, Dinah Washington, Marilyn Monroe, Patsy Cline, and Janis Joplin. The author's empathy with these women as performers is evident. She celebrates their vitality and talent, focuses on their struggle with the male

musical establishment, and finds patterns in their "distressed" lives, which for many here ended either tragically or prematurely. Her appended bibliography includes a section on feminism, politics, and society, in addition to particular musical and biographical sources, implying the book's suitability for use in introductory women's studies courses.

893. Bayton, Mavis. "Out on the Margins: Feminism and the Study of Popular Music." *Women: A Cultural Review* 3, no. 1 (Summer 1992): 51–59.

    Admonishing both musical academe for its trivialization of popular music study and feminist musicology for its lack of representation of popular music topics, the author identifies the lacunae which exist in feminist writing about popular music, noting that most feminist studies of popular music are undertaken by those primarily involved with disciplines other than music (e.g. sociology, communications and media studies, anthropology, etc.). Bayton recognizes the need for additional research on women's music-making from creation to performance, studies which analyse the music created by women, and studies which focus on the function of music in women's lives (e.g. especially on the importance of dance to women's use of music).

894. Bowers, Jane M. "Feminist Visions: Four Black American Musicians." *Feminist Collections* 11, no. 1 (Fall 1989): 10–12.

    Film/video review essay. Discusses: *Alberta Hunter: My Castle's Rockin* (blues); *Cissy Houston: Sweet Inspiration* (gospel); *Tiny and Ruby: Hell Divin' Women* (jazz).

895. Cooper, Carol. "Repeat Performance: From Jazz to Folk to Pop, Soul, Poetry and Rap, From One Generation to the Next, Our Performers Mirror Each Other and Carry On the Tradition." *Essence* 21 (May 1990): 144–148.

896. Early, Gerald. "Her Picture in the Papers: Remembering Some Black Women [in blues, jazz, and popular music]." *Antaeus* 60 (Spring 1988): 9–38.

897. Ellison, Mary. "Freedom is a Lonely Word: Women and Song." In *Lyrical Protest: Black Music's Struggle Against Discrimination*, pp. 105–118. New York: Praeger, 1989.

    The author concentrates on the role of song as a means of resistance and as an expression of independence for black women, from slave songs to blues to the more recent vocal styles of black women. As she does so, the author refers to particular songs, singers, and recordings throughout her discussion.

898. George, Nelson. "Native Son: Sisters Who Sing." *Village Voice* 36 (5 March 1991): 19.

    A black male journalist's view of black women trying to make it in the music world.

899. "Girl Groups are Back! 90's Style. Talented Female Vocalists are Once Again Adding Glamour and Soul to the Music Scene." *Ebony* 45, no. 11 (September 1990): 96–100.

    Profiles of five black female musical groups: pop vocal stylists En Vogue and Good Girls; the gospel group Witness; rappers Silk Tymes Leather; instrumentalists/vocalists Klymaxx.

900. Hoke, S. Kay. "American Popular Music." In *Women and Music: A History*, ed. Karin Pendle, pp. 258–281. Bloomington, IN: Indiana University Press, 1991.

    An essay on the musical styles and the women musicians of American popular music from circa 1940 to 1990. Hoke begins with a brief overview of the women of Tin Pan Alley and the Big Band era, profiling the singer Peggy Lee. In country music, the author recognizes the contributions of the Carter Family, Kitty Wells, Patsy Cline, Loretta Lynn, and Dolly Parton. She quickly surveys the women artists in the gospel music tradition, and then moves on to 1950's rock (Big Mama Thornton, Carole King), the 1960's folk revival (Joan Baez, Joni Mitchell), rock (Janis Joplin), and soul (Aretha Franklin, Diana Ross and the Supremes). In the 1970s the influence of feminism was evident in the growth of music (and music companies) emanating from the women's movement, with performers who addressed political, feminist, and lesbian concerns. Madonna is singled out as the most important female rock artist of the 1980s and the video age.

901. Lueck, Therese L. "One Voice: The Legacy of Women Singers in Popular Music." In *America's Musical Pulse: Popular Music in Twentieth-Century Society*, ed. Kenneth J. Bindas, pp. 221–228. Contributions to the Study of Popular Culture, no. 33. Westport, CT: Greenwood Press, 1992.

    The author provides a panoramic view of women's contributions to the vocal art in popular music and its various sub-genres, such as blues, folk, jazz, gospel, etc. However, what emerges is a loosely-constructed and unconvincing sociological argument for the innate primacy of women as singers, stemming from their natural singing ability as displayed in the domestic sphere (lullabies, ballads, laments, moans, etc.).

902. McAdams, Janine C. "Female Artists the Essence of the Night: Magazine Honors 8 Celebrities at 20th Anniversary Bash." *Billboard* 102 (3 November 1990): 31.

903. McAdams, Janine C. "Hear them Roar: Countess, Tisha Among Current Crop." *Billboard* 104 (31 October 1992): 17.

    New black female artists are featured: singers Countess Vaughn and Tisha Campbell, singer/songwriter Lonette McKee, and female rapper Boss.

904. Mellers, Wilfrid. *Angels of the Night: Popular Female Singers of Our Time*. New York: Blackwell, 1986.

Reviewed in *Jazz Journal International* 40 (February 1987): 25; *Popular Music* 6, no. 3 (1987): 355–357.

A scholarly study recognizing the significance of the female voice in the music of women pop, rock, jazz, blues, and folk artists.

905. Okamoto, David. "In Fine Form." *Jazziz* 7, no. 3 (April/May 1990): 36–38, 40, 46, 56, 71.

New women singer-songwriters using a blend of jazz, pop, and "hip-pop" are discussed, including Basia, Tracey Thom, Diane Reaves, and Sade.

906. Perry, Claudia. "Sexism, Women and Song." *Houston Post* 12 April 1992, in *Newsbank: Review of the Arts, Performing Arts* 19, Fiche 53 (May 1992): E7–E8.

Sexism in the music industry creates difficulties for women seeking to break new ground and succeed professionally, and the author reviews recent albums by k.d. lang, Wynonna Judd, and En Vogue from this perspective.

907. "Photographic Essay [black women musicians and artists]." *Sage* 4, no. 1 (Spring 1987): 3–10.

908. Post, Laura. "What's it Like, Performing in Both Women's Music and Mainstream Music? Rhiannon and Phranc." *Hot Wire* 7, no. 3 (September 1991): 22–25, 56.

909. Post, Laura. "Women and Their Guitars." *Hot Wire* 8, no. 3 (September 1992): 22–23, 58.

Nineteen women guitarists performing in the women's music scene talk about the guitars they've played in the past and their current favorites.

910. Rogers, Sheila, and Herb Ritt. "The Women's Movement." *Rolling Stone* 561 (21 September 1989): 73–77, 80–86.

Photo essay.

911. Schwartz, Ellen. *Born a Woman: Seven Canadian Women Singer-Songwriters*. Winlaw, B.C.: Polestar Book Publishers, 1988.

Reviewed in *Canadian Composer* 236 (December 1988): 28–29. Chapters on Heather Bishop, Ferron, Marie-Lynn Hammond, Connie Kaldor, Rita MacNeil, Lucie Blue Tremblay, Sylvia Tyson. Includes a discography.

912. Selbin, Eric. "Women Musicians: Taking It From the Top." *Utne Reader* 26 (March 1988): 16–17.

Record review essay on the new wave of feminist musicians who break free from the stereotypes associated with 'women's music'.

913. Sexton, Paul. "Female Acts Find Niche in Britain." *Billboard* 104 (7 March 1992): 10, 30.

In 1992, North American singers/song writers Tori Amos, Betsy Cook, Ashley Maher,and Buffy Sainte-Marie have relocated to England in order to record and perform in that country's eclectic music scene.

914. Trowbridge, Jennifer. "Feel the Beat: Four Percussionists." *Hot Wire* 5, no. 2 (May 1989): 18–23, 56.

Profiles of four women percussionists who have "broken new paths— in and out of the women's music scene": Nurudafina Pili Abena, Carolyn Brandy, Nydia Mata, and Edwina Lee Tyler.

# Part B.  Popular Music and Musical Theatre

915. Andrade, Valéria. "Notas para um estudo sobre compositoras da música popular brasileira-seculo XIX." *Travessia* 23 (1991): 235–252.

In Portuguese. A study of women composers of Brazilian popular music of the nineteenth century.

916. Aston, Elaine. "Male Impersonation in the Music Hall." *New Theatre Quarterly* 4, (no. 15, August 1988): 247–257.

The practice of male impersonation, or cross-dressing, in the English music hall was a challenge to the conservative image of the beautiful woman as a domestic, chaste creature. The history of the breeches' role in popular theater is examined as  gender play based on sexual ambiguity. The songs and song texts sung by Vesta Tilley, a famous music hall performer, are discussed.

917. Bauer, Elizabeth Eleonore. "Massary Massary: auf den Spuren der letzten Operettendiva ." *Neue Zeitschrift für Musik* 148, no. 10 (October 1987): 7–15.

In German. Translated title: "Massary, Massary: On the Trail of the Last Operetta Diva." Fritzi Massary pioneered the emancipation of women from the traditional soubrette role in the world of Viennese operetta and musical theater. From the early revue girl cocquette to the androgynous, exotic, economically independent, and socially unconventional New Woman of the 1920s, Massary's stage roles in the operetta from 1900–1930 are examined, and the author traces the ways in which her esteemed popularity allowed her to simultaneously portray and create new feminine identities for the early twentieth-century woman.

918. Benhamou, Paul. "Pauline Julien et Angèle Arsenault: Chansons de Libération." In *Continental, Latin-American and Francophone Women Writers: Selected Papers from the Wichita State University Conference on Foreign Literature, 1984–1985*, ed. Eunice Myers and Ginette Adamson, pp. 45–54. Lanham, MD: University Press of America, 1987.

In French. An examination of the voice of feminism in song texts by the prominent Quebecois singer/songwriters Pauline Julien and Angèle Arsenault.

919. Bratton, J. S. "Irrational Dress." In *The New Woman and Her Sisters: Feminism and the Theatre 1850–1914*, ed. Vivien Gardner and Susan Rutherford, pp. 77–91. Ann Arbor: University of Michigan Press, 1992.

The author surveys the practice of male impersonation by women music hall performers of late nineteenth-century Britain.

920. Cosgrove, Stuart. "Bimbos and Brainboxes; Male Misconceptions About the New Generation of Female Singer-Songwriters." *New Statesman and Society* 1 (August 5, 1988): 42–43.

The author laments the popularity of "bimbos" Kylie Minogue and Emma Ridley when intelligent popular music is being written and recorded by female "brainboxes" such as Tracy Chapman, Linda Tillery, Natalie Merchant, and Vaneese Thomas.

921. Fletcher, Kathy. "Planché, Vestris, and the Transvestite Role: Sexuality and Gender in Victorian Popular Theater." *Nineteenth Century Theatre* 15, no.1 (Summer 1987): 9–33.

James Robinson Planché and Madame Vestris were theatrical partners in the production of burlesques, ballad operas, French revues, and other theatrical extravaganzas during the Victorian era. This article investigates the practice of male impersonation/female transvestism in their productions. While their approach to gender ambiguity was tongue-in-cheek and comedic in nature, its intention was to challenge prescriptive sexual behaviors and to provide a diversion to the strictures of Victorian society.

922. Hadleigh, Boze. *The Vinyl Closet: Gays in the Music Industry*. San Diego, CA: Los Hombres Press, 1991.

Prefaced with the statement, "Mention of an individual in this book does not necessarily indicate sexual orientation," this is a gossipy look at male and female homosexuality in the popular music industry. The chapter entitled "Songbirds" (pp. 99–154) deals specifically with (actual and alleged) lesbian and bisexual women in music.

923. Harris, Geraldine. "But is it Art? Female Performers in the Café-Concert." *New Theatre Quarterly* 5 (no. 20, November 1989): 334347.

Somewhat analagous to the British music-hall, the French Café-Concert of the middle and late nineteenth century was a form of popular entertainment predicated on catering to the male gaze. The author first examines period journalism in order to reveal the position of women in popular culture, and then describes the women musical performers and performances by women on the stage of the Café-Concert. Performances took two

forms, as *corbeille*, young, pretty women in costume, sat on stage as adorn-
ments for the male audience, while the stars of the show, the talented
*phénomène* (female novelty act performers), distinguished themselves from
the *corbeille* not only by accomplishment, but some anomaly, either physi-
cal, sexual, theatrical, etc. The author then discusses female stars of the Café-
Concert, including Thérésa, Yvette Guilbert, and others.

924. Huston, John. "All My Friends are Girls Wrapped in Boys; Gender in Pop."
   *Christopher Street* 12, no. 12 (Issue 144): 16–23.

925. Ingrassia, Thomas A. "Commentary: Supremes' 25th Anniversary is Here (The
   Realm of Pop Music is Still a Man's World)." *Billboard* 101 (17 June 1989): 9.

926. Isler, Scott. "Why Now? The Record Company Perspective." *Musician* 116
   (June 1988): 46–47.
      Part of this issue's "Special Report: The Women's Movement of
   1988," pp. 36–60+. On the recent popularity and success of women pop
   music singer-songwriters.

927. Kaufmann, Dorothea. "'Tüchtige Dirigentin und routinierte Trommlerin per
   sofort gesucht.' Musikerinnen in der 'Popmusik' des 19. Jahrhunderts."
   *Zeitschrift für Musikpädagogik 14 (no. 50, May 1989): 21–26.*
      In German. Translated title: "'Qualified Woman Conductor and
   Experienced Female Drummer Wanted Immediately': Women Musicians in
   the 'Pop Music' of the Nineteenth Century." The author presents a history of
   the *Damenkapellen* (popular ladies' bands and orchestras) of the nineteenth
   century, as garnered from newspapers, music criticism, programs, and other
   period documents. Instrumentation, repertoire, and the performance venues
   of these all-female ensembles are considered within the context of the back-
   ground of discriminatory sociocultural attitudes towards women.

928. Koether, Jutta. "Some Post-Girlism Girls." *Spex* [Germany] 11 (1990):
   26–31.
      On women in pop music.

929. Milward, J. "New Singer-Songwriters: These Big Girls Don't Cry."
   *Mademoiselle* 94 (September 1988): 108+.

930. Moore, John. "'The Hieroglyphics of Love': The Torch Singers and
   Interpretation." *Popular Music* 8, no. 1 (January 1989): 31–58.
      Defining the torch song as "a lament sung by a woman who desperate-
   ly loves a commonplace or even brutish man," the author examines how the
   performance of a torch song by the female vocalist is distinguished by an
   exoticism evoked through visual appearance, vocal technique, performance
   venue, and musical accompaniment. Moore further examines the thematic

content of the lyrics of torch songs, as well as their social and psychological connotations. Singers discussed include Fanny Brice, Libby Holman, Helen Morgan, Sophie Tucker, and Ruth Etting.

931. O'Brien, Lucy. "Revenge of Dollybird Pop: On the Revival of Pop's Grande Dames." *New Statesman and Society* 2 (3 March 1989): 48.

932. Okrent, Daniel. "Boy Meets Girl Singer." *Esquire* 110, no. 3 (September 1988): 58.
      Five requirements a girl singer must possess in order to meet the male ideal.

933. Pacheco, Sonia M. "Las compositoras puertorriqueñas." *Canción Popular* 4 (1989): 75–77.
      In Spanish. Some of the Puerto Rican women composers discussed in this article are: Ana Otero (1861–1905), Monserrate ("Monsita") Ferrer Otero, Mercedes Arias (19th c.), Mercedes Torres (b. 1902), Mirta Silva (b. 1927), Gloria Madera, Silvia Rexach (1921–1961), and Aurea ("Puchi") Balseiro.

934. Pacini, Deborah. "Social Identity and Class in *Bachata*, An Emerging Dominican Popular Music." *Latin American Music Review* 10, no. 1 (Spring/Summer 1989): 69–91.

935. Paulsson, Kajsa. "Damorkestern Baby Stars." In *Kvinnors Music*, ed. Eva Öhrstöm and Märta Ramsten, pp. 116–120. Stockholm, Sweden: Sveriges Utbildningsradio AB and Svenska Rikskonserter, 1989.
      ISBN 9126898101. In Swedish. The Baby Stars (a ladies' dance orchestra from Sweden in the 1940s), are the focus of this article.

936. Puterbaugh, Parke. "Girl Groups for All Seasons." *Stereo Review* 57, no. 9 (September 1992): 84.
      Reviews of new albums by popular music vocal groups Wilson Phillips and the Honeys.

937. Rogers, Delmer D. "Victorian-Age Women Composers of Popular Music in Texas." *AWC News/Forum* 9 (Spring/Summer 1991): 16–18.
      The author examines the repertoire of women composers of popular music in late nineteenth-century Texas, noting that musical education for women, the establishment of local music publishing enterprises, the variety of ethnic popular musics, and the development of arts patronage contributed to an environment which encouraged the musical pursuits of women.

938. Scott, Derek. "Rise of the Woman Ballad Composer." In *The Singing Bourgeois: Songs of the Victorian Drawing Room and Parlour*, pp. 60–80. Milton Keynes, U.K.: Open University Press, 1989.

939. Sicoli, M. L. Corbin. "Women Winners: Major Popular Music Awards." *Popular Music and Society* 13, no. 1 (Spring 1989): 99–101.

940. Sullivan, Caroline. "Girls on Top." *Melody Maker* 62 (28 March 1987): 30–31.

    Women in pop music.

941. Wells, Alan. "Women on the Pop Charts: A Comparison of Britain and the United States, 1960–1988." *Popular Music and Society* 15, no. 1 (Spring 1991): 25–32.

    A comparative look at the success rate of female artists in the United States and Britain.

942. Westerfield, Jane Robertson. *An Investigation of the Life Styles and Performance of Three Singer-Comediennes of American Vaudeville: Eva Tanguay, Nora Bayes and Sophie Tucker.* Diss. D.A., Ball State University, 1987.

    Abstract in *Dissertation Abstracts International: A. Humanities and Social Sciences* 48, no. 10 (April 1988): 2486. DA# 8729825.

943. Whitall, Susan. "Sugar and Spice—and Squeals: That's What Girl Singers are Made Of." *Detroit News* 2 July 1989, in *Newsbank: Review of the Arts, Performing Arts* 16, Fiche 115 (August 1989): F9–F10.

944. Wright, Christian. "Red-hot and Blah; Female Pop Singers Negate the Power of Their Voices with the Schlock They've Chosen to Sing." *Mademoiselle* 97, no. 7 (July 1991): 62–63.

    Pop records of Mariah Carey, Whitney Houston, Tara Kemp, and Wilson Phillips are criticized for their emphasis on female image over musical and vocal substance.

945. Young, Jon. "After the Revolution." *Musician* 162 (April 1992): 86, 88.

    The author welcomes the fact that commercial record companies are supporting women artists whose music is strong and substantial. He reviews recent albums by Michelle Shocked (*Arkansas Traveller*), Tracy Chapman (*Matters of the Heart*), and k.d. lang (*Ingenue*) .

946. Zimmerman, Kevin. "Women Popsters and Politics: New Voice or Just a Fad?" *Variety* 336, no. 10 (20 September 1989): 135–136.

# Part C.  Rock Music

947. Arnold, Gina. "Women Who Stand Up for Rock." *San Jose Mercury News* 28 August 1988, in *Newsbank: Review of the Arts, Performing Arts* 15, Fiche 187 (October 1988): D5–D6.

948. Becker, Audrey. "New Lyrics by Women: A Feminist Alternative." *Journal of Popular Culture* 24, no. 1 (Summer 1990): 1–22.

      Citing sources ranging from *Billboard* chart listings (which measure record sales) to scholarly studies of youth culture and popular music, Becker first examines the patriarchy of mainstream American pop, which "merchandises [women], trivializes their work, and compromises their potential" (p. 18). In her search for a feminist "alternative canon" (p. 17) in mainstream rock music, she finds only a few women rock singer/songwriters who have met with a modest degree of success in this milieu. Here, she focuses on Tracey Thorn (from the group Everything But the Girl), Natalie Merchant (from the group 10,000 Maniacs) and Suzanne Vega. In analyzing the thematic content, the use of language, and the literary style of selected songs written by these women, she finds feminist voices at rock music's periphery.

949. Behrendt, Michael. "Girl Groups: Die dramatische Song- Inszenierung und die Kollision von Text und Musik." *Englische und amerikanische Rocklyrik, 1950–1975: ästhetische und historische Strukturen*, pp. 79–86. Europäische Hochschulschriften [European University Studies] Ser. 14. Angelsächsische Sprache und Literatur [Anglo-Saxon Language and Literature], Bd. 233. Frankfurt am Main: Peter Lang, 1991.

      ISBN 3631439369. In German. A study of the texts of songs performed by girl groups of the late 1950s and early 1960s.

950. Brandt, Pamela Robin. "2 Nice Girls=4 Proud Lesbians." *Ms.* 2, No. 3 (November/December 1991): 85.

      Two Nice Girls talk about being avowed lesbian musicians in the rock music mainstream.

951. Campbell, A. Gail. "Pop's New Dream Girls: Girl Groups Reign Supreme in the 90's." *Washington Times* 23 May 1990, in *Newsbank: Review of the Arts, Performing Arts* 17, Fiche 80 (June 1990): C3–C4.

952. Cline, Cheryl. "*Bitch*: the Women's Rock Mag with Bite." *Hot Wire* 3, no.3 (July 1987): 44–45.

      A writer for *Bitch* comments on the diversity of this women's rock magazine, both in the opinions and subjects represented; excerpts of various articles are presented to illustrate her point.

953. Cline, Cheryl. "Mulling it Over: Cockrock." *Hot Wire* 4, no. 2 (March 1988): 54, 63.

      The author criticizes recent scholarly books by Simon Frith (*Sound Effects: Youth, Leisure and the Politics of Rock 'n' Roll*) and Robert Pattison (*Triumph of Vulgarity*) for their trivialization of women's role in rock to that of male admirers, spectators, and teeny boppers, and not as rock musicians, thus further reproducing cultural attitudes which discriminate against women in rock.

954. Cohen, Sarah. "The Threat of Women." In *Rock Culture in Liverpool: Popular Music in the Making*, pp. 201–222. Oxford: Clarendon Press, 1991.

This anthropologist/author's study of the 1980s rock music scene in Liverpool, England, examines male hostility towards the participation of women in English rock, and reveals an underlying fear of women. Topics such as the loss of masculine identity, the loss of independence, the fear of domesticity, manifestation of female characteristics, fear of divisiveness to male solidarity, and the disintegration of the male preserve are discussed.

955. Coopman, Jeremy. "Teenage Girls Conquer British Charts; Safer as Role Models?" *Variety* 330 (6 April 1988): 64+.

956. Dix, John. *Stranded in Paradise: New Zealand Rock 'n' Roll, 1955–1988*. S.l: Paradise Publications, [1989?].

ISBN 0473006383. Includes a brief discussion of women rock musicians from New Zealand during the late 1970s and 1980s (pp. 246, 250–251). Sonya Waters, Sharon O'Neill, the Topp Twins and Jay Clarkson are mentioned.

957. Farin, Klaus, and Anke Kuckuck. *ProEmotion: Frauen im Rock Business; Begegnungen, Gespräche, Reportagen*. Reinbek, Germany: Rowohlt, 1987.

ISBN 3499158817. In German. Translated title: "ProEmotion: Women in the Rock Music Business: An Introduction, With Interviews and Commentary."

958. "Femme Rockers Strike New Chord With Fans." *Variety* 338 (7 March 1990): 59.

959. Ferreira, Christine. "Like a Virgin: The Men Don't Know, But the Little Girls Understand." *Popular Music and Society* 11, no. 2 (1987): 5–16.

The music industry's packaging of women's sexuality in rock has prevented the real contributions of women in rock from being considered. From Willi Mae Thornton, to the glamorous girl groups of the 1960s, to white counter-culture stars of the 1960s and early 1970s (e.g. Joan Baez, Janis Joplin, and Grace Slick), to 1970s disco divas, to early 1980s' hard rockers and Madonna, women have contributed significantly to rock and women audiences have responded to their female message.

960. Flanagan, Bill. "Anima Rising: Why the Best New Rock Acts of 1988 are Women." *Musician* 116 (June 1988): 36–38, 121.

Part of this issue's "Special Report: The Women's Movement of 1988," pp. 36–60+.

961. "Frauenbands: Der Mythos lebt." *Musikexpress/Sounds* (December 1991): 34–35.

In German. All-women's rock bands.

962. Frith, Simon. "From Bobbysox to Dungarees." In *Music for Pleasure: Essays in the Sociology of Pop*, pp. 151–153. New York: Routledge, 1988.
    A look at girl-talk in the music of black girl groups, with particular reference to Sister Sledge.

963. Frith, Simon. "The Voices of Women." In *Music for Pleasure: Essays in the Sociology of Pop*, pp. 154–157 New York: Routledge, 1988. .
    The author considers the music of British all-women's rock 'n' roll bands, reflecting on rock and feminism.

964. Furth, Daisy von. "For Girls About To Rock." *Spin* 8 (April 1992): 26.
    Description of Riot Grrrls' activities; names of fanzines are included, as is an address to obtain more information.

965. Gaar, Gillian G. *She's a Rebel: The History of Women in Rock & Roll*, Pref. Yoko Ono. Seattle: Seal Press, 1992.
    Reviewed in *New York Times Book Review* (7 February 1993): 22; *Village Voice* 38 (19 January 1993): 56. This encyclopedic history of women in rock from the 1950s to the 1990s not only surveys women rock musicians, recording producers, managers, and rock journalists, but also delves into broader issues such as discrimination in the rock music industry and the musical culture of the feminist movement. Included is an extensive bibliography, a selected list of feature-length videos, a detailed general index, plus title and album indices.

966. Greig, Charlotte. *Will You Still Love Me Tomorrow? Girl Groups From the 50s On*. London: Virago Press, 1989.
    Reviewed in *Melody Maker* 65 (19 August 1989): 15; *Rock & Roll Confidential* 73 (December 1989): 6–7; *Popular Music* 9, no. 3 (October 1990): 386–387.

967. Greig, Charlotte. *Will You Still Love Me Tomorrow? Mädchenbands von den 50er Jahren bis Heute*. German trans. Markus Schröder. Reinbek, Germany: Rowohlt, 1992.
    Reviewed in *Neue Zeitschrift für Musik* 153, no. 2 (February 1992): 50. German translation of the English original, published in 1989.

968. Grein, Paul. "Chartbeat: Women Have a Lock on Top Singles Spots." *Billboard* 102 (26 May 1990): 8.

969. Grein, Paul. "Chartbeat: Women Dominate in '90." *Billboard* 102 (30 June 1990): 10.

970. Groce, Stephen B., and Margaret Cooper. "Just Me and the Boys? Women in Local-Level Rock and Roll." *Gender and Society* 4, no. 2 (June 1990): 220–229.

971. Gudgeon, Chris. "First Ladies of Rock." *Canadian Musician* 13, no. 6 (December 1991): 44–46, 48.

　　The success of hard rock singer/songwriters Lee Aaron, Darby Mills, and Chrissy Steele is examined, as they comment on the place of women in the Canadian music scene, life as club musicians, and on tips for prospective women rock singers.

972. Harper, Jorjet. "Transistor Sisters." *Hot Wire* 4, no. 2 (March 1988): 42–44, 63.

　　The author reflects on growing up in the early 1960s listening to the music of the girl groups and solo female singers. The Bobbettes, The Shirelles, songwriters Ellie Greenwich and Carole King, The Marvelettes, The Ronettes, The Shangri-Las, and the Supremes are discussed.

973. Harrington, Richard. "Femme Trend." *Sacramento Bee* 16 October 1988, in *Newsbank: Review of the Arts, Performing Arts* 15, Fiche 230 (December 1988): A10–A13.

　　Tracy Chapman, Toni Childs, Michelle Shocked, Marti Jones, Sam Phillips, Melissa Etheridge, and Julia Fordham, women of substance without the glitter, have been embraced by the mainstream music industry. As the author states, "Sisterhood is not only powerful, it's turning out to be quite marketable." Several of the above-mentioned artists comment on their being identified with this new female trend in rock.

974. Hill, Edward. "All-Girl Sound is Back with a Vengeance." *Cleveland Plain Dealer* 18 July 1988, in *Newsbank: Review of the Arts, Performing Arts* 15, Fiche 137 (August 1988): F7.

975. Holden, Stephen. "Goodbye, Earth Angel, So Long, Earth Mother: A Generation of Smart, Restless Women Has Emerged in a World Where They No Longer Need to be Typecast." *New York Times* 4 September 1988, II: 22.

　　Notes the new sounds and the androgynous image of young women singers and songwriters such as Tracy Chapman, k.d. lang, Sinéad O'Connor and Michelle Shocked.

976. Janowitz, Tama. "Sex as a Weapon." *Spin* 3, no. 1 (April 1987): 54–62.

　　Sex is used as a vehicle of power by women rock musicians of the music video age, who now have a degree of control their product. But is the music by these women taken seriously? Belinda Carlisle, Marianne Faithfull, Mary Wilson, Grace Jones, and others comment.

977. Japenga, Ann. "Punk's Girl Groups are Putting the Self Back in Self-Esteem." *New York Times* 15 November 1992, 2: 30.

　　Young, feminist, and punk, the rock music and culture of the Riot Grrrls is examined by the author. A movement originating in the Pacific

Northwest U.S., the Riot Grrrls are represented by all-girl groups such as Bikini Kill, Heaven's to Betsy, Bratmobile, etc. Comments by Bratmobile's drummer, Molly Neuman, are featured.

978. Jones, Allan, et al. "87 Review: Girls on Top." *Melody Maker* 63 (19–26 December 1987): 49.

979. Joy, Sally Margaret, Paul Lester, Jim Arundell, et al. "Busting Out of Bimbo Hell?" *Melody Maker* 68 (19 September 1992): 44–46.
    In this article the authors "cut through all the patronising crap printed elsewhere...to examine the fate of the new femme rockers and wonder whether the revolution is just an illusion after all" (p. 44). They posit that the numbers of women musicians playing within the rock music scene is fairly low as compared to their male counterparts, and they find the mainstream music industry (including rock critics) still more interested in sexual image than talent.

980. Joy, Sally Margaret, and Everett True. "Revolution Grrrl Style Now." *Melody Maker* 68 (10 October 1992): 30–32.
    Riot Grrrls.

981. Kaczorowski, Geary. "The New Women of Rock." *Schwann CD Catalog* 4, no. 6 (June 1989): A6–A7, 423–424.

982. Kristena, Claude. *Les filles du rock*. Lausanne, Switzerland: Favre, 1989.
    ISBN 2828904121. In French. Translated title: *The Women of Rock*.

983. Kromsten, Katharina Brette. "Tjejband." In *Kvinnors Musik*, ed. Eva Öhrström, and Märta Ramsten, pp. 126–130. Stockholm, Sweden: Sveriges Utbildningsradio AB and Svenska Rikskonserter, 1989.
    ISBN 9126898101. In Swedish. Translated title: "Girl Bands." This is a survey of girl groups from the U.S. and Europe during the 1960s, 1970s, and 1980s, including those in Sweden. Mentioned are the Nursery Rhymes, Husmoderns Bröst, Shit and Chanel, Malaria, Häxfeber, Pink Champagne, The Slits, and a number of others.

984. Kronke, David. "Women Rockers: Female Musicians Bridge Music's Gender Gap." *Dallas Times Herald* 28 August 1988, in *Newsbank: Review of the Arts, Performing Arts* 15, Fiche 188 (October 1988): G7–G9.

985. Kronke, David. "Works of Note Break the Rules." *Dallas Times Herald* 28 August 1988, in *Newsbank: Review of the Arts, Performing Arts* 15, Fiche 188 (October 1988): G10–G11.
    Reviews of recently released rock albums by women.

986. "Leading Ladies [in rock, for the year 1988]." *Rolling Stone* 541/542 (15–29 December 1988): 60–61.

987. Leland, John. "The Return of Good Girls. . .The Staying Power of Bad Girls." *Newsweek* 117 (20 May 1991): 57.

   The author is critical of women popsters regardless of whether they present "good girl" or "bad girl" images. He remarks on the success of women pop music artists such as Amy Grant and Wilson Phillips who are successful without having to be sexually explicit in their material and performance. "Bad girls" such as Madonna and Christina Amphlett of the Divinyls achieve success with sexually explicit images or lyrics.

988. Lerner, Elinor. "To Robin Roberts." *NWSA Journal* 2, no. 2 (Spring 1990): 329–339.

   Letter in response to: Roberts, Robin. "'Sex as a Weapon'— Feminist Rock Music Videos." *NWSA Journal* 2, no. 1 (Winter 1990): 1–15.

989. Lewis, Lisa A. "Female Address in Music Video: Voicing the Difference Differently." Paper presented at the International Television Studies Conference, London, England, 10–12 July 1986.

   Available from ERIC, ED 294 519, in microfiche or paper copy. For an abstract see *Resources in Education* 23, no. 10 (October 1988): 88.

990. Lewis, Lisa A. *Female Address in Music Video: The Emergence of a Contradictory Cultural Discourse.* Diss. Ph.D., University of Texas at Austin, 1987.

   Abstract in *Dissertation Abstracts International: A. Humanities and Social Sciences.* 49, no. 3 (September 1988): 371. DA# 8806366.

991. Lewis, Lisa A. "Female Address in Music Video." *Journal of Communication Inquiry* 11 (Winter 1987): 73–84.

992. Lewis, Lisa A. "Form and Female Authorship in Music Video." *Communication* 9, no. 3–4 (1987): 355–378.

993. Lewis, Lisa A. *Gender Politics and MTV: Voicing the Difference.* Philadelphia, PA: Temple University Press, 1990.

   Reviewed in *Women's Review of Books* 8, no. 3 (December 1990): 27; *Nation* 251 (August 27–September 3, 1990): 206–209; *Women and Politics* 11, no. 2 (1991): 116–117. The author challenges those who dismiss MTV as sexist, and instead investigates the ways in which music video offers female artists the potential to promote a uniquely feminist message within the mass medium of MTV. The author begins by tracing the development of MTV, and acknowledges its ideological underpinnings as a youth-oriented medium "express[ing] the underlying social goal of maintaining females in an under-privileged position" (p. 5). Chapter 3 focuses on the early days of "male-address video," while Chapters 4 through 6 discuss the challenge to the reproduction of patriarchy posed by women musicians (Tina Turner, Pat Benatar, Cyndi Lauper, and Madonna) who "waged a cultural struggle

against MTV's disparagements by appropriating the symbols used in MTV's male address" (p. 221) and who, in doing so, appealed to an eager, young female audience. The response of female audiences to female stars and female-address videos is then analyzed (Chapter 7).

994. Light, Alan. "The New Girl Groups: Savvy Producers Bring a Formula From the Sixties Back to the Charts." *Rolling Stone* 581 (28 June 1990): 15–16.

995. McClary, Susan. "Living to Tell: Madonna's Resurrection of the Fleshly." *Genders* 7 (March 1990): 1–21.
    The author examines the music of Madonna as feminist discourse. She introduces the reader to the ways in which narrative schemas in western classical and popular music (i.e. tonality/departure/ closure) serve as a metaphor for male dominance/female desire/dread and eventual eradication of the female. Within this framework she analyzes the music of Madonna (e.g. "Live to Tell," "Open Your Heart," "Like a Prayer"), revealing that themes of "survival, pleasure, [and] resistance to closure" are meticulously constructed in the musical and visual components of her work.

996. McNeil, Legs. "Slut Metal: Female Heavy Metal-ers Were an Idea Whose Time Had Come, But Maybe Just a Little Too Early for the Boys in the Hallway." *Spin* 5, no. 4 (July 1989): 44–46, 48, 126.

997. Mifflin, Margo. "Guest Editorial: The Fallacy of Feminism in Rock." *Keyboard* 16, no. 4 (April 1990): 14.

998. Millington, June, and Sherry Shute. "Rockin' the Cradle of Women's Music: June Millington and Sherry Shute." *Hot Wire* 7, no. 3 (September 1991): 16–19, 42.
    These pioneering women rock guitarists reflect on their lives and careers.

999. Morris, Chris. "1988 in Review: Women Flexed Chart Muscle; Metal Dented Deeper." *Billboard* 100 (24 December 1988): 38, 43.

1000. Moses, Mark. "Radio Sweethearts." *New Yorker* 65 (20 March 1989): 83–86.
    On the female singers of urban contemporary pop radio: Karyn White, Chaka Khan, Anita Baker, Paula Abdul, Evelyn King.

1001. "NARAS [National Academy of Recording Arts and Sciences] Finds Lots of Women Rockers." *Variety* 333 (16 November 1988): 66.

1002. Nasrallah, Dana. "Teenage Riot." *Spin* 8 (November 1992): 78–81.
    A profile of Riot Grrrls, whose followers are young, feminist and punk, and whose message is spread through confrontational rock music by

all-girl bands such as Bratmobile and Bikini Kill, through fanzines, and likewise community gatherings.

1003. Nett, Emily. "'Women in Rock Music' Revisited: A Response to Sawchuck's Critique in *Atlantis*, Vol. 14, no. 2." *Atlantis* 15, no .2 (Spring 1990): 77–80.

   The author responds to Kimberly Sawchuck's criticism of the article co-authored by Nett and Deborah Harding ("Women in Rock Music." *Atlantis* 10, no. 1 (Fall 1984): 61–76). The discussion further considers the application of feminist theories of sexuality and semiotic theories to rock music.

1004. Nylén, Leif. "Kvinnligt-manligt i rockens rollspel, från Elvis Presley till Fia Skarp." In *Kvinnors Musik*, ed. Eva Öhrström and Märta Ramsten, pp. 131–138. Stockholm, Sweden: Sveriges Utbildningsradio AB and Svenska Rikskonserter, 1989.

   ISBN 9126898101. In Swedish. Translated title: "Feminine/Masculine in the Role-Play of Rock." The author analyzes the way rock musicians utilize male and female appearances and postures in their performance, specifically with reference to either exaggerating a given gender image, or using gender-opposite appearances to effect an androgynous performance guise.

1005. Pareles, Jon. "Heavy-Metal Girls." *Mademoiselle* 94 (July 1988): 58+.

1006. Pareles, Jon. "Women Rock Their Way: Recent Recordings Suggest That Women Are Ready To Shake Up Rock Songwriting." *New York Times* 5 June 1988, II: 32.

1007. Powers, Ann. "No Longer Rock's Playthings: A Growing Cadre of Female Musicians is Changing Perceptions of How Women Can Rock and Roll." *New York Times* 14 February 1993, II: 1, 34.

   Groups such as L7, Sonic Youth, Hole, Bikini Kill, and others represent a new feminism in rock, evident not only in the diversity of musical styles and female images, but with an activism spawned by political issues of significance to women, such as reproductive rights, AIDS, sexual harrassment (e.g., Anita Hill's testimony during the Clarence Thomas hearings), and rock music censorship.

1008. Powers, Ann. "That Girl by the Stage, and, Why She's There." *New York Times* 20 December 1992, 2: 30.

   With the publication of rock groupie Pamela Des Barre's *Take Another Little Piece of My Heart: a Groupie Grows Up* (William Morrow, 1992), the author reflects on the revelations of "rock world's hidden history and its groundings in desire," while considering the influence that feminism has made in the rock milieu and the changing image of women in today's rock.

1009. Pratt, Ray. "Women's Voices, Images and Silences." In *Rhythm and Resistance: Explorations in the Political Uses of Popular Music*, pp. 143–174. Media and Society Series. New York: Praeger, 1990.

This is a well-documented discussion which critically assesses much of the media hype concerning the inroads made by women artists in rock music and more positive images of women in their songs and videos. The author maintains that the cultural message of rock still perpetuates unrealistic and stereotypical notions of female (and male) behavior through a product shaped by the essentially male-dominated music industry, ignoring the social and political realities of the majority of women.

1010. Reynolds, Simon. "Belting Out That Most Unfeminine Emotion: Today's Female Rockers are Unafraid to Vent Their Anger, and Their Fans Find That Comforting." *New York Times* 9 February 1992, II: 27.

Using the vocabularies of soul, the blues, punk, and heavy metal, new all-female rock bands express visceral emotions: fury, rage, ennui, desolation, rebellion, and dissatisfaction with domestic roles. Interviewed are Kat Bjelland of Minneapolis-based Babes in Toyland, Courtney Love of Hole, and Inger Lorres of the Nymphs. The latter two are Los Angeles-based groups.

1011. Roberts, Robin. "'Sex as a Weapon': Feminist Rock Music Videos." *NWSA Journal* 2, no. 1 (Winter 1990): 1–15.

"Studying music videos, especially feminist music videos, reveals the inaccuracy and inadequacy of regarding popular culture as a source of only the objectification and subordination of women" (p. 2). Examples of such videos are analyzed, specifically: Pat Benatar's "Sex as a Weapon," Janet Jackson's "Nasty," and Tina Turner's "Typical Male." Form, content, and (most importantly) performer style, humor, and self-awareness contribute to the subversive nature of these women's music videos. The author thus demonstrates that "the use of postmodern art forms by female rock performers points the way toward new cultural forms for feminists" (p. 2).

1012. Rosen, Craig. "Sisters Under the Grunge: L7 and Hole and the Future of Rock 'n' Roll." *Musician* 168 (October 1992): 68–72.

Profiles of these two feminist grunge metal rock bands, their musicians, style, and connections with the rock group Nirvana.

1013. Ross, Sean. "Fems Take to Hard Rock, Radio Call-Out Suggests." *Billboard* 100 (8 October 1988): 1, 74.

1014. Schlattman, Tim. "From Disco Divas to the Material Girls." *Popular Music and Society* 15, no. 4 (Winter 1991): 1–14.

The author compares 1970s' and 1980s' pop singles charts and album-oriented rock (AOR) charts in order to ascertain whether reports in the media alleging substantial gains made by women in the rock music industry

were in fact reflected in record sales and top rankings of women artists on various record charts. He determines that although women were substantially more successful in the 1980s in placing recordings on Top 40 pop and dance singles charts as compared to the 1970s, they made only minimal inroads into AOR sales and placement in published rock album rankings during this time period.

1015. Schoemer, Karen. "Girls with Guitars: Michelle Malone, Alannah Myles and Johnette Napolitano Get Down to Rock and Roll Basics." *Mademoiselle* 96 (October 1990): 112.

1016. Shute, Sherry. "Life as a Woman Rocker." *Hot Wire 4, no. 2 (March 1988): 18–19.*
    This Canadian rock guitar player reflects on the resistance of the women's music scene to rock and roll; she also comments on her experiences of being a woman rock musician in Canada.

1017. Sinker, Mark. "Choice Cuts: Mark Sinker on Manchester's Gender-Bending Pop." *New Statesman and Society* 4 (1 March 1991): 28.
    Male and female British rock musicians whose image and message reject traditional modes of sex and gender.

1018. Spencer, Lauren. "Grrrls Only: From the Youngest, Toughest Daughters of Feminism, Self-Respect You Can Rock To." *Washington Post* 3 January 1993 (Sunday Ed.), C: 1.
    On the Riot Grrrls subculture of young feminist rockers.

1019. Sprague, David. "Madonna, Tiffany and Belinda [Carlisle]: Would You Buy These Women? And If Not, Would You Rent?" *Creem Magazine* 19, no. 9 (May 1988): 19–23.
    The author focuses on the difference between the legitimate contributions of Madonna and the fleeting pop/rock efforts of her imitators.

1020. Stein, Arlene. "Androgyny Goes Pop." *Out/Look* 3, no. 4 (Spring 1991): 26–33.
    Androgynous female rock/pop artists working within the musical mainstream appeal to a wide audience through gender ambiguity in their songs and visual presentation. The impact of their success on the feminist/lesbian cultural community is discussed.

1021. Steward, Alan D. "Declarations of Independence: The Female Rock and Roller Comes of Age." In *Beyond Boundaries: Sex and Gender Diversity in Communication*, ed. Cynthia M. Lont and Sheryl A. Friedley, pp. 283–298. Fairfax: George Mason University Press, 1989.
    This essay discusses the rise of the female rock performer in the 1980s and the themes of forcefulness and independence which emerge

from the music of Patti Smith, Marianne Faithfull, Chrissie Hynde, Genya Ravan, and Robin Lane.

1022. Thompson, Ben. "Blood on the Tracks: What Happens When Heavy Metal Goes Feminist?" *New Statesman and Society* 5 (11 December 1992): 33.

All-girl rock bands from the U.S., such as Hole, Babes in Toyland, and L7 are making the transition from margin to mainstream with first rate, hard-rocking music. These groups are becoming popular in England, but L7's recent appearance at the Reading Festival in August 1992 was met with a barrage of male hostility against these women. Lead singer Donita Sparks responded by throwing her used tampon at the crowd.

1023. "Tired of Tenderness." *New York Daily News* 12 March 1989, in *Newsbank: Review of the Arts, Performing Arts* 16, Fiche 58 (April 1989): D1–D2.

Women rockers portray a tough image.

1024. Violanti, Anthony. "Rockabye Ladies: Women in Rock Are Changing the Music Scene, As Well As What It Means To Be Female." *Buffalo News* 12 June 1992, in *Newsbank: Review of the Arts, Performing Arts* 19, Fiche 83 (July 1992): B11–B14.

Women artists such as Melissa Etheridge, Courtney Love, and Tori Amos confront sexual and social issues in their expressive, hard-driving rock music.

1025. "Vrouwenpop." In *Encyclopedie van de Nederlanse Popmuziek, 1960–1990*, ed. Frans Steensma, p. 172. Amsterdam: Bonaventura, 1990?

ISBN 9068821075. A brief overview of women rock musicians from the Netherlands. Discography included.

1026. "Where the Girls Are: If You Knew Peggy Sue, Then You'd Know She's Now a Plumbing Contractor." *Esquire* 113, no. 5 (May 1990): 122–125.

Commentary by the real women who inspired the writers of the songs "Runaround Sue" (Dion), "Peggy Sue" (Buddy Holly), "Donna" (Ritchie Valens), "Cathy's Clown" (Everly Brothers).

1027. "Women in Metal." *New Yorker* 64 (28 November 1988): 32–33.

1028. "Women's Work." *Keyboard* 16, no. 6 (June 1990): 8.

Letters in response to: Mifflin, Margo. "Guest Editorial: The Fallacy of Feminism in Rock." *Keyboard* 16, no. 4 (April 1990): 14.

1029. Wurtzel, Elizabeth. "Girl Trouble." *The New Yorker* 68 (29 June 1990): 63–66, 68–70.

While questioning the "one size fits all" approach to writing about women in popular music, the author discusses recent women's music as an autonomous art form due to the variety of artists and songs carrying a unique-

ly female message. She notes the increase in the numbers of women working as instrumentalists (not just lead singers) in bands, as well as the success of all-female bands. In particular, the music and politics of the all-female bands (e.g. L7, Hole, the Breeders, and Wilson Phillips) is discussed. The author finds it troubling that all-women's hard-core rock groups wish to renounce their feminine identity in favor of emulating the male model in rock.

1030. Wurtzel, Elizabeth. "Sounds: Natural Women." *New York* 23 (5 March 1990): 92–93.
A survey of the 12 best rock albums made by women from 1970–1990.

# Part D.  Jazz and Experimental Music

1031. Bachmann, Dieter. "Editorial: Body and Soul, die grossen Sängerinnen des Jazz." *du: Die Zeitschrift der Kultur*, no. 4 (April 1992): 13–15.
In German. An introduction to this special issue devoted to women jazz singers.

1032. Becker, Matthias. *Chormusik im Jazz*. Wissenschaftliche Schriften, Reihe 13, Musikwissenschaftliche Beiträge, Bd. 101. Idstein, Germany: Schulz-Kirchner Verlag, 1992.
ISBN 3824800667. In German. The author's doctoral dissertation (University of Frankfurt, 1991). This monograph on the musical styles and stylists of ensemble singing in the medium of vocal jazz includes a discussion of the "sister acts" of the 1920s and 1930s (pp. 32–36; Brox Sisters, Duncan Sisters, Keller Sisters and Lynch, Pickens Sisters, Ponce Sisters, Williams Sisters, and others.) More substantial coverage is given to the artistry of the Boswell Sisters (pp. 40–46). Appended is an extensive dictionary of vocal jazz groups, with information sources cited.

1033. Berendt, Joachim Ernst. *The Jazz Book, From Ragtime to Fusion and Beyond*. Brooklyn, NY: Lawrence Hill Books, 1992.
Included is a brief history of female jazz singers and styles they employed: blues, gospel, soul, scat, the classic song style, and recent "voice/body as instrument" styles (pp. 384–395).

1034. Billard, François. *Les Chanteuses de jazz*. Paris: Éditions Ramsay/de Cortanze, 1990.
ISBN 2859568344. In French. A history of women jazz singers, from the twenties through the present, accented with photographs, interviews, and a filmography.

1035. Bouchard, Fred. "Standard Bearers." *Down Beat* 59, no. 7 (July 1992): 40–41.

Reviews of new albums by women jazz singers: Sathima Bea Benjamin, Dee Dee Bridgewater, Rosemary Clooney, Kirsten Gustafson, Eartha Kitt, Nancy Marano, Susannah McCorkle, Vanessa Rubin, Carol Sloane.

1036. Bouchard, Fred. "Women Leaning on Their Men." *Down Beat* 57, no. 7 (July 1990): 42–43.
Jazz singers on compact disc.

1037. Bruér, Jan, and Lars Westin. "Kvinnliga jazzmusiker: finns dom?" In *Kvinnors Musik*, ed. Eva Öhrström and Märta Ramsten, pp. 120–125. Stockholm, Sweden: Sveriges Utbildningsradio AB and Svenska Rikskonserter, 1989.
ISBN 9126898101. In Swedish. Translated title: "Women Jazz Musicians: Do They Exist?" The author briefly examines the history of women's participation in jazz, identifies musicians from the U.S. and Europe (including Sweden), and discusses their struggles for recognition in the jazz world.

1038. Büchter-Römer, Ute. *New Vocal Jazz: Untersuchungen zur zeitgenössischen improvisierten Musik mit der Stimme anhand ausgewählter Beispiele.* Europäische Hochschulschriften, Reihe 36. Musikwissenschaft, Bd. 63. Frankfurt am Main, Germany: Peter Lang, 1991.
ISBN 3631439792. Diss. Universität Gesamthochschule Duisburg, 1989. In German. Translated title: *New Vocal Jazz: An Examination into Contemporary Musical Improvisation with the Voice, Accompanied by Selected Examples.* Introduced with an explanation of the author's methodology and a brief historical examination of the practice of vocal extemporization, this volume on new vocal jazz styles and vocal improvisation in various forms of experimental music analyzes in detail the techniques of women singers: Cathy Berberian, Lauren Newton, Jeanne Lee, Urszula Dudziak, Maria João, Maria de Alvear. Each singer profile includes a biographical essay, an overview of their musical contributions, and a musical analysis of transcriptions of their vocal works. Numerous musical and textual examples are included.

1039. Crowther, Bruce. "Three Jazz Voices." *Jazz Journal International* 44, no. 11 (November 1991): 14–15.
The creative vocal styles of Marlene VerPlanck, Carol Kidd, and Sathima Bea Benjamin are considered.

1040. Dahl, Linda. "Equal Time: A Historical Overview of Women in Jazz." In *America's Musical Pulse: Popular Music in Twentiety-Century Society*, ed. Kenneth J. Bindas, pp. 205–212. Contributions to the Study of Popular Culture, no. 33. Westport, CT: Greenwood Press, 1992.
This essay recognizes the importance of the accomplishments of early women jazz instrumentalists who forged careers for themselves in the male-

dominated musical world of jazz. Highlighted are the accomplishments of: Lil Hardin Armstrong, jazz arranger, pianist, composer; trumpet player Valaida Snow, who achieved greater success in Europe than in America; Mary Lou Williams, pianist and composer; Ina Ray Hutton and her all-women jazz orchestra the Melodears; and drummer Dottie Dodgion.

1041. Dahl, Linda. *Stormy Weather: The Music and Lives of a Century of Jazzwomen.* Limelight ed. New York: Limelight Editions, 1992.
    Originally published in 1984 by Pantheon Books. Now a classic in the field of women and music, this history of women jazz musicians and their experiences in the predominantly-male jazz scene surveys both the achievements of women instrumentalists and singers and offers a glimpse into their personal lives. Profiles of a number of women are featured, including: Willene Barton, Carla Bley, Clora Bryant, Dottie Dodgion, Helen Humes, Sheila Jordan, Helen Keane, Melba Liston, Mary Osborne, and Ann Patterson. Includes extensive notes, a bibliography, and discography.

1042. Davis, Francis. *Outcats: Jazz Composers, Instrumentalists, and Singers.* New York: Oxford University Press, 1990.
    In the chapter entitled "Outchicks" (pp. 122–128), the author profiles soprano saxophonist Jane Ira Bloom and pianist Michele Rosewoman, including a discussion of the discrimination they've encountered as women instrumentalists in the jazz world. Also included are profiles of singers Ella Fitzgerald (pp. 141–143), Sheila Jordan (pp. 157–167), and Susannah McCorkle (pp. 167–176).

1043. Elwood, Philip. "Vintage Films That Bring Back Some Fascinating Jazz." *San Francisco Examiner* 26 January 1987, in *Newsbank: Review of the Arts, Performing Arts* 13, Fiche 115 (March 1987): F5-F6.
    Women in jazz films.

1044. Friedwald, Will. "Cult of the White Goddess: Mildred Bailey, Connee Boswell and Lee Wiley." In *Jazz Singing*, pp. 68–90. New York: Charles Scribners Sons, 1990.

1045. Friedwald, Will. "Sing Me a Swing Song: Canaries of the Hellenic Era." In *Jazz Singing*, pp. 91–125. New York: Charles Scribners Sons, 1990.

1046. Friedwald, Will. "Sing, Sing, Sing." *Down Beat* 55, no. 7 (July 1988): 30, 32.
    A survey of 17 new jazz albums by women vocalists.

1047. Giddins, Gary. *Faces in the Crowd: Players and Writers.* New York: Oxford University Press, 1992.
    Part II of this collection of the author's previously published essays is entitled "Divas," with chapters on the following women jazz singers: Billie

Holiday (pp. 65–70), Ella Fitzgerald (pp. 71–76), Kay Starr (pp. 77–86), Dinah Washington (pp. 87–92), and Sarah Vaughan (pp. 93–100).

1048. Gourse, Leslie. "In the Limelight: Women Who Play Jazz." *American Visions* 4, no. 2 (April 1989): 32–37.

This survey of black women jazz musicians of the 1980s mentions the following instrumentalists: keyboard players Patrice Rushen, Patti Bown, and Geri Allen; percussionists Marilyn Mazur and Terri Lynn Carrington; saxophonist/composer Fostina Dixon; bassist Kim Clarke ; and host of others.

1049. Gourse, Leslie. "Women in Jazz." *Jazz Times* (August 1990): 6.

An overview of women instrumentalists on the contemporary jazz scene.

1050. Hassinger, Jane. "Close Harmony: Early Jazz Styles in the Music of the New Orleans Boswell Sisters." In *Women and Music in Cross-Cultural Perspective*, ed. Ellen Koskoff, pp. 195–201. Contributions in Women's Studies, no. 79. Westport, CT: Greenwood Press, 1987.

The author first considers the musical and cultural contexts from which the unique jazz vocal style of the Boswell Sisters of New Orleans emerged, noting the influence of the "Blues Queens" (i.e. Ma Rainey, Bessie Smith, Victoria Spivey, Ethel Waters, etc.) and role of women musicians in the jazz world during that time period. Innovative in their vocal arrangements and their use of the singing voice to simulate the sounds of musical instruments, the style of the Boswell Sisters was imitated by later vocal stylists of the 1940s (e.g., Andrews Sisters).

1051. Hendricks, Jon, and Ian Carr. "Stimme für Stimme: Eine Hörwanderung mit Jazzsängerinnen." *du: Die Zeitschrift der Kultur* 4 (April 1992): 46–62, 89.

In English, with excerpts in German. Translated title: "Voice for Voice: A Listening Session with Female Jazz Singers." Part of a special issue devoted to women jazz singers. Jazz critic and musician Ian Carr queries jazz singer Jon Hendricks about his reactions to recorded excerpts of female jazz singers of the past and present. In doing so various topics are discussed regarding musicianship, vocal style, technique, and lifestyle. In addition, the importance of women's singing in the black church is stressed as a factor in the vocal development of the great black female singers. Jon Hendricks' views on the following singers are presented: Ma Rainey, Bessie Smith, Billie Holiday, Ella Fitzgerald, Sarah Vaughan, Annie Ross, Blossom Dearie, Janis Joplin, Peggy Lee, Anita O'Day, Carmen McRae, Chris Connor, Betty Roché, Abbey Lincoln, Monica Zetterlund, Flora Purim, Helen Merrill, Karin Krog, Betty Carter, Cleo Laine, Aretha Franklin, Esther Phillips, Mahalia Jackson, Nina Simone, Sheila Jordan, Urszula Dudziak, and Roberta Flack.

1052. Hicks, Robert. "Voices with Vision: Jeanne Lee, Terry Jenoure and Amina Claudine Meyers." *Option* 34 (September/ October 1990): 74–79.

    The female voice in black music is discussed with particular reference to the improvisatory jazz vocal techniques of these three women singers.

1053. "Is There A Place for Women in Jazz Strictly on a Merit Basis." *Down Beat* 56, no. 9 (September 1989): 44.

    55th Anniversary Issue.

1054. Koplewitz, Laura. "Toshiko Akiyoshi: Jazz Composer, Arranger, Pianist and Conductor." In *The Musical Woman: An International Perspective. Volume 2, 1984–1985*, ed. Judith Lang Zaimont, Catherine Overhauser, and Jane Gottlieb, pp. 256–279. Westport, CT: Greenwood Press, 1987.

    The author examines the life, career, and music of this Japanese jazz composer/arranger. A lengthy selected discography and bibliography is included.

1055. Lee, Wayne. "Jazzy Ladies." *Jazziz* 4, no. 4 (June/July 1987): 46–48.

    The author surveys about thirty recent jazz albums by contemporary female jazz vocalists performing solo or as a member of a vocal jazz ensemble.

1056. Lynch, Kevin. "Women Cruising in Jazz." *Capital Times [Madison, WI]* 12 April 1990, in *Newsbank: Review of the Arts, Performing Arts* 17, Fiche 65 (May 1990): B12–B13.

1057. McPartland, Marian. *All in Good Time*. New York: Oxford University Press, 1987.

    McPartland's collected reflections on her life as a jazz pianist include two chapters which pertain to general women's issues in jazz. In Chapter 1, "You've Come a Long Way Baby" (pp. 3–17), McPartland surveys the American and British women jazz instrumentalists and singers who served as early role models and mentors, and addresses the topic of discriminatory attitudes towards women in the jazz world. In Chapter 12, "The Untold Story of the International Sweethearts of Rhythm" (pp. 137–159), McPartland traces the development of this successful and first-class all-female jazz band, noting that "during their exciting yet difficult years of barnstorming across the country, they blazed a trail, taking hardship and prejudice in stride. Their story should be an inspiration to jazzwomen of today."

1058. Miller, Susanna L. "A History of Women in Jazz." *Crisis* 98, no. 2 (February 1991): 25–28, 48.

    Part of a special issue entitled "A Report on Black Music in the New World." This concise, but excellent, historical overview of black women in jazz begins with a discussion of women's participation in music which

pre-dated jazz, such as music from the African heritage, songs of slavery and resistance, public voodoo ceremonies in New Orleans, music of the black church, and the post-Civil War concert band movement. Influential musical families trained both male and female musicians. Noting the masculinization of jazz in its beginning stages, the author surveys the contributions of black women jazz musicians from the 1920s through 1980s, demonstrating that their determination in overcoming obstacles and sexual discrimination should be considered within the larger context of their heritage of musical expression.

1059. Naura, Michael. "Die Kunst der Einfühlung: Der Begleiter." *du: Die Zeitschrift der Kultur* 4 (April 1992): 78–80.

In German. Translated title: "The Art of Empathy: The Accompanist." Part of a special issue devoted to women jazz singers. On the artistic relationship between the piano accompanist and female vocalist.

1060. Peretti, Burton W. *The Creation of Jazz: Music, Race and Culture in Urban America*. Urbana, IL: University of Illinois Press, 1992.

The author traces the exclusion of women from jazz to jazz's early stages of development at the turn of the century, when it existed as a black male fraternity of musicians (pp. 35–36). The role of the working female blues singer within the musical life of New Orleans and Chicago is described (pp. 66–69). Male dominance of instrumental jazz music and attitudes towards female jazz instrumentalists in early jazz is discussed (pp. 122–125).

1061. Placksin, Sally. "Das erste Kapital-Die Frauen, die aus dem Süden kamen." *du: Die Zeitschrift der Kultur* 4 (April 1992): 18–21.

In German. Translated title: "The First Chapter—The Women Who Came From The South." Part of a special issue devoted to women jazz singers. Introductory article on the role of women in early blues and jazz and the roots of their vocal style.

1062. Placksin, Sally. *Frauen im Jazz: von der Jahrhundertwende bis zur Gegenwart*. Vienna, Austria: Hannibal, 1989.

German translation of the author's *Jazzwomen: 1900 to the Present*, originally published in 1982 by Wideview (NY).

1063. Placksin, Sally. "Frauen im Jazz." *Jazz Podium* 38, no. 7 (July 1989): 8–9.
In German.

1064. Primack, Bret. "Ladies Night Out." *Spectrum (Schwann)* 3, no. 3 (Summer 1992): 20–23.

Profiles of three young women jazz musicians: trumpet player Rebecca Coupe Franks, pianist and vocalist Eliane Elias, and pianist Renee Rosnes.

1065. Rito, Rio. "Women Musicians Not Inferior Says—Rio Rito." *Down Beat* 56, no. .9 (September 1989): 24.
55th Anniversary Issue.

1066. Rüedi, Peter. "Die kurze und glückliche Geschichte des Jazzgesanges." *du: Die Zeitschrift der Kultur* 4 (April 1992): 22–27.
In German. Translated title: "The Short and Lucky History of Jazz Singing." Part of a special issue devoted to women jazz singers. The author begins by defining the parameters of female jazz singing, from the standpoint of a jazz purist. In this discussion he raises important issues with regard to the human body as musical intrument and the manner in which the bodily/erotic associations of female jazz singing have often inhibited this art form's serious consideration. Here he also cites the ability of the great jazz singers to emancipate themselves from the often banal lyrics of American standards through vocal improvisation and highly individualized vocal technique. He then proceeds to pay homage to the numerous women who have made jazz singing a musical art form.

1067. Schulte-Hofkruger, Brigitte. "Reflexionen über Frauen im Jazz." *Jazz Podium* 36, no. 10 (October 1987): 67.
In German. A response to an article by Horst Stiefelmaier in *Jazz Podium* 36, no. 8 (August 1987): 9–10.

1068. Schweizer, Irène. "Ambivalenz." *du: Die Zeitschrift der Kultur* 4 (April 1992): 86–87.
In German. Translated title: "Ambivalence." Part of a special issue devoted to women jazz vocalists. The author, a female jazz instrumentalist, expresses her feelings of ambivalence towards the dominance of the female voice and likewise of the stereotypical exotic image of the female vocal jazz soloist. The perpetuation of such stereotypes, posits the author, prevents the serious consideration of women jazz instrumentalists.

1069. Sealock, Barbara. "Women Jazz Musicians Slate Pair of Concerts." *Boston Herald* 4 December 1987, in *Newsbank: Review of the Arts, Performing Arts* 14, Fiche 84 (December 1987): C5.

1070. Sher, Liz. "The International Sweethearts of Rhythm." *Sage: A Scholarly Journal of Black Women* 4, no. 1 (Spring 1987): 59–60.

1071. Simmonds, Ron. "Equal Rights." *Crescendo and Jazz Music* 28, no. 5 (1991): 24–25.
The author, a British jazz musician, reflects on his early "ill-mannered" behavior towards women jazz players, especially the trumpet player Gracie Cole, with whom he performed at one time. Recent honors bestowed upon Ms. Cole prompt the author to discuss discriminatory attitudes towards women instrumentalists in jazz.

1072. Sohmer, Jack. "Words of Love." *Down Beat* 56, no. 8 (August 1989): 35–36.
      Women jazz singers on compact disc.

1073. Stewart, Milton L. "Stylistic Environment and the Scat Singing Styles of Ella Fitzgerald and Sarah Vaughan." *Jazz Forschung/Jazz Research* 19 (1987): 61–76.
      In English, with abstract in German. Includes musical examples. The author presents a detailed musical analysis of the scat singing styles of Ella Fitzgerald ("Flying Home" and "How High the Moon") and Sarah Vaughan ("Sassy's Blues," "Lullaby of Birdland," and "How High the Moon"). Concentrating on the relationship between vocal technique, the simulation of instrumental sounds with the voice, improvisation, and the role of the singer as jazz ensemble member, the author notes in his final paragraph, "Ella Fitzgerald is at once a be-bop horn soloist and the wind sections of a big band. Sarah Vaughan is at once a horn soloist and a cool school drummer. [They] seem to be demonstrating to instrumentalists and listeners that singers can do things that other band members can do and more. One of the most effective ways to study the instrumental style of an era, therefore, may be to study its scat singers."

1074. Stiefelmaier, Horst Dieter. "Reflexionen über Frauen im Jazz." *Jazz Podium* 36, no. 8 (August 1987): 9–10.
      In German. Translated title: "Reflexions on Women in Jazz."

1075. Timmerman, Iris. "Frauen im Jazz." *Jazz Podium* 36, no. 5 (May 1987): 3–5.

1076. Voynow, Sarah K. "The History of the Harp in a Jazz Ensemble." *American Harp Journal* 13, no. 2 (Winter 1991): 913.
      The growth of the big band and innovative orchestration from 1920–1950 provided harpists with opportunities to play ragtime, swing, jazz, bepop, and later other genres such as new age, rock, fusion, etc. Notable women jazz harpists mentioned are Adele Girard, Laura Newell, Betty Glamann, Corky Hale, Dorothy Ashby, Deborah Henson-Conant and others.

1077. Wehling, Peter. "Rolle der Frau als Vokalistin im amerikanischen Jazz." *Jazz Podium* 36, no. 8 (August 1987): 7–8.
      In German. Translated title: "The Role of the Woman Vocalist in American Jazz."

1078. Wendt, Gunna, ed. *Jazz-Frauen.* Hamburg, Germany: Luchterhand-Literaturverlag, 1992.
      ISBN 3630710824. Reviewed in *Jazz Podium* 42, no. 1 (January 1993): 65. The women jazz instrumentalists, singers, and composers who have been active in Europe are the focus of this collection of interviews, portraits, and self-portraits. The final section of the book is devoted to the histo-

ry of jazz women as revealed through works of poetry and personal statements about musicians.

1079. "Why Women Musicians Are Inferior." *Down Beat* 56, no. 9 (September 1989): 24.
    55th Anniversary Issue.

1080. Wiedemann, E. "Tre jazz-kvinder: om Irene Becker, Marilyn Mazur og Lotte Ankur." *Dansk Musiktidsskrift* 67, no. 4 (1992–1993): 126–131.

1081. "Women Improvisors." *Ear* 13, no. 8 (November 1988): 30.

1082. "Women in Jazz." *New Bedford [Mass.] Standard Times* 18 June 1987, in *Newsbank: Review of the Arts, Performing Arts* 14, Fiche 6 (July 1987): D5–D6.

1083. Wyndham, Tex. "Solo: Why the Proportion of Female Dixieland Musicians is Miniscule." *Mississippi Rag* 14 (April 1987): 19.

# Part E.  Blues and Gospel Music

1084. Bowers, Jane M. "'I Can Stand More Trouble Than Any Little Woman My Size': Observations on the Meanings of the Blues of Estelle 'Mama' Yancey." *American Music* 11, no. 1 (Spring 1993): 28–53.
    Since the blues is a supremely individual and personal form of expression, the author first questions the authenticity of the "female" themes contained in blues written by male songwriters for the professional women blues singers of the classic blues era, and instead focuses on the blues as sung and written by Estelle "Mama" Yancey. In doing so Bowers reveals the autobiographical aspects of Yancey's blues, as well as the manner in which her blues represents more universal aspects of black women's lives.

1085. Budds, Michael J. "African-American Women in Blues and Jazz." *Women and Music: A History*, ed. Karin Pendle, pp. 282–297. Bloomington, IN: Indiana University Press, 1991.
    The introductory discussion on the participation of women in the African-American musical tradition emphasizes the role of women in performing and leading music for worship, and their secular utilization of music in the domestic sphere. After the Civil War, and into the twentieth century, black women entered the public world of professional entertainment. The author then provides a general introduction to the blues, lists the major female artists of the genre, and profiles the music and careers of Gertrude "Ma" Rainey and Bessie Smith. Budds introduces the section on jazz with an examination of the obstacles of gender discrimation and prescriptive social behaviors which prevented women from participating fully as musicians in

the male dominated world of jazz. While Budds concentrates on individual women musicians who made their mark in the male jazz world, such as Billie Holiday, Ella Fitzgerald, and Mary Lou Williams, he notes that many women instrumentalists who desired to play in jazz ensembles had no choice but to play (as did their counterparts in the classical music world), in all-women's ensembles.

1086. Carby, Hazel. "In Body and Spirit: Representing Black Women Musicians." *Black Music Research Journal* 11, no. .2 (Fall 1991): 177–192.

The author criticizes the essentialistic approach to the study of black women as offered in the college and university curriculum, noting the manner in which courses which focus on the black woman in culture and society reduce the black female subject to a one-dimensional, overly-romanticized figure. To assist educators in challenging "notions of an essential black female subjectivity" (p. 178), the author looks critically at five recent films about black women blues and gospel musicians: *Wild Women Don't Have the Blues* (produced by Carole van Falkenberg and Christine Dall, 1989); *Cissy Houston: Sweet Inspiration* (produced by Dave Davidson, 1987); *Say Amen, Somebody* (produced by George T. Nierenberg); *Alberta Hunter: My Castle's Rockin'* (produced by Stuart Goldman, 1988); *Tiny and Ruby: Hell Divin' Women* (produced by Greta Schiller and Andrea Weiss, 1988).

1087. Carby, Hazel. "It Jus Be's Dat Way Sometime: The Sexual Politics of Women's Blues." In *Gender and Discourse: The Power of Talk*, ed. Alexandra Dundas Todd and Sue Fisher, pp. 227–242. Advances in Discourse Processes, no. 30. Norwood, NJ: Ablex Publishing Corporation, 1988.

Power and sexuality as embodied in women's blues songs of the 1920s and 1930s is considered here, using examples of song texts by Bessie Smith, Ma Rainey, Clara Smith, Ethel Waters, and Ida Cox.

1088. Davis, Angela Y. "Black Women and Music: A Historical Legacy of Struggle." In *Wild Women in the Whirlwind: Afra-American Culture and the Contemporary Literary Renaissance*, ed. Joanne M. Braxton and Andrée Nicola McLaughlin, pp. 3–21. New Brunswick, NJ: Rutgers University Press, 1990.

Davis examines the early history of black music in America, examining the "traditions forged originally on the continent of Africa, then reshaped and honed by the conditions of slavery, the Reconstruction years, and the two world wars" (pp. 3–4). Within the context of this history, she investigates African-American music by women and its role in the preservation of ethnic and cultural identity, and the shaping of social and political consciousness. Women's song genres in West African music (work songs, lullabies, songs of courtship, ritual music, etc.) became the slave songs and spirituals which functioned as commentary on their oppression. Davis discusses the role of spirituals in the anti-slavery work of Harriet Tubman and Sojourner Truth. Once slavery ended however, oppression remained and the

blues emerged as a secular musical expression which "forged a communal consciousness" (p. 12). Davis devotes the rest of the essay to the blues of Getrude "Ma" Rainey. Rainey was a successful black woman entertainer who again, through music, gave a public voice to the "African-American predicament" (p. 19), and addressed in particular the experiences and tribulations of black women. Texts to the songs "Blues Oh Blues," "Bad Luck Blues," "Ma and Pa's Poorhouse Blues," "South Bound Blues," "Trust No Man," and "Prove It On Me Blues" are analyzed. Texts of the songs of Bessie Smith ("Poor Man's Blues") and Billie Holiday ("Strange Fruit") are discussed in this context.

1089. Goode, Gloria Davis. *Preachers of the Word and Singers of the Gospel: The Ministry of Women Among Nineteenth Century African-Americans.* Diss. Ph.D., University of Pennsylvania, 1990.

   Abstract in *Dissertation Abstracts International: A. Humanities and Social Sciences* 51, no. 12 (June 1991): 4165. DA# 9112565. Spiritual autobiographies of nineteenth-century African-American women preachers of the Northern U.S. are studied in detail, contributing to our knowledge black culture, and particularly the role of women as leaders in the black church. Folk theology, preaching style, and the spirituals of black women preachers of the North are examined, and the author stresses the importance of these autobiographical narratives to black folklife research.

1090. Harrison, Daphne Duval. *Black Pearls: Blues Queens of the 1920's.* New Brunswick, NJ: Rutgers University Press, 1988.

   Reviewed in *Billboard* 100 (10 September 1988): 21; *American Music* 7, no. 2 (Summer 1989): 205–207; *Jazz Journal International* 41, no. 9 (September 1988): 11; *Black Perspective in Music* 16, no .2 (Fall 1988): 250–252. The author examines the contributions of the blues women of the 1920s by presenting both an historical account of the role of black women in American popular culture during the early twentieth century as well as a detailed analysis of the content, style, and social meanings of blues songs by numerous blueswomen. Through the use of blues texts as well as documents reflecting life in the 1920s (e.g. newspapers, magazines, journals), Harrison seeks to correlate the art of these women with "the struggle by blacks to assimilate or to gain equality; the moral questions raised about women on the stage, singing and dancing jazz and blues; and the popularity and critical reception of the blues women" (p. 15). Individual chapters focus on Sippie Wallace, Victoria Spivey, Edith Wilson, and Alberta Hunter. The final pages include capsule biographies of Ida Cox, Lucille Hegamin, Rosa Henderson, Bertha "Chippie" Hill, Sara Martin, Lizzie Miles, Clara Smith, and Trixie Smith. A glossary of colloquialisms, notes, bibliography, and subject and song title indexes are included.

1091. Harrison, Daphne Duval. "Wild Women Don't Have the Blues. Part I." *Living Blues* 19, no. 2 [No. 79] (March–April 1988): 25–30.

Excerpted from the author's *Black Pearls: Blues Queens of the 1920's*, the author examines the thematic content and musical style of women's blues.

1092. Harrison, Daphne Duval. "Wild Women Don't Have the Blues. Part II." *Living Blues* 19, no. 3 [No. 80] (May–June 1988): 28–30.

Excerpted from the author's *Black Pearls: Blues Queens of the 1920's*. Further explorations into the function and content of women's blues via an analysis of lyrics of particular songs.

1093. Montell, William Lynwood. *Singing the Glory Down: Amateur Gospel Music in South Central Kentucky, 1900–1990.* Lexington, KY: University Press of Kentucky, 1991.

Women in the history of gospel music, including issues regarding gender in the performance of gospel music, is discussed (pp. 83–118).

1094. Reitz, Rosetta. "Big Mamas." *Hot Wire* 8, no. 3 (September 1992): 18–21.

The producer of Rosetta Records' album *Big Mamas: Independent Women's Blues, Volume 2* discusses her experiences and discoveries in compiling this album of classic women's blues, and discusses the women and the music featured on the album. Through these songs, women "refused shabby treatment and asserted themselves in the one area of their lives that they could control—to give or not to give affection" (p. 18).

1095. Reitz, Rosetta. "Mean Mothers: Independent Women's Blues." *Hot Wire* 5, no. 3 (September 1989): 34–36.

The author explores women blues singers of the classic era whose songs reflect a woman's desire for independence, respect, and dignity. These singers and their songs are found on *Mean Mothers: Independent Women's Blues, Volume 1*, a recording produced by Rosetta Reitz and issued on her label Rosetta Records.

1096. Skipper, James K., Jr., and Paul L. Leslie. "Women, Nicknames, and Blues Singers." *Names: Journal of the American Name Society* 36, no. 3–4 (September/December 1988): 193–202.

Amongst the artists represented in Sheldon Harris' *Blues Who's Who*, twenty-eight nicknames associated with American women blues singers (1890–1975) are selected and analyzed. The author thus presents "a conceptual orientation by which to better understand the role of women's nicknames in American society, and suggest some avenues for further research" (p. 193).

1097. Spencer, Jon Michael. "Isochronisms of Antistructure in the Black Holiness-Pentacostal Testimony Service." *Journal of Black Sacred Music* 2, no. 2 (Fall 1988): 1–18.

Discusses the role of women in the ritual of testimony.

1098. Yurchenco, Henrietta. "Mean Mama Blues: Bessie Smith and the Vaudeville Era." In *Music, Gender, and Culture*, ed. Marcia Herndon and Susanne Ziegler, pp. 241–251. International Council for Traditional Music. ICTM Study Group on Music and Gender. Intercultural Music Studies, no. 1. Wilhelmshaven, Germany: Florian Noetzel Verlag, 1990.

ISBN 3795905931. The author recognizes the importance of Bessie Smith as an independent voice expressing the female perspective on relationships between men and women. Quoting texts from her songs, the author demonstrates how themes such as abandonment, violence and abuse, sexuality, love and devotion, independence, parties and good-times, and hard economic times are expressed through her music.

# Part F.  Rap and Hip-Hop

1099. Adinolfi, Francesco. "Rap e Antifemminismo." In *Suoni dal Ghetto: La Musica Rap Dalla Strada alle Hit–Parade*, pp. 119–126. Genova: Edizioni Costa & Nolan, 1989.

In Italian. Rap and anti-feminism.

1100. Berry, Venisc T. "Feminine or Masculine: The Conflicting Nature of Female Images in Rap Music." In *Cecilia Reclaimed: Feminist Perspectives on Gender and Music*, ed. and intro. Susan C. Cook and Judy S. Tsou, pp. 183–201. Urbana, IL: University of Illinois Press, 1994.

1101. Browne, David. "Queens of the Hip-Hop (Yes, There Is Such a Thing as a Female Rapper)." *New York Daily News* 23 October 1988, in *Newsbank: Review of the Arts, Performing Arts* 15, Fiche 211 (November 1988): C13–C14.

1102. Coleman, Bill. "Female Rappers Give Males Run For the Money." *Billboard* 100 (21 May 1988): 1, 29.

1103. Cooper, Carol. "Girls Ain't Nothin' But Trouble?" *Essence* 19, no. 12 (April 1989): 80, 119.

Women rap artists.

1104. Cooper, Carol. "Music: Turn the Beat Around." *Village Voice* 33 (9 February 1988): 81–84.

Latin hip-hop as a popular music form performed by women.

1105. DiPrima, Dominique. "Beat the Rap." *Mother Jones* 15, no. 6 (September/October 1990): 32–36, 80–82.

This article presents a background of women's involvement in the rap scene, focusing on Salt 'n' Pepa, M.C. Lyte, and Queen Latifah.

1106. DiPrima, Dominique. "Women in Rap." *Hot Wire* 7, no. .2 (May 1991): 36–38.

Although acknowledging sexism in rap music and the industry which produces it, the author defends rap as a cultural form which is used by the black community to address social, racial, and political issues. Women, in particular, have used rap to put forth a uniquely black feminist message. DiPrima identifies some of the major women in rap and quotes selected rap lyrics.

1107. Gregory, Deborah. "Rapping Back: Tired of the Sexist Lyrics and Attitudes of Some Male Rappers, These Young Women are Fighting Back with Words." *Essence* 22, no. 4 (August 1991): 60–62, 119–120.
Yo Yo, M.C. Lyte, Harmony, and Queen Latifah are featured.

1108. Hunt, Dennis. "Female Rappers Diss and Tell." *Los Angeles Times* 19 August 1990, in *Newsbank: Review of the Arts, Performing Arts* 17, Fiche 131 (September 1990): A10–A13.

1109. Jones, Lisa. "Hip-Hop Nation: Pussy Ain't Free."*Village Voice* 33 (19 January 1988): 34–35, 37.

1110. "Ladies First." *Rolling Stone*, nos. 593–594 (13 December 1990): 81–82.
The forceful and outspoken female rappers of 1990 are featured.

1111. Mapp, Ben. "Billboard Spotlight: State of Rap. Women Rappers Break New Ground—Different Voices, Different Issues Expand Rap's Range and Help Tear Down the Walls." *Billboard* 103 (23 November 1991): R8, R21.
Women rappers identify social issues which impact upon their music and careers, e.g. male envy and competition with regard to female rap artists, the effect of motherhood on one's career, building a support network for women artists, etc.

1112. Marshall, Mary Ann. "It's a Girl Thang." *Spin* 6 (February 1991): 72.
Focus on women in rap music.

1113. Massalon, Jennifer, and Marie Elsie St. Leger. "Women Rappers: Fight the Power." *Ear* 15, no. 1 (March 1990): 30–36.

1114. McAdams, Janine C. "Female Rappers Take Their Show on Road [Black Women in Rap '91]." *Billboard* 103 (9 February 1991): 27.

1115. McAdams, Janine C. "Rap Forum Not Fully Exploited by Women." *Billboard* 103 (23 November 1991): 19.
Fewer new rap music releases voice women's interests.

1116. McAdams, Janine C. "The Rhythm and the Blues: Female Rappers Step into the Spotlight." *Billboard* 101 (16 September 1989): 79.

1117. McDonnell, Evelyn. "Bum Rush the Locker Room." *Musician* 151 (May 1991): 30, 32.

    On women rappers Yo-Yo and Nikki D.

1118. Morgan, Joan. "Music: Throw the 'F'." *Village Voice* 36 (11 June 1991): 75.

    A feminist look at women's hip-hop records.

1119. Pareles, Jon. "The Women Who Talk Back in Rap: Female Rappers are Still Outnumbered, But New Albums Prove that Men Don't Have the Last Word." *New York Times* 21 October 1990, II: 33, 36.

1120. Pearlman, Jill. "Rap's Gender Gap." *Option* 22 (September/ October 1988): 32–36.

    Interviews with women rap artists M.C. Lyte, Roxanne Shante, and Sparky D.

1121. Roberts, Robin. "Music Videos, Performance and Resistance: Feminist Rappers." *Journal of Popular Culture* 25, no. 2 (Fall 1991): 141–152.

    A feminist analysis of Roxanne's "Roxanne's on a Roll," M.C. Lyte's "Lyte as a Rock," and Salt 'n' Pepa's "Shake Your Thang." Issues such as racism, sexism, the use of erotic as power, and the projection of the female self in these rap performances are discussed.

1122. Smith, Dinita. "The Queen of Rap: Latifah Sells Womanism." *New York* 23 (3 December 1990): 123–126, 128–132, 138–146.

    One of the more articulate articles on women in rap, the article focuses on Queen Latifah but begins with a general overview of the development of rap and women's involvement in the genre.

1123. Summers, Gerrie E. "All-Female Rap Show Going To PPV." *Billboard* 103 (26 October 1991): 27, 31.

    25 female rap acts perform at the Ritz in N.Y. for a pay per view television special "Sisters in the Name of Rap: Rap Fest 1."

1124. Thigpen, David E. "Not For Men Only: Women Rappers Are Breaking the Mold With a Message of Their Own." *Time* 137 (27 May 1991): 71–72.

    Focuses on Monie Love, Queen Latifah, and Salt 'n' Pepa.

1125. Wallace, Michelle. "When Black Feminism Faces the Music, and the Music is Rap." *New York Times* 29 July 1990, II: 20.

1126. Wallace, Michelle. "Women Rap Back." *Ms.* 1, no. 3 (November/ December 1990): 61.

# Part G.  Folk and Country Music

1127.  Altman, Billy. "Country Just Ain't What It Used To Be." *New York Times* 31 January 1993, II: 24–25.

Country music is redefining itself, communicating a different view of the relationship between the sexes, and challenging or discarding male/female stereotypes.

1128.  "Appalshop Notes: Appalshop is Producing a New Radio Series Titled 'Southern Songbird: The Women of Old-Time and Early Country Music'." *Sing Out* 35, no. 2 (1990): 30.

1129.  Bufwack, Mary A., and Robert K. Oermann. *Finding Her Voice: The Saga of Women in Country Music*. New York: Crown Publishers, 1993.

1130.  Bufwack, Mary A., and Robert K. Oermann. "Women in Country Music." *Popular Culture in America*, ed. Paul Buhle, pp. 91–101. Minneapolis, MN: University of Minnesota Press, 1987.

This article examines gender relationships and the working class experience as articulated through the songs of women country musicians, especially Loretta Lynn, Tammy Wynette, and Dolly Parton.

1131.  Burdine, Lucille, and William B. McCarthy. "Sister Singers." *Western Folklore* 49, no. 4 (October 1990): 406–417.

The differing song repertoires of sisters Julie Hefley (age 70) and Susie Campbell (age 72) of Mt. Judea, Arkansas are the subject of this study. The authors examine issues such as the transmission of an Ozark family song tradition, the sisters' selection and retention of repertoire from that tradition, and manner in which the experiential and personality differences of these two women influence the addition of new repertoire to that song tradition.

1132.  Cauthen, Joyce H. *With Fiddle and Well-Rosined Bow*. Tuscaloosa, AL: University of Alabama Press, 1989.

Delia Mullins, Emma Crabtree, Pearl Duncan Morgan, and Eula Spivey Rushing were champion women fiddlers of the 1920s and 1930s (pp. 73–76).

1133.  "Cherish the Ladies [ensemble of Irish-American women folk musicians] Tour." *Sing Out* 33 (Fall 1987): 70.

1134.  "Cowgirls Are Doing It For Themselves." *Journal of Country Music* 15, no. 1 (1992): 34–35.

This is chronological listing of country music's "women's anthems," including title, performer, writer, and the song's famous lyrical catch phrase. Part of a special issue on women in country music.

1135. Fairweather, Sharon Stapleton. *Women's Work: Carrying the Culture.* Photog. Debbie De Vita. Boone, N.C.: Southern Appalachian Historical Association, 1991.

   A survey of the women artists, artisans, and musicians of Watauga County, North Carolina.

1136. Gleason, Holly. "Another Country: There's a New Woman in Country Music. She's Young, Independent and She Isn't Standing Around Waitin' For Her No-Good Man." *Harper's Bazaar* 122 (October 1989): 112, 124.

1137. Graff, Gary. "Country Women Call the Tune." *Detroit Free Press* 10 May 1991, in *Newsbank: Review of the Arts, Performing Arts* 18, Fiche 69 (June 1991): B2–B3.

   New and established women country music performers are surveyed about changes in the music industry and the role of women in country music.

1138. Haney, F. Paul. "A Sampling: Women in Bluegrass, From the Women's Point of View." *Bluegrass Unlimited* 24 (December 1989): 20–28.

   This is a general overview of women in bluegrass music from the early days to the present, including biographical profiles, interviews and reflections on the musical life of women in the primarily male-dominated bluegrass world. Musicians discussed include: Molly O'Day, Lulu Belle Wiseman, Coon Creek Girls (and Lily May Ledford), Rachel Veach, Minnie Pearl, and more recently Murphy Henry, Peggy Harvey, Mary Jo Leet, and Lynn Morris. New all-women bands include the New Coon Creek Girls, Dixie Reign, and Sidesaddle.

1139. Kingsbury, Paul. "Will the Circle Be Unbroken: Threads of an Ongoing Conversation." *Journal of Country Music* 15, no. 1 (1992): 27–33.

   Part of a special issue entitled "Women in Country." A variety of country artists and record producers are interviewed on the topic of women in country music.

1140. Kingsbury, Paul. "Woman, Walk the Line: Women Have Made Great Strides in Country Music, Haven't They?" *Journal of Country Music* 15, no. 1 (1992): 20–26.

   Part of a special issue entitled "Women in Country." With more women artists composing their own songs and taking control of record production, country music has become more relevant to women. Thus, these women become successful commercially, but not without resistance from male studio musicians and record company executives.

1141. Morris, Edward. "Nashville Scene: Female Writers Set High Lyrical Standard—Cash, Carpenter, Berg, Wheeler Offer True Insights." *Billboard* 102 (10 November 1990): 43.

1142. Morris, Kenneth E. "Sometimes It's Hard To Be a Woman." *Popular Music and Society* 16, no. 1(Spring 1992): 1–11.

The author analyzes the famous country song from 1968, "Stand By Your Man," co-written by Tammy Wynette and Billy Sherrill. Though often criticized as an "ode to female subservience," the song has never been fully studied. The author examines the song in relation to the difficult domestic life of the songwriter, other songs by Wynette which deal with themes of divorce and marital infidelity, and the unusual circumstances surrounding the co-writing of the song. The ambivalent voices communicated by the verse (Wynette's/female) and the chorus (Sherrill's/male) reflect the imbalance of power in this "collaborative relationship." While the chorus is the hook which reinforces obedient female behavior, the verses express the anxiety and sorrow of a woman emotionally torn by societal expections of monogamy and loyalty when faced with her man's infidelity. The song is then compared with the 1961 rhythm and blues hit, "Stand By Me."

1143. Oerman, Robert K. "Honky-Tonk Angels: Kitty Wells and Patsy Kline [and others]." In *Country: The Music and Musicians*, pp. 314–341. New York: Abbeville Press, 1988.

1144. Pareles, Jon. "Lifted Voices from Women of a Certain Age: The Better Moments on Three New Recordings Prove There's Real and Examined Life for Grown-Ups." *New York Times* 19 March 1989, II: 28.

Reviews of new albums by seasoned women performers of folk-rock and country: Bonnie Raitt's *Nick of Time*, Phoebe Snow's *Something Real*, and Lacy J. Dalton's *Survivor*.

1145. Ramsten, Märta. "Lena Larsson." In *Kvinnors Musik*. Ed. Eva Öhrström and Märta Ramsten, pp. 83–88. Stockholm, Sweden: Sveriges Utbildningsradio AB and Svenska Rikskonserter, 1989.

ISBN 9126898101. In Swedish. Discusses the life and musical activity of Lena Larsson (1882–1967) of Göteborg, whose formidable singing talents and knowledge of songs in the Swedish oral tradition led to her prominence as a folk performer at concerts, festivals, and on radio and television.

1146. Stuttgen, Joanne Raetz. "Kentucky Folksong in Northern Wisconsin: Evolution of the Folksong Tradition in Four Generations of Jacobs Women." *Southern Folklore* 48, no. 3 (1991): 275–289.

This article focuses on the women ballad singers of the Jacobs family and the changes which occurred in the Anglo-Irish based ballads from their home state of Kentucky as the family migrated to Wisconsin. The changing attitudes of the women about their singing and the preservation of a tradition is examined as well.

1147. Wood, Gerry. "Nashville Scene: Cayman Meet Generates Musical Heat: Rising Female Stars Wow Confab Crowd." *Billboard* 102 (14 July 1990): 25.

1148. Wynn, Ron. "Women Take New Roads in Country." *Washington Times* 22 June 1988, in *Newsbank: Review of the Arts, Performing Arts* 15, Fiche 119 (July 1988): F14.

# Part H.  Woman-Identified Music

1149. Anderson, Jamie. "Mulling It Over: Humor in Women's Music." *Hot Wire* 6, no. 1 (January 1990): 46–47, 60.
 The article discusses the manner in which lesbian songwriters use humor to "validate, educate, and entertain" (p. 46). Includes selective discography.

1150. Armstrong, Toni, Jr. "The Double Bill." *Hot Wire* 7, no. 1 (January 1991): 40–43.
 Eight woman-identified performers (Lee Lynch, Karen Williams, Julie Homi, Terri Jewell, Alix Dobkin, Jewelle Gomez, Suede, Audre Lorde) are asked about their favorite artists and performing venues.

1151. Armstrong, Toni, Jr. "Mulling it Over: The Great White Folk Music Myth." *Hot Wire* 4, no. 3 (July 1988): 22.
 The author questions those who view women's music as a "white-girl-with-guitar" genre.

1152. Ball, Charlene. "Hotlanta: A Stroll Through the Women's Communities of Atlanta." *Hot Wire* 7, no. 3 (September 1991): 28–31, 59.
 A survey of women's music and culture in Atlanta, Georgia.

1153. Brannon, Rebecca. "Madison's Fourth Annual Lesbian Variety Show: 'I Got This Way From Kissing Girlz'." *Hot Wire* 6, no. 2 (May 1990): 36–38.

1154. Bruce, Lauren. "Feminist Music in the Largest State: Alaska." *Hot Wire* 7, no. 2 (May 1991): 28–29, 40.

1155. Einhorn, Jennifer. "Women's Music: Where Did It Go?" *Sojourner* 17, no. 1 (September 1991): 34–35.
 Einhorn addresses the "unwavering demand for women in mainstream music" and the popularity of lesbian pop and rock artists whose "smarts and savvy" go beyond considerations of gender to appeal to a wide spectrum of musical tastes. The implications of this trend for smaller women's music record labels and feminist/lesbian musical culture is explored, and the resistance of women in mainstream rock to promote a feminist political message or openly declare their lesbian sexuality is questioned. Commentary by Judy Dlugacz (President, Olivia Records) and Holly Near reveal both sides of the issue.

1156. Friends of the Hammer. "Lesbian Musical Theatre." *Hot Wire* 5, no. 2 (May 1989): 30–31.

    *In Search of the Hammer* and *The Return of the Hammer*, written by Cappy Kotz and Phrin Prickett, were lesbian musicals performed by the Front Room Theatre Guild in Seattle during the 1980s.

1157. Gerdin, Mia. "Varför har tjejer så tunna röster? Om kvinnorörelsens musik." In *Kvinnors Musik.*, ed. Eva Öhrström and Märta Ramsten, pp. 101–108. Stockholm, Sweden: Sveriges Utbildningsradio AB and Svenska Rikskonserter, 1989.

    ISBN 9126898101. In Swedish. Translated title: "Why Do Women Have Such Weak Voices? About the Music of the Women's Movement." During the feminist movement of the 1960s, music played an important role in forging a sense of women's community and consciousness. While women seized the courage to sing and play together and break with accustomed sex roles, the music of the women's liberation movement drew upon common themes to put forth their textual message. In the male-dominated rock music industry, it was not until the mid-1970s that women were able to go beyond the boundaries of folk-inspired women's music and enter into the world of rock and roll. Rock and roll now has become means of feminist expression, where women are putting forth a message of aggressiveness and obstinacy on stage. The author discusses the changing world of feminist pop in Sweden, mentioning numerous singers and all-women's bands in that country playing woman-identified music.

1158. Gilbert, Ronnie, and Toni Armstrong, Jr. "Ronnie Gilbert." *Hot Wire* 8, no. 2 (May 1992): 2–5, 56.

    Ronnie Gilbert candidly reflects on her years as an active participant in women's music and culture, including her views on the use of the terms "women's music," "feminist" and "lesbian" as cultural labels, and the lack of cohesiveness between heterosexual and lesbian women, their artistic and cultural work, and more.

1159. Jesudason, Melba, and Sally Drew. "Feminist Music and WOMONSONG Choir of Madison, Wisconsin." *Studies in Popular Culture* 15, no. 1 (1992): 61–74.

    Defining women's music as that which aims to promote social change through the manifestation of a feminist or lesbian aesthetic, the authors present a well-written and researched introduction to woman-identified music and culture. As they discuss the subtle distinctions between lesbian and feminist music—the first concentrating on woman's personal space and freedom and the second concentrating more on political and social freedom—they delve into the related messages conveyed in both musics. Noting the importance that women's music plays in the formation of identity, community, and solidarity, they then focus on one feminist singing group, the Womonsong Choir of Madison, Wisconsin, and discuss the supporting role

played by larger woman-identified cultural organizations, such as the Michigan Womyn's Festival and the Sister Singers Network (an association of more than forty community-based women's choirs).

1160. Jordan, Elena. "Labrys: The Duo and the Label." *Hot Wire* 4, no. 1 (November 1987): 22–23.

Elena Jordan and Patricia Lyons are the duo Labrys, performing music geared toward the lesbian community. Their record label also produces "lesbian-identified music."

1161. Langen, Toby, Sharon Lynn, and Laura Berkson. "Re:Inking. Three Songwriters: Tret Fure, Janis Ian, Laura Berkson." *Hot Wire* 4, no. 1 (November 1987): 16–19, 59–61.

1162. Lont, Cynthia M. "Women's Music: No Longer a Small Private Party." In *Rockin' the Boat: Mass Music and Mass Movements*, ed. Reebee Garofalo, pp. 241–253. Boston: South End Press, 1992.

First the author documents the history of women's (i.e. feminist and lesbian-identified) music in order to redress the lack of media attention given to this subcultural form, overlooked due to its foundation in the lesbian community. Women's music of the 1970s and 1980s is compared with that of the new wave of women pop/rock performers of the 1990s. Though they may be feminists, these new women performers, with a more mainstream message and fashionably androgynous looks, have been commercially accepted in the pop/rock world, co-opting the musical niche of their more radical sisters. The future of the women's music subculture is examined in light of this trend.

1163. Lowenstein, Alice, and Toni Armstrong Jr. "Chicago: Our Kind of Town." *Hot Wire* 8, no. 3 (September 1992): 24–28.

This survey of feminist art and culture in Chicago introduces the reader to individual women creative artists and women's cultural groups within that city.

1164. MacAuslan, Janna. "Mulling it Over: Humor in Women's Music." *Hot Wire* 6, no. 1 (January 1990): 46–47, 60.

1165. McAllister, Pam. "Women in Harmony: Songs for Peace and Freedom." *Woman of Power* 10 (Summer 1988): 6–11.

1166. Near, Holly. *Fire in the Rain. . .Singer in the Storm: An Autobiography*. New York: Quill/William Morrow, 1990.

The autobiography of this well-known singer/songwriter, political activist, and feminist reads as a history of the feminist/lesbian music and culture movement in America, as she describes her founding of Redwood Records (an independent record label promoting world peace and feminism), the working relationships forged with women active within the women's

music network, and life on the lesbian music scene. Illuminating and candid are her musings in Chapter 12 ("Proceed with Care"). As a performer representing the lesbian/feminist cultural community, where art and politics merge and the personal becomes political, Near philosophizes over issues concerning public sexual identity (i.e. whether one declares themself to be gay, straight, bisexual) vs. sexual independence and privacy, and artistic freedom vs. political responsibility.

1167. Petersen, Karen E. "An Investigation into Women-Identified Music in the United States." In *Women and Music in Cross-Cultural Perspective*, ed. Ellen Koskoff, pp. 203–212. Contributions in Women's Studies, no. 79. Westport, CT: Greenwood Press, 1987.

Petersen traces the development of women-identified music in the United States. Coinciding with the Women's Movement of the 1960s and emerging from the inability of the male-dominated and often misogynist rock music world to address the concerns and emotions of women, women-identified music celebrates the creativity of women, and speaks to the political/social concerns of feminism as well as the sexuality of lesbianism. The author surveys the network of women-identified music: the musicians and songwriters, women-owned and operated record companies, women's music producers, music distributorships, music festivals, etc. Petersen touches on the issue of the current viability of women-identified music, given the increasing numbers of feminist-oriented popular and rock music artists crossing over into the musical mainstream.

1168. Pollock, Mary S. "The Politics of Women's Music: a Conversation with Linda Tillery and Mary Watkins." *Frontiers: a Journal of Women's Studies* 10, no. 1 (1988): 14–19.

1169. Post, Laura. "Women Musicians on Sabbatical." *Hot Wire* 8, no. 2 (May 1992): 38–40, 47.

." . .Personal stories of three musicians: two who have returned from time off (Nancy Vogl and Deidre McCalla) and one who is now in the middle of her sabbatical (Alix Dobkin)."

1170. Rickard, Marilee, and Deborah Harris. *Singing For Our Lives: A History of Women's Music, 1969–1991*. Thesis. M.S., Mankato State University, 1991. Slide/tape/text presentation.

1171. Rose, Betsy. "Mulling it Over: In Search of the Cutting Edge. Part One: Asking the Questions." *Hot Wire* 4, no. 1 (November 1987): 52–53.

This singer/songwriter reflects on the future of feminist music.

1172. Sara. "ASL [American Sign Language] Interpreting for Concerts: What Producers Should Know." *Hot Wire* 6, no. 3 (September 1990): 18–19, 46.

"This article is the first in a series about how. . .to bridge the gaps between the deaf and hearing cultures in the women's music community." This list of suggestions focuses on the technical details producers should know when including sign language interpretation at concert events.

1173. Schonfeld, Rosemary. "Report from the Front Lines: Women's Music in Europe." *Hot Wire* 5, no. 2 (May 1989): 26–27.
    This British performer of woman-identified music compares the English, European, and American women's music scenes.

1174. Seeling, Ellen. "Mulling it Over: The Politics of Instrumental Music." *Hot Wire* 4, no. 3 (July 1988): 18–20.
    A woman trumpet player reflects on the political implications of the scarcity of virtuoso female instrumentalists and instrumental ensembles involved in the women's music scene.

1175. Sloan, Judith. "Is She or Isn't She...An Outrageous Feminist." *Hot Wire* 8, no. 1 (January 1992): 22–23, 58.
    "Since the women's music and culture scene is primarily lesbian, what's in it for a heterosexual woman?" A heterosexual, feminist performer working in the women's music scene addresses this question, reflecting on sexual orientation, gender, art, politics, and the differences she has encountered in performing in both the mainstream and women's circuits.

1176. Starr, Victoria. "The Bleat Goes On." *Village Voice* 38 (3 August 1993): 24.
    On the occasion of the twentieth anniversary of Olivia Records, the author reflects upon the state of women in rock and pop music and the continued marginal status of feminist/lesbian-identified music.

1177. Starr, Victoria. "The Changing Tune of Women's Music: A Once Powerful Movement Loses Its Identity as a New Generation Steps Out to a Different Beat." *The Advocate* 604 (2 June 1992): 68–71.

1178. Sutton, Terri. "Whatever Happened to 'Women's Music'?: New Female Stars Belie Notion That There is a Women's Music." *Utne Reader* 49 (January/February 1992): 30, 32, 34.
    The author examines the current debate over the demise of woman-identified music resulting from the popularity of creative female musicians who have achieved success within the rock/pop mainstream. She refers to recent writings of Jennifer Einhorn, Arlene Stein, Robin Roberts, Margo Mifflin and Susan McClary to inform her discussion.

1179. Tilchen, Maida. "The State of Music: A Lesson From History." *Hot Wire* 3, no. 2 (March 1987): 32–33.
    Reprinted from *Gay Community News* (23 November 1986). The

author criticizes the lack of a political, community, feminist, and lesbian consciousness in the women's music being co-opted by the mainstream music industry. "Women's music has been so successful that capitalists have discovered it as one more consumer product, and since [lesbian/feminist] values are great drains on profits, they are not part of the slick, new package."

1180. Weinbaum, Batya. "Music, Dance and Song: Women's Cultural Resistance in Making Their Own Music." *Heresies* 22 (1987): 18–22.

Part of a special issue entitled "Art in Unestablished Channels." This article examines the feminist aesthetic at work in the rise of women's music and women's cultural communities. Weinbaum explains how contemporary woman-identified musical communities, by providing cultural space that is woman-controlled (i.e. exclusionary of men), seek to encourage a "matriarchal consciousness" (p. 18) based on women's culture and ritual in ancient times.

1181. Wenzel, Lynn. "Spirited Women Music Makers Hit High Notes." *New Directions for Women* 18, no. 4 (July/August 1989): 14–16.

1182. Yount, Rena, Toni Armstrong Jr., and Alix and Adrian Dobkin. "Moms and Daughters: Bernice and Toshi Reagon; Alix Dobkin and Adrian Hood." *Hot Wire* 5, no. 2 (May 1989): 34–39.

Feminist women musician mothers and their relationships with their daughters are examined.

# Part I. Music of Labor and Political Protest

1183. MacAuslan, Janna. "Noteworthy Women: Protest Songs of the Suffrage Era." *Hot Wire* 7, no. 3 (September 1991): 12–13.

The author identifies women's suffrage songs, their composers, and the sources in which they can be found.

1184. Porter, Gerald. *The English Occupational Song.* Diss. University of Umeå, 1992. Acta Universitatis Umensis. Umeå Studies in the Humanities, no. 105. Umeå, Sweden: University of Umeå ; Stockholm, Sweden: Dist. by Almqvist and Wiksell International, 1992.

ISBN 9171746498. In English. Includes abstract. Drawing upon recorded and printed song collections from the seventeeth to the twentieth centuries, this is one of the few studies examining the representation of men's and women's work in English vernacular songs, as well as their sociological and psychological meanings. Noting that "since traditional song often challenges established norms of gender and class" (p. 32), the author demonstrates in Chapter One how the hegemonaic mediation of early field-

workers and commercial enterprises (e.g. broadsides) effectively censored, standardized, or altogether did not reproduce certain occupational songs if they overstepped societal standards relating to class, gender, and sexuality. Chapter Three, "Occupation as Metaphor," discusses how the travesty ballad (i.e. a song where a female protagonist disguises herself as a man) "temporarily suspends the patriarchal order," whereas the eroticism found in occupational songs represents a "metaphorical association between production and reproduction" (p. 92). Chapter Four, entitled "Group Cohesion and Disintegration" investigates the idea of community and resistance as it relates to both class and gender, with a specific discussion of the women's work song as an expression of resistance. Appendices include musical examples, a list of close to two hundred songs cited in the text (with source references), an extensive bibliography, a name index, and an occupation index.

1185. Ramsten, Märta. "Fabriksarbete och sång." In *Kvinnors Musik*, ed. Eva Öhrström and Märta Ramsten, pp. 42–47. Stockholm, Sweden: Sveriges Utbildningsradio AB and Svenska Rikskonserter, 1989.

   ISBN 9126898101. In Swedish. Translated title: "Factory Work and Singing." Includes a general discussion of the role of song in easing women's labors, and concentrates on songs of Swedish women factory workers of the 1930s.

1186. Seitz, Barbara. "Songs, Identity and Women's Liberation in Nicaragua." *Latin American Music Review* 12, no. 1 (Spring/Summer 1991): 21–41.

   The effect of the Sandanista revolution on women in Nicaragua as seen through women's songs.

1187. Yurchenko, Henrietta. "Trouble in the Mines: A History in Song and Story by Women of Appalachia." *American Music* 9, no. 2 (Summer 1991): 209–224.

   Songs by two generations of women from the coal mining areas of Appalachia chronicle the struggle for unionization during the 1920s and 1930s. The lives and songs of Aunt Molly Jackson, Sarah Ogan Gunning, and Florence Reece are discussed. In the 1960s and 1970s, Hazel Dickens continued singing songs about the coal mines, as well as repertoire dealing with feminist issues.

CHAPTER 8

# Women, Gender, and Music in Non-Western
# Cultural Contexts

## Part A. General and Cross-Cultural Perspectives

1188. Boggs, Vernon W. "Latin Ladies and Afro-Hispanic Music: On the Periphery But Not Forgotten." In *Salsiology: Afro-Cuban Music and the Evolution of Salsa in New York City*, pp. 109–119. Contributions to the Study of Music and Dance, no. 26. Westport, CT: Greenwood Press, 1992.

The author examines the reasons for women's peripheral role in the making of music in Afro-Hispanic Culture. While the lyrics to songs are highly sexual, and women performers are valued less for their talent and more for the sexuality they exude onstage, Afro-Hispanic society offers a contradictory message with expectations of virginity before marriage, monogamy, motherhood and obedience from its women. Because of these attitudes, women who desire to participate seriously in music must overcome many obstacles. The author notes some women who have been successful as musicians in Afro-Hispanic society, including singers Ester Borja, Celia Cruz, Graciela Grillo Perez, Lupe Victoria Yoli ("La Lupe"), as well as the all-female Orquesta Anacaona, and composer/vocalist/guitarist Maria Teresa Vera. He recognizes the scholarly work of Cristobal Diaz Ayala, who in his *Musica Cubana del Areyto a la Nueva Trova* (Hato Rey, Puerto Rico: Editorial Cubanacan, 1981), documents the contributions of more than 270 women throughout the history of Afro-Hispanic Music.

1189. Brooks, Iris. "Taboos." *Ear* 13, no. 4 (June 1988): 17.

Taboos associated with women playing particular instruments from non-Western cultures.

232

1190. Cohen, Judith R. "Judeo-Spanish Songs in Montreal and Toronto." *Jewish Folklore and Ethnology Review* 12, no. 1–2 (1990): 26.

Part of a special issue devoted to Jewish women. The author summarizes the findings of her research on the Judeo-Spanish song traditions of women who have emigrated to Canada from Morocco and the Eastern Mediterranean.

1191. Cohen, Judith R. "'Ya Salió de la Mar': Judeo-Spanish Wedding Songs Among Moroccan Jews in Canada." In *Women and Music in Cross-Cultural Perspective*, ed. Ellen Koskoff, pp. 55–67. Contributions in Women's Studies, no. 79. Westport, CT: Greenwood Press, 1987.

Vocal repertoire of Morrocan Jewish women now living in Montreal, and specifically wedding songs in the Sephardic tradition, are studied here. Cohen first discusses general aspects of women's music making, and subsequently examines the particulars of social context, textual themes, performance practice, and forces of continuity and change as they are manifested in the wedding song tradition of this Sephardic community in Canada.

1192. Cox, Renée. "A Gynecentric Aesthetic." *Hypatia* 5, no. 2 (Summer 1990): 43–62.

In examining the possibilities for a female artistic aesthetic for today's world, Cox reviews in detail the investigations into female artistic expression undertaken by philosopher Heide Göttner-Abendroth (e.g., the matriarchal principle in the arts of the ancient world) and anthropologist Alan Lomax (e.g., the elevated status of women in the culture of contemporary African foraging societies, as demonstrated through his theory of cantometrics, which demonstrates the relationships between song, dance, and social structure).

1193. DeVale, Sue Carole. "Musical Instruments and Ritual: A Systematic Approach." *Journal of the American Musical Instrument Society* 14 (1988): 126–160.

This article presents a framework by which one may investigate the importance of musical instruments in the ritual music of particular cultures. In the "receptive mode" (p. 126), one would investigate the instrument-making process itself as a site of ritual and ceremony, where instruments are imparted with particular spiritual powers during phases of the contruction of a particular instrument. In the "transitive mode" (p. 126), a musical instrument then becomes "an active agent essential to the effectiveness of ritual for persons, places, or things. . ." (p. 146). In her study, DeVale examines the manner in which gender, in performance and in association with characteristics of musical instruments, is an essential component in the study of rituals performed for and with musical instruments.

1194. Herndon, Marcia and Susanne Ziegler, ed. *Music, Gender, and Culture.* International Council for Traditional Music. ICTM Study Group on Music

and Gender. Intercultural Music Studies, no. 1. Wilhelmshaven, Germany: Florian Noetzel Verlag, 1990.

ISBN 3795905931. Reviewed in *Notes* 48, no. 2 (December 1991): 523–525; *Choice* 28, no. 11–12 (July/August 1991): 1791. Most of the articles in this compilation emanate from the meeting of the ICTM Study Group on Music and Gender which took place in Heidelberg in 1988, as part of a joint meeting with the fourth "Komponistinnen Gestern-Heute" (Women Composers Yesterday-Today) festival and the Fifth International Congress on Women in Music. The book's major premise is to question prevailing theories and methods in the field of ethnomusicology which have produced little in the way of documentation or in-depth study of the musical role of women in traditional culture. Sixteen essays seek to redress this omission by investigating not only women's music-making roles, but also gender as it shapes the forms and expressions of music within particular cultures from around the world. Includes a comprehensive bibliography and an index. Essays are individually cited in this bibliography.

1195. Heskes, Irene. "Jewish Women and Liturgical Music." *Notes* 48, no. 4 (June 1992): 1193–1202.

A historical overview of the musical contributions of Jewish women from antiquity through the twentieth century, concentrating mostly on the culture of the Diaspora. The author traces the historical process by which Jewish women, in order to continue to express themselves musically given Jewish religious doctrine forbidding the woman's voice in liturgical music, either performed religious music in sexually segregated contexts, or expanded their role in vocal and instrumental music performed for communal rituals, for social entertainments, and for domestic purposes.

1196. Ice, Joyce. "Review Essay: Women, Folklore, Feminism and Culture." *New York Folklore* 15, no. 1–2 (Winter/Spring 1989): 121–137.

This review of the literature on feminist folklore scholarship highlights published collections issued by the American Folklore Society.

1197. Jeffrey, Peter. *Re-Envisioning Past Musical Cultures: Ethnomusicology in the Study of Gregorian Chant.* Chicago Studies in Ethnomusicology. Chicago, IL: University of Chicago Press, 1992.

In his brief discussion (pp. 71–72) of the women's *planctus*, or lament, as a category of chant, the author documents sources on the liturgical lament for female Biblical figures, and compares the liturgical lament with the lament's non-liturgical manifestations as a women's musical genre in a variety of non-Western cultures.

1198. Jones, L. JaFran. "Women in Non-Western Music." In *Women and Music: A History*, ed. Karin Pendle, pp. 314–330. Bloomington, IN: Indiana University Press, 1991.

The author presents an overview of suggested ways of considering the music of women from various non-Western cultures. The author stresses that studies of non-Western music cultures should examine both men's and women's music, and the relationship between gender ideology and musical culture. In the section entitled "Making Music," Jones enumerates various perspectives by which one can study the women's music of a particular culture. Depending on the function of the music in society (e.g., work songs, music accompanying rituals or celebrations, music for worship), music will be performed in different contexts (private/domestic vs. public, segregated by gender vs integrated by gender, etc.), and may have different musical characteristics. She provides examples from a variety of cultures to illustrate various genres of women's music (e.g., lullabies, work songs, play songs, instrumental and vocal music to accompany birth and wedding celebrations, laments for the dead, and music accompanying particular women's rituals). She also notes that women, as preservers of cultural heritage through motherhood and childraising, have important roles as transmitters of musical culture.

1199. Kartomi, Margaret J. *On Concepts and Classifications of Musical Instruments*. Chicago, IL: University of Chicago Press, 1990.

A valuable organological study, the author examines musical instrument classification in selected cultures and within these discussions reveals how the concept of gender, vis-à-vis specific male/female roles in performance on particular instruments or masculine/feminine qualities of the musical instruments themselves, becomes a factor in musical instrument classification in a number of cultures. Discussed are the gender characteristics of the musical instruments of: Ancient Greece (pp. 116–118, 293) ; the Javanese gamelan (pp. 89, 105, 290–291) ; the Mandailing peoples of Sumatra (pp. 220–224, 300) ; the Minang Kabau peoples of Western Sumatra (pp. 230–233). Societal roles may dictate male or female participation in music- making, in addition to the gender characteristics given to the instruments themselves. This is discussed with relation to music from the Philippines (pp. 235, 301) and the music and instruments (panpipes, flutes) of the Solomon Islands (pp. 255, 271–272).

1200. Kimberlin, Cynthia Tse. "What Am I To Be? Female, Male, Neuter, Invisible. . .Gender Roles and Ethnomusicological Field Work in Africa." *World of Music* 33, no. 2 (1991): 14–34.

Part of a special issue entitled "Women in Music and Music Research." Using the observations and experiences of selected African music scholars, this study addresses the way gender and cultural factors affect and control methodology.

1201. Kodish, Debora. "Absent Gender, Silent Encounter." *Journal of American Folklore* 100, no. 4 (1987): 573–578.

The author examines the implicit gender meanings in accounts of male folklorists (Hamish Henderson and John Quincy Wolf) in which they described their first contacts with folk informants, in this case traditional singers Jeannie Robertson (Scotland) and Almeda Riddle (United States). Both male folklorists recount their initial meetings in language descriptive of the conquest and pseudo-sexual awakening of the silent, quiescent female. Both women singers, however, subsequently speak of the men as outsiders, creating additional burdens to their responsibilities of house, home, and family. Their contrasting account reveals that both women are fully aware of their roles as tradition bearers and performers in their communities. The author thus reveals the dynamics of gender, though unexplicit, as it operates in folklore scholarship and fieldwork.

1202. Koskoff, Ellen. "Gender, Power, and Music." In *The Musical Woman: An International Perspective. Volume 3, 1986–1990*, ed. Judith Lang Zaimont, Jane Gottlieb, Joanne Polk, and Michael J. Rogan, pp. 769–788. Westport, CT: Greenwood Press, 1991.

The author asserts that cross-cultural beliefs about male and female roles are evident in the musical activities, performing contexts, musical rituals and ceremonies, and musical instruments of those cultures. Thus, music-making divided along gender lines is a manifestation of culturally constructed notions of sexuality and power. The author then introduces the reader to recent theories relating to cross-cultural perspectives on gender and social power. Women's connection to fertility is the one element which gives them added power, since fertility is linked to the natural and supernatural realms which are beyond man's control. Music is viewed cross-culturally as a communicative link between the domains of the human, the natural, and the supernatural. The human performance of music has the potential power to transport one to the spiritual realm, to manipulate emotions, to affect one's physical state, etc., and thus the select individuals who perform music are in a position of power. Therefore, the degree to which a culture divides musical activity along gender lines depends upon their beliefs with regard to the control of the potentially malevolent or benevolent powers of music, combined with forces which would balance male and female power relations.

1203. Koskoff, Ellen. "An Introduction to Women, Music, and Culture." In *Women and Music in Cross-Cultural Perspective*, ed. Ellen Koskoff, pp. 1–23. Contributions in Women's Studies, no. 79. Westport, CT: Greenwood Press, 1987.

In introducing the concepts of gender theory and their applications to ethnomusicology, the author surveys and cites a wide range of valuable literature. While acquainting the reader with the contributors to this volume of essays, she explores such topics as "Gender Ideology and Its Effect on Women's Music Making," "Music in Inter-Gender Relations," and the rela-

236

tionships between music, gender and societal constructs of prestige, power, and value.

1204. Koskoff, Ellen. "Miriam Sings Her Song: The Self and Other in Anthropological Discourse." In *Musicology and Difference: Gender and Sexuality in Music Scholarship*, ed. Ruth Solie, pp. 149–163. Berkeley, CA: University of California Press, 1993.

Koskoff reveals how differences in the anthropological reportage of cultural practices relate to the perspective taken by the observer/self, and the degree to which the observer integrates the perspective of the observed/Other. Koskoff offers three accounts of the separation of men and women in the religious and musical practices of the Lubavitcher Jews (Brooklyn, New York), with a particular focus on the *kol isha*, the doctrine which forbids a man from listening to a woman sing. The first two accounts are outsider-based, the first using the technique of descriptive ethnography, and the second using the technique of analytic ethnography, here written from a feminist perspective. In contrast is the insider perspective; Lubavitcher women comment on Koskoff's interpretations. Koskoff maintains that, in allowing the Other voice to be heard, a researcher might "equalize the traditional power relationship between the observer self and the observed Other" (p. 160), so as to lead to a fuller, more representative account of the culture being studied.

1205. Koskoff, Ellen. "The Sound of a Woman's Voice: Gender and Music in a New York Hasidic Community." In *Women and Music in Cross-Cultural Perspective*, ed. Ellen Koskoff, pp. 213–223. Contributions in Women's Studies, no. 79. Westport, CT: Greenwood Press, 1987.

This article first examines the separate roles of men and women in the social and religious worlds of an ultra-orthodox Jewish community, the Lubavitcher Hasidim. Koskoff then examines how this group's musical practices reflect Lubavitcher religious beliefs, attitudes regarding social status, and codes of male and female behavior. Musical practices, delineated by gender, thus reflect a "world view that places the mundane and the spiritual realms in opposition" (p. 221).

1206. Koskoff, Ellen, ed. *Women and Music in Cross-Cultural Perspective*. Contributions in Women's Studies, no. 79. Westport, CT: Greenwood Press, 1987.

Reviewed in *American Anthropologist* 90, no. 4 (December 1988): 1003; *Notes* 45, no. 3 (March 1989): 515–516; *Fontes Artis Musicae* 36, no. 2 (April–June 1989): 154–155; *Ethnomusicology* 33, no. 3 (Fall 1989): 514–520; *Gender and Society* 5, no. 1 (March 1991): 125–127. Fifteen essays on women's music-making in non-Western contexts address the way "a society's gender ideology and resulting gender behaviors affect. . .musical thought and practice" (Intro. p. 1), and likewise the ways in which music not

only reflects gender behaviors but can serve as a mechanism for change in this regard. Geographic areas studied include Greece, the Balkans, Tunisia, Afghanistan, India, Java, Malaysia, Japan, Brazil, and the United States; the role of women in the music of the Hasidic and Sephardic traditions is also considered. Broader essays introduce reader to the literature and theory of gender as it relates to the field of ethnomusicology, and investigate the ways in which musical performance functions as a power mechanism affecting the lives of women. Includes subject index. Essays are individually cited in this bibliography.

1207. Lincoln, Bruce. *Emerging From the Chrysalis: Rituals of Women's Initiation.* New York: Oxford University Press, 1991.

    Originally published by Harvard University Press (1981). This book describes music used in menarcheal rituals of two cultures. Kinaalda, the Navaho ritual celebrated at the onset of menstruation, is accompanied by a special song cycle, called Blessingway (pp. 17–24; texts included). Music is also used in the menarcheal rituals of the Tukuna peoples of the Northwest Amazon; stamping tubes, drums, and various wind instruments accompany this ritual.

1208. Lull, James, and Roger Wallis. "The Beat of West Vietnam." *Popular Music and Communication.* ed. Newbury Park, CA: Sage Publications, 1992. 207–236.

    This study examines the role of music in the cultural adaptation and identity of Vietnamese immigrants living in California's San Francisco Bay area. The role of women in Vietnamese popular music is discussed (pp. 221–223).

1209. Merrill-Mirsky, Carol. *"Eeny Meeny Pepsadeeny": Ethnicity and Gender in Children's Musical Play.* Diss. Ph.D., University of California, Los Angeles, 1988.

    Abstract in *Dissertation Abstracts International: A. Humanities and Social Sciences* 49, no. 9 (March 1989): 2445. DA# 8826013. This is an investigation into gender and cultural identity in the musical games of girls, aged six to twelve, from African-American, European-American, Hispanic, and Asian backgrounds.

1210. Post, Jennifer C. "Erasing the Boundaries between Public and Private in Women's Performance Traditions." In *Cecilia Reclaimed: Feminist Perspectives on Gender and Music,* ed. Susan C. Cook and Judy S. Tsou, pp. 35–51. Urbana, IL: University of Illinois Press, 1994 (forthcoming).

1211. Robertson, Carol E. "The Ethnomusicologist as Midwife." In *Musicology and Difference: Gender and Sexuality in Music Scholarship,* ed. Ruth Solie, pp. 107–124. Berkeley, CA: University of California Press, 1993.

    The author uses the metaphor of midwifery in her observations of the permutations of gender identity found amongst the Mapuche healer/chanters of Argentina and Hawaiian performers of music and dance, as these "individuals who. . .travel between the center and the periphery hold a special

kind of power inaccessible to persons who are 'fixed' in the center" (p. 108). The metaphor is also extended to ethnomusicological scholarship, as the author describes how the researcher carefully negotiates between the mainstream cultural politics of Western academia, the particular cultural tradition which she "nurse[s]...into public perception" (p. 123), and the need for fluidity between the margins and the mainstream in order transcend various barriers to our musical knowledge.

1212. Robertson, Carol E. "Power and Gender in the Musical Experiences of Women." In *Women and Music in Cross-Cultural Perspective*, ed. Ellen Koskoff, pp. 225–244. Contributions in Women's Studies, no. 79. Westport, CT: Greenwood Press, 1987.

> The author examines several musical cultures and identifies three relationships between power, gender, and musical performance: 1) where music is used by males (e.g., in Tierra del Fuego, among the Mundurucú of the Amazon, in Mexico, etc.) to assert and maintain their dominance, and thus control the lives of females by preventing their access to and participation in the performance of music, which is equated with power; 2) where women within male-dominated societies (e.g., Ghana and Argentina) create their own separate forms of musical expression and ritual which balance gender dynamics, affording women the ability to bond, "carve out their own domains of performance power" (p. 230), and temporarily create their own social reality, and thus resist control; 3) where feminist women (e.g., the [Washington] D.C. Area Feminist Chorus) create their own communities, and likewise "repertoires and rituals that empower women to propel social changes within their own environments" (pp. 225–226). In order to effect a more systematic approach to the subject by those pursuing this line of inquiry, Robertson then presents a set of guidelines and questions relating to the cross-cultural study of power, gender, and musical performance.

1213. Robertson, Carol E. "Singing Social Boundaries Into Place: The Dynamics of Gender and Performance in Two Cultures, Part I." *Sonus* 10, no. 1 (Fall 1989): 59–71.

> The first of a two-part article examining the manner in which socioreligious beliefs regarding sexuality and gender delineate the forms and functions of music with particular cultures, and the musical roles of men and women within those cultures. The role of music within life cycle rituals is examined within two cultures, the Mapuche of the Argentinian Andes and the Kassena-Nankani peoples of northern Ghana. Here in Part I, the author studies female initiation rites, noting that becoming a woman in Mapuche culture privileges her to participate in ancestral vocal traditions identified with her father's lineage.

1214. Robertson, Carol E. "Singing Social Boundaries Into Place: The Dynamics of Gender and Performance in Two Cultures, Part II." *Sonus* 10, no. 2 (Spring 1990): 1–13.

The second of a two-part article examining the manner in which socio-religious beliefs regarding sexuality and gender delineate the forms and functions of music with particular cultures, and hence the different musical roles of men and women within those cultures. The role of music within life cycle rituals is examined within two cultures, the Mapuche of the Argentian Andes and the Kassena-Nankani peoples of northern Ghana. Part II concentrates on female funereal rites amongst the Kassena-Nankani of the Ghana-Burkina Faso border. This ritual is characterized by the female celebrants speaking and singing in Nankom, the language of the deceased Nankani woman's parents, a language which must be renounced by Nankani women when they marry husbands of neighboring Kassena communities. This ritual allows the deceased woman to finally reunite with her past. In contrast, the initiation of young females into womanhood amongst the Mapuche (Argentina) is marked by their access to their ancestral past through participation in vocal ritual.

1215. Rothstein, Robert A. "The Mother-Daughter Dialogue in the Yiddish Folk Song: Wandering Motifs in Time and Space." *New York Folklore* 15, no. 1–2 (Winter/Spring 1989): 51–65.

   The author examines the origins and texts of mother/daughter dialogue songs centering on the choice of a husband. Textual variants and regional differences are explored.

1216. Rounds, Martha. "Celebrating Women's World Music: Libana." *Hot Wire* 7, no. 1 (January 1991): 44–45.

   This article profiles the membership of Libana, a women's musical ensemble which, through the research and performance of women's music from various world cultures, provides a glimpse of "women's experience in traditional cultures" (p. 44), while also introducing contemporary feminist music from non-Western cultures.

1217. Shelemay, Kay Kaufman. *A Song of Longing*. Urbana, IL: University of Illinois Press, 1991.

   A feminist ethnomusicologist reflects on her experiences while conducting fieldwork investigating the music of the Ethiopian Jews of the Beta Israel community (i.e., the Falasha) from 1973 to 1975, a time of unrest in Ethiopia. She explores the impact of gender, social class, and politics on the fieldwork experience of the ethnomusicologist.

1218. Shloush, Chana. "Making Music for Women Only: Orthodox Women, Who Believe That a Man is Forbidden to Hear a Woman Sing, Say 'No Men Allowed' At Their Increasingly Popular Performances." *Lilith* 19 (Spring 1987): 15–16.

   As an increasing number of women in Brooklyn, New York's Orthodox Jewish community unite to form all-women's choirs and instrumental ensembles, their performances are received enthusiastically. The article profiles the very popular singer, Ruthi Navon, who speaks to the issue of

reconciling her love for singing and performing in public with the limitations which the Orthodox Jewish faith places upon women.

1219. Slobin, Mark. "1970s–1980s: New Trends, New Gender." In *Chosen Voices: The Story of the American Cantorate*, pp. 112–132. Music in American Life. Urbana, IL: University of Illinois Press, 1989.

Reviewed in *American Music* 10, no. 1 (Spring 1992): 95–98. This chapter discusses change and innovation in the American cantorate in recent times, with particular reference to the ordination of women as hazzanim (i.e., cantors) and the overall increase in the participation of women in Reform and Conservative Jewish ritual.

1220. Slobin, Mark. "Women Cantors." *Jewish Folklore and Ethnology Review* 12, no. 1–2 (1990): 33.

Part of a special issue devoted to Jewish women. The author, Director of the History of the American Cantorate Project, summarizes his findings on the participation of women in the cantorate.

1221. Weich-Shahak, Susana. *Judeo-Spanish Moroccan Songs for the Life Cycle: Recordings, Transcriptions and Annotations*. Yuval Music Series, no. 1. Jerusalem: Jewish Music Research Center, Hebrew University of Jerusalem, 1989.

Reviewed in *The World of Music* 33, no. 3 (1991): 92–95; *Notes* 48, no. 3 (March 1992): 1086–1089. Includes accompanying cassette. Introduction in both English and Spanish. The songs selected for this publication were collected in Israel from 1976 to 1987, and represent one aspect of the musical repertoire of this particular community of immigrant Sephardic Jews from Northern Morocco: songs devoted to the life cycle (birth, initiation, mating, death). The author's introduction discusses the various song genres under consideration: songs of birth and childhood, bar mitzvah songs, courtship and wedding songs, and songs of death and mourning. She also discusses the poetical and musical conventions used in order to devise a preliminary typology for this song repertoire. Thirty-two songs (and variants) are transcribed with music and Spanish texts; annotations are written in English and Hebrew. Most of the informants from whom these songs were collected are women.

# Part B.  Geo-Cultural Zones

## B. 1 AFRICA

1222. Ben Barka, Bahija. "Chansons d'escarpolette." *Cahiers de Littérature Orale* 23 (1988): 209–218.

In French. This article discusses content and style in folk songs collected from and performed by women in Rabat, Morocco, concerning the theme of love.

1223. Bender, Wolfgang. "Great Female Singers: Mali." In *Sweet Mother: Modern African Music*, trans. Wolfgang Freis, pp. 21–30. Chicago, IL: University of Chicago Press, 1991.

 The lives and musical contributions of Fanta Damba, Mokontafe Sako, and Fanta Sacko are discussed.

1224. Borel, François. "Rythmes de passage chez les Touaregs de l'Azawagh." *Cahiers de musiques traditionelles* 1 (1988): 28–38.

 In French. Part of a special issue entitled, "De bouche à oreille" [From mouth to ear]. This article examines musical transmission and apprenticeship amongst the nomadic Touareg peoples of north-central Nigeria, with a particular focus on gender-based differentiations in musical forms and genres, and the musical activities of girls and boys in Touareg culture.

1225. Brandes, Edda. *Imzad-Musik der Kel-Ahaggar-Frauen in Süd-Algerien.* Orbis Musicarum, no. 4. Göttingen, Germany: Edition Re, 1989.

 ISBN 3927636045. In German. Reviewed in *The World of Music* 33, no. 2 (1991): 111–115. Includes one sound cassette. A study of the bowed-string (imzad) music of the women musicians of the Ahaggar Mountains of southern Algeria.

1226. Brandes, Edda. "The Relation of Women's Music to Men's Music in Southern Algeria." In *Music, Gender, and Culture*, ed. Marcia Herndon and Susanne Ziegler, pp. 115–130. International Council for Traditional Music. ICTM Study Group on Music and Gender. Intercultural Music Studies, no. 1. Wilhelmshaven, Germany: Florian Noetzel Verlag, 1990.

 ISBN 3795905931. This article investigates the gender delineation of musical roles amongst the Kel-Ahaggar (Berber tribe) of Southern Algeria. Noting that the Kel-Ahaggar social structure is one based on matrilineal descent, the author then examines how this is reflected in the gender-specific grammatical forms of the Kel-Ahaggar language (implying gender equality), and explains how other customs place women in a position of importance and action, rather than subordination and deference (e.g., women choose their own husbands, men wear veils, etc.) This is reflected to an extent in music making, as the author describes how male and female gender roles are reflected in musical performance and in the making of musical instruments. She details the importance of the imzad, a single-stringed bowed instrument made and played only by women. She thus concludes that women have the primary musical role within the culture of the Kel-Ahaggar.

1227. Brandes, Edda. "The Role of the Female Ethnomusicologist in the Field: Experiences in Traditional Algerian Communities." *World of Music* 33, no. 2 (1991): 35–49.

 Part of a special issue entitled "Women in Music and Music Research." As a female researcher in an Islamic society, the author discuss-

es the role that gender played in her ability to conduct meaningful research in a community in southern Algeria.

1228. Calame-Griaule, Geneviève. "'Prends ta houe, mon frere': Chants funéraires dogon." *Cahiers de Littérature Orale* 27 (1990): 77–88.

In French, with English abstract. Part of a special issue devoted to sung funereal ritual. The texts of Dogon (West African) women's funeral songs are analyzed.

1229. Carlisle, Roxanne Connick. "Women Singers in Darfur, Sudan Republic." In *A Century of Ethnomusicological Thought*, ed. Kay Kaufman Shelemay, pp. 207–224. Garland Library of Readings in Ethnomusicology, no. 7. New York: Garland Publishing, 1990.

Originally published in Anthropos 68 (1973): 785–800. Based upon the author's fieldwork in the Darfur province of Sudan from 1967 to 1968, this article studies women's sung poetry in this region with a particular recognition of the role of women in Dafur society as bearers of tradition.

1230. Collins, John. *West African Pop Roots*. Philadelphia, PA: Temple University Press, 1992.

Includes a cursory look at the changing gender roles for women in music, and the women pop music artists of the Ivory Coast (pp. 232–233) and Ghana (pp. 279–280).

1231. Coplan, David B. "Musical Understanding: The Ethnoaesthetics of Migrant Workers Poetic Song in Lesotho." *Ethnomusicology* 32, no. 3 (Fall 1988): 337–368.

Discusses *sefela*: women's sung poetry.

1232. Dargie, David. "Umngqokolo: Xhosa Overtone Singing and the Song Nondel'ekhaya." *African Music* 7, no. 1 (1991): 33–47.

Umngqokolo is a form of overtone singing performed by women and girls of the Xhosa culture in the Lumko district of South Africa. The songs, based on the scales and harmonic patterns produced from the overtone system of the Xhosa musical bow, are accompanied by rhythmic clapping and body movements while singing. This scholarly article analyzes the melodic and rhythmic patterns of umngqokolo, using particular songs as examples, and introduces us to several women singers and bow players, from whom the author collected a variety of songs and techniques.

1233. Duran, Lucy. "Djely Mousso: Lucy Duran Describes Mali's Undisputed Stars, the Women Singers from Their Ancient Tradition." *Folk Roots* 75 (September 1989): 34–35, 37–39.

An overview of the prominent women praise singers from Mali.

1234. Jones, L. JaFran. "A Sociohistorical Perspective on Tunisian Women as Professional Musicians." In *Women and Music in Cross-Cultural Perspective*, ed. Ellen Koskoff, pp. 69–83. Contributions in Women's Studies, no. 79. Westport, CT: Greenwood Press, 1987.

Since the past and present musical roles of women in Tunisia have been poorly documented, the author first examines and evaluates the objectivity of existing literature on Tunisian history vis-à-vis women's issues in the Arab-Islamic world, revealing various details concerning women as professional musicians and the contexts in which they performed. She also demonstrates that the anonymous or exclusionary treatment of women in relation to music in most of this literature prevents the whole story from being told. Unique to this Islamic country is the independence of women which came with it's political independence in 1956. In comparing the pre- and post-independence periods of Tunisian history, Jones evaluates the gains made by women in the areas of music education and involvment in professional music performance. She acknowledges that political independence has not yet freed Tunisian women from the "encumbrance of the historic singing slave-girl image" (p. 80), as women have yet to be widely accepted as instrumentalists, nor have they been able to enter the realm of music composition.

1235. Joseph, Rosemary. "Zulu Women's Bow Songs: Ruminations on Love." *Bulletin of the School of Oriental and African Studies* 50, no. 1 (1987): 90–119.

Based on the author's fieldwork on the music of Zulu women from the Natal region of South Africa, this well-researched essay takes a detailed look at a particular genre of women's song, the love song, performed to the accompaniment of a musical bow. Joseph first discusses the notion of love in African culture. In her extensive explanation of the bow-song, the author positions the genre within a larger sociocultural context, discusses subcategories of songs within the bow-song genre, and describes the actual musical style and technique used by the female player of the musical bow. The author then considers issues with regard to the performance of the bow-song, and lastly analyzes the song texts, examining the particulars of language, literary style, and thematic content (e.g. love, separation, conflict, anxiety, etc.).

1236. Kubik, Gerhard. *Malaŵian Music: A Framework for Analysis.* Malaŵi: Center for Social Research, University of Malaŵi, Zomba ; Department of Fine and Performing Arts, Chancellor College, University of Malaŵi, 1987.

The relationship between genre and gender in the traditional music of Malaŵi is examined. Genres explored include the private, contemplative mouth-bow music of young women, kwela (flute) music of adolescent males, songs performed during female initiation rites, male-partnered or female-partnered xylophone music, and the song as oral literature.

1237. Monts, Lester. "Vai Women's Roles in Music, Masking, and Ritual Performance." *African Musicology: Current Trends. Volume I*, ed.

Jacqueline Cogdell DjeDje and William G. Carter, pp. 219–235. Los Angeles, CA: African Studies Center, University of California Los Angeles, 1989.

    The musical roles of Vai women musicians of Liberia and Sierra Leone are the subject of this study, with particular reference to musical performance within rituals of the Sande secret society.

1238. Okafor, R. C. "Women in Igbo Musical Culture." *Nigerian Field* 54, no. 3–4 (October 1989): 133–140.

1239. Rorich, Mary. "Shebeens, Slumyards and Sophiatown: Black Women, Music and Cultural Change in Urban South Africa." *The World of Music* 31, no. 1 (1989): 78–104.

1240. Schmidt, Cynthia E. "Group Expression and Performance Among Kpelle Women's Associations of Liberia." *Music, Gender, and Culture*, ed. Marcia Herndon and Susanne Ziegler, pp. 131–142. International Council for Traditional Music. ICTM Study Group on Music and Gender. Intercultural Music Studies, no. 1. Wilhelmshaven, Germany: Florian Noetzel Verlag, 1990.

    ISBN 3795905931. "Among the Kpelle of Liberia, the life of a community is animated by both women's and men's associational groups, with music and dance being an important component of group solidarity" (p. 131). The specific focus of this article is on the mode of performance and on the role of musical expression in two women's associational groups: the Sande secret society and the rice farming work cooperative (*kuu*). In a society in which male authority is systemic and sex roles are clearly defined, these cultural expressions of women, manifested through societal alliances, act as "important vehicles for power. . .They promote confidence, organized leadership and resources, thereby creating leverage within the society" (p. 139).

1241. Schmidt, Cynthia E. "Womanhood, Work and Song Among the Kpelle of Liberia." In *African Musicology: Current Trends. Volume I*, ed. Jacqueline Cogdell DjeDje and William G. Carter, pp. 237–263. Los Angeles, CA: African Studies Center, University of California Los Angeles, 1989.

    Gender roles in the music culture of Liberia are investigated, with a particular focus on women's work songs, and music used in the female rituals of the Sande secret society .

1242. Timpunza Mvula, Enoch Selestine. *Women's Oral Poetry as a Social Strategy in Malawi*. Diss. Ph.D., Indiana University, 1987.

    Abstract in *Dissertation Abstracts International: A. Humanities and Social Sciences* 48, no. 9 (March 1988): 2420. DA# 8727535. Women's sung poety is examined for its societal and communicative functions. The songs not only reflect society's view of women's roles, but women use the songs to evaluate, interpret and redefine those roles.

1243. Virolle-Souibès, Marie. "Le Ray côté femmes. Entre alchimie de la douleur et spleen sans ideal, quelques fragments de discours hedonique / The Ray Among Women. Between the Alchemy of Pain and a Spleen Without Ideals, Fragments of Hedonic Discourse." *Peuples Mediterraneens / Mediterranean Peoples* 44–45 (July–December 1988): 193–220.

    In French, with abstract (p. 343) in English. Folksongs of Algerian women are examined here, specifically those in the *ray* genre. These melancholy songs on the physical pleasures of life, sung in the form of a lament or a song of complaint, provide women with a means of expression within the realm of patriarchal society.

1244. Vogels, Raimund. *Tanzlieder und liturgische Gesänge bei den Dagaaba in Nordwestghana: Zur Verwendung einheimischer Musik im katholischen Gottesdienst.* Beiträge zur Ethnomusikologie, nr. 18. Hamburg, Germany: Wagner, 1988. 2 vols.

    ISBN 3889790364. In German. Translated title: *Dance Songs and Liturgical Chants of the Dagaaba of Northwest Ghana: The Use of Indigenous Music in Catholic Worship*. The author analyzes the melodic, rhythmic and textual content of women's songs accompanying the *nuru* and 'kaare' dances of northwestern Ghana, and explores the manner in which these traditional melodies have manifested themselves in the liturgical music of the Catholic Church in this region.

1245. Wagner-Glenn, Doris. *Searching for a Baby's Calabash: A Study of Arusha Maasai Fertility Songs as Crystallized Expression of Central Cultural Values*. Fwd. John Mbiti. Affalterbach, Germany: Philipp Verlag, 1993.

    ISBN 3980187020. In English. Fertility songs of Arusha Maasai women (of Tanzania) are considered from an ethnological and historical perspective, and texts and music are analyzed; photographs and musical transcriptions included. The book is accompanied by a 40-minute cassette of musical examples discussed in the book.

### B.2 ASIA, AUSTRALIA, AND OCEANIA

1246. Addiss, Stephen. "Text and Context in Vietnamese Sung Poetry: The Art of *Hát à Đào*." In *Selected Reports in Ethnomusicology. Volume IX: Text, Context and Performance in Cambodia, Laos, and Vietnam*, ed. Amy Catlin, Eran Fraenkel, and Therese Mahoney, pp. 203–224. Los Angeles, CA: Department of Ethnomusicology, University of California Los Angeles, 1992.

    In this study of Vietnamese women's sung poetry, *hát à đào*, the author first provides historical background on the evolution of the genre, and then examines the poetry, music, and aspects of performance.

1247. Banerjee, Sumanta. "Marginalization of Women's Culture in Nineteenth Century Bengal." In *Recasting Women: Essays in Indian Colonial History,*

ed. Kumkum Sangari and Sudesh Vaid, pp. 127–179. New Brunswick, NJ: Rutgers University Press, 1990.

First published in cloth in India, by Kali for Women, 1989. This essay traces the history of Bengali women's popular song and poetry and investigates the reasons for this genre's ultimate disappearance by the end of the nineteenth century. The women who sang these bawdy, sexual folk songs, expressive of a woman's independence, came under both patriarchal and Western domination during the nineteenth century. Indigenous popular forms of female expression thus disintegrated with the "cultural emancipation" imposed upon women by "Christian missionaries, English administrators and the Bengali bhadralok [upper classes]" (p. 160). Colonial-based education for women, in reinforcing a stereotypical European ideal of female behavior, thus perpetuated cultural forms which conformed to a more Westernized model.

1248. Barwick, Linda. "Central Australian Women's Ritual Music: Knowing Through Analysis Versus Knowing Through Performance." *Yearbook for Traditional Music* 22 (1990): 60–79.

The author analyzes field recordings of Australian women's ritual music made between 1966 and 1971 by Catherine Ellis, Isobel White, Luise Hercus, and Margaret Kartomi. She subsequently questions this exercise in "impersonal" musical analysis, though this approach is often used in the discipline of ethnomusicology. She further argues that the value of one's own observation of and involvement in performance must be considered, along with musical analysis, in order to gain a full understanding of the music of a particular traditional culture.

1249. Barwick, Linda. "Partial Records: The Problematics of Loss and Change in Historical Ethnomusicology." In *Tradition and its Future in Music: Report of SIMS 1990 Osaka*, ed. Tokumaru Yosihiko, et al., pp. 139–145. International Musicological Society. Symposium. Tokyo, Japan: Mita Press, 1991.

ISBN 4895830837. The author discusses the difficulties with utilizing historic ethnomusicological documentation for contemporary research. Variables in fieldwork operations which may potentially cause gaps in the recorded documentation of performances include funding, technical production, language and cultural unfamiliarities, and the particular agenda of the researcher. She uses as a case in point her study of the extensive audio, visual, and written performance documents created from Catherine Ellis' fieldwork in Central Australian women's music during the late 1960s. She also notes the difficulties she encountered with written documents, in her study of the origins and variants of a 19th century popular Italian song. Although historical performance documents are sometimes incomplete researcher-mediated artifacts, the author posits that the problems encountered with these materials should be instructive, so as to improve the quality and usefulness of current and future fieldwork documentation.

1250. Becker, Judith. "Earth, Fire, *Sakti* [female power] and the Javanese Gamelan." *Ethnomusicology* 32, no. 3 (Fall 1988): 385–391.

The author demonstrates how Javanese spiritual beliefs regarding male and female forces in the universe are reflected in the making of musical instruments, thus further imparting gender characteristics on the sounds created by gamelan instruments. The combination of male and female instruments within the gamelan ensemble is therefore symbolic of the Javanese beliefs regarding gender and spiritual power.

1251. Butocan, Aga Mayo. *Palibunibunyan: A Repertoire of Musical Pieces for the Maguindanaoan Kulintangan*. Manila, Philippines: Ethnomusicology Program Publications. Philippine Women's University, 1987.

Includes accompanying cassette. This collection of modern kulintang (Philippine gong and drum ensemble) pieces also explores how gender roles manifest themselves in the association of musical instruments with male and female players in traditional and modern performance practice (pp. 17–24). Females traditionally play the kulintang and gandingan gongs, as well as the dabakan, a goblet-shaped drum. Only males perform on the agong, a large gong whose sound is believed to possess supernatural power. Males and females both play the babandir, a lead instrument in the kulintang ensemble.

1252. Catlin, Amy. "Apsaras and Other Goddesses in Khmer Music, Dance and Ritual." In *Apsara: The Feminine in Cambodian Art; An Exhibition and Publication on the Arts of Cambodian Women in the Los Angeles Area, December 1, 1987–January 6, 1988*, curator and ed. Amy Catlin, pp. 28–35. Los Angeles, CA: The Woman's Building, 1987.

Several essays exploring the relationships between ancient representations of female deities in Cambodian sculpture and the feminine principle in Cambodian music, dance, and costume are presented. Catlin's essay concentrates primarily on the musical aspects of Cambodian dance/music performances by women, with a discussion of goddess images found in dance, music, and song, illustrated by musical transcriptions, song texts, and photographs. A separate cassette tape accompanies this booklet. Available from The Woman's Building, 1727 N. Spring St., Los Angeles, CA 90012.

1253. Catlin, Amy. "Homo Cantens: Why Hmong Sing During Interactive Courtship Rituals." In *Selected Reports in Ethnomusicology. Volume IX: Text, Context and Performance in Cambodia, Laos, and Vietnam*, ed. Amy Catlin, Eran Fraenkel, and Therese Mahoney, pp. 43–60. Los Angeles, CA: Department of Ethnomusicology, University of California Los Angeles, 1992.

This examination of Hmong New Year courtship rituals examines the courtship songs of both unmarried and widowed Hmong women.

1254. Catlin, Amy. "Songs of Hmong Women: Virgins, Orphans, Widows and Bards." In *Textiles as Texts: Arts of Hmong Women from Laos. An*

*Exhibition of Traditional Clothing and Songs of the Hmong Women of Southern California, December 4, 1986–January 15, 1987,* curator Amy Catlin and Dixie Swift, pp. 28–30. Los Angeles, CA: The Woman's Building, 1987.

This essay examines the role of women in preserving the bardic traditions in Hmong culture. The author examines the poetic songs sung by single women during courtship rituals, as well as love songs, orphan's songs, daughter-in-law songs and widow's songs. An accompanying cassette tape produced by the author is also available. Available from The Woman's Building, 1727 N. Spring St., Los Angeles, CA 90012.

1255. Chambard, Jean Luc. "La Chanson de la terre que tremble ou la punition du roi qui avait voulu regner sans sa reine: Le roi dans la tradition populaire féminine en hindî de l'Inde du Nord." *Cahiers de Littérature Orale,* no. 29 (1991): 125–157.

In French, with abstract in English. Translated title: "The Song of the Earth Which Quakes, or Punishment for the King Who Wanted to Reign Without his Queen: The King in Female Popular Hindu Traditions of Northern India." A women's song collected by the author in Malwa (Madhya Pradesh, India) reflects various meanings with respect to gender relations, male/female power, seasonal ritual and socioreligious world view.

1256. Claus, Peter J. "Kin Songs." In *Gender, Genre and Power in South Asian Expressive Traditions,* ed. Arjun Appadurai, Frank J. Korom, and Margaret A. Mills, pp. 136–177. South Asia Seminar Series. Philadephia, PA: University of Pennsylvania Press, 1991.

The author analyzes the content and performance context of songs of the Tulu-speaking women of the Karnataka region of southern India. These tragic sung epics reveal much about Tuluva gender ideology, religious and moral beliefs, and kinship structure. The context of the singing, taking place while women plant, transplant, harvest, etc., thus takes on an important ritual association symbolic of the sustenance of the community through fertility and regeneration.

1257. Coaldrake, A. Kimi. "Female *Tayū* in the *Gidayū* Narrative Tradition of Japan." In *Women and Music in Cross-Cultural Perspective,* ed. Ellen Koskoff, pp. 151–161. Contributions in Women's Studies, no. 79. Greenwood Press: 1987.

This article examines the *onna gidayu* tradition (the female musical theatre) of the Meiji-Taisho period in Japan (1868–1926) and concentrates on the significant role played by the female *tayū* (female chanters/shamisen players), and especially on the life and career of one of its major proponents, Takemoto Ayanosuke I.

1258. DeVale, Sue Carole. "Musical Instruments and the Micro-/Macrocosmic Juncture." In *Tradition and its Future in Music: Report of SIMS 1990*

*Osaka*, ed. Tokumaru Yosihiko, et al., pp. 255–262. International Musicological Society. Symposium. Tokyo, Japan: Mita Press, 1991.

ISBN 4895830837. The author examines how the musical instruments of the Balinese gamelan, considered here both individually and collectively in a ritual and performative context, act as "symbolic subsystems" (p. 255) articulating information concerning "the domains of the human body, of maleness and femaleness, and of human social interaction and human/spirit interaction" (p. 255–256).

1259. DeVale, Sue Carole, and I. Wayan Dibia. "An Exploration of Meaning in Balinese Gamelan." *The World of Music* 33, no. 1 (1991): 5–51.

The later part of this article (pp. 39–51) discusses male and female gender characteristics bestowed upon the musical instruments of the gamelan as a reflection of the universal male and female elements in Balinese culture and ritual.

1260. Dournes, Jacques. "In Memoriam: Le chant du *cok*." *Cahiers de Littérature Orale*. 27 (1990): 89–111.

In French, with English abstract. Part of a special issue devoted to sung funereal ritual. The ritual significance of the *cok*, a women's funereal song of the Joraï peoples of Austronesia, is explored in this article.

1261. Ellis, Catherine J., and Linda Barwick. "Antikirinja Women's Song Knowledge 1963–1972: Its Significance in Antikirinja Culture." In *Women, Rites and Sites: Aboriginal Women's Cultural Knowledge*, ed. Peggy Brock, pp. 21–40. Sydney, Australia: Allen & Unwin, 1989.

This survey of Catherine Ellis' fieldwork amongst Aboriginal women of Central Australia emphasizes the equation of women's song knowledge with cultural power, due to the relationship between song, ceremony, and ritual. The essay discusses the songs used in women's secret ceremonies, their performance and transmission, the relationship between the separate song repertoires of men and women, the manner in which the repertoire has changed over the years, and the impact of those forces of change on the preservation of Antikirinja women's musical heritage and, by extension, women's powerful role in their culture.

1262. Ellis, Catherine, Linda Barwick, and Megan Morais. "Overlapping Time Structures in a Central Australian Women's Ceremony." In *Language and History: Essays in Honour of Luise A. Hercus*, ed. Peter Austin, et al., pp. 101–136. Pacific Linguistics Series C, no. 116. Canberra, Australia: Department of Linguistics, Research School of Pacific Studies, The Australian National University, 1990.

ISBN 0858833980. The state of timelessness created through the "overlapping cyclical structures in music and movement" (p. 101) in the ceremonial rituals of Aboriginal women of Central Australia is analyzed in detail, with introductory material discussing the history of ethnmusicologi-

cal fieldwork conducted amongst the Aboriginal peoples of Australia, and the significance of documenting the previously overlooked culture of women. Comparisons are then made between the music of closed women's ceremonies and an open men's ceremony (*inma ngintaka*). The author then examines the significance of women's ceremonial music to the preservation of Central Australian culture, for in this culture, it is through the state of timelessness, or "dreaming," that the "creation and re-creation of the universe, including the daily world of the people" (p. 101) takes place.

1263. Feld, Steven. *Sound and Sentiment: Birds, Weeping, Poetics, and Song in Kaluli Expression.* 2nd ed. University of Pennsylvania Press Conduct and Communication Series. Philadelphia, PA: University of Pennsylvania Press, 1990.

The author's study of the relationship between sound, language, and culture amongst the Kaluli people of Papua New Guinea examines patterns in Kaluli speech, song, and poetry, and how these expressions reflect aspects of the Kaluli belief system with respect to gender, nature (and birds, in particular), emotion, and the spirit world. In particular, text, performance, music, and meaning in women's and men's forms of wept mourning and ceremonial songs are analyzed in detail, with women's songs in particular being discussed in the chapter entitled, "Weeping That Moves Women To Song" (pp. 86–129). "Dialogic editing" contained in the Postscript to this new edition integrates a Kaluli assessment of ideas presented in the original edition. Here (pp. 261–264), the author acknowledges that, as a male ethnographer communicating primarily with men, Kaluli women's views on music, emotional expression, and gender difference need additional study.

1264. Feld, Steven. "Wept Thoughts: The Voicing of Kaluli Memories." *Oral Tradition* 5, no. 2–3 (May–October 1990): 241–266.

Sung-texted wept laments (*sa-yalab*) performed by Kaluli women of Papua New Guineau are examined from an interdisciplinary perspective which recognizes five major concerns of recent research on the lament: the relationships between speech and song, with a definition of the boundaries of each within the performance of the lament; improvisation as an important aspect in lament composition and performance; the lament as a stylized social expression of emotion and collective grief of a particular culture or community; the lament as a gender-specific genre; and the lament as ritual and metaphor signifying one's passage to another world, through the evocation of familiar places, locations, and events which intensify the listener's remembrance of the deceased.

1265. Firth, Raymond. "Sex and Slander in Tikopia Song: Public Antagonism and Private Intrigue." *Oral Tradition* 5, no. 2–3 (May–October 1990): 219–240.

The author investigates a dance-song genre from Tikopia, Solomon Islands, characterized by a man or woman (assisted by a chorus of friends or supporters) taunting, insulting, or protesting the behavior of another. These

protest songs, performed in explicit sexual language, give public voice to private matters relating to male/female relations and the sexual conduct and practice of unmarried women and men. The author examines performance contexts and thematic content of the songs, and reflects on the significance of this institutionalized acknowledgement of pre-marital erotic behavior on the ultimate stability of the marriage relationship amongst the Tikopia.

1266. Fritsch, Ingrid. "The Social Organization of the *Goze* in Japan: Blind Female Musicians on the Road." *CHIME (Chinese Music Europe)*, no. 5 (Spring 1992): 58–64.

This article investigates the history and societal role of the *goze*, a guild-like musical organization of blind, itinerant female singers from Japan, who accompany themselves on the shamisen.

1267. Grant, Beata. "The Spiritual Saga of Woman Huang: From Pollution To Purification." In *Ritual Opera, Operatic Ritual: "Mu-lien Rescues His Mother" in Chinese Popular Culture. Papers from the International Workshop on the Mu-lien Operas, with an Additional Contribution on the Woman Huang Legend by Beata Grant*, ed. David Johnson, pp. 224–311. Publications of the Chinese Popular Culture Project, no. 1. Berkeley, CA: University of California; dist. by IEAS Publications, 1989.

This study of the intermingling of Chinese religion and ritual in various forms of the popular Mu-lien opera investigates the narrative saga on which Mu-lien opera is based, namely the Woman Huang legend. This cultural parable of religious piety, honor, dedication to family, and ulimate salvation revolves around the metaphor of female pollution. The female protagonist, through death, purification, and rebirth (into a man), is ultimately redeemed, reflecting Chinese social and religious values pertaining to female sexuality and gender roles.

1268. Henry, Edward O. *Chant the Names of God: Music and Culture in Bhojpuri-Speaking India*. San Diego, CA: San Diego State University Press, 1988.

Reviewed in *The World of Music* 33, no. 1 (1991): 98–101. Extensive discussion of women's and men's song types within this society and culture in Northern India. Women's song genres include those to accompany various rites and customs, and are participatory in nature. They include wedding songs, songs in worship of the mother-goddess to insure or celebrate the birth of a son, laments, work songs, and those that are seasonal in nature.

1269. Igarashi, Tomio. *Goze: Tabi geinin no kiroku*. Tokyo, Japan: Ofusha, 1987.

ISBN 4273021447. A study of the *goze*, the guild of itinerant female musicians from Japan.

1270. Kaeppler, Adrienne L. "The Production and Reproduction of Social and Cultural Values in the Compositions of Queen Sālote of Tonga. In *Music,*

*Gender, and Culture*, ed. Marcia Herndon and Susanne Ziegler, pp. 191–219. International Council for Traditional Music. ICTM Study Group on Music and Gender. Intercultural Music Studies, no. 1. Wilhelmshaven, Germany: Florian Noetzel Verlag, 1990.

ISBN 3795905931. Considered to be the most important Tongan composer of the twentieth century, the compositions of Queen Sālote reflect and reinforce Tongan values relating to gender, kinship, and social hierarchy, and serve as the most notable example of the Tongan aesthetic ideal of indirectness through metaphoric usage in music, text and dance. Musical examples are included.

1271. Katariya, Geeta, and Anjali Capila. "Women as Portrayed in Folk Songs: Attempts to Create Alternatives." *Man in India* 67, no. 2 (June 1987): 124–136.

1272. Ma Guangxing. "Wedding, Etiquette, and Traditional Songs of the Minhe Region Tu." *Asian Folklore Studies* 49, no. 2 (1990): 197–222.

This discussion of traditional song and custom in this particular region of China addresses the manner in which gender and culture function within a patriarchally organized society.

1273. Orbell, Margaret. "'My Summit Where I Sit': Form and Content in Maori Women's Love Songs." *Oral Tradition* 5, no. 2–3 (May–October 1990): 185–204.

Interplay between the use of set themes or expressions and oral improvisation in the performance of traditional Maori women's love songs (*waiata aroha*) is examined.

1274. Orbell, Margaret. *Waiata: Maori Songs in History—An Anthology*. Birkenhead, Auckland, Aus.: Reed Books, 1991.

ISBN 0790001837. Featured in this book are *waiata*, Maori songs of lament and complaint which are characterized by elaborate poetical texts and slow improvised melodies. The collected texts of nineteenth-century *waiata* are translated and analyzed, and three forms of waita are identified. These include laments for the dead (*waiata tangi*), sung by women and men. The two other forms are composed only by women: songs of complaint and unrequited love (*waiata aroha*) and songs of love, flirtation and wit (*waiata whaiaipo*).

1275. Poedjosoedarmo, Gloria R. "Phonetic Description of Voice Quality in Javanese Traditional Female Vocalists." *Asian Music* 19, no. 2 (1988): 93–126.

1276. Post, Jennifer C. "Professional Women in Indian Music: The Death of the Courtesan Tradition." In *Women and Music in Cross-Cultural Perspective*, ed. Ellen Koskoff, pp. 97–109. Contributions in Women's Studies, no. 79. Westport, CT: Greenwood Press, 1987.

Post traces the history of women as professional musicians, concentrating first on the hereditary women musicians of the courtesan class, performing music and dance in secular (court) and religious (temple) contexts up until the mid- nineteenth century. The author then identifies societal changes which later led to opportunities for women as performers of Indian music, but negated the older, indigenous female forms of expression, such as the musician as dancer. The changes included the influence of British colonialism and western paradigms of male/female behavior, of social reform movements, of the disintegration of court patronage of musicians, change in the context of performance from the court to the public milieu, and subsequent economic imperatives which forced hereditary musical clans to accept students (men and women) not belonging to the family. Post then examines the struggles of the hereditary female musician classes within the twentieth century, and the processes of cultural and social change which led, ultimately, to their demise.

1277. Prasad, Onkar. *Folk Music and Folk Dances of Banaras*. Calcutta: India. Anthropological Survey of India (Memoir, no. 71), 1987.

This insightful study examines the folk (*laukik*) music and dance traditions of Banaras within the context of North Indian culture and society. The dichotomy between Indian folk and classical music, the segregation of Indian society on the basis of gender and caste, and the belief system contained therein, necessitate various classifications of folk song and dance types. The author proposes a "genderical classification" of folk music, based on the gender of the performers and the occasions for which the music is performed (pp. 16–19, 23–24). Most music performed by females accompanies various life-cycle rituals, and thus is hidden from males, placing women's music and dance in Banaras within the private sphere. The author, a male, describes the difficulties of the anthropologist in gaining access to these private performances (pp. 8, 111). Professional women performers who challenge the traditionally male reserve of the public sphere (pp. 43–44, 47) are of low social status. The textual and musical content of women's song forms are discussed, along with a sociocultural examination of the context of the performances of these songs (pp. 67–69, 89–93). The most significant discussion of the differentiation in musical participation based on gender is contained in Chapter 8 (pp. 110–129), a detailed description of the *nautch* (folk dance) and *nakal* (folk music/drama) forms, some of which are performed exclusively by females and some exclusively by males. Both male and female forms of the nautch and nakal involve gender role reversal, the significance of which is discussed at length. The female nautch and nakal is viewed solely by women, often involves a frank description of the emotional and sexual relationships between men and women, and remains in the private sphere. The male nautch and nakals are performed in the public sphere, however, and women are not allowed to participate in these performances, since "women who perform in the public are considered deviant" (p. 127).

1278. Roseman, Marina. "Inversion and Conjuncture: Male and Female Performance among the Temiar of Peninsular Malaysia." In *Women and Music in Cross-Cultural Perspective*, ed. Ellen Koskoff, pp. 131–149. Contributions in Women's Studies, no. 79. Westport, CT: Greenwood Press, 1987.

    In her examination of social groupings and musical structure in Temiar ceremonial performance, the author demonstrates that the different social and musical roles for men and women in the Temiar belief system are equalized by the symbolic inversion which takes place during the process of ritual musical performance. Though men and women have different roles, they both collaborate in the creative process, with alternating solo lines (male spirit-medium) melding into the variously overlapping, alternating and repeating female choral responses (female singers, percussionists, and trance dancers).

1279. Rossen, Jane Mink. "Politics and Songs: A Study in Gender on Mungiki." In *Music, Gender, and Culture*, ed. Marcia Herndon and Susanne Ziegler, pp. 173–189. International Council for Traditional Music. ICTM Study Group on Music and Gender. Intercultural Music Studies, no. 1. Wilhelmshaven, Germany: Florian Noetzel Verlag, 1990.

    ISBN 3795905931. Based on the author's field work on Mungiki (or Bellona), one of the Polynesian Solomon Islands, this article explores gender delineation in the performance and composition of songs for ritual, public, and personal use. The author delves into the influence of external forces, such as religious missionaries, on music and ritual, noting that norms of behavior as prescribed by missionaries have taken their toll on men's and women's participation in dance and music. Rossen observes that while men have access to all genres and contexts of performance, women's range of participation is often more limited, with the exception of women of talent and status, such as the woman named Tekamu from whom the author collected a variety of composed songs. Yet, women are noted for singing and composing the most popular of the song forms: *tangi*, or laments.

1280. Rossen, Jane Mink. "Ubesungne Kvinder: Sang og Politik på Mungiki, Salomonøerne." *Musik & Forskning* 13 (1987/1988): 132–146.

    In Danish, with summary in English. Translated title: "Unsung Women: Song and Politics on Mungiki, Solomon Islands."

1281. Sax, William S. *Mountain Goddess: Gender and Politics in a Himalayan Pilgramage*. New York: Oxford University Press, 1991.

    The author's travels to the Himalayas of India lead to his examination of the oral traditions and rituals surrounding the pilgrimage of the Hindu goddess Nandadevi (pp. 15–25, 36, 40). Epic songs sung by village women play a large part in that ritual, but are largely dismissed by men in that society as folklore, and have thus remain unstudied, preserving male hegemony.

A study of the texts of these women's songs reveal a cosmogony which is uniquely female in its perspective, sometimes reflecting and sometimes countering gender roles within the village.

1282. Schwörer-Kohl, Gretel. "Considering Gender Balance in Religion and Ritual Music Among the Hmong and Lahu in Northern Thailand." In *Music, Gender, and Culture*, ed. Marcia Herndon and Susanne Ziegler, pp. 143–155. International Council for Traditional Music. ICTM Study Group on Music and Gender. Intercultural Music Studies, no. 1. Wilhelmshaven, Germany: Florian Noetzel Verlag, 1990.

ISBN 3795905931. The degree to which women participate in music used in tribal ritual amongst the Hmong and Lahu peoples of Northern Thailand is examined, as well as the manner in which gender enters into their ritual belief systems and, by extension, the music accompanying those rituals.

1283. Srivastava, I. "Woman as Portrayed in Women's Folk Songs of North India." *Asian Folklore Studies* 50, no. 2 (1991): 269–310.

This study considers themes manifested in women's folk songs from Northern India, and the importance of folk song as a socially permissible means by which women may express their inner emotions and comment on their lives, experiences, and situations. The song genres discussed here include songs of female deities, birth and wedding songs, seasonal songs, songs accompanying various festivals, and songs accompanying a woman's daily labor.

1284. Sutton, R. Anderson. "Identity and Individuality in an Ensemble Tradition: The Female Vocalist in Java." In *Women and Music in Cross-Cultural Perspective*, ed. Ellen Koskoff, pp. 111–130. Contributions in Women's Studies, no. 79. Westport, CT: Greenwood Press, 1987.

The author first provides a historical view of the role of the *pesindhèn*, the professional female vocal soloist in the gamelan ensemble performance tradition in Java, and follows with a discussion of how that role is viewed within contemporary Javanese culture. Sutton concentrates on the musical skills exhibited by the *pesindhèn* and the manner in which the singer's individual style and virtuosity interacts with the ensemble.

1285. Tenzer, Michael. *Balinese Music*. Berkeley, CA: Periplus Editions, 1991.

The author briefly discusses (pp. 109–110) the participation of women in Balinese music, noting their enrollment in conservatories in the late 1970s and the subsequent formation of all-women's gamelans.

1286. Tewari, Laxmi G. "Sohar: Childbirth Songs of Joy." *Asian Folklore Studies* 47, no. 2 (1988): 257–276.

The songs analyzed here were collected from the Uttar Pradesh region of India. *Sohar*, or songs sung by women during the cycle of pregnancy and childbirth, comprise an "important body of women's oral literature" (p. 270)

in Hindu culture. Song texts are presented (in English translation), with commentary on their content, context, and performance.

1287. Trawick, Margaret. "Wandering Lost: A Landless Laborer's Sense of Place and Self." In *Gender, Genre and Power in South Asian Expressive Traditions*, ed. Arjun Appadurai, Frank J. Korom, and Margaret A. Mills, pp. 224–266. South Asia Seminar Series. Philadephia, PA: University of Pennsylvania Press, 1991.

   The author considers how caste and gender work as "conjoined determinants of women's lived experience and their self-representations" (Intro. p. 10). In this particular case, representation of the self relates to a Tamil Untouchable woman's powerful hymn, sung to the goddess Singamma. A comparative analysis is made between the content and meaning of the hymn, expressing Singamma's tribulations as an outcast, her death, and her ultimate regeneration and triumph, as compared to the more harsh realities of Untouchable life as related through the autobiographical details of the woman singer. The singer thus becomes transformed by her identification with the goddess hymn.

1288. Wiratini, Ni Made. "The Female Performer and Her Roles in Balinese Dance Drama." *UCLA Journal of Dance Ethnology* 14 (1990): 26–32.

1289. Yeh, Nora. "Wisdom of Ignorance: Women Performers in the Classical Chinese Music Traditions." In *Music, Gender, and Culture*, ed. Marcia Herndon and Susanne Ziegler, pp. 157–172. International Council for Traditional Music. ICTM Study Group on Music and Gender. Intercultural Music Studies, no. 1. Wilhelmshaven, Germany: Florian Noetzel Verlag, 1990.

   ISBN 3795905931. This essay on the *nanyin* classical musical tradition of southeastern China explores the manner in which the woman's voice is heard through its numerous songs, even though the *nanyin* in the past was a male performance tradition when seen and heard in the public sphere, unless performed by women of the courtesan class in the private sphere of elite patronage. The author explores the social, philosophical, religious, and literary influences on the representation of the female experience through the *nanyin*.

1290. Zanten, Willem van. *Tembang Sunda: An Ethnomusicological Study of the Cianjuran Music in West Java*. Diss. Leiden, The Netherlands: Rijksuniversiteit Leiden, 1987.

   ISBN 9066240768. In English, with summary in Dutch. This ethnomusicological study of Sundanese music includes a discussion of the position of the female artist in West Javan society and participation women in the performance of Sundanese music (pp. 52–59).

### B. 3 EUROPE

1291. Andreesco, Ioana, and Mihaela Bacou. "Le chant des aubes, rituel funéraire roumain." *Cahiers de Littérature Orale* 27 (1990): 77–88.

In French, with English abstract. Part of a special issue devoted to sung funereal ritual. The "songs of the dawns," women's ritual songs of lamentation sung after death and during burial ceremonies, are discussed in terms of their position within the belief system of traditional Romanian culture.

1292. Arrebola, Alfredo. "Le Mujer en el Cante Flamenco." *Dos Siglos de Flamenco: Actas de la Conferencia Internacional, Jerez 21–25 Junio 88*, pp. 381–384. International Theatre Institute. Centro Español, et al. Jerez, Spain: Fundación Andaluza de Flamenco, [1989?].

ISBN: 844045189X. Brief discussion regarding women as creators and singers of flamenco song, and of the representation of women in song texts and literature.

1293. Auerbach, Susan. "From Singing to Lamenting: Women's Musical Role in a Greek Village." In *Women and Music in Cross-Cultural Perspective*, ed. Ellen Koskoff, pp. 25–43. Contributions in Women's Studies, no. 79. Westport, CT: Greenwood Press, 1987.

In her investigations into the vocal traditions of women over the age of fifty in a rural village in Epirus, Greece, the author demonstrates how societal constructs of gender are inextricably linked to men's and women's participation in music and their specific musical roles. In this case, she examines how the musical activities of women change as they move from youth (singing) to adulthood (lamenting). Women, who are solely responsible for taking care of the dead and the rituals of mourning, thus spend much of their mature lives as lamenters for the dead. In analyzing the texts and music of laments collected in her fieldwork however, Auerbach demonstrates how laments are sung by women to reflect other types of trouble and suffering in their lives; "in other words, they utilize the expressive forms allotted them to comment on the fate allotted them as women" (p. 41).

1294. Caufriez, Anne. "Women's Musical Instruments in Traditional Portugal." I. *Tradition and its Future in Music: Report of SIMS 1990 Osaka*, ed. Tokumaru Yosihiko, et al., pp. 243–248. International Musicological Society. Symposium. Tokyo, Japan: Mita Press, 1991.

ISBN 4895830837. This brief examination of the role of women in traditional music-making in Portugal first discusses the predominance of the woman's voice in the *fado*, a major song genre in Portuguese traditional music. The author then follows with a discussion of symbolic gender associations with particular groups of musical instruments, as well as limitations on men and women playing particular instruments because of these various social and ritual associations. Percussion instruments are those which have a long-standing tradition of being associated with women's roles and activities. These instruments are described and the context in which women perform on these instruments is discussed. Instruments and their performance contexts include: *adufe* (drum; seasonal and religious ceremonies), *pandeiro* (drum;

accompanies spinning songs), *conchas* (shells; spinning songs and instrumental ensemble accompaniment), *castanholas* (castenets; agricultural work songs and spinning songs), *pandeireta* (tambourine; feminine dances, games, festivities), *sarronca* (friction drum; olive picking, symbol of fertility), *matraca* (noisemaker; used for Holy Week ceremonies), *buzio* (conch; herding livestock, symbol of the shepherdess).

1295. Coote, Mary P. "On the Composition of Women's Songs." *Oral Tradition* 7, no. 2 (October 1992): 332–348.

As she examines the question of composition and oral transmission with regard to genres and forms of women's song found in the South Slavic oral tradition, the author draws upon the wealth of women's songs found in the seminal published song study/collection of Vuk Stefanović Karadžić, and the archival collection of Milman Parry, transcribed and edited excerpts of which were published by Béla Bartók and Albert Lord. Coote profiles songs from the repertoires of individuals representing three generations of women singers from Gacko in Bosnia- Herzegovina. Applying the Parry-Lord theory of oral composition to her analysis of these women's songs, she investigates the degree to which composition and improvisation is used in song and ballad narrative versus the many other types of women's lyrical songs (life-cycle songs, work songs, courtship songs, ritual songs, etc.) and the examines forces of continuity and change at work given the dynamics between language, formulaic repetition, function, and context of performance (private vs. public) in this Slavic song tradition. Sample song texts appended.

1296. Czekanowska, Anna. "Towards a Concept of Slavonic Women's Repertoire." In *Music, Gender, and Culture*, ed. Marcia Herndon and Susanne Ziegler, pp. 57–70. International Council for Traditional Music. ICTM Study Group on Music and Gender. Intercultural Music Studies, no. 1. Wilhelmshaven, Germany: Florian Noetzel Verlag, 1990.

ISBN 3795905931. The author surveys the genres, performance contexts, vocal styles, and musical structure of women's songs within the folk culture of Slavonic Europe, concentrating on the commonality of ritual and ceremonial songs throughout various geographical areas relating to the cult of fertility. Harvest songs, life-cycle songs, spring calling songs, wedding songs, and lullabies are discussed and analyzed. The author notes how this common musical thread reflects an "institutionally privileged" (p. 69) status which recognizes the importance of women to the continued life and well-being of the community and culture.

1297. Doliner, Gorana. "Traditional Church Singing in Kraljevica (Croatia): The Work of Lujza Kozinović." *The World of Music* 33, no. 2 (1991): 50–64.

Part of a special issue entitled "Women in Music and Music Research." The article considers the work of Sister Lujza Kozinović, composer, researcher of traditional music, music teacher, and compiler of one of

the most significant collections of old church singing from Croatia. The participation of women in sacred music, and the role of nuns in the preservation of musical culture is discussed.

1298. Dougan-Krstic, Nadine. "Gender and Role Reversals in Contemporary Carnival: City versus Village in Lovranstina, Yugoslavia." *UCLA Journal of Dance Ethnology* 13 (1989): 40–47.

1299. Flam, Gila. "Domestic Songs." In *Singing for Survival: Songs of the Lodz Ghetto 1940–1945*, pp. 104–127. Urbana, IL: University of Illinois Press, 1992.

This chapter examines the song repertoire of Miriam Harel, a survivor of the Holocaust and an inhabitant of the Nazi-created and controlled Jewish ghetto in Lodz, Poland. Because her songs were intended for her family, and thus were sung in a private, domestic context, the singer could freely express her emotions and feelings (and the listeners could likewise participate in those feelings). Songs lamenting the transportation and death of children and adult family members, hunger, loss of beauty, despair, and vengeance against the Germans could be sung without fear of censorship, reprisal, or other inhibiting behavioral and social codes. These domestic songs had an important function, aiding in the survival of individuals during this time of psychological stress and physical violence.

1300. Holst-Warhaft, Gail. *Dangerous Voices: Women's Laments and Greek Literature*. London: Routledge, 1992.

As the author describes in her introduction, the ritual practice of lamenting for the dead as performed by women in ancient and rural societies has all but disappeared within modern, patriarchal-based Western nation-states, so that less-passionate, more politically and socioculturally advantageous forms of mourning now occur in Western culture and society. The author studies the laments of Greek women within this context, noting the manner in which laments in modern Greek literature differ in content and language from sung laments performed by women in traditional ritual contexts. The depersonalization of death and dying in modern society and the threat of women's lament practices to the state seeking to recruit men into battle can be traced in the manner in which mourning and lamenting is manifested in modern Greek literature. The author notes the spate of recent published studies on the lament, and the use of the lament as a source of musical inspiration in the work of composer Diamanda Galas. "By recognizing echoes and appropriations of lament in the beginnings of western literature," the author states, "we may come to understand what the suppression and loss of women's voices as a vehicle for expressing communal grief has meant for our society" (pp. 12–13).

1301. Johnson, Anna. "Fäbodmusiken: kvinnornas, djurens och de vida skogarnas musik." In *Kvinnors Musik*, ed. Eva Öhrström and Märta Ramsten, pp.

34–41. Stockholm, Sweden: Sveriges Utbildningsradio AB and Svenska Rikskonserter, 1989.

    ISBN 9126898101. In Swedish. Translated title: "Shieling Music [i.e., Swedish herding music]: Women, Animals and the Music of the Sirens of the Great Forests." Shieling music, music sung and played by women to call or herd animals such as cattle, or that used to fend off beasts of prey, is a unique form of musical expression utilized by rural women of northern Scandinavia.

1302. Johnson, Anna. "The Sprite in the Water and the Siren of the Woods: On Swedish Folk Music and Gender." In *Music, Gender, and Culture*, ed. Marcia Herndon and Susanne Ziegler, pp. 27–40. International Council for Traditional Music. ICTM Study Group on Music and Gender. Intercultural Music Studies, no. 1. Wilhelmshaven, Germany: Florian Noetzel Verlag, 1990.

    ISBN 3795905931. The author first discusses how references to musical male and female supernatural beings in Swedish mythology (male water-sprite/fiddler and female woods siren/singer) can be viewed as a reflection of gender roles which exist in Swedish folk music in general. She then focuses on particular genres of Swedish traditional music associated with male and female roles and functions in society. While the traditional male role was to perform on instruments (e.g., fiddle, bagpipe, keyed fiddle, accordion) for public performance, women's music was performed in the domestic sphere, or accompanied daily chores of rural life. Unique to Sweden are the vocally embellished herding songs of women of the shielings, and the music played by these same women on animal horns and wooden trumpets in order to keep predators at a distance. The author notes that as the rural way of life disintegrates in Sweden, the traditional women's music genres are also being silenced, while the more performance-oriented folk music survives.

1303. *Mourning Songs of Greek Women*. Trans. and intro. Konstantinos Lardas. Garland Library of World Literature in Translation, no. 15. New York: Garland, 1992.

    As the author states in the Introduction, "These mourning songs were composed and sung by women lamenting the deaths of their sons and daughters, their husbands and their friends, their mother and their fathers." The texts to these sung poems, presented here in English translation, are organized according to the subject of the lament. Appended is a listing of the published sources from the original Greek language upon which the translations are based.

1304. Petrovic, Ankica. "Women in the Music Creation Process in the Dinaric Cultural Zone of Yugoslavia." *Music, Gender, and Culture*, ed. Marcia Herndon and Susanne Ziegler, pp. 71–84. International Council for Traditional Music. ICTM Study Group on Music and Gender. Intercultural Music Studies, no. 1. Wilhelmshaven, Germany: Florian Noetzel Verlag, 1990.

ISBN 3795905931. The author surveys the characteristics common to the musical repertoire of women in Dinaric Yugoslavia (Bosnia-Herzegovina, parts of Croatia, Serbia, Montenegro, and Albania), stressing the importance of the distinct, separate, and mostly inferior status of women as compared to men within society. The author explains how sex, age, and marital status (all of which factor into a woman's social status) dictate the types of music performed by women and the contexts (public/private) in which they are performed.

1305. Ramsten, Märta. "Barnkammaren och köket." In *Kvinnors Musik*, ed. Eva Öhrström and Märta Ramsten, pp. 53–56. Stockholm: Sveriges Utbildningsradio AB and Svenska Rikskonserter, 1989.

ISBN 9126898101. In Swedish. Translated title: "The Nursery and the Kitchen." Lullabies and children's songs.

1306. Ramsten, Märta. "Margareta Helena Lallér och Greta Naterberg." In *Kvinnors Musik*, ed. Eva Öhrström and Märta Ramsten, pp. 71–76. Stockholm, Sweden: Sveriges Utbildningsradio AB and Svenska Rikskonserter, 1989.

ISBN 9126898101. In Swedish. Active during the nineteenth century, these two women singer/storytellers from the island of Gotland were transmitters of repertoire from the Swedish oral tradition.

1307. Rice, Timothy. "Understanding Three-Part Singing in Bulgaria: The Interplay of Theory and Experience." In *Selected Reports in Ethnomusicology. Volume VII: Issues in the Conceptualization of Music*, ed. James Porter and A. Jihad Racy, pp. 43–59. Los Angeles, CA: Department of Ethnomusicology, University of California Los Angeles, 1988.

In his study of female multipart singing of Southwestern Bulgaria, the author's conceptualization of this music is challenged by his experiences and observations during fieldwork, and his emotional response to the music in live performance.

1308. Shehan, Patricia K. "Balkan Women as Preservers of Traditional Music and Culture." In *Women and Music in Cross-Cultural Perspective*, ed. Ellen Koskoff, pp. 45–53. Contributions in Women's Studies, no. 79. Westport, CT: Greenwood Press, 1987.

Shehan examines the role of women in preserving the continuity of the musical traditions in the Balkans given centuries of political and cultural domination by outside forces. She notes that although women in the Balkans have an inferior social status in relation to men, Balkan women have been the sustainers of native culture, using music to accompany daily work, birth, courtship, marriage, mourning, and other life-cycle rituals, as well as religious, calender, and seasonal celebrations.

1309. Spohr-Rassidakis, Agni. *Fünf Totenklagemelodien aus der Gegend des Assterùssia-Gebirges auf Kreta: Eine vergleichende Studie*. Orbis Musicarum 6. Göttingen, Germany: Edition Re, 1990.

ISBN 3927636169. In German. Translated title: *Five Lament Melodies from the Asteroùsian Mountain Region on the Island of Crete: A Comparative Study*. Based on the author's field work in women's folk song traditions of southern Crete, this study examines in detail the musical aspects of women's laments, and in particular whether there are archetypical elements in these laments which shape the degree and manner of musical variation and improvisation utilized by lament singers. Five melodies collected from three women singers are transcribed in detail and analyzed. Various elements such as range, tonality, structure, melody, rhythm, meter, and text are examined in each example, with a concluding discussion comparing the five.

1310. Subirats, María Angeles. *La nana andaluza: estudio etno-musicológico*. Andalucia, Spain: Centro de Documentation Musical de Andalucia, 1990.

ISBN 8487769012. In Spanish. A musical study of the Andalusian lullaby.

1311. Sugarman, Jane C. *Engendering Song: Singing and the Social Order at Prespa Albanian Weddings*. Diss. Ph.D., University of California at Los Angeles, 1993.

Abstract in *Dissertation Abstracts International: A. Humanities and Social Sciences* 54, no. 2 (August 1993): 368. DA #9317484. Based on field work in Prespa (Macedonia, former Yugoslavia) and in Prespa immigrant communities in the United States, this study examines men's and women's wedding music repertoires and performance practices, as well as the manner in which the social notion of gender shapes Prespa musical culture.

1312. Sugarman, Jane C. "The Nightingale and the Partridge: Singing and Gender Among Prespa Albanians." *Ethnomusicology* 33, no. 2 (Spring/ Summer 1989): 191–215.

The singing of Prespa Albanian women and men of the (former) Yugoslav republic of Macedonia is analyzed to demonstrate how differences in performance style, vocal timbre, the social context of singing, and the poetics of song texts reflect gender distinctions and notions of masculinity and femininity in Prespa Albanian society and culture at large.

1313. Sultan, Nancy. "Women in *Akritic* Song: The Hero's 'Other' Voice." *Journal of Modern Greek Studies* 9, no. 2 (October 1991): 153–170.

The theme of the wandering male hero as represented in various Greek folksong types is examined with particular reference to the importance of women in insuring the hero's immortality through their singing of ritual laments associated with the life cycle and rites of passage. Sultan "explore[s] in several traditional songs the tension between the male hero's linearity and the cyclical nature of women's song,... highlight[ing] the idea that the completion of the hero's life cycle is dependent on his permanent reintegration into the woman's world in general, and woman's song in particular" (pp. 153–154).

1314. Tolbert, Elizabeth. "Magico-Religious Power and Gender in the Karelian Lament." In *Music, Gender, and Culture*, ed. Marcia Herndon and Susanne Ziegler, pp. 41–56. International Council for Traditional Music. ICTM Study Group on Music and Gender. Intercultural Music Studies, no. 1. Wilhelmshaven, Germany: Florian Noetzel Verlag, 1990.

    ISBN 3795905931. The domain of older women, the sung funeral and wedding laments of eastern Finland and Soviet Karelia are examined with relation to how cultural attitudes regarding gender opposition and sexuality shape performance of the lament. Via symbolic language, improvisatory singing, and emotional, trance-like performance displaying elements of weeping, singing and speech, the author explains how women who sing these laments minister between the worlds of the living and the dead, expressing the collective grief of the living while ensuring that the souls of the dead reach their final destination. She also explores the relationship between age (and the sexual ambiguity which comes with the loss of female sexuality), lamenting, and female acquisition of shamanistic power. She then examines the musical structure of the lament, the relationship between music and text, and the stylistic differences between male "singing" and female "lamenting" which further reflect the opposition of gender roles.

1315. Tolbert, Elizabeth. *The Musical Means of Sorrow: The Karelian Lament Tradition*. Diss. Ph.D., University of California at Los Angeles, 1988.

    Abstract in *Dissertation Abstracts International: A. Humanities and Social Sciences*. 49, no. 10 (April 1989): 2860. DA# 8828071. Reviewed in *The World of Music* 33, no. 2 (1991):109–111. Lamenting, a musical ritual of women in the Karelian regions of the Soviet Union and eastern Finland, is investigated in this dissertation. In particular, the author analyzes the manner in which symbolic language, musical improvisation, and the ecstatic nature of performance impart laments with magical and religious symbolism, and signify a role for the lamenter which is a powerful one.

1316. Tolbert, Elizabeth. "Women Cry With Words: Symbolization of Affect in the Karelian Laments." *Yearbook for Traditional Music* 22 (1990): 80–105.

### B. 4 MIDDLE EAST

1317. Avishur, Yitzhak. *Women's Folk Songs in Judeao-Arabic from Jews in Iraq*. Studies in the History and Culture of Iraqi Jewry, no. 4. Or Yehuda, Israel: Iraqi Jews' Traditional Culture Center, Institute for Research on Iraqi Jewry, 1987.

    In Hebrew, with additional title pages, introduction, and a summary (22 p.) in English. Song texts are transliterated from Iraqi-Jewish script into roman script. Reviewed in *Asian Folklore Studies* 49, no. 1 (1990): 182–184. Drawing primarily upon nineteenth-century manuscript sources, this in-depth study of Iraqi-Jewish women's folk songs devoted to life-cycle rituals is perhaps the first of it's kind. Song texts and variants are presented,

as well as an analysis of the social context in which the songs are performed. The author describes musical elements in these songs, such as the use of improvisation, the melodic and rhythmic character, accompanying musical instruments used, etc. The types of songs examined include lullabies, children's songs, wedding songs, laments, and dirges. Another category, songs for the *ziyāra* (sacred pilgrimages to the tombs of Jewish saints thought to be buried in Iraq), is recognized as being part of the women's song repertoire.

1318. Bailey, John, and Veronica Doubleday. "Modèles d'impregnation musicale en Afghanistan." *Cahiers de musiques traditionelles* 1 (1988): 112–124.

In French. Special issue entitled "De bouche à oreille" [From mouth to ear], on the oral transmission of music in non-Western cultures. The authors address the manner in which boys, girls, and young adults acquire an interest and proficiency in music in Afghanistan. Noting the segregated nature of Afghan society according to gender and familial background, they provide four models of musical transmission, looking at the musical activities of girls from non-hereditary musical families, the musical activities of boys from non-hereditary musical families, the musical activities of girls from hereditary musical families, and the musical activities of boys from hereditary families.

1319. Bailey, John. *Music of Afghanistan: Professional Musicians in the City of Herat*. Cambridge, England: Cambridge University Press, 1988.

This study includes an examination of women's participation in the musical life of Afghanistan, including the musical instruments used (pp. 33, 90, 160) and repertoire performed (e.g., wedding songs, pp. 95–96, 125–131), their status as professional musicians (pp. 33–36, 58–59, 134–136) and societal attitudes towards women musicians (pp. 114–116, 148–149).

1320. Danielson, Virginia Louise. "Artists and Entrepreneurs: Female Singers in Cairo during the 1920s." In *Women in Middle Eastern History: Shifting Boundaries in Sex and Gender*, ed. Nikki R. Keddi and Beth Baron, pp. 292–309. New Haven, CT: Yale University Press, 1991.

This essay examines the role and status of the professional female singer in early twentieth-century Cairo, and her commercial success during an era when musical theatre, radio, and sound recordings offered many professional opportunities for the woman musician. The author notes that the nineteenth-century female guilds of musicians prepared women to negotiate contracts and handle their careers, as the commercial role of the female musician expanded during the early part of twentieth century. The lives of a number of prominent female singer/musicians are discussed, including Umm Kulthum, a pioneering and influential Egyptian singer who forged an immensely successful career as a sound recording artist.

1321. Doubleday, Veronica. *Three Women of Herat*. London: Jonathan Cape, 1988.

Reprinted in 1990 by University of Texas Press, Austin, TX. Reviewed in *Ethnomusicology* 32, no. 3 (Fall 1988): 480–481. The author's fieldwork in Herat, Afghanistan, encompassed entering the woman's world, a world hidden from men. Her study of the role of women in Herati society and culture focuses on the author's relationships with three individuals from whom she gains knowledge of societal rules, religious ritual, family relationships, the effect of *purdah* (seclusion) on women's lives, and the instrumental and vocal music performed by and for women. Her friendship with Shirin, a musician and bandleader from the women's hereditary musical clan known as the Minstrels, leads her to learn the music and perform in women's groups. Her fascinating narrative unveils this hidden story of the history of women's music in Afghanistan, its repertoire, instruments, societal attitudes towards professional women musicians, and more.

1322. Reinhard, Ursula. "The Veils Are Lifted: Music of Turkish Women." In *Music, Gender, and Culture*, ed. Marcia Herndon and Susanne Ziegler, pp. 101–113. International Council for Traditional Music. ICTM Study Group on Music and Gender. Intercultural Music Studies, no. 1. Wilhelmshaven, Germany: Florian Noetzel Verlag, 1990.

ISBN 3795905931. The author describes the different musical roles for women in Turkey as compared with Turkish women musicians living outside their native country. She describes how the musical roles and genres performed differ by the type of society (rural vs. urban) and type of performer (amateur vs. professional), and discusses the degree to which Western culture and societal attitudes have acted as an agent of change on Turkish traditions. She then profiles the musical career of Şah Turna, a poet/singer from Turkey now living in Germany, whose songs address the social and political status of Turkish women.

1323. Sakata, Hiromi Lorraine. "Hazara Women in Afghanistan: Innovators and Preservers of a Musical Tradition." In *Women and Music in Cross-Cultural Perspective*, ed. Ellen Koskoff, pp. 85–95. Contributions in Women's Studies, no. 79. Westport, CT: Greenwood Press, 1987.

The author first examines the impact of socioreligious beliefs on the organization of male and female music-making amongst the Islamic Hazara peoples of central Afghanistan, and then analyzes the music performed by men and women sung within their respective milieus (public vs. private). In doing so, she reveals that the melodic prototypes which are characteristic of Hazara music are to be found within the repertoire of women, especially lullabies. She thus reveals a discrepancy between the belief in male cultural dominance and the musical evidence which suggests that women play a strong role as musical innovators and preservers.

1324. Sawa, Suzanne Meyers. "Role of Women in Musical Life: The Medieval Arabo-Islamic Courts." *Canadian Woman Studies* 8, no. 2 (Summer 1987): 93–95.

1325. Shiloah, Amnon. *Jewish Musical Traditions*. Detroit, MI: Wayne State University Press, 1992.

Songs relating to birth and wedding rituals, as well as lamentations, are discussed as women's genres (pp. 170–180). The drum is mentioned (pp. 40–41) as an instrument associated with women's music. The author emphasizes that the woman's role in the Jewish musical tradition exists mainly within the domestic sphere.

1326. Shiloah, Amnon. "The Jewish-Yemenite Tradition: A Case Study of Two Women Poet-Musicians." In *Tradition and its Future in Music: Report of SIMS 1990 Osaka*, ed. Tokumaru Yosihiko, et al., pp. 447–450. International Musicological Society. Symposium. Tokyo, Japan: Mita Press, 1991.

ISBN 4895830837. With over twenty years of observation and study of continuity and change in the musical styles of two traditional Jewish-Yemenite women singers, the author questions the validity of recent musical writings which assert that sex and gender are the primary forces which influence musical style.

1327. Ziegler, Susanne. "Frauen als professionelle Hochzeitsmusikanten in der Türkei." *Folklor i njegova umetnička transpozicija,* pp. 23–35. Beograd, Yugoslavia Fakultet Muzičke Umetnosti, 1987.

In German, with summaries in English and Serbian. On the role of women as professional wedding musicians in southern Turkey.

1328. Ziegler, Susanne. "Gender-Specific Traditional Wedding Music in Southwestern Turkey." In *Music, Gender, and Culture*, ed. Marcia Herndon and Susanne Ziegler, pp. 85–100. International Council for Traditional Music. ICTM Study Group on Music and Gender. Intercultural Music Studies, no. 1. Wilhelmshaven, Germany: Florian Noetzel Verlag, 1990.

ISBN 3795905931. The performance and repertoire of men's and women's music for the traditional wedding ceremony in Southwestern Turkey are analyzed and compared for features which are gender-specific. The author determines that the differences in musical style and context of performance which exist in the music of women (e.g., vocal music, accompanied only by a frame drum, soft in volume, performed in an enclosed space separate from the men, musically and stylistically restricted, little improvisation) and the music of men (e.g., instrumental, loud in volume, public, musically varied with stylistic individuality encouraged) are determined by the socioreligious belief systems and codes of behavior of the inhabitants of rural Turkey.

**B. 5 NORTH AMERICA**

1329. Babcock, Barbara A., and Nancy J. Parezo. "Interpreting the Native American: Folklore and Ethnomusicology." In *Daughters of the Desert: Women Anthropologists and the Native American Southwest—An Illustrated Catalog*, pp. 89–110. Albuquerque, NM: University of New Mexico Press, 1988.

　　Photographic portraits, photographs from the field, and excerpts of writings and music illustrate the short biographies of the following women: ethnomusicologists Frances Densmore and Natalie Curtis Burlin; musician and dance ethnologist Gertrude Kurath; folklorist and novelist Frances Gillmore.

1330. Cavanagh, Beverly D. "Music and Gender in the Sub-Arctic Algonkian Area." In *Women in North American Indian Music: Six Essays*, ed. Richard Keeling, pp. 55–66. Society for Ethnomusicology Special Series, no. 6. Bloomington, IN: Society for Ethnomusicology, 1989.

　　Continuing the line of feminist-oriented anthropological research followed by Eleanor Leacock, the author delves further into the study of the musical cultures of three Northeastern Algonkian tribes (Naskapi, Montagnais, and Eastern Cree) to determine the extent to which gender differentiates musical roles, styles, and participation in particular genres. The way in which Algonkian peoples interpret concepts of masculine and feminine in their music is also investigated.

1331. Frisbie, Charlotte J. "Gender and Navajo music: Unanswered Questions." In *Women in North American Indian Music: Six Essays*, ed. Richard Keeling, pp. 22–38. Society for Ethnomusicology Special Series, no. 6. Bloomington, IN: Society for Ethnomusicology, 1989.

　　In this preliminary study, the author finds that there are few examples where gender prescribes certain vocal styles or singing of particular genres in Navaho music culture. Gender's primary effect can be seen in restrictions on the participation of women in ceremonial ritual during their menstruation. Otherwise, singing (which is the primary Navaho musical activity) is an activity in which males and females equally participate, both as creators and performers, with slight gender differences in vocal ranges and style. The author states, however, that more research needs to be done on the construction of gender in Navaho musical culture before any definitive conclusions can be drawn.

1332. Giglio, Virginia. *Oklahoma Cheyenne Women's Traditional Everyday Songs*. Diss. Ph.D., University of Oklahoma, 1991.

　　Abstract in *Dissertation Abstracts International: A. Humanities and Social Sciences* 52, no. 11 (May 1992): 3763. DA# 9210498. Songs accompanying the daily lives of Cheyenne women are studied. Transcriptions and

translations of songs are presented, the composers are identified, genres are documented, and a women's vocal style begins to emerge.

1333. Hatton, Orin T. "Gender and Musical Style in Gros Ventre War Expedition Songs." In *Women in North American Indian Music: Six Essays*, ed. Richard Keeling, pp. 39–54. Society for Ethnomusicology Special Series, no. 6. Bloomington, IN: Society for Ethnomusicology, 1989.

    This examination into the manifestion of gender roles and relations in the war expedition songs of the Gros Ventre Indians of the western Plains is based on interpreting singing both as performance and as communication. The consideration of music as discourse allows an analysis of song content and musical style that incorporates Gros Ventre beliefs in power relations (between humans and supernatural entities), respect relations, and a host of other social considerations. Songs recorded by two male and two female elders reveal two distinct vocal techniques based on gender (pulsating/male vs flat/female), indicative of traditional notions of respect relations. However, additional musical analyses demonstrate no clear cut classification of style or musical content based on gender roles. Rather, the degree to which both males and females strictly adhere to ethnic tradition in a changing world is the basis for differences in musical style.

1334. Herndon, Marcia. "Biology and Culture: Music, Gender, Power, and Ambiguity." In *Music, Gender, and Culture*, ed. Marcia Herndon and Susanne Ziegler, pp. 11–26. International Council for Traditional Music. ICTM Study Group on Music and Gender. Intercultural Music Studies, no. 1. Wilhelmshaven, Germany: Florian Noetzel Verlag, 1990.

    ISBN 3795905931. The author first clarifies the meanings of the terms "sex" and "gender," the former being a biological term and latter a sociocultural one. She then examines "the relationship between biology and culture in determining culture- specific musical behavior, thought and action" (p. 11), in this case with reference to the musical activities of the Cherokee Indians, looking at two particular musical categories: sacred/ceremonial music and ballgame songs.

1335. Keeling, Richard. *Cry For Luck: Sacred Song and Speech Among the Yurok, Hupa, and Karok Indians of Northwestern California*. Berkeley, CA: University of California Press, 1992.

    The author acknowledges that much of the existing research on the Yurok, having been conducted by male ethnomusicologists, has interpreted rituals from a male point of view and has overlooked possibilities of separate rituals used by women. Practices such as male avoidance of women, a view of sexuality as contamination, the exclusion of women from sacred rituals, isolation of women during menstruation have been described in terms of supreme male dominance in the the culture of the Yurok (pp. 61–64). However, the author uncovers evidence of female performance in some public and some private rituals, demonstrating that this picture is not totally accurate. Such rituals described in this book are: female singing in the Brush

Dance (performed to cure a sick child, pp. 111–114), male/female singing in the Flower Dance (public ritual for the occasion of a girl's first menstruation, pp. 116–126), money medicine songs sung by a Yurok woman (pp. 166–168), spoken medicine formulas for childbirth and child rearing (pp. 146–150), love medicine songs (pp. 172–182), medicine formulas to counteract effects of menstruation (pp. 183–184), basketry medicine songs (pp. 184–186), etc.

1336. Keeling, Richard. "Musical Evidence of Female Spiritual Life Among the Yurok." In *Women in North American Indian Music: Six Essays*, ed. Richard Keeling, pp. 67–78. Society for Ethnomusicology Special Series, no. 6. Bloomington, IN: Society for Ethnomusicology, 1989.

    A closer look at recent research, as well as archival recordings and narratives gathered earlier in the twentieth century, reveals that Yurok women had a separate, rather than nonexistent, spiritual life which has yet to be fully documented. The author identifies evidence from existing research which presents an alternative view to that which previously established a clearly dominant male role in the performance of music in Yurok ritual.

1337. Keeling, Richard, ed. *Women in North American Indian Music: Six Essays*. Society for Ethnomusicology Special Series, no. 6. Bloomington, IN: Society for Ethnomusicology, 1989.

    Reviewed in *American Music* 9, no. 4 (Winter 1991): 18–22; *Notes* 47, no. 4 (June 1991): 1148–1149; *American Ethnologist* 18, no. 3 (1991): 633–634; *American Anthropologist* 93, no. 2 (1991): 456–457. These essays are based on papers presented at the thirty-second Annual Meeting of the Society for Ethnomusicology during a session entitled, "Gender as a Determinant of Style in American Indian Music." Keeling's introduction stresses how these six studies, with an emphasis on tribal culture rather than geographic culture theory, have avoided the pitfalls which have led to inaccurate generalizations about Indian music, and ones which have previously left women out of the picture. Included are: Vander, Judith. "From the Musical Experience of Five Shoshone Women"; Vennum, Thomas, Jr. "The Changing Role of Women in Ojibway Music History"; Frisbie, Charlotte J. "Gender and Navajo Music: Unanswered Questions"; Hatton, Orin T. "Gender and Musical Style in Gros Ventre War Expedition Songs"; Cavanagh, Beverly D. "Music and Gender in the Sub-Arctic Algonkian Area"; Keeling, Richard. "Musical Evidence of Female Spiritual Life Among the Yurok."

1338. Shapiro, Anne Dhu. "Music in the Service of Ritual Transformation: The Mescalero Apache Girls' Puberty Ceremony." In *Music and Child Development: Biology of Music Making. Proceedings of the 1987 Denver Conference*, ed. Frank R. Wilson and Franz L. Roehmann, pp. 106–116. St. Louis, MO: MMB Music, 1990.

1339. Vander, Judith. "From the Musical Experience of Five Shoshone Women." In *Women in North American Indian Music: Six Essays*, ed. Richard

Keeling, pp. 5–12. Society for Ethnomusicology Special Series, no. 6. Bloomington, IN: Society for Ethnomusicology, 1989.

Highlighting selected aspects of material presented in the author's monograph, *Songprints* (Urbana: University of Illinois Pres, 1988), Vander outlines the ways the musical experiences of five Shoshone women are specifically shaped by gender. While tribal beliefs concerning menstruation and power limit women's ability to participate in the music connected with certain religious rituals, the author presents evidence that women are not totally excluded from the realm of power, as women have been given, through dreams and visions, songs which have been incorporated into the Ghost Dance repertoire. She discusses the complementary male and female musical roles in the Sun Dance musical ensemble. Changes in Shoshone society and culture, especially since 1950, have given women greater economic independence, allowing them to assume new roles, and thus expand their musical participation into genres traditionally associated with men.

1340. Vander, Judith. *Songprints: The Musical Experience of Five Shoshone Women*. Urbana, IL: University of Illinois Press, 1988.

With accompanying cassette. Reviewed in *Choice* 26, no. 9 (May 1989): 1529; *Sonneck Society Bulletin* 15, no. 3 (Fall 1989): 137; *Journal of Musicological Research* 12, no. 1–2 (1992): 121–122. By focusing on the musical lives of five Shoshone women (Emily Hill, Angelina Wagon, Alberta Roberts, Helene Furlong, and Lenore Shoyo), each having their own unique "songprint" (i.e., repertoire), the author provides a framework by which she can examine broader issues of gender roles in Shoshone music, the various music genres associated with social occasions, ceremonies and rituals in Shoshone musical culture, and how the forces of change and continuity operate within the Shoshone musical culture.

1341. Vennum, Thomas, Jr. "The Changing Role of Women in Ojibway Music History." In *Women in North American Indian Music: Six Essays*, ed. Richard Keeling, pp. 13–21. Society for Ethnomusicology Special Series, no. 6. Bloomington, IN: Society for Ethnomusicology, 1989.

From his investigation into the forces of continuity and change in the role of women in Ojibway music, the author concludes, "Where once the role of women in Ojibway music was nearly on a par with men, through historical forces, culture contact, and vast reduction in the number of musical genres performed, it has diminished greatly today."

## B. 6 CENTRAL AND SOUTH AMERICA

1342. Basso, Ellen B. "Musical Expression and Gender Identity in the Myth and Ritual of the Kalapalo of Central Brazil." In *Women and Music in Cross-Cultural Perspective*, ed. Ellen Koskoff, pp. 163–176. Contributions in Women's Studies, no. 79. Westport, CT: Greenwood Press, 1987.

Basso investigates the paradoxical "opposition and complementarity" (p. 164) of Kalapalo attitudes towards gender and sexuality as it relates to ritual musical performance and reception of that performance. First discussing how musical roles and performance contexts are determined by gender identity, she then demonstrates how the separate musical performances of women's *Yamurikumalu* and men's *Kagutu* manifest shared musical forms and structures, but use the symbols and images (costume, instruments, singing, behaviors, etc.) of the opposite gender. Music then is used communicate across the boundaries of gender, while the context and manner of the performance reinforces distinct beliefs with regard to gender identity and polarity.

1343. Brizuela, Leopoldo. *Cantoras: Reportajes a Gerónima Sequeda y Leda Valladares.* Buenos Aires, Argentina: Torres Agüero, 1987.

 ISBN 9505491050. In Spanish. Two Argentinian women are profiled: Géronima Sequeda, an Argentinian folk singer, and Leda Valladares, a singer, composer, writer, and folk song collector.

1344. Chernela, Janet M. "Gender, Language and Placement in Uanano Songs."*Journal of Latin American Lore* 14, no. 2 (Winter 1988): 193–206.

 The author examines how gender relations and the role of women in society is expressed through the songs of the Uanano of Northwest Brazil via the notion of placement, i.e., "the location of the self in relation to others living in the society and in relation to those who have gone before" (p. 193). In particular, factors such as patrilineal descent, linguistic exogamy, and patrilocality present a conflict for Uanano women, as expressed in songs describing an individual woman's sense of displacement.

1345. Crook, Larry Norman. *Zabumba Music from Caruaru, Pernambuco: Musical Style, Gender and the Interpenetration of Rural and Urban Worlds.* Diss. Ph.D., University of Texas at Austin, 1991.

 Abstract in *Dissertation Abstracts International: A. Humanities and Social Sciences* 52, no. 5 (November 1991): 1560. DA #9128204. In his analysis of the Zabumba fife and drum music from Caruaru, a small city in northeastern Brazil, the author examines how the two distinct musical styles which exist reflect contrasting sets of values relating to gender and sexuality, tradition and change, and urban and rural life, and explains how music is also used to mediate these social oppositions.

1346. Hernandez, Deborah Pacini. "Cantando la Cama Vacia: Love, Sexuality and Gender Relationships in Dominican *Bachata.*" *Popular Music* 9, no. 3 (October 1990): 351–367.

1347. Hernandez, Ramon. "Women in Tejano Music: Today's Top Contenders." *Billboard* 101 (25 March 1989): T8.

1348. Holston, Mark. "The Women of Merengue." *Americas* 42, no. 3 (May/June 1990): 54–55.

1349. Myers, Robert. "Tropicalistas: Gal Costa, Maria Bethania and the Women Behind the Music of Brazil." *Option* 25 (March/ April 1989): 54–57.
      This discussion of the role of women in popular Brazilian music includes interviews with Gal Costa and Maria Bethania.

1350. Oliven, Ruben George. "Man/Woman Relations and the Construction of Brazilian Identity in Popular Music." *Social Science Information / Information sur les Sciences Sociales* 27, no. 1 (March 1988): 119–138.

1351. Ottley, Rudolph. *Women in Calypso*. Arima, Trinidad: R. Ottley, 1992.
      ISBN 9768136243. A survey, including interviews, of women calypsos of Trinidad and Tobago.

CHAPTER NINE

# Women, Gender, Music and Forms
# of Representation

## Part A. General and Multidisciplinary Perspectives

1352. Austern, Linda Phyllis. "Music for Characterization: Women." In *Music in English Children's Drama of the Later Renaissance*, pp. 155–160. Musicology, no. 13. Philadelphia, PA: Gordon and Breach, 1992.

   The author considers the manner in which musical associations with women characters in English children's drama of the seventeenth century reflect the Renaissance debate over the dual nature of women and the dual nature of music.

1353. Burgan, Mary. "Heroines at the Piano: Women and Music in Nineteenth Century Fiction." In *The Lost Chord: Essays on Victorian Music*, ed. Nicholas Temperly, pp. 42–67. Bloomington, IN: Indiana University Press, 1989.

   Previously published in the Autumn 1986 issue of *Victorian Studies*.

1354. Coffey, Richard. "Letters: Language, Music and the Church." *American Organist* 26, no. 2 (February 1992): 14–18.

   Response to: Milligan, Mary. "Professional Concerns Forum: An Introduction to Feminist Thought." *American Organist* 25, no. 9 (September 1991): 36–47, and letters in American Organist 25.12 (December 1991): 14–16.

1355. Coffman, Sue. "In the Beginning Were the Words, But Not the Same Yesterday, Today and Forever: Textual Changes in Three Recent Hymnals." *The Hymn* 44, no. 2 (April 1993): 6–11.

Recent language revisions (e.g. changes to incorporate inclusive language) in three hymnals (*United Methodist Hymnal*, *The Presbyterian Hymnal*, and *The Baptist Hymnal*) are examined, compared, and evaluated on the basis of their artistic/literary success.

1356. Cusick, Suzanne G. "Gendering Modern Music: Thoughts on the Monteverdi-Artusi Controversy." *Journal of the American Musicological Society* 46, no. 1 (Spring 1993): 1–25.

An investigation into the early seventeeth-century conflict over the hierarchical relationship between the elements of music and text, as voiced in the writings of Giulio Cesare Monteverdi (concerning the new musical style of the madrigals of his brother Claudio) and the music treatises of Giovanni Maria Artusi, reveals a rhetoric charged with metaphorical language relating to sexuality and gender opposition. The argument over Monteverdi's "feminine" modern music which places music as the servant of the text, and the gender rhetoric used by both sides in this controversy, indicates that broader issues should be considered here, such as the social function of the madrigal and the performance of vocal polyphony by women singers (e.g. popularity of the *concerti di donne*). The author then argues that once informed of these gender-based considerations in musical aesthetics, we might better understand Monteverdi's madrigals and, by extension, the way in which gender-based values manifest themselves throughout music history. Analyzed are *Cruda Amarilli* and *O Mirtillo* from Claudio Monteverdi's fifth book of madrigals.

1357. Engh, Barbara. "Loving It: Music and Roland Barthes." In *Musicology and Difference: Gender and Sexuality in Music Scholarship*, ed. Ruth Solie, pp. 66–79. Berkeley, CA: University of California Press, 1993.

The author examines the manner in which music is gendered as feminine in the postmodern writings of Roland Barthes.

1358. Hovda, Robert W. "The Evolving Language of Worship." *The Hymn* 38, no. 4 (October 1987): 16–21.

Delivered as the keynote address for the annual conference of the Hymn Society of America, held in Fort Worth, Texas, on June 8, 1987. The article addresses the philosophical and theological issues relating to the use of inclusive language in worship and hymnody.

1359. Jennings, Carolyn. "Remember the Riddle?"*Choral Journal* 31, no. 7 (February 1991): 31–33.

The author discusses patriarchal bias in language, urges choral directors to seek out religious music that uses inclusive language, and likewise stresses the need for new gender-inclusive English translations of musical works with texts based on ancient sources.

1360. Koza, Julia Eklund. *Music and References to Music in "Godey's Lady's Book," 1830–1877*. Diss. Ph.D., University of Minnesota, 1988.

Abstract in *Dissertation Abstracts International: A. Humanities and Social Sciences* 49, no. 6 (December 1988): 1308. DA# 8815808. Here, the author has cataloged and analyzed musical references and illustrations in this American women's magazine from the nineteenth century, in order to ascertain the manner in which normative attitudes regarding women's participation in music was perpetuated through this medium.

1361. Koza, Julia Eklund. "Music and the Feminine Sphere: Images of Women as Musicians in *Godey's Lady's Book*, 1830–1877." *Musical Quarterly* 75, no. 2 (Summer 1991): 103–129.

This study concerning the representation of women musicians analyzes the manner in which women are portrayed as musicians in textual descriptions contained in articles (both fiction and non-fiction) and illustrations contained in the nineteenth-century American women's magazine, *Godey's Lady's Book*. The author discusses gender role stereotyping and the portrayal of women as primarily amateur musicians performing within domestic settings. The article also discusses nineteenth-century attitudes towards women who are active as music professionals, such as composers, performers, or teachers.

1362. Kramer, Lawrence. "Culture and Musical Hermeneutics: The Salome Complex." *Cambridge Opera Journal* 2, no. 3 (November 1990): 259–294.

The author begins with an examination of fin-de- siècle attitudes with regard to gender and sexuality, demonstrating multiple meanings in the representation of the Salome figure in the male-composed art, literature, and music of this period. Though Salome is most often portrayed as the erotic, feared female, the author explores how cultural authority is retained by her male interpreters. He then demonstrates his thesis through a musical analysis of Richard Strauss' operatic version of *Salome*.

1363. Lewin, David. "Women's Voices and the Fundamental Bass." *Journal of Musicology* 10, no. 4 (Fall 1992): 464–482.

Drawing upon the musical criticism of Lawrence Kramer (*Music as Cultural Practice 1800–1900*. Berkeley: University of California Press, 1990) and Susan McClary (*Feminine Endings: Music, Gender and Sexuality*. Minneapolis: University of Minnesota Press, 1991), the author examines the works of Wagner (*Tristan und Isolde*), Strauss (*Salome*), and Schoenberg (*Erwartung* and his *String Quartet, Op. 10*) in order to demonstrate the transcendence of the female voice and how it "is typically acoustically free of what we conceive as the functional bass line" (p. 473). He then examines the musical theories of Gioseffo Zarlino (*Istitutioni harmoniche*) and Rameau (*Traité de l'harmonie*), discovering opposite theories concerning the relation of melody to harmony, and on the equanimity of harmonic voices. The gendered language found in their treatises leads to a general discussion of gender considerations in today's music theory pedagogy. Questioning, but ultimately affirming, the traditional course of study offered

in music schools, he suggests alternatives which would provide a gender-informed approach to the study of music theory. Linking the musical experience to the internal bodily sensations humans experience using their high (female) or low (male) voice, Lewin would first require all music students to have keyboard proficiency, and then would require each student to learn a solo instrument (either treble or bass) sounding in a different register than that of the student's singing voice.

1364. Lindley, David. "Shakespeare's Provoking Music." In *The Well-Enchanting Skill: Music, Poetry and Drama in the Culture of the Renaissance; Essays in Honor of F. W. Sternfeld*, ed. John Caldwell, Edward Olleson, and Susan Wollenberg, pp. 79–90. Oxford: Clarendon Press, 1990.

Studying the dramatic and rhetorical uses of music within the plays of Shakespeare reveals the Renaissance conception of music as engendered with female characteristics. Shakespeare uses the metaphor of music for womankind to provoke characters into action, to arouse emotions of both the characters in the play and the audience, and to indicate the subversion of patriarchal authority and the feminization (i.e., weakening resolve) of male characters.

1365. Maus, Fred. "Hanslick's Animism." *Journal of Musicology* 10, no. 3 (Summer 1992): 273–292.

Maus examines the conflict between the intellectual and emotive/sensual properties of music as expounded by Eduard Hanslick in his *On the Musically Beautiful*, revealing the gendered language which Hanslick uses in his discussions on music and feeling, mental vs. bodily responses to music, and music vs. nature.

1366. McCarthy, David B. "Singing a New Song: the Presbyterian Hymnal and its Reception." *Ars Musica Denver* 4, no. 2 (Spring 1992): 28–34.

Issues and controversies involving inclusive language and diversity are discussed with regard to the revision of the *Presbyterian Hymnal*.

1367. McClary, Susan. "Towards a Feminist Criticism of Music." *Canadian University Music Review* 10, no. 2 (1990): 9–18.

Part of a special issue on alternative musicologies. The author demonstrates the ways in which feminist theory might inform and reform musicological discourse. A critique of music from a feminist perspective might examine how and why societal attitudes regarding gender, race, and class are constructed in both texted and instrumental music repertoires. She provides a feminist interpretation of Mozart's *Die Zauberflöte*, and demonstrates how "gender is carefully organized and packaged." McClary examines how gender ideology is manifested in theoretical writings about music dating from the eighteenth through the twentieth centuries, thus challenging those who claim that music is an autonomous, value-free art form. A feminist criticism of music would reveal how the dichotomy of gender (male/female) is the

basis for other "Western binary oppositions" of mind/body, reason/emotion, European/racial non-white, elite/working class, etc., and is also evident in works of music. A feminist critique of music would acknowledge the physical, sensual, and sexual characteristics of music instead of subverting such inquiry in favor of one which focuses on an order, rationality, and codification which removes music from the physical human experience. McClary argues that women musicians and composers, if thus informed, would be able to make choices and explore alternatives which might lead them to discover a more personal, female aesthetic. The author states, however, that musicology continues to resist feminist-grounded criticism.

1368. McRobbie, Angela. "Settling Accounts With Subcultures: A Feminist Critique." In *On Record: Rock, Pop and the Written Word*, ed. Simon Frith and Andrew Goodwin, pp. 66–80. New York: Pantheon, 1990.

Reprinted from *Screen Education* 34 (Spring 1980): 37–49. Previous studies of British youth subcultures are biased specifically towards male youth subcultural forms. Before a serious consideration of female subcultures can be undertaken, existing studies must be evaluated. The author thus offers a feminist critique of two "subcultural classics," raising questions with regard to the manner in which gender and sexual issues are presented, and most importantly their implications for women. Reassessed in this article are: *Learning to Labour* (London: Saxon House, 1977) by Paul Willis, and *Subculture: The Meaning of Style* (London: Methuen, 1979) by Dick Hebdige.

1369. Mizrahi, Joan Berman. *The American Image of Women Musicians and Pianists, 1850–1900*. Diss. D.M.A., University of Maryland, 1989.

Abstract in *Dissertation Abstracts International: A. Humanities and Social Sciences*. 50, no. 7 (January 1990): 1843. DA# 8924275. References to women musicians and pianists in periodical literature and fiction from the late nineteenth century are analyzed, demonstrating the interrelation between images of femininity, domesticity, and music, with particular reference to the piano.

1370. Pageot, Édith Anne. "Image de la femme dans le symbolisme: étude comparée de Gustave Moreau et Claude Debussy." *Sonances* 8, no. 2 (Winter 1988): 27–29.

In French. Translated title: "Woman's Image in Symbolism: A Comparative Study of Gustave Moreau and Claude Debussy." The author draws upon post-impressionist aesthetics as she compares female representation in the art of Gustave Moreau (in his *Salomé dansant devant Hérode*) and in the music of Claude Debussy (in his *Pelléas et Mélisande*).

1371. Quantrille, Wilma. "A Woman Responds to Charles Wesley." *Methodist History* 29, no. 4 (July 1991): 199–212.

The hymns of Charles Wesley are examined from a feminist perspective. The author finds that "for women deeply concerned for the survival of the planet and passionately seeking to find new expression for their long silent praise, the Wesley hymns help to open the possibility of a new revelation of God through the Spirit for the present age" (p. 212).

1372. Rathke, Michael. "Editing and Choosing Hymns for Inclusive Language." *American Organist* 25, no. 5 (May 1991): 53.

The author presents a set of guidelines for those who may be responsible for either editing or selecting hymns using inclusive language principles.

1373. Reitter, Karin. "Und noch einmal Carmen." *Österreichische Musik Zeitschrift* 47, no. 5 (May 1992): 258–267.

In German. Translated title: "And Once Again, Carmen." This study of the literary (Prosper Mérimée), operatic (Georges Bizet) and theatrical (Harry Kupfer) versions of *Carmen* examines the protagonist as portrayed in each version as a variation on the theme of the myth of woman as erotic and fatal "Other."

1374. Ruiter, Jacob. "Zum Dualismus des Männlichen und des Weiblichen." *Der Charakterbegriff in der Musik: Studien zur deutschen Ästhetik der Instrumentalmusik 1740–1850*, pp. 159–170. Beihefte zum Archiv für Musikwissenschaft, no. 29. Stuttgart, Germany: Franz Steiner Verlag Wiesbaden, 1989.

ISBN 3515051562. In German. Translated title: "On the Dualism of Masculine and Feminine." On the language of gender in German writings on music aesthetics, and male/female dualism in German music of the eighteenth and nineteenth centuries.

1375. Rutherford, Susan. "The Voice of Freedom: Images of the Prima Donna." In *The New Woman and Her Sisters: Feminism and the Theatre 1850–1914*, ed. Vivien Gardner and Susan Rutherford, pp. 95–113. Ann Arbor, MI: University of Michigan Press, 1992.

The representation of the prima donna as the symbol of the liberated "New Woman" of the turn of the century is examined via the literary works of George Eliot (*Armgart*), George Sand (*Consuelo*), Willa Cather (*Song of the Lark*), and Gertrude Atherton (*Tower of Ivory*). The lives of a number of actual singers of the era are discussed (e.g. Pauline Viardot-Garcia and Mary Garden) to assess how closely the literary image resembles reality.

1376. Sharp, Timothy W. "The Decade of the Hymnal 1982–1992: Choral Piety and Belief, Hardbound." *Choral Journal* 32, no. 9 (April 1992): 31–44.

The author explores the changing world of hymnody during the past decade, examining in particular the proliferation of new hymnals and the degree to which these new hymnals reflect societal and cultural change.

Pertinent to the subject of women and gender, the author outlines the issues regarding hymnal revisions based on principles of inclusive or gender-free language; comparisons are made between the various hymnals with respect to this issue. In this regard, the author also notes the more frequent appearance of repertoire by women composers in recently published hymnals. The bibliography and notes refer one to additional sources on this topic emanating from different religious denominations.

1377. Solie, Ruth A. "On Difference." In *Musicology and Difference: Gender and Sexuality in Music Scholarship*, ed. Ruth Solie, pp. 1–20. Berkeley, CA: University of California Press, 1993.

Solie "chart[s] the terrain of the difference debate" (p. 3), first by defining the concept of difference as it relates to the study of gender and culture, and then by outlining theories of difference put forth by scholars in a variety of disciplines. She then introduces the notion of difference as applied to music and musicological discourse with a summary of the major themes contained in the essays contributed to this book.

1378. Springer, Morris. "A Flight of Nightingales." *Opera News* 53 (18 February 1989): 21–23.

The author seeks to refute the uncomplimentary caricaturization of the soprano voice often used in musical criticism, and instead "sings the praises of a maligned breed, the high coloratura" (p. 21).

1379. Steegman, Monica. "'Wendezeit' im Klavierspiel? Nachgedanken zu einer Pianistinnen-Konzertreihe." *Neue Zeitschrift für Musik* 148, no. 4 (April 1987): 14–18.

In German. Translated title: "A Turning Point in Piano Playing? Thoughts on a Series of Concerts by Women Pianists." The author reflects on the concert series "Pianistinnen- Porträts," featured during the Berliner Festwochen. Presenting first a historical look at gender associations with the piano as a musical instrument, the author then looks at the writings of music critics, comparing the language of gender used by the same in their concert reviews describing the playing of men and women pianists. She then moves on to examine the degree to which there may be a discernable male or female aethestic which is communicated in performance.

1380. Tick, Judith. "Charles Ives and Gender Ideology." In *Musicology and Difference: Gender and Sexuality in Music Scholarship*, ed. Ruth Solie, pp. 83–106. Berkeley, CA: University of California Press, 1993.

Ives' male rhetoric and his prejudicial attitudes towards "feminine" qualities in music is placed within the context of the sociocultural polemics of the early twentieth century. Tick demonstrates that by devaluing the music of his European predecessors as feminine, Ives sought to distinguish and defend, in masculine terms, his own, modernist music.

1381. Treitler, Leo. "Gender and Other Dualities of Music History." In *Musicology and Difference: Gender and Sexuality in Music Scholarship*, ed. Ruth Solie, pp. 23–45. Berkeley, CA: University of California Press, 1993.

The author examines the oppositional self/Other relationship as it pertains to the manner in which attitudes toward gender and race are manifested in the language of Western musical history and criticism, particularly in accounts on medieval chant.

1382. Trooien, Roberta Pierce. *The Rhetoric of Hymn Texts: A Feminist Perspective*. Diss. Ph.D., University of Minnesota, 1990.

Abstract in *Dissertation Abstracts International A: Humanities and Social Sciences* 51, no. 8 (February 1991): 2732. DA# 9100986. The four hymnals studied are attentive to inclusive language and are official publications of large denominations: Catholic *Worship III*, 1986; Episcopalian *Hymnal 1982*, 1984; *Lutheran Book of Worship*, 1978; *United Methodist Hymnal*, 1989. Analysis of the texts, while superficially inclusive, reveal a basic metaphor system which reinforces patriarchal structure and male hegemony.

1383. Tucker, Sherrie. "'Where the Blues and the Truth Lay Hiding': Rememory of Jazz in Black Women's Fiction." *Frontiers* 13, no. 2 (1993): 26–44.

The author examines fictional works by black women writers which focus on jazz and the experience of black women musicians in the jazz world. In doing so, she demonstrates the links between literature and music in African-American culture, and shows how this body of literature offers an alternative to the jazz history and criticism "penned by white men who generally recall a gender-specific, male art form."

1384. Wheelock, Gretchen A. "'Schwartze Gredel' and the Engendered Minor Mode in Mozart's Operas." In *Musicology and Difference: Gender and Sexuality in Music Scholarship*, ed. Ruth Solie, pp. 201–221. Berkeley, CA: University of California Press, 1993. .

The author documents the rhetoric of gender in eighteenth-century theoretical writings on music (e.g. by Jean-Jacques Rousseau, Johann Kirnberger, and Joseph Riepel) focusing on the relationships between major and minor mode, as well as the affective characteristics of major and minor keys and harmonies, expressed in terms which associate the major with male and the minor with female. Riepel's writing, in particular, notes the "schwarze Gredel" (the minor tonic) as disturbing to tonal stability because of its musical ambiguity. With this in mind, Wheelock moves to the opera arias of Mozart. Of the 24 arias by Mozart written in the minor key, 17 are allotted to female characters. The author further analyzes the female actions and emotions (e.g. rage, vengeance, jealousy, grief, conflict, fear) represented in these minor-key arias, and notes that the manner in which the "schwarze Gredel" can inform our interpretation of those minor-key arias assigned to male characters.

1385. White, Hayden. "How ideology Works: Kramer, Solie and Rosand." In *Music and Text: Critical Inquiries*, ed. Steven Paul Scher, pp. 298–306. Cambridge, England: Cambridge University Press, 1992.

   Includes critical commentary on Ruth Solie's essay included in the same book, entitled "Whose Life? The Gendered Self in Schumann's *Frauenliebe* Songs" (pp. 219–240).

1386. "Women Players." *Chambers' Music Quotations*, pp. 242–244. Edinburgh: W. and R. Chambers, 1991.

   Introduction and selection by Derek Watson. Quotations of note on the theme of women's (in)ability to be true musicians.

1387. Wren, Brian. *What Language Shall I Borrow? God-talk in Worship: A Male Response to Feminist Theology*. New York: Crossroad, 1989.

   This contemporary hymn writer presents the issues regarding patriarchal religious language and its foundations, and offers a male perspective on the inclusive language debate in hymnology (i.e., altering gender-specific religious metaphors and alternating male and female signification in hymns). Texts of his inclusive language hymns are presented within the framework of issues being discussed.

# Part B. The Construction of Gender in Western Art Music

1388. Abbate, Carolyn. "Opera; or, the Envoicing of Women." In *Musicology and Difference: Gender and Sexuality in Music Scholarship*, ed. Ruth Solie, pp. 225–258. Berkeley, CA: University of California Press, 1993.

   Drawing upon poststructuralist theory (e.g. Roland Barthes) which challenges the concept of one authorial voice (e.g. the male composer), Abbate recognizes the authorial role of the performer, and particularly the female singer, in her reading of opera. Abbate discusses how the operatic female voice, in the role of the (male) authorial subject, hence masquerades or inverts gender conventions, and thus our perceptions of subject and object. She analyzes Patrick Conrad's film *Mascara* and Richard Strauss' opera *Salome* from this perspective.

1389. Arblaster, Anthony. "Women in Opera." *Viva la Libertà: Politics in Opera*, pp. 225–243. London: Verso, 1992.

   Beginning with an assessment of the views espoused by Catherine Clément in *Opera, or, the Undoing of Women*, the author considers the portrayal women in opera as victims of male desire, control, and violence. While the fatal demise of independent female characters in opera is overwhelmingly evident, the author posits that these tragic operas, though created by men, speak "more eloquently for women, for their qualities and

achievements, and against their humiliations and sufferings, than we might expect" (p. 243). In this light the author analyzes the following operas: Verdi's *La Traviata*, Bizet's *Carmen*, Tchaikovsky's *Eugene Onegin*, Janáček's *Katya Kabanova*, and Berg's *Lulu*.

1390. Atlas, Raphael. "Text and Musical Gesture in Brahms's Vocal Duets and Quartets with Piano." *Journal of Musicology* 10, no. 2 (Spring 1992): 231–260.

The author analyzes five vocal chamber works by Brahms (*Walpurgisnacht, Neckereien, Die Schwestern, Klange I* and *Zigeunerlied*) to illustrate relationships between text and musical gesture. Brahms' musical gestures often tell a different story than that being related textually. For example, *Neckereien* relates a story of a woman's resistance to a male suitor, using the metaphor of the hunt. While the text relates a story of rejection of the male suitor by the female, musical gesture relates a story of male dominance and female acquiescence. The author demonstrates through musical analysis that for Brahms' women, "no" means "yes," reflecting the attitudes of the day with respect to male and female gender roles within society.

1391. Bannour, Wanda. "Vierges et sorcières: Les héroïnes d'opéra de Tchaïkowsky." In *Littérature et Opéra. Colloque de Cerisy 1985*, ed. Philippe Berthier and Kurt Ringger, pp. 129–141. Grenoble, France: Presses Universitaires de Grenoble, 1987.

ISBN 2706102772. In French. Translated title: "Virgins and Sorceresses: Heroines of Tchaikovsky's Opera." The author links the significant events of Tchaikovsky's life to the composer's choice of opera libretti and his portrayal of female operatic characters. Particular attention is given to the composer's epistolary relationship with his long-time patroness and distant admirer, the Baroness Nadezhda von Meck, as well as to his unsuccessful marriage, and his homosexual identity.

1392. Bauer, Jeffrey Peter. *Women and the Changing Concept of Salvation in the Operas of Richard Wagner*. Diss. Ph.D., Pennsylvania State University, 1992.

Abstract in *Dissertation Abstracts International: A. Humanities and Social Sciences* 53, no. 8 (February 1993): 2832. DA# 9236786.

1393. Bolen, Jean Shinoda. *Ring of Power: The Abandoned Child, the Authoritarian Father and the Disempowered Feminine: A Jungian Understanding of Wagner's Ring Cycle*. San Francisco, CA: Harper San Francisco, 1992.

Cultural myth in Wagner's *Ring* is studied from sociological and psychological perspectives. Bolen recounts the plot of the *Ring* as a quintessential story of patriarchal authority and the dysfunctional family, using the theories of Carl Gustav Jung to explore the psychology of power,

gender, and sexuality through the archetypical male and female characters of the *Ring*.

1394. Borchmeyer, Dieter. "Mozarts rasende Weiber." *Mozarts Opernfiguren: Grosse Herren, rasende Weiber— gefährliche Liebschaften*, ed. Dieter Borchmeyer, pp. 167–212. Facetten deutscher Literatur, no. 3. Bern, Switzerland: Verlag Paul Haupt, 1992.

ISBN 3258045739. In German. Translated title: "Mozart's Raving Women." A survey of the portrayal of women in Mozart operas and the history of the relationship between women and hysteria as represented in seventeenth and eighteenth-century theater.

1395. Brett, Philip. "Britten's Dream." In *Musicology and Difference: Gender and Sexuality in Music Scholarship*, ed. Ruth Solie, pp. 259–280. Berkeley, CA: University of California Press, 1993.

This study of the operatic works of Benjamin Britten reveals themes which echo the alienation experienced by the composer in his life as a homosexual. Particular attention is given to his view of gender in society as reflected in *A Midsummer Night's Dream*.

1396. Caswell, Austin B. "Maeterlinck's and Dukas' *Ariane et Barbe-Bleue*. A Feminist Opera?" *Studies in Romanticism* 27, no. 2 (Summer 1988): 203–220.

Based on Maurice Maeterlinck's drama, set to music by Paul Dukas, and conceived of during the wave of turn-of-the-century feminism, the opera *Ariane et Barbe-Bleue* exhibits a feminist discourse, though this was not necessarily the intention of its creators. Caswell queries, "What is the definition of artistic feminism? Does it depend on authorial intention?. . .Does it depend on the artist's gender? Can it include works which. . .are feminist only by accident, or are feminist despite the stated intentions of the artist, or are judged so by the evaluation of subsequent generations of readers?" (p. 1). *Ariane et Barbe-Bleue*, the author argues, is feminist by dint of the latter perspective, as Maeterlinck was aiming to parody feminism in this drama, and Dukas intended to portray Ariane's humanitarianism rather than her female zeal. The unconsciously-constructed feminist overtones of the opera are revealed by recognizing the significance of Maeterlinck's relationship with Georgette Leblanc, an actress, singer, and feminist, as well as through a detailed examination of text, music, letters of Maeterlinck and Dukas, and period music criticism.

1397. Clément, Catherine. *Die Frau in der Oper: besiegt, verraten und verkauft.* Trans. Annette Holoch. Stuttgart: J. B. Metzlersche Verlagsbuchhandlung, 1992.

ISBN 3476007855. With foreword by Silke Leopold. In German. Originally published in 1979 by Editions Grasset et Fasquelle as *L'opéra, ou, La défaite des femmes*.

1398. Clément, Catherine. "Mademoiselle Le Bouc." *Avant-Scène Opéra* 96 (March 1987): 86–89.

In French. Women protagonists and the musical and dramatic portrayals of hysteria in nineteenth-century opera.

1399. Clément, Catherine. *Opera, or, the Undoing of Women.* Trans. Betsy Wing and fwd. Susan McClary. Minneapolis, MN: University of Minnesota Press, 1988.

Originally published in 1979 by Editions Grasset et Fasquelle as *L'opéra, ou, La défaite des femmes.* Reviewed in *Opera Quarterly* 7, no. 2 (Summer 1990): 137–139; *Cambridge Opera Journal* 2, no. 1 (March 1990): 93–98; *19th Century Music* 14, no. 1 (Summer 1990): 75, 80–81; *Gender and Society* 4, no. 4 (December 1990): 561–562. "In opera, the forgetting of words, the forgetting of women, have the same deep roots" (p. 22). In this pioneering work of feminist music criticism, Clément places an emphasis on analyzing opera texts and their underlying psychological meanings, challenging conventional music criticism's tendency to focus primarily on musical aspects of opera. As the author demonstrates, the beautiful, and often resisting music written for female characters of opera belies the suffering, madness, and death offered to the same by the libretto and by musical convention. The author identifies these female operatic victims of parental and social tyranny, male seduction and betrayal, and patriarchal control. She then presents a succession of opera synopses, interpreted here from a feminist perspective. The operas discussed include: *La Bohème, Carmen, Don Giovanni, Eugene Onegin, Falstaff, Lucia di Lammermoor, Madama Butterfly, Die Meistersinger, Norma, Otello, Pelléas et Mélisande,* the *Ring* cycle, *Der Rosenkavalier, La Traviata, Tristan und Isolde, Turandot,* and *Die Zauberflöte.* In addition, Clément scrutinizes the cult of the prima donna, constructed and reproduced by the (male) opera establishment and its audience, and destructive in its real-life effects on professional women singers, most notably Maria Callas and Maria Malibran.

1400. Debly, Patricia. "Social Commentary in the Music of Haydn's Goldoni Operas." In *Metaphor: A Musical Dimension,* ed. Jamie C. Kassler, pp. 51–68. Australian Studies in the History, Philosophy and Social Studies of Music, no. 1. Sydney, Australia: Currency Press, 1991.

The author analyzes the music of Joseph Haydn's operas *Lo speziale, Le pescatrici* and *Il mondo della luna* in light of the satire and social commentary included in the texts, written by librettist Carlo Goldoni. The author focuses on the relationships between the sexes in these operas, and how Haydn's use of musical metaphor serve to dramatize the texts of the male and female characters.

1401. Delacoma, Wynne. "Opera Ain't Over Till Sexism Sings—Women Take 'Double' Beating." *Chicago Sun Times* 12 March 1989, in *Newsbank: Review of the Arts, Performing Arts* 16, Fiche 64 (April 1989): C4–C5.

1402. Diener, Betty Sue. *Irony in Mozart's Operas*. Diss. Ph.D., Columbia University, 1992.

Abstract in *Dissertation Abstracts International: A. Humanities and Social Sciences* 54, no. 1 (July 1993): 19. DA# 9313583. Mozart's use of musical, literary, and dramatic irony in his operatic works provides insights into the composer's outlook with regard to gender roles, and particularly the role of women, in eighteenth-century society.

1403. Donington, Robert. *Opera and Its Symbols: The Unity of Words, Music, and Staging*. New Haven, CT: Yale University Press, 1990.

An exploration into archetypes of femininity, masculinity, and the maternal as contructed in various operas. See index for references to particular operas, as well as to: "Eternal feminine/masculine" and "Femininity" (p. 241) ; "Mother-image" (pp. 243–244), etc.

1404. Eastman, Holly. "The Drama of Passions: Tate and Purcell's Characterization of Dido." *Musical Quarterly* 73, no. 3 (1989): 364–381.

1405. Emslie, Barry. "Woman as Image and Narrative in Wagner's *Parsifal*: A Case Study." *Cambridge Opera Journal* 3, no. 2 (July 1991): 109–124.

Freudian theory and Christian ideology frame this discussion of the contradictory religious and sexual representations of Woman in the opera *Parsifal*, personified through the character of Kundry.

1406. Fehn, Ann Clark, and Jürgen Thym. "Who is Speaking? Edward T. Cone's Concept of Persona and Wolfgang von Schweinitz's Settings of Poems by Sarah Kirsch." *Journal of Musicological Research* 11, no. 1–2 (1991): 1–31.

Cone's concept of persona (see his *Composer's Voice*. Berkeley, CA: University of California Press, 1974) should be looked at critically when the gender of the poet is female and the music is composed by a male. In Schweinitz's song cycle *Papiersterne* (1981), based on poems from Sarah Kirsch's highly autobiographical *Drachensteigen* (1979), the strong female voice of the poet resists domination by the composer's voice, creating a duality that allows for multiple readings of the songs.

1407. Ford, Charles. *Così? Enlightened Sexuality, Logic and Music*. Diss. Ph.D., University of Sussex, 1989.

1408. Ford, Charles. *Così? Sexual Politics in Mozart's Operas*. Music and Society. Manchester, England: Manchester University Press, 1991.

Preface by Peter Martin. Distributed in the U.S. and Canada by St. Martin's Press. Reviewed in *Music and Letters* 73, no. 4 (November 1992): 591–593; *Popular Music* 11, no. 3 (October 1992): 373–376. Focusing on what could be considered icons of western European culture, namely *Così fan tutte* and other Mozart operas, the author's detailed analysis of the construction of gender within the music of the operas of Mozart is placed within the overall context of an

understanding of the complexity of the reason/masculine vs. nature/feminine conflict in Enlightenment thought. By concentrating on the music of a composer who left little to chance, the author demonstrates that evidence of the musical reproduction of Enlightment attitudes concerning the relationship between the sexes should cause us to reassess the notion that the absolute music of the classical era transcends contemporaneous social and cultural influences.

1409. Furman, Nelly. "The Languages of Love in *Carmen*." In *Reading Opera*, ed. Arthur Groos and Roger Parker, pp. 168–183. Princeton, NJ: Princeton University Press, 1988.

1410. Ganz, Arthur. "Transformations of the Child Temptress: Mélisande, Salomé, Lulu." *Opera Quarterly* 5, no. 4 (Winter 1987/ 1988): 12–20.
    The author explores the theme of familial eroticism as manifested in the following operas: Pélléas et Mélisande (music by Claude Debussy / play by Maurice Maeterlinck), Salomé (music by Richard Strauss / play by Oscar Wilde), and Lulu (music by Alban Berg / plays by Frank Wedekind).

1411. Hauel, Sylvie. "L'Opéra romantique et ses femmes." *L'Avant-scène opéra* 108 (April 1988): 86–89.
    In French. The musical and dramatic representation of women in romantic opera, with particular reference to Donizetti's *Don Pasquale*.

1412. Hill, Cecil. "*Theodora* and the 18th Century Feminist Movement." In *Alte Musik als ästhetische Gegenwart: Bach, Händel, Schütz; Bericht über den internationalen musikwissenschaftlichen Kongress, Stuttgart 1985, Band 2*, ed. Dietrich Berke and Dorothee Hanemann, pp. 49–54. Kassel, Germany: Bärenreiter, 1987.
    ISBN 3761807678. In English. The unsuccessful reception of Handel's *Theodora* is examined in light of issues raised by the feminist movement of the eighteenth century. As the author states, the chaste heroicism of Theodora which ultimately leads to her death was a scenario that neither the traditional nor the more liberated women of Handel's audience found satisfactory.

1413. Howard, Patricia. "The Influence of the Précieuses on Content and Structure in Quinault's and Lully's Tragédies Lyriques." *Acta Musicologica* 63, no. 1 (January-April 1991): 57–72.
    The preeminence of women's roles in the French theatre of the middle and late seventeeth century is viewed by the author as a direct response to the "feminist" themes inherent in the précieux movement in salon culture beginning circa 1650. As the author explains, the précieuses were advocates of female celibacy, deferred marriage, physical and emotional independence for women, and courtly love. The characters developed by the poet/dramatist Philippe Quinault, under précieux patronage, reflected many of the values of the précieuses. However, in studying the librettos written by Quinault for the tragédies lyriques of Jean-Baptiste Lully, the author demonstrates how his

female characters aspire to celibacy, but ultimately struggle in vain to over-
come their sexual passion and biological destiny. Howard also analyzes the
musical constructions used by Lully to support the content and textual struc-
ture of Quinault's verse. The combined message of music and text thus sub-
verts the précieux views which were prevalent during that time period.

1414. Howard, Patricia. "Quinault, Lully, and the *Précieuses*: Images of Women in
Seventeenth-Century France." In *Cecilia Reclaimed: Feminist Perspectives
on Gender and Music*, ed. and intro. Susan C. Cook and Judy S. Tsou, pp.
70–89. Urbana, IL: University of Illinois Press, 1994 (forthcoming).

1415. Hudson, Elizabeth. "Gilda Seduced: A Tale Untold." *Cambridge Opera
Journal* 4, no. 3 (November 1992): 229–251.
   The author first examines the influence of the potential censor on the tex-
tual, dramatic, and musical treatment of the veiled story of Gilda's seduction in
Verdi's *Rigoletto*, as compared to the less-obscured narrative found in Hugo's
dramatic original. Hudson focuses particularly on the "displacement of narra-
tive content in Gilda's tale," by examining the detailed manner in which
Gilda's abduction is represented. Verdi's musical portrayal of Gilda is indica-
tive of patriarchal notions of male domination and power over the dependent,
passive, and unrealized female. The manner in which Verdi musically trans-
forms Gilda in her aria/confession "Tutte le feste" (Act II) is revealed as a
musical expression of events not fully articulated in the text (i.e., her sexual
experience). Hudson likewise examines the manner in which Verdi expresses,
in musical terms, the insincere intentions of the Duke towards Gilda.

1416. Kaiser, Antje. "Leben oder Sterben 'Hand in Hand': Musikalische
Frauencharaktere in Friedrich Schenkers 'Bettina'." *Musik und Gesellschaft*
38, no. 3 (March 1988): 135–137.
   In German. Translated title: "Life or Death 'Hand in Hand': The
Musical Characterization of Women in Friedrich Schenker's [opera] *Bettina*
[1984]." Part of a special issue devoted to women and music.

1417. Kennicott, Philip. "Song of the Wild: Leonie Rysanek Shares Her
Insights into the Characters of the Three Women of the House of
Atreus." *Opera News* (11 April 1992): 34–36, 60.
   Leonie Rysanek, the first singer to play all three female roles of
Richard Strauss' *Elektra* during her career, discusses these operatic roles.

1418. Kestner, Joseph. "Born of Obsession: Both Wilde's Play and Strauss' Opera
[*Salome*] Spring From a Nineteenth-Century Fixation on the Femme Fatale."
*Opera News* 53 (4 March 1989): 24–26, 44.

1419. Kestner, Joseph. "The Dark Side of Chivalry: The Neo-Medieval
Repudiation of Women, and Exaltation of Men, Are Reflected in *Parsifal*."
*Opera News* 55 (30 March 1991): 18–21, 44.

1420. Kestner, Joseph. "The Feared Woman." *Opera News* 51 (11 April 1987): 34–37, 50.

Samson *et Dalila* and the theme of the "femme fatale" in literature, music, and art.

1421. Khittl, Christoph. *'Nervencontrapunkt': Einflüsse pyschologischer Theorien auf Kompositorisches Gestalten.* Vienna, Austria: Böhlau Verlag, 1991.

ISBN 3205054172. In German. Translated title; *'Neural Counterpoint': The Influence of Psychological Theory on the Form and Structure of Composition.* The author applies eighteenth-century psychological theory to the actions of the characters in Mozart's *Cosi fan tutte*. He then examines nineteenth-century theory on the female psyche as it relates to Wagner's representation of women his operas, followed by a study of hysteria circa 1900 as it relates to Richard Strauss' *Elektra*.

1422. Kramer, Lawrence. "*Carnaval*, Cross-Dressing, and the Woman in the Mirror." In *Musicology and Difference: Gender and Sexuality in Music Scholarship*, ed. Ruth Solie, pp. 305–325. Berkeley, CA: University of California Press, 1993.

Kramer's analysis of Robert Schumann's *Carnaval*, a cycle of piano pieces analogous to the carnival and its festive atmosphere, reveals Schumann's musically-encoded meanings which challenge nineteenth-century sociocultural conventions: the self freed from social restraint; gender play and masquerade; and acknowledgement of female identity.

1423. Kramer, Lawrence. "Liszt, Goethe, and the Discourse of Gender." In *Music as Cultural Practice, 1800–1900*, pp. 102–134. California Studies in 19th Century Music, no. 8. Berkeley, CA: University of California Press, 1990.

The author analyzes the musical construction of the masculine and feminine in Liszt's *Faust Symphony*, and relates the dynamics of gender manifested in the work to female representation in general in nineteenth-century patriarchal culture.

1424. Kramer, Lawrence. "Musical Form and Fin-de-Siècle Sexuality." In *Music as Cultural Practice, 1800–1900*, pp. 135–175. California Studies in 19th Century Music 8. Berkeley, CA: University of California Press, 1990.

Viewed in relation to late nineteenth-century thought and discourse on sexuality, and with particular reference to Sigmund Freud's *Three Essays on the Theory of Sexuality*, the author examines nineteenth-century cultural representations of male and female libidinal desire in literature (Kate Chopin), art (Gustav Klimt), and music, concentrating on Richard Wagner's *Tristan und Isolde* and Hugo Wolf's lied, *Ganymede*.

1425. Lehmann, Lotte. "Lotte Lehman on *Der Rosenkavalier*: Perspectives From Her Spoken and Painted Interpretations." *Opera Quarterly* 8, no. 2 (Summer 1991): 47–57.

The roles of the Marschallin, Octavian, and Sophie from Richard Strauss' *Der Rosenkavalier* are discussed by Lotte Lehman, the first singer to perform all three of the opera's principal soprano roles during her career.

1426. Littlejohn, David. "*Norma*: The Case for Bel Canto." In *The Ultimate Art: Essays Around and About Opera*, pp. 156–171. Berkeley, CA: University of California Press, 1992.

Vincenzo Bellini's *Norma* is examined here, with a particular emphasis on the title role, which according to the author, embodies "all that the soprano voice is capable of expressing of the supreme independent difference of the gender it represents" (p. 171). The technical and dramatic challenges of the role are examined, as are several of the sopranos who have successfully performed the role: Giuditta Pasta, Lillie Lehman, Maria Malibran, Maria Callas, etc. Various critical interpretations of the relationship between Norma and Adalgisa are presented. Although Norma is slighted by her lover Pollione for the younger woman Adalgisa, the two women are viewed by the author as "sisters," not rivals, as evidenced by their two duets which feature passages sung in unison.

1427. Locke, Ralph P. "Constructing the Oriental 'Other': Saint-Saëns's *Samson et Dalila*." *Cambridge Opera Journal* 3, no. 3 (November 1991): 261–302.

The author examines Orientalism as manifested in western culture, and especially within the opera *Samson and Dalila* by Saint-Saëns. He then concentrates on the dual portrayal of Dalila as femme fatale and the female symbol of the threatening Oriental 'Other.'

1428. Locke, Ralph P. "What Are These Women Doing in Opera?" *Opera News* 57 (July 1992): 35–36.

Part of a special issue on women in opera. Drawing heavily on the work of Catherine Clément (*Opera, or, The Undoing of Women*), the author examines the degree to which women's operatic roles reflect and reinforce traditional gender roles and male domination of women.

1429. McClary, Susan. "The Blasphemy of Talking Politics During Bach Year." In *Music and Society: The Politics of Composition, Performance and Reception*, ed. Richard Leppert and Susan McClary, pp. 13–62. Cambridge, England: Cambridge University Press, 1987.

The construction of gender and the occurence of masculine and feminine musical imagery is examined (pp. 52–55) in the author's musical analysis of Johann Sebastian Bach's *Wachet auf, ruft uns die Stimme* (Cantata 140).

1430. McClary, Susan. *Georges Bizet: Carmen*. Cambridge Opera Handbooks. Cambridge, England: Cambridge University Press, 1992.

Reviewed in *Opera* 43, no. 12 (December 1992): 1401–1404. Chapter 3 is devoted to "Images of Race, Class and Gender in Nineteenth-Century French Culture." Chapter 4 considers the exotic musical language used by Bizet to represent the sexuality of Carmen and the theme of the femme

fatale. Chapter 6 centers on the opera's reception as the author describes how Bizet's infusion of realism (e.g., race, class, sexuality, and gender roles) created tension in the traditional music world.

1431. McClary, Susan. "Narrative Agendas in 'Absolute' Music: Identity and Difference in Brahm's Third Symphony." In *Musicology and Difference: Gender and Sexuality in Music Scholarship*, ed. Ruth Solie, pp. 326–344. Berkeley, CA: University of California Press, 1993.

   The author introduces the subject of narrativity in absolute music with a survey of music criticism written from this perspective, and examines the rhetoric of gender in selected writings about music. She then undertakes a detailed musical analysis of Brahms' *Third Symphony*, revealing, through his use of tonality, the discourse of gender in the work.

1432. McClary, Susan. "Structures of Identity and Difference in *Carmen*." *Women: A Cultural Review* 3, no. 1 (Summer 1992): 1–15.

   Part of a special issue on women and music. McClary compares the literary and operatic versions of *Carmen*, with particular reference to Woman as symbolic of the racial, sexual, societal, and cultural "Other" which threatens the identity of the central male character, and to Bizet's musical structures and devices which enhance the narrative and drama of the libretto.

1433. McGeary, Thomas. "'Warbling Eunuchs': Opera, Gender and Sexuality on the London Stage, 1705–1742." *Restoration and 18th Century Theatre Research. Second Series* 7, no. 1 (Summer 1992): 1–22.

   Focusing on the performance of Italian opera (and castrati in female operatic roles) in early eighteenth-century London, the author examines British literary criticism of that time period so as to analyze the prevailing attitudes with regard to gender associations with opera as music/theater.

1434. Melinand, Michele. "Solitude." *Musical* 3 (May 1987): 118–123.

   In French. Women in the operatic works of Jean-Baptiste Lully and André Campra.

1435. Meyer, Andreas. "Eheliche Liebe oder Gattentreue: eine anthropologisch-literarische Invektive über ein nach Ansicht der Herren Gaveaux, Paër und Beethoven musikträchtiges Sujet [Leonore]." *Neue Zeitschrift für Musik* 148, no. 12 (December 1987): 14–19.

   In German. Translated title: "Conjugal Love or Marital Fidelity: An Anthropological/Literary Invektive on the Representation of this Musical Subject in Works of Gaveaux, Paër and Beethoven." The author examines the role of Leonore as represented in the operatic works of Pierre Gaveaux, Ferdinando Paër, and Ludwig van Beethoven.

1436. Neef, Sigrid. "Alles was ist, ist um seiner selbst willen da: zum Bild der Frau in Dessaus Opern." *Musik und Gesellschaft* 39 (June 1989): 291–296.

In German. On the image of women in the operatic works of the twentieth-century German composer, Paul Dessau.

1437. O'Grady, Deidre. *The Last Troubadours: Poetic Drama in Italian Opera 1597–1887*. London: Routledge, 1991.

 The author examines the dramatic role of female protagonists in Italian opera in discussions on: nuns and priestesses as characters in Romantic Italian opera (pp. 103–118); mad scenes of female protagonists in the operas of Bellini and Donizetti (pp. 128–151); the gypsy in Romantic Italian opera (159–165); the role of courtesan; and criticism of the mores of Italian society within the plots of Romantic Italian opera (pp. 166–179).

1438. Pels, Dick, and Aya Crebas. "Carmen, or, The Invention of a New Feminine Myth." *Theory, Culture and Society* 5, no. 4 (November 1988): 579–610.

 The themes of female annihilation, morality, and class difference are to be found in nineteenth-century operatic works, such as Puccini's *La Boheme*, Verdi's *La Traviata*, and Bizet's *Carmen*. The sexual and social independence of Carmen, however, allows for multiple audience identifications, which has led to a revivial of interest in this dramatic work.

1439. Pipes, Charlotte Fakier. *A Study of Six Selected Coloratura Soprano "Mad Scenes" in Nineteenth-Century Opera*. Diss. D.M.A., Louisiana State University and Agricultural and Mechanical College, 1990.

 Abstract in *Dissertation Abstracts International: A. Humanities and Social Sciences* 52, no. 4 (October 1991): 1126. DA# 9123230. The author examines the development of the mad scene in opera and analyzes six examples with respect to the interactions between text, plot, and music: 1) "Al dolce guidami" (*Anna Bolena* by Gaetano Donizetti); 2) "Ah! Non credea mirarti" (*La Sonnambula* by Vincenzo Bellini); 3) "Qui la voce" (*I Puritani* by Vincenzo Bellini); 4) "Argon gl'incensi" (*Lucia di Lammermoor* by Gaetano Donizetti); 5) "Ombra leggiera" (*Dinorah* by Giacomo Meyerbeer); 6) "Ah vos yeux, mes amis" (*Hamlet* by Ambroise Thomas).

1440. Poizat, Michel. *The Angel's Cry: Beyond the Pleasure Principle in Opera*. Trans. Arthur Denner. Ithaca, NY: Cornell University Press, 1992.

 Originally published in France as *L'Opéra, ou Le Cri de l'ange: Essai sur la jouissance de l'amateur d'opéra* (Paris: Éditions A.M. Métaillé, 1986). Reviewed in *Cambridge Opera Journal* 3, no. 3 (November 1991): 303–306. *Opera* 43, no. 12 (December 1991): 1446. The voice in opera, analyzed using the psychoanalytic theory of Jacques Lacan, is the subject of this book. The history of operatic composition is viewed as an ongoing conflict between the importance of singing versus that of the text. According to Poizat, this tension between vocal sound and language is one in which the former has reigned supreme over the latter, as evidenced by the evolution of higher vocal ranges, female vocal supremacy, the display of vocal agility, and the twentieth century disintegration of musicality into primal sound. In

the portion of the book entitled "Angel, Woman and God," the author delves into a variety of gender-related topics in opera: the voice of the castrato; "travesti," or trouser roles; the diva; and angelic or divine vocal symbolism. He moves on to a general discussion of the musical construction of masculine and feminine in opera, and the essentialization of male/female relations in opera libretti. Discussions of particular operas include Richard Wagner's *Tristan und Isolde* and *Parsifal*, and Alban Berg's *Lulu*. Excerpts of the book appear in *Cambridge Opera Journal* 3, no. 3 (November 1991): 195–211 ("The Blue Note" and "The Objectified Voice and the Vocal Object").

1441. Reeder, Ray. "The End." *MadAminA!* 11, no. 2 (Fall 1990): 20–21. A discussion of dramatic conclusions leading to the fatal demise of female characters in opera.

1442. Reinhold, Daniela, and Werner Hintze. "Kundry oder Die Suche nach dem Ich: Ein Frauenschicksal als Gesellschaftsbild in Wagner's *Parsifal*." *Musik und Gesellschaft* 38, no. 3 (March 1988): 124–129.
    In German. Translated title: "Kundry, or, The Search for the Self: A Woman's Destiny as Determined By Her Role in Society in Wagner's *Parsifal*." Part of a special issue devoted to women and music.

1443. Rosenberg, Wolf. "Ist *Così fan tutte* eine frauenfeindliche Oper?" *Dissonance*, no. 27 (February 1991): 13–19.
    In German. Translated title: "Is *Così fan tutte* [Mozart] an Opera Which is Inimical to Women?"

1444. Rosenn, Eva. *Feminine Discourse in Medieval Provencal, Old French and Galician-Portuguese Lyrics*. Diss. Ph.D., Columbia University, 1992.
    Abstract in *Dissertation Abstracts International: A. Humanities and Social Sciences* 53, no. 6 (December 1992): 1904. DA# 9232078. The author reveals various strategies at work in the use of the feminine voice by male and female composers of troubador lyrics; the lyrics of Marie de France receive particular attention.

1445. Santucci, Pellegrino. "La Madonna e la Musica (I)." *Rivista Internationale di Musica Sacra/International Church Music Review* 10, no. 3–4 (July–December 1989): 339–366.
    In Italian. Translated title: "The Madonna in Music (Part 1)."

1446. Santucci, Pellegrino. "La Madonna e la Musica (II)." *Rivista Internationale di Musica Sacra/International Church Music Review* 11, no. 1 (January–March 1990): 59–84.
    In Italian. Translated title: "The Madonna in Music (Part 2)."

1447. Santucci, Pellegrino. "La Madonna e la Musica (III)." *Rivista Internationale di Musica Sacra/International Church Music Review* 11, no. 3 (July–September 1990): 265–286.
    In Italian. Translated title: "The Madonna in Music (Part 3)."

1448. Schreiber, Ulrich. "Von der Retterin zur femme fatale: Zum Frauenbild in der Oper des 19. Jahrhunderts." In *Jahrbuch der Bayerischen Staatsoper 1992/1993*, pp. 72–85. Munich, Germany: Gesellschaft zur Förderung der Münchner Opern-Festspiele ; Bruckmann, 1992.

　　ISBN 3765424919. In German. Translated title: "From Savior to Femme Fatale: On the Image of Women in Nineteenth-Century Opera." The author considers this stereotypical dual image of women in opera from the late eighteenth century through the turn of the twentieth century as a reflection of the reality of patriarchal attitudes towards women in society.

1449. Simon, John. "Daughter of Death." *Opera News* 56 (11 April 1992): 14–18.

　　The author studies the "pathological" Elektra character of Richard Strauss, as viewed by various opera critics. A comparison of the Elektra character in opera and in Greek and European theatre is presented.

1450. Smart, Mary Ann. "The Silencing of Lucia." *Cambridge Opera Journal* 4, no. 2 (July 1992): 119–141.

　　The representation of female madness in Donizetti's opera *Lucia di Lammermoor* is the subject of this article. The author focuses on the musical resistance of the feminine voice of Lucia (heard through highly embellished passages of coloratura and resistance to operatic form). This musical resistance is juxtaposed against the boundaries of plot, and of visual/theatrical representations of madness which symbolize patriarchal forces which aim to dominate, and finally, silence Lucia. The use of orchestral musical quotation in the mad scene, while evoking a confused musical discourse, reinforces the reality of past events which have driven the character to madness, thus acting as another dominating force. The author utilizes recent theories espoused by Michel Foucault (*Madness and Civilization*), Susan McClary (*Feminine Endings*), and Catherine Clément (*Opera, or, the Undoing of Women*). Includes musical examples and illustrations.

1451. Solie, Ruth A. "Whose Life? The Gendered Self in Schumann's *Frauenliebe* Songs." In *Music and Text: Critical Inquiries*, ed. Steven Paul Scher, pp. 219–240. Cambridge, England: Cambridge University Press, 1992.

　　Robert Schumann's *Frauenliebe und –leben* song cycle, with texts by Adelbert von Chamisso, is viewed as a cultural manifestation of the patriarchal view of women within nineteenth-century society. The song cycle is analyzed from two basic perspectives: 1) as a cultural representation of a male ideology seeking to reinforce traditional images of women, marriage, and domesticity, and 2) as a musical work which asserts its male authority through its impersonation of a female voice, using a falsely feminized male voice.

1452. Treitler, Leo. "The Lulu Character and the Character of *Lulu*." In *Music and the Historical Imagination*, pp. 264–305. Cambridge, MA: Harvard University Press, 1989.

The author examines the Lulu chararacter as musically and dramatical-
ly portrayed in Berg's opera. As one of several cultural works of the time
period which represent Woman as sexual temptress, Berg's *Lulu* also delves
into the self-destructive potential of male passion.

1453. Vargas, Ignacio. "La voz femenina en las óperas de Verdi." *Monsalvat* 183
(June 1990): 19–21.
The feminine voice in the operas of Verdi.

1454. Willier, Stephen Ace. *Early Nineteenth-Century Opera and the Impact of the
Gothic.* Diss. Ph.D., University of Illinois at Urbana–Champaign, 1987.
Abstract in *Dissertation Abstracts International: A. Humanities and
Social Sciences* 49, no. 1 (July 1988): 11. DA# 8803237. The author
explores the nineteenth-century operatic preoccupation with madness, and its
precursors in the themes of "terror, confinement, paranoia, repression, [and]
sexual sadism" (p. 3) which occur in late eighteenth-century gothic literature,
and the extreme historical and social changes from which both these forms,
the operatic mad scene and gothic literature, emanated. As the author notes,
"the repressed female of sensibility is at the heart of an overwhelming num-
ber of gothic plots, the gothic being concerned with freedom of all kinds" (p.
4). The dissertation first identifies and discusses French, German, and Italian
operatic works of the late eighteenth and nineteenth centuries which are
based on particular works of gothic fiction as well as those which manifest
gothic features, (e.g., works of Rossini, Donizetti, Bellini, Verdi, and others).
The final third of the dissertation is devoted to surveying the numerous and
varied representations of men's and women's madness in the works of
Donizetti, Bellini, Verdi, Halévy, and others. Helpful appendices classify the
conventions and motifs of madness and the gothic in opera via two lists: "A
Selective and Chronological Catalogue of Operas Displaying Gothic
Features, 1784–1859" and "Elements Associated with the Gothic Featured in
Opera from 1784–1859."

# Part C. The Construction of Gender
# in Popular Music Forms

1455. Beltrao Junior, Synval. "A Cultura Brasileira e a Mulher: Uma Leitura
Através da Música Popular." *Cahiers du Monde Hispanique et Luso-
Bresilien Caravelle* 57 (1991): 133–145.
In Portuguese. Attidudes towards women in Brazilian culture are
examined via the representation of women in Brazilian popular song texts of
the eighteenth century and onwards.

1456. Bradby, Barbara. "Do-Talk and Don't-Talk: The Division of the Subject in
Girl-Group Music." In *On Record: Rock, Pop, and the Written Word*, ed.

Simon Frith and Andrew Goodwin, pp. 341–368. New York: Pantheon, 1990.

Bradby first takes issue with the manner in which rock criticism both dismisses the contributions of girl groups to the history of rock music and characterizes music created for a female audience as sexually repressed. The author then undertakes a detailed linguistic analysis of the song texts of girl group songs "to reveal a structure of feminine discourse which offers positions for the female subject" (p. 343), and one which points to a duality between girl-talk and the maternal voice in these songs.

1457. Butruille, Susan G., and Anita Taylor. "Women in American Popular Song." In *Communication, Gender and Sex Roles in Diverse Interaction Contexts*, ed. Lea P. Stewart and Stella Ting-Toomey, pp. 179–188. Norwood, NY: Ablex, 1987.

The author examines the representation of women in traditional American folksong, and recent music by women singers in the folk idiom.

1458. Cook, Susan C. "'Cursed Was She': Gender and Power in American Balladry." In *Cecilia Reclaimed: Feminist Perspectives on Gender and Music*, ed. Susan C. Cook and Judy S. Tsou, pp. 202–224. Urbana, IL: University of Illinois Press, 1994 (forthcoming).

1459. Cooper, Virginia W. "Lyrical Sexism in Popular Music: A Quantitative Examination." In *America's Musical Pulse: Popular Music in Twentieth-Century Society*, pp. 229–236. Contributions to the Study of Popular Culture, no. 33. Westport, CT: Greenwood Press, 1992.

The author first explores the qualities of popular music which make it lyrically and musically accessible, and argues that when repeated and memorized over time, the attitudes and values expressed in popular song become a powerful socializing force. The lyrics of 1,164 popular songs about women, published in *Song Hits Magazine* during 1946, 1956, 1966 and 1976, are examined to evaluate the frequency and forms of female stereotypes in these songs. Eleven female stereotypes emerge, including woman as delicate, evil, supernatural, mother, child, sex-object, beauty object, and pedestal object. Lyrics express a fixation on the bodily attributes of women, depict the woman as dependent upon a man, or depict the woman as being possessed by a man. Although rock and roll is often viewed as an expression of rebellion against the norm, lyrics regarding sexual attitudes reveal the opposite, demonstrating the pervasiveness of these images which have been perpetuated over time. Thus, regardless of external societal changes, most popular music continues to both reflect and reproduce gender stereotypes.

1460. Dugaw, Dianne. *Warrior Women and Popular Balladry, 1650–1850*. Cambridge, England: Cambridge University Press, 1989.

Reviewed in *Folk Music Journal* 6, no. 1 (1990): 86–87; *Journal of Folklore Research* 29, no. 1 (1992): 73–81. This is a comprehensive study

of the female warrior ballad, its protagonists, song lyrics and variants, and the broader implications of the widespread popularity of this ballad type among male and female singers and listeners. Themes of female heroism, eroticism, and male and female gender role reversal in English popular culture are examined, as is the heroine's final destiny to return to the normality of her gender. Thus, the ballads have a dual role of both upsetting and reinforcing societal attitudes towards gender. Includes musical examples.

1461. Fraser, Barbara Means. "The Dream Shattered: America's Seventies Musicals." *Journal of American Culture* 12, no. 3 (Fall 1989): 31–37.
   The author examines the changing role of women in society as depicted through the protagonists and plots of musicals of the seventies.

1462. Frith, Simon, and Angela McRobbie. "Rock and Sexuality." In *On Record: Rock, Pop, and the Written Word*, ed. Simon Frith and Andrew Goodwin, pp. 371–389. New York: Pantheon, 1990.
   Published originally in *Screen Education* 29 (1978). The authors explore the manner in which rock expresses sexuality and represents masculine and feminine gender roles, as well as the relation of this representation to male control of the production and marketing aspects of the music business. They begin with a discussion of "Masculinity and Rock", demonstrating the various male images projected in cock rock and teenybop music. They explain, in "Music, Femininity, and Domestic Ideology," that music by women is produced, packaged, and marketed in a manner which domesticates and softens the message and delivery, with a few notable exceptions of women who maintain control over their art. They discuss the subordination of women in rock and the repression of female sexuality through songs which endorse male stereotypes of female behavior: romance, tenderness, fidelity, sacrifice. However, they note contradictions in the use of music by women, as women gravitate towards the ideology of rock as a rebellion from traditional modes of behavior. Contradictory also is the presentation of men as sex objects, the androgynous appearance donned by some rock stars and other manifestations of sexual ambiguity, and the role that the music itself plays in creating a meaning inherently different than that expressed in the lyrics. Finally, the authors discuss the role of rock as dance music, an important and socially acceptable expression of physicality and sexuality, for men and especially for women.

1463. Goldstein, Richard M. "'I Enjoy Being a Girl': Women in the Plays of Rodgers and Hammerstein." *Popular Music and Society* 13, no. 1 (Spring 1989): 1–8.

1464. Hampton, Dream. "Music: Niggaz, Please." *Village Voice* 36 (23 July 1991): 69.
   The misogyny expressed in rap music is counterproductive to rap's message of resistance to social, political, and racial oppression. The rap music of N.W.A. is scrutinized from this perspective.

1465. Haselwerdt, Maggie. "Let's Talk About Girls." *Rock and Roll Confidential* 63 (December 1988): 1–2.
How some rock music imitates patterns of female sexual response.

1466. Herrera-Sobek, María. *The Mexican Corrido: A Feminist Analysis.* Bloomington, IN: Indiana University Press, 1990.
Reviewed in *Choice* 28, no. 3 (November 1990): 493. Referring to the study edited by Estella Lauter and Carol Rupprec entitled *Feminist Archetypal Theory: Interdisciplinary Re-Visions of Jungian Thought* (Knoxville: University of Tennessee Press, 1985), the author analyzes the recurring images of women in Mexican corridos [ballads], and identifies a number of archetypes, four of which (good mother and terrible mother, mother-goddess, lover, and soldier) are discussed in this book.

1467. Herrera-Sobek, María. "*Mulas, Gallinas*, and *Sapos*: Women, Animal Metaphors, and Humor in Mexican/Chicano *Canciones* and *Corridos.*" In *Recent Ballad Research: Proceedings of the 19th International Folk Ballad Conference of the Kommission für Volksdichtung of the Société Internationale d'Ethnologie et de Folklore. Freiburg im Breisgau, Deutsches Volksliedarchiv, 1–6 May 1989*, ed. Tom Cheesman, vol. 1, pp. 19–33. Folklore Society Library Publications, no. 4. London: Folklore Society Library, 1990. Vol. 1.
The author examines the use of animals as metaphors for women in this particular type of male humorous folk song in Mexican/Chicano culture. She demonstrates how corridos, or ballads, with textual images which portray women as passive animals (e.g., chicks, hens, mules, cats, mice, etc.), allude not only to sexual practice, but to patriarchal and misogynist social attitudes which "parody, humiliate, abuse or chastise women." Applying Mikhail Bakhtin's theories on the role and function of folk humor as a cultural expression, she posits that this particularly degrading example of male derision of females is a manifestation of man's fear of the opposite gender.

1468. Huffman, James R., and Julie L. Huffman. "Sexism and Cultural Lag: The Rise of the Jailbait Song." *Journal of Popular Culture* 21, no.2 (Fall 1987): 65–83.

1469. Ikome, Nkangonda, and Amisi Bakari. "La condition de la femme à travers la musique zairoise moderne de 1964 à 1984." *Afrikanistische Arbeitspapiere* 20 (December 1989): 5–47.
In French. A content analysis of lyrics to modern popular songs from Zaire during the period from 1964 to 1984 reveals that negative and stereotypical images of women still continued to be projected through song texts, even though this period was one of societal change. Song texts are quoted to illustrate how these images and stereotypes were perpetuated through mass media entertainment.

1470. James, Barbara, and Renate Wagner. "'Schlaf, Kindchen schlaf, die Mutter. . .': Arbeit und Alltag im Wiegenlied." In *Frauenalltag—Frauenforschung: Beiträge zur 2.Tagung der Kommission Frauenforschung in der Deutschen Gesellschaft für Volkskunde, Freiburg, 22.–25. Mai 1986*, ed. Arbeitsgruppe Volkskundliche Frauenforschung Freiburg, pp. 325–331. Frankfurt am Main, Germany: Peter Lang, 1988.

    ISBN 3820499881. In German. Translated title: "'Sleep, my child, sleep, Mother....': Work and Daily Life in the Lullaby." An examination of how women's lives are reflected in the texts of children's songs and lullabies.

1471. Jorgens, Elise Bickford. "Politics and Women in Cavalier Song: A Report from a Collection of Secular Song Manuscripts." *Explorations in Renaissance Culture* 15 (1989): 25–48.

    English continuo songs written from 1630 to 1650 for courtly entertainments and social gatherings were reflective of the culture and society of the day. While songs in published collections are rather polite and uncontroversial in nature, the author demonstrates that songs which are to be found in manuscript collections provide a different picture, with texts reflecting the political upheaval of the time, uneasy attitudes towards courtship, love and sexuality, and general social malaise. Looking at cavalier songs in particular, the author analyzes the textual content of several songs from different manuscript collections, and discusses how history, politics, and negative attitudes towards women are juxtaposed within the songs, indicating the pervasiveness this malaise.

1472. Klotiņš, Arnolds, and Valdis Muktupāvels. "Traditional Musical Instruments and the Semantics of Their Functions in Latvian Folk Songs." In *Linguistics and Poetics of Latvian Folk Songs: Essays in Honour of the Sesquicentennial of the Birth of Kr. Barons*, ed. Vaira Vīķis-Freibergs, pp. 186–217. Kingston and Montreal: McGill–Queen's University Press, 1989.

    The author analyzes the texts of folk songs in the Boston/Montreal Data Base of Latvian Folk Songs for those which mention musical instruments, as well as the context in which a musical instrument is referred to in a song text. Musical instruments are used: in songs describing particular social functions ; in relation to the male or female playing the instrument; as feminine or masculine symbols.

1473. Lewis, George H. "Interpersonal Relations and Sex Role Conflict in Modern American Country Music." *International Review of the Aesthetics and Sociology of Music* 20, no. 2 (December 1989): 229–237.

1474. Loranger, Dennis. "Woman, Nature and Appearance: Themes in Popular Song Texts from the Turn of the Century." *American Music Research Center Journal* 2 (1992): 68–85.

The author examines the relationships between the representation of the cultural figure of the New Woman in popular song (1890–1910) and contemporaneous attitudes regarding societal and technological change. Song texts discuss conflicting values towards city vs. country, technology vs. nature, change vs. tradition, sophistication vs. simplicity, and appearance vs. the truth. Natural images are equated with the Ideal Woman, reinforcing traditional attitudes towards feminine beauty, spiritual honesty, and domestic bliss. Other songs discuss a more independent, sophisticated, urban woman (i.e the New Woman). This is often done by juxtaposing textual images of new technology (e.g., the automobile) with sexual innuendo, stylishness with promiscuity, theater with artificiality, and societal sophistication with tragedy.

1475. Lundy, Karen Saucier. "Women and Country Music." In *America's Musical Pulse: Popular Music in Twentieth-Century Society*, ed. Kenneth J. Bindas, pp. 213–219. Contributions to the Study of Popular Culture, no. 33. Westport, CT: Greenwood Press, 1992.

    The image of women in country music is examined in order to ascertain the degree to which recent changes in the roles of men and women in society are reflected in this conservative popular music genre. The lyrics of country songs through the 1980s reveal that, with a few exceptions, country music has changed very little. Rather, it has served to perpetuate gender role stereotypes for both men and women, while the real world has changed dramatically.

1476. Maik, Linda L. "Mothers in Ballads: Freud's Maternal Paradigm." *Southern Folklore* 46, no. 2 (1989): 117–132.

    The role of the mother in four Child ballads is examined from the perspective of Freudian theory. These ballads include: *The Wife of Usher's Well* (Child 79), *Lord Randall* (Child 12), *Edward* (Child 13), and *Bonny Barbara Allen* (Child 84). "All these ballads can be read as stories of children's achieving—or not achieving—sexual maturity, and the roles of all these mothers generally support Freud's interpretation of the maternal role in human development" (p. 118).

1477. Martín, Alicia. "Representacion de la mujer en dos fuentes del cancionero popular." *Revista de Investigaciones Folkloricas* 5 (December 1990): 36–46.

    In Spanish, with English summary (p. 4). Translated title: "The Image of Woman in Two Sources of Popular Song." An analysis of song lyrics from two sources of Argentian popular song reveals the manner in which women are represented within the masculine discourse of these song forms. The first source is comprised of songs collected in the late 1980s from street musicians (murgas) during Carnival time. Texts from a second set of songs from the national rock music movement are also analyzed, and the author then makes comparisons between the themes appearing in both sources.

1478. McAdams, Janine C. "Nothing Sexy About Sexist Lyrics [in rap and hip-hop]." *Billboard* 102 (13 October 1990): 25.

1479. McAdams, Janine C. "The Rap against Rap: Sexist Images Put Down Women on Road to Big Sales." *Billboard* 101 (17 June 1989): B14, B22, B26.

1480. Mendenhall, Christian. "American Musical Comedy as a Liminal Ritual of Woman as Homemaker." *Journal of American Culture* 13, no. 4 (Winter 1990): 57–69.

   Leading roles of women in the musical theater from 1943–1964 are studied. The image of women in post-World War II musicals sought to reinforce traditional, idealized images of women as wives and homemakers, to counteract the more independent role they had during the war as being (often) single women in the workforce. In musicals of this era, the author argues, the moulding of the woman into this traditional role is analogous to a rite of passage, which is celebrated once the transition has taken place.

1481. Mohammed, Patricia. "Reflections on the Women's Movement in Trinidad." *Feminist Review* 38 (Summer 1991): 33–47.

   The message of the female calypso is examined as a cultural expression of a changing Trinidad which has seen a growing feminist movement over the past twenty years, although there has also been a concurrent increase in violence and brutality, especially of the domestic variety. A textual analysis of the lyrics of female calypsos reveals themes of male brutality against women, rape, male dependence on women as wage earners, sexual harassment of women in the work force, changes in gender roles, and women's increasing assertiveness.

1482. Morris, Edward. "The Darker Meaning of Holly Dunn's Song: Is *Maybe I Mean Yes* Traitorous to Women?" *Billboard* 103 (3 August 1991): 33.

   Discusses the controversy surrounding this popular song because of lyrics that prescribe indirection, flirtation, and evasiveness as acceptable behavior for women.

1483. Neuenfeldt, Karl Wm. "Sun, Sea, Sex and Senoritas: 'Shorthand' Images of Ethnicity, Ethos, and Gender in Country Songs Set in the Circum-Caribbean." *Popular Music and Society* 15, no. 2 (Summer 1991): 1–22.

   This article investigates the negative image of non-Anglo women in country songs set in "south of the border" locales, as well as interethnic male/female relationships in these country songs, expressed in bywords and symbols unique to the genre. Songs of female and male songwriters are equally criticized for their use of ethnocentric clichés.

1484. Oliven, Ruben George. "The Woman Makes (and Breaks) the Man: The Masculine Imagery in Brazilian Popular Music." *Latin American Music Review* 9, no. 1 (Spring/Summer 1988): 90–108.

1485. Palmer, Roy. "The Sexes." In *The Sound of History: Songs and Social Comment*, pp. 197–234. New York: Oxford University Press, 1988.

This discussion examines the manner in which English popular balladry of the past reflects the nature of male/female relationships in English society. Ceremonies of "rough music" (p. 197) publicly displayed the disapproval of the community with regard to unacceptable behavior between men and women, such as violence and adultery. Songs on topics such as wife selling, weddings, bundling, love, sexuality, marital relations, prostitution, infidelity, etc. are identified and discussed; selected lyrics of folk songs and broadsides are presented, illustrating the author's discussion.

1486. Peterson-Lewis, Sonja. "A Feminist Analysis of the Defenses of Obscene Rap Lyrics." *Black Sacred Music* 5, no. 1 (Spring 1991): 68–79.

Rap lyrics juxtaposing sex with violence against women have been judged obscene in some areas of the country. The author analyzes the rationalizations of those defending rap lyrics which have been judged legally obscene (e.g., 2 Live Crew's album *As Nasty As They Wanna Be*), according to the theoretical framework offered by Mary Daly in her *Beyond God the Father: Toward a Philosophy of Women's Liberation*. She criticizes particular arguments defending obscenity in rap, examining the manner in which women's issues can be trivialized or particularized. She likewise debunks defenses which sanctify sexual violence for the sake of Art, and takes issue with the sexually violent exploitation of women in rap (especially black women) as a metaphor for all human persecution.

1487. Preston, Cathy Lynn. "'The Tying of the Garter': Representations of the Female Rural Laborer in 17th-, 18th-, and 19th-Century English Bawdy Songs." *Journal of American Folklore* 105, no. 417 (Summer 1992): 315–341.

The author demonstrates how English ballads and broadsides of the seventeenth to nineteenth centuries, through a narrative describing the male conquest of a stereotypically-portrayed, sexually-active female rural laborer, reveal relationships and societal attitudes with regard to power and gender, class, and regional identity (e.g., rural vs. city). The texts of the following ballads are analyzed: *Spotted Cow*, *Tying of the Garter*, *A Pleasant New Court Song Between a Young Courtier and his Lass*, *The Merry Hay-Makers*, and *A Ballad of the Courtier and the Country Clown*.

1488. Ramsten, Märta. "Husmorsrollen skildrad i visan." In *Kvinnors Musik*. ed. Eva Öhrström and Märta Ramsten, pp. 29–33. Stockholm, Sweden: Sveriges Utbildningsradio AB and Svenska Rikskonserter, 1989.

ISBN 9126898101. In Swedish. Translated title: "The Housewife's Role as Portrayed in Folk-Song." How Swedish folksong addresses the daily life and work of the housewife and mother.

1489. Robinson, William Andrew. *The End of Happily Ever After: Variations on the Cinderella Theme in Musicals, 1960–1987.* Diss. Ph.D., Bowling Green State University, 1990.

Abstract in *Dissertation Abstracts International: A. Humanities and Social Sciences* 52, no. 3 (September 1991): 742. DA# 9122798. The gradual disintegration of the Cinderella heroine and the fairy-tale romance in the Broadway musical from ca. 1920 to 1987 can be seen as a reflection of social and cultural change. Ten musicals are considered in this discussion. Early musicals from ca. 1920, such as *Irene* and *Sally*, reflect the stereotypical Cinderella myth. From the 1940s through the 1960s, *Annie Get Your Gun*, *My Fair Lady*, *The Unsinkable Molly Brown*, and *Sweet Charity* served as a transition, varying the theme to some extent. More contemporary heroines can be found in musicals from the 1970s and 1980s, such as *Follies*, *Evita*, *Dreamgirls* and *Into the Woods*.

1490. Rūķe-Draviņa, Velta. "The Apple Tree in Latvian Folk Songs." In *Linguistics and Poetics of Latvian Folk Songs: Essays in Honor of the Sesquicentennial of the birth of Kr. Barons*, ed. Vaira Vīķis-Freibergs, pp. 169–185. Kingston and Montreal: McGill-Queen's University Press, 1989.

This essay examines tree motifs, and specifically apple tree imagery, in Latvian folk song texts. The apple tree is often used in descriptions of scenes accompanying social rites such as childbirth, courtship, and marriage. It is also used to represent the female character in Latvian folk song texts.

1491. Santa Cruz, Maria Aurea. *A Musa Sem Máscara: A Imagem da Mulher na Música Popular Brasileira.* Rio de Janeiro, RJ: Editora Rosa dos Tempos, 1992.

ISBN 8585363533. In Portuguese. The author explores the image of women in popular Brazilian music as illustrated through a content analysis of 79 popular songs.

1492. Sawchuck, Kimberly Anne. "Towards a Feminist Analysis of 'Women in Rock Music': Patti Smith's *Gloria.*" *Atlantis* 14, no. 2 (Spring 1989): 44–54.

The author begins with a critique of the assertions made in the article "Women in Rock Music" by Deborah Harding and Emily Nett (*Atlantis* 10, no. 1 (Fall 1984): 61–76). Tracing the development of rock as a subcultural phenomenon of the working class male, discussing the male-dominated music industry, and analyzing the representation of women in rock, Nett and Harding conclude that a distinct or "authentic" female voice is not to be found in the genre. According to the author, Harding and Nett's feminist analyses of the consumption of rock music and the contents of rock lyrics is "riddled with theoretical difficulties and political traps for women." In light of the five year discrepancy between the appearance of the original and the present article, Sawchuck's explanation should be viewed not as criticism of

the original authors, but more as an example of the developments made in feminist music criticism since 1984. In Part II of the article, entitled "The Politics of Pleasure: Patti Smith's *Gloria*," Sawchuck analyzes this rock song in order to demonstrate the ways that women can work within the genre to "subvert their positioning within the system," and create a distinctly female voice.

1493. Scheurer, Timothy E. "Goddesses and Goldiggers: Images of Women in Popular Music of the 1930s." *Journal of Popular Culture* 24, no. 1 (Summer 1990): 23–38.

1494. Smith, Danyel. "Dreaming America: When You're Boy–Rap's Biggest Fan, Looking Beyond the 'Bitch' Factor Isn't Always Simple." *Spin* 8 (November 1992): 122.
    The article expresses this female writer's ambivalence towards the assertive political but patriarchal/misogynist message of male rappers.

1495. Suh, Mary. "The Many Sins of *Miss Saigon*." *Ms.* 1, no. 3 (November/ December 1990): 63.
    On the stereotypical image of Asian women portrayed in this musical.

1496. Syndergaard, Larry. "Realizations of the Feminine Self in Three Traditional Ballads from Scotland and Denmark." *Michigan Academician* 20, no. 1 (Winter 1988): 85–100.
    The three ballads from the Anglo-Scandinavian tradition analyzed here offer positive, strong, and independent portrayals of women, countering stereotypical notions of women's weakness in European balladry. The author reveals both the surface meanings of the ballads and underlying inner conflicts facing the protagonist during the process of female self-realization. The ballads analyzed are *Proud Snigelse* (in *Danmarks gamle Folkeviser* 185), *Maiden Defends Honor* (in *Danmarks gamle Folkeviser* 189C), and *The Gypsy Laddie* (in *The English and Scottish Popular Ballads*, Child 200 B).

1497. Tunnell, Kenneth D. "Blood Marks the Spot Where Poor Ellen Was Found." *Popular Music and Society* 15, no. 3 (Fall 1991): 95–115.
    A content analysis of bluegrass murder ballads reveals that in almost all songs a woman dies a cruel death at the hands of a man, and usually for reasons of male jealousy or a desire to control a woman. As a cultural expression particular to the Appalachian region, these songs had historical and societal functions. As part of the oral history of the region, these songs functioned as a means of preserving the details of actual incidents. The songs, however, also reinforced societal norms, albeit through fear and shock. They represent an extension of the frontier independence and machismo of men in this region, and of male dominance over women in an area where clear cut, traditional gender roles were to be preserved.

1498. Walser, Robert. *Running With the Devil: Power, Gender, and Madness in Heavy Metal Music.* Music Culture Series. Hanover, NH: University Press of New England, 1993.

Includes extensive discography and bibliography.

1499. Wehse, Rainer. "Die Frau in der britischen Flugblatt-Schwankballade." In *Recent Ballad Research: Proceedings of the 19th International Folk Ballad Conference of the Kommission für Volksdichtung of the Société Internationale d'Ethnologie et de Folklore. Freiburg im Breisgau, Deutsches Volksleidarchiv, 1–6 May 1989*, ed. Tom Cheesman, vol. 1 pp. 34–43. Folklore Society Library Publications, no. 4. London: Folklore Society Library, 1990.

In German. Translated title: "Women in British Broadsheet Jocular Ballads." Summary in English. The author analyzes the textual content of 366 British broadside ballads from the sixteenth to the nineteenth centuries for their portrayal of women in songs relating to courtship and marriage. In doing so, he finds that the texts, in addition to reflecting ideal female/male behaviors, often oppose or offer alternatives to gender stereotypes and standards of behavior. Thus, the author argues, the songs can be seen as a expression of conflict and resistance.

1500. Wheatley, Elizabeth. "Stylistic Ensembles on a Different Pitch: A Comparative Analysis of Men's and Women's Rugby Songs." *Women and Language* 13, no. 1 (Fall 1990): 21–26.

In analyzing the texts of male and female rugby songs, the author demonstrates that while male songs reinforce the sport as a masculine territory, expressing the ideology of the sexual conqueror of the passive female, women's rugby songs express the social and sexual irrelevancy of men through a discourse which points to a dissolution of gender boundaries in all social realms.

# Part D. The Construction of Gender in Music Video and Cinematic Music

1501. Brown, Mary Ellen, and John Fiske. "Romancing the Rock: Romance and Representation in Popular Music Videos." *Onetwothreefour* 5 (Spring 1987): 61–73.

The authors compare the female experience represented in the conventional narrative of the popular literary romance genre with similar, but more resistive narratives offered by rock music video. With this in mind, two videos are analyzed: a-ha's *Take on Me* and Madonna's *Material Girl*.

1502. Fields, Jessica. *Standing By, Getting By, and Getting Away: Hollywood and the Women of Nashville.* Thesis. M.A., University of North Carolina at Chapel Hill, 1992.

An analysis of the lives of women country singers as represented in Hollywood film. Films discussed include *Sweet Dreams*, *Coal Miner's Daughter*, and *Wild Texas Wind*.

1503. Flinn, Carol. *Film Music and Hollywood's Promise of Utopia in Film Noir and the Woman's Film*. Diss. Ph.D., University of Iowa, 1988.

Abstract in *Dissertation Abstracts International: A. Humanities and Social Sciences*. 49, no. 8 (February 1989): 2000. DA# 8815078.

1504. Flinn, Carol. "Male Nostalgia and Hollywood Film: the Terror of the Feminine." *Canadian University Music Review* 10, no. 2 (1990): 19–26.

Part of a special issue entitled "Alternative Musicologies." The use of music within the film noir genre of the 1940s is analyzed from a feminist perspective, with the author concentrating on the film *Detour* (1945) as representative of this genre. The central musical theme is associated with a female character from the past of the male protagonist, and the recurrent use of this female theme creates a disturbing sense of nostaglia, longing, and fantasy for that which will never be fulfilled, which leads the male character to his doom.

1505. Flinn, Carol. *Strains of Utopia: Gender, Nostalgia, and Hollywood Film Music*. Princeton, NJ: Princeton University Press, 1992.

An important addition to the literature of feminist film criticism, the author draws upon the theories of Roland Barthes, Julia Kristeva, and Theodore Adorno in order to analyze the utopian nature of film music. Music's ability to evoke a sense of well-being, nostalgia, and escape within the film viewer is examined, as are other issues relating to gender-related discourse in Hollywood films of the 1930s and 1940s.

1506. Freitag, Wolfgang. "Mozart und die Frauen." In *Amadeus & Co.: Mozart im Film*, pp. 212–222. Mödling, Austria: Edition Umbruch, 1991.

ISBN 3900602123. Cinematic representations of Mozart's life and musical works are the subject of this book. The chapter cited is devoted to the portrayal of the women in films dedicated Mozart.

1507. Glogauer, Werner. "Sex und Gewalt als auffälligste Inhalte von Videoclips: Ergebnisse von Analysen." *Musik und Bildung* 20, no. 11 (November 1988): 835–840.

In German. An analysis of sex and violence in music videos.

1508. Kalinak, Kathryn. *Settling the Score: Music and the Classic Hollywood Film*. Wisconsin Studies in Film. Madison, WI: University of Wisconsin Press, 1992.

The author discusses the musical encoding used to symbolize female characters and sexuality in the Hollywood film, with particular reference to

Max Steiner's score for *The Informer* (pp. 120–122, 126) and David Raksin's score for *Laura* (pp. 161–170).

1509. Kaplan, E. Ann. "Feminism/Oedipus/Postmodernism: The Case of MTV." In *Postmodernism and Its Discontents: Theories, Practices*, ed. E. Ann Kaplan, pp. 30–44. London: Verso, 1988.

The author analyzes MTV as an example of postmodern culture, and discusses its conflicting messages which are sometimes beneficial to women and sometimes not. Feminist cultural study of MTV is important, because it is a medium which addresses a mass female (and male) audience. MTV markets itself as a symbol of resistance, and many women are drawn to MTV as a vehicle for liberation from feminine constraints. However, MTV is a commercial enterprise which has co-opted postmodernism, but still represents male qualities of violence, aggression, and misogyny.

1510. Kaplan, E. Ann. *Rocking Around the Clock: Music Television, Postmodernism and Consumer Culture*. New York: Methuen, 1987.

Reviewed in *Contemporary Sociology* 18 (May 1989): 415; *Journal of Popular Film and Television* 17 (Spring 1989): 38; *Popular Music and Society* 12 (Summer 1988): 63. Using cinematic, semiotic, and psychoanalytic theory to inform her examination of MTV as a postmodern, "televisual apparatus" (p. 22), Kaplan explores various feminist issues with regard to male representations of the mother as "Other," the male/female gaze, and "the plethora of gender positions" which move "rock videos into the postmodern stance, in which it is unclear what position a text is taking toward what it shows" (p. 90). The implications of this ambiguity resulting from the lack of a clear male or female discourse is explored in detail. Kaplan analyzes a number of videos by women rock musicians (e.g., Madonna, Donna Summer, Cyndi Lauper, Tina Turner, Pat Benatar, Aretha Franklin, and Annie Lennox), illustrating the multiplicity of feminist perspectives communicated. Excerpts from the book are integrated into Kaplan's essay "Whose Imaginary" (1988).

1511. Kaplan, E. Ann. "Whose Imaginary? The Televisual Apparatus, the Female Body and Textual Strategies in Select Rock Videos on MTV." In *Female Spectators: Looking at Film and Television*, ed. E. Deidre Pribram, pp. 132–156. London: Verso, 1988.

Expanded version in *Rocking Around the Clock: Music Television, Postmodernism and Consumer Culture* (London: Methuen, 1987). Kaplan first examines the "decentering televisual apparatus" of MTV as one which epitomizes mass consumption. She then explains how MTV's postmodernism presents the viewer with a disjointed pastiche of continous images which diffuse polarities and identifications, disintegrate the relationship between subject/image, create an overall message of ambiguity, and thus prevent one from discerning a "critical position" or stance. With gender

distinctions in particular increasingly blurred, MTV allows for multiple audience identifications (encouraging mass consumption), but in doing so diffuses any feminist message while simultaneously resisting feminist criticism. To demonstrate her point, Kaplan analyzes various music videos by women artists. The "post-feminist" videos by female artists of the 1980s project an ambiguous female image, and thus are a marketable item, appearing often on MTV; Madonna's *Material Girl* is analyzed as an example. Kaplan contrasts this representation with videos of the late 1970s and 1980s taking a more socially feminist stance: Cyndi Lauper's *Time After Time*, Donna Summer's *She Works Hard for the Money*, Pat Benatar's *Love is a Battlefield*, Tina Turner's *Private Dancer*, and the Aretha Franklin/Annie Lennox collaboration of *Sisters Are Doin' It for Themselves*.

1512. Kinder, Marsha. "Phallic Film and the Boob Tube: The Power of Gender Identification in Cinema, Television, and Music Video." *Onetwothreefour* 5 (Spring 1987): 33–49.

  The author questions the polemics of recent studies concerning gender issues in film, television, and music videos.

1513. Kircher, Cassie. "Disruption of Glamour: Gender and MTV." *Platte Valley Review* 18, no. 1 (Winter 1990): 40–47.

  Referring to John Berger's analysis of male and female glamour in advertising, as presented in his *Ways of Seeing* (London: Penguin, 1972), the author discusses gender and issues of sexual difference in music videos. In rock video, glamour is equal to action, authority, and power, which are qualities seen primarily in male rock videos, often demonstrated at the expense of women via images which are misogynist and/or violent. On MTV, women musicians must be attractive, so as to be objects of pleasure for the male gaze. Women appear, and rarely act in their own rock videos, while men are viewed in action, controlling their world, all of which reinforces stereotypical and discriminatory social constructions of gender.

1514. Langguth, Paula E. "Fade In/Fade Out: Videos Featuring Women Instrumentalists." *Hot Wire* 7, no. 2 (May 1991): 14–15, 41.

  Reviews of *Madame Sousatzka*, *Tiny and Ruby—Hell Divin' Women*, *The Competition*, and *Duet for One*.

1515. McAdams, Janine C. "Let's Talk About Sexism on Recent Raps: Wreckx-N-Effect, Disco Rick, Duice, Dre Revealed." *Billboard* 105 (23 January 1993): 21.

  In the wake of the Anita Hill/Clarence Thomas hearings, the sexism of recent rap videos is criticized.

1516. Oglesbee, Frank W. "Eurythmics: An Alternative to Sexism in Music Videos." *Popular Music and Society* 11, no. 2 (1992): 53–64.

Though focusing on the music and videos of Dave Stewart and Annie Lennox of the Eurhythmics, this article deals with the broader issue of the representation of gender in rock videos. Beginning with a general discussion on the "sad state of women in music videos," the author describes how androgyny is utilized by Annie Lennox, and other artists in music and the theatre, to challenge gender stereotypes while engaging the viewer into multiple responses to the performance.

1517. Pelka, Fred. "*Dreamworlds*: How the Media Abuses Women." *On the Issues* 21 (Winter 1991): 20–24, 39–40.

The video *Dreamworlds: Desire/Sex/Power in Rock Video* is the subject of this article. A general introduction to the issues under consideration in the video is presented, followed by an interview with its creator, Sut Jhally.

1518. Schwichtenberg, Cathy. "Madonna's Postmodern Feminism: Bringing the Margins to the Center." *Southern Communication Journal* 57, no. 2 (Winter 1992): 120–131.

The postmodern representations of gender, and the resultant possibilities for multiple sexual identifications, are examined in Madonna's music videos "Express Yourself" and "Justify My Love."

1519. Seidman, Stephen A. "An Investigation of Sex-Role Stereotyping in Music Videos." *Journal of Broadcasting and Electronic Media* 36, no. 2 (Spring 1992): 209–216.

In studying a random sample of 182 MTV music videos broadcast in 1987, the author focuses upon the stereotypical portrayal of occupational roles and the affective behaviors of the males and females represented in the videos. The author's content analysis reveals that, in general, MTV "portrayed males as more adventuresome, aggressive, and domineering, and females as more affectionate, nurturing, dependent, and fearful, because such stereotypically masculine characteristics are considered more positively than are feminine traits in American society" (p. 215). Regarding the manner in which working females are portrayed in music videos, the author finds few women in professional occupational roles, and most often finds women either excluded from occupational scenes altogether or more commonly presented as lower class workers or as sex-objects in the workplace. The author concludes that MTV, as a mass medium, consistently reproduces a female image which has negative connotations, and has much to be responsible for in perpetuating stereotypical notions of male and female behavior to youthful audiences.

1520. Stockbridge, Sally. "Rock Video: Pleasure and Resistance." In *Television and Women's Culture*, ed. Mary Ellen Brown, pp. 102–113. Newbury Park, CA: Sage Publications, 1990.

The author discusses gender construction in rock videos with particular reference to the male and female gaze. She posits that rock videos by

women undermine the cultural construction of the passive female, and thus through direct address, they serve as an empowering force for women.

1521. Tagg, Philip. "An Anthropology of Stereotypes in TV Music?" *Svensk tidskrift för musikforskning (Swedish Journal of Musicology)* 71 (1989): 19–42.
    In English. The author investigates issues relating to the identification of gender characteristics in particular musical qualities found in a test sample of ten TV and movie themes.

1522. Texier, Catherine. "Have Women Surrendered in MTV's Battle of the Sexes: Sexist Attitudes Prevail in Music Videos but Some Performers are Starting to Fight Back." *New York Times* 22 April 1990, II: 29, 31.

1523. Vincent, Richard C. "Clio's Consciousness Raised? Portrayal of Women in Rock Videos, Re-examined." *Journalism Quarterly* 66, no. 1 (Spring 1989): 155–160.

1524. Vincent, Richard C., Dennis K. Davis, and Lilly Ann Boruszkowski. "Sexism on MTV: The Portrayal of Women in Rock Videos; Depiction of Gender Roles is Fairly Traditional and Sexism is High." *Journalism Quarterly* 64, no. 4 (Winter 1987): 750–755, 941.

# Part E. Music Iconography
# and the Representation of Women

1525. Degenhardt, Gertrude. *Musikfrauen: Bilder— Women in Music: Imagines.* Contrib. Sybille Brantl, Uta Henning, Marieluise Müller, Antje Olivier, Christa Spatz, and Klaus Weschenfelder. Koblenz, Germany: Mittelrhein-Museum ; Mainz, Germany: Editions GD, 1990.
    ISBN 392392903X. In German, with English translations. This striking volume includes twelve color etchings from the ninety which comprise Gertrude Degenhardt's cycle *Women In Music*. Six insightful essays, penned by critics in the fields of music, art, literature, and journalism, illuminate this contemporary artist's realizations of Woman as musician— realizations which stand in stark contrast to renderings of women musicians by male artists, and intended for the male gaze. The artist's etchings are thus analyzed given the history of the woman musician in patriarchal Western culture. The six essays include: "On Music-Making Damsels" by Sybille Brantl (pp. 34–37); "The Instrumentarium of Woman" by Uta Henning (pp. 38–42); "Melodies of Life" by Marieluise Müller (pp. 44–47); "Possessed by a Demon" by Antje Olivier (pp. 48–51); "The Daughters of Mothers in Black" by Christa Spatz (pp. 52–57); and "Music in Women" by Klaus Weschenfelder (pp. 58–63).

1526. Ford, Terence, and Andrew Green. *RIdIM/RCMI Inventory of Music Iconography, No. 3: The Pierpont Morgan Library, Medieval and*

*Renaissance Manuscripts*. New York: Research Center for Musical Iconography, City University of New York, 1988.

The General Index (p. 112), under the heading "woman musician," lists references to artwork held by the Pierpont Morgan Library depicting women musicians.

1527. Guidobaldi, Nicoletta. "Il ritorno delle Muse nel Quattrocento." *RIdIM/RCMI Newsletter* 17, no. 1 (Spring 1992): 15–21.

In Italian. The author investigates the depiction of the female muse in fifteenth-century Italian artworks, and relates the visual images to literary images found in theoretical writings from this time period. Black and white reproductions of nine artworks accompany the text.

1528. Heartz, Daniel. "A Keyboard Concertino by Marie Antoinette?" In *Essays in Musicology: A Tribute to Alvin Johnson*, ed. Lewis Lockwood and Edward Roesner, pp. 201–212. Philadelphia, PA: American Musicological Society, 1990.

An analysis of a portrait (ca. 1770) of young Marie Antoinette seated with musical score before her at a keyboard instrument gives the author occasion to pursue a more general discussion of the musical training and accomplishments of the Austrian archduchesses, the daughters of empress Maria Theresa.

1529. Hurwitt, Elliott. *RIdIM/RCMI Inventory of Music Iconography, No. 7: The Frick Collection, New York.*, ed. Terence Ford. New York: Research Center for Musical Iconography, City University of New York, 1987.

The Index (p. 24), under the heading "woman musician," lists artwork held by the Frick Collection depicting women musicians.

1530. Leppert, Richard. *Music and Image: Domesticity, Ideology and Socio-Cultural Formation in Eighteenth-Century England*. Cambridge, England: Cambridge University Press, 1988.

Reviewed in *Music and Letters* 71, no. 2 (May 1990): 254–256; *Musical Quarterly* 75, no.1 (Spring 1991): 88–92. The author undertakes a detailed and carefully-documented study of visual representations and literary descriptions of domestic music-making in the milieu of the eighteenth-century English bourgeoisie and upper classes, revealing the manner in which music was not so much a mirror of social and cultural conventions and codes, but rather an active agent in the reproduction of dominant ideologies with regard to gender, sexual politics, class, and family. Analyzing artist portraits of individuals and groups, for the most part, the monograph includes discussions entitled: "Music, Socio-Politics, Ideologies of Male Sexuality and Power" (pp. 11–27); "Music, Sexism and Female Domesticity" (pp. 28–50); "Music Education as Social Praxis" (pp. 51–70); "Music and the Body: Dance, Power, Submission" (pp. 71–106); "The Male at Music: Praxis, Representation and the Problematic of Identity" (pp. 107–146); "The

Female at Music: Praxis, Representation and the Problematic of Identity"
(pp. 147–175); "Music in Domestic Space: Domination, Compensation and
the Family" (pp. 176–200); "The Social and Ideological Relation of Musics
to Privatized Space" (Epilogue, pp. 201–214).

1531. Leppert, Richard. "Music as a Sight in the Production of Music's Meaning."
In *Metaphor: A Musical Dimension*, ed. Jamie C. Kassler, pp. 69–88.
Australian Studies in the History, Philosophy, and Social Studies of Music,
no. 1. Sydney, Australia: Currency Press, 1991.
    The importance of visual representations of music to the understand-
ing of the meaning of music in seventeeth-century Western European culture
and society is considered here. The author examines the musical iconogra-
phy of four Dutch painting of this era, finding a window through which sev-
enteenth-century attitudes regarding gender, class, and sexuality may be
viewed. The paintings analyzed are: *Music Party (Allegory of Fidelity in
Marriage* by Jan Miense Molenaer, an anonymous *vanitus* painting, and
*Peasants Dancing* and *Village Wedding* by David Teniers the Younger.

1532. Leppert, Richard. "Music, Domestic Life and Cultural Chauvinism: Images of
British Subjects at Home in India." In *Music and Society: The Politics of
Composition, Performance and Reception*, ed. Richard Leppert and Susan
McClary, pp. 63–104. Cambridge, England: Cambridge University Press, 1987.
    The musical role of women in British domestic life of eighteenth-cen-
tury India is the subject of this icongraphical study, which discusses how
idealized social attitudes about female domesticity are revealed through
images of women at the harpsichordord or in other musical contexts.
Cultural hegemony is the second subject of this essay. The author demon-
strates not only how these images prescribe roles and behaviors for women,
but how music is the symbol by which the British demonstrate their domi-
nating influence over the peoples of a foreign, non-Western land . . . India.

1533. Leppert, Richard. "Sexual Identity, Death, and the Family Piano." *19th
Century Music* 16, no. 2 (Fall 1992): 105–128.
    This important iconographical study of the metaphorical connections
between music, women, domesticity, and morality focuses on the piano
from 1650 to 1900 as both a domestic art object subjected to the gendered
gaze, and as a symbol of female domestication and submission. This article
departs from other literature on this topic by its fastidious study of the
imagery of male violence and female death used in both the ornamental
paintings and inscriptions on actual period keyboard instruments, and like-
wise in nineteenth-century paintings which represent the woman at the
piano. Accompanying the article are seventeen photographic reproductions
of pianos and paintings.

1534. Lindley, Mark. "Helene Fourment as St. Cecilia Playing the Virginals."
*RIdIM Newsletter* 15, no. 2 (Fall 1990): 13–20.

On the representation of St. Cecilia at the keyboard, as depicted by Peter Paul Rubens and others.

1535. Linn, Karen. *That Half-Barbaric Twang: The Banjo in American Popular Culture*. Urbana, IL: University of Illinois Press, 1991.

The integration of the banjo into white popular culture of the late nineteenth century included women playing the instrument, as is demonstrated by the representations of women as banjoists in art and literature of that time period (pp. 6, 23, 30–34). Circa 1920, illustrations of the banjo and women (now dancing rather than playing the instrument) coincided with the onset of jazz, and signified changing social mores and the rejection of Victorian culture (pp. 98–104).

1536. Martin, Linda, and Kerry Segrave. "Visual Violations." In *Anti-Rock: the Opposition to Rock 'n' Roll*, pp. 273–279. Hamden, CT: Archon Books, 1988.

The image of women on rock album covers and in rock video.

1537. Owens, Margareth Boyer. *RIdIM/RCMI Inventory of Music Iconography, No. 2: Art Institute of Chicago*, ed. Terence Ford. New York: Research Center for Musical Iconography, City University of New York,, 1987.

Consult the Index (p. 24), under the subject heading "woman musician" (and various cross references), for artworks held by the Art Institute of Chicago depicting women musicians or women within a musical context.

1538. Pizà, Antoni. "Musical Inspiration As Seen Through the Artist's Eye." *RIdIM Newsletter* 14, no. 2 (Fall 1989): 5–10.

An iconographical study of the composer in the process of creating a musical work reveals that the pictoral metaphor for inspiration is most often represented by a female, in both secular and sacred contexts.

1539. Raitt, Suzanne. "The Singers of Sargent: Mabel Batten, Elsie Swinton, Ethel Smyth." *Women: A Cultural Review* 3, no. 1 (Summer 1992): 23–29.

Part of a special issue on women in music. The author studies John Singer Sargent's representation of the female body via his portraiture of these three women as singers, taking into account factors such as sexual identity, persona, marital status, etc.

1540. Russell, Tilden A. "The Development of the Cello Endpin." *Imago Musicae* 4 (1987): 335–356.

Evidence garnered from cello method books and iconographic material informs this investigation into the adoption of the cello endpin, which includes an exploration into the relationship between the utilization of this device and the growing number of women playing the instrument during the nineteenth century.

1541. Seebass, Tilman. "Lady Music and her Proteges: From Musical Allegory to Musicians' Portraits." *Musica Disciplina* 42 (1988): 23–61.

   This study of musical iconography from 1200–1550 offers insights into changes in artistic aesthetics and style during the transition from the Middle Ages to the Renaissance. This change from allegory to reality is investigated with relation to artworks which first utilize female imagery to represent music as an art, and later to artworks where portraiture is used to represent actual musicians.

1542. Slim, H. Colin. "Music and Dancing with Mary Magdalen in a Laura Vestalis." In *The Crannied Wall: Women, Religion, and the Arts in Early Modern Europe*, ed. Craig A. Monson, pp. 139–160. Studies in Medieval and Early Modern Civilization. Ann Arbor, MI: University of Michigan Press, 1992.

   The connection of Saint Mary Magdalene with representations of music and dance is analyzed in a recently discovered early sixteenth-century Flemish painting of Mary Magdalene in the Devonshire Collection in Chatsworth (Derbyshire). The author assesses the painting as a classic example of musical iconography, and analyzes its contrasting worldly and spiritual symbols in light of the broader connections between female and musical elements in the literature, art and music of the late Middle Ages and Renaissance.

1543. Slim, H. Colin. "A Painting About Music At Dresden by Jacopo Tintoretto." *Explorations in Renaissance Culture* 13 (1987): 1–17.

   An expanded version of this article appears in *Imago Musicae* 4 (1987). The author traces the provenance of Tintoretto's *Le donne musicanti* (Music-Making Women), and dates the painting to the late 16th century. The iconographical significance of this painting of six women, all playing musical instruments in an outdoor setting, is explored. By interpreting the painting as an allegory on the number six, a number which figures prominently in the astronomical and musical theories of the day (as put forth by Copernicus and Zarlino, respectively), the author explains how Tintoretto connects female imagery with music and natural world.

1544. Slim, H. Colin. "Tintoretto's 'Music-Making Women' at Dresden." *Imago Musicae* 4 (1987): 45–76.

   This detailed and carefully-researched iconographical analysis of Jacopo Tintoretto's painting *Music-Making Women* (at the Dresden Gemäldegalerie) discusses Tintoretto's background and the significance of his musical knowledge to the analysis of the painting, presents new evidence which dates the painting to the late sixteenth century, and compares the Dresden painting with other "Muse" paintings commissioned from Tintoretto by Emperor Rudolph II. Slim then examines this painting of six musical women, critically assesses previous interpretations of the painting, and then describes the imagery used in the painting as an allegory on the

number six. The author demonstrates how the number six figures significantly into the works of two major theorists of the time: Gioseffo Zarlino, in his musical treatise *Le istitutioni harmoniche*; and Copernicus, in his *De revolutionibus orbium coelestium*.

1545. Tenhaef, Peter. "Die Harfe als Idealisierunginstrument von Musik und Frau." *Das Orchester* 40, no. 9 (1992): 1024–1035.

This is an iconographical study of women and their association with the harp, paralleling other idealized notions regarding music and its feminine associations (e.g., harmony, love, nature, etc.)

CHAPTER TEN

# Gender and Audience Reception, Music Preference, and Women's Uses of Music

1546. Baker, David J. "High Notes, Pornography and the Death of Opera." *Opera News* 56 (21 December 1991): 8–11, 51.

The author maintains that opera is in decline due its reduction to essentials by the consumer of operatic culture today. Utilizing the theories of Roland Barthes, who speculated that a bourgeois culture in its decadent and declining stages would manifest a fetish for detail, the author states that today's audiences celebrate operatic art which adheres to four essential characteristics: repertoire which dates from the nineteenth century; the prominence of vocal display vs. the quality of the musical work as a whole; the supremacy of the female voice; the singer's execution of the important one-note (e.g., the high C), which is the high point of the performance. According to the author, this glorification of the cult of the diva and resistance to supporting new operatic repertoire will ultimately lead to the demise of opera.

1547. Bradley, Dick. *Understanding Rock 'n' Roll: Popular Music in Britain 1955–1964.* Buckingham, England: Open University Press, 1992.

ISBN 0335097545. In a section entitled "Gender, Sexuality and the Youth Culture" (pp. 99–106), the author examines how early rock 'n' roll, a musical rebellion "masculine in its conception and execution," reflects the common post-World War II stereotype of Woman as either passive sex-object or housewife/mother. The popularity of Black-American urban music and white R & B artists amongst the male British youth of that time is traced to the manner in which messages relating to sexual behavior, female oppression, and male dominance were appropriated by white male youth to transcend the frustrations of teenage life and restrictions relating to class, social mobility, and parental authority.

1548. Breines, Wini. "The Other Fifties: Beats, Bad Girls, and Rock and Roll." In *Young, White and Miserable: Growing Up Female in the Fifties*, pp. 127–166. Boston, MA: Beacon Press, 1992.

   This chapter discusses the place of rock and roll music in teenage life of the late 1950s, and girls' use of white rock and roll, with its borrowings from black rhythm and blues, as a means of rebellion "with sex and race as the not-so-hidden narratives" (p. 55). As Breines further states, "The cultural duality of the music, simultaneously mainstream and subversive, innocent and dangerous, parallels the paradox girls faced vis-à-vis [virginity,] glamour and sexuality."

1549. Brown, Jane D., and Laurie Schulze. "Effects of Race, Gender and Fandom on Audience Interpretations of Madonna's Music Videos." *Journal of Communication* 40, no. 2 (Spring 1990): 88–102.

1550. Christenson, Peter G., and Jon Brian Peterson. "Genre and Gender in the Structure of Music Preferences." *Communication Research* 15, no. 3 (June 1988): 282–301.

1551. Cocks, Jay. "A Nasty Jolt for the Tops of the Pops: N.W.A's [Niggers with Attitude] Grotesque New Rap Album Soars to No. 1, Raising Questions About Why Ghetto Rage and Brutal Abuse of Women Appeal to Mainstream Listeners." *Time* 137 (1 July 1991): 78–79.

   On the N.W.A. album *Efil4zaggin*.

1552. Denski, Stan Walter. *An Examination of Popular Music Preferences and Functions by the Contemporary Popular Music Audience*. Diss. Ph.D., Ohio University, 1990.

   Abstract in *Dissertation Abstracts International: A. Humanities and Social Sciences* 51, no. 7 (January 1991): 2189. DA# 9024117. This study investigates gender as a primary factor influencing the music preferences and the uses of contemporary music amongst the male and female undergraduate college students surveyed.

1553. Fenster, Mark Andrew. *The Articulation of Difference and Identity in Alternative Popular Music Practice*. Diss. Ph.D., University of Illinois at Urbana–Champaign, 1992.

   Abstract in *Dissertation Abstracts International: A. Humanties and Social Sciences* 53, no. 7 (January 1993): 2144. DA# 9236459. Focusing on issues of reception, cultural production, and musical choice, and on the formidable power wielded by mainstream popular music and the popular press, the author investigates the production of alternative musics (here, gay/lesbian punk rock, bluegrass, and rap musics), and the significance of the music to its fans, through the forging of individual and group identities based on the recognition of difference (such as ethnicity, gender, sexuality, class, and taste).

1554. Fjell, Judy. "The Hidden Craft of Writing a Set List." *Hot Wire* 4, no. 1 (November 1987): 50–51.

This woman's singer/songwriter delineates the issues in creating a set list, taking into account such things as venue, audience (and their sexual orientation and politics), mood, etc.

1555. Gamman, Lorraine, and Margaret Marshment, eds. *Female Gaze: Women as Viewers of Popular Culture*. London: Women's Press, 1988.

U.S. edition published in 1989 by Real Comet Press. Reviewed in *Nation* 251 (27 August–3 September 1990): 206–209. The thirteen essays in this collection explore the positive possibilities for women as viewers of mainstream popular culture, as feminist positions within various forms of popular media, such as popular fiction, television, film, rock video, etc., are identified.

1556. Garratt, Sheryl. "Teenage Dreams." In *On Record: Rock, Pop, and the Written Word*, ed. Simon Frith and Andrew Goodwin, pp. 399–409. New York: Pantheon, 1990.

Excerpted from Sheryl Garratt's and Sue Steward's history of women in rock music, *Signed, Sealed and Delivered* (1984), the author offers her personal reflections on female fandom, female sexuality, and women's use of rock music.

1557. Hansen, Christine Hall, and Ranald D. Hansen. "The Influence of Sex and Violence on the Appeal of Rock Music Videos." *Communication Research* 17, no. 2 (April 1990): 212–234.

1558. Hicken, Leslie Wayne. *Relationships Among Selected Listener Characteristics and Musical Preference*. Diss. D. Mus. Ed., Indiana University, 1992.

Abstract in *Dissertation Abstracts International: A. Humanities and Social Sciences* 53, no. 4 (October 1992): 1089. DA#9222331. Based on a population sample of eleventh and twelfth grade high school students, this study investigates the interrelationships between their music preferences and factors such as: musical training, aptitude, and familiarity; field dependence-independence; gender; and socioeconomic status.

1559. Kalis, Pamela, and Kimberly A. Neuendorf. "Aggressive Cue Prominence and Gender Participation in MTV." *Journalism Quarterly* 66, no. 1 (Spring 1989): 148–154, 229.

Beginning with a review of the literature on the effect of violence in the media on television viewers, this article studies both the frequency and the nature of the portrayal of men and women in aggressive or violent contexts in music videos broadcast on MTV, as well as the degree to which members of the MTV audience recognize these aggressive cues in music videos and associate with representations of aggression and gender on MTV.

318

1560. Karlin, Liz. "The 'Shrinking' Audience: Learning from the Mainstream." *Hot Wire* 3, no. 2 (March 1987): 48–50.

The author examines the demographics of the audience for women-identified music, and discusses the implications of the general decline in support for performing arts events within the women's music network. The article is based on information from Arnold Mitchell's *The Professional Performing Arts: Attendance Patterns, Preferences and Motives* (Madison, WI: Association of College, University and Community Arts Administrators, 1984).

1561. Killian, Janice N. "Effect of Model Characteristics [race and sex] on Musical Preference of Junior High School Students." *Journal of Research in Music Education* 38, no. 2 (Summer 1990): 115–123.

1562. "Ladies' Choice." *Rock and Roll Confidential* 63 (December 1988): 1.

Hard rock and heavy metal acts appeal to women.

1563. LeBlanc, Albert, Wendy L. Sims, Sue A. Malin, et al. "Relationship Between Humor Perceived in Music and Preferences of Different-Age Listeners." *Journal of Research in Music Education* 40, no. 4 (Winter 1992): 269–282.

This study investigates the degree to which age and gender effects one's perception of and preference for musical humor.

1564. Leong, Laurence Wai-Teng. *Cultural Resistance: Theories of Resistance in Cultural Studies*. Diss. Ph.D., University of California San Diego, 1990.

Abstract in *Dissertation Abstracts International: A. Humanities and Social Sciences* 52, no. 2 (August 1991): 689. DA# 9119016. Cultural resistance, the means by which minority individuals or groups (as determined by age, class, gender, economic status, or ethnicity) subvert cultural norms or use them to their advantage, is investigated here. In particular, the author examines theories of cultural resistance with regard to education, lifestyle, popular music, and audience viewing.

1565. Lewis, Lisa A. "Consumer Girl Culture: How Music Video Appeals to Girls." In *Television and Popular Culture: The Politics of the Popular*, ed. Mary Ellen Brown, pp. 89–101. London: Sage Publications, 1990.

The music videos and star styles of Madonna and Cyndi Lauper, with their symbolic uses of images and texts which refer to consumer girl culture, appeal to adolescent girls. Female fans then imitate these star styles via dress, conduct, and speech, giving this group subcultural characteristics.

1566. Rabinowitz, Peter J. "'With Our Own Dominant Passions': Gottschalk, Gender, and the Power of Listening." *19th Century Music* 16, no. 3 (Spring 1993): 242–252.

While musicologists often dismiss Gottschalk's music as sentimental, the author reassesses the music of Gottschalk and the experience of listening

to his music as a sensual, and individually-empowering experience, given the era in which his work was composed and the largely female contingent who both played his piano music and enjoyed its performance.

1567. Rumsey, Gina, and Hilary Little. "Women and Pop: A Series of Lost Encounters." In *Zoot Suits and Second-Hand Dresses: An Anthology of Fashion and Music*, ed. Angela McRobbie, pp. 239–244. Boston, MA: Unwin Hyman, 1988.

First appeared in *Monitor*, no. 4 (1985). The authors examine the dichotomy between popular culture and growing up female in today's society. Even if instilled with feminist ideals, young women must endure the "aural sexism" (p. 239) of rock if they wish to be socially acceptable to their peers.

1568. Shepherd, John. "Music and Male Hegemony." In *Music and Society: The Politics of Composition, Performance and Reception*, ed. Richard Leppert, and Susan McClary, pp. 151–172. Cambridge, England: Cambridge University Press, 1987.

Music has occupied a position within western society that is not dissimilar to that of women; that is, subject to processes of control and domination. Beginning with a general discussion of gender relations and cultural reproduction, the author argues "the existence of music [as sound], like the existence of women, is potentially threatening to the extent that it sonically insists on the social relatedness of human worlds and as a consequence implicitly demands that individuals respond." The principles of western classical music focus on the purity of sound and aim to control timbre, and thus timbre becomes linked with gender. Corruption of the purity of timbre is linked to popular genres such as cock-rock, heavy metal, blues and soft-rock, which are viewed as expressions of sexuality, thus explaining gender preferences for certain types of popular musics.

1569. Shepherd, John. "Music and Male Hegemony." In *Music as Social Text*, pp. 152–173. Cambridge, England: Polity Press, 1991.

This essay was previously published in *Music and Society: The Politics of Composition, Performance and Reception* (Cambridge: Cambridge University Press, 1987).

1570. Shepherd, John, and Jennifer Giles-Davis. "Music, Text and Subjectivity." In *Music as Social Text*, pp. 174–183. Cambridge, England: Polity Press, 1991.

Research into the musical preferences of teenage girls of the English-speaking middle class shows gender to be the most important influence on the girls' musical tastes and consumption patterns. The girls studied enjoyed music with which they could vocalize, internally and externally. The authors argue that sound and text are important factors, allowing music to be sounded within one's self, thus allowing it to be reproduced. The physical and

780.1 she

emotional qualities of music allow the individual to be possessed, or elated by the music; these qualities are important in the preferences of the girls.

1571. Smith, Sheila Ann. *A Study of Personality Factors and Music Preference, Involvement and Use Among Youth*. Diss. Ed.D., Western Michigan University, 1989.

Abstract in *Dissertation Abstracts International: B. The Sciences and Engineering* 50, no. 5 (November 1989): 2181. DA# 8919768. A study of music preferences and uses of music in males and females of 18 to 20 years of age.

1572. Stark, Ellen. "Women: If You Like Heavy Metal, Don't Tell Your Date." *Psychology Today* 23 (November 1989): 14.

A review of the research by Dolf Zillman and Azra Bhatia studying the effect of musical preference on perceptions of attractiveness.

1573. Sunderland, Patricia Ann. *Cultural Meanings and Identity: Women of the African-American Art World of Jazz*. Diss. Ph.D., University of Vermont and State Agricultural College, 1992.

Abstract in *Dissertation Abstracts International: B. The Sciences and Engineering* 53, no. 9 (March 1993): 5007. DA# 9300145. Utilizing psychological, cultural, and feminist theories, and based upon interviews with women in New York's jazz community, the author studies the manner in which women's participation as non-musicians in the community of jazz constructs an African-American identity (here, amongst the European-American women interviewed), and in general, imparts cultural meanings to these women's lives.

1574. Wacholtz, Larry Edward. *The Communication of Recorded Country Music: A Q–Technique Portrait of Seven Listener Types*. Diss. Ph.D., Ohio State University, 1992.

Abstract in *Dissertation Abstracts International: A. Humanities and Social Sciences* 53, no. 2 (August 1992): 341. DA# 9219041. The author investigates demographic considerations (e.g., age, gender, educational level) with regard to marketing country music recordings to particular audiences based on listener music preferences.

1575. Wells, Alan. "Images of Popular Music Artists: Do Male and Female Audiences Have Different Views." *Popular Music and Society* 12, no. 3 (Fall 1988): 1–17.

1576. Wells, Alan. "Popular Music: Emotional Use and Management." *Journal of Popular Culture* 24, no. 1 (Summer 1990): 105–117.

This is a study investigating the degree to which gender determines the consumption, use of, and preference for types of popular music amongst college students. Results show that while there are some differences in the

choice and use of music by males and females, both groups view music as a shared experience, used for dance, listening, and manipulating emotions.

1577. Wise, Sue. "Sexing Elvis." In *On Record: Rock, Pop, and the Written Word*, ed. Simon Frith and Andrew Goodwin, pp. 390–398. New York: Pantheon, 1990.

   Originally published in *Women's Studies International Forum* 7 (1984). The author, a feminist, lesbian, and an Elvis Presley fan, offers an alternative interpretation to that put forth by male rock critics concerning Elvis as a performer and his appeal to a female audience.

1578. Zillman, Dolf, and Azra Bhatia. "Effects of Associating with Musical Genres on Heterosexual Attraction." *Communication Research* 16, no. 2 (April 1989): 263–288.

# Psychological and Physiological Studies on Women and Gender Issues in Music

1579. Abel, Jennifer L., and Kevin T. Larkin. "Anticipation of Performance Among Musicians: Physiological Arousal, Confidence, and State-Anxiety." *Psychology of Music* 18, no. 2 (1990): 171–182.

Examines gender differences with relation to the occurrence of performance anxiety.

1580. Brandfonbrenner, Alice G. "From the Editor—Women in Music: The Weaker Sex?" *Medical Problems of Performing Artists* 4, no. 1 (March 1989): 1–2.

The author examines the "ways in which gender may...influence the health and happiness of female instrumentalists" (p. 1), concentrating on situations which arise in the professional and personal lives female musicians which are apt to produce psychological stress (discriminatory attitudes, sexual politics, choice between motherhood and career, etc.) and new research which indicates that some female instrumentalists may face the risk of particular performance injuries (see Middlestadt 1989).

1581. Castarède, Marie France. *La voix et ses sortilèges*. Rev. ed., pref. Didier Anzieu. Confluents Psychanalytiques. Paris: Société d'édition Les Belles Lettres, 1989.

ISBN 2251334319. In French. First edition reviewed in *Cambridge Opera Journal* 3, no. 3 (November 1991): 303–306. The author's background in clinical psychology, psychoanalysis, and music informs this feminist exploration into the voice in opera. A wide spectrum of issues are considered, including a discussion on the physiology of vocal production, the reception of the voice as a cultural phenomenon, psychoanalytic issues with regard to the maternal voice and the mother/child relationship, a

Freudian interpretation of the singing voice as a psycho-sexual apparatus, the singing voice as a gendered cultural expression, and the voice as a theraputic medium.

1582. Coleman, Kathleen A. *Music Therapy: A Theraputic Intervention for Girls With Rett Syndrome.* Fort Washington, MD: International Rett Syndrome Association, Inc., 1987.

    Available from ERIC, ED# 290 279, in microfiche or paper copy. For an abstract see *Resources in Education* 23, no. 6 (June 1988): 53.

1583. Davis, Cynthia Allison. "The Effects of Music and Basic Relaxation Instruction on Pain and Anxiety of Women Undergoing In-Office Gynecological Procedures." *Journal of Music Therapy* 29, no. 4 (Winter 1992): 202–216.

    Twenty-two women from 17 to 43 years of age were studied to ascertain the degree to which music and relaxation techniques relieved stress and pain during several gynecological procedures. Some evidence from the study suggests that music therapy and relaxation techniques can be valuable, especially in painful procedures (e.g., punch biopsy). A list of the music utilized is included.

1584. Franke, Carrie. "The Women of Silence." *Philosophy of Education. Proceedings of the Annual Meeting of the Philosophy of Education Society (U.S.)* 45 (1989): 150–153.

    A response to Joan Munro's paper in the same volume (pp. 140–149), entitled "Music and Understanding: The Concept of Understanding Applied to Music." Here, Franke discusses how abused female children and adults, who live in a world of silence where "words are heard as instruments of oppression, to isolate and subordinate" (p. 151), may benefit from educational and theraputic uses of music listening and the experience of understanding through music.

1585. Gackle, Lynne. "The Adolescent Female Voice: Characteristics of Change and Stages of Development." *Choral Journal* 31, no. 8 (March 1991): 17–25.

1586. Gonzalez, Marilyn M. "The Choir Corner: The Care and Feeding of the Female Alto." *American Organist* 24, no. 4 (April 1990): 92–94.

1587. Gregoire, Michele A. "Factors Affecting the Careers of Women Performing Artists with Disabilities." *Music Therapy Perspectives* 5 (1988): 46–51.

    See also Gregoire (1987).

1588. Gregoire, Michele A. "Profiles of Handicapped Women Performers." In *Proceedings of the 1987 Southeastern Music Education Symposium (Volume 6, Number 2). Athens, GA, 8–9 May 1987,* ed. Dr. James A. Braswell, pp. 96–112. Athens, GA: University of Georgia, Center for Continuing Education, 1987.

This study adds significantly to the scant research on the lives and experiences of women performing artists with disabilities. In both this paper and her slightly more in-depth account subsequently published in 1988, the author identifies historical and contemporary handicapped professional women musicians whose disabilities occurred in the developmental years of their lives. Via a questionnaire sent to contemporary women performers with disabilities, a facsimile of which accompanies both the 1987 and 1988 articles, the author profiles the personal, educational, and professional experiences of these women, providing information on the existence and influence of supportive or non-supportive individuals on the careers of the respondents, the manner in which performing has contributed to the personal growth of these women artists, and the manner in which the respondent's disability has affected her ability to work and perform.

1589. Hansen Christine H., and Ranald D. Hansen. "How Rock Music Videos Can Change What is Seen When Boy Meets Girl: Priming Stereotypical Appraisal of Social Interactions." *Sex Roles* 19, no. 5–6 (September 1988): 287–316.

1590. Hansen, Christine H. "Priming Sex-Role Stereotypic Event Schemas with Rock Music Videos: Effects on Impression Favorability, Trait Inferences and Recall of a Subsequent Male-Female Interaction." *Basic and Applied Social Psychology* 10, no. 4 (December 1989): 371–391.

1591. Hassler, Marianne. *Androgynie: eine experimentelle Studie über Geschlechtshormone, räumliche Begabung und Kompositionstalent.* Göttingen, Germany: Verlag für Psychologie, 1990.

In German. Translated title: *Androgyny: An Experimental Study on Sex Hormones, Spatial Ability, and Creative Musical Talent.*

1592. Hassler, Marianne. "Creative Musical Behavior in Adolescence." *Canadian Music Educator/Musicien Educateur au Canada. Research Edition* 33 (December 1991): 55–64.

Part of a Special ISME Research Edition publishing the proceedings of the Thirteenth ISME International Seminar in Music Education taking place in Stockholm in July 1990. Boys and girls of 9 to 14 years of age, with varying levels of musical abilities, were studied in order to investigate the relationship between physiological androgyny (i.e., testosterone level), psychological androgyny (measured via the Bem Sex-Role Inventory), musical talent (measured via Wing's Standardized Tests of Musical Intelligence), and musical creativity (i.e., ability to compose and improvise, as assessed by a panel of musical experts).

1593. Hassler, Marianne. "Creative Musical Behavior and Sex-Hormones: Musical Talent and Spatial Ability in the Two Sexes." *Psychoneuroendocrinology* 17, no. 1 (March 1992): 55–70.

More results from the author's study of the psychobiology of sexual difference as it relates to musical ability.

1594. Hassler, Marianne. "Frauen komponieren: Die kritische Phase der Adoleszenz." *Österreichische Musik Zeitschrift* 46, no. 7–8 (July/August 1991): 368–372.

In German. Translated title: "Women Composing: The Critical Stage of Adolescence." Part of a special issue devoted to women in music. The author explores the relationships between sexual difference, musical creativity, and the stages of human development.

1595. Hassler, Marianne. "Functional Cerebral Asymmetries and Cognitive Abilities in Musicians, Painters and Controls." *Brain and Cognition* 13, no. 1 (May 1990): 1–17.

Part of a comprehensive investigation into the relationship between musical ability, gender (and in particular, androgyny), and various cerebral functions, this paper presents evidence "that special talents, in addition to sex and handedness, seem to be associated with functional hemispheric asymmetries that differ from the norm of subjects without special talents. Results were obtained from young adult musical composers, instrumentalists, painters and nonmusicians of both sexes" (p. 3).

1596. Hassler, Marianne. "Maturation Rate and Spatial, Verbal, and Musical Abilities: A Seven Year Longitudinal Study." *International Journal of Neuroscience* 58, no. 3–4 (1991): 183–198.

A study relating gender to musical and cognitive abilities during the process of maturation.

1597. Hassler, Marianne. "Testosterone and Artistic Talents." *International Journal of Neuroscience* 56 (1991): 25–38.

Testoterone levels of male and female artists and musicians are measured so as to determine the possible correlation between hormones, psychological androgyny, and creative ability.

1598. Hassler, Marianne. "Weibliches Komponieren." *Musik Psychologie: empirische Forschungen, ästhetische Experimente; Jahrbuch der Deutschen Gesellschaft für Musikpsycholgie* 8 (1991): 32–45.

In German, with a summary in English by the author. Hassler examines the musical, psychological, and biological factors involved in the compositional processes women and men composers. The author compares biographical data on composers Dora Pejačević and Alban Berg, and relates this data to her extensive study on gender and the psychobiology of musical ability.

1599. Hassler, Marianne, and Niels Birbaumer. "Handedness, Musical Abilities, and Dichaptic and Dichotic Performance in Adolescents: A Longitudinal Study." *Developmental Neuropsychology* 4, no. 2 (1988): 129–145.

Male and female adolescents are studied for differences in musical abilities.

1600. Hassler, Marianne, Eberhard Nieschlag, and Diether De La Motte. "Creative Musical Talent, Cognitive Functioning and Gender: Psychobiological Aspects." *Music Perception* 8, no. 1 (Fall 1990): 35–48.

1601. Hassler, Marianne, and Eberhard Nieschlag. "Masculinity, Femininity, and Musical Composition: Psychological and Psychoendocrinological Aspects of Musical and Spatial Faculties." *Archiv für Psychologie* 141, no. 1 (1989): 71–84.
     In English, with abstract in German. Abstract also in *Psychological Abstracts* 77, no. 3 (March 1990): 733.

1602. Hassler, Marianne, and Eberhard Nieschlag. "Salivary Testosterone and Creative Musical Behavior in Adolescent Males and Females." *Developmental Neuropsychology* 7, no. 4 (1991): 503–521.

1603. Houden, Helen, and Steve Austin. "The Effects of Estrogen Replacement Therapy in the Menopausal Singing Voice." *Journal of Research in Singing and Applied Vocal Pedagogy* 14, no. 2 (June 1991): 41–50.

1604. Kellaris, J. J., and R. C. Rice. "The Influence of Tempo, Loudness and Gender of Listener on Responses to Music." *Pyschology and Marketing* 10, no. 1 (January/February 1993): 15–30.
     Comparisons between male and female responses to tempo and loudness of instrumental music are studied, with the results having implications for the use of music in advertising and in retail settings.

1605. Middlestadt, Susan E., and Martin Fishbein. "The Prevalence of Severe Musculoskeletal Problems Among Male and Female Symphony Orchestra String Players." *Medical Problems of Performing Artists* 4, no. 1 (March 1989): 41–48.
     An analysis of data obtained through a national survey sponsored by the International Conference of Symphony and Opera Musicians indicates "statistically significant differences" in the occurrence of serious musculoskeletal injuries affecting the musical performance of men and women players of different types of string instruments. These factors—location of injury, gender, and instrument type—most often interact to produce a specific injury. For example, women playing the larger string instruments (e.g., viola and cello) have a higher incidence of hand and wrist disorders than do men. These findings are found to be consistent with previous research.

1606. Sataloff, Dahlia M., and Emely Karandy. "Breast Cancer in Singers." *NATS Journal* 48, no. 2 (November/December 1991): 21–23, 49.

1607. Shetler, Donald J. "The Inquiry into Prenatal Musical Experience: A Report of the Eastman Project 1980–1987." In *Music and Child Development:*

*Biology of Music Making. Proceedings of the 1987 Denver Conference*, ed. Frank R. Wilson and Franz L. Roehmann, pp. 44–62. St. Louis, MO: MMB Music, 1990.

Also published in *Pre- and Peri-Natal Psychology Journal* 3, no. 3 (Spring 1989): 171–189, with a more comprehensive bibliography. A pilot study undertaken by the author at the Eastman School of Music (Rochester, N.Y) observed prenatal and postnatal responses to music, with preliminary findings suggesting a correlation between in-utero musical stimuli and musical and cognitive development in the same newborn infants. The author reviews relevant research to date, describes the methodology used in the current study, and discusses his observations and conclusions.

1608. Smith, Karen L. *The Effects of Contemporary Rock and Roll Music on Duration, VOb2s, Blood Pressure, Heart Rate and Perceived Exertion in Females Aged 18–31 Years*. Thesis. M.S., University of Wisconsin—La Crosse, 1987.

Issued in 1990 on microfiche from Microform Publications, College of Human Development and Performance, University of Oregon (UO# 90 110). A study of the physiological effects of rock music when used for women's exercise.

1609. St. Lawrence, Janet S., and Doris J. Joyner. "The Effects of Sexually Violent Rock Music on Males' Acceptance of Violence Against Women." *Psychology of Women Quarterly* 15, no. 1 (March 1991): 49–63.

Abstracted in *Women Studies Abstracts* 20, no. 3 (Fall 1991): 40. Based on a sample of seventy-five undergraduate males, this study investigates the degree to which heavy-metal music, interacting with other variables such as religious orientation and sex-role orientation, affects male attitudes towards women, their approval of violence against women, and sexual arousal.

1610. Standley, Jayne M., and Clifford Madsen. "Comparison of Infant Preferences and Responses to Auditory Stimuli: Music, Mother and Other Female Voice." *Journal of Music Therapy* 27, no. 2 (Summer 1990): 54–97.

1611. Stein, Ada Mae. "Music to Reduce Anxiety During Cesarean Births." In *Applications of Music in Medicine*, ed. Cheryl Dileo Maranto, pp. 179–190. Washington, D.C.: National Association for Music Therapy, 1991.

This study examines the effects of both white noise and music in reducing anxiety in women undergoing Cesarean surgery with a regional anaesthetic. The musical selections from four different genres (classical, jazz, easy listening, country) which were used by the music therapist in this case are included in the appendices.

1612. Waleson, Heidi. "Full Cry: Divas as Moms." *Wall Street Journal* 27 April 1990, Leisure and Arts Section: A10 (Eastern ed.); A13 (Western ed.).

Physiological and psychological effects of motherhood on female opera singers.

1613. Wilkin, Phyllis E. "'Antenatal and Postnatal Responses to Music and Sound Stimuli'—A Clincal Report." *Canadian Music Educator/Musicien Educateur au Canada. Research Edition* 33 (December 1991): 223–235.

Part of a Special ISME Research Edition publishing the proceedings of the Thirteenth ISME International Seminar in Music Education taking place in Stockholm in July 1990. Fifty-seven pregnant women were studied in order to ascertain the physical responses of the fetus during the various stages of pregnancy to: the style and instrumentation of music listened to by the mother; the number of hours of maternal listening; the continued exposure of a given musical work. The physical responses of the newborn infant to the same musical stimuli used during the prenatal period are then observed. The author then discusses the implications of the results on parent education. The author concludes in the final paragraph that, "What is experienced by the fetus both emotionally and cognitively, will influence emotional and cognitive responses throughout the life which follows."

# Score Anthologies in All Musical Genres

1614. *18 Country Ladies, 38 Country Hits*. Miami, FL: Columbia Pictures Publications/Belwin, F 2845SMX, 1987.

> Arranged for voice and piano, with guitar chords. Songs written and/or sung by female country music artists: Lynn Anderson, Patsy Cline, Holly Dunn, The Forester Sisters, Janie Fricke, Crystal Gayle, Emmylou Harris, The Judds, Loretta Lynn, Barbara Mandrell, Reba McEntire, Lorrie Morgan, Anne Murray, Juice Newton, Olivia Newton-John, Dolly Parton, Linda Ronstadt, and Tammy Wynette.

1615. *80's Ladies: Top Hits From Country Women of the 80's*. Winona, MN: Hal Leonard Publishing, HL 00359741, 1988.

> Arranged for voice, piano and guitar. Includes songs by Rosanne Cash, Holly Dunn, The Forester Sisters, Crystal Gayle, The Judds, Reba McEntire, Anne Murray, K.T. Oslin, Sweethearts of the Rodeo, and Tanya Tucker.

1616. Adkins Chiti, Patricia, ed. *Una Voce Poco Fa. . .ovvero le musiche delle Primedonne Rossiniane*. Rome, Italy: Garamond Editrice, 1992.

> Reviewed in *International League of Women Composers (ILWC) Journal* (February 1993): 10. Available directly from the publisher: Garamond Editrice, Via Quintino Sella, 41–00187, Rome, Italy. Contains 28 original songs and duets for voice and piano composed by nine Rossini primedonne: Isabella Colbran, Angelica Catalani, Maria Malibran, Caroline Ungher Sabatier, Josephine Fodor Mainvielle, Guiditta Pasta, Adelina Patti, Pauline Viardot-Garcia, and Marietta Brambilla. Songs texts are presented in their original language; literal English translations are provided. The textual component of the book, which includes historical background and biographical details on each composer/ singer, is presented in Italian and English.

1617. Briscoe, James, ed. *Historical Anthology of Music by Women*. Bloomington, IN: Indiana University Press, 1987.

Reviewed in *Notes* 45, no. 2 (December 1988): 379–380; *American Music Teacher* 38, no. 4 (February/March 1989): 62–63; *Historical Performance* 3, no. 1 (Spring 1990): 29–30; *ILWC Journal* (September 1991): 22–23. Also available from Indiana University Press (ISBN 025331268X) are three companion cassettes. Traversing a wide variety of styles and genres, including music of the private and public spheres, this significant score anthology unites selected works by thirty-seven women composers from the ninth through the twentieth centuries into one volume, in order to facilitate the teaching of the contributions of women to Western art music. Composers' works are prefaced by a biographical introduction (written by various contributors), with suggestions for further reading and listening. Composers and musical works represented are: Kassia (Byzantine chants *Augustus, the Monarch* and *The Fallen Woman*); Hildegard von Bingen (*Chants De Sancta Maria, In Evangelium, Kyrie*); the Countess of Dia (*A Chantar*, troubadour song); Anne Boleyn (*O Deathe, Rock me Asleepe*); Maddalena Casulana (*Madrigal VI*); Francesca Caccini (two solo songs from *Il Primo Libro* and "Aria of the Shepherd" from *La Liberazione di Ruggiero*); Isabella Leonarda (selections from *Messa Prima*, for chorus, strings, continuo); Elisabeth-Claude Jacquet de La Guerre (selections from *Suite in D Minor for Harpsichord*, and the cantata *Semele*); Maria Margherita Grimani (Sinfonia from *Pallade e Marte*); Anna Amalie, Princess of Prussia (Adagio from *Sonata in F Major for Flute and Continuo*); Marianne Martinez (Allegro from *Sonata in A Major for Piano*); Maria Theresia von Paradis (*Morgenlied eines armen Mannes* for voice and keyboard, and *Sicilienne* for violin and keyboard); Maria Agata Szymanowska (*Nocturne* for piano); Josephine Lang (*Frühzeitiger Frühling* for voice and piano); Fanny Mendelssohn Hensel (*Schwanenlied* for voice and piano); Clara Schumann (*Liebst du um Schönheit* for voice and piano, Allegro Moderato from *Trio in G Minor for Violin, Violoncello and Piano* (1846), and *Variations on a Theme by Robert Schumann* for piano); Louise Farrenc (Allegro deciso from *Trio in E Minor for Flute or Violin, Violoncello, and Piano*); Pauline Viardot-Garcia ("Die Beschwörung" from *Zwölf Gedichte von Pushkin*); Amy Beach (*Elle et moi* for voice and piano, Allegro con fuoco from *Symphony No. 1*, and *A Hermit Thrush at Morn* for piano); Cécile Chaminade (Andante from *Sonata in C Minor for Piano*); Dame Ethel Smyth (scene from Act 1 of *The Wreckers*); Lili Boulanger (selections from *Clairières dans le ciel* for voice and piano); Alma Mahler (*Der Erkennende* for voice and piano); Rebecca Clarke (Allegro from *Trio for Violin, Cello, and Piano* (1921)); Germaine Tailleferre (Modéré sans lenteur from *Sonata in C# Minor for Violin and Piano* (1923)); Ruth Crawford Seeger (*Prelude No. 2 for Piano*, "Rat Riddles" from *Three Songs for Contralto, Oboe, Percussion, and Orchestral Ostinati*, and selections from *String Quartet* (1931)); Miriam Gideon (*The Hound of Heaven* for voice, oboe, and string trio); Grazyna Bacewicz (*Sonata No. 2 for Piano*

(1953)); Louise Talma (*La Corona: Seven Sonnets by John Donne* for mixed chorus); Julia Perry (*Homunculus C.F.* for percussion, harp, and piano); Vivian Fine ("The Triumph of Alcestis" from the ballet *Alcestis*); Violet Archer (Preamble from *Sonata for Alto Saxophone and Piano* (1972)); Pauline Oliveros (selections from *Sonic Meditations*); Thea Musgrave ("Monologue of Mary" from the opera *Mary, Queen of Scots*); Ellen Taaffe Zwilich (*Symphony No. 1* first movement).

1618. Caswell, Austin, ed. *Embellished Opera Arias*. Recent Researches in the Music of the Nineteenth and Early Twentieth Centuries, nos. 7–8. Madison, WI: A–R Editions, 1989.

Documenting the nineteenth century practice of vocal embellishment as applied to the standard Italian and French operatic repertoire of the time, this anthology draws upon the memoirs, notebooks, pedagogical literature, and performance parts of the premier vocal performers and pedagogues of this era. Almost all the twenty-two embellishments presented are for female voices, and include those written by Laure Cinti-Damoreau, Barbara Marchisio, and Jenny Lind. Also included are the embellishments written by Rossini for Giuditta Pasta, well known for her improvisatory abilities. The thoroughly researched introduction, plus the presentation of both the original piano/vocal excerpts with the embellished passages above the vocal line provides an excellent glimpse of the scope of vocal virtuosity in the nineteenth century.

1619. Drucker, Ruth, and Helen Strine, ed. *A Collection of Art Songs by Women Composers*. Fulton, MD: HERS Publishing, 1988.

Reviewed in *NATS Journal* 45, no. 3 (January/February 1989): 49–50, 56. Songs, for voice with piano accompaniment. Includes: *Vanne felice rio* and *Giusto amor* by Luise Reichardt; *Sempre più t'amo* by Isabella Colbran; *Schwanenlied, Frühling*, and *Nach Süden* by Fanny Mendelssohn Hensel; *Mandoline* and *Crépuscule du soir mystique* by Poldowski (née Irene Wieniawska); *Vous m'avez regardé avec toute votre âme* by Lili Boulanger; *L'espoir luit comme un brin de paille* by Marguerite Canal; *The Western Wind* by Amy Beach; *Apparitions* by Eleanor Freer; *A Letter* by Marion Bauer; *Half Minute Songs* by Carrie Jacobs Bond. Each composer receives a brief biographical profile.

1620. Epstein, Selma, ed. *Piano Duets, Duos and Music for One Hand by Women Composers*. Dickeyville, MD: Chromattica USA, 1993.

In two volumes. For a description of the compilation see the author's article in the International League of Women Composers (ILWC) Journal (September 1991): 33.

1621. Glickman, Sylvia, ed. *American Women Composers: Piano Music from 1865–1915*. Bryn Mawr, PA: Hildegard Publishing Co., 1990.

332

Reviewed in *Choice* 29, no. 3 (November 1991): 458; *Piano Quarterly* 39 (Winter 1991/1992): 17. Includes biographical notes on each composer. Contents: *Lake Shore Dream* by Faustina Hasse Hodges; *La Favorite* (Etude Mazurka) by Jane Torry Sloman; *Twilight Fancies* by Clara Scott; *Grand National Medley* by Eliza Pattiani; *Dreaming* op. 15/3 and *Sous les Etoiles* op. 65/4 by Amy Beach; *Rhapsody* by Margaret Ruthven Lang; *Scherzo* by Clara Kathleen Rogers; *Valse Boheme* by Celeste Heckscher; *Prelude and Dance* by Helen Hopekirk; *Reverie* by Carrie Jacobs-Bond; *Dusty (A Rag)* by May Aufderheide; *Hoosier Rag* by Julia Niebergall; *Phoebe Thompson's Cakewalk* by Sadie Koninsky; *Wireless Rag* by Adeline Shepherd; *Staccato Polka* by Clara Gottschalk Peterson.

1622. Glickman, Sylvia, and Martha Furman Schleifer, eds. *Women Composers: Music by Women through the Ages*. Boston, MA: G.K. Hall, Forthcoming, 1995–1997.

Twelve volumes projected covering the following eras: Early Middle Ages and the Renaissance, Baroque and Early Classical Eras, Classical Era, Nineteenth Century, Twentieth Century. Each musical work presented will be accompanied by an essay including biographical information on the composer, the historical context of the musical work, a bibliography, works list, and discography.

1623. Harbach, Barbara, ed. *Eighteenth Century Women Composers for the Harpsichord or Piano. Volume 1*. Pullman, WA: Vivace Press, VIV 1801, 1992.

Reviewed in *Continuo* 16, no. 3 (June 1992): 30; *Clavier* 31, no. 10 (December 1992): 32–33. *American Music Teacher* 42, no. 3 (December/ January 1992/1993): 71. Includes: Elisabetta de Gambarini's *Aria, Gavotte and Variations* (on "Lover, Go and Calm Thy Sighs") and *Gigue*; Maria Hester Park's *Sonata I in F Major* ; and *Lesson VI in D Major* by A Lady.

1624. Harbach, Barbara, ed. *Eighteenth Century Women Composers for the Harpsichord or Piano. Volume 2*. Pullman, WA: Vivace Press, VIV 1802, 1992.

Reviewed in *Continuo* 16, no. 3 (June 1992): 30; *American Music Teacher* 42, no. 3 (December/January 1992/1993): 71. Includes: *Sonata No. 3 in A Major* by Marianne Martinez; *Sonata in C Major* op. 7 by Maria Hester Park.

1625. Harbach, Barbara, ed. *Women Composers for the Harpsichord*. Bryn Mawr, PA: Theodore Presser, Elkan-Vogel 460–00089, 1987.

Reviewed in *Notes* 45, no. 2 (December 1988): 379; *Piano Quarterly* 138 (Summer 1987): 6–7. Includes baroque and classical harpsichord compositions by women composers: *Minuet, Tambourin*, and *Allegro* from *Lessons for the Harpsichord* op. 2 (1748) by Elisabetta da Gambarini;

*Allegro* from the *Harpsichord Sonata in E Major* by Marianne Martinez; *Rondo allegro* from the *Harpsichord Sonata in E Flat Major* by Marianna d'Auenbrugg.

1626. Hinson, Maurice, ed. *At the Piano With Women Composers*. Van Nuys, CA: Alfred Publishing, 1990.

This compilation of eighteen piano works by thirteen women composers is "performance and teaching-oriented and based on the most reliable sources available" (p. 6). The introduction includes a capsule biography of each composer and Hinson's program notes for each piece. The compositions date from the eighteenth, nineteenth, and early twentieth centuries, and they include: Rondo from the *Sonata in E Flat Major* by Marianna von Auenbrugger; *Song of Youth* op. 45/1 and *Summer Song* op. 45/3 by Agathe Backer-Grøndahl; "Promenade" (No. 1 from the *Young People's Carnival* op. 25), *Scottish Legend* op. 54/1 and *Waltz* op. 36/3 by Amy Beach; *Le sommeil de l'enfant* op. 35 by Teresa Carreño; "Scarf Dance" op. 37/3, from *Three Ballet Scenes* by Cécile Chaminade; *Impromptu* by Louise Farrenc; *Berceuse* by Wanda Landowska; *Nocturne in B Flat Major* by Maria Szymanowska; Mazurka (No. 5 from *Soirées Musicales* op. 6) by Clara Schumann; *Sonata in E Major* by Marianne Martinez; *Mélodies* (op. 4/2 and op. 5/4) by Fanny Mendelssohn Hensel; Gigue and Tambourin (from *Lessons for the Harpsichord* op. 2) by Elisabetta de Gambarini; *Wireless Rag* by Adaline Shepherd.

1627. Jackson, Barbara Garvey, ed. *Arias from Oratorios by Women Composers of the Eighteenth Century. Volume 1.* Fayetteville, AR: Clarnan Editions, CN6, 1987.

Score and parts. Reviewed in *Early Music* 20, no. 1 (February 1992): 163–164. These selections for voice with various instruments are based on manuscripts from the Österreichische Nationalbibliothek, Vienna. They include: "Consolati che il petto" from *S. Gemigniano, (Vescovo e) Protettore di Modena* by Catterina Benedetta Grazianini (for alto, oboe, violins, and continuo); "Quanto, quanto mi consola" from *Santa Beatrice d'Este* by Camilla de Rossi (for soprano, alto, and continuo); "Strali fulmini, tempeste, procelle" from *Il sacrifizio di Abramo* by Camilla de Rossi (for soprano with string orchestra, in a reduction for keyboard); "Cielo, pietoso cielo" from *S. Alessio* by Camilla de Rossi (for soprano, solo violin and string orchestra, in a reduction for keyboard); *L'esser fida* (for soprano, oboe and continuo) and *A un core innocente* (for alto, violin, viola, and continuo) by Maria Margharita Grimani.

1628. Jackson, Barbara Garvey, ed. *Arias from Oratorios by Women Composers of the Eighteenth Century. Volume 2.* Fayetteville, AR: Clarnan Editions, CN13, 1990.

Keyboard/vocal score and parts (2 trumpets, 2 violins, viola, violoncello). The second volume of this series is entitled *Two Arias for Male Voice, Two Trumpets in C, and Strings* by Camilla de Rossi. The arias

include: "Sonori concenti" from *S. Alessio* (for tenor); "Qui dove il Po" and "Poiche parmi di sentire" from *S. Beatrice d'Este* (for baritone).

1629. Jackson, Barbara Garvey, ed. *Arias from Oratorios by Women Composers of the Eighteenth Century. Volume 3*. Fayetteville, AR: Clarnan Editions, CN14, 1990.

Entitled *Arias with Continuo and Cello Obbligato*, the third volume of this series features compositions by Camilla de Rossi and Catterina Benedetta Grazianini, published in the format of a vocal/keyboard score with parts for solo violoncello, basso continuo, (and 2 violins and viola, in the third work). The arias include: "Il ancor ti resta in petto" from *Santa Teresa* and "A veder si raro oggetto" from *S. Gemigniano, (Vescovo e) Protettore di Modona [sic]* by Catterina Benedetta Grazianini; "Rompe il morso" and "Lascia, o figlio, il tuo dolore" from *Il figliuol prodigo*, and "Sono il fasto, e la bellezza" from *S. Beatrice d'Este* by Camilla de Rossi.

1630. Jackson, Barbara Garvey, ed. *Arias from Oratorios by Women Composers of the Eighteenth Century. Volume 4*. Fayetteville, AR: Clarnan Editions, CN15, 1992.

The fourth volume of this series, *Ensemble Arias by Catterina Benedetta Grazianini and Camilla de Rossi*, is issued as a vocal/keyboard score with one part for violoncello continuo. The ensembles by Grazianini include: "Tutti pace, frena il pianto" from *Santa Teresa*; "In questo chiaro dì" and "Dia lode il grato core" from *S. Gemigniano, (Vescovo e) Protettore di Modena*. Also included is Camilla de Rossi's "Quello nave, che riposa" from *Il figliuol prodigo*.

1631. Jackson, Barbara Garvey, ed. *Lieder By Women Composers of the Classic Era, Volume 1*. Fayetteville, AR: ClarNan Editions, CN7, 1987.

Six songs for high voice and piano, including: *Kennst du das Land* by Hélène Liebmann (née Riese); *Da eben seinen Lauf vollbracht* by Maria Theresia von Paradis; *Die Wachtel* and *Das Mädchen am Ufer* by Corona Schröter; *Die Erscheinung* and *Der Bund* by Sophia Maria Westenholz (née Fritscher).

1632. Johnson, Calvert, ed. *Organ Music by Women Before 1800*. Pullman, WA: Vivace Press, VIV 303, 1993.

Includes: *Conditor Alme* by Gracia Baptista; *Ave verum corpus* and *Egos flos campi* by Caterina Assandra; *A Dirge for Funerals* by Miss Steemson.

1633. Libana (women's ensemble), comp. *Fire Within: Magical and Contemplative Rounds and Songs From Around the World*. Durham, NC: Ladyslipper, 1990.

A 40-page collection of women's music, folk-songs, and ritual music from world cultures. Contents include: *Fire Within* by Marytha Paffrath;

*Hotaru koi* (Traditional: Japan); *Treeplanter's Round* by Dorothy Attneave Jackson; *Con el viento* (from Renaissance Spain); *Good Friend* by Jan Harmon; *Kona kai opua i ka lai* (Traditional: Hawaii); *O Virgo spendens* (Spanish, 14th c.); *Rise Up O Flame* (unattributed); *Neesa* (Native American); *Lullaby* (Traditional: Sweden); *Clear Horizon* by Jan Harmon; *Ode to Contentment* (Traditional: Shaker); *I Will Be Gentle With Myself* (unattributed); *Now I Walk In Beauty* (based on Hopi Indian text); *Be Like a Bird* (unattributed); *Lo yisa goy* (Traditional: Jewish); *Kwaheri* (Traditional: Kenya); *And She Will Rise* by Dakota Butterfield.

1634: Lindeman, Carolyn A., ed. *Women Composers of Ragtime: A Collection of Six Selected Rags by Women Composers*. Bryn Mawr, PA: Theodore Presser, 410–41250, 1985.

Reviewed in *Notes* 43, no. 3 (March 1987): 683. Includes works by Adaline Shepherd, Julia Lee Niebergall, Irene M. Giblin, and May Frances Aufderheide.

1635. Matsushita, Hidemi, ed. *Lieder by Women Composers of the Classic Era, Volume 2*. Fayetteville, AR: ClarNan Editions, CN8, 1987.

Includes Maria Theresia von Paradis' *Zwölf Lieder auf ihrer Reise in Musik gesetzt* (1784–1786), for soprano and harpsichord.

1636. O'Boyle, Carmel, ed. *Irish Woman's Songbook*. St. Paul, MN: Irish Books and Media, 1987.

1637. Rieger, Eva, and Käte Walter, eds. *Frauen komponieren: 22 Klavierstücke des 18.–20. Jahrhunderts*. 2nd rev ed. Mainz, Germany: Schott, No. 7197, 1992.

Translation on title page: *Female Composers: 22 Piano Pieces from the 18th–20th Centuries*. First edition reviewed in *Notes* 45, no. 2 (December 1988): 379. This edition includes: *Rondeau* by Elisabeth-Claude Jacquet de La Guerre; *Sonate No. 3* by Marianne Martinez; *Nocturne* by Maria Szymanowska; *Mélodie* op. 4/2 and *Mélodie* op. 5/4 by Fanny Mendelssohn Hensel; *Andante con sentimento* by Clara Schumann; *Impromptu* by Louise Farrenc; *Pierette* (Air de ballet) op. 41 by Cécile Chaminade; *Langsamer Walzer* by Ilse Fromm-Michaels; *Elegie für die linke Hand allein* by Else Schmitz-Gohr; *Slow* by Lotte Backes; *D'un vieux jardin* by Lili Boulanger; *Barbaric Dance* by Priaulx Ranier; *Two Bagatelles* op. 48/1,3 by Elisabeth Lutyens; *Prelude for a Pensive Pupil* by Peggy Glanville-Hicks; *Introduction* by Verdina Schlonsky; *2 Pièces brèves* by Jacqueline Fontyn; *Piano muziek* by Barbara Heller; *Chillan* by Susanne Erding.

1638. Rieger, Eva, and Käte Walter, ed. *Frauen komponieren: 25 Lieder für Singstimme und Klavier*. Mainz, Germany: Schott, ED 7810, 1992.

Translation on title page: *Female Composers: 25 Songs for Voice and Piano*. Foreword and notes on the composers in English and German.

Includes: *Auf dem Land und in der Stadt* by Anna Amalia, Duchess of Saxe-Weimar; *Erlkönig* and *Manchen langen Tag* by Corona Schröter; *Die Blume der Blumen, Genoveva*, and *Hinüber wall'ich* by Luise Reichardt; *Morgenfreude* op. 4/2 and *Trennung ohne Abschied* by Emilie Zumsteeg; *Neue Liebe neues Leben, Mignon*, and *Die Ersehnte* by Fanny Mendelssohn Hensel; *An den Mond* op. 7/5, *Wunsch* op. 7/2, and *Römische Nacht* op. 15/1 by Johanna Kinkel; *Ob ich manchmal Dein gedenke* op. 27/3, *Frühzeitiger Frühling, Nur der Abschied schnell genommen* op. 15/ 1 by Josephine Lang; *Liebst du um Schönheit* op. 12/4, *Warum willst du and're fragen* op. 12/11, *Sie liebten sich beide* op. 13/ 2, and *Es fiel ein Reif in der Frühlingsnacht* by Clara Schumann; *Frühlingsnacht* op. 18/5 and *Der Rose bitte* op. 39 by Luise Adolpha Le Beau; *Die stille Stadt* and *Ich wandle unter Blumen* by Alma Mahler.

1639. *She's Got the Blues: Songs Made Famous By the Great Women of Blues.* Milwaukee, WI: Hal Leonard, HL 00311579 , 1992.

Over sixty songs, arranged for piano, vocal, guitar. Contents: *Baby, Won't You Please Come Home, Baby What You Want Me To Do, Basin Street Blues, Billie's Blues, Black Coffee, Blue Turning Grey Over You, Crazy Blues, Don't Explain, Don't Get Around Much Anymore, Down-Hearted Blues, Everyday (I Have the Blues), Fever, Fine and Mellow, Gloomy Sunday, Good Man Is Hard To Find, Gulf Coast Blues, Hear Me Talkin' To Ya, Hold What You've Got, I Ain't Got Nobody, I Almost Lost My Mind, I Cried For You, I Will Not Be Denied, I'm A Woman, Jailhouse Blues, Jealous Kind, Lady Sings the Blues, Love Me or Leave Me, Lover Man, Mad About Him Sad Without Him How Can I Be Glad Without Him, Man That Got Away, Mean to Me, My Handy Man Ain't Handy No More, My Man Blues, Nobody Knows You When You're Down and Out, Pink Bedroom, Please Help Me Get Him Off My Mind, Riverside Blues, San Francisco Bay Blues, See See Rider, Sentimental Journey, Some of These Days, Some Other Spring, Sorrowful Blues, Spoonful, St. Louis Blues, Stormy Weather, Strange Fruit, 'Tain't Nobody's Bizness If I Do, This Bitter Earth, Trouble in Mind, Trouble is a Man, Two Cigarettes in the Dark, Vision of Love, Wang Dang Doodle, When the Sun Comes Out, Why Don't You Do Right, Why Was I Born, Woman Alone With the Blues, Yellow Dog Blues, Your Red Wagon.*

1640. Straus, Joseph N., ed. *Music by Women for Study and Analysis.* Englewood Cliffs, N.J.: Prentice Hall, 1993.

Reviewed in *Women of Note Quarterly* 1, no. 1 (May 1993): 13. An anthology of 102 excerpts of musical works by almost 20 women composers active from the Baroque era through the twentieth century, this compilation facilitates the inclusion of women composers' music into beginning theory and harmony coursework. Excerpts chosen for inclusion in this anthology are also readily available in their entirety in the form of published scores and recordings from standard sources, facilitating further study. The arrangement

of the anthology is by the particular type of harmonic example being illustrated, i.e., diatonic chords in the 5/3, 6/3 and 6/4 positions, seventh chords, ninth chords, applied (secondary chords), modulation, linear progressions and sequences, Neapolitan II, augmented triads, augmented sixth chords, common tone augmented sixth and diminished seventh chords, etc. Composers represented are: Amy Beach, Margaret Bonds, Lily Boulanger, Nadia Boulanger, Cécile Chaminade, Elisabeth-Claude Jacquet de La Guerre, Fanny Mendelssohn Hensel, Josephine Lang, Isabella Leonarda, Alma Mahler, Marianne Martinez, Mary Carr Moore, Florence Price, Luise Reichardt, Clara Wieck Schumann, Ethel Smyth, Barbara Strozzi, Maria Szymanowska, and Pauline Viardot-Garcia. Included also are indexes of topics and of composers and their works.

1641. Walker-Hill, Helen, ed. *Black Women Composers: A Century of Piano Music*. Bryn Mawr, PA: Hildegard Publishing Company, 09109, 1992.

    Includes: "Prayer Before Battle" (from *Four Moorish Pictures*) by Amanda Aldridge; *Prankster* by Mable Bailey; *Piano Etude No. 2* by Regina Harris Baiocchi; *Troubled Water* by Margaret Bonds; Selections from *Portraits in Jazz*, including "Billie's Song," "A Taste of Bass," and "Blues for the Duke," by Valerie Capers; *Cuba Libra* (Cuban Liberty March) by Anna Gardner Goodwin; "Spring Intermezzo" (from *Four Seasonal Sketches*) by Betty Jackson King; *Mother's Sacrifice* by L. Viola Kinney; *Preludes Nos. 1 and 2* by Tania León; *A Summer Day* by Lena Johnson McLin; *A Little Whimsey* by Dorothy Rudd Moore; *Before I'd Be a Slave* by Undine Smith Moore; *Prelude for Piano* by Julia Perry; *Homage* by Zenobia Powell Perry; *Fantasie Negre* by Florence B. Price; *Rippling Spring Waltz* by Estelle D. Ricketts; "Fortune Favored the Bold Prayer" (from *White Nile Suite*) by Philippa Duke Schuyler; Allegro Moderato (III) from *A Summer Afternoon in South Carolina* by Joyce Solomon; and *Nightlife* by Mary Lou Williams.

1642. Wenner, Hilda E., and Elizabether Freilicher, ed. *Here's to the Women: 100 Songs For and About American Women*. Syracuse, NY: Syracuse University Press, 1987.

    Reprinted in 1991 by Feminist Press, New York. Reviewed in *Library Journal* 112 (July 1987): 80; *Sing Out* 33 (Fall 1987): 109; *Folk Roots* 9 (January 1988): 43+. Songs (melodies with chord symbols), accompanied by a description of each song and brief notes on its composer or singer. Songs focus on the following themes: Friends and Lovers; Activism; Labor; Contemporary Issues; Growing Up; Role Models; Women Emerging. Includes a bibliography and discography.

1643. *Women Composers Series. Volume 21*. New York: Da Capo Press, 1988.

    Barbara Strozzi's *I sacri musicali affetti*. Cantatas for solo voice and continuo. Introduction by Ellen Rosand.

1644. *Women Composers Series*. Volume 22. New York: Da Capo Press, 1988.
Entitled *Anthology of Songs*, and with a new introduction by Susan C. Cook and Judy S. Tsou, this volume is comprised of works by four French women composers (dating from ca. 1820 to 1900) found in the University of Michigan Music Library's Women's Music Collection. The anthology includes works for voice and piano by Pauline Duchambge (1778–1858), Loïsa Puget (1810–1889), Pauline Viardot-Garcia (1821–1910) and Jane Vieu (1871–1955). Contents of the anthology is as follows: songs by Pauline Duchambge (*A Mon Ange Gardien, La Blanchisseuse de Fin, Cancione Amorosa, Les Cloches du Couvent, La Sincère*); songs by Loïsa Puget (*Appelle-moi ta Mère, La Bayadère, Le Ciel sur Terre, Demain, Je Serai Dame, Une Députation de Demoiselles, Fleur-de-Marie, Morte d'Amour, Le Postillon de Séville, La Petite Bergère, La Reine des Fous*); songs by Pauline Viardot-Garcia (*Berceuse Cosaque, Bonjour Mon Coeur, Les Cavaliers, Chanson de la Pluie, Der Jüngling und das Mädchen, Madrid, Rossignol, Rossignolet, Seize Ans, Sérénade Florentine, Die Soldatenbraut*); songs by Jane Vieu (*La Belle au Bois Dormant, Carillons Blancs, Chanson Fleurie, La Flûte de Bambou, Sérénade Japonaise*).

1645. *Women Composers Series. Volume 23*. New York: Da Capo Press, 1990.
Keyboard sonatas. Includes: Francesca Lebrun's *Six Sonatas for the Harpsichord or Pianoforte with an Accompaniment for a Violin or German Flute* (London, 1778); Marie-Emmanuelle Bayon's *Six sonates pour le clavecin ou le pianoforte dont trois avec accompagnement de violon oblige* (Paris, ca. 1765).

1646. *Women Composers Series. Volume 24*. New York: Da Capo Press, Forthcoming.
*Twenty-eight Songs* by Mary Carr Moore.

1647. *Women Composers Series. Volume 25*. New York: Da Capo Press, 1992.
*Twenty-three songs* by Amy Beach. Introduction by Mary Louise Boehm.

1648. "Women of the West: Heroines, Hurdy-Gurdies and Fashionable Women." In *Way Out in Idaho: A Celebration of Songs and Stories*. Comp. and intro. Rosalie Sorrels. Lewiston, ID: Confluence Press; Boise, ID: Idaho Commission on the Arts, 1991.
Folk-songs and stories from Idaho reflecting women's experiences.

# Sound Recording Anthologies

## Part A.  Concert Music:
## Contemporary and "Classical"

1649. *18 Divas Françaises: Historic Recordings 1908–1954*. France: Music
Memoria, 30221 (CD), 1989.
  Opera arias, recorded 1908–1954. Vocalists featured include Suzanne
Balguérie, Emma Calvé, Germaine Cernay, Renée Doria, Germaine Féraldi,
Georgette Frozier, Yvonne Gall, Lucette Korsoff, Jane Laval, Germaine
Lubin, Germaine Martinelli, Solange Petit-Renaux, Lily Pons, Maria de
Reszké, Fanely Revoil, Gabrielle Ritter-Ciampi, Charlotte Tirard, and Ninon
Vallin.

1650. Ars Femina Ensemble. *'Non tacete!': (I'll Not Be Silent)*. Louisville, KY:
Nannerl Recordings, NRARS 002 (CD and cassette), 1991.
  Baroque and classical music by women composers. Includes: *Cari
Musici* (motet) by Bianca Maria Meda; *Sonata in A Major*, for viola
d'amore, violoncello and cembalo, by Elisabeth-Claude Jacquet de La
Guerre; *Lamento*, for soprano, strings and continuo, by Elisabeth Olin;
*Sonata Quarta*, for violins and continuo, by Marianne Martinez; *A False
Designe To Be Cruel*, for soprano and virginal, by Mary Harvey, the Lady
Dering; *Se Pieta da Voi Trovo*, for soprano and strings, by Cecilia Maria
Barthélemon; Suite from *La Liberazione di Ruggiero* by Francesca Caccini.

1651. Bay Area Women's Philharmonic, and Joanne Falletta, conductor. *Baroquen
Treasures*. Providence, RI: Newport Classic, NCD 60102, 1990.
  Includes *Sinfonia in C* (1770) by Marianne Martinez; Sinfonia from *Il
sacrifizio di Abramo* (1709) by Camilla de Rossi; Suite from the ballet *Les*

*Genies* (1736) by Mlle. Duval; *Concerto No. 5 in B Flat for Violin* by Maddalena Laura Lombardini Sirmen; *Jonas*, Cantata No. 4 (1708), by Elisabeth-Claude Jacquet de La Guerre.

1652. Blees, Thomas, violoncello. *Musik für Violoncello und Klavier von Komponistinnen des 19. Jahrhunderts*. Maria Bergmann, piano acc. Münster, Germany: FSM, FCD 97 728 (CD), 1990.

    Translated title: *Music for Violoncello and Piano by Female Composers of the Nineteenth Century*. Includes: Louise Farrenc's *Sonata, Violoncello and Piano, op. 46*; Clara Faisst's "Adagio consolante" from her *Stücke, Violoncello and Piano, op. 7*; Luise Adolpha Le Beau's "Romanze" from her *Stücke, Violoncello and Piano, op. 24*; Emilie Mayer's *Sonata, Violoncello and Piano, D Major, op. 47*.

1653. Bourgonjen, Meta, alto. *Honneur aux dames*. Ro van Hessen, piano acc. Leeuwarden, The Netherlands: Stichting Famke, LP, 1987?

    Twentieth-century works for voice and piano by European women composers, including Elsa Barraine (*Le marché du monde*), Hanna Beekhuis (*Marc groet's morgens de dingen and Cupidootje*), Henriëtte Bosmans (*Liebestrunken*), Lili Boulanger (*Nous nous aimerons tant* and *Au pied de mon lit*), Marguérite Canal ("Les gondoles sont là" from *Jardin de l'infante*), Marcelle de Manziarly (*A son très cher et spécial* and *Chétive créature humaine*), Annie Mesritz van Velthuysen (*Allegro, Scherzo*, and *Finale*), Louise Vogel Van Der Wert (*Marc groet's morgens de dingen*), and Bertha Frensel Wegener-Koopman (*Do Not Go My Love*). Also includes vocal music by Cécile Chaminade (*Anneau d'argent*), Fanny Mendelssohn Hensel (*Italien*), and Clara Schumann (*Liebst du um Schönheit* and *An einem lichten Morgen*).

1654. Bournemouth Sinfonietta, Ariosa Chamber Orchestra, and Carolann Martin, conductor. *Journeys: Orchestral Works by American Women*. New York: Leonarda, LE 327 (CD), 1987.

    Reviewed in *Fanfare* 12, no. 1 (September/October 1988): 347; *American Music* 7, no. 4 (Winter 1989): 482–484. Includes: *Journeys* by Nancy Van de Vate; *Rainforest* by Kay Gardner; *Overture-Parachute Dancing* by Libby Larsen; *Lament* for string orchestra, by Marga Richter; *Summer Night* by Katherine Hoover (with soloists K. Hoover, flute, and Peter Kane, horn); *Elegy* by Ursula Mamlock; and *Perihelion II* for string orchestra, by Jane Brockman.

1655. Bratlie, Jorunn Marie, piano. *Ole Olsen and Seven Women Composers*. Oslo, Norway: Norsk Kulturråd, NKFCD 50024–2 (CD), 1991.

    Reviewed in *American Record Guide* 55, no. 2 (March/April 1992): 174. Includes: *Little Suite for Piano and String Orchestra* (with the Norwegian Radio Symphony conducted by Christian Eggen) by Ole Olsen;

*Nocturne* and *Humoreske* by Inger Bang Lund; *Barcarolle* op. 1/1 and *Scherzo* op. 1/2 by Borghild Holmsen; *Valse mélancolique* by Hanna Marie Hansen; *Kinderspiele* op. 15/3, *Romanse* op. 3, and *I Tanker* (In Thoughts, op. 19) by Mathilde Berendsen Nathan; *I Baaten* (In the Boat, op. 61/1) and *Legende* op. 16/1 by Signe Lund; *Spørgsmal og Svar* (Question and Answer) and *Halling* by Birgit Lund; *Baeken* (The Brook, op. 8/2), *Valmue* (Poppy, op. 5/1), and *Godt Humør* (In High Spirits, op. 4/1) by Anna Severine Lindeman.

1656. Briscoe, James, comp. *Historical Anthology of Music by Women [Companion Cassettes]*. Bloomington, IN: Indiana University Press, ISBN 025331268X, 1991.

Reviewed in *American Music Teacher* 42, no. 4 (February/March 1993): 65–66. Three cassettes. These recordings accompany the score anthology by the same title compiled and edited by James Briscoe, and selections are presented in the same order in which they occur in the anthology. The cassettes may also be used with *Women and Music: A History*, edited by Karin Pendle. Various recorded performances, some previously commercially released as noted. Published editions recorded, performers, and timings are also noted. There are no direct cross-references to the printed source they accompany, however.

1657. Clara Wieck Trio. *Trio g-Moll op. 17 [by] Clara Schumann. Trio d-Moll op. 11 [by] Fanny Mendelssohn Hensel*. Bietigheim, Germany: Bayer Records, 100 094 (CD), 1990.

Trios for violin, violoncello and piano.

1658. *Divas 1917–1939*. Charlottesville, VA: Nimbus Records, NI 1795 (3 CDs), 1990.

Boxed set of three separately issued discs of the singing of Rosa Ponselle (Nimbus NI 7805), Amelita Galli-Curci (Nimbus NI 7806), and Eidé Norena (Nimbus NI 7821).

1659. *Divas. Volume 1: 1906–1935*. Charlottesville, VA: Nimbus Records, NI 7802 (CD), 1989.

Reviewed in *American Record Guide* 53, no. 1 (January/February 1990): 128–129. Compilation of opera arias featuring sopranos Amelita Galli-Curci, Frieda Hempel, Nina Koshetz, Lilli Lehmann, Nellie Melba, Claudia Muzio, Mária Németh, Eidé Norena, Adelina Patti, Rosa Ponselle, and Luisa Tettrazzini.

1660. *Divas. Volume 2: 1909–1940*. Charlottesville, VA: Nimbus Records, NI 7818 (CD), 1991.

Reviewed in *ARSC Journal* 23, no. 1 (Spring 1992): 73–74. Compilation of opera arias featuring sopranos Geraldine Farrar, Mafalda Favero, Kirsten Flagstad, Amelita Galli-Curci, Mabel Garrison, Alma Gluck, Frieda Hempel, Maria Ivogün, Nina Koshetz, Selma Kurz, Frida

Leider, Eidé Norena, Sigrid Onégin, Rosa Ponselle, Lotte Schöne, Maggie Teyte, and Ninon Vallin.

1661. Duo Pontremoli. *Sonata in A Minor, Op. 34 [by] Amy Beach. Sonata No. 4 [by] Grazyna Bacewicz.* Baton Rouge, LA: Centaur, CRC 2119 (CD), 1992. Sonatas for violin and piano.

1662. Dwyer, Paula Ennis, piano. *New Dimensions: Music by Women.* Columbus, OH: Coronet Records, LPS 3127, 1987?
    Piano works by women composers including: *Of Shadows Numberless* (suite) by Miriam Gideon; *Second Sonata for Piano* by Nancy Van de Vate; *Hyperbolae* by Shulamit Ran; *Seven Macabre Songs for Piano* by Tina Davidson.

1663. Elizabethan Conversation, and Susan G. Sandman, musical director. *Early Music by Women Composers.* 1989.
    Audio cassette available from Susan G. Sandman, P.O. Box 148, Aurora, NY 13026 (315–364–8406). Music from the 12th to the 17th centuries by Queen Blanche of Castile, Maroie de Dregnau de Lille, Countess of Dia, Mary Harvey (The Lady Dering), and Anne Boleyn.

1664. Epstein, Selma, piano. *European Piano Teacher's Convention.* Dickeyville, MD: Chromattica USA (cassette), 1992.
    Recorded in London, July 1992. Includes piano works by: Amy Beach, Miriam Hyde, Agathe Backer-Grøndahl, Maria Hester Parke, Teresa Carreño, Grace Williams, Sarah Hopkins.

1665. Epstein, Selma, piano. *Japanese Tour, October 1989. Music by American Women Composers and Chopin.* Dickeyville, MD: Chromattica USA (cassette), 1989.
    Includes piano works by: Amy Beach, Jeraldine Herbison, Judith Zaimont, Radie Britain, Margaret Ruthven Lang, Florence Price, Beth Anderson, Elinor Remick Warren, Dianne Goolkasian-Rahbee, Tina Davidson, Vally Weigl, Philippa Duke Schuyler, Constance Runcie, and Alexandra Pierce. These performances are also available on video.

1666. Epstein, Selma, piano. *Mostly Romantic Music by Women Composers.* Dickeyville, MD: Chromattica USA (cassette), 1987.
    Recorded November 8, 1987 at Luton Industrial College, England. Includes the following piano works: *Song of Parting* by Leslie Epstein; *Visnet* op. 39/9 and *Nocturne* op. 20/2 by Agathe Backer-Grøndahl; *Bourrée* by Florence May; *Le Murmur* by Maria Szymanowska; *Mazurka* by Madeleine Dring; *Sonata in C Minor* op. 21 by Cécile Chaminade; *Sonata No. 1* by Julie Candeille; *In a May Morning* by John Ireland; *Bigelow March* by Ella Grainger; *Rhapsody in E Minor* by Margaret Ruthven Lang; *Étude d'amour* by Mana Zucca; *Fantasia Fugata* by Amy Beach.

343

1667. Epstein, Selma, piano. *Music by Women Composers: St. John's Smith Square, London, England*. Dickeyville, MD: Chromattica USA (cassette), 1989.

    Recorded May 20, 1989. Includes the following solo piano works: *Fantaisie* by Maria Theresia von Paradis; *Old Chapel by Moonlight* and *A Hermit Thrush at Eve* by Amy Beach, *Ostinato* by Alexandra Pierce, *Requiem* by Marga Richter, *Asmaradana* by Betty Beath, *Three Preludes* by Henriëtte Bosmans, *Sonatine* by Tera de Marez Oyens, *Opalescence* by Ruth Gipps, *Théme et variations* by Lili Boulanger.

1668. Epstein, Selma, piano. *A Musical Marathon*. Dickeyville, MD: Chromattica USA (cassette), 1992.

    Recorded March 1992, in Burlington, Vermont. Includes piano works by composers Violet Archer, Grazyna Bacewicz, Amy Beach, Gertrude van der Bergh, Teresa Carreño, Madeleine Dring, Fanny Mendelssohn Hensel, Dulci Holland, Helen Hopekirk, Miriam Hyde, Dolores White, and Marie Wurm.

1669. Epstein, Selma, piano. *National Women's Music Festival*. Dickeyville, MD: Chromattica USA (cassette), 1987.

    With Mavis Marso, piano (in the first and second works). Recorded at Indiana University, May 31, 1987. Includes: *Two Waltzes for Three Hands* by Maria Szymanowska; *Piano Concerto No. 6* by Maria Hester Parke; *Nocturne* op. 20/2 and *Visnet* op. 39/9 by Agathe Backer-Grøndahl; *Variations on a Theme of Robert Schumann* by Clara Schumann; *Sonata in C# Minor* by Ethel Smyth; *Ostinato 1985* by Alexandra Pierce; *Clotilde Kleeberg Gavotte* by Marie Wurm; and *Waltz Finale* by Madeleine Dring.

1670. Epstein, Selma. *Roundtable Discussion on Researching Women Composers*. Dickeyville, MD: Chromattica USA (cassette), 1992.

    Recorded in Seoul, Korea, November 23, 1992. With Korean women composers and Selma Epstein.

1671. Epstein, Selma, piano. *Seminar and Lecture-Recital on Black Composers*. Dickeyville, MD: Chromattica USA (cassette), 1993.

    Recorded February 1993, at San Diego State University. Includes works by composers Undine Smith Moore, Jeraldine Herbison, Rachel Eubanks, Avril Coleridge Taylor, Florence Price, and others.

1672. Epstein, Selma, piano. *Vrouw en muziek*. Dickeyville, MD: Chromattica USA (cassette), 1989.

    Recorded in Amsterdam, April 9, 1989. Includes: *Fantaisie* by Maria Theresia von Paradis; *Ostinato* by Alexandra Pierce; *Opalescence 72* by Ruth Gipps; *The Lake at the Evening* by Helen Gipps; *Valse française* by Madeleine Dring; *Old Chapel by Moonlight*, *Nocturne* op. 107, and *Hermit Thrush at Eve* by Amy Beach; *Un morceau* by Lili Boulanger; *Requiem* by

Marga Richter; *Asmaradana* by Betty Beath; *Angklung* by Anne Boyd; *Three Preludes* (1918) by Henriëtte Bosmans; and *Sonatine* (1963) by Tera de Marez Oyens.

1673. Epstein, Selma, piano. *Women Composer: An International Sampler.* Dickeyville, MD: Chromattica USA (cassette), 1988.

Recorded March 24, 1988 at Radio Station 4 MBS-FM, Brisbane, Australia. Includes: *Angklung* by Anne Boyd; *Bourrée* by Florence May; *Fantaisie* by Maria Theresia von Paradis; *Song Without Words* by Fanny Ralston; *Variations for Piano* op. 57a by Ruth Gipps; *Grande Sonate No. 1* by Julie Candeille; *Valse française* and *American Dance* by Madeleine Dring; *Requiem* by Marga Richter; *Young Birches* by Amy Beach; *Scherzo* op. 47 by Louise Farrenc; *Two Dances* by Katherina Kozeluch Cibbini; *Festa* by Elizabeth Poston; and *Troubled Waters* by Margaret Bonds.

1674. Epstein, Selma, piano. *Women Composers.* Dickeyville, MD: Chromattica USA (cassette), 1988.

Recorded April 6, 1988 at California State University, Hayward. Includes: *Fantaisie* by Maria Theresia von Paradis; *Evening by the Sea* by Helene Gipps; *Piano Variations* by Ruth Gipps; *Grande Sonate No. 1* by Julie Candeille; *Valse française* and *American Dance* by Madeleine Dring; *Requiem* by Marga Richter; *Young Birches* by Amy Beach; *Scherzo* by Louise Farrenc.

1675. Epstein, Selma, piano. *Women in Arts.* Dickeyville, MD: Chromattica USA (cassette), 1990.

Recorded April 1990, in Liverpool, England. Includes works by: Rebecca Clarke, Florence May, Elizabeth Maconchy, Jeanne Walraven, Maria Hester Parke, Constance Runcie, Grazyna Bacewicz, Betty Beath, Anne Boyd, Marjolijn Anstey, Philippa Duke Schuyler, Margaret Bonds, Jeraldine Herbison, Avril Coleridge Taylor, Luise Adolpha Le Beau, and Agathe Backer-Grøndahl.

1676. Epstein, Selma, piano. *Women in Music Festival, Georgia State University, Atlanta, GA.* Dickeyville, MD: Chromattica USA (cassette), [1991].

Premieres of works by Australian women composers: Miriam Hyde, Betty Beath, Mona McBurney, Sarah Hopkins, Dulci Holland.

1677. Estampie (Musical Group). *A Chantar: Songs of Women— Courtly Love in the Middle Ages.* S.l.: Christophorus, CD 74583, 1990?

Reviewed in *Continuo* 14, no. 6 (December 1990): 28.

1678. Fanny Mendelssohn-Quartett, and Céline Dutilly, piano. *Works by Fanny Mendelssohn Hensel, Gloria Coates, and Violeta Dinescu.* Ludwigsburg Egolsheim, Germany: Tonstudio Bauer, 69511 (LP), 1988.

Distributed by Frauenmusik Vertrieb (Düsseldorf, Germany). Includes: *Piano Quartet in A Flat Major* by Fanny Mendelssohn Hensel; *String Quartet No. 3* by Gloria Coates; *Terra Lonhdana* by Violeta Dinescu.

1679. Field, Lucille, voice. *Lucille Field Sings Songs by American Women Composers*. Harriet Wingreen, piano acc. Lomita, CA: Cambria Records CD 1037 (CD), CT 1037 (cassette), 1990.

Includes: Five Songs from *Sonja* by Patsy Rogers; *Five Songs on Texts by Carl Sandburg* by Ruth Crawford Seeger; *Songs for the Four Parts of the Night* by Nancy Van de Vate; *Ayelet Hashakhar* (Morning Star) by Miriam Gideon; *Four Songs* by Florence B. Price; *Three Songs* by Dorothy Klotzman.

1680. Funseth, Solveig, piano. *Women Composers*. Stockholm: Swedish Society Discofil, SCD 1043, 1988.

Reviewed in *Fanfare* 13, no. 1 (September/October 1989): 418; Nordic Sounds (March 1989): 10–11. Piano music by women composers including: *Nocturne in B Flat Major* by Maria Szymanowska; *Lied* (op. 2/1), *Pastorella*, and *Melodie* by Fanny Mendelssohn Hensel; *Romances* (op. 11/1 and op. 21/1) by Clara Schumann; *Fem smärre Tonbilder* (Five Small Tone Pictures, op. 7) by Elfrida Andrée; *Novelette* (op.25/1), *Gavotte* (op. 25/2), *Intermezzo* (op. 25/3), *Laendler* (op. 36/7), and *Albumblatt* (op. 59/5) by Agathe Backer-Grøndahl; *Vågornas Vaggsång* (Lullaby of the waves, op. 7/1), *Valse* (op. 8/2), *Scherzo* (op. 8/5) and *Mazurka* (op. 7/2) by Laura Valborg Aulin; *D'un vieux jardin, D'un jardin clair*, and *Cortege* by Lili Boulanger.

1681. Goldberg, Loretta, pianos. *Soundbridge*. Greenville, ME: Opus One, CD 152, 1991.

Contemporary works by women composers for the piano, MIDI-grand piano, and quartertone piano. Reviewed in *International League of Women Composers (ILWC) Journal* (September 1991): 16. Works for MIDI-grand piano include: *90s: A Calender Bracelet* by Sorrel Hays and *Rhapsody* by Daria Semegen. Works for traditional piano include: *Past Present* by Sorrel Hays; *Second Piano Sonata (The Peyote)* by Tui St. George Tucker; and *Red Mesa* by Annea Lockwood. One work for quartertone piano is featured: *My Melancholy Baby: Fantasy on the Famous Theme by Ernie Burnett* by Tui St. George Tucker.

1682. *Great Soprano Cabalettas*. Legato Classics, LCD–161–1 (mono CD), 1990.

Reviewed in *American Record Guide* 53, no. 5 (September/October 1990): 150. Live performances 1940–1988. Works by Verdi, Donizetti, Rossini, Bellini and Meyerbeer performed by Montserrat Caballe, Maria Callas, Anita Cerquetti, Maria Chiara, Magda Olivero, Elena Souliotis, Leontyne Price, Katia Ricciarelli, and others.

1683. *Great Sopranos of our Time.* Hollywood, CA: Angel, CDM 62040, 1988.
Featuring Montserrat Caballe ; Maria Callas; Ileana Cotrubas; Mirella Freni; Edita Gruberova; Elisabeth Schwarzkopf; Renata Scotto; Joan Sutherland; Victoria de los Angeles.

1684. Harbach, Barbara, harpsichord. *18th Century Solo Harpsichord Music by Women Composers, Vol. 2.* Nashville, TN: Gasparo Records, GSCD 281 (CD), 1990.
Reviewed in *Gramophone* 67 (December 1989): 1170; *Fanfare* 14, no. 2 (November/December 1990): 438. Includes: *Lesson VI in D Major* by A Lady; *Sonata in G Major* op. 3 by Cecilia Maria Barthélemon; *Concerto in E Flat Major* and *Sonata in C Major* op. 7 by Maria Hester Parke; and *Lesson I* (G Minor) and *Lesson II* (G Major) by Elizabeth Turner.

1685. Harbach, Barbara, harpsichord. *Music for Solo Harpsichord by 18th Century Women Composers.* London, England: Kingdom Records, KCLCD 2010 (CD), 1989.
Reviewed in *Fanfare* 13, no. 2 (November/December 1989): 276–278; *Pan Pipes* 82, no. 1 (Fall 1989): 6; *Fanfare* 13, no. 4 (March/April 1990): 366. Includes: *Sonata in E* op. 1/3 by Cecilia Maria Barthélemon; *Sonata in E* (1765) and *Sonata in A* by Marianne Martinez; *Sonata in E Flat Minor* by Marianna d'Auenbrugg; *Five Pieces* (from op. 2) by Elisabetta de Gambarini; *Sonata in F* by Maria Hester Parke.

1686. Harbach, Barbara, organ. *Women Composers for Organ.* Jaffrey, NH: Gasparo, GSCD-294 (CD), 1993.
Includes: *Sonatina* by Violet Archer; *Conditor Alme* by Gracia Baptista; *Prelude on an Old Folk Tune* by Amy Beach; *On an Ancient Alleluia* by Roberta Bitgood; *Passacaglia* by Edith Borroff; *Prelude et Fugue* by Jeanne Demessieux; *Fanfare* and *Toccata* by Barbara Harbach; *Prelude* by Fanny Mendelssohn Hensel; *Quantum Quirks of a Quick Quaint Quark* (no. 2) by Marga Richter; *Prelude* and *Fugue* by Clara Schumann; *A Dirge for Funerals* by Miss Steemson; *Psalm 104 "Hanover"* and *Fugue* by Elizabeth Stirling; *Sonnet* by Mary Jeanne van Appledorn; *Preludium und Fuge* by Grete von Zieritz; *In Celebration* by Gwyneth Walker.

1687. Harnisch, Christine, piano. *Concerto Etudes and Toccatas by 19th and 20th Century Women Composers.* Staufen, Germany: Aurophon, AU 31473 (CD), 1991.
Includes: *Etudes* (nos. 5, 7, 8, 9, 10) and *Nocturne* ("Le Murmure") by Maria Szymanowska; Selections from *10 Etudes* (nos. 1, 3, 4) by Grazyna Bacewicz; *En Route* (Etude caractéristique, op. 4) by Wanda Landowska; Selections from *Six Etudes de Concert* op. 11 by Agathe Backer-Grøndahl; *Toccata* ("Die Maschine") by Maria Hofer; Étude and the Toccatina from *Soirées Musicales* by Clara Schumann; *Toccata in C Minor* op. 39, *Automne*

op. 35, *Étude Pathétique* op. 124, and *Étude Romantique* op. 132 by Cécile Chaminade.

1688. Heidelberger Madrigalchor, and Gerald Kegelmann, cond. *Chöre und Lieder [von] Lili Boulanger, Fanny Hensel und Clara Schumann.* Bietigheim, Germany: Bayer Records, BR 100 041 (CD), BR 30 041 (LP), 1989.

    With Mitsuko Shirai and Regine Böhm, mezzos; Christine Friedek, soprano; Bernhard Gärtner, tenor ; Hartmut Holl and Sabine Eberspächer, pianos. Reviewed in *Fanfare* 13, no. 2 (November/December 1989): 276–278. Works by Lili Boulanger include: *Les Sirènes*, for soprano, chorus and piano; *Renouveau*, for soprano, alto, and tenor solo, chorus and piano; *Hymne au soleil*, for alto solo, chorus and piano; *Soir sur la plaine*, for soprano and tenor solo, chorus and piano; *Four Songs*, for mezzo-soprano and piano. Works by Fanny Mendelssohn Hensel include: *Gärtenlieder* op. 3 (six songs for SATB). Works by Clara Schumann include: *Drei gemischte Chöre nach Gedichten von Emanual Geibel* (1848), for 4-part a capella chorus.

1689. *Jewel Box.* New York: Tellus, No. 26 (CD and cassette), 1992.

    New music and audio art compositions by women composers associated with the Harvestworks AIR program. Issued by *Tellus: the Audio Magazine*, 596 Broadway (#602), New York, NY 10012. Includes: *Blue Harp Studies* nos. 1 and 2, for harp and electronics, by Anne LeBaron; *Story Road*, for voice and electronics, text by Melody Sumner and electronics by Laetitia Sonami; *Navai*, for unaccompanied vocal ensemble, by Sussan Deihim and with texts from the poetry of Hafez Roumi-Tabib; *EO-9066*, for vocal quartet and electronics, by Bun-Ching Lam; *Smell*, for voice and percussion, by Catherine Jauniaux and Ikue Mori; *Boys Love Baseball*, poetry recitation with musical accompaniment, by Sapphire; *Ruler Etude*, electronic music, by Mary Ellen Childs; *Coordinated Universal Time*, for live vocals, sampled vocals, violin, violoncello, percussion and harmonium, by Michelle Kinney.

1690. *Joya: Works by Women Composers from Around the World.* Lomita, CA: Cambria Records, CT-1040 (cassette), 1989.

    Includes: *Joya* by Haruna Aoki; *Missa Brevis*, for concert choir, by Ruth Henderson; *Big Sur Triptych* by Deon Price.

1691. *Lieder by Women Composers from the Classical Period to Modern Times. Volume 1: From Maria Walpurgis to Clara Schumann.* Ocean, NJ: Musical Heritage Society, MHS 512350 Z (CD) ; MHS 312350 H (cassette), 1989.

    Performed by: Yoshie Tanaka, mezzo-soprano; Wolfgang Holzmair, baritone; Yasuko Mitsui and Rosario Marciano, pianos. Reviewed in *Musical Heritage Review* 13, no. 7 (Release No. 421)(1989): 48. Includes lieder by Maria Walpurgis (*Prendi l'ultimo addio*), Anna-Amalia, Duchess of Saxe-Weimar (*Sie scheinen zu spielen*), Corona Schröter (*Für Männer*

*uns zu plagen*; *Jugendlied*), Maria Theresia von Paradis (*Endlich winkt der Freund der Müden*; *Es war einmal ein Gärtner*; *Ihr Lieben, die ich Schwermuthsvolle*), Maria Szymanowska (*Peine et plaisir*; *Le connais-tu?*), Luise Reichardt (*Unruhiger Schlaf*; *Wassernoth*; *Daphne am Bach*; *Heimweh*; *Nach Sevilla!*), Bettina von Arnim (from *Faust*), Fanny Mendelssohn Hensel (*Sehnsucht*; *Die Nonne*; *Duett*; *Heimweh*; *Verlust*), and Clara Schumann (*Liebst du um Schönheit*; *An einem lichten Morgen*).

1692. Lontano (Musical Group), and Odaline de la Martinez, conductor. *British Women Composers. Volume 1*. England: Lorelt, LNT 101 (CD), 1992.

Reviewed in *Tempo* 182 (September 1992): 64, 66. Contemporary music for voice(s) and instrumental ensemble. Includes *It All Depends on You* by Errollyn Wallen; *The Road is Wider than Long* by Lindsay Cooper; *My Dark Heart* by Elizabeth Maconchy; *The Old Woman of Beare* by Nicola Lefanu.

1693 Lontano (Musical Group), and Odaline de la Martinez, conductor. *British Women Composers. Volume 2*. England: Lorelt, LNT 103 (CD), 1993.

Reviewed in *Classic CD* 35 (April 1993): 67. Contemporary chamber and vocal music. Includes: *Canciones* by Odaline de la Martinez; *Airs from Another Planet* by Judith Weir; *Pibroch* by Melinda Maxwell; *Winter Sun, Summer Rain* by Hilary Tann; and the Suite from the ballet *Dancing with the Shadow* by Eleanor Alberga.

1694. Luzzaschi, Luzzasco. *The Secret Music of Luzzasco Luzzaschi: 'Madrigali a uno, due e tre soprani' (1601) for the Ladies of Ferrara*. Musica Secreta, vocal ensemble. Wotton-Under-Edge, Gloucestershire, England: Amon Ra Records, CD SAR 58, 1992.

Madrigals for one, two, and three voices, written by the composer for the *concerto delle donne*.

1695. Mabry, Sharon, soprano. *Music by Women Composers. Volume 3*. Rosemary Platt, piano acc. Columbus, OH: Coronet Records, LPS 3127, 1987.

Songs for soprano and piano. Reviewed in *Pan Pipes* 80 (Fall 1987): 18. Includes: *Chants* ("Attente," "Reflets," "Le Retour") by Lili Boulanger; "The Kingfisher" and "April Rise" from *Songs of Earth and Air* by Rhian Samuel; *Goethe Lieder* by Mary Howe; *Irreveries from Sappho* by Elizabeth Vercoe. Volumes 1 and 2 of this series issued on Coronet LPS 3105 and LPS 3121.

1696. Macalester Trio. *Chamber Works By Women Composers*. Hackensack, NJ: Vox Box, CDX 5029 (CD), 1991.

With accompanying soloists Robert Zelnick (violin), Tamas Strasser (viola), and Paul Freed (piano). Originally issued in LP format in 1979 on Vox SVBX 5112. Includes: *Trio for Piano, Violin, Violoncello, G Minor* op. 17 by Clara Schumann; *Trio for Piano, Violin, Violoncello* op. 150 by Amy

Beach; *Sonata in C# Minor for Violin and Piano* by Germaine Tailleferre; *Nocturne and Cortège* by Lili Boulanger; *Trio for Piano, Violin, Violoncello, D Minor* op. 11 by Fanny Mendelssohn Hensel; *String Quartet in B Minor* by Teresa Carreño; *Trio No. 1 for Piano, Violin, Violoncello, G Minor* op. 11 by Cécile Chaminade.

1697. Marin, Susana, piano. *Susana Marin Plays Works by Spanish Women Composers*. England: RNE, M3/03 (CD), 1992.

   Dist. by Scott Butler Disc and Tape Factors, Unit 2, Lansdowne Mews, Charleton Lane, London SE7 8AZ.

1698. Musica Femina, flute/guitar duo. *Returning the Muse to Music*. P.O Box 15121, Portland, OR 97215: Lilac Recordings, D-3 (CD; also available on cassette) , 1989.

   Dist. also by Ladyslipper Inc., P.O. Box 3124-R, Durham, N.C. 27715. Kristan Aspen, flute; Janna MacAuslan, classical guitar. Includes works by Francesca Caccini, Therese Edell, Theresa Clark, Isabella Leonarda, Maria Theresia von Paradis, Janna MacAuslan, Gwyneth Walker, and Elisabeth-Claude Jacquet de La Guerre, as well as a work from *Jane Pickering's Lute Book*.

1699. Rees, Leanne, and Stephanie Stoyanoff, piano duo. *Rees and Stoyanoff, Duo Pianists: Music by American Women Composers*. Bethesda, MD: Bravura, BR 1001, 1988.

   Dist. American Women Composers, 1690 36th St. NW, Suite 409, Washington, D.C. Reviewed in *Fanfare* 12, no. 2 (March/April 1989): 368–369; *American Record Guide* 52, no. 6 (November/December 1989): 160. Includes: *Toccata for Two* by Melissa Postnikoff; *American Dance Suite* by Julia Smith; *Sonata for Two Pianos* by Esther Williamson Ballou; Prelude from the *Suite for Two Pianos* by Amy Beach; *Capitol Trilogy* by Harriet Bolz; *Maria's Rags* by Jean Butler.

1700. Sephira Ensemble Stuttgart, and Rosina Sonnenschmidt, soprano. *Kurtisane und Nonne*. Bietigheim-Sissingen, Germany: Bayer, 100 078—100 079 (2 CDs), 1991.

   Reviewed in *Fanfare* 14, no. 4 (March/April 1991): 466–467; *Musica* (Germany) 45, no. 2 (March/April 1991): 123–124. Italian solo cantatas, motets, and songs, with instrumental accompaniment, by Barbara Strozzi and Isabella Leonarda. Works by Barbara Strozzi: Selections from *Diporti di Euterpe* ("Lagrime mie"; "Non occore"; "Tradimento!"; "Appresso a i molli argenti"); selections from *Ariette* op. 6 ("Lilla dici"; "Miei pensieri"); selections from *Arie* op. 8 ("Luci belle"; "Hor che Apollo"); "Soccorete luci avare," from *Cantate, ariette e duetti*, op. 2. Works by Isabella Leonarda: Nos. 2 and 12 from her *Sonata* op. 16; "Alta del ciel regina," from *Motets* op. 14 ; "Veni amor, veni Jesu," from *Motets*, op. 15.

1701. Sinfonye, and Stevie Wishart, musical director. *Bella Domna-The Medieval Woman: Lover, Poet, Patroness and Saint*. London: Hyperion, CDA 66283 (CD), A 66283 (LP), KA 66283 (cassette), 1988.

    Reviewed in *American Record Guide* 51 (September/October 1988): 105–106; *Fanfare* 12 (September/October 1988): 325–326. Troubadour and trouvère vocal and instrumental music. Includes: *Cantigas de amigo* by Martin Codax; *Onques n'amai tant que jou fui amee* by Richard de Fournival; *A chantar m'er de so qu'ieu non volria* by the Countess of Dia; and anonymous vocal and instrumental selections from the 13th and 14th centuries.

1702. Sinfonye, and Stevie Wishart, musical director. *'The Sweet Look and the Loving Manner': Trobairitz Love Lyrics and Chansons de Femme from Medieval France*. London: Hyperion, CDA 66625 (CD), 1993.

    Reviewed in *Fanfare* 17, no. 1 (September/October 1993): 353.

1703. Thomas, Anne Marsden, organ. *The Feminine Touch*. St. Albans, England: Lammas, LAMM 077C (cassette only; also available from Furore-Verlag, fue 1104), 1988.

    Organ music by women composers. Includes: *Pièces sur des airs populaires flamands* by Nadia Boulanger; *Prelude and Fugue for Organ, No. 2* by Elsa Barraine; *Te Deum* by Jeanne Demessieux; *Short Chorale Preludes* by Ethel Smyth; *English Pastorale* by Freda Swain.

1704. *Women and Technology. Concert/Radio Program*. Iowa City, IA: Elizabeth Hinkle-Turner, 1992.

    Available in DAT and cassette formats on a rental basis only. Electro-acoustic music by women composers, compiled by Elizabeth Hinkle-Turner. Features the music of Daria Semegen, Laurie Spiegel, Anna Rubin, Priscilla McLean, Carla Scaletti, Elizabeth Hinkle-Turner, Cindy McTee, Sally Reid, Sylvia Pengilly, Joanne D. Carey, and Jean Eichelberger Ivey. Recipients are responsible for any performance rights fees. For orders or more information contact Elizabeth Hinkle-Turner, Experimental Music Studios, School of Music, University of Iowa, Iowa City, IA. (319) 335–1666.

1705. *Women at an Exposition: Music Composed by Women and Performed at the 1893 World's Fair in Chicago*. Westbury, NY: Koch International Classics, 3–7240–2H1, 1993.

    Reviewed in *Fanfare* 17, no. 1 (September/October 1993): 373–374. Performed by Sunny Joy Langton, soprano; Susanne Mentzer, mezzo-soprano; Elaine Skorodin, violin; Kimberly Schmidt, piano. Works by Amy Beach include: *Singing Joyfully* (vocal duet); *Romance for Violin and Piano* op. 23; *Sweetheart, Sigh No More* (song); *In Autumn* (piano solo). Works by Cécile Chaminade include: *Rosemonde* (song); *Chanson brétonne* (piano solo); *L'été* (song). Songs by Kate Vannah include: *Good Bye, Sweet Day*. Songs

by Liza Lehmann include: her realization of Thomas Arne's *Polly Willis*; *Titania's Cradle*. Songs by Maude Valerie White include: *The Throstle*; *Ici Bas*. Works by Clara Kathleen Rogers include: two selections from *Browning Songs* op. 27 ("Ah, Love But A Day" and "Out of My Own Great Woe"); *Sonata for Violin* op. 25. Songs by Mary Knight Wood include: *Ashes of Roses*. Songs by Clara Schumann include: "Liebst du um Schönheit" (from *Lieder* op. 12).

1706. *Women Composers and Their Music: An Historical Sampling from the Middle Ages to the Present*. New York: Leonarda Records, LP1–1 (v.1); LP1–2 (v.2) (cassettes), 1988.

    Reviewed in *AWC News/Forum* 9 (Spring/Summer 1991): 15–16. A two-cassette sampler of music from Leonarda Records LP catalog, with voice-over composer interviews and commentary.

1707. *Women Composers: The Lost Tradition Found*. Tape Supplement to the Book. New York: Leonarda Productions, LPI 3–4 (two cassettes), 1988.

    Accompanying tapes to Diane Peacock Jezic's book by the same title. Tape 1, side 1: Medieval, Baroque, Classical. Tape 1, side 2: Romantic Songs. Tape 2, side 1: Instrumental Music. Tape 2, side 2: Six Living U.S. Composers. Notes refer to numbered examples in the book. Some examples previously released by Leonarda, as noted. Published editions recorded, performers, and timings are included in the program notes.

1708. Women's Philharmonic, and Joanne Falletta, conductor. *The Women's Philharmonic*. With Angela Cheng (piano) and Gillian Benet (harp). Westbury, NY: Koch International, 3–7169–2 H1 (CD), 1992.

    Reviewed in *International League of Women Composers (ILWC) Journal* (October 1992): 26; *American Record Guide* 56, no. 2 (March/April 1993): 158–159; *Time* 141 (January 18, 1993): 65. Includes: *Ouverture* (c. 1830) by Fanny Mendelssohn Hensel; *Piano Concerto in A Minor* op. 7 by Clara Schumann; *Concertino for Harp and Orchestra* by Germaine Tailleferre; *D'un soir triste* and *D'un matin de printemps* by Lili Boulanger.

# Part B.   Recordings in Various Popular Genres

1709. Anna Crucis Women's Choir. *But We Fight For Roses Too*. Philadelphia, PA: Anna Crucis Women's Choir, cassette, 1990.

    Distributed by Ladyslipper. Established in 1975, and (according to the liner notes) "the oldest feminist choir in the United States," this women's choral ensemble presents a varied repertoire of feminist music, songs of social activism, and multicultural women's music.

1710. *Antone's Women: Bringing You the Best in Blues*. Austin, TX: Antone's Records, ANT 9902 (CD or cassette), 1992.

Reviewed in *Living Blues* 105 (September/October 1992): 66+. Billing itself as the first ever all-female contemporary blues compilation, this sampler features Marcia Ball, Lou Ann Barton, Angela Strehli, Sarah Brown, Barbara Lynn, Sue Foley, Toni Price, and Lavelle White.

1711. *Best of the Girl Groups. Volume 1*. Santa Monica, CA: Rhino Records, R2 70988 (CD), 1990.

Selections by The Shangri-Las, The Chiffons, The Dixie Cups, The Ad Libs, Betty Everett, The Jaynetts, The Shirelles, Claudine Clark, The Exciters, Skeeter Davis, The Jelly Beans, Cher, and Evie Sands.

1712. *Best of the Girl Groups. Volume 2*. Santa Monica, CA: Rhino Records, R2 70989 (CD), 1990.

Selections by The Angels, The Chiffons, Little Eva, The Toys, The Raindrops, Ellie Greenwich, The Cookies, The Murmaids, The Honeys, The Shirelles, The Exciters, Robin Ward, Carole King, The Caravelles, The Essex, The Paris Sisters, and Joanie Sommers.

1713. *Better Boot That Thing: Great Women Blues Singers of the 1920's*. New York: RCA/Bluebird, 07863-66065-2 (CD), 07863-66065-4 (cassette), 1992.

Features: Alberta Hunter (*I'll Forgive You 'Cause I Love You But the Wrongs You've Done I Can't Forget, I'm Gonna Lose Myself Way Down In Louisville, My Daddy's Got A Brand New Way To Love, Sugar, Beale Street Blues*); Bessie Tucker (*Fort Worth and Denver Blues, Penitentiary, Better Boot That Thing, Bogey Man Blues, Whistling Woman Blues*); Victoria Spivey (*Blood Hound Blues, Dirty Tee Bee Blues, Moaning the Blues, Telephoning the Blues, Showered with Blues*); and Ida May Mack (*Wrong Doin' Daddy, Elm Street Blues, When You Lose Your Daddy, Mr. Forty Nine Blues, Good-bye Rider*).

1714. *Blues Ladies. Volume One (1934–1937)*. Vienna, Austria: Document Records, DLP 579, 1989.

With Billie McKenzie, Irene Sanders, Trixie Butler, Za Zu Girl.

1715. *Blues with the Girls*. France: EPM Musique, FDC 5508 (CD), 1989.

Dist. Qualiton Imports. With Big Time Sarah, Bonnie Lee, and Zora Young. Recorded in Paris, 1982.

1716. *Blues Women, with Taft Jordan, 1952*. England: Krazy Kat, KK 793, [1988].

Performed by Irene Redfield, Millie Bosman, and Beulah Bryant. Reviewed in *Living Blues* 19, no. 3 [Issue no. 80] (May/June 1988): 43.

1717. *Canaille—International Women's Festival of Improvised Music*. P.O. Box 468, CH 8024, Zürich, Switzerland: Intakt Records, 002, 198?

    U.S. Dist. North Country Distributors, Cadence Building, Redwood, NY 13679. Includes music by Lindsay Cooper, Maggie Nicols, Flora St. Loop, Annemarie Roelofs, Co Streiff, Mariette Roupe van der Voort, Maud Sauer, Maartje Ten Hoorn, Elvira Plenar, Irène Schweizer, Joëlle Léandre, Petra Ilyes, and Marilyn Mazur.

1718. Catlin, Amy, prod. and comp. *Apsara: The Feminine in Cambodian Art*. Los Angeles, CA: Apsara Media, 1987. 1 cassette.

    Recordings of Cambodian musicians living in Southern California and in refugee camps in Thailand. Accompanies the exhibition catalog by the same title. Includes Cambodian (Khmer) wedding music, classical dance music, and Ayay dialogue songs.

1719. Catlin, Amy, comp. and prod. *Virgins, Orphans, Widows, and Bards: Songs of Hmong Women*. Los Angeles, CA: The Woman's Building, 1987. 1 cassette.

    Available from The Woman's Building Gallery, 1727 N. Spring St., Los Angeles, CA 90012. Reviewed in *Ethnomusicology* 32, no. 2 (Spring/ Summer 1988): 164. Songs sung by Hmong women of Laos. Selections include *Orphan's song, Daughter-in-law's song, Love song, Widow's song, Song of Homesickness, Schooling Song*.

1720. *Chanteuses*. New York: Verve Records, 314 513 463–2 (CD), 314 513 463–4 (cassette), 1992.

    Female jazz vocalists including: Ella Fitzgerald, Anita O'Day, Blossom Dearie, Sarah Vaughan, Dinah Washington, Nina Simone, Shirley Horn, Helen Merrill, Monica Zetterlund, Patti Page, Billie Holiday, and Pearl Bailey.

1721. *Chanteuses de jazz: 1921–1939*. France: L'Art Vocal, L'Art Vocal 7 (CD), 1990.

    Dist. Qualiton Imports. Jazz circa 1920–1940. Katie Crippen with Henderson's Novelty Orchestra; Lena Wilson, with Porter Grainger; Eva Taylor, with the Clarence Williams' Blue Five; Edmonia Henderson; Bertha "Chippie" Hill; Alberta Hunter; Adelaide Hall with Duke Ellington and his orchestra; Baby Cox with Duke Ellington and his orchestra; Bessie Smith; Victoria Spivey with the Luis Russell Orchestra; Ivie Anderson with Duke Ellington and this orchestra; Gladys Palmer with Roy Eldridge and his orchestra; Billie Holiday with Teddy Wilson and his orchestra; Lil Armstrong and her swing orchestra; Helen Humes with Count Basie and his orchestra; Ethel Waters; Thelma Carpenter with Coleman Hawkins and his orchestra; Laurel Watson with Roy Eldridge and his orchestra.

1722. *Chants des femmes de la vieille Russie: Traditions de Kiéba, Br'ansk et des Simielski de Sibérie*. Paris: Maison des Cultures du Monde, W 260018, 1990.

Dist. Auvidis. Translated title on container: *Women's Songs from Old Russia*. Françoise Gründ, compiler. Recorded in 1990. Notes and song texts in French with English translations.

1723. Eskin, Virginia, piano. *Fluffy Ruffle Girls: Women in Ragtime*. Boston, MA: Northeastern, NR 9003–CD, 1992.

Reviewed in *American Record Guide* 56, no. 2 (March/April 1993): 171. Ragtime by early twentieth century and contemporary women composers: Marion Davis' *Fluffy Ruffle Girls*; May Aufderheide's *Novelty Rag, Totally Different Rag, Richmond Rag, The Thriller, Dusty Rag, Buzzer Rag*; Geraldine Dobyns' *Possum Rag*; Julia Lee Niebergall's *Horseshoe Rag, Red Rambler Rag, Hoosier Rag*; Irene Cozad's *Eatin' Time*; Judith Lang Zaimont's *Reflective Rag, Judy's Rag*; Charlotte Blake's *That Poker Rag, That Tired Rag*; Irene Giblin's *Sleepy Lou, Black Feather Two-Step, Chicken Chowder*; Imogene Giles' *Red Peppers*; Gladys Yelvington's *Piffle Rag*; Mary Baugh Watson's *Dish Rag*; Adaline Shepherd's *Pickles and Peppers*. All selections previously released on *Pickles and Peppers* (1987), with the exception of the title song and Irene Giblin's *Black Feather Two-Step*.

1724. Eskin, Virginia, piano. *Pickles and Peppers, and Other Rags by Women*. Boston, MA: Northeastern Records, NR 225 (LP), 1987.

Reviewed in *Fanfare* 11 (September/October 1987): 368. Early twentieth-century and contemporary ragtime by women composers. For contents see entry for Eskin's *Fluffy Ruffle Girls*.

1725. *Female Country Blues Singers (1929–1931)*. Vienna, Austria: Document, DLP 586, 1990?

Reviewed in Frank Scott's *Down Home Guide to the Blues* (Chicago, IL: Down Home Music 1991. p. 208). More in the style of vaudeville than country blues, this recording features Alura Mack, Lena Matlock, and Lillie Mae.

1726. *Female Country Blues. Vol. 1: The Twenties (1924–1928)*. Vienna, Austria: RST/Story of Blues, CD–3529, 1992.

Dist. by D. A. Music USA, 362 Pinehurst Lane, Marietta, GA 30068. Previously released on LP on RST/Blues Documents BD–2040. Reviewed in *Living Blues* 105 (September/October 1992): 79+. Blues by Anna Lee Chisolm, Virginia Childs, Eva Parker, Cora Perkins, and Lulu Jackson.

1727. *First Ladies of Jazz*. New York: Savoy Jazz, ZDS 1202 (CD), 1989.

Mary Lou Williams; Jutta Hipp with Hans Koller; Beryl Booker Trio with Don Byas.

1728. *First Ladies of Rap*. Plymouth, MN: K-tel International, 6038–2 (CD), 1992.

Selections by Queen Latifah, Sister Souljah, MC Trouble, MC Smooth, Nikkie D., J.J. Fad, Oaktown's 3.5.7., Def Dames, Get Fresh Girls, and Monie Love.

1729. *Forty Years of Women in Jazz: A Double Disc Feminist Retrospective*. New York: Jass/Stash Records, J-CD 9—J-CD 10 (2 CDs), 1989.

Reviewed in *Mississippi Rag* 18 (December 1990): 24–25. Recordings from 1926–1959. All-women's jazz ensembles, female soloists, or female soloists with bands, including Lovie Austin, Memphis Minnie, Mary Lou Williams, Mary Lou Williams' Girl Stars, Vivian Garry and her All Girl Band, Marjorie Hyams, Mary Osborne, Barbara Carroll, Jutta Hipp, Ina Rae Hutton, Lil Armstrong, Valaida Snow, Melba Liston, International Sweethearts of Rhythm, Dorothy Donegan, Adele Girard, Margie Hyams, L'Ana Webster, Kathy Stobart, Beryl Booker, Nellie Lutcher, Rose Murphy, Hazel Scott, Jean Star, L'Ana Hyams' All Stars, Vi Redd, Sarah McLawler, etc.

1730. *Girls with Guitars*. London: Impact Records, LP 012, 1989.

Reviewed in *Melody Maker* 65. (18 February 1989): 33. A compilation of various British all-girl groups (e.g., The Chimes, The Martells, The Kittens, Goldie and the Gingerbreads, The Vernons Girls, The Other Two, etc.)

1731. *Great Gospel Women*. Newton, NJ: Shanachie, CD–6004 (CD), C–6004 (cassette), 1993.

Selections by Mahalia Jackson, Willie Mae Ford Smith, Sister Rosetta Tharpe, Marion Williams, Clara Ward, Cora Martin, Dorothy Love Coates, Roberta Martin, Marie Knight, Mary Johnson Davis, Frances Steadman, Lucy Smith Collier, Gladys Beamon Gregory, et. al.

1732. *Great Ladies of Jazz*. Plymouth, MN: K-Tel, 539-2 (CD), 539-4 (cassette), 1991.

Includes June Christy, Carmen McRae, Dakota Station, Dinah Washington, Sarah Vaughan, Anita O'Day, Billie Holiday.

1733. *Great Ladies of Jazz II*. Plymouth, MN: K-Tel, 60232 (CD), 1991.

Includes recordings by Ella Fitzgerald, Peggy Lee, Sarah Vaughan, Anita O'Day, Carmen McCrae, Julie London, Dinah Washington, Billie Holiday, Morgana King, and Nancy Wilson.

1734. *Heroines. She's Back*. Jan Labate (alto sax and viola), Victoria Trent (bass and vocals), and Sybl Joan Glebow (drums, chromatic harmonica and vocals). Redwood, NY: Cadence Records, CJR 1040, 1991.

Reviewed in *Coda* 241 (January/February 1992): 21. Described in *Coda* as "a joy to behold," this recording presents jazz originals and improvisations by the three women of Heroines, featuring unique instrumentations and vocal styles.

1735. *Hot Wire* 3, no. 2 (March 1987): Soundsheet. Chicago, IL: Hot Wire, 1987.

Sampler inserted into the journal, *Hot Wire*. Includes selections from albums by Linda Sheets, Judi Friedman, Ruth Pelham, and Susan Savell.

1736. *Hot Wire* 3, no. 3 (July 1987): Soundsheet. Chicago, IL: Hot Wire, 1987.
    Sampler inserted into the journal, *Hot Wire*. Includes selections from albums by Jasmine, Laura Anderson, The Fabulous Dyketones, and Heather Bishop.

1737. *Hot Wire* 4, no. 1 (November 1987): Soundsheet. Chicago, IL: Hot Wire, 1987.
    Sampler inserted into the journal, *Hot Wire*. Includes selections from albums by Lynn Lavner, Nancy Day, Laura Berkson and Labrys.

1738. *Hot Wire* 4, no. 2 (March 1988): Soundsheet. Chicago, IL: Hot Wire, 1988.
    Sampler inserted into the journal, *Hot Wire*. Includes selections from albums by the Washington Sisters, Linda Cullum, Marla B. Brodsky, and Sherry Shute.

1739. *Hot Wire* 4,no. 3 (July 1988): Soundsheet. Chicago, IL: Hot Wire, 1988.
    Sampler inserted into the journal, *Hot Wire*. Includes selections from albums by Alison Farrell, Betsy Rose, Therese Edell, and Suede.

1740. *Hot Wire* 5, no. 1 (January 1989): Soundsheet. Chicago, IL: Hot Wire, 1989.
    Sampler inserted into the journal, *Hot Wire*. Includes selections from albums by Therese Edell, Alix Dobkin, Faith Nolan and Bobbi Carmitchell.

1741. *Hot Wire* 5, no. 2 (May 1989): Soundsheet. Chicago, IL: Hot Wire, 1989.
    Sampler inserted into the journal, *Hot Wire*. Includes selections from albums by Julia Haines, Alice di Micele, Karen Beth, Mimi Baczewska; also a selection from the lesbian/feminist musical *In Search of the Hammer*.

1742. *Hot Wire* 5, no. 3 (September 1989): Soundsheet. Chicago, IL: Hot Wire, 1989.
    Sampler inserted into the journal, *Hot Wire*. Includes selections from albums by Therese Edell, Alice Di Micele, Chris Williamson/Teresa Trull, and Cruz Devon.

1743. *Hot Wire* 6, no. 1 (January 1990): Soundsheet. Chicago, IL: Hot Wire, 1990.
    Sampler inserted into the journal, *Hot Wire*. Includes selections from albums by Monica Grant, Jamie Anderson, Jane Howard, and Wes.

1744. *Hot Wire* 6, no. 2 (May 1990): Soundsheet. Chicago, IL: Hot Wire, 1990.
    Sampler inserted into the journal, *Hot Wire*. Includes selections from albums by Libana, Marlene, Karen Beth, and Helen Hooke.

1745. *Hot Wire* 6, no. 3 (September 1990): Soundsheet. Chicago, IL: Hot Wire, 1990.
    Sampler inserted into the journal, *Hot Wire*. Includes selections from albums by Catie Curtis, Two Nice Girls, Yer Girlfriend, and Erica Wheeler.

1746. *Hot Wire* 7, no. 1 (January 1991): Soundsheet. Chicago, IL: Hot Wire, 1991.
    Sampler inserted into the journal, *Hot Wire*. Includes selections from albums by Ruth Barrett, Ferron, Faith Nolan, Alice Di Micele and Leah Zicari.

1747. *Hot Wire* 7, no. 2 (May 1991): Soundsheet. Chicago, IL: Hot Wire, 1991.
    Sampler inserted into the journal, *Hot Wire*. Includes selections from albums by Marla BB, Jane Winslow, Betty, Susan Herrick, Pam & Maggie, and Libby Roderick.

1748. *Hot Wire* 7, no. 3 (September 1991): Soundsheet. Chicago, IL: Hot Wire, 1991.
    Sampler inserted into the journal, *Hot Wire*. Includes selections from albums by Jamie Anderson, Barb Barton, Linda Smith, and Tivela Seeche.

1749. *Hot Wire* 8, no. 1 (January 1992): Soundsheet. Chicago, IL: Hot Wire, 1992.
    Sampler inserted into the journal, *Hot Wire*. Includes selections from albums by Lynn Thomas, Karen Pernick, Ellen Rosner, Monica Grant, Venus Envy, and Wimmin on the Edge.

1750. *Hot Wire* 8, no. 2 (May 1992): Soundsheet. Chicago, IL: Hot Wire, 1992.
    Sampler inserted into the journal, *Hot Wire*. Includes selections from albums by Casselberry-Dupreé, Jamie Anderson, Leah Zicari, Pam Hall, and Macula Lutea.

1751. *Hot Wire* 8, no. 3 (September 1992): Soundsheet. Chicago, IL: Hot Wire, 1992.
    Sampler inserted into the journal, *Hot Wire*. Includes selections from albums by Tracy Drach, Justina and Joyce, Ellyn Fleming, and Barb Galloway and Cacy Lee.

1752. *"I'm Ready For My Closeup": The Hollywood Ladies Sing, Volume 1*. New York: RCA, 8597-2-R (CD), 8597-4-R (cassette), 1989.
    Songs from twenty films—original recordings by Fanny Brice, Betty Hutton, Deanna Durbin, Marlene Dietrich, Ginger Rodgers, Marilyn Monroe, Connee Boswell, Jeanette MacDonald, etc.

1753. *In Celebration of Black Women Singers*. Madison, WI: Board of Regents. University of Wisconsin System, BCB01T (cassette), 1992.
    Produced by Wisconsin Public Radio and available from The Audio Store, 821 University Ave., Madison, WI 53706. (800–972–8346). Four topics are discussed by notable scholars: "Blues Culture and Early Women Blues Singers" by Hazel Carby; "Josephine Baker, the Cleopatra of Jazz" by Phyllis Rose; "Billie Holiday" by Robert O'Meally; "Contemporary Black Women Rap Musicians" by Tricia Rose.

1754. *Jailhouse Blues: 1936 & 1939*. New York: Rosetta Records, RR 1316 (LP) and RC 1316 (cassette), 1987.

Women's a cappella blues, work songs, and spirituals; field recordings from the Parchman State Penitentiary (Mississippi) women's camp.

1755. *Jazz Divas: Live*. New York: Verve Records, 314 515 562–2 (CD), 314 515 562–4 (cassette), 1992.

Original recordings from 1946–1990, with performances by Anita O'Day, Sarah Vaughan, Ella Fitzgerald, Billie Holiday, Betty Carter, Nina Simone, Dee Dee Bridgewater, and Shirley Horn.

1756. *Jazz Divas: Studio*. New York: Verve Records, 314 515 563–2 (CD), 314 515 563–4 (cassette), 1992.

Recordings by Anita O'Day, Sarah Vaughan, Morgana King, Helen Merrill, Abbey Lincoln, Ella Fitzgerald, Billie Holiday, Betty Carter, Nina Simone, Dinah Washington, Shirley Horn, Blossom Dearie, and Sheila Jordan.

1757. *The Ladies*. New York: Savoy, ZDS 1200 (CD), 1990.

Jazz vocals circa 1946–1955 by Ernestine Anderson, Etta Jones, Annie Ross, Mary Ann McCall.

1758. *Ladies Get the Blues*. New York: Mercury, 422 834 199–1 (LP), 422 834 199–4 (cassette), 1988.

Contemporary country music by Reba McEntire, Leona Williams, Kathy Mattea, Teri Hensley, and Donna Fargo. Selections released on Mercury Records during the 1980s.

1759. *Ladies Sing Jazz: 1925/1940*. Paris, France: Zeta, ZET 751 (CD), 1991.

Dist. EPM Musique. Recorded 1925–1940 in New York. Includes selections by Bessie Smith, Billie Holiday, Ella Fitzgerald, Ethel Waters, Adelaide Hall, Ivie Anderson, with various accompanying orchestras.

1760. Laine, Cleo. *Woman to Woman*. New York: RCA, 7999–2 RC (CD), also released on LP and cassette, 1989.

Reviewed in *Fanfare* 13, no. 3 (January/February 1990): 430. Popular songs by women composers including Carrie Jacobs Bond, Blossom Dearie, Billie Holiday, Judy Collins, and Joni Mitchell.

1761. Lavin, Christine, Patty Larkin, Megon McDonough, and Sally Fingerett. *"Buy Me Bring Me Take Me, Don't Mess My Hair—": Life According To Four Bitchin' Babes*. Cambridge, MA: Philo Records, PH 1140 (CD), 1991.

Recorded live at the Birchmere (Alexandria, VA). Songs on women's themes by these four folk singers and songwriters.

1762. Libana (Women's Vocal/Instrumental Ensemble). *Fire Within*. Durham, NC: Ladyslipper, LR 108 (CD and cassette), 1990.

A recorded collection of women's music, folk-songs, and ritual music from world cultures. Contents include: *Fire Within* by Marytha Paffrath; *Hotakoi* (Traditional: Japan); *Treeplanter's Round* by Dorothy Attneave Jackson; *Con el viento* (from Renaissance Spain); *Good Friend* by Jan Harmon; *Kona kai opua i ka lai* (Traditional: Hawaii); *O Virgo spendens* (Spanish, 14th c.); *Rise Up O Flame* (unattributed); *Neesa* (Native American); *Lullaby* (Traditional: Sweden); *Clear Horizon* by Jan Harmon; *Ode to Contentment* (Traditional: Shaker); *I Will Be Gentle With Myself* (unattributed); *Now I Walk In Beauty* (based on Hopi Indian text); *Be Like a Bird* (unattributed); *Lo yisa goy* (Traditional: Jewish); *Kwaheri* (Traditional: Kenya); *And She Will Rise* by Dakota Butterfield.

1763. *Mean Mothers: Independent Women's Blues, Volume 1*. New York: Rosetta Records, RRCD 1300 (CD; also on cassette), 199?

Reissue of the 1980 LP (RR1300). Historic blues sung by Martha Copeland, Bessie Brown, Maggie Jones, Susie Edwards, Bernice Edwards, Gladys Bentley, Mary Dixon, Bertha Idaho, Rosa Henderson, Harlem Hannah, Lil Armstrong, Blue Lou Barker, Rosetta Howard, Ida Cox, Lil Green, and Billie Holiday.

1764. *Memphis Girls*. Vienna, Austria: RST/Blues Documents, BD–2029 (LP), 1988.

Reviewed in Frank Scott's *Down Home Guide to the Blues* (Chicago: Down Home Music, 1991. p. 196). Selections by Leola Manning, Madelyn James, Hattie Hart, and Minnie Wallace.

1765. *Mississippi Girls (1928–1931)*. Vienna, Austria: RST/Story of Blues, CD–3515–2, 1991.

Distr. by D. A. Music USA, 362 Pinehurst Lane, Marietta, GA 30068. Originally issued on LP on RST/Blues Documents BD-2018. "A truly wonderful collection," says Frank Scott in his *Down Home Guide to the Blues* (Chicago, IL: Down Home Music, 1991, p. 197). Includes selections by Rosie Mae Moore and Mary Butler (accompanied by Charlie McCoy, Ishman Bracey and Bo Carter), as well as Mattie Delaney, Geechie Wiley and Elvie Thomas, accompanying themselves on guitar.

1766. *Motown Girl Groups*. Los Angeles, CA: Motown, MCD09095MD (CD), 1987.

Selections sung by Martha Reeves and the Vandellas, Diana Ross and the Supremes, The Marvelettes, Mary Wells, and Gladys Knight and the Pips.

1767. *Pan Woman: Steelbands of Trinidad and Tobago*. Hollywood, CA: Delos, DE 4017 (CD), 1991.

Reviewed in *Percussive Notes* 31, no. 3 (February 1993): 80. Recent digital recording featuring a sampling of steel band ensembles from Trinidad and Tobago, including: Pandigenous, Neal and Massey Trinidad All Stars, Solo Harmonites, SilverStars, Phase II Pan Groove, Exodus, and Vat 19 Fonclaire. Program notes focus on the history of women in steel band orchestras and feature short bios on prominent women steel pan players.

1768. Paz, Suni. *Entre Hermanas—Between Sisters: Women's Songs Sung in Spanish*. With assisting vocalists and instrumentalists. Washington, D.C.: Folkways Records, 08768 (cassette), 1991.

   Liner notes include Spanish song texts, with English translations.

1769. *Peace Camps Sing*. New York: Tallapoosa Music, cassette, 1987.

   Available from Ladyslipper. Songs of feminism and political activism, performed by Helen and Hershi (duet), the Seneca Singers, Cassandra and others. Recorded between 1983 and 1985 at the Greenham Common Peace Camp, the Seneca Women's Peace Camp, the Puget Sound Peace Camp, and in Manhattan.

1770. *Rockin' Ladies of the 80's*. Woodland Hills, CA: Warner Special Products, OPCD–1584 (CD), 1990.

   Top rock 'n' roll hits performed by Pat Benatar, Taylor Dayne, Lone Justice, Christine McVie, Debbie Harry, Sheena Easton, Til Tuesday, The Sugarcubes, Linda Ronstadt, and Bonnie Raitt.

1771. *Sisters of Soul*. Santa Monica, CA: Rhino Records, R2 71037 (CD), 1992.

   Selections by Mary Wells, Baby Washington, Dee Dee Sharp, The Sweet Inspirations, Barbara Lynn, Judy Clay, Tammy Lynn, Jackie Moore, Laura Dee, Dee Dee Warwick, Jean Battle, Esther Phillips, Irma Thomas, Betty LaVette, The Pointer Sisters, Bettye Swann, Margie Joseph, Toby Lark, Mary Lou, Margie Alexander, Lorraine Johnson, Rozetta Johnson, One'sy Mack.

1772. *Songs We Taught Your Mother*. Berkeley, CA: Fantasy/Original Blues Classics, OBC–520 (LP); OBC–520–C (cassette), 1988.

   Blues, performed by Alberta Hunter, Lucille Hegamin, Victoria Spivey, with accompanying small jazz ensembles. Reissue of a 1961 recording on the Bluesville label (BV 1052). Frank Scott's *Down Home Guide to the Blues* (Chicago, IL: Down Home Music, 1991) describes this record as "a fine set of jazz/blues from three popular artists who originally recorded in the 20s and 30s" (p. 244).

1773. *St. Louis Girls 1929–1937*. Vienna, Austria: RST/Blues Documents, 2055 (LP), 1990?

   Dist. Roundup Records, P.O. Box 154, N. Cambridge, MA 02140. Blues by Mae Belle Miller, Elizabeth Washington, Mary Johnson, et. al.

1774. *Stax Soul Sisters*. Berkeley, CA: Stax Records, MPS–8543 (LP), MPSC–8543 (cassette), 1988.

> Women recording on the R & B label, Stax Records. With Shirley Brown, Veda Brown, Barbara Lewis, Linda Lyndell, Carla Thomas, Mavis Staples, Jean Knight, Mabel John, Margie Joseph, Inez Foxx, Judy Clay.

1775. *Tanguera: Woman in Tango*. Berlin, Germany: Haus der Kulturen der Welt, SM 1503–2 (CD), 1992.

> Dist. Wergo/Spectrum. Motion picture soundtrack. Classic and feminist tangos sung by Silvana Deluigi with Juan-José Mosalini, bandoneon, and other instrumentalists. Notes in English and German, with Spanish song texts included.

1776. *Tejano Roots: The Women*. El Cerrito, CA: Arhoolie Records, CD–343, 1991.

> Reviewed in *Sing Out* 37, no. 2 (1992): 130. Tex-Mex music (1946–1970) by women vocalists including: Carmen and Laura Hernandez, Las Abajeñas, Hermanas Fraga, Rosita Fernandez, Hermanas Segovia, Delia Gutiérrez, Laura Cantú, Hermanas Cantú Hermanas Guerrero, María Luisa Guerrero, Chelo Silva, Las Rancheritas, Lydia Mendoza, and Hermanas Mendoza.

1777. *Tough Mamas*. England: Krazy Kat, 7448 (LP), 1990?

> Obscure blues and R & B, 1940–1960, sung by Big Mama Thornton, Madonna Martin, Ann Carter, Pearl Reaves, Honey Brown, et. al.

1778. *Two Girls Started To Sing: Bulgarian Village Singing*. Cambridge, MA: Rounder Records, LP–1055, CD–1055, C–1055, 1990.

> Field recordings (1978–1988) of various types of Bulgarian women's singing, collected by Martha Forsyth.

1779. *Vahine: Chanteuses de Tahiti*. Boulogne, France: Playa Sound, PS 65038 (CD), 1989.

> Popular music from Tahiti performed by a selection of women singers including (last names not mentioned) Henriette, Emma, Apiti, Esther, Leone, Claudine, Poline, Liliane, Loma, Marie, Suzanne, Les Frangipanes, Heikura, and Irma.

1780. *The Wassoulou Sound: Women of Mali*. New York: Stern's Africa, STCD 1035 (CD), STC 1035 (cassette), 1990?

> Reviewed in *New York Times* 1 March 1991, II: 30; *Musician* 161 (March 1992): 94. Popular music by five women singers from Mali, accompanied by chorus, and various electrified and acoustic instruments. Women singers featured are: Sali Sidibe, Oumou Sangaré, Coumba Sidibe, Dienaba Diakité, and Kagbe Sidibe.

1781. *The Women: Classic Female Jazz Artists 1939–1952.* New York: Bluebird/ BMG Music, 6755–2–RB (CD), 6755–4–RB (cassette), 1990.

    Reviewed in *New York Times*, 3 August 1990, C:17. Program notes by Leonard Feather, with discography. Includes selections by: Mary Lou Williams' Girl Stars (*Harmony Grits, Boogie Misterioso, Conversation*); Mary Lou Williams' Trio (*Hesitation Boogie*); Beryl Booker Trio (*Oops! My Lady, Low Ceiling*); Vivien Garry Quintet (*A Woman's Place is in the Groove, Operation Mop*); Una May Carlisle (*Blitzkrieg Baby (You Can't Bomb Me), Beautiful Eyes*); International Sweethearts of Rhythm (*Vi Vigor, Don't Get It Twisted*); Hazel Scott with the Sextet of the Rhythm Club of London (*Calling All Bars, Mighty Like the Blues*); Edythe Wright with Tommy Dorsey and the Clambake Seven (*Nice Work If You Can Get It*); Alberta Hunter (*My Castle's Rockin'*); Ethel Waters (*Baby, What Else Can I Do*); Mildred Bailey (*Rockin' Chair, Georgia on My Mind*); Helen Ward with Gene Krupa and his Swing Band (*Mutiny in the Parlor*); Helen Forrest with Lionel Hampton (*I Don't Stand a Ghost of a Chance With You*); Barbara Carroll Trio (*Barbara's Carol*); Kay Davis with Duke Ellington and his Orchestra (*Transblucency*).

1782. *Women of Africa.* London: CSA Records, CD 5003 (CD), ZCSLC 5003 (cassette), 1989.

    Dist. Ladyslipper. With Lady Isa, Stella Chiweshe & the Earthquake, Patience Africa & the Pedlers, Dulce & Orchestra Marrabenta Star de Mozambique, Ilanga featuring Busi Ncube, Sarah Mabokela, Doreen Ncube, Mahotella Queens, Maggie Mhuriro, Dorothy Masuka, Mingas & Orchestra Marrabenta Star de Mozambique.

1783. *Women's Railroad Blues: Sorry But I Can't Take You.* New York: Rosetta Records, RC 1301 (cassette), 1987.

    Previously issued on LP on Rosetta RR 1301. Blues about women, men, and trains, by Trixie Smith, Clara Smith, Bessie Smith, Bertha Chippie Hill, Ada Brown, Sippie Wallace, Martha Copeland, Bessie Jackson, Lucille Bogan, Blue Lou Barker, Sister Rosetta Tharpe, and Nora Lee King.

## CHAPTER FOURTEEN

# Audio/Visual Media

1784. *American Women Conductors and Composers in Performance*. Eugene, OR: University of Oregon Instructional Media Center, 1987. 35 min. Videocassette (VHS). Color.

1785. *Black Mother, Black Daughter*. Dir. Sylvia Hamilton and Claire Preito. National Film Board of Canada (Distributor), 1251 Avenue of the Americas, New York, N.Y. 10020. 1989. 28 min. Videocassette (VHS) ; 16mm film; rental available.

   Reviewed in *Choice* 28, no. 3 (November 1990): 232. Examines intergenerational transmission of a cultural heritage, captured through oral histories (including songs) of black women in Nova Scotia.

1786. *Chamber Music and Songs by Women Composers. Programs I, II, III*. New York: Aviva Players, 1990? 28 min. each volume. Videocassette (VHS). Performed by the Aviva Players; Mira Spektor, artistic director. Available from the Aviva Players c/o Mira Spektor, 262 Central Park West 14E, New York, N.Y. 10024. (212) 362–2277.

   Program I: Works by Julia Smith (*Cornwall Trio: Allegro*), Cécile Chaminade (*Concertino, flute, piano*; *Au pres de ma mie*), Mira Spektor ("I Want to Go Home" [aria] from *Lady of the Castle*; *Love is More Thicker*), Maria Theresia von Paradis (*Sicilienne*), Clara Schumann (*Notturno*). Program II: Works by Louise Farrenc (*Trio in E Minor: Scherzo*), Lou Rodgers (*Ophelia's Mad Songs from Shakespeare*), Nadia Boulanger (*Piece, cello, piano*), Mira Spektor (*Guinevere Among the Grapefruit Peels*; *Mr. Fixer*), May Aufderheide (Two piano rags: *Dusty* and *Blue Ribbon Rag*), Amy Beach (*Sea Song*; *The Years at the Spring*). Program III: Works by Fanny Mendelssohn Hensel(Lied from *Trio in D Minor, for violin, cello, piano*), Clara Schumann (Songs: *Das ist mein Tag* and *Liebst du um*

*Schonheit*), Lili Boulanger (*Nocturne*; *Cortege*), Mary Howe (*Patria*), Eastman Martin (*Come to the Fair*), Alicia Ann Scott (*Think on Me*), Amy Beach (*Canadian Boat Song*), Mira Spektor (*My Daughter the Cypress*; *Early Morning Rain*).

1787. *The Changer: A Record of the Times*. Prod. and dir. Frances Reid and Judy Dlugacz. Oakland, CA: Olivia Records, V904, 1991. Videocassette (VHS).

A video focusing on the women and music behind Chris Williamson's *The Changer and the Changed* record album. Interviews with women musicians and concert footage from public performances and recording sessions provide a documentary history of independent women's music and popular lesbian songwriters of the 1970s and 1980s. Interviewed are Chris Williamson, Bonnie Raitt, Meg Christian, Holly Near, Margie Adam, Vicki Randle, and others.

1788. *Dreamworlds: Desire/Sex/Power in Rock Video*. Writ., ed., and narr. Sut Jhally. Amherst, MA: University of Massachusetts at Amherst, Department of Communication, Centre for the Study of Communication, 1990. 55 min. Videocassette (1/2 in., VIIS). Color. Accompanied by a summary sheet.

Reviewed in *New York Times* 2 June 1991, II: 31, 40. See also Mr. Jhally's response, *New York Times* 23 June 1991, II: 4, 22. Controversial as much for the creator's method of production as well as for its subject matter, this video explores the ways in which sex, misogynist imagery, and violence against women are used in music videos; these videos in turn function as a marketing device to boost rock album sales to a young (and mostly male) audience. Mr. Jhally explores the techniques of production used to create this male fantasy "dreamworld" (fetishized, isolated body parts, with the gaze of the camera on the female body; camera shots of desirable women in the audience or surrounding the male performer). He likewise examines the portrayal of women (competitive, jealous, sexually aroused, desperate and dependent, always dressed in scant clothing), the roles they play (anonymous, exotic, the innocent or the experienced sexual object), and the scenes of violence played out in the course of selected rock videos (e.g. passive recipient of blindfolding, rape, imprisonment).

1789. *Eviva Belcanto*. Universal City, CA: MCA/Universal Home Video, MCAC 81216, 1992. 47 min. Videocassette (VHS). Color, stereo.

Reviewed in *Instrumentalist* 46, no. 9 (April 1992): 78. Marilyn Horne and Monserrat Caballé together in concert, performing Vivaldi, Meyerbeer, Mercadante and Rossini.

1790. *Girls Bite Back*. Dir. Wolfgang Büld. Berlin: Revenge Video ; Munich: Licensed from GRF, 1992. 45 min. Videocassette (VHS). Color.

Recorded live, Autumn 1980. This behind-the-scenes view of women punk and New Wave rock groups from Europe and the U.S. includes inter-

views with and performances by Siouxsie & the Banshees, Nina Hagen, The Slits, Girlschool, Lilliput, Zaza, and Mania D.

1791. *Girls of Rock 'n' Roll*. Comp. and ed. Sandy Oliveri. Rock 'n' Roll History Video. New York: Good Times Home Video, 8115, 1989. 30 min. Videocassette (VHS). Color & B/W.

A compilation of original live performances by "girl group sound" women artists of 1960's top 40 pop. Features Connie Francis, The Crystals, The Ronettes, Lesley Gore, The Supremes, Mary Wells, and the Dixie Cups.

1792. *Grandi Primadonne*. Universal City, CA: MCA/Universal Home Video, MCAC–81217, 1992. 41 min. Videocassette (VHS). Color, stereo.

Reviewed in *The Instrumentalist* 46, no. 9 (April 1992): 78. Marilyn Horne and Monserrat Caballé perform Handel, Rossini, Puccini and Offenbach in their recital in Munich in 1991.

1793. *Griottes of the Sahel: Female Keepers of the Songhay Oral Tradition in Niger*. Writ. and prod. Thomas A. Hale. University Park, PA: Pennsylvania State University Audiovisual Services, 1991. 12 min. Videocassette (VHS). Color.

Female praise singers.

1794. *Jazz Women on Video: Foremothers, Volume I*. Women's Heritage Series. New York: Rosetta Records, RRV 1320, 1990. 28 min. Videocassette (VHS). B/W.

Also distributed by Ladyslipper. This video on women jazz musicians active during the period from 1932 to 1952 features performances by Nina Mae McKinney, Helen Humes, Maxine Sullivan, Ida Cox, Sister Rosetta Tharpe, Billie Holiday, Rita Rio's Mistresses of Rhythm, Ada Leonard's All-American Girl Orchestra, and the International Sweethearts of Rhythm.

1795. *Ladies Sing the Blues*. New York: View Video, 1313,, 1988. 60 min. Videocassette (VHS). B/W.

With Billie Holiday, Dinah Washington, Bessie Smith, Lena Horne, Ethel Waters, Peggy Lee, Sarah Vaughan, and Ruth Brown. Reviewed in *Library Journal* 114 (November 1, 1989): 123; *Musician* 140 (June 1990): 111; *Cadence* 16 (August 1990): 65–66; *Coda* 237 (May/June 1991): 22–23.

1796. *Olivia Records' 15th Anniversary Concert Highlights Video*. Oakland, CA: Olivia Records, 1989? 73 min. Videocassette (VHS).

Features Chris Williamson, Teresa Trull, Lucie Blue Tremblay, Deidre McCalla, Dianne Davidson, Tret Fure, Nancy Vogl, Robin Flower. Olivia Records, 4400 Market St., Oakland, CA 94608.

1797. *The Sensual Nature of Sound: 4 Composers*. Prod. Michael Blackwood. New York: Michael Blackwood Productions, 1993. 58 min. Videocassette (VHS). Color.

Available from Michael Blackwood Productions, Inc., 251 West 57th Street, New York, NY 10019. (212) 247–4710 or FAX (212) 247–4713. Also available on a rental basis in film and VHS formats. Interviews with composers Laurie Anderson, Tania León, Meredith Monk, and Pauline Oliveros are accompanied by film excerpts of their works in performance.

1798. *Shindig! Presents Groovy Gals: Live Rock 'N' Roll Performances From the Hit '60s Music Series*. Durham, NC: Ladyslipper (Distributor), Cat. # RH 1457VC, 199? 30 min. Videocassette.

A recommended title from the Ladyslipper catalog, this video takes a nostalgic look at female rock and pop artists. A compilation of performances from this 1960's television show, the video features Leslie Gore, Fontella Bass, Petula Clark, Aretha Franklin, the Shangri-Las, The Supremes, The Toys, Tina Turner, and more.

1799. *Sisters in the Name of Rap*. Durham, NC: Ladyslipper (Distributor), Cat. # PLG 84495 VC, 199? 55 min. Videocassette.

Queen Latifah, Salt 'n' Pepa, M.C. Lyte, Nefertiti, and Tam Tam; live from the Ritz in New York.

1800. *Song of Survival*. Prod. (for Veriation Films) Stephen Longstreth, Helen Colijn, David Espar, et al. S.l.: Song of Survival Productions, 1985 ; New York: Brighton Video, 1987. 57 min. Videocassette (VHS) ; 16mm film. Color.

Currently distributed by the Altschul Group, 1560 Sherman Ave., Evanston, IL 60202. (800–323–9084). This film relates the importance of music to the survival of Australian, Dutch, and British women imprisoned in Sumatra by the Japanese during World War II. The memory of classical music aided these women as they arranged musical works for their own vocal orchestra, sustaining their spirit through this time of duress. Women survivors are interviewed, and the Peninsula Women's Chorus (Palo Alto, CA), directed by Patricia Hennings, re-creates performances of these same musical works.

1801. *Tiny and Ruby: Hell Divin' Women*. Prod. Greta Schiller and Andrea Weiss. New York: Cinema Guild, 1988. 30 min. Videocassette (VHS) ; 16mm film.

This film profiles women jazz musicians Ernestine "Tiny" Davis (trumpet) and Ruby Lucas (drummer; a.k.a. Renee Phelan) and their long-time musical and personal partnership, and is a sequel to Greta Schiller's *International Sweethearts of Rhythm* (New York: Cinema Guild, 1986).

1802. *Two Homes, One Heart: Sacramento Sikh Women and Their Songs and Dances*. Prod. and dir. Joyce Middlebrook. California: J.M. Middlebrook, 1992. 26 min. Videocassette (1/2 in). Color.

Distributed by the Yuba Sutter Regional Arts Council, Marysville, CA. An examination of the music and dance forms of Sikh women now living in Sacramento, California.

1803. *Up From the Footnotes: Women in Music.* Comp. and narr. Jeannie Pool.
Sigma Alpha Iota, 1989? 32 min. Slide/tape program. Rental only.
      Available from Sigma Alpha Iota, c/o Mrs. Myron Downs, Audio/
Visual Project Director, 29 Crestwood Rd., Simsbury, CT 06070. (203)
651–8861.

1804. *A Video Letter from New York Women 1991 to the Utrecht Congress on
Women in Music.* Prod. Sorrel Hays. New York: JAI Productions, 1991. 54
min. Videocassette (VHS or 3/4 in.).
      Article describing the production of this video in *ILWC Journal*
(September 1991): 29. Available from JAI Productions, 323 W. 82nd Street
#3A, New York, NY 10024.

1805. *Wild Women Don't Have the Blues.* Prod. Carole van Falkenburg and
Christie Dall. San Francisco: California Newsreel, 1989. 55 min.
Videocassette (1/2 in. and 3/4 in.) ; 16mm film.
      Available for purchase or rental from California Newsreel, 149 Ninth
St. #420, San Francisco, CA 94103. Reviewed in *Choice* 27, no. 5 (January
1990): 892; *Jazz Educators Journal* 23.1 (Fall 1990): 60; *New Directions for
Women* 19, no. 3 (May/June 1990): 9.

1806. *Women in Rock.* Dir. and prod. Stephanie Bennett. Universal City, CA:
MCA Home Video, 1987. Beta (80428–19); VHS (80428–18).
      Reviewed in *Rolling Stone* 493 (12 February 1987): 96; *High Fidelity*
37 (July 1987): 79; *Billboard* 99 (17 January 1987): 41+; *Creem* 18 (May
1987): 64+. The history of women in rock 'n' roll is presented via a pastiche
of interviews, rare film clips, music videos, and live performances with
artists such as Brenda Lee, Carole King, Aretha Franklin, Janis Joplin, Grace
Slick, Bette Midler, Blondie, Pat Benatar, Madonna, and a host of other
women rockers.

1807. *Women in Rock.* Dir. and prod. Stephanie Bennett. New York: A* Vision
Entertainment, 1991. Laserdisc. 12 in.
      Interviews, film clips and live performances, with Carole King, Aretha
Franklin, Tina Turner, Janis Joplin, Pat Benatar, The Bangles, Madonna, and
Whitney Houston. Originally issued in 1987 by MCA Home Video.

## CHAPTER FIFTEEN

# Publishers, Record Labels, and Distributors
# Featuring Women in Music Materials

1808. *Antone's Records*. 500 San Marcos, Suite 200, Austin, TX 78702. (800) 962–5837 or (512) 322–0617.

    This women-managed record company features contemporary blues artists, many of whom are women.

1809. *Arsis Press (BMI)*. 1719 Bay Street S. E., Washington, D.C. 20003. (202) 544–4817.

    Publishes concert and sacred choral music by women composers.

1810. *Broude Brothers Limited*. Choral Department. 141 White Oaks Road, Williamstown, MA 01267. (413) 458–8131.

    Catalog entitled "Choral Music Composed By Women" lists titles from this publisher's choral repertoire as well as from their series "Nine Centuries of Music by Women."

1811. *C.F. Peters*. 373 Park Avenue South, New York, N.Y. 10016. (212) 686–4147.

    "Works by Women Composers" catalog, listing scores, instrumentation, etc. Also reproduced in *Notes* 48, no. 2 (December 1991): 742–744.

1812. *Cambria Records and Publishing*. Box 374, Lomita, CA 90717. (310) 831–1322.

    Issues recordings and scores by women composers.

1813. *Chromattica U.S.A.* 2443 Pickwick Road, Dickeyville, MD. 21207. (301) 448–3334.

Cassette recordings of piano music by women composers, as performed by Selma Epstein. Also, a series of score anthologies devoted to piano music by women composers. List available upon request.

1814. *ClarNan Editions.* 235 Baxter Lane, Fayetteville, AR 72701. (501) 442–7414.

Scores and performance parts of works by classical women composers.

1815. *Coronet Recording Company.* 4971 North High Street, Columbus, OH 43214. (614) 888–6624.

"Music by Women Composers Series" in three volumes.

1816. *Da Capo Press, Inc.* 233 Spring Street, New York, NY 10013. (800) 321–0050 or (212) 620–8000.

As part of their excellent "Women Composers Series," Da Capo publishes hard-cover musical score editions of works written by European and American women composers from various historical periods; 24 volumes currently in print.

1817. *Edition Donna.* Nicolaistrasse 2, D–4750, Unna, Germany. Tel. 0 23 03–238091.

Chamber music by women composers.

1818. *Edition GD.* Klosterstrasse 1 1/10, D–55124 Mainz, Germany. Tel. 49/6131/42523 and FAX 49/6131/45717.

Publisher of Gertrude Degenhardt's extensive cycle of artworks entitled "Vagabondage—Women in Music."

1819. *Editions ARS FEMINA.* P.O. Box 7692, Louisville, KY 40257–0692. (502) 897–5719.

Music written by women before 1800, based on manuscripts and published in modern performance editions. Catalog and price list available.

1820. *Empty Closet Enterprises, Inc.* 5210 North Wayne, Chicago, IL 60640. (312) 769–9009.

Publisher of the periodical *Hot Wire* and the directory *Women's Music Plus.*

1821. *Frauenmusik-Vertrieb.* Nicolaistrasse 2, D–59423 Unna, Germany. Tel. 0 23 03–238091.

Scores and recordings of works by classical and contemporary women composers, as well as books about women musicians.

1822. *Furore-Verlag.* Naumburgerstrasse 40, D–34127 Kassel, Germany. Tel. 49/0561/897352.

Renate Matthei's publishing house, specializing in women in music materials (books, scores, etc.), and particularly those pertaining to women composers.

1823. *Greenwood Press, Inc.* 88 Post Road West, Box 5007, Westport, CT 06881. (203) 226–3571 or (800) 225–5800.

Bio-bibliographies and reference works on women composers.

1824. *Hildegard Publishing Company.* Box 332, Bryn Mawr, PA 19010. (215) 649–8649.

"Contemporary editions of music by women composers of the past, and music by women composers of today."

1825. *Ladyslipper, Inc.* P.O. Box 3124–R, Durham, NC 27705. (800) 634–6044.

Ladyslipper's annotated catalog and resource guide lists records, tapes, compact discs, and videos by women, as well as selected feminist books and song anthologies, and is particularly valuable for its extensive listing of print and non-print materials emanating from the feminist and lesbian cultural network. Reviewed in *Notes* 45, no. 2 (December 1988): 307; *Home and Studio Recording* 4, no. 11 (November 1991): 68.

1826. *Leonarda Records.* P.O. Box 1736, Cathedral Station, New York, NY 10025. (212) 666–7697.

Features recordings of concert music by women composers.

1827. *Muse Records/Savoy Jazz.* 160 West 71st Street, New York, N.Y. 10023. (212) 873–2020.

This record label features a generous sampling of recordings by women jazz artists.

1828. *Nannerl Recordings.* C/o Editions ARS FEMINA, P.O. Box 7692, Louisville, KY 40257–0292. (502) 897–5719.

Performances by the ARS FEMINA ensemble; music by women composers before 1800.

1829. *Olivia Records.* 4400 Market Street, Oakland, CA 94608–3424. (510) 655–0364 or (800) 631–6277.

A record label focusing exclusively on music created by and for women.

1830. *Redwood Records.* P.O. Box 10408, Oakland, CA 94610. (800) 888–7664 or (510) 835–1445.

Part of the Redwood Cultural Network, this label features music of feminism and world social activism.

1831. *Rosetta Records, Inc.* 115 West 16th Street, #267, New York, NY 10011.

      Recordings of women's blues and early jazz, on tape, compact disc, and video.

1832. *Sisra Publications (ASCAP)*.
      See Arsis Press. An imprint of Arsis Press for ASCAP affiliated composers.

1833. *Stash Records*. 140 West 22nd Street, 12th Floor, New York, NY 10011. (212) 243–4321.
      "Women in Jazz Series."

1834. *Theodore Front Musical Literature*. 16122 Cohasset Street, Van Nuys, CA 91406. (818) 994–1902.
      This distributor's 23-page catalog, entitled "Music By Women Composers," lists an excellent selection of recently-issued scores by European and American publishers which feature concert music written by women.

1835. *Tokkata-Verlag für Frauenforschung*. Nicolaistrasse 2, D–4750, Unna, Germany. Tel. 0 23 03–238091.

1836. *Vivace Press*. NW 310 Wawawai Road, Pullman, WA 99163–2959. (509) 334–4660 or (800) 543–5429.
      Vivace publishes musical scores of works by women composers and also issues the periodical *Women of Note Quarterly*.

# Name Index

Abbate, Carolyn, 1388
Abel, Jennifer L., 1579
Adams, Daniel, 795
Addiss, Stephen, 1246
Adinolfi, Francesco, 1099
Adkins Chiti, Patricia, 587, 1616
Ainley, Rosa, 891
Aldrich, Elizabeth, 740
Alexiou, Margaret, 199
Allen, Doris, 796
Allen, Sue Fay, 1
Allen Family, 177
Allison, Doreen R., 741
Altman, Billy, 1127
Anders, Johannes, 200
Andersen, Leslie, 407
Anderson, Jamie, 201, 1149
Andrade, Valéria, 915
Andreesco, Ioana, 1291
Andrews, Cathy, 314
Andrews, Mildred Tanner, 798
Anna Crucis Women's Choir, 1709
Arblaster, Anthony, 1389
Archer, Robyn, 892
Ardoin, John, 799
Armstrong, Toni, Jr., 202–204, 360–361, 436, 485, 509, 1150–1151, 1163, 1182
Arnold, Gina, 315, 947
Arrebola, Alfredo, 1292
Ars Femina Ensemble, 1650
Aspen, Kristan, 157, 362, 515
Association of Canadian Women Composers, 53
Aston, Elaine, 916
Atlas, Raphael, 1390
Atterbury, Betty W., 531
Auerbach, Susan, 1293
Austern, Linda Phyllis, 689–690, 1352
Austin, Steve, 1603
Avishur, Yitzhak, 1317

Babcock, Barbara A., 1329
Bachmann, Dieter, 1031
Bacou, Mihaela, 1291
Baier, Christian, 800
Bailey, John, 1318–1319
Bakari, Amisi, 1469
Baker, David J., 1546
Baker, Katherine Marie, 476
Ball, Charlene, 1152
Ballstaedt, Andreas, 742
Banerjee, Sumanta, 1247
Bannour, Wanda, 1391
Bareis, Urban, 4
Barkin, Elaine, 120
Baroncelli, Nilcéia Cleide da Silva, 54
Barr, Cyrilla, 837
Barrere, George, 801
Barry, Nancy H., 532–533
Barthelmes, Barbara, 205
Barwick, Linda, 1248–1249, 1261–1262
Basart, Ann P., 121
Basso, Ellen B., 1342
Battersby, Christine, 588
Bauer, Elizabeth Eleonore, 917
Bauer, Jeffrey Peter, 1392
Bay Area Women's Philharmonic. See Women's Philharmonic
Bayton, Mavis Mary, 437–438, 893.
Beath, Betty, 363
Becker, Audrey, 948
Becker, Judith, 1250
Becker, Matthias, 1032
Behrendt, Michael, 949
Beltrao Junior, Synval, 1455
Ben Barka, Bahija, 1222
Benda, Susanne, 206
Bender, Wolfgang, 1223
Benhamou, Paul, 918
Bennett, Stephanie, 1806

Berdes, Jane L. Baldauf, 589, 706–707
Berendt, Joachim Ernst, 510, 1033
Berkson, Laura, 1161
Bernstein, Jane A., 743
Berry, Venise T., 1100
Bessman, J., 364
Bhatia, Azra, 1578
Bialosky, Marshall, 408
Bickel, Jan E., 2
Billard, François, 1034
Bindas, Kenneth J., 802
Binder, Daniel, 545
Birbaumer, Niels, 1599
Blackwood, Michael, 1797
Blees, Thomas, 1652
Block, Adrienne Fried, 409, 477, 744–747
Bobbett, Gordon C., 534
Boenke, Heidi M., 3
Boggs, Vernon W., 1188
Bohlman, Philip V., 122
Bolen, Jean Shinoda, 1393
Borchmeyer, Dieter, 1394
Borel, François, 1224
Borroff, Edith, 207, 365, 671
Bosi, Kathryn, 691
Bouchard, Fred, 1035–1036
Bourgonjen, Meta, 1653
Bournemouth Sinfonietta, 1654
Bowers, Jane M., p. xii, 4, 123–124, 590, 708, 894, 1084
Bradby, Barbara, 1456
Bradley, Dick, 1547
Brady, Anna, 5
Brand, Bettina, 591
Brandenberg, Neal A., 535
Brandes, Edda, 208, 1225–1227
Brandfonbrenner, Alice G., 1580
Brandt, Kate, 439
Brandt, Pamela Robin, 950
Brannon, Rebecca, 1153
Brantl, Sybille, 1525
Bratlie, Jorunn Marie, 1655
Bratton, J. S., 919
Braxton, Joanne M., 1088
Breines, Wini, 1548
Brennan, Shawn, 55
Brett, Philip, 125, 1395
Briccetti, Joan, 486
Bridenthal, Renate, 698
Briscoe, James, 1617, 1656
British Library, 6
Brizuela, Leopoldo, 1343
Brooks, Iris, 1189
Brown, Dorothy M., 803
Brown, Howard Mayer, 692–693

Brown, Jane D., 1549
Brown, Mary Ellen, 1501
Brown, Rae Linda, 804
Browne, David, 1101
Broyles, Michael, 748
Bruce, Lauren, 1154
Bruenger, David, 440
Bruér, Jan, 1037
Brümann, Bettina, 366
Buchau, Stephanie von, 367
Büchter-Römer, Ute, 1038
Buck, Elizabeth B., 77
Budds, Michael J., 1085
Buehlman, Barbara, 441
Bufwack, Mary A., 1129–1130
Büld, Wolfgang, 1790
Burdine, Lucille, 1131
Burgan, Mary, 1353
Burrell, Diana, 410
Burstyn, Joan N., 126
Butocan, Aga Mayo, 1251
Butruille, Susan G., 1457
Buzzarté, Monique, 7

Cai, Camilla, 749
Calame-Griaule, Geneviève, 1228
Callahan, Anne, 672
Campbell, A. Gail, 951
Campbell, Margaret, 750
Canadian Women's Indexing Group, 8
Canning, Hugh, 592
Cant, Stephanie, 536
Cantor, Muriel G., 72
Capila, Anjali, 1271
Carby, Hazel, 1086–1087, 1753
Carlisle, Roxanne Connick, 1229
Carpenter, Ellon D., 593
Carr, Ian, 9, 1051
Cash, Alice H., 209
Castarède, Marie-France, 1581
Caswell, Austin B., 1396, 1618
Catlin, Amy, 1252–1254, 1718
Caufriez, Anne, 1294
Cauthen, Joyce H., 1132
Cavanagh, Beverly D., 1330
Chambard, Jean-Luc, 1255
Chambers, R., 805
Chaves, Mary, 394
Chernela, Janet M., 1344
Ch'maj, Betty E. M., 127
Christenson, Peter G., 1550
Christophersen, Hans, 63
Citro, Constance F., 73
Citron, Marcia J., p. xiii, 128–130, 210–211, 709, 751

Clara Wieck Trio, 1657
Claus, Peter J., 1256
Clément, Catherine, 1397–1399
Cline, Cheryl, 952–953
Cloutier, Lise, 443
Coaldrake, A. Kimi, 1257
Coates, Gloria, 411
Cocks, Jay, 1551
Coffey, Richard, 1354
Coffman, Sue, 1355
Cohen, Aaron, 56, 131
Cohen, Judith R., 1190–1191
Cohen, Paul, 806
Cohen, Sarah, 954
Coldwell, Maria V., 673
Cole, Patrick, 368
Coleman, Bill, 1102
Coleman, Kathleen A., 1582
College Music Society (Committee on the
    Status of Women in Music) 133
Collins, John, 1230
Comber, Chris, 537
Cook, Susan C., 134, 212, 369–371, 1458
Cooper, Carol, 895, 1103–1104
Cooper, Margaret, 970
Cooper, Sarah, 891
Cooper, Virginia W., 1459
Coopman, Jeremy, 955
Coote, Mary P., 1295
Coplan, David B., 1231
Corbett, John, 213
Corbin, Lynn A., 538
Cosgrove, Stuart, 920
Cossé, Peter, 135
Cowden, Robert L., 539
Cox, Renée, 511–512, 1192
Crebas, Aya, 1438
Creech, Kay, 807
Crews, Thomas L., 808
Crook, Larry Norman, 1345
Crouch, Mira, 444
Crowther, Bruce, 1039
Crutchfield, Will, 594, 752
Cusick, Suzanne G., 710, 1356
Cuthbert, Marlene, 77
Czekanowska, Anna, 1296

Dahl, Linda, 1040–1041
Dahm, Cecilie, 753
Dall, Christie, 1805
Dalton, Jody, 214
Danielson, Virginia Louise, 1320
Danner, Peter, 810
Dargie, David, 1232
Davidson, Mary Wallace, p. xiii

Davidson, Tina, 412, 513
Davies, Cynthia, 487
Davis, Angela Y., 1088
Davis, Cynthia Allison, 1583
Davis, Erik, 215
Davis, Francis, 1042
Davis, Gwenn, 10
De La Motte, Diether, 1600
Debly, Patricia, 1400
Degenhardt, Gertrude, 1525
Delacoma, Wynne, 1401
Dell'Antonio, Andrew, 216
Delzell, Judith K., 540–541
Denski, Stan Walter, 1552
Detels, Claire, 514
DeVale, Sue Carole, 1193, 1258–1259
DeVenney, David P., 11
Diamond, Lucy, 488, 489
Dickstein, Ruth, 12
Diederichs-Lafite, Marion, 136, 852
Diemer, Emma Lou, 478
Diener, Betty Sue, 1402
DiPrima, Dominique, 1105–1106
Dix, John, 956
Dlugacz, Judy, 316–317, 1787
Dobbins, Frank, 694
Dobkin, Alix and Adrian, 1182
Doliner, Gorana, 1297
Donington, Robert, 1403
Dopp, Bonnie Jo, 13
Doubleday, Veronica, 1318, 1320
Dougan-Krstic, Nadine, 1298
Dournes, Jacques, 1260
Drew, Sally, 1159
Driscoll, F. Paul, 490
Drucker, Ruth, 1619
Duckett, Linda B., 372
Duckles, Vincent H., 14
Due Pontremoli, 1661
Duffy, Thom, 217, 373
Dugaw, Dianne, 1460
Dunaway, Judy, 595
Duncan, Scott, 812
DuPree, Mary, 542
Duran, Lucy, 1233
Durbin, Elizabeth, 137
Dwyer, Paula Ennis, 1662
Dyer, Richard, 445

Eagle, David, 711
Early, Gerald, 896
Eastman, Holly, 1404
Edmonds, Edward, 755
Edwards, J. Michele, 139–140, 674, 813
Einemann, Marita, 218

Einhorn, Jennifer, 1155
Elias, Cathy Ann, 695
Elizabethan Conversation, 1663
Elkins-Marlow, Laurine, 814
Ellis, Catherine J., 1261–1262
Ellis, Diane C., 74, 75
Ellison, Cori, 596
Ellison, Mary, 897
Elwood, Philip, 1043
Emery, Ron, 219
Emslie, Barry, 1405
Engeler, Margaret, 318
Engh, Barbara, 1357
Epstein, Selma, 15, 141, 220, 319, 1620,
    1664–1676
Eskin, Virginia, 1723–1724
Estampie (Musical Group), 1677
Evans, Carmen Murphy, 815

Fainlight, Ruth, 816
Fairweather, Sharon Stapleton, 1135
Falk, Joyce Duncan, p. xiii
Falkenburg, Carole van, 1805
Fallows, David, 696
Fanny Mendelssohn-Quartett, 1678
Farin, Klaus, 957
Feather, Carol Ann, 446
Fehn, Ann Clark, 1406
Feld, Steven, 1263–1264
Feldman, Ann E., 756
Feng Jing, 817
Fenster, Mark Andrew, 1553
Ferguson, Marijke, 661
Ferreira, Christine, 959
Ferris, Lesley, 142
Field, Lucille, 1679
Fields, Jessica, 1502
Fier, Debbie, 177
Finger, Susan Pearl, 818
Fink, Monika, 143
Fink, Sue, 221
Firnkees, Gertrud, 819
Firth, Raymond, 1265
Fishbein, Martin, 1605
Fishell, Janette, 375
Fiske, John, 1501
Fjell, Judy, 1554
Flam, Gila, 1299
Flanagan, Bill, 960
Fletcher, Kathy, 921
Flinn, Carol, 1503–1505
Ford, Charles, 1407–1408
Ford, Terence, 1526
Fordham, John, 447
Forte, Jeanie Kay, 144

Fox, Mimi, 515
France, Kim, 491
Franckling, Ken, 321
Franke, Carrie, 1584
Fraser, Barbara Means, 1461
Frauenmusik-Forum, 820
Freilicher, Elizabeth, 1642
Freitag, Wolfgang, 1506
French, Iris T., 414
Friedwald, Will, 1044-1046
Friends of the Hammer, 1156
Friou, Robert E., 322
Frisbie, Charlotte J., 376, 1331
Frith, Simon, 962-963, 1462
Fritsch, Ingrid, 1266
Fromm, Paul, 415
Fry, Stephen M., 323, 377
Fuller, Sophie, 757
Funayama, Nobuku, 145
Funseth, Solveig, 1680
Furman, Nelly, 1409
Furth, Daisy von, 964

Gaar, Gillian G., 965
Gackle, Lynne, 1585
Galles, Duane L. C. M., 675
Gamman, Lorraine, 1555
Ganz, Arthur, 1410
Gaquin, Deidre A., 73
Gardner, Kay, 324, 325, 516–517
Garratt, Sheryl, 1556
Gärtner, Heinz, 712
Gatens, William A., 146
Gates, Eugene, 518
Gates, J. Terry, 543
Gaume, Matilda, 821
George, Nelson, 898
Gerdin, Mia, 1157
Gianturco, Carolyn, 713
Giddins, Gary, 1047
Gidwitz, Patricia Lewy, 714–715
Giglio, Virginia, 1332
Gilbert, Ronnie, 1158
Giles-Davis, Jennifer, 1570
Gillard, Cheryl, 147
Gippo, Jan, 832
Gläss, Susanne, 597
Gleason, Holly, 1136
Glickman, Sylvia, 379, 1621–1622
Glogauer, Werner, 1507
Godefroid, Philippe, 148
Gojowy, Detlef, 224–227, 598
Goldberg, Loretta, 1681
Goldner, June Riess, 599
Goldstein, Richard M., 1463

Gonzalez, Marilyn M., 1586
Goode, Gloria Davis, 1089
Gordy, Laura Ann, 716
Gottlieb, Jane, 196, 198, 380
Göttner-Abendroth, Heide, 519
Gourse, Leslie, 449, 1049
Gradenwitz, Peter, 600
Graff, Gary, 1137
Grant, Beata, 1267
Grattan, Virginia L., 57
Gray, John, 16, 17
Gray, Michael, 18
Gray, Sarah, 228
Green, Andrew, 1526
Green, Cynthia, 19
Greene, Michael, 381
Gregoire, Michele A., 1587–1588
Gregory, Deborah, 1107
Greig, Charlotte, 966–967
Grein, Paul, 968–969
Groce, Stephen B., 970
Groh, Jan Bell, 822
Gronemeyer, Gisela, 229, 823–824
Gross, Olga, 601–602
Gruber, Clemens M., 603
Gudgeon, Chris, 971
Guelker-Cone, Leslie, 20
Guidobaldi, Nicoletta, 1527
Gunden, Heidi Von, 520
Guse, Celia, 230

Haas, Gerlinde, 662, 758–759
Hadleigh, Boze, 922
Hale, Mimi, 479
Hale, Thomas A., 1793
Hall, Alan, 231
Hall, Corey, 232
Hall, Marnie, 326
Hallgarth, Susan A., 58
Hamilton, Sylvia, 1785
Hampton, Dream, 1464
Handy, D. Antoinette, 450
Haney, F. Paul, 1138
Hansen, Christine Hall, 1557, 1589–1590
Hansen, Ranald D., 1557, 1589
Harbach, Barbara, 1623–1625, 1684–1686
Harley, Donald V. S., 544
Harnisch, Christine, 1687
Harper, Jorjet, 233–235, 521, 663–664, 972
Harper, Lea, 382
Harrington, Richard, 973
Harris, Deborah, 1170
Harris, Geraldine, 923
Harrison, Daphne Duval, 21, 1090–1092
Haselwerdt, Maggie, 1465

Hassinger, Jane, 1050
Hassler, Marianne, 1591–1602
Hatton, Orin T., 1333
Hauel, Sylvie, 1411
Hay, Beverly, 717
Hayes, Deborah, 718, 825
Hays, Sorrel, 1804
Hazen, Margaret Hindle, 760
Hazen, Robert M., 760
Heartz, Daniel, 1528
Heidelberger Madrigalchor, 1688
Heinrich, Adel, 22
Henahan, Donal J., 416
Hendricks, Jon, 1051
Hennessee, Don A., 59
Henning, Uta, 1525
Hennings, Patricia, 327, 328
Henry, Edward O., 1268
Henry, Murphy, 236
Henson, Brenda, 237
Hernandez, Deborah Pacini, 934, 1346
Hernandez, Ramon, 1347
Herndon, Marcia, 1194, 1334
Heroines, 1734
Herrera-Sobek, María, 1466–1467
Heskes, Irene, 1195
Hessen, Ro van, 23
Hester, Karen, 329
Hettergott, Alexandra, 238
Hicken, Leslie Wayne, 1558
Hickok, Gloria Vando, 149
Hicks, Robert, 1052
Higgins, Paula, 697
Higher Education Arts Data Services, 76
Hildebrand, David K., 719
Hildebrand, Lee, 330
Hill, Cecil, 1412
Hill, Edward, 974
Hill, Robert, 826
Hinely, Mary Brown, 197
Hinkle-Turner, Elizabeth, 827
Hinson, Maurice, 1626
Hintze, Werner, 1442
Hixon, Don L., 59
Hochberg, Marcy, 239
Hoekstra, Dave, 451
Hoffman, Freia, 604–605
Höft, Brigitte, 26, 626
Hoke, S. Kay, 900
Holden, Stephen, 975
Holston, Mark, 1348
Holst-Warhaft, Gail, 199, 1300
Hoover, Katherine, 240
Horn, David, 25
Horowitz, Is, 383

Hotaling, Ann Caroline, 522
Houden, Helen, 1603
Hovda, Robert W., 1358
Howard, Patricia, 1413–1414
Hubbs, Nadine Marie, 150
Hudson, Elizabeth, 1415
Huffman, James R., 1468
Huffman, Julie L., 1468
Humm, Maggie, p. xiii
Humphreys, Nancy, 331
Hunt, Dennis, 1108
Hurwitt, Elliott, 1529
Huston, John, 924
Hyde, Derek, 761

Ice, Joyce, 1196
Igarashi, Tomio, 1269
Ikome, Nkangonda, 1469
Ingenhoff, A., 242
Ingrassia, Thomas A., 925
Innaurato, Albert, 606
International Alliance for Women in Music, 78
International League of Women Composers, 60. *See also*, International Alliance for Women in Music
International Women's Brass Conference, 61
Internationales Komponistinnen-Festival Kassel (1987), 607
Irving, Howard, 762
Isler, Scott, 926

Jackson, Barbara Garvey, 27, 332–334, 720, 1627–1631
Jackson, Richard, 25
Jacobs, Tom, 452
Jacobson, Marion S., 828
Jacobsson, Stig, 608
Jais-Mick, Maureen, 384
James, Barbara, 1470
Janowitz, Tama, 976
Japenga, Ann, 977
Jeffrey, Peter, 28, 1197
Jennings, Carolyn, 1359
Jennings, Lucile H., 151
Jensen, Byron William, 763
Jepson, Barbara, 453, 492
Jeske, Lee, 243
Jesudason, Melba, 1159
Jezer, Rhea, 480
Jezic, Diane Peacock, 545, 609, 1707
Jhally, Sut, 1788
Johnsen, Gladys, 454
Johnson, Anna, 1301–1302
Johnson, Calvert, 1632

Johnson, Rose-Marie, 29
Jones, Allan, 978
Jones, Edward Huws, 721
Jones, Jenna Jordan, 546
Jones, L. JaFran, 1198, 1234
Jones, Lisa, 1109
Jordan, Carolyne Lamar, 764
Jordan, Elena, 1160
Jorgens, Elise Bickford, 1471
Joseph, Rosemary, 1235
Joy, Sally Margaret, 979–980
Joyce, Beverly A., 10
Joyner, Doris J., 1609

Kaczorowski, Geary, 981
Kaeppler, Adrienne L., 1270
Kager, Reinhard, 244
Kaiser, Antje, 1416
Kakinuma, Toshie, 829
Kalinak, Kathryn, 1508
Kalis, Pamela, 1559
Kämpfer, Frank, 385, 610
Kane, Karen, 245, 335
Kaplan, E. Ann, 1509–1511
Karandy, Emely, 1606
Kareda, Urjo, 830
Karlin, Liz, 1560
Karna, Duane, 30
Kartomi, Margaret J., 1199
Kassabian, Anahid, 152
Katariya, Geeta, 1271
Kaufmann, Dorothea, 927
Keeling, Richard, 1335–1337
Keenan-Takagi, Kathleen, 1
Kellaris, J. J., 1604
Keller, Michael A., 14
Kelly-Gadol, Joan, 698
Kendrick, Robert, 722
Kennicott, Philip, 1417
Kestner, Joseph, 1418–1420
Keyes, Cheryl L., 336
Keyser, Dorothy, 723
Khittl, Christoph, 1421
Kielian-Gilbert, Marianne, 246
Killam, Rosemary N., 481
Killian, Janice N., 1561
Kilmister, Sally, 153
Kimberlin, Cynthia Tse, 386, 1200
Kinder, Marsha, 1512
Kingsbury, Paul, 1139–1140
Kinney, Michelle, 417
Kircher, Cassie, 1513
Kivi, K. Linda, 154
Klotins, Arnolds, 1472
Knight, Ellen, 831

Kodish, Debora, 1201
Koether, Jutta, 928
Kohno, Toshiko, 832
Koplewitz, Laura, 1054
Koskoff, Ellen, 1202–1206
Kosky, Christine, 455
Koza, Julia Eklund, 547–550, 1360–1361
Kozinn, Allan, 387
Kramer, Lawrence, 1362, 1422–1424
Kreitner, Kenneth, 765
Kristena, Claude, 982
Kroll, Renate, 724
Kromsten, Katharina Brette, 983
Kronke, David, 984–985
Krummel, Donald William, 31
Krydl, Hans M., 833
Kubik, Gerhard, 1236
Kuckuck, Anke, 957
Kuhns, Connie, 248, 337
Kulturinstitut Komponistinnen Gestern-Heute, 834
Kuwabara, Mari, 611
Kwami, Robert, 551
Kydd, Roseanne, 612

Laine, Cleo, 1760
Lamb, Roberta K., 552–554
Langen, Toby, 1161
Langguth, Paula E., 1514
Lardas, Konstantinos, 1303
Laredo, Ruth, 613
Larkin, Kevin T., 1579
Laster, James, 32, 33
Latz, Inge, 155
Lavin, Christine, 1761
Lavner, Lynn, 515
Lawson, Kay, 456
Lazier, Kate, 493
LeBlanc, Albert, 1563
Lebrecht, Norman, 457
Leder, Jan, 34
Lee, Wayne, 1055
Lefanu, Nicola, 418, 835
Lefebvre, Marie-Thérèse, 614
Lehmann, Lotte, 1425
Leland, John, 987
Lems-Dworkin, Carol, 35
Leong, Laurence Wai-Teng, 1564
LePage, Jane Weiner, 62
Leppert, Richard, 1530–1533
Lerner, Elinor, 988
Leslie, Paul L., 1096
Lewin, David, 1363
Lewis, George H., 1473
Lewis, Lisa A., 989–993, 1565

Lewis, Ruth A., 156
Libana, 1633, 1762
Lievense, Willy, 836
Light, Alan, 994
Lincoln, Bruce, 1207
Lindeman, Carolynn A., 555, 1634
Lindley, David, 1364
Lindley, Mark, 1534
Lindmayr, Andrea, 615, 725
Ling, Jan, 766
Linn, Karen, 1535
Lipman, Samuel, 616
Little, Hilary, 1567
Little, Lowell, 556
Littlejohn, David, 1426
Livingston, Carolyn, 557
Llewellyn, Becky, 249
Locke, Ralph P., 837, 1427–1428
Loeb, Catherine, 36
Loesser, Arthur, 617
Longstreth, Stephen, 1800
Lont, Cynthia M., 338–339, 1162
Lontano, 1693
Loranger, Dennis, 1474
Lovric, Jenny, 444
Lowe, Jim, 250
Lowenstein, Alice, 1163
Lück, Harmut, 252
Lueck, Therese L., 901
Lull, James, 1208
Lumpe, Vera, 251
Lundy, Karen Saucier, 1475
Lynch, Kevin, 1056
Lynn, Sharon, 1161

Ma Guangxing, 1272
Maas, Martha, 665
Mabry, Sharon, 37, 838–841, 1695
Macalester Trio, 1696
MacAuslan, Janna, 157, 618, 842–843, 1164, 1183
Macey, Patrick, 699
Machover, Wilma, 158
Macy, Laura W., 676
Madsen, Clifford, 1610
Mageau, Mary, 419
Magliocco, Hugh, 459
Maher, Beverly, 460
Maik, Linda L., 1476
Mapp, Ben, 1111
Marez Oyens, Tera de, 253, 340
Marianello, Linda, 461
Marin, Susana, 1697
Maris, Barbara English, 38
Marshall, Clifford T., 558

Marshall, Mary Ann, 1112
Marshment, Margaret, 1555
Martín, Alicia, 1477
Martin, Linda, 1536
Massalon, Jennifer, 1113
Matheopoulos, Helena, 844
Mathiesen, Penelope, 726
Matsushita, Hidemi, 1635
Matthei, Renate, 620
Maurstad, Tom, 388
Maus, Fred, 279, 1365
May, Wanda, 559
Mayfield, Geoff, 494
Mayhall, Marcellene Hawk, 767
Mayhall, Walter, 767
McAdams, Janine C., 902–903, 1114–1116,
    1478–1479, 1515
McAllister, Pam, 1165
McCarthy, David B., 1366
McCarthy, Hazel, 462
McCarthy, Margaret W., 768
McCarthy, William B., 1131
McClary, Susan, 159–162, 995, 1367,
    1429–1432
McCray, James, 39
McDonnell, Evelyn, 254, 495, 1117
McElfresh, Suzanne, 255, 256
McGeary, Thomas, 1433
McGinty, Doris Evans, 845
McGovern, Dennis, 619
McKinnon, James, 666
McLane, Daisann, 496
McLaren, Jay, 63
McLaughlin, Andrée Nicola, 1088
McNeil, Legs, 996
McPartland, Marian, 1057
McRobbie, Angela, 1368, 1462
Melinand, Michele, 1434
Mellers, Wilfrid, 904
Mendenhall, Christian, 1480
Mendl-Schrama, Heleen, 846
Menk, Nancy, 32, 33
Merrill-Mirsky, Carol, 1209
Mertl, Monika, 420
Metzelaar, Helen, 23, 621, 727
Meyer, Andreas, 1435
Meyers, Carol L., 667
Michelini, Ann N., 668
Middlebrook, Joyce, 1802
Middlestadt, Susan E., 1605
Mielitz, Christine, 163
Mifflin, Margo, 997
Miller, Bonny H., 769
Miller, Philip L., 622

Miller, Susanna L., 1058
Milligan, Mary, 164
Millington, June, 998
Mills, Margaret A., 1256
Milward, J., 929
Mitgang, Laura, 847
Mizrahi, Joan Berman, 1369
Moenninger, M., 257
Mohammed, Patricia, 1481
Molinari, Guido, 770
Mölk, Ulrich, 677–678
Monroe, Ervin, 463
Monson, Craig A., 700
Monson, Karen, 497
Montell, William Lynwood, 1093
Monts, Lester, 1237
Moor, Paul, 848
Moore, John, 930
Moore, Julianna, 623, 771
Moore, Randall S., 560
Moreno, Salvador, 165
Morgan, Joan, 1118
Morris, Bonnie, 258
Morris, Chris, 498–499, 999
Morris, Edward, 1141, 1482
Morris, Kenneth E., 1142
Morris, Mitchell, 166
Moses, Mark, 1000
Moskovitz, Elisa M., 561–562
Motte, Diether de la, 624
Muktupavels, Valdis, 1472
Mullally, Robert, 728
Müller, Marieluise, 1525
Müllman, Bernd, 261, 262
Murray, Judi, 259
Musica Femina, 40, 1698
Musica Secreta, 1694
Myers, Margaret, 167, 625
Myers, Robert, 1349

Nasrallah, Dana, 1002
Nathan, David, 500–501
National Women Composers Resource
    Center, 79
Naura, Michael, 1059
Near, Holly, 1166
Neef, Sigrid, 1436
Nelson, Florence, 389
Nett, Emily, 1003
Neubecker, Annemarie Jeanette, 669
Neuen, Donald, 563
Neuendorf, Kimberly A., 1559
Neuenfeldt, Karl Wm., 1483
Neuenschwander, Leni, 626, 849

Neuls-Bates, Carol, 850–851
Nevin-Schor, Amanda M., 627
New York Women Composers, Inc., 80
Newcomb, Anthony, 701–702
Nichols, Elizabeth, 564
Nichols, Janet, 628
Nieschlag, Eberhard, 1600–1602
Nilsson, Ann-Marie, 679
Noble, David, 263
Norden, Barbara, 264
Nylén, Leif, 1004

O'Boyle, Carmel, 1636
O'Brien, Lucy, 931
Oermann, Robert K., 1129–1130, 1143
Oglesbee, Frank W., 1516
O'Grady, Deidre, 1437
Öhrström, Eva, 168–169, 523, 629–630, 729,
    773–777
Okafor, R. C., 1238
Okamoto, David, 905
Okrent, Daniel, 932
O'Leary, Jane, 265, 266, 296
Oliven, Ruben George, 1350, 1484
Oliveri, Sandy, 1791
Olivier, Antje, 41, 42, 64, 391, 1525
Olson, Judith E., 772
O'Meally, Robert, 1753
O'Neil, Jean, 464
Oppenheim, Jill R., 267
Orbell, Margaret, 1273–1274
Orsoni, Jerry, 565
Oster, Martina, 47
Ostleitner, Elena, 43, 422, 566, 852
Ostrander, Linda, 423–425
Ottley, Rudolph, 1351
Overhauser, Catherine, 198, 486
Owens, Margareth Boyer, 1537

Pacheco, Sonia M., 933
Paden, William D., 680–681
Page, Christopher, 682
Pageot, Édith-Anne, 1370
Palacios, Diane, 853
Palmer, Larry, 854
Palmer, Robert V., 567
Palmer, Roy, 1485
Palmquist, Jane E., 568
Paolucci, Bridget, 502
Pareles, Jon, 1005–1006, 1119, 1144
Parker, David, 855
Parker, Linda F., 856
Parsons, Patrick R., 503
Pasler, Jane, 170

Paulsson, Kajsa, 935
Payne, Barbara, 568
Paz, Suni, 1768
Pearlman, Jill, 1120
Peebles, Sarah, 342
Peeples, Georgia, 778
Pelka, Fred, 1517
Pels, Dick, 1438
Pemberton, Carol, 569
Pendle, Karin, 171, 631, 703
Peretti, Burton W., 1060
Perry, Claudia, 906
Perry, Pamela J., 857
Petard, Gilles, 44
Petersen, Barbara A., 426, 858
Petersen, Karen E., 1167
Peterson, Jon Brian, 1550
Peterson-Lewis, Sonja, 1486
Petrovic, Ankica, 1304
Pfaff, Timothy, 268
Phalen, Tom, 465
Philipp, Beate, 859
Phillips, Kenneth, 570
Picard, Patricia, 571
Pieiller, Evelyne, 172
Pipes, Charlotte Fakier, 1439
Pizà, Antoni, 1538
Placksin, Sally, 1061–1063
Poe, Elizabeth Wilson, 683
Poedjosoedarmo, Gloria R., 1275
Poizat, Michel, 1440
Polin, Claire, 269
Polk, Joanne, 196, 632–634
Pollack, Howard, 860
Pollock, Mary S., 1168
Pool, Jeannie, 270, 392, 861, 1803
Poole, Jane L., 393
Porter, Gerald, 1184
Post, Jennifer C., 1210, 1276
Post, Laura, 271, 466, 572, 908–909, 1169
Pouffe, Hélène, 741
Powell, Maud, 779
Power, Kikuyo Matsumoto, 573
Powers, Ann, 1007–1008
Prammer, H., 272
Prasad, Onkar, 1277
Pratt, Ray, 1009
Preito, Claire, 1785
Preston, Cathy Lynn, 1487
Primack, Bret, 1064
Prizer, William F., 704
Pschera, Alexander, 273
Pugh, Aelwyn, 635
Pulido, Esperanza, 636–637

Puterbaugh, Parke, 936
Putnam, Thomas, 274

Quantrille, Wilma, 1371
Quintana, J. Terrie, 730

Rabinowitz, Peter J., 1566
Rabson, Carolyn, 482
Raitt, Suzanne, 1539
Ramsten, Märta, 169, 173, 1145, 1185,
   1305–1306, 1488
Randel, Don Michael, 174
Rathke, Michael, 1372
Redpath, Lisa, 45
Reeder, Ray, 1441
Rees, Leanne, 1699
Reich, Nancy B., 46, 780–782
Reid, Frances, 1787
Reid, Sally, 394
Reid, Sarah Johnston, 395
Reinhard, Ursula, 1322
Reinhold, Daniela, 1442
Reisinger, Eva, 275
Reitter, Karin, 1373
Reitz, Rosetta, 1094–1095
Reynolds, Margaret, 505
Reynolds, Simon, 1010
Rhéaume, Claire, 638–639
Ribouillault, Danielle, 276
Rice, R. C., 1604
Rice, Timothy, 1307
Richardson, Carol P., 483
Richmond, Eero, 640
Richter, Ottfried, 862.
Rickard, Marilee, 1170
Rickert, Janice, 277
Rieger, Angelica, 684
Rieger, Eva, 47, 175–176, 278, 524–525,
   574–575, 605, 641–642,
731, 887, 1637–1638
Riis, Thomas, 279
Riley, Joanne, 705
Riley, Richard, 467
Ripley, Colette S., 643, 863
Rito, Rio, 1065
Roberts, Robin, 1011, 1121
Robertson, Carol E., 1211–1214
Robertson, Ruth, 644
Robinson, Deanna Campbell, 77
Robinson, Susan Louise Bailey, 864
Robinson, William Andrew, 1489
Roell, Craig H., 783
Rogan, Michael J., 196
Rogers, Delmer D., 937
Rogers, Margaret N., p. xiii

Rogers, Sheila, 910
Roma, Catherine, 177, 280, 344, 865–868
Roos, James, 869
Rorem, Ned, 178
Rorich, Mary, 1239
Rosand, Ellen, 732–733
Rose, Betsy, 1171
Rose, Phyllis, 1753
Rose, Tricia, 1753
Roselli, John, 645
Roseman, Marina, 1278
Rosen, Craig, 1012
Rosen, Jesse, 468
Rosenbaum, Joshua, 469
Rosenberg, Donald, 281
Rosenberg, Wolf, 1443
Rosenbluth, Jean, 396
Rosenn, Eva, 1444
Roske, Michael, 784
Ross, Sean, 1013
Rossen, Jane Mink, 1279–1280
Rothenbusch, Esther, 785
Rothstein, Robert A., 1215
Rounds, Martha, 1216
Rüedi, Peter, 1066
Ruggieri, Eve, 734
Ruiter, Jacob, 1374
Ruke-Dravina, Velta, 1490
Rumsey, Gina, 1567
Russell, Dave, 871
Russell, Tilden A., 1540
Rutherford, A., 576
Rutherford, Susan, 1375
Ryder, Georgia A., 872

Saba, Therese Wassily, 873
Sachs, Lloyd, 282
Sadie, Julie Anne, 66, 735–736
Said, Edward W., 526
Sakata, Hiromi Lorraine, 1323
Salsini, John Louis, 786
Samuel, Rhian, 66, 179, 180
Sandman, Susan G., 648
Santa Cruz, Maria Aurea, 1491
Santucci, Pellegrino, 1445–1447
Sara, 1172
Sataloff, Dahlia M., 1606
Sawa, Suzanne Meyers, 1324
Sawchuck, Kimberly Anne, 1492
Sawkins, Lionel, 737
Sax, William S., 1281
Scauzillo, Retts, 283
Schechter, John M., 647
Scheurer, Timothy E., 1493
Schiller, Greta, 1801

Schlachter, Gail Ann, 67
Schlattman, Tim, 1014
Schlegel, Ellen Grolman, 48
Schleifer, Martha Furman, 1622
Schmidt, Cynthia E., 1240–1241
Schmidt, Mia, 397
Schmidt, Siegrun, 47
Schoemer, Karen, 1015
Schonfeld, Rosemary, 1173
Schramm, Carola, 181
Schreiber, Ulrich, 1448
Schulte-Hofkruger, Brigitte, 1067
Schulze, Laurie, 1549
Schwartz, Ellen, 911
Schweizer, Irène, 1068
Schwichtenberg, Cathy, 1518
Schwörer-Kohl, Gretel, 1282
Scott, Derek, 938
Scotto Di Carlo, Nicole, 576
Sealock, Barbara, 1069
Searing, Susan E., 36
Seebass, Tilman, 685, 1541
Seeger, Nancy, 284–285, 345–346
Seeling, Ellen, 1174
Segrave, Kerry, 1536
Seidman, Stephen A., 1519
Seitz, Barbara, 1186
Selbin, Eric, 912
Seltzer, George, 874
Senelick, Laurence, 182
Sephira Ensemble Stuttgart, 1700
Servatius, Viveca, 686
Sexton, Paul, 913
Shafer, Sharon Guertin, 738
Shaffer, Jeanne E., 286
Shapiro, Anne Dhu, 183–184, 1338
Sharp, Timothy W., 1376
Shatin, Judith, 875
Shayne, Julie, 577
Shehan, Patricia K., 1308
Shelemay, Kay Kaufman, 1217
Shepherd, John, 185, 1568–1570
Sher, Liz, 1070
Sheridan, Wilma, 484
Shetler, Donald J., 1607
Shiloah, Amnon, 1325–1326
Shloush, Chana, 1218
Shona, 287
Shropshire, Liz, 876
Shteir, Rachel B., 186
Shute, Sherry, 998, 1016
Sicoli, M. L. Corbin, 939
Simek, Ursula, 566, 800
Simmonds, Diana, 892
Simmonds, Ron, 1071

Simon, John, 1449
Sinfonye, 1701–1702
Sinker, Mark, 1017
Skipper, James K., Jr., 1096
Slim, H. Colin, 1542–1544
Sloan, Judith, 1175
Slobin, Mark, 1219–1220
Smart, Mary Ann, 1450
Smetko, Paul David, 578
Smith, Catherine Parsons, 288, 877
Smith, Danyel, 1494
Smith, Dinita, 1122
Smith, Elizabeth J., 787
Smith, Karen L., 1608
Smith, Pamela, 347
Smith, Sheila Ann, 1571
Snyder, Jane McIntosh, 665
Söderberg, Marianne, 579
Sohmer, Jack, 1072
Solie, Ruth A., 187–188, 289, 648, 1377, 1451
Sonntag, Brunhilde, 649–653
Sorrels, Rosalie, 1648
Spagnardi, R., 506
Spatz, Christa, 1525
Spektor, Mira, 1786
Spencer, Jon Michael, 1097
Spencer, Lauren, 1018
Sperber, Roswitha, 887.
Spohr-Rassidakis, Agni, 1309
Sprague, David, 1019
Springer, Christina, 290
Springer, Morris, 1378
Srivastava, I., 1283
St. Lawrence, Janet S., 1609
Stafford, Beth, 68
Stamps, Wickie, 348
Standley, Jayne M., 1610
Stark, Ellen, 1572
Starr, Victoria, 1176–1177
Steane, J. B., 654
Steegman, Monica, 1379
Stein, Ada Mae, 1611
Stein, Arlene, 1020
Stephen, Lynnéa Y., 349–350, 878
Stephens, Kevin, 291
Steward, Alan D., 1021
Stewart, Dave, 189
Stewart, Milton L., 1073
Stewart-Green, Miriam, 292
Stiefelmaier, Horst Dieter, 1074
Stineman, Esther F., 36
Stockbridge, Sally, 1520
Story, Rosalyn M., 655
Stout, Glennis, 656, 879
Straus, Joseph N., 1640

Strauss, Neil, 427
Strine, Helen, 1619
Studdal, Ashley, 507
Sturman, Susan, 293
Stuttgen, Joanne Raetz, 1146
Subirats, María Angeles, 1310
Sugarman, Jane C., 1311–1312
Suh, Mary, 1495
Sullivan, Caroline, 940
Sultan, Nancy, 1313
Summers, Gerrie E., 1123
Summerville, Suzanne, 294–296
Sunderland, Patricia Ann, 1573
Sutro, Dick, 351
Sutter, André, 626
Sutton, Catherine, 297
Sutton, R. Anderson, 1284
Sutton, Terri, 1178
Swados, Elizabeth, 428
Syndergaard, Larry, 1496
Szántó, Annamaria, 298

Tagg, Philip, 1521
Tann, Hilary, 299
Tarnowski, Susan M., 580
Taylor, Anita, 1457
Taylor, Louise Ganter, 581
Tenhaef, Peter, 1545
Tenzer, Michael, 1285
Tewari, Laxmi G., 1286
Texier, Catherine, 1522
Thaler, Lotte, 300
Thigpen, David E., 1124
Thomas, Anne Marsden, 1703
Thomas, Gary, 125
Thomas, Jean Waters, 788
Thompson, Ben, 1022
Thomson, Margie, 190
Thurman, Leon, 582
Thym, Jürgen, 1406
Tick, Judith, 301, 399–400, 590, 789, 1380
Tierney, Helen, 69
Tignac, Catherine Z., 880
Tilchen, Maida, 1179
Timbrell, Charles, 881
Timmerman, Iris, 1075
Timpunza Mvula, Enoch Selestine, 1242
Tolbert, Elizabeth, 1314–1316
Tomlinson, Gary, 289
Toorn, Pieter C. van den, 191
Trawick, Margaret, 1287
Treitler, Leo, 1381, 1452
Tremblay-Matte, Cécile, 192, 193
Trooien, Roberta Pierce, 1382
Trowbridge, Jennifer, 914.

Tsou, Judy S., 134
Tubeuf, André, 657
Tucker, Sherrie, 1383
Tunnell, Kenneth D., 1497

Urso, Camilla, 790

Vagts, Peggy, 49, 583
Van de Vate, Nancy, 302–303, 401–402,
    429–430
Van Dyke, Elizabeth Artemis, 353
Van Dyke, Mary Louise, 50, 527
Vander, Judith, 1339–1340
Vargas, Ignacio, 1453
Vennum, Thomas, Jr., 1341
Verdino-Sullwold, Carla Maria, 403
Vetterlein, Hans, 354
Viano, Richard J., 739
Vincent, Richard C., 1523–1524
Vinebohm, Lisa, 355
Violanti, Anthony, 1024
Virolle-Souibès, Marie, 1243
Vogels, Raimund, 1244
Voynow, Sarah K., 1076

Wacholtz, Larry Edward, 1574
Wachtel, Peggyann, 304
Wadsworth, Susan, 508
Wagner, Renate, 1470
Wagner-Glenn, Doris, 1245
Waleson, Heidi, 431, 470–471, 1612
Walker, Hazel, 404
Walker-Hill, Helen, 51, 194, 356, 882, 1641
Wallace, Michelle, 1125–1126
Walowitz, Paula, 305
Walser, Robert, 1498
Walsh, Michael, 472
Walter, Käte, 1637–1638
Webb, Betty, 357
Weber, J. F., 883
Weems, Helen R., 884
Wehling, Peter, 1077
Wehse, Rainer, 1499
Weich-Shahak, Susana, 1221
Weinbaum, Batya, 1180
Weingartz–Perschel, Karin, 42, 64
Weiss, Andrea, 1801
Weissman, Dick, 405
Weissweiler, Eva, 306, 885–887
Wells, Alan, 941, 1575–1576
Wendt, Gunna, 1078
Wenner, Hilda E., 1642
Wenzel, Lynn, 195, 888, 1181
Weschenfelder, Klaus, 1525.
West, M. L. (Martin Litchfield), 670

West, Martha Ullman, 308
Westerfield, Jane Robertson, 942
Wheatley, Elizabeth, 1500
Wheelock, Gretchen A., 1384
Whitall, Susan, 943
White, Adam, 309
White, Cathi, 455
White, Hayden, 1385
Whitesitt, Linda, 658–659, 791
Widmaier, Andreas, 742
Wiedemann, E., 1080
Wigler, Stephen, 473
Wilkin, Phyllis E., 1613
Willier, Stephen Ace, 1454
Winner, Joan K., 584
Wiratini, Ni Made, 1288
Wise, Sue, 1577
Wishart, Stevie, 1701–1702
Wohlthat, Martina, 310, 474
Women Band Directors National Association, 70
Women's Philharmonic, 1651, 1708
Wood, Elizabeth, 125, 529–530
Wood, Gerry, 1147
Wren, Brian, 1387
Wright, Christian, 944

Wright, David, 792
Wright, Josephine, 793
Wubbenhorst, Thomas Martin, 585
Wurtzel, Elizabeth, 1029–1030
Wyndham, Tex, 1083
Wynn, Ron, 1148

Yanow, Scott, 358
Yardley, Anne Bagnall, 687–688
Yeh, Nora, 1289
Young, Gayle, 434–435
Young, Jon, 945
Yount, Rena, 1182
Yurchenco, Henrietta, 1098, 1187

Zaimont, Judith Lang, 196–198, 313, 486
Zannino, Mimi, 406
Zanten, Willem van, 1290
Zdzinski, Stephen F., 586
Ziegler, Susanne, 1194, 1327–1328
Zierolf, Robert, 890
Zillman, Dolf, 1578
Zimmerman, Kevin, 946
Zschunke, Andrea, 660

# Subject Index

The subject index is arranged in word-by-word order. Composers and musicians may be found in one of the following areas: as individual headings, as general subheadings under a main subject, or the end of the *Composers* and *Musicians* headings, listed under the subhead *names of specific.*

The following abbreviations are used: Audiovisual: *av,* Recording: *r,* Score: *sc.*

Africa, 16, 35, 551, 1192, 1222, 1230, 1241, 1244, 1245, 1469, 1793*av;* Afro-Hispanic music, 1188; gender and, 1200, 1224, 1226, 1234, 1236, 1237, 1240; instruments, 1225, 1226; music education, 551; singers, 1223, 1233; sung poetry, 1229, 1231, 1242
African-American women in music. *See* Composers, Black; Musicians, Black
American music, 20, 31, 803; American Federation of Musicians, 289, 389, 874; American Music Center, 394; American Musicological Society, 216, 289, 369, 370, 371, 378, 399, 400; Boston, 793; California, 861; composers, 279, 557, 719, 769, 797, 813, 818; Federal Music Project, 802; feminism and, 134; gender and, 127; Kansas, 763; in ladies' magazines, 134, 1360, 1361; Los Angeles, 818; Maryland, 719; New Jersey, 126; New York, 80, 307, 322, 409, 413, 421, 427; orchestras, 804; score anthologies, 1642*sc,* 1648*sc;* Southern, 197; Texas, 937. *See also* Blues; Folk music; Jazz; North American Indian music; Organizations
Anderson, Beth, 1665*r*
Anderson, Laurie, 159, 628, 813, 823, 824, 1797*av*
Andrée, Elfrida, 773, 774, 1680*r*
Anna Amalia (Duchess of Saxe-Weimar), 609, 625, 631, 718, 720

Anna Amalia (Princess of Prussia), 591, 609, 718, 1617*sc,* 1638*sc,* 1691*r*
Anstey, Marjolijn, 1675*r*
Archer, Violet, 1617*sc,* 1668*r*
Arnim, Bettina von, 591, 1691*r*
ARS FEMINA project, 349, 352, 357, 1819, 1828
Asian music: Cambodia, 1252, 1718; China, 817, 1267, 1272, 1289; Himalayas, 1281; Hmong, 1253, 1254, 1282, 1719*r;* India, 1206, 1255, 1256, 1268, 1271, 1276, 1277, 1281, 1283, 1285, 1287; Islamic, 1324; Japan, 145, 1257; South Korea, 205; Turkey, 1322, 1327, 1328; Vietnam, 1208, 1246
Aspen, Kristen, 1698*r*
Assandra, Caterina, 713
Association of Women's Music and Culture (AWMAC), 234, 271
Audiovisual media (A/V), 38, 158, 1506, 1513, 1514, 1516, 1752*r;* ambiguity in, 1510, 1511; attraction and, 1589, 1590; audience and, 1549, 1557; composers for, 407, 876; consumer girl culture, 1565; country music and, 1502; encoding, 1504, 1508; films, 1503, 1504; gaze and, 1510, 1513, 1520, 1788*av;* MTV, 993, 1509, 1510, 1511, 1513, 1519, 1522, 1524, 1559; postmodernism and, 1509, 1510, 1511, 1518; recordings, 158; romance and, 1501;

Audiovisual media (A/V) (*continued*)
stereotypes in, 1513, 1519, 1520, 1788*av;*
utopia and, 1505; violence and, 1507,
1557, 1559
Auenbrugg, Marianna d' (Auenbrugger,
Marianna von), 1625*sc,* 1626*sc,* 1685*r*
Aufderheide, May Frances, 1621*sc,* 1634*sc,*
1723*r,* 1786*av*
Aulin, Laura Valborg, 1680*r*
Australia, 105, 787; composers, 249, 419,
825, 1676*r;* non-Western music, 1248,
1261, 1262
Austria, 238, 566, 852; composers, 80, 244,
422, 603, 758

Bacewicz, Grazyna, 653, 863, 890, 1617*sc,*
1661*r,* 1668*r,* 1675*r,* 1687*r*
Backer-Grøndahl, Agathe, 751, 753, 1626*sc,*
1664*r,* 1666*r,* 1669*r,* 1675*r,* 1680*r,* 1687*r*
Bailey, Pearl, 1720*r*
Ballou, Esther Williamson, 1699*r*
Baptista, Gracia, 1632*sc,* 1686*r*
Barkin, Elaine, 120, 162
Barraine, Elsa, 253, 1653*r,* 1703*r*
Barthélemon, Cecilia Maria, 718, 1650*r,*
1684*r,* 1685*r*
Bauer, Marion, 744, 1619*sc*
Bay Area Women's Philharmonic, 79, 115,
139, 220, 268, 611, 848, 878, 1651*r,* 1708*r*
Beach, Amy, 134, 609, 628, 744, 745, 756,
789, 1617*sc,* 1619*sc,* 1621*sc,* 1626*sc,*
1640*sc,* 1647*sc,* 1661*r,* 1663*r,* 1665*r,*
1666*r,* 1667*r,* 1668*r,* 1672*r,* 1673*r,* 1674*r,*
1686*r,* 1696*r,* 1699*r,* 1705*r,* 1786*av*
Beath, Betty, 796, 1667*r,* 1672*r,* 1675*r,* 1676*r*
Beekhuis, Hanna, 1653*r*
Bergh, Gertrude van der, 621, 1668*r*
Bingen, Hildegard von, 332, 625, 635, 671,
674, 1617*sc*
Bishop, Heather, 1736*r*
Bitgood, Roberta, 1686*r*
Bluegrass, 236, 1138, 1497, 1553. *See also*
Country music; Folk music
Blues, 69, 171, 1710*r,* 1713*r,* 1714*r,* 1715*r,*
1716*r,* 1726*r,* 1754*r,* 1763*r,* 1764*r,* 1772*r,*
1773*r,* 1777*r,* 1783*r;* 1920s, 1090, 1091,
1092; African-American history and, 1088;
anthologies, 21; black women and, 1084,
1085; distributors, 1808, 1831; female
themes in, 1084; films about, 1086; nick-
names and, 1096; power and sexuality in,
1087; recording anthologies, 336, 1094,
1095; recording companies, 321, 351;
score anthologies, 1639*sc;* stereotypes in,
544. *See also* Jazz

Body, 142, 185, 209, 1363, 1364, 1511; avant-
garde music and, 824; composition and,
524, 525; iconography of, 604, 1539; as
instrument, 1033, 1066; instruments and,
604, 1258, 1259; postmodernism and, 514
Boetzelaer, Josina, 727
Boleyn, Anne, 1617*sc,* 1663*r*
Bolz, Harriet, 1699*r*
Bond, Carrie Jacobs, 1619*sc,* 1621*sc,* 1760*r*
Bond, Victoria, 839
Bonds, Margaret, 356, 843, 882, 1640*sc,*
1673*r,* 1675*r*
Borroff, Edith, 1686*r*
Bosmans, Henriëtte, 621, 1667*r,* 1672*r*
Boulanger, Lili, 609, 625, 653, 751, 842, 1617*sc,*
1619*sc,* 1637*sc,* 1640*sc,* 1653*r,* 1667*r,*
1672*r,* 1680*r,* 1688*r,* 1695*r,* 1696*r,* 1708*r*
Boulanger, Nadia, 457, 842, 883, 890, 1640*sc,*
1703*r,* 1786*av*
Bourgeois culture, 604, 693, 739, 742, 782;
music albums, 758; piano and, 617, 742.
*See also* Salon culture
Boyd, Anne, 1673*r,* 1675*r*
Brahms, Johannes, 150, 616, 1431
Brass, 61, 222, 445; band, 760, 765, 871, 927;
band directors, 70, 111, 441, 446, 565;
composers, 807; Ladies Military Band,
760; repertoire, 7, 568; saxophonists, 440,
447, 806, 1042; trombonists, 440, 454, 459
Brazilian music, 1342, 1344, 1345, 1346,
1347, 1349, 1350; composers, 915; repre-
sentation in, 1455, 1484, 1491
Briscoe, James, 171, 212
Britain, Radie, 1665*r*
Brockman, Jane, 1654*r*
Brown, Ruth, 1795*av*
Bussani, Dorothea, 717
Butler, Jean, 1699*r*

Caccini, Francesca, 609, 618, 631, 635, 710,
720, 1617*sc,* 1650*r,* 1698*r*
Canada, 20, 147, 154, 464, 911; composers,
53, 151, 414, 435, 612; contemporary
musicians, 20, 154; festivals, 201, 248;
French-Canadian composers, 154, 192,
193; music education, 741; radio shows,
337, 355; rock and roll, 971, 1016
Canal, Marguérite, 1619*sc,* 1653*r*
Candeille, Julie, 718, 1625*sc,* 1666*r,* 1673*r,*
1674*r*
Canon, 130, 279, 648, 1744; gender and, 129,
130, 209
Carey, Joan D., 1704*r*
Carreño, Teresa, 747, 792, 1626*sc,* 1664*r,*
1668*r,* 1696*r*

Cello. *See* Violoncello

Central American music. *See* South and Central American music

Chamber music, 272, 781, 858, 873, 881, 1786*av;* nineteenth century, 792; twentieth century, 850; distributors, 1817; festivals, 238; repertoire, 47

Chaminade, Cécile, 308, 609, 625, 631, 751, 1626*sc*, 1637*sc*, 1640*sc*, 1653*r*, 1666*r*, 1687*r*, 1696*r*, 1705*r*, 1786*av*

Childs, Mary Ellen, 1689*r*

Choral music, 1, 20, 39, 47, 1688*r*, 1709*r;* twentieth century, 865; distributors, 1809, 1810; festivals, 280; lay choruses, 862; public singing, 543; repertoire, 30, 327, 328; in universities, 855; women's choirs, 30, 32, 33, 39; women's choruses, 287, 808, 867

Cibbini, Katherina Kozeluch, 1673*r*

Citron, Marcia, 210, 211, 297

Clark, Theresa, 1698*r*

Clarke, Rebecca, 609, 1617*sc*, 1675*r*

Classical music, 69, 1789*av;* gender and, 159; Great Britain, 114. *See also* Western art music

Coates, Gloria, 1678*r*

Cohen, Aaron, 121, 131, 132

Colbran, Isabella, 1616*sc*, 1619*sc*

Composers, 18, 37, 48, 54, 66, 71, 82, 83, 84, 86, 95, 121, 178, 219, 224, 609, 635; sixteenth century, 27; seventeenth century, 27, 720; eighteenth century, 27, 710, 718, 720, 738; nineteenth century, 27, 772, 781; twentieth century, 62, 69, 815, 827, 833, 834, 860; in academia, 365, 478, 479; American, list of names, 747; American Women Composers Midwest, 311; anonymous, 334; for audio/visual media, 407, 876; Austria, 800; avant-garde, 886; Baroque, 357, 1650*r;* Belgium, 205; biographies, 56, 62, 64, 116, 650; Cohen project, 131, 132; competitions, 93, 323, 379, 435, 626, 644, 794, 849; contemporary, 838, 839, 840, 841, 859, 866, 890; in education, 546, 553, 554, 555; Elizabethan, 1663*r;* employment, 72, 74, 78, 96; environmental music, 522, 524, 525; European, 41, 42, 625, 626, 649, 781, 859; feminist aesthetics and, 513, 520, 524, 525; Finland, 205, 640; funding, 435; gender and, 124, 189, 209, 410; history, 590; instrumental, 568, 864; interviews, 650, 651, 652, 653; Italy, 703, 720, 733; Kulturinstitut Komponistinnen, 273; lesbian and gay, 209; Los Angeles, 818; in magazines, 769;

male bias toward, 757, 759; Maryland, 719; Minnesota, 417; minority, 408; motivation and productivity, 423, 424, 425; music education and, 365, 557, 583; National Women Composers Resource Center, 115; Norway, 753; organ music, 22; photographs, 56, 591; psychological theory and, 1421, 1598; repertoire, 15, 47; resources for, 15, 37, 79, 115, 322; reviews, 96, 135, 250; Romania, 205; Romantic, 1666*r;* Russia, 206; score anthologies, 47, 1622*sc*, 1631*sc*, 1634*sc*, 1640*sc;* sexism and, 176, 180, 415, 418, 432, 649; sexual politics, 427; social analysis, 751; Soviet Union, 273, 598; Spain, 1697*r;* status, 426, 427, 433, 434; students, 860; Sweden, 523, 773, 774, 775, 776, 777; Switzerland, 91, 318, 820; technology and, 805; Venice, 702; Victorian, 755, 757, 761, 937; *names of specific composers*, 587, 590, 591, 603, 609, 614, 618, 621, 625, 631, 635, 641, 650, 651, 652, 718, 720, 751, 758, 813, 819, 824, 833, 838, 860, 863, 870, 875, 890. *See also* Composers, Black; International League of Women Composers; *under related headings*

Composers, Black, 15, 40, 149, 194, 797; twentieth century, 888; Chicago, 882; piano music, 51, 141, 356; score anthologies, 1641*sc*. *See also* Musicians, Black

Concerts, 86, 231, 263, 287, 309, 311; aristocratic, 739; European tours of America, 746, 747; impresarios, 791; producers, 240. *See also* Festivals

Conductors, 45, 69, 609, 1692*r*, 1693*r;* twentieth century, 62, 828, 883; band, 111; discrimination, 462; Exxon/Arts Endowment program, 468; Great Britain, 846; minorities, 457; opera, 502; personal narratives, 474; professional concerns, 452, 453, 456, 462, 471; profiles, 62, 828, 846

Conferences, 86, 207, 359, 1804*av;* cultural diversity, 271; feminist music theory, 210, 246, 279; First National Congress on Women in Music, 313; music and gender, 211, 260; New Music Seminar (NMS), 215, 254, 390, 396. *See also* International Congress on Women in Music

Cook, Susan C., 212

Cooper, Lindsay, 1692*r*

Countess of Dia, 1617*sc*, 1663*r*, 1701*r*

Country music, 98, 451, 1130, 1144, 1725*r*, 1758*r;* business aspects, 1137, 1140; ethnocentrism in, 1483; fiddlers, 1132; images

Country music (*continued*)
of women in, 1136, 1473, 1475; lyrics, 1134, 1141, 1142; marketing, 1574; Nashville, 1141, 1147, 1502; old-time and early, 1128; Ozark song tradition, 1130; redefinition, 1127; score anthologies, 1614*sc*, 1615*sc*. *See also* Bluegrass; Folk music
Cox, Ida, 1087, 1090, 1794*av*
Cozzolani, Chiara Margarita, 722

Dance, 740, 935, 1192, 1265, 1462
Davidson, Dianne, 316
Davidson, Tina, 1662*r*, 1665*r*
Davis, Marion, 1723*r*
Degenhardt, Gertrude, 1818
Deihim, Sussan, 1689*r*
Della Pieta, Anna Maria, 134, 706, 707
Demessieux, Jeanne, 1703*r*
Dinescu, Violeta, 1678*r*
Directories, 55, 58, 71
Discographies, 65, 171, 531, 609, 825, 859; twentieth century music, 812, 825; black composers, 51; by composer, 135; electronic music, 875; harp music, 151; jazz, 9, 34, 1032; lesbian and gay music, 63; violin music, 29
Distributors, 55, 58; composers and, 1822, 1823, 1826, 1828; Goldenrod, 314; Ladyslipper, Inc., 1698*r*, 1709*r*, 1769*r*, 1782*r*, 1798*av*, 1825; minorities, 494; Women's Independent Label Distributors (WILD), 488
Dring, Madeline, 1666*r*, 1668*r*, 1669*r*, 1672*r*, 1673*r*, 1674*r*
Drinker, Sophie, 648
Duchambge, Pauline, 1644*sc*

Early music, 281, 332, 542, 648, 702, 1663*r*
Edell, Therese, 1698*r*
Electronic music, 875, 1681*r*, 1689*r*
Epstein, Leslie, 1666*r*
Epstein, Selma, 1664—76*r*
Ethnomusicology, 4, 376, 1204, 1251, 1329; gender and, 1194, 1200, 1203, 1334, 1335; Gregorian chant and, 1197; guidelines for, 1212; historical, 1249; midwifery and, 1211; observer, 1227; power and music, 1202, 1206, 1212, 1255; social boundaries and, 1213, 1214; Soviet Union, 593. *See also* Musicology; Non-Western music
Eubanks, Rachel, 1671*r*

Faisst, Clara, 1652*r*
Falletta, Joanne, 139, 452, 456, 1651*r*, 1708*r*

Farrence, Louise, 609, 625, 781, 1617*sc*, 1637*sc*, 1652*r*, 1673*r*, 1674*r*, 1786*av*
Fay, Amy, 768
Feinstein, Elaine, 231
Feminist aesthetics, 171, 588; body and, 514; female voice, 510; gender and, 127, 512, 518, 523; jouissance, 512; matriarchal, 511, 519, 1192; music as healing, 516, 517; scrutiny of, 518
Feminist theory, 52, 103, 120, 123, 138, 146, 152, 156, 209, 279, 877, 1354; eighteenth century, 1412; on nineteenth century musicians, 768; archetypes, 1466; French, 512; historical approaches, 123; lesbian, 8, 52, 211, 1577; male resistance to, 186; methodologies, 124; music education and, 575; of musical organicism, 150; musicology, 123, 128, 134, 1367; of opera, 1399; periodicals, 8; of popular music, 891, 892, 893; rhetoric of, 279; rock and roll, 1003; social contexts, 122; subcultures and, 1368
Festivals, 10, 58, 71, 86, 96, 229; benefit, 217; Canada, 201, 248; chamber music, 238; Chard Festival of Women Composers, 264; choral, 230, 280, 2320; Columbian Exposition of 1893, 756; documenting, 258; Electric Music Festival, 291; Festival Internationale de Musiciennes Innovatrices, 293; Festival of Women Improvisors, 241, 255; Festivals of Women's Music, 240; folk, 248; Frauenmusik Festival, 286; Goddess Festival: New York Open Center, 304; Greek women, 199; guitar, 276; jazz, 213, 232, 282; in New York, 312; piano, 200; Women Composers Festival at Aspekten, 298; Women of the New Jazz, 232; women-identified, 203, 228, 245, 283, 284, 285, 314, 807, 1159. *See also* Concerts; International Women Composers Festival; Women-identified music
Fine, Vivian, 628, 631, 813
Fitzgerald, Ella, 1085, 1720*r*, 1755*r*
Flute, 3, 49, 90, 618; gender and, 771. *See also* Woodwinds
Flutists, 448, 656, 801, 832; nineteenth century, 623; twentieth century, 879; early European, 754; Georgian age, 711; in orchestras, 461, 463
Folk music, 24, 97, 118, 143, 1201, 1761*r*; Appalachia, 1135, 1185; feminist scholarship and, 1196; Irish, 5, 151, 1133, 1146, 1636*sc*; Kentucky, 1146; score anthologies, 1633*sc*, 1648*sc*; Swedish, 1145; West Coast, 118; Wisconsin, 1146. *See also* Bluegrass; Country music; Non-Western music

Fontyn, Jacqueline, 819, 838, 1637*sc*
France, 134, 172, 735
Freed from Silence: International Festival of
   Women Composers. *See* International
   Women Composers Festival
Fromm, Paul, 415
Fromm-Michaels, Ilse, 890, 1637*sc*
Fuller, Sophie, 211, 288, 297
Funding, 67, 223, 412, 435
Fure, Tret, 316, 1161

Galas, Diamanda, 159
Gambarini, Elisabetta de, 1622*sc,* 1623*sc,*
   1625*sc,* 1626*sc,* 1685*r*
Gardner, Kay, 516, 517, 1654*r*
Gender, 123, 159, 160, 301, 1356; seven-
   teenth-century Florence, 710; nineteenth-
   century Europe, 782; in children's games,
   1209; competitions and, 379; composition
   and, 123, 124, 524, 525, 526; construction
   of, 120, 127, 211, 1422; curriculum and,
   571; emotion and music preference, 1570,
   1576; ethnomusicology and, 1194, 1200,
   1203, 1334, 1335; feminist aesthetics and,
   127, 512, 518, 523; humor and, 1563; ide-
   ology, 1380, 1385; instrument selection
   and, 748, 762; in language/music gap, 153;
   loudness and tempo responses, 1604;
   medieval song and, 697; in Mozart, 1367,
   1384, 1394; music preference and, 1550,
   1552, 1558, 1561, 1568, 1569, 1570, 1571,
   1610; musical subcultures and, 209; music-
   making and, 1202, 1203, 1204, 1205,
   1206; opera queens and, 166; patriarchy
   and, 127; performance and, 182, 1195,
   1198, 1212, 1218, 1226, 1277; popular
   music and, 924; postmodernism and, 137;
   power and music, 1202, 1206, 1212, 1255;
   professional issues, 129, 130, 386, 444;
   sexuality and, 279; spirituality and, 1202,
   1250
Germany, 102, 251, 397, 600; composers, 26,
   43, 176, 205, 411, 591, 620, 772, 833, 885,
   886, 887; exclusion of women from music,
   175. *See also* International Women
   Composers Festival
Giblin, Irene M., 1634*sc,* 1723*r*
Gideon, Miriam, 631, 858, 1617*sc,* 1662*r,*
   1679*r*
Gilbert, Ronnie, 1158
Gipps, Ruth, 1667*r,* 1672*r,* 1673*r,* 1674*r*
Glanville-Hicks, Peggy, 631, 825, 890, 1637*sc*
Glover, Sarah, 761
Goolkasian-Rahbee, Dianne, 1665*r*
Gospel music, 1085, 1086, 1093, 1097, 1731*r*

Grainger, Ella, 1666*r*
Graziani, Catterina Benedetta, 1627*sc,*
   1629*sc,* 1630*sc*
Great Britain, 114; composers, 743, 805, 866;
   conductors, 846; English occupational
   song, 1184; popular music, 913; song, 148,
   721, 1184, 1471, 1487, 1499
Grimani, Maria Margharita, 631, 1627*sc*
Grossman, Deena, 313
Guerre, Elisabeth-Claude Jacquet de la, 609,
   618, 625, 631, 720, 738, 1617*sc,* 1637*sc,*
   1640*sc,* 1650*r,* 1651*r,* 1698*r*
Guitar, 618, 786
Guitarists, 276, 460, 595, 873; American, 810;
   rock and roll, 998, 1014; women's music,
   909

Hansen, Hanna Marie, 1655*r*
Harp, 647, 1076, 1545; construction, 151, 601,
   602
Harpsichord, 22, 854, 1684*r;* score antholo-
   gies, 1624*sc,* 1625*sc,* 1645*sc*
Harvey, Mary, 1650*r,* 1663*r*
Hays, Doris, 313
Hays, Sorrel, 1681*r*
Henderson, Ruth, 1690*r*
Hensel, Fanny Mendelssohn, 195, 591, 609,
   624, 628, 635, 652, 709, 716, 770, 781,
   792, 1617*sc,* 1619*sc,* 1626*sc,* 1638*sc,*
   1640*sc,* 1653*r,* 1657*r,* 1668*r,* 1678*r,*
   1680*r,* 1686*r,* 1687*r,* 1691*r,* 1696*r,* 1708*r,*
   1786*av;* gender and, 518; professionalism
   and, 782
Herbison, Jeraldine, 1665*r,* 1671*r,* 1675*r*
Hill, Mildred, 157
Hill, Patti Smith, 157
Hinkle-Turner, Elizabeth, 1704*r*
History, 610, 641; ancient Greece, 519, 661,
   662, 663, 665, 668, 669, 670; ancient
   Israel, 667; ancient Rome, 668; blues,
   1088; brass, 760; composers, 590; feminist
   aesthetics, 511; France, 682; jazz, 88,
   1034, 1040, 1041, 1042, 1058, 1066;
   medieval Europe, 671, 672, 673, 674;
   Muses, 661; music archaeology, 662; of
   music education, 569; opera, 596, 645;
   popular music, 900; public singing, 543;
   rock and roll, 965; sacred music, 666;
   vocalists, 599; western art music, 171, 590;
   women-identified music, 1162, 1167
Hofer, Maria, 1687*r*
Holiday, Billie, 168, 892, 1051, 1085, 1088,
   1720*r,* 1721*r,* 1755*r,* 1794*av,* 1795*av*
Holland, Dulci, 1668*r,* 1676*r*
Holmès, Augusta, 751, 756

Holmsen, Borghild, 1655*r*
Hoover, Katherine, 1654*r*
Hopekirk, Helen, 744, 789, 1621*sc,* 1668*r*
Hopkins, Sarah, 1664*r,* 1676*r*
Horne, Lena, 1795*av*
Horne, Marilyn, 1789*av,* 1792*av*
Howe, Mary, 840, 1695*r,* 1786*av*
Humes, Helen, 1794*av*
Hunter, Alberta, 1090, 1713*r,* 1721*r,* 1772*r,* 1781*r*
Hyde, Miriam, 1668*r,* 1675*r*
Hymnology, 1371; composers, 50, 527; hymnody, 50, 755, 785; Swedish, 679; textual changes, 1355, 1358, 1359, 1366, 1372, 1376, 1382, 1387. *See also* Sacred music

Iconography, 1532; banjo, 1534; collections, 1529, 1537; of composer, 1538; contemporary, 1525; domesticity, 1530; harp, 1545; Italy, 1527; Marie Antoinette, 1528; Mary Magdalene, 1542; medieval, 1526, 1541; Netherlands, 1531; piano, 1533; Renaissance, 1526; rock and roll, 1536; of singers, 1539; St. Cecilia, 1534; Tintoretto, 1543, 1544
Improvisation, 1717*r;* festivals, 241, 255; jazz, 232, 1038, 1052, 1066, 1081
Instruments: ancient Greece, 1199; banjo, 1535; bourgeois culture and, 604; construction, 487, 507, 1193; gamelan, 1199, 1250, 1258, 1284; imzad, 1225, 1226; kulintang, 1251; music education and, 558; musical bow, 1232, 1235, 1236; non-Western, 1199; Oboe, 19; Portugal, 1294; ritual and, 1193; syrinx, 662; taboos against, 1189; violoncello, 1540
International Congress on Women in Music, 210, 218, 362; Fifth (Bremen, Heidelberg), 218, 265, 302; Sixth, 269, 365; Seventh (Utrecht), 206, 210, 266, 273, 294; Eighth, 296; Tenth, 214; Eastern Division, 299; Lesbian Caucus, 362; merger proposal, 392
International League of Women Composers (ILWC), 266, 313, 363, 392, 394, 401, 430
International Women Composers Festival: Heidelberg, 225, 226, 227, 275, 300, 887; Kassel, West Germany, 242, 257, 261, 262, 278, 303, 306, 310, 391, 607, 885, 886; Salzburg, 244, 298
International "Women in Music" Festival, 252
International Women's Music Festival, 221
Internationales Komponistinnenfestival: *See* International Women Composers Festival

Italy: composers, 703, 708, 720, 733; musicians, 587, 695, 702, 708, 720. *See also* Opera
Ivey, Jean Eichelberger, 813, 827, 839, 1704*r*

*Jane Pickering's Lute Book,* 1698*r*
Japan, 145, 573, 618, 620, 829, 1206; *goze,* 1266, 1269; jazz, 1054; *onna gidayu,* 1257
Jauniaux, Catherine, 1689*r*
Jazz, 69, 117, 149, 171, 247, 1727*r,* 1729*r,* 1732*r,* 1733*r,* 1734*r,* 1753*r,* 1755*r,* 1756*r,* 1757*r,* 1759*r,* 1772*r,* 1781*r,* 1794*av,* 1801*av,* 1805*av;* 1980s, 1048; 1990s, 1049; accompaniment, 1059; all-women's ensembles, 139, 1085; biographies, 1041, 1042, 1044, 1045, 1047, 1050, 1051, 1063; black musicians, 1048, 1052; distributors, 1827, 1831, 1833; Dixieland, 1083; early styles, 1050; European artists, 1078; festivals, 213, 232, 243; fiction and, 1383; in films, 1043; Great Britain, 114; harp, 151, 1076; history, 88, 1034, 1040, 1041, 1042, 1058, 1066; improvisation, 232, 1038, 1052, 1066, 1081; instrumentalists, 34, 1068; International Sweethearts of Rhythm, 139, 149, 1057, 1070, 1781*r,* 1794*av;* Japan, 1054; music education, 542; musicians, 17, 895, 1048, 1068; nonmusicians, 1573; percussionists, 449; piano, 243, 1057; professional issues, 368; recording companies, 321, 351, 358; recordings, 336, 1035, 1036, 1046, 1055; saxophonists, 806; scat singing, 1073; sexism and, 1071, 1079, 1085; sister acts, 1032; Southern, 1061, 1062, 1063; in Sweden, 1037; vocalists, 9, 88, 1031, 1032, 1033, 1039, 1049, 1051, 1066, 1068, 1077; women's exclusion from, 1060. *See also* Blues; Vocalists
Jewish music, 1195, 1217, 1218, 1317, 1325; cantorate, 1219, 1220; Hasidim, 1204, 1205, 1206; Judeo-Spanish songs, 1190, 1191, 1221; Lodz ghetto, 1299; Sephardic, 1206; Yemenite, 1326; Yiddish, 1215
Joglaresse, 684. *See also* Trobairitz

Keyboard music, 466, 762, 1645*sc. See also* Harpsichord; Organ; Piano music
Kinkel, Johanna, 102, 591, 607, 641, 781, 1638*sc*
Kinney, Michelle, 1689*r*
Klotzman, Dorothy, 1679*r*
Kuyper, Elisabeth, 591, 621, 641, 651

Lam, Bun-Ching, 1689*r*
Landowska, Wanda, 890, 1626*sc,* 1687*r*

Lang, Josephine, 709, 781, 1617*sc*, 1638*sc*, 1640*sc*

Lang, Margaret Ruthven, 744, 756, 789, 1621*sc*, 1665*r*, 1666*r*

Larsen, Libby, 631, 864, 1654*r*

Lazarev, Michael, 581

Le Beau, Luise Adolpha, 536, 590, 591, 625, 641, 781, 1638*sc*, 1652*r*, 1675*r*

LeBaron, Anne, 1689*r*

Lee, Peggy, 1051, 1795*av*

Lefanu, Nicola, 180, 211, 288, 297, 410, 478, 635, 866, 1692*r*

León, Tania, 1641*sc*, 1797*av*

Leonarda, Isabella, 332, 609, 618, 720, 736, 1617*sc*, 1640*sc*, 1698*r*, 1700*r*

Lesbian feminist theory. *See* Feminist theory

Lesbian and gay composers, 209

Lesbian music. *See* Women-identified music

Libmann, Maria Hélène, 1631*sc*

Library collections, 12, 27, 68, 89, 320; American, 744; American Memorial Library, 354; archives, 320, 341, 353; British, 6; Internationale Komponistinnen Bibliothek, 340; Mannheim, 26; San Francisco Bay Area, 331; Schmidt, Arthur P., 744

Lind, Jenny, 168, 746, 1618*sc*

Lindeman, Anna Severine, 1655*r*

Lockwood, Annea, 1681*r*

Loeffler, Charles Martin, 831

Lombardini-Sirmen, Maddalena Laura, 707, 718, 720, 736, 1651*r*

Lund, Birgit, 1655*r*

Lund, Inger Bang, 753, 1655*r*

Lund, Signe, 753, 1655*r*

Lutyens, Elisabeth, 635

MacAuslan, Janna, 1698*r*

McBurney, Mona, 1676*r*

McCalla, Deidre, 316

McClary, Susan, 120, 122, 134, 170, 179, 188, 191, 209, 211; on feminist approach, 212

Mack, Ida May, 1713*r*

McLean, Priscilla, 1704*r*

Maconchy, Elizabeth, 635, 1675*r*, 1692*r*

McTee, Cindy, 1704*r*

Mahler, Alma Schindler, 603, 641, 650, 751, 1617*sc*, 1638*sc*, 1640*sc*, 1770

Mamlock, Ursa, 1654*r*

Manziarly, Marcelle de, 1653*r*

Marchesi, Mathilde, 752

Martin, Carolann, 1654*r*

Martin, Eastman, 1786*av*

Martinez, Marianne, 625, 652, 718, 720, 738, 1617*sc*, 1624*sc*, 1625*sc*, 1626*sc*, 1637*sc*, 1640*sc*, 1650*r*, 1651*r*, 1684*r*, 1685*r*

Martinez, Odaline de la, 846, 1692*r*, 1693*r*

Mason, Lowell, 569, 748

Massary, Fritzi, 917

Maxwell, Melinda, 1693*r*

May, Florence, 1666*r*, 1672*r*, 1673*r*, 1674*r*

Mayer, Emilie, 591, 1652*r*

Mendelssohn, Fanny. *See* Hensel, Fanny Mendelssohn

Meyrswalden, Mathilde Kralik von, 759

Mikusch, Margaet von, 591

Millington, June, 572

Molza, Tarquinia, 705

Monk, Meredith, 631, 813, 823, 824, 1797*av*

Moore, Mary Carr, 631, 798, 818, 1640*sc*, 1646*sc*

Moore, Undine Smith, 813, 1641*sc*, 1671*r*

Mozart, Anna Maria, 725

Mozart, Nannerl, 725, 731

Mozart, Wolfgang Amadeus, 574, 712, 714, 715, 725, 734

Musgrave, Thea, 631, 635, 866, 872, 1617*sc*

Music: alternative, 116; criticism, 495, 496; discourse, 159, 162, 209; electro-acoustic, 1704*r*; electronic, 870, 875, 1681*r*, 1689*r*; feminine aesthetic, 130; gendering of, 153; as healing, 516, 517; iconography, 1531; language gap, 153; meaning of, 1531; poetics, 209; political music, 1183, 1184, 1185; as socially constructed, 18. *See also* Non-Western music; Western art music

Music education, 175, 211, 212, 476, 856; seventeenth century, 735; eighteenth century, 735; nineteenth century, 548, 740, 741; Bach scholarship, 767; Canada, 741; career programs, 579; composers and, 365, 536, 583; curriculum, 536, 546, 571, 584; discography, 531; educators, 585, 796; feminism and, 575, 609; France, 682, 735; gender issues, 552; in Gothic Europe, 671; Great Britain, 761; history, 569; instrument selection, 535, 540, 575, 580; Italy, 703, 704; Japan, 573; male role in, 547; materials, 47; medieval, 682, 687; mothers and babies, 564; non-Western music, 542; piano, 796; prenatal, 581, 582, 1607, 1613; professional concerns, 483, 784; Renaissance, 693, 694, 698, 703, 704; secondary, 546, 547; sexual harassment, 539; sound recordings, 1656*r*; student performance, 532, 533, 534; support systems, 578, 586, 632, 633, 634; technology and, 537; textbooks, 538, 541, 545, 549, 550, 559, 566, 575, 628; women's schools, 728, 730, 741. *See also* Universities

Music industry, 119, 372, 373, 395, 484, 906; administration, 372, 395, 484; career preparation, 405, 406; gays in, 922; journalism, 495, 496, 506; minorities in, 405, 573; production companies, 58, 285, 286; sound engineering, 245. *See also* Musicology; Professional issues; Universities

Music therapy, 1582, 1583, 1584, 1611

Musicians, 10, 18, 65, 69, 71, 219, 605, 635; sixteenth century, 702; seventeenth century, 720; eighteenth century, 720; nineteenth century, 69, 781; twentieth century, 62; adolescent, 570, 1585, 1592, 1594, 1596, 1599; amateur, 762, 766, 781; American image, 1369; androgyny and, 1591, 1592, 1597; aristocratic class, 782; biographies, 59, 62, 811; characteristics, 585; charitable efforts, 788; cognitive ability, 1595, 1596; creativity and, 130, 515, 1591, 1592, 1593, 1594, 1595, 1596, 1597, 1598, 1599, 1600, 1601, 1602; criticism and, 130; disabled, 1587, 1588; East Germany, 385; economic status, 69; gender roles, 762; as listener, 130; medieval women's communities and, 671; Mexico, 636, 637; mother/daughter, 177; in nunneries, 708; performance attire, 627; photographs, 154; rock and roll, 25; salon culture, 614, 729; sexism and, 1386; spatial ability, 1591, 1593; support systems, 632, 633, 634; Sweden, 629, 630, 766; testosterone and, 1597, 1602; travel and touring, 404; unions, 874; Venice, 589, 702, 706, 707; *names of specific musicians*, 587, 604, 773, 852, 854. *See also* Musicians, Black

Musicians, Black, 894, 898, 899, 1785*av;* nineteenth century, 764, 793; arts management, 500; blues and gospel, 1084, 1085, 1086; Boston, 793; jazz, 896, 1048, 1052; in orchestras, 450; rap music, 1106, 1125; recordings, 44, 356; rock and roll, 962; Seattle, 798; singers, 655; song and, 897; string quartets, 469; in university curriculum, 1086; vocalists, 764, 897, 1753*r;* Washington, D.C., 845. *See also* Composers, Black

Musicology, 12, 124, 187, 212, 767, 1377; canon and, 648; feminism and, 123, 128, 134, 161, 179, 1367; folklore, 1201; historiography, 122; lesbian music, 125; research, 183, 184; self/Other and, 153, 1201, 1204, 1381, 1427, 1510; Soviet Union, 593; status of musicologists, 482. *See also* Ethnomusicology; Universities

Nathan, Mathilde Berendsen, 1655*r*

Near, Holly, 1155, 1166

Netherlands, 23, 600, 1025; composers, 621, 727, 836, 1655*r*

Niebergall, Julia Lee, 1621*sc,* 1634*sc,* 1723*r*

Non-Western music, 118, 171, 542, 1188—1351, 1198; Afghanistan, 1318, 1319, 1321, 1323; Albania, 1311, 1312; Andalusia, 1310; Bali, 1285, 1288; Balkan, 1308; Bosnia Herzegovina, 1295; Bulgaria, 1307, 1778*r;* conferences, 359; Crete, 1309; Croatia, 1297; Egypt (Cairo), 1320; flamenco, 1292; Greek, 1293, 1300, 1303, 1313; International Council for Traditional Music (ICTM), 208, 359, 386, 1194; Japan, 1257, 1266, 1269; Java, 1275, 1284, 1290; Latvia, 1472, 1490; Libana, 1633*sc,* 1762*r;* Malaysia, 1278; Mali, 1780*r;* Maori, 1273, 1274; Mapuche, 1211, 1213, 1214; Mungiki, 1279, 1280; New Zealand, 190; Papua New Guinea, 1263, 1264; Philippines, 1199, 1251; Portugal, 1294; professionals, 1188, 1234, 1275, 1276, 1277, 1320, 1327; Russia, 1722*r;* Scandinavia, 1301, 1496; shieling, 1301, 1302; Sikh, 1802*av;* Slavic, 1295, 1296, 1297; Solomon Islands, 1199; Soviet Karelia, 1314, 1315, 1316; Sumatra, 1199; Tahiti, 1779*r;* Tonga, 1270; Tukuna, 1207; Yugoslavia, 1298, 1304. *See also* Africa; Asian music; Folk music; North American Indian music; South and Central American music

North American Indian music, 1329—41; Abenaki, 154; Algonkian, 1330; Apache, 1338; California Indians, 1335, 1336; Cherokee, 1334; Cheyenne, 1332; Gros Ventre, 1333; Navajo, 1207, 1331; Ojibway, 1341; Shoshone, 1339, 1340

Olin, Elisabeth, 1650*r*

Oliveros, Pauline, 520, 813, 824, 1617*sc,* 1797*av*

Olivier, Antje, 340

Opera, 104, 393, 619, 816, 1649*r;* seventeenth century, 732; African-American divas, 655; archetypes in, 1403; arts management, 490, 502, 505; Baroque, 723; bel canto, 1426; Bizet, 1430, 1432, 1438; Britten, 1395; Campra, 1434; castrati, 645, 1433, 1440; China, 1267; coloratura scenes, 1439, 1450; composers, 56, 603, 631, 872; construction of gender in, 1388, 1389, 1391—1412, 1415—21, 1425—28, 1430, 1432—43, 1448—50, 1452—54;

contemporary, 835; demise of, 1546; Dessau, 1436; divas, 168, 587, 606, 732, 799, 830, 869, 917, 1375, 1440, 1546, 1658*r,* 1659*r,* 1660*r;* dramatic conclusions, 1389, 1438, 1441; familial eroticism in, 1410; female duet, 657; feminist criticism of, 1399; femme fatale in, 1418, 1420, 1427, 1430, 1448; Florentine, 710; gender and, 529, 728; gothic elements in, 1454; Handel, 592, 1412; Haydn, 1400; history, 596, 645; hysteria and, 1398, 1421; image of women in, 209; Italian, 723, 1436; Leonore role, 1435; libretti, 1440; Lully, 1413, 1414, 1434; Lulu character, 1452; mad scene in, 1439, 1450, 1454; mezzo-sopranos, 594, 844; motherhood and, 1612; Mozart, 715, 717, 1367, 1384, 1394, 1402, 1407, 1408, 1443; opera queens, 166; operetta, 56, 917; professional issues, 367, 645, 1399; psychological issues, 1440, 1581; representation in, 1373, 1411; Saint-Saëns, 1420, 1427; Schenker, 102, 1416; score anthologies, 1618*sc;* sexism in, 1401; sexual ambiguity in, 592; soprano roles, 1425, 1426; sopranos, 844, 1682*r,* 1683*r;* sound recordings, 1649*r,* 1658*r,* 1659*r,* 1660*r;* stereotypes, 654; Strauss, 1362, 1410, 1417, 1418, 1421, 1425, 1449; Tchaikovsky, 1389, 1391; teachers, 752; transvestism in, 645, 723, 1422, 1440; Venice, 732; Verdi, 1415, 1453; Vienna, 917; voice types, 654, 1440; Wagner, 1392, 1393, 1405, 1419, 1421, 1424, 1440, 1442

Orchestras, 568, 927; nineteenth century, 790; arts management, 486; black women in, 450; Chinese, 817; composers, 815; compositions, 79, 864; discrimination, 459, 467; European, 459, 461; First Women's Chamber Orchestra, 238; management, 486; musicians, 443, 444; opportunities in, 448; Orchestrette Classique, 822; professional concerns, 463, 474; score anthologies, 1617*sc;* sound recordings, 1654*r;* string, 47, 48, 597, 707, 1604, 1617*sc;* Talma Ladies Orchestra, 760; United States, 851; violinists, 790; Woman's Symphony Orchestra of Chicago, 804; Women Composer's Orchestra, 220; women's exclusion from, 660; Women's String Symphony Orchestra of Baltimore, Inc., 884. *See also* Women's ensembles

Organ, 22, 643, 863, 1686*r,* 1703*r;* organists, 384, 442, 793; score anthologies, 1632*sc*

Organizations, 15, 55, 58, 96, 137, 363; amateur, 748; American Civil War, 788; Association of Women's Music and Culture, 234; Boston, 748; charitable, 788; Institute for Musical Arts, 572; list, 380; National Endowment for the Arts (NEA), 412, 429; patrons, 171, 793, 837, 850, 857, 1413; Vrouw en Muziek, 253, 836; Women in Music, Inc., 364, 398; women's music clubs, 658, 659, 798, 814, 889. *See also* American music; Distributors; Recording companies; *under related headings*

Oyens, Tera de Marez, 621, 625, 653, 870, 1667*r,* 1672*r*

Paradis, Maria Theresia von, 603, 609, 618, 621, 709, 718, 720, 736, 738, 1617*sc,* 1631*sc,* 1635*sc,* 1667*r,* 1672*r,* 1673*r,* 1674*r,* 1691*r,* 1698*r,* 1786*av*

Parke, Maria Hester, 718, 1623*sc,* 1624*sc,* 1664*r,* 1669*r,* 1675*r,* 1684*r,* 1685*r*

Pasta, Giuditta, 1616*sc,* 1618*sc*

Patronage, 171, 793, 837, 850, 857; précieux movement, 1413

Pedagogy. *See* Music education

Pengilly, Sylvia, 1704*r*

Percussion, 259, 528, 556, 1294, 1767*r;* percussionists, 449, 795, 914

Performance: anxiety, 1579; gender and, 182; injuries, 1580, 1605; performing arts, 72, 73, 74, 75, 113; postmodernism and, 144; practice, before 1600, 696; public/private, 134, 1210

Periodicals, 8, 55

Perry, Julia, 356, 813, 843, 1617*sc,* 1641*sc,* 6631

Pianists: nineteenth century image of, 1369; American image of, 1369; duos, 1699*r;* female aesthetic and, 1379; historical role of, 642; Marin, Susan, 1697*r;* professional concerns, 473; repertoire, 561; Southern United States, 197; stereotypes of, 613; undergraduate, 561

Piano: nineteenth century, 789; in fiction, 1353; iconography, 1533; pedagogy, 796; score anthologies, 1617, 1620*sc,* 1621*sc,* 1623*sc,* 1626*sc,* 1637*sc,* 1638*sc,* 1641*sc,* 1645*sc;* sound recordings, 1661*r,* 1662*r;* as symbol, 617, 776, 783

Piano music, 1664—76*r,* 1680*r;* nineteenth century, 781; twentieth century European, 819; by black composers, 51, 141, 356; distributors, 1813; jazz, 243, 1057; quartets, 1678*r;* solo, 150; soprano and, 1695*r;* Spanish, 1697*r;* trios, 48, 1696*r;* violin and, 1661*r;* violoncello and, 1652*r*

Pierce, Alexandra, 1665*r,* 1667*r,* 1669*r,* 1672*r*

Pool, Jeannie G., 214, 313

Popular music, 25, 77, 151, 939, 941, 1474, 1482; nineteenth century, 1474; 1930s, 1493; African, 16; alternative, 1553; arts management, 493; attraction and, 1572, 1578; construction of gender in, 1455—1500; cultural diversity and, 77, 271; cultural resistance and, 1564; Dominican Republic, 933; fans, 1549, 1556; female gaze, 1555; feminist criticism, 891; French Café-Concert, 923; girl groups, 1711*r,* 1712*r;* Great Britain, 913, 941, 1730*r;* history, 900; images of artists, 1575; musicals, 1461, 1463, 1480, 1489, 1495; photographs, 907, 910; set list, 1554; singers, 901, 903, 904, 905, 936; soul, 1771*r,* 1774*r;* stereotypes and, 891, 901, 906, 920, 924, 932, 943, 944; Tanguera, 1775*r;* Tex-Mex, 1776*r;* vaudeville, 900, 942, 1098

Postmodernism, 138, 142, 144, 514

Postnikoff, Melissa, 1699*r*

Poston, Elizabeth, 1673*r*

Price, Deon, 1690*r*

Price, Florence B., 356, 628, 843, 1640*sc,* 1641*sc,* 1665*r,* 1671*r,* 1679*r*

Price, Leontyne, 655

Professional issues: church musicians, 366; employment, 72, 74, 78, 96, 360; music education, 483; professionalism, 129, 130, 702; profiles of professionals, 361; sexism, 367, 368, 381, 906. *See also* Music industry

Publishing, 46; ARS FEMINA project, 349, 352; ClarNan Editions, 333, 1814; classical editions, 350; Hildegard Publishing Company, 350. *See also* Distributors; Recording companies

Puget, Löisa, 631, 1644*sc*

Purcell, Henry, 728

Queen Blanche of Castille, 1663*r*

Radio shows, 58, 71, 325, 342; Amazon Radio, 347; Canadian, 337, 355; Rubymusic Radio, 337; Sophie's Parlor Media Collective, 345; women's music, 324, 325

Ragtime, 1634*sc,* 1723*r,* 1724*r*

Rainey, Gertrude "Ma," 1085, 1087, 1088

Ralston, Fannie, 1673*r*

Ran, Shulamit, 1662*r*

Ranier, Priaulx, 866, 1637*sc*

Rap music, 491, 895, 903, 1099—1126, 1515, 1553, 1728*r,* 1798*av;* anti-feminism and, 1099; arts management, 491; audience reception, 1551; black feminism and, 1106, 1125; gender and, 1120; hip-hop, 1104; recordings, 1115, 1118; sexism in, 1106, 1107, 1464, 1478, 1479, 1486, 1494; videos, 1121, 1123; women's image in, 134, 1100, 1121

Recording companies, 44, 46, 58, 513, 926; Antone's Records, 343, 1808; ARS FEMINA project, 349; arts management, 492, 503, 504; blues, 321, 351; demo tapes, 335; discrimination suits, 498, 499; jazz, 321, 351, 358; Labrys, 1160; Leonarda Records, 326, 609, 1706*r,* 1707*r,* 1826; management, 492; Nannerl Recordings, 352, 1650*r,* 1828; Olivia Records, 176, 233, 315, 316, 317, 330, 1176, 1796*av,* 1829; Redwood Records, 329, 338, 339, 1166, 1830; Rosetta Records, 321, 336, 358, 1094, 1095, 1831; support of women, 945

Reichardt, Luise, 591, 609, 709, 720, 738, 781, 1619*sc,* 1638*sc,* 1640*sc,* 1691*r*

Reid, Sally, 1704*r*

Reitz, Rosetta, 351, 1095

Renaissance, 694, 701, 1364, 1526; *concerto della donne,* 702, 703, 705, 1356, 1694*r;* dual nature and, 1352; English, 134, 689, 690, 1663*r*

Renié, Henriette, 151

Repertoire: band, 568; brass, 7; chamber music, 47; choral, 30, 327, 328; composers, 15, 47; concertos, 47; flute, 3, 49; harpsichord, 22, 1624*r,* 1625*r,* 1645*r;* organ, 22, 1632*sc;* piano, 561; quartet, 313; selection, 561, 562; string orchestra, 47; violin, 29; voice, 47. *See also* Score anthologies

Representation, 209, 677, 678, 1370, 1530; dualistic language of, 1374; gender and, 1357, 1365; in ladies' magazines, 1360, 1361; Salomé figure and, 1362, 1410, 1418; in vocal music, 693

Richter, Marga, 609, 1654*r,* 1667*r,* 1673*r,* 1674*r,* 1686*r*

Rock and roll, 25, 87, 108, 119, 1770*r,* 1806*av,* 1807*av;* 1950s, 949, 966, 967, 1548; 1960s, 92, 949, 972, 994; 1970s, 1157; 1980s, 1021; 1990s, 949; all-women's bands, 961; androgyny in, 975, 1020; anti-sexist, 348; black groups, 962; Britain, 954, 963, 1017, 1547, 1730*r;* business, 957; Canada, 971, 1016; creative

process, 437, 438; emotions and, 1010; exercise and, 1608; fanzines, 92; feminism and, 948, 997, 1003, 1028, 1157, 1492; gender and, 1017; girl groups, 1711*r*, 1712*r*, 1730*r*, 1766*r*, 1791*av*, 1798*av;* Great Britain, 114; groupies, 1008; grunge, 1012; guitarists, 1014; hard rock, 1012, 1029; heavy metal, 987, 993, 995, 1005, 1022, 1027, 1498, 1562, 1572; history, 965; journalism, 495, 496, 506; lesbians in mainstream, 950; local-level, 970; lyrics, 1456, 1459; Madonna, 159, 168, 987, 993, 995, 1019, 1510, 1511, 1518, 1549; magazines, 952; mainstream, 973; male attitudes and, 1609; Motown, 1766*r;* music videos, 989, 990, 991, 992, 993; Netherlands, 1025; New Zealand, 956; Pacific Northwest, 977; performance postures, 1004; punk, 977, 1002, 1790*av;* Riot Grrrls, 964, 977, 980, 1002, 1018; Seattle, 465; sexism and, 108, 953, 954, 955, 979, 1009, 1456, 1567; sexuality and, 976, 987, 988, 1011, 1462, 1465; social acceptance and, 1567; success in, 951, 955, 958, 960, 968, 969, 973, 978, 986, 999, 1014, 1030; Sweden, 983; teenagers and, 955, 1548; urban pop radio, 1000; women's image, 959, 976, 979, 987, 1006, 1007, 1023, 1026

Rogers, Clara Kathleen, 1621*sc*, 1705*r*

Rossi, Camilla de, 738, 1627*sc*, 1628*sc*, 1629*sc*, 1630*sc*, 1651*r*

Rubin, Anna, 1704*r*

Runcie, Constance, 1665*r*, 1675*r*

Sacred music, 366, 615, 720; African, 16; Benedictine order, 722; Brigittine order, 679, 686; canonesses, 675; *Consecratio virginum*, 688; Counter-Reformation and, 700; Dominican order, 699; Gregorian chant, 1197; history, 666; Madonna image in, 1445, 1446, 1447; medieval religious communities, 28, 674, 682, 687, 700; plainchant, 675; professional issues, 366; religious communities, 638, 639, 687, 688, 708, 741; Slavic, 1297. *See also* Hymnology

Salon culture, 709, 773, 777; précieux movement, 1413. *See also* Bourgeois culture

Samuel, Rhian, 189, 1695*r*

Sandman, Susan G., 1663*r*

Sapphire, 1689*r*

Sappho, 663, 664

Savonarola, Girolama, 699

Scaletti, Carla, 1704*r*

Schröter, Corona, 738, 1631*sc*, 1638*sc*, 1691*r*, 1720

Schumann, Clara Wieck, 536, 590, 591, 609, 628, 635, 653, 709, 716, 749, 770, 780, 781, 792, 1617*sc*, 1626*sc*, 1638*sc*, 1640*sc*, 1657*r*, 1669*r*, 1680*r*, 1686*r*, 1687*r*, 1688*r*, 1691*r*, 1696*r*, 1705*r*, 1708*r*, 1786*av;* professionalism and, 782; students of, 616

Schuyler, Philippa Duke, 1641*sc*, 1665*r*, 1675*r*

Score anthologies, 41, 47, 513; American music, 1642*sc*, 1648*sc;* black composers, 356, 1641*sc;* blues, 1639*sc;* composers, 47, 1622*sc*, 1631*sc*, 1634*sc*, 1640*sc;* distributors, 1813, 1814, 1816, 1819, 1834; folk music, 1633*sc*, 1648*sc;* harpsichord, 1624*sc*, 1625*sc*, 1645*sc;* opera, 1618*sc;* oratorios, 1627*sc*, 1628*sc*, 1629*sc*, 1630*sc;* orchestras, 1617; organ music, 1632*sc;* piano, 1617*sc*, 1620*sc*, 1621*sc*, 1623*sc*, 1626*sc*, 1637*sc*, 1638*sc*, 1641*sc*, 1645*sc;* songs, 1635*sc;* string music, 1617; violin music, 1617; vocal music, 1616*sc*, 1617*sc*, 1619*sc*, 1627*sc*, 1628*sc*, 1629*sc*, 1630*sc*, 1635*sc*, 1638*sc*, 1642*sc*. *See also* Repertoire

Scott, Alicia Ann, 1786*av*

Seeger, Ruth Crawford, 590, 813, 821, 1617*sc*, 1679*r*

Semegen, Daria, 870, 1681*r*, 1704*r*

Shepherd, Adaline, 1621*sc*, 1634*sc*, 1723*r*

Shrude, Marilyn,, 150

Singers. *See* Vocalists

Sloan-Hunter, Margaret, 177

Smith, Bessie, 168, 892, 1085, 1087, 1088, 1098, 1721*r*, 1795*av*

Smith, Julia, 1699*r*, 1786*av*

Smyth, Ethel, 210, 457, 529, 530, 590, 628, 635, 743, 751, 757, 761, 1617*sc*, 1640*sc*, 1669*r*, 1703*r*

Sonami, Laetitia, 1689*r*

Sonata form, 130, 159, 211, 297

Songs, 6, 697, 704, 1406, 1459; seventeenth century, 724; eighteenth century, 724; American popular, 1457, 1458; ballads, 134, 761, 938, 1184, 1458, 1460, 1476, 1485; British broadside, 1487, 1499; cavalier, 1471; childbirth, 1286; children's, 775, 1305, 1470; colonization and, 1247; contemporary, 838, 839, 840, 841; courtly love, 1677*r;* English, 721, 1184, 1471, 1485, 1487; fertility, 1245, 1256; flamenco, 1292; French, 724; funeral, 1228, 1260, 1291, 1314, 1315, 1316, 1317; instruments, 1232; Jewish, 1221; Judeo-Spanish, 1190,

Songs (*continued*)
1191; laments, 1243, 1263, 1264, 1293, 1300, 1303, 1314, 1315, 1316, 1317; lieder, 622, 709, 1635*sc,* 1691*r;* love songs, 123, 704, 1222, 1235, 1254, 1273; lullabies, 1305, 1470; overtone singing, 1232; Parry-Lord theory and, 1295; poetry, 1229, 1231; Rugby, 1500; social structure and, 1192, 1213, 1284; sung poetry, 1246; torch songs, 930; travesty ballad, 1184; Victorian ballad, 761; wedding, 1191, 1198, 1272, 1311, 1314, 1315, 1316, 1317, 1327, 1328; work songs, 1241. *See also* Vocal music; Vocalists

Songwriters, 57, 157, 929; feminist criticism of, 920; French-Canadian, 192, 193

Sound recording anthologies, 41; Baroque music, 1650*r,* 1651*r;* distributors, 1826; early music, 1663*r; Historical Anthology of Music by Women,* 171; music education, 1656*r;* Netherlands, 1655*r;* opera, *r*1660*r,* 1649*r,* 1658*r,* 1659, 1659*r,* 1660*r;* orchestras, 1654*r;* piano, 1661*r,* 1662*r;* violin, 1661*r;*violoncello, 1652*r;* 1652; vocal music, 1653*r*

South and Central American music: Argentina, 1343, 1477; Dominican Republic, 933, 1346; Merengue, 1348; Mexico, 165, 636, 637, 1466, 1467; Nicaragua, 1185; Puerto Rico, 933; Tejano, 1347; Trinidad, 1351, 1481. *See also* Brazilian music

Spektor, Mira, 1786*av*

Spiegel, Laurie, 1704*r*

Spivey, Victoria, 1090, 1713*r,* 1721*r,* 1772*r*

Stirling, Elizabeth, 1686*r*

String quartets, 313, 469, 470, 831, 1678*r;* American String Quartette, 831; Fanny Mendelssohn Quartett, 1678*r*

Strozzi, Barbara, 590, 607, 609, 628, 635, 652, 720, 733, 1640*sc,* 1643*sc,* 1700*r*

Sullivan, Maxine, 1794*av*

Sumner, Melody, 1689*r*

Swain, Freda, 1703*r*

Sweden, 169, 173, 1185, 1488; dance orchestras, 935; folk music, 1145; jazz in, 1037; rock and roll, 983, 1157; salon culture, 729, 773, 777; traditional music, 1301, 1302, 1305, 1306

Switzerland, 91, 318, 820

Szymanowska, Maria Agata, 781, 1617*sc,* 1637*sc,* 1640*sc,* 1666*r,* 1669*r,* 1680*r,* 1687*r,* 1691*r*

Tailleferre, Germaine, 625, 847, 890, 1617*sc,* 1696*r,* 1708*r*

Talma, Louise, 813, 1617*sc*

Tann, Hilary, 1693*r*

Taylor, Avril Coleridge, 1671*r,* 1675*r*

Tegnér, Alice, 775

Tharpe, Rosetta, 1794*av*

Tower, Joan, 628, 813, 864

Transvestism, 916, 919, 921; opera and, 645, 723, 1422, 1440; travesty ballads, 1184

Tremblay, Lucille Blue, 316

Trobairitz, 110, 210, 590, 671, 672, 673, 680, 1444, 1702*r; cansos,* 683; literary aspects of, 681

Troubadours, 1701*r. See also* Trobairitz

Tucker, Tui St. George Tucker, 1681*r*

Turner, Elizabeth, 1684*r*

Universities, 211; nineteenth century, 826; composers and, 120, 478, 479, 536, 545; curriculum, 68, 1086; faculty, 68, 76, 477, 480, 481; independent scholars, 482; libraries, 68, 482; musical canon and, 130; musicologists, 482; orchestras, 864; professional issues, 365, 369, 370, 371; Southern, 197; syllabi, 81. *See also* Music education

Urso, Camilla, 746, 747

Van Appledorn, Mary Jeanne, 1686*r*

Van de Vate, Nancy, 432, 813, 833, 840, 1654*r,* 1662*r,* 1679*r*

Van den Toorn, Pieter C., 188

Van Der Wert, Louise Vogel, 1653*r*

Van Velthuysen, Annie Mesritz, 1653*r*

Vandervelde, Janika, 159

Vannah, Kate, 1705*r*

Vaudeville, 1725*r*

Vaughan, Sarah, 1051, 1720*r,* 1755*r,* 1795*av*

Venice, 589, 702, 707, 732

Vercoe, Elizabeth, 841, 1695*r*

Viardot-Garcia, Pauline, 609, 631, 781, 1616*sc,* 1617*sc,* 1640*sc,* 1644*sc*

Vienna, 660, 917

Vienna Philharmonic, 660

Vieu, Jane, 1644*sc*

Violin music, 29, 779; instrument-making, 487, 507; piano and, 1661*r;* score anthologies, 1617; sound recordings, 1661*r;* trios, 881, 1696*r*

Violinists, 707, 790, 809, 831; country fiddlers, 1132; professional concerns, 458, 472

Violoncello, 268, 1696*r;* cellists, 750, 1540, 1652*r*

Vocal music, 510, 1694*r,* 1700*r,* 1705*r;* before 1600, 696; 1620-present, 292; avant-garde, 824; barbershop, 99; French Baroque, 737; Italian ballata, 677; mezzo-

soprano, 2; pedagogy, 570; popular music, 901; Renaissance, 692, 693; repertoire, 47; score anthologies, 1616, 1616*sc,* 1617, 1617*sc,* 1619*sc,* 1627*sc,* 1628*sc,* 1629*sc,* 1630*sc,* 1635, 1635*sc,* 1638*sc,* 1642*sc,* 1643*sc,* 1644*sc,* 1646*sc,* 1647*sc,* 1648*sc;* sound recordings, 1653*r;* visual arts and, 292; voice types, 701

Vocalists, 148, 587, 1789*av,* 1792*av;* adolescent, 570, 1585; alto, 1586; barbershop, 99; black, 655, 764, 897, 1753*r;* body perceptions and, 1363; breast cancer and, 1606; Canada, 154; castrati, 210, 596, 645, 737, 1433, 1440; children, 560; estrogen replacement and, 1603; falsetti, 737; iconography of, 1526; Italian, 691, 693, 695, 777; Ladies of Ferrara, 691, 702, 703, 705, 1694*r;* male ideal of, 932; mezzo-sopranos, 2; Mozart and, 712, 714, 715; non-Western, 1275; solo, history of, 599; sopranos, 2, 563, 576, 712, 714, 715, 737, 752, 1378, 1695*r;* treble, 701. *See also* Blues; Gospel music; Jazz; Songs; Songwriters

Vogl, Nancy, 316

Wagner, Richard, 102, 166
Wakefield, Mary, 761
Walker, Gwyneth, 1686*r,* 1698*r*
Wallen, Errollyn, 231, 1692*r*
Walpurgis, Maria, 625, 631, 718, 1691*r*
Walraven, Jeanne, 1675*r*
Warren, Eleanor Remick, 1665
Washington, Dinah, 1795*av*
Waters, Ethel, 1795*av*
Wegener-Koopman, Bertha Frensel, 1653*r*
Weigl, Vally, 1665*r*
Weir, Judith, 631, 635, 866, 1693*r*
Westenholz, Sophia Maria, 738, 1631*sc*
Western art music: seventeenth century, 735; eighteenth century, 735; nineteenth century, 153; Baroque, 311, 357, 723, 737, 1650*r,* 1651*r;* early, 32, 281, 542, 648, 702, 1663*r;* formalism, 188; gender and, 134, 159; history, 171, 590; Musica Femina, 250, 360, 618; organicism, 150; recording procedures, 648; Romanticism, 588, 1666*r;* salon culture, 600; sonata form, 130, 159, 211, 297; tonality, 159; women's exclusion from, 130. *See also* Music
White, Delores, 1668*r*
White, Maude Valerie, 1705*r*
Williams, Grace, 866, 1664*r*
Williams, Mary Lou, 1085, 1781*r*
Williamson, Chris, 316, 1787*av*

Women in music, 31, 93, 95, 100, 106, 107, 112, 123, 127, 136, 163, 1803*av;* eighteenth century, 731; 1980–1987, 46; cultural heritage, 1199; films, 38; history, 610, 641; international, 196, 198; as listeners, 130; madness and, 159; as muse, 608; networking, 78; resources, 133; role models, 101; silencing of, 700; special collections, 46; stereotypes, 912; videos, 38; women's studies, 68, 81, 89

Women-identified music, 13, 85, 94, 124, 137, 209, 437, 1149—87, 1153, 1735—51*r,* 1768*r,* 1769*r,* 1787*av,* 1796*av;* acoustic, 118; Alaska, 1154; arts management, 485; Atlanta, 1152; audience reception, 1560; biographies, 1161; Canadian, 918; changes in, 1176, 1177, 1178, 1179; Chicago, 1163; choral, 867, 868, 1159, 1709*r;* communities, 1212; conferences, 362; cross-cultural, 1216; defining, 509, 521; distributors, 1820, 1825, 1829, 1830; Europe, 1173; feminist aesthetics and, 521; feminist criticism of, 891; festivals, 201, 202, 203, 204, 314; fugue, 210; Gulf Coast Women's Music Festival, 237; heterosexuals in, 1175; history, 1162, 1167; humor and, 1149, 1164; immigration laws, 436, 439; instrumental, 1174; mainstream, 950, 1155, 1162, 1178, 1179; management, 488, 489; matriarchy and, 1180; Michigan Womyn's Music Festival, 203, 228, 245, 807, 1159; mother-daughter relationships, 177, 1182; musical theater, 1156; musicALASKAwomen, 295; musicians, 1150; musicology, 125; National Women's Music Festival, 277, 290; North East Women's Musical Retreat, 267; Ohio, 344; opera and, 529, 530; pacifist, 1165, 1166; performance venues, 71; politics, 1166, 1168; punk rock, 1553; recording companies, 176, 233, 315, 316, 317, 321, 329, 330, 336, 338, 339, 358, 1094, 1095, 1160, 1166, 1176, 1796*av;* recordings, 63; Rhythm Fest 1990, 239; sabbaticals, 1169; of Sappho, 663; sex roles and, 1157; sign language interpretation, 1172; Sister Singers Network, 867, 1159; Sisterfire, 284, 285; Southern, 235, 237, 239, 283; Southern Women's Music and Comedy Festival, 235; subcultures and, 338, 339; terminology, 1157; Washington, D.C., 346; as white music, 1151; Wimnfest '89, Albuquerque, 305; Winter WomynMusic I, 283; Women's Way festival, 217; Womonsong Choir, 287, 1159

Women's ensembles, 55, 154; all-women's, 139, 629, 789, 861, 927; Ars Femina Ensemble, 357; Baroque, 357; concert bands, 807; jazz, 1794*av;* Jewish, 1218; Musica Femina, 1698*r;* orchestras, 861, 884; in prison camps, 1800*av;* women's schools, 728, 730. *See also* Brass; Orchestras; Rock and roll; String quartets
Women's Philharmonic. *See* Bay Area Women's Philharmonic
Wood, Elizabeth, 212
Wood, Mary Knight, 1705*r*

Woodwinds, 274, 556, 558, 726, 778, 880; bassoonists, 880. *See also* Brass; Flute, Flutists
Wurm, Marie, 1668*r,* 1669*r*

Yancey, Estelle "Mama," 1084

Zaimont, Judith Lang, 609, 796, 1665*r,* 1723*r*
Zieritz, Grete von, 1686*r*
Zucca, Maria, 1666*r*
Zumsteeg, Emilie, 709, 1638*sc*
Zwilich, Ellen Taaffe, 609, 628, 812, 813, 864, 1617*sc*